Italian Renaissance Art

Second Edition

D0165902

Volume I: 1300–1510

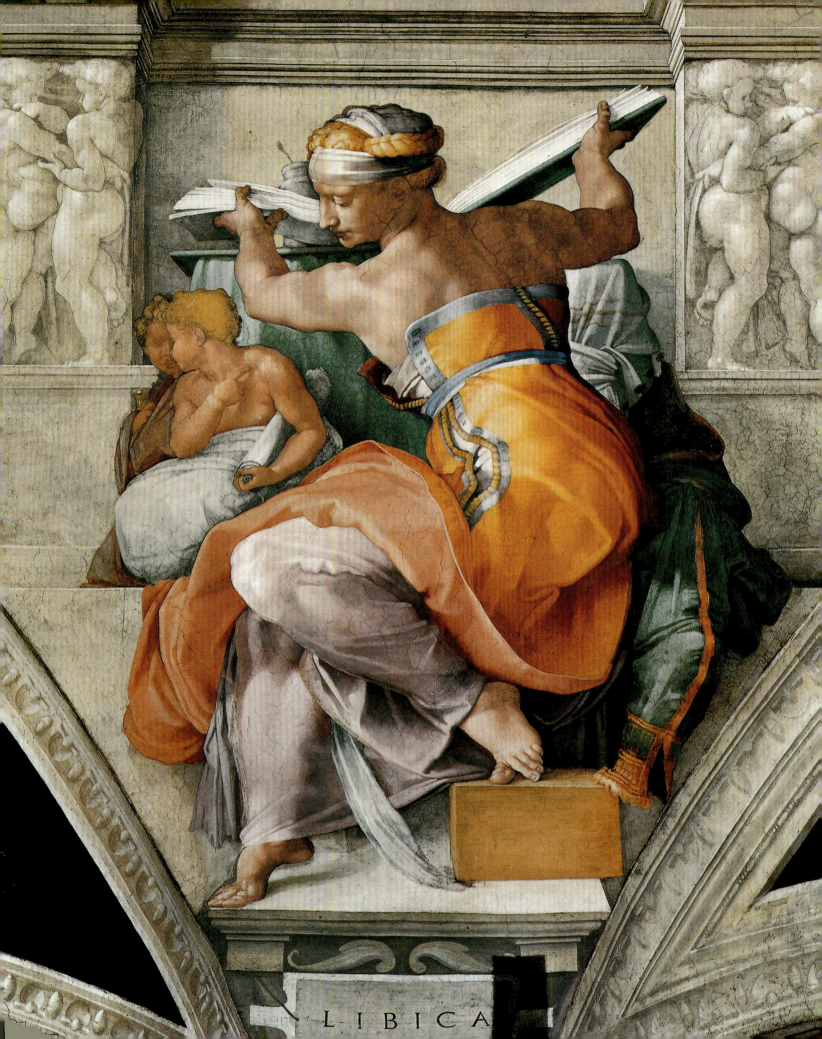

LIBICA

Stephen J. Campbell and Michael W. Cole

Italian Renaissance Art

Second Edition

Volume I: 1300–1510

858 illustrations

Thames & Hudson

To Our Teachers

On the cover: Paolo Uccello, *The Battle of San Romano* (detail), *c.* 1436.
National Gallery, London/akg-images
Half-title and title pages: Michelangelo, Sistine Ceiling, detail: *Libyan Sibyl*

Italian Renaissance Art © 2012 and 2017 Thames & Hudson Ltd, London

Text © 2012 and 2017 Stephen J. Campbell and Michael W. Cole

All Rights Reserved. No part of this publication may be reproduced or transmitted
in any form or by any means, electronic or mechanical, including photocopy,
recording or any other information storage and retrieval system, without prior
permission in writing from the publisher.

First published in 2012 in paperback in the United States of America by
Thames & Hudson Inc., 500 Fifth Avenue, New York, New York 10110

Revised edition 2017

thamesandhudsonusa.com

Library of Congress Control Number 2017937586

ISBN 978-0-500-29332-4

Designed by Christopher Perkins

Printed and bound in China by C&C Offset Printing Co. Ltd

LUTHER COLLEGE LIBRARY
University of Regina

Contents

UNIVERSITY COLLEGE LIBRARY

Preface to the first edition

We would like to express our gratitude to our editor, Ian Jacobs, for his support of this project over the past seven years; his experience, open-mindedness, and good judgment resulted in a much better-conceived text than we would otherwise have written. We also wish to thank Richard Mason for his patient copy-editing, Mari West for her resourcefulness in the acquisition of illustrations, and Lucy Smith for her commitment to seeing the best possible book through to publication. We are aware that others behind the scenes at the press – a designer, a mapmaker, a fact-checker, and a proof-reader among them – devoted their considerable skills to the volume along the way, and we feel fortunate to have been able to work with the whole Thames & Hudson team.

Many colleagues provided guidance and advice about the organization of the book and our treatment of particular artists and works. We are extremely grateful to the numerous anonymous readers who drew on their art-historical expertise and on their teaching experience to comment on the proposal and on drafts of chapters. Francesco Benelli, Morten Steen Hansen, Megan Holmes, Monique O'Connell, Mark Rosen, Luke Syson, and Madeleine Viljoen all generously answered specific questions we posed to them as the book neared completion. A group of undergraduates from Johns Hopkins University and Williams College, finally, provided valuable insight from the point of view of student readers: Trillia Fidei-Bagwell, Sofia Finfer, Hanna Seifert, and Matthew Turtoro.

Preface to the second edition

This second edition of the book substantially expands our survey of fourteenth-century art, a field with remarkable monuments, an excellent literature, and all too few specialists. We have revised our treatment of a number of artists, including especially Leonardo da Vinci, and increased our coverage of the peninsula, particularly Southern Italy. For the new edition, we have also prepared an appendix explaining the key materials and techniques used by Renaissance artists; meanwhile the historical account of making remains a major leitmotif in the main part of the book. The new edition includes several new text boxes, many new illustrations, and a host of smaller changes.

In preparing this second edition of our book, we benefited from correspondence with Bruce Boucher, Rachel Boyd, George Gorse, Morten Steen Hansen, E. J. Johnson, Fernando Loffredo, Lia Markey, Daniel Wallace Maze, Jonathan Nelson, and Patricia Simons – and received feedback from Thames & Hudson's anonymous reviewers – who pointed to errors, offered advice on various passages and otherwise helped us to improve our text. At Thames & Hudson, we owe thanks once again to Lucy Smith, as well as to Jasmine Burville and Annalaura Palma.

While we are gratified to see that a number of the topics on which we focused in the first edition – including the Renaissance dialectic of repetition and originality, the travels of artists, the relationship between the individual maker and the workshop, and the nature of "popular" art – continue to generate a rich literature, we have modified our bibliography only where it was necessary to indicate new sources and debts.

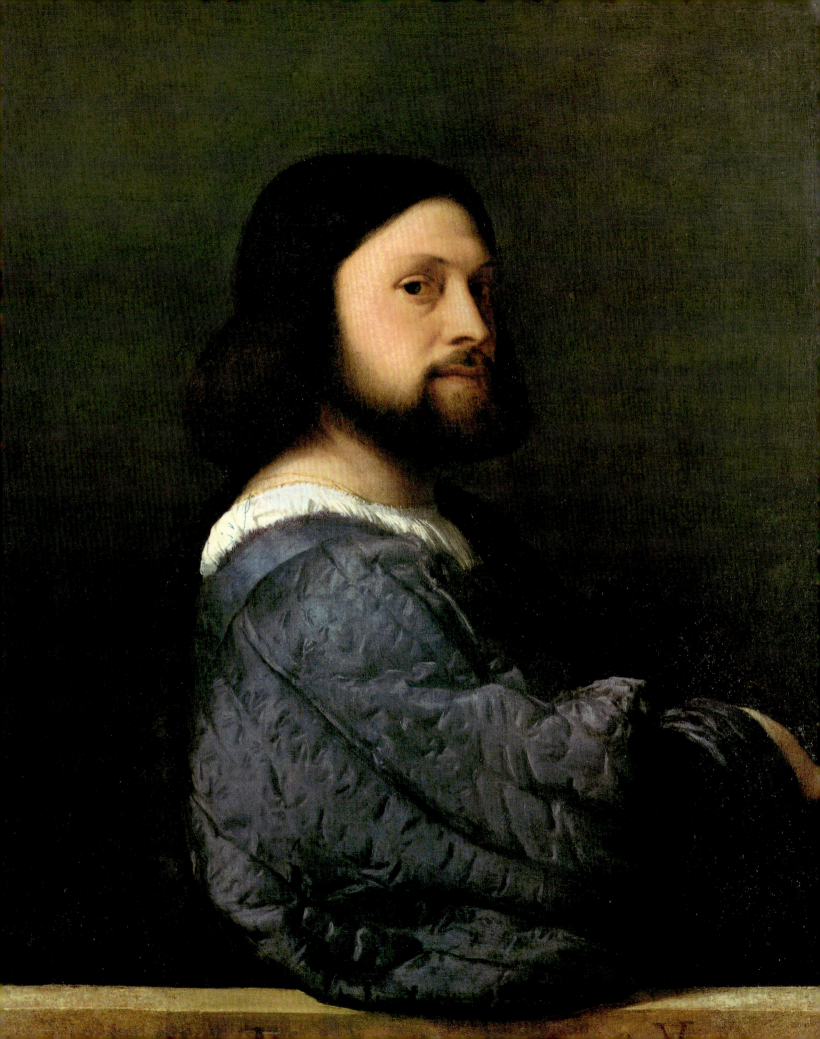

Introduction

Introduction to Volume I

Looking Back, Looking Forward

The art we now present in our university courses and display in our galleries and museums is more diverse than ever before. A global, cross-cultural frame of reference, comprising the multiple traditions that represent our various roots, has largely replaced a single coherent tradition centered on Europe. Yet despite this, the art produced in Italy half a millennium ago maintains a surprisingly strong presence in our shared landscape. The painter Leonardo da Vinci, the architect Filippo Brunelleschi, and the sculptor Donatello provide the central focus for popular films, blockbuster novels, and TV series. A single restored bronze by the sculptor and painter Andrea del Verrocchio, brought to the United States, can draw crowds to museums in any city. The attribution of a new sculpture or painting to Michelangelo, however spurious, makes local newspapers everywhere. Tourists who might not frequent their local galleries will cross an ocean to look at paintings by Botticelli and Raphael. Italy's major art-history research centers today host a strikingly international community of scholars.

Artists in fifteenth-century Italy already recognized that they were doing something remarkable, and when they set out to say what it was, they frequently explained their accomplishments with reference to antiquity. Among the first post-classical art treatises, for example, is Lorenzo Ghiberti's (c. 1378–1455) *Commentaries*, written around 1440. Ghiberti, a goldsmith, began by compiling material from ancient authors about the famous artists of the distant past, implying that this was what provided the foundation for knowledge and study in his day. He then went on to place his own art in relation to that of the previous two centuries, when his immediate forerunners had begun to rediscover art's lost "true principles." To Ghiberti, the present could be explained by organizing history into a simple sequence: first, the period of the Greeks and the Romans, when painting and sculpture flourished in nobility and "perfect dignity"; second, a moment in the early stages of Christianity when Christian zealots, led by Pope Sylvester, sought to obliterate the idolatrous cult images of the pagans; third, the "Middle Ages" that followed this destruction of paintings and sculptures, along with "the commentaries and books and outlines and rules

that gave instructions in so worthy and noble an art"; and finally, Ghiberti's own age. His heroic and mythic narrative provides a basis for what we call the "Renaissance" (the French word for "rebirth").

Such stories, with their trajectory of artistic loss and cultural recovery, exercised a powerful grip on the imagination of subsequent writers. To others, however, it has seemed that the importance of Italian art after about 1400 lay not in its return to origins but in the emergence of something entirely new and characteristically modern – the idea of art itself.

Related to this was an interest in the makers of the new art. For example, long sections of Ghiberti's *Commentaries* take the form of artists' biographies. No one since antiquity had written a history of art around the lives of those who made it, though a number of later writers followed Ghiberti's lead, including Giorgio Vasari, whose *Lives of the Artists* (1550, revised and expanded 1568) remains our single most important source of information on the entire era. In turn, Vasari's approach to history, in which he organized his account of painting, sculpture, and architecture around the experiences and intentions of individual makers, has remained the most powerful model for the writing of art history in the centuries since. Indeed, it has become difficult to imagine how we might think about the objects in our museums if we did not consider them as works created by particular individuals, though such a way of thinking may not have predominated in Europe in the centuries preceding Ghiberti, and it has been rare in many cultures around the world. The very idea of "the artist" was something to which Ghiberti and his contemporaries were giving new emphasis, even reinventing, as they thought about their own world in relation to a vanished past.

The invention of the artist has broad consequences: once we think of a painting as an "authored" work, we are apt, for example, to identify it with the style that for us defines its artist's "look," and to associate the work with specific and timely biographical circumstances. This book will frequently go down such a path, though we should remember that throughout the two centuries it covers, the idea of an art willed into being by artists competed with other possibilities: that a particular work's contents and appearance had been dictated by

0.1
Paolo Veronese, frescoes at
Villa Barbaro, 1560–61

the patron who ordered it, for example; that the work adhered closely to shared and expected formal conventions; or that it was produced by a team or workshop in which no single maker predominated.

The artist's point of view was but one of a number of ways of understanding a painting, sculpture, or building. To many viewers, images served as important vehicles of connection with the supernatural, even as active agents of divine power. To others, they were testaments to the devotion of the people who commissioned them, commemorations of an individual or a family, soliciting prayers on their behalf from a wider public. Much of this book will focus on the ways in which individual objects crystallized these concerns, relating them to or playing them off against one another. How, it will ask, did the artistic knowledge manifest, say, in illusionistic techniques or an awareness of the ancient past matter for the power of images, as historical viewers perceived this? How did works occasioned by devotional circumstances also express or pursue practical, worldly, and even political concerns?

New Technologies and Theories of Art

The legacy of the Renaissance lay not just in this conception of the artist but also in the chief preoccupations of the arts themselves. Fifteenth-century Italy (and fifteenth-century Europe more broadly) witnessed the introduction of a group of technologies and formats that would quickly attain a newly elevated status. These

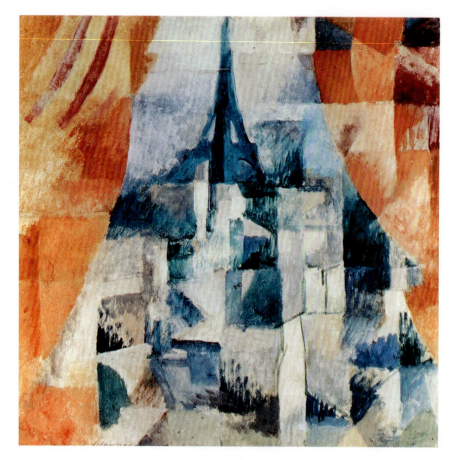

ABOVE

0.2

Robert Delaunay,
Simultaneous Windows
(2nd motif, 1st part), 1912.
Oil on canvas, 21⅝ × 18¼"
(55.2 × 46.3 cm). Solomon
R. Guggenheim Museum,
New York

RIGHT

0.3

René Magritte, *The Human
Condition*, 1933. Oil on
canvas, 39⅜ × 31⅞ × ⅝"
(100 × 81 × 1.6 cm).
National Gallery of Art,
Washington, D.C.

Factory at Tortosa of 1909 (fig. 0.4) does not so much reject a Renaissance way of doing things as quote it, making the building blocks of the Renaissance painting serve a new function.

Perhaps most importantly, the Renaissance developed a twofold sense of what all serious art had to involve, one that has shaped nearly all art since. On the one hand, it regarded art as something that originated in its maker's mind. When Raphael wrote that he started painting with a "certain idea," when Michelangelo described the sculptor pursuing the "concept" contained in the block of stone, or when Vasari reduced painting, sculpture, and architecture to a principle of "design," these artists were asserting that their labor was not merely manual but also intellectual, in some cases even that it was *primarily* a work of thought, such that the physical task of execution could be left to others. On the other hand, and to a certain extent in direct opposition to this, the Renaissance regarded art as an opportunity for manual showmanship. Every Renaissance artist went through a workshop apprenticeship that lasted for years and cultivated a degree of technical skill that his successors today have all but lost. The training focused on the student's capacity to do the same things his master could, so that the youth could disappear into the elder's projects.

By the time Ghiberti was writing his *Commentaries*, young artists had also come to recognize a value not only in advertising their skills but also in individualizing the hand behind the work, even manufacturing the

included the oil painting, executed on canvas at an easel; the drawing in ink, chalk, or pastel on paper; the medal; and the print. In some cases, these media replaced earlier ways of doing things: as we will see, oil supplanted the earlier egg-based tempera painting, for example, and canvas gradually took over the role of the wooden panel. Other formats with more continuous histories, such as the small bronze and the marble statue, became a focus of attention in the same years in a way that they had not for centuries before. Into the early twentieth century, being an "artist" usually meant making the sorts of things that fifteenth-century Italians had introduced.

Moreover, it was not just media that mattered to artists after the Renaissance, but also what Renaissance artists did with them. For example, modern works as varied as Robert Delaunay's *Simultaneous Windows: Eiffel Tower* of 1912 (fig. 0.2) and René Magritte's *The Human Condition* of 1933 (fig. 0.3), among others, wrestle with an idea invented by the author, artist, and architect Leon Battista Alberti in the 1430s, that a painting was like a window, that one should approach its surface as something one looked through, at what lies beyond (fig. 0.1). Pablo Picasso's early Cubist works (1907–9) depend on a group of other devices – *chiaroscuro* (light/dark contrast) and orthogonal projection (diagonal lines that appear to recede into space) – that Renaissance painters and sculptors had used to construct illusions of three-dimensionality. Such a painting by Picasso as *Brick*

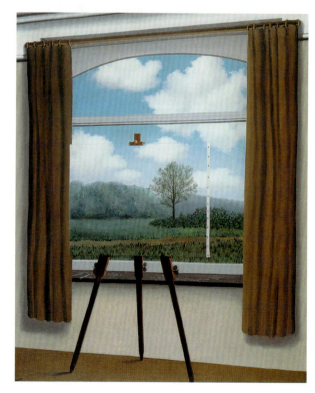

work in such a way as to draw attention to the process that had produced it. The colossal bronze that demanded ingenuity and finesse to cast, the unfinished marble that reminded viewers of the block from which it had come, the highly worked oil painting that indexed a confident, almost athletic handling of the brush – these, too, were touchstones of Renaissance art, and often the products of the same artists who insisted that art be a display of thought.

We might well begin, then, with both a retrospective and a prospective account of the period this book examines, with an art that claimed to replace or surpass what had been lost centuries before even as it set the stage for Modernist movements in the twentieth century. Indeed, recent scholars have debated whether the centuries this book considers are better regarded as a "Renaissance" (a period distinguished by cultural achievement from the centuries that preceded and followed them) or as the beginning of an "early modern" period that ended only with the social and technological transformations of the late 1700s. With our title we are using a conventional designation for the period rather than taking a position on this question: throughout, our text will attempt to acknowledge both perspectives.

1300 to 1510

Our main story begins in 1400 (in chapter 2), and looks back at the preceding century (chapter 1) from that point. This is not a completely arbitrary choice: 1400 is roughly the date of Ghiberti's earliest sculptures, and, in part because of this, it is the moment that Vasari, looking back from around the 1550s, regarded as a watershed, when the arts finally left their "childhood." Still, the concerns we have been introducing so far did not represent cultural novelties so much as new priorities. Some medieval painters and sculptors already looked to the distant past, and some certainly regarded themselves as "artists" of a sort that Ghiberti would have found familiar. By around 1300 some were employing such devices as perspective, which would become hallmarks of Renaissance art. As already noted, new technologies, such as oil painting and printing on paper, set the Quattrocento (the fifteenth century) apart from earlier periods, and the period covered by this book witnessed a dramatic escalation both in the production of art and in its variety. Beyond this, however, the most we can probably say is that things that were once exceptional came to be the norm – and even that is sometimes difficult to judge. We should not overlook those instances in which continuities with the so-called "Middle Ages" stand out more than any return to antiquity or heralding of the future.

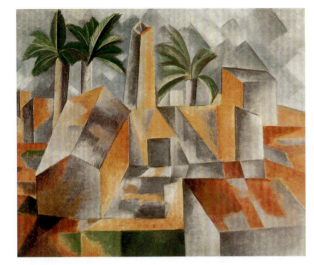

0.4

Pablo Picasso, *Brick Factory at Tortosa*, 1909. Oil on canvas, 20 × 23¾" (50.7 × 60.2 cm). State Hermitage Museum, St. Petersburg

Through the period covered by this book, images were developing as a sophisticated medium for conveying complex ideas in a synthetic and memorable form. And this brings us to a theme that will recur frequently: the fact that artists, with encouragement from patrons and viewers, increasingly sought to explore the relationship between images and words, considering how the capacities of each might differ from, and overlap with, the other.

The Sienese painter Simone Martini was one of the first artists in Europe to be celebrated not just as a craftsman who rendered what could be seen but also as a poet who created from his imagination. The acclamation came from Francesco Petrarca (Petrarch; 1304–1374), one of the greatest poets in the Italian language, who knew Simone at Avignon in southern France and composed two sonnets on a portrait by Simone of Petrarch's dead beloved, Laura. Simone, according to Petrarch, had painted the picture with a poet's visionary power, apparently without seeing the lady herself. He also decorated the frontispiece for Petrarch's copy of the major poems by the great Latin poet Virgil (70–19 BCE; fig. 0.5).

On this folio Virgil looks to the stars for inspiration, reclining beneath a laurel tree that represents at once puns on the name of the dead Laura and also the branches from which the ancients fashioned poets' crowns. To the left, Servius, a late classical commentator on Virgil, figuratively "draws the veil" away to make the poet's text more clear to various readers. An inscription paraphrases the allegory: "Servius, speaking here above, uncovers the secrets of Maro [i.e. Virgil], that they may be revealed to leaders, shepherds, and farmers." Ostensibly, this identifies the poems' threefold audience, though a knowledgeable viewer would recognize that the three figures also designated the estates represented in Virgil's three great poems: soldiers in the epic *Aeneid*, shepherds in the pastoral *Eclogues*, and farmers in the

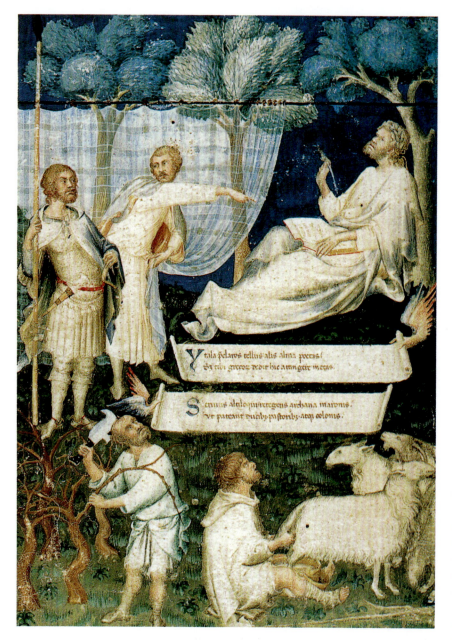

0.5

Simone Martini, frontispiece to Petrarch's Virgil, *c.* 1336. 11⅝ × 7⅞" (29.5 × 20 cm). Biblioteca Ambrosiana, Milan

Such images as Simone's frontispiece demonstrate that the idea of a "Renaissance" was one that artists as well as poets could cultivate – and well before 1400 – by associating themselves with the authority of the ancient past and with the eloquence of poetry. While many of the conventional designations that scholars have used to denote broad periods in the history of art – "Baroque," "Rococo," "Gothic" – originated as pejorative terms, Petrarch's elevation of Simone's painting into something like an emblem of an age appears to get close to the artist's own intentions. Simone's interests, moreover, were by no means eccentric, especially in the centuries that followed: Botticelli's *Primavera* (*c.* 1482; *see* fig. 9.24), Andrea Mantegna's *Parnassus* (1497; *see* fig. 11.4), Raphael's *School of Athens* (1510–11; *see* fig. 12.50), and even the Early Christian revival of the later sixteenth century, as we will see, sustain the myth of a lost origin restored in the present.

This book proposes to take that myth seriously, though not quite at face value: there is too much that it does not account for. The dramatic rise of artistic production in the fourteenth and fifteenth centuries followed from a complex set of economic, political, religious, and other causes, many of them remote from any imperative of cultural renewal. Few observers of the arts in the two centuries after 1400 would have agreed that the primary purpose of painting, sculpture, or architecture was to proclaim the progressive skills and ingenuity of artists, a basic aspect of the Renaissance myth. Most truly misleading, perhaps, is the myth's theme of a "return" to the past; more often than not, the appeal to ancient origins was a means of seeking sanction for doing something decidedly new. It is probably more valid to consider the art of the 1400s and 1500s as establishing an agenda, setting in motion a series of concerns about representation and about art that persist into the present. The most fundamental legacy of Renaissance art, more than the principle of "revival," is the idea of a work of art pointing beyond itself to other objects and images, some of them located in an imaginary and largely invented past: the idea of art as a dialogue, where works always show a consciousness of other works, with which they actively compete. This demanded beholders who were capable of making the comparisons, an interested public that could comprehend art as a field of non-professional knowledge.

didactic *Georgics*. Another inscription, finally, proclaimed an essential affinity and equivalence not only between painting and poetry but also between Virgil and Simone: "Mantua made Virgil, who composed such verses; Siena [made] Simone, whose hand painted them."

In the eyes of cultivated witnesses like Petrarch, the heirs of the great ancient poets were the great artists as well as the writers of his time. Although he sometimes took a more negative view, stressing the limitations of an art that he saw as working through the sense of sight rather than through the intellect, Petrarch suggested that painters could communicate through images just as a poet could through metaphors and other figures of speech.

The Book and Its Structure

This book is a survey, a history of art in Italy and art made by Italians abroad. This first volume of the book covers the years 1300 to 1510; the second volume, available separately, takes the reader from 1490 to 1600. We have aimed to be comprehensive though not encyclopedic; we have

made choices in, and set limits to, what we cover so as to be able to focus on individual objects and monuments.

One of the reasons we have organized the book as we have, following a neutral chronological sequence of decades rather than building chapters around the careers of the leading individuals, is to underscore the limits of the biographical approach and to allow attention to the alternatives. We wish to emphasize that the writing of history is the making of a narrative, and that different stories can be told about any of the works we discuss: the life of its author, the interests of its buyer, or patron, the tradition behind its subject matter, the responses of its audience, and so on. Dividing the book into chapters that each cover a single decade has posed challenges – some decades simply seem more important than others, for example, requiring chapters of unequal length – but the approach also offers a number of advantages. For one thing, the arbitrariness of a decade-by-decade story allows us to avoid the impression that retrospectively constructed periods (the "High Renaissance," "Mannerism") had some determining influence on human behavior. For another, it allows us to compare works produced simultaneously in different Italian cities, characterizing what is most distinctive in local traditions and practices while also highlighting essential common ground – for instance, the striking and seldom examined tendency of regional cities in the mid Quattrocento to emulate Rome, or the building and ornamentation of city squares throughout Italy in the mid Cinquecento (1500s). Our approach enables us both to underscore the significance and meaning of particular architectural sites and to track the changing artistic geography in a given period.

Finally, by following a neutral chronological sequence of decades rather than building chapters around leading individuals, we hope to emphasize the limits of the biographical approach and allow attention to the role of patrons, the importance of expected formal conventions, and the teamwork exemplified by the workshops of major artists. Thus, anyone wanting to read about Donatello, who lived from *c.* 1386 to 1466, will need to look at several different chapters of the book. Whereas it might seem more convenient to present his work together, there will be a clear gain in understanding the sculptor's work in relation to artistic and historical transformations over time, and to a shifting series of contexts: public and domestic, sacred and secular, the city of Florence and the Venetian territorial state.

Each chapter aims to bring out the circumstances and expectations that define the historical moments at which works were made, the issues and concerns that even quite different contemporary objects and monuments shared. Thus, every chapter has a theme, one that the works made in a particular decade lend themselves particularly well to exploring. We do not mean to suggest, however, that the issues identified in our titles are the only ones that mattered at that moment, or that such issues have only momentary relevance. Indeed, the topics of our chapters more often than not point to key aspects of art across the period; highlighting a single broad theme in each chapter enables us to observe historical patterns and to introduce complex topics to which later chapters will return. Occasionally we have loosened the chronological boundaries of a chapter for the sake of drawing connections between material, though we have resisted the temptation to do this often.

The thematic structure prohibits the book from giving an entirely neutral account of the art, or from approaching objects with a consistent set of questions from one chapter to the next. We do hew closely throughout, however, to issues that are central to our own scholarly interests and to what we regard as the most vital tendencies in contemporary scholarship on Renaissance art. These include the status of the image: the lingering importance of the icon, the invention of the *historia*, the allure and dangers of the idol. They include the Renaissance concern with place and placelessness, the significance of site to meaning, and the changing geography of the period. We look at ways in which makers and patrons came to regard art as a kind of knowledge, whether they understood it as a place for empirical record-making or as an aspiring science, one related to other emerging modes of visual description. We consider how works of art addressed or enfolded an anticipated beholder.

Most of all, perhaps, we describe objects as examples of *artifice*: we focus on the technical skill and the very *art* of making them. We suggest that objects and their *madeness*, the nature of their physical workmanship – their media, materials, and handling – became the subject of some of the most notable works of Renaissance art, frequently to a degree that reinforces and enriches other meanings of the work. The production of images in Renaissance culture was driven by the memory of previous images and controlled by often unspoken assumptions about format, genre, and type. Historical transformation played out not only as a sequence of discoveries and innovations, but also as a gradually changing notion of the relation of the Renaissance artist to the work at hand, a changing sense of what authorized or legitimated the act of making (variously, divine truth, truth to nature, emulation of the ancients, and the fashioning of the artist as an author). This self-reflexive dimension to works of art sustains a rich historical narrative of its own, which we seek to bring into view alongside narratives about patrons, institutions, and religious practice.

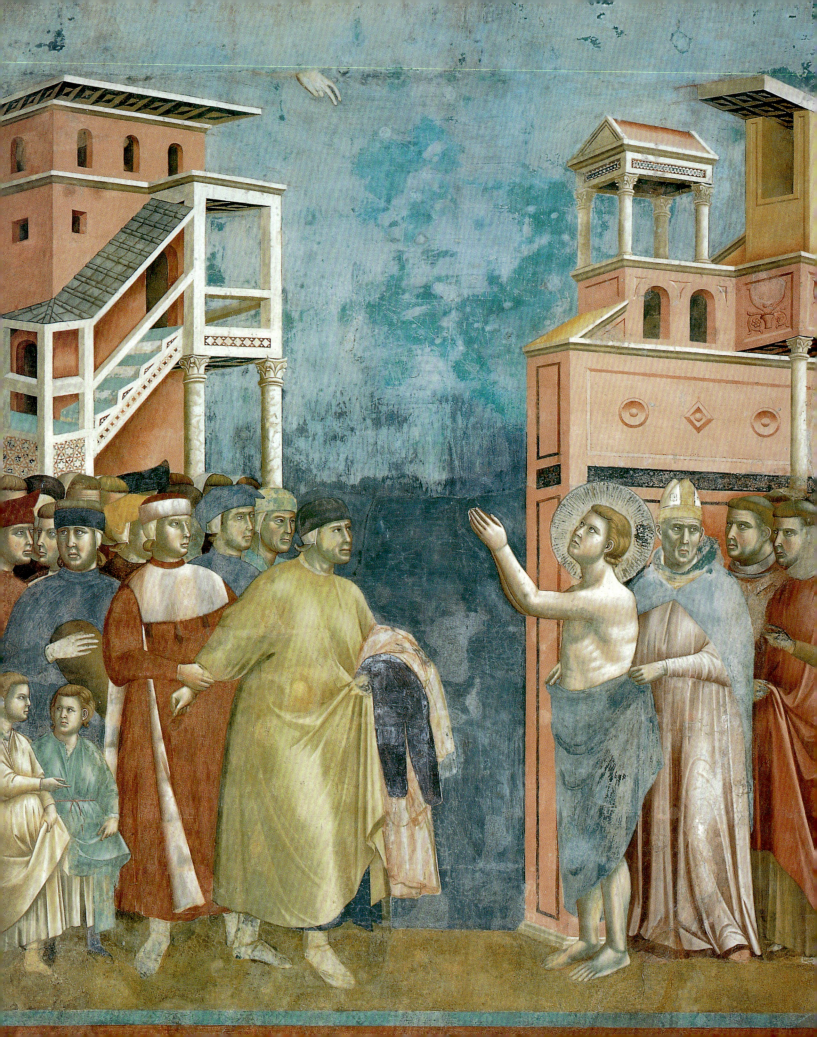

1300—1400
The Trecento Inheritance

<div style="text-align: right; font-size: 2em;">1</div>

1300–1400
The Trecento Inheritance

Political Geography and the Arts

What kind of a world awaited the craftsman who arrived on the scene at the end of the fourteenth century, or **Trecento**? An answer to that question probably depends on just where that craftsman arrived. This book's title refers to "Italy," although no such country existed at any point during the centuries this book treats – the idea of nations took hold in Europe only in the eighteenth century, and the country of Italy with its more or less current boundaries dates only to the late nineteenth century. In the years leading up to 1400, most of what we now call Italy was divided between three large interregional pow-

ers that vied for power and influence (*see* map, p. 63). To the north was the **Holy Roman Empire**, which claimed the inheritance of the ancient domain of the Caesars and at least nominally controlled all of present-day Belgium, Germany, Switzerland, and Austria; its theoretical claims to rule extended as far south as Florence and Siena, although many northern Italian city states asserted their practical independence as early as the twelfth century. Further south were the **Papal States**, over which the Pope in Rome maintained not just spiritual but also temporal rule. Beyond the Papal States was Naples, which was both a city and a kingdom, encompassing the whole lower part of the peninsula. South of this, finally, was the large island of Sicily, which in the medieval period was ruled in alternation by dynasties originating in what we know today as Germany, France, and Spain. Territories and their boundaries were subject to dramatic change: in the fifteenth century, the Kingdom of Aragon, centered in Spain, would unite the kingdoms of Naples and Sicily. Florence and Milan would engage in campaigns of territorial expansion, absorbing their neighbors and forming regional blocs of influence; and Venice in the north-east would become a true empire in its own right, reaching south and east along the Adriatic coast, into what is now Greece. It is worth remembering throughout that when artists moved from one city to another, they were often going to a place with a different government, different customs, and even a different language.

In 1400, as today, wealth was concentrated in the north, allowing for more lavish patronage and for more expensive decorative projects; the economy there was mercantile, by contrast to the largely agrarian south. The north also held most of the major population and artistic centers. Painting, sculpture, and architecture often served there as an outlet for regional rivalries, as communities tried to outdo one another in their monuments no less than in their military adventures.

Architecture and Place

A city's location often had consequences for the look of its buildings and art. When Florence began erecting newly monumental and permanent civic buildings in the thirteenth century, for example, it faced them with a

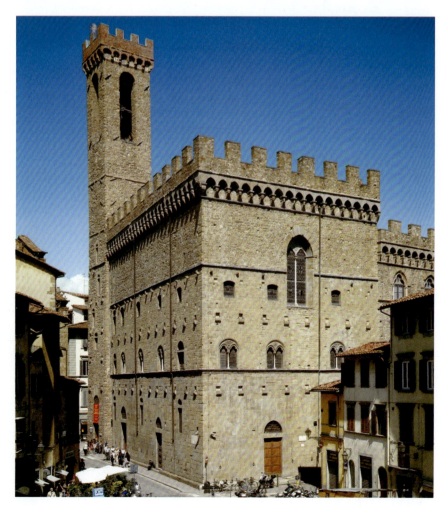

1.1

The Bargello, Florence, 1256–1323. Through most of the Renaissance, the building was called the Palazzo del Podestà. Its current name derives from a police office housed there beginning in 1574.

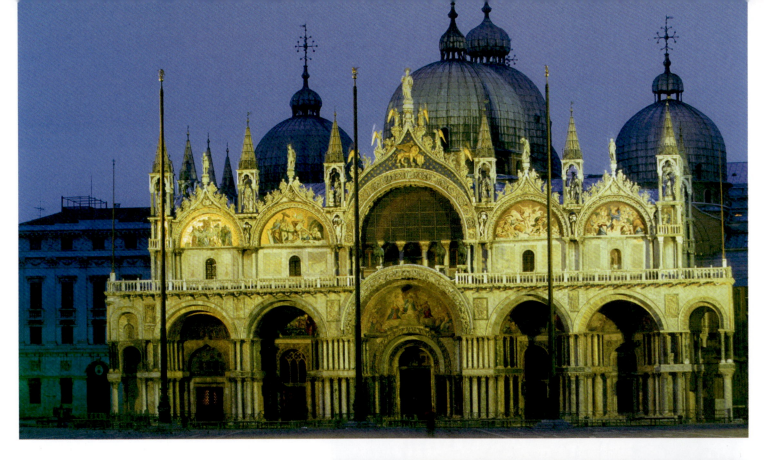

material called *pietra forte* (literally, "strong stone"). On the fortified tower built between 1256 and 1323 to house the "bargello," the captain of the civic militia (fig. 1.1), this stone creates an effect of heaviness and impregnability, though an additional appeal must have lain in the fact that it had a local source. This made the stone cheaper to acquire and transport, and it distinguished the look of Florentine buildings from their counterparts in towns without such quarries; the local architecture in Florence, therefore, comes across as a direct extension of the surrounding land.

Venice, by contrast, favored a colorful architecture comprising imported stones. The **basilica** of San Marco (figs. 1.2–1.3), its most magnificent religious building and a church that is attached to the city's seat of government, presents an exterior clad with sheets of striated marble, as well as with *spoglia*, columns, and reliefs stripped from other buildings, many of them in distant lands. Inside, mosaics seem to cover every surface: even after locals had mastered the techniques used to make the small glass and stone *tesserae* that form the embedded designs, the

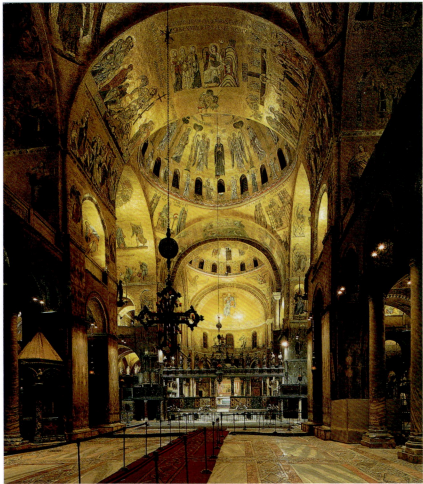

1.2 and 1.3
Basilica of San Marco, Venice, begun 1063. The mosaics in the nave's closest vault are from the sixteenth century; those in the dome beyond are from the thirteenth.

exotic-looking materials would have announced Venice's long-standing connection to foreign cities, particularly Byzantium (now called Istanbul). The architecture advertised Venice's ability to exploit eastern trade routes. San Marco, like many Venetian buildings, could have been made only in a city on the water, one that served as a major gateway to the East; the city that had launched Europe's holy crusades in the late eleventh and twelfth centuries, and one that would long be a hub for European trade. In Venice, as in Florence, location mattered, although in just the opposite way.

Florence's town hall, or Palazzo dei Priori (fig. 1.4), begun in 1299, wears a *pietra forte* rustication echoing that of the earlier Bargello. The rival city of Siena built its rejoinder to this in brick. In both cases city officials opted for a durable but relatively humble material, one that discouraged any pretense to magnificence on the part of those who as government officers temporarily quartered in the buildings. These would set the standard for what communal order looked like elsewhere, too: when, two centuries later, a series of architects including Michelangelo imagined a new government complex for the center of Rome, all in one way or another modified the surviving medieval structures on the site, keeping the familiar combination of elements, with a single tall tower rising over a **piazza**.

In the period this book covers, architecture took on few new functions. The place of a city, its mode of government, and its economic relationship to the wider world all helped determine what kind of buildings that city needed, and most new structures conformed in one way or another to much older types. With the qualified exception of palaces, grand urban residences that came into their own only in this period, the most impressive

1.4
Arnolfo di Cambio, Palazzo dei Priori (now Palazzo Vecchio), Florence, begun 1299

1.5
Giacomo Grimaldi, Reconstruction of the interior of Old St. Peter's, Rome. Drawing, from "Descrizione della Basilica Antica di S. Pietro in Vaticano," 1619. Vatican Library, Rome. A seventeenth-century view of the by then demolished basilica that was originally constructed around the mid fourth century CE.

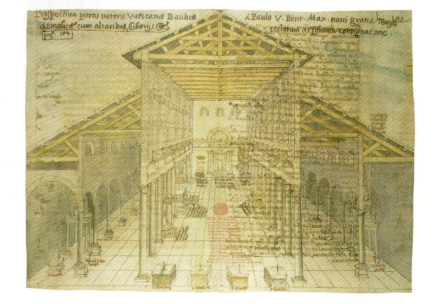

structures of the moment were not new at all, but were rather renovations or expansions of standing works. To give just one dramatic example: beginning in 1063, Venice established the basilica of San Marco by combining and replacing elements from two earlier churches. In the early thirteenth century the city then modified the whole western side of the structure, accommodating a **narthex** (a wide vestibule). The church's **domes** were enclosed by taller, broader ones a few decades later. Mosaics were added in phases over a period of three centuries, and new *spoglia* were joined regularly to the exterior walls. It is senseless, in short, to assign the building to a single architect or workshop, or even to give "San Marco" as such a date.

What we can talk about are the conventional forms that buildings took. The largest churches of the period, for example, were all basilicas: structures rectangular in plan and divided by aisles, following conventions that had originated in ancient Rome. Under the Caesars, basilicas had served a variety of purposes; early Christians adopted them for more specific religious ends. An iconic example was St. Peter's in Rome (begun *c.* 330–360; fig. 1.5), which focused on a **tabernacle** that covered the remains of the apostle credited with introducing Christianity to the city in the first century CE. In its original form this basilica consisted of a high, wide **nave** that led from the main eastern entrance to the altar zone at the west end. Looking up, visitors could have seen open wooden trusses supporting a peaked roof. Below these a **clerestory** contained the windows providing the main source of illumination. A second level of pitched roofs began their descent just below these windows, widening the space at the lower levels in order to include aisles at both sides. Columns plundered from other buildings supported these side roofs and separated the aisles. The nave terminated in an **apse**, a **vaulted** semicircular projection that marked the holiest part of the space. Dividing the apse from the nave was a hall-like **transept** that ran on a north–south axis. Later churches involved one or more variations on this model: they might have two side aisles rather than four; they might eliminate the transept, or move it forward so as to create a more cross-like plan. Anyone who wished to reject the basic template, however, worked against the weight of a tradition that had endured for a millennium.

In most bigger towns and cities the main church was the cathedral – the topic of chapter 2. Accompanying the cathedral, either as an extension of the church or as a freestanding building, was often a **baptistery**, a congregational space where infants received their first sacrament (fig. 1.6). Whereas medieval churches, following the model of the basilica, were longitudinal and **cruciform**,

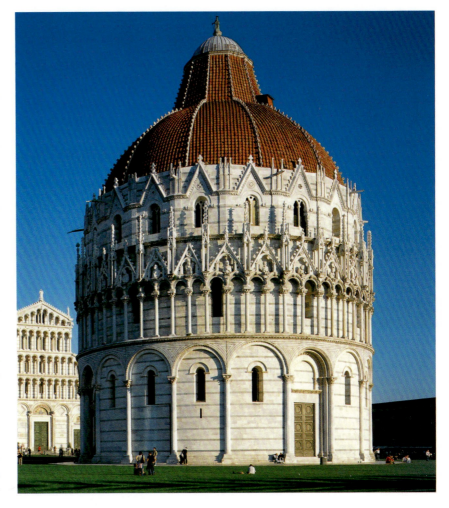

baptisteries were centrally planned, that is, uniform on all sides; they accommodated a gathering around the font that was at least ostensibly the main attraction of the space. All Italian towns had basilican churches, but *republics* tended to lend more importance to baptisteries than cities under dynastic rule, since the buildings in the former served as a place for the town to come together and welcome a new citizen into its midst. As architectural types, baptisteries would have a far more limited future than the town hall or the basilica, although, as we shall see, towns continued to decorate their baptisteries, often employing major artists to do so.

1.6

Baptistery, Pisa, 1059–1128

The Pisano Family: The New Architectural Sculpture

In the decades leading up to 1400, a number of the best sculptors came of age in Pisa, where the massive works linked to the city's cathedral served as a training ground. As in other cities, Pisa's cathedral complex supported a range of civic uses, and elaborately carved monuments

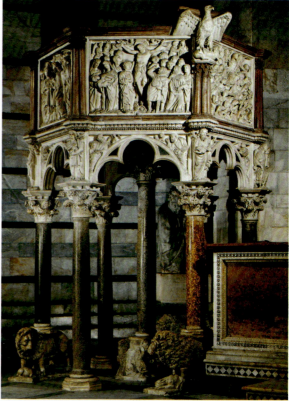

ABOVE LEFT
1.8
Nicola Pisano, pulpit: relief of the Annunciation and the Nativity. Marble, 33½ × 44½" (85 × 113 cm). Baptistery, Pisa

ABOVE RIGHT
1.7
Nicola Pisano, pulpit, 1260. Marble, height approx. 15' (4.65 m). Baptistery, Pisa

in stone gave shape and meaning to the rituals that took place there. Even before it had completed its enormous baptistery, notably, the city elected to furnish this structure with an elevated pulpit, (fig. 1.7), giving the building a purpose that went beyond the administration of the sacrament.

This pulpit is signed "Nicola Pisanus" – the Latinized "Nicola Pisano," or Nicholas of Pisa (*c.* 1220–1278/84) – though the sculptor seems to have come from Apulia in south-eastern Italy. Completed around 1260, the hexagonal structure features five reliefs that narrate in sequence the life of Christ, beginning with the Annunciation and Nativity and ending with the Last Judgment. Dividing the scenes are **colonnettes**, below which appear personified Virtues and the figure of St. John, patron of Baptism; prophets and **sibyls** occupy the **spandrels**. The idea of a polygonal pulpit with a sculptural program appears to be completely unprecedented, testifying at once to the inventiveness of its maker and to the varying functions of the baptistery as a space. Documents suggest that the pulpit served as an elevated platform for reading passages from the New Testament – the episodes in the life of Christ that the reliefs themselves depicted – as well as for knightings and other ceremonies.

In the panel that combines the Annunciation and Nativity (fig. 1.8), the figures look monumental despite their relatively small scale: broad faces and heavily draped limbs draw on the style of an ancient Roman sarcophagus relief. There were a number of these reliefs close by, reused for burials in the neighboring cathedral cemetery, or Camposanto: one, showing the story of the

ancient Greek princess Phaedra, provided the model for the Virgin with her veiled head, while a heroic nude male figure inspired the figure of Fortitude among the Virtues below. Such conspicuous "Romanism" evoked the glories of the ancient empire of the Caesars, and we might wonder whether the idea came from Nicola's patrons or from the artist himself. In the years around 1250, Pisa was cultivating a political alliance with the Holy Roman Empire to the north, but Nicola may also have worked directly for the Emperor Frederick II at his residence in Capua, outside Naples; if that is correct, Nicola would have seen at first hand how a court associated itself with ancient Roman forms.

The Pisa Baptistery pulpit inspired ambitious local imitations. Nicola himself went on to produce a pulpit for Siena Cathedral, in collaboration with his son Giovanni (*c.* 1250–*c.* 1315), who carved two more, for the church of Sant'Andrea at Pistoia (fig. 1.9) and for Pisa Cathedral. By the turn of the fourteenth century, these pulpits had come to take a somewhat different form. Giovanni had moved away from his father's static, monumental effects, multiplying his figures and making them more consistent in size, as well as more slender, elaborately articulated, and restlessly dynamic. The Pistoia pulpit was relocated and slightly reconfigured in the seventeenth century, but it still gives the impression of generational change.

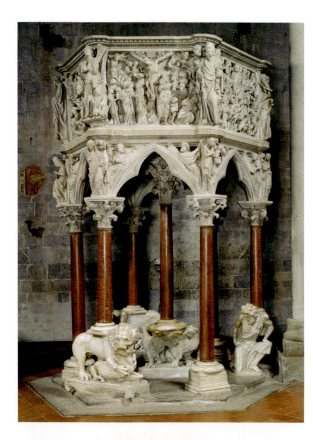

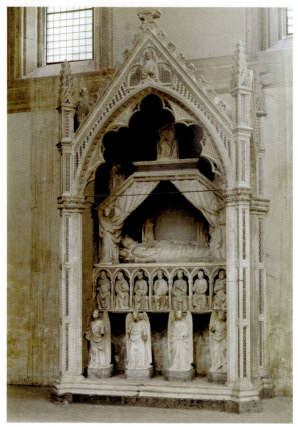

Giovanni's version of the Annunciation and Nativity (fig. 1.10), for example, closely follows his father's composition, but whereas Nicola's arrangement of figures encouraged the viewer to admire their majestic, expressionless faces, Giovanni favors profiles, which allow the characters to engage more with one another. Repetitive forms like we saw in Nicola's sheep and shepherds largely disappear, as Giovanni seeks ways to maximize variety and figural invention. He prioritizes the representation of emotion over that of nobility: the baby at lower left now struggles at the thought of his impending bath. Angular draperies cede to flowing linear patterns.

Giovanni and his patrons, who represented a parish church rather than a cathedral, probably regarded such changes more as an emulation than a critique of his father's model: the inscription announces the work to have been carved by "Giovanni, who produced no bad things," adding that he was "the son of Nicola but blessed with greater art." Indeed, Giovanni shows a modern sensibility in the way in which his work refers not (like his father's) back to antiquity, but instead to the sculpture of the previous generation. The columns – no longer *spoglia* – are again supported by lions, to which Giovanni now adds an entirely new motif: a crouching human figure, probably representing Adam. In subsequent centuries, painting would come to be the medium most celebrated for ambitious renderings of narrative events. For Renaissance artists, however, sculptures like Giovanni's were the works to rival.

Giovanni Pisano's most distinguished student was Tino da Camaino (*c.* 1285–*c.* 1337), who in 1315 created a tomb for Emperor Henry VII in Pisa Cathedral before moving south to enter the employ of the Angevin rulers

ABOVE LEFT

1.9

Giovanni Pisano, pulpit, 1297–1301. Marble, height approx. 14'10" (4.55 m). Sant'Andrea, Pistoia

ABOVE RIGHT

1.10

Giovanni Pisano, pulpit: relief of the Annunciation and the Nativity

FAR LEFT

1.11

Tino da Camaino, Tomb of Mary of Hungary, after 1235. Marble. Santa Maria Donnaregina, Naples

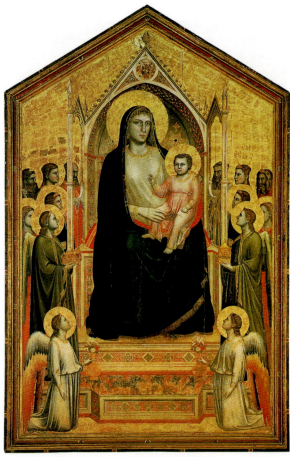

RIGHT

1.12

Cimabue, *Virgin and Child with Angels*, 1280–86. Tempera on panel, 11'7" × 7'4" (3.85 × 2.23 m). Uffizi Gallery, Florence

FAR RIGHT

1.13

Giotto, *Virgin and Child with Angels (Ognissanti Madonna)*, *c.* 1310. Tempera on panel, 10'8" × 6'25" (3.25 × 2.04 m). Uffizi Gallery, Florence

of Naples. One monument by Tino that survives in something close to its original condition is the tomb of the city's former regent, Mary of Hungary, in the church of Santa Maria Donna Regina (fig. 1.11), completed 1325–26. Here, Tino collaborated with the local architect Gagliardo Primario to create a monument that stood at the border of architecture and sculpture. Four winged figures representing the Cardinal Virtues (Fortitude, Justice, Prudence, Temperance) bear a sarcophagus, the sides of which celebrate Mary's fecundity, portraying eleven of her fourteen children. The lid of the sarcophagus becomes the floor of a kind of chamber, where angels draw aside the curtains to reveal Mary laid out as if on her deathbed, but presented as a much younger woman than she was when she died in 1323. The sense that a momentous event is unfolding continues above, where a second figure of Mary kneels before her namesake, the Virgin Mary, while an angel bears an offering from the deceased regent: the church of Santa Maria Donna Regina itself, which Mary had endowed.

Giotto: The Painter and the Legend

When Lorenzo Ghiberti (*c.* 1378–1455) looked back at what previous artists had accomplished, he concluded that one painter was of special significance: Giotto di Bondone (*c.* 1267–1337). Giotto "brought in natural art, and grace with it," wrote Ghiberti, "He was thoroughly expert in the whole art, he was the inventor and discoverer of much learning that had been buried some six hundred years." Such comments no doubt betray a regional perspective. The writer who had made Giotto's very name a byword for renewal and innovation was the poet Dante Alighieri (1265–1321), a literary colossus in the Florence of Ghiberti's day. Elevating Giotto promoted these qualities as defining features of significant art, but it also linked renewal to a local origin. Ghiberti referred to Giotto as a native of "Etruria," the ancient region now known as Tuscany, to which Florentines traced their own cultural beginnings: "In that time," Ghiberti wrote of the 1300s, "the art of painting flourished in Etruria more than in any other age, much more than it ever did even in Greece."

The comparison was doubly significant. When Ghiberti referred to the art of "Greece," he was presumably thinking in part about the ancient Greeks, who flourished in the time of his own alleged ancestors, the **Etruscans**. Beyond this, though, he had in mind the sacred art of the eastern Mediterranean, a more recent tradition centered on the imperial capital of Byzantium.

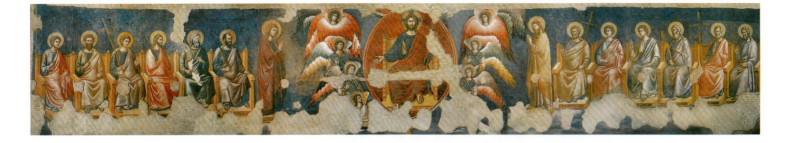

Ghiberti and his contemporaries regarded the "Greek style" – what we would call the **Byzantine** tradition – as decisive for the painting in Italy that had developed in the century before Giotto. For several centuries travelers had imported Byzantine paintings of Christ and the Virgin, known as **icons**, from the eastern Mediterranean; several of these were regarded as especially holy because they were thought to have been painted in the first century CE, by the Evangelist St. Luke, from the living Virgin herself. Late medieval Italians learned to work in this style and painted their own icons. Giotto's teacher was the Florentine artist Cimabue (*c.* 1240–*c.* 1302), and in Ghiberti's eyes Cimabue was a master of the Greek style.

Ghiberti's view had a certain empirical basis. Cimabue's *Virgin and Child with Angels* from 1280–86 (fig. 1.12), for example, possesses many features that are characteristic of the Greek style: the impressive, superhuman figures seem to inhabit a timeless and largely spaceless realm. The gold striations defining the folds of the Virgin's gown represent highlights, implying a degree of three-dimensionality, but they primarily reinforce the general effect of linear pattern on a flat surface. The painting's characters are symmetrical and repetitive: the Virgin's gesture and facial rendering, in particular, borrow formulas established by earlier pictures.

Ghiberti's characterization of Cimabue as a Byzantine ("Greek") works only so far: unlike many of his predecessors, Cimabue constructed his Virgin's throne so as to suggest recession in space. This does not compromise the overall effect of flatness, but the throne appears more solid and substantial than the figures. Still, Giotto's treatment of the same subject in his *Ognissanti Madonna* (fig. 1.13), painted nearly thirty years later than Cimabue's image, bears out Ghiberti's general perception of the difference between the two artists. Compared to Cimabue's, Giotto's Virgin and Child are solid and weighty. Rather than relying on golden highlights, Giotto painted shadows of diminishing intensity on the faces and bodies, and he used a lighter tone of blue to suggest the shifting appearance of light on a robe that falls in thick, sculptural folds over the Virgin's projecting knees. In Giotto's painting the angels appear to stand one behind the other rather than filling the picture surface from top to bottom.

The long list of works that Ghiberti ascribed to Giotto, only some of which survive, are now mostly thought to be the work of multiple artists or teams of artists, some of them probably associated with, or trained by, the historical Giotto, some not. The idea of one brilliant individual transforming the history of art makes for a compelling story; it is a key myth of the Renaissance. At best, however, Giotto was one of the more accomplished members of a wave of artists working in a range of new styles around 1300, not all of whom were Tuscan. Ghiberti mentions the Roman painter and mosaicist Pietro Cavallini (*c.* 1250–*c.* 1330), whose wall paintings at St. Peter's in Rome were "most excellently done and with great relief," yet the staunchly patriotic Ghiberti makes Cavallini something less than a peer of the Florentine Giotto: "[Cavallini] retains a bit of the old Greek style." Very little of Cavallini's work now survives, but some fragments of wall paintings (fig. 1.14), executed around 1290 on the inner facade of the Roman church of Santa Cecilia in Trastevere, pre-date anything that can be ascribed to Giotto, and they belie Ghiberti's implication that Giotto was the earliest artist to model his figures in light and shade.

Mural Painting: The "Upper Church" at Assisi

Cavallini's *Last Judgment* belonged to a larger project of redecoration that would originally have included the entire nave of Santa Cecilia. Though working more directly under the auspices of the cardinal who had title to the church, Cavallini painted during the reign of Pope Nicholas IV, the century's greatest sponsor of large-scale murals. Nicholas was the first Pope to have come from the ranks of the **Franciscans**, one of the new **Mendicant Orders** that had arisen during the 1200s, after the charismatic visionary preacher Francis of Assisi (1181/82–1226) and the zealous crusader against heresy Dominic de Guzmán (1170–1221) each founded priestly brotherhoods that embraced the vows of poverty, chastity, and obedience. The mendicants – primarily the **Franciscans** and the **Dominicans**, but also the Carmelites, Servites, and Augustinians – sought to make the teachings of the Church intelligible and relevant to the ordinary people of

1.14

Pietro Cavallini, *The Last Judgment, c.* 1290. Fresco. Santa Cecilia in Trastevere, Rome

1.15
Basilica of San Francesco, Assisi, view of the murals in the upper church, before 1310.

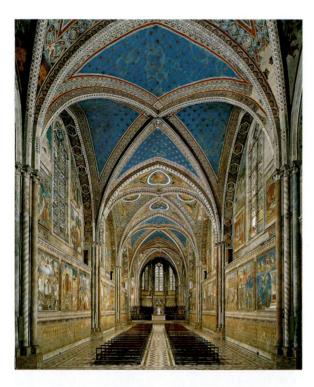

BELOW
1.16
Giotto, *St. Francis Renouncing his Worldly Possessions*, before 1310. Fresco. San Francesco, Assisi, upper church

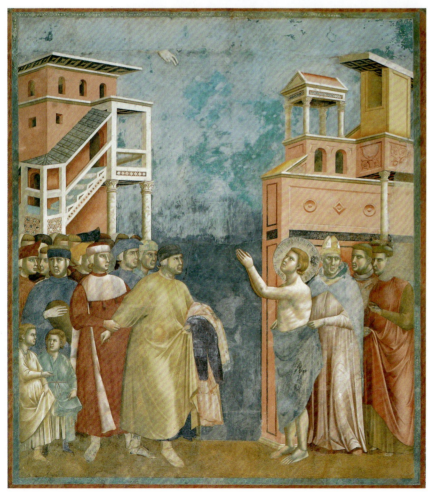

Europe. Unlike monks, who dwelt apart from the urban world in monasteries, mendicant friars lived and worked in the cities, drawing vast crowds to new, large churches designed for preaching. In their sermons, the friars particularly dwelt on the virtue of charity, confronting the mercantile principle of self-interest with an insistence on the common good and regard for the poor.

Pope Nicholas himself took a particular interest in the pioneer basilica of the Franciscan Order, San Francesco in Assisi (begun 1228), encouraging pilgrims from all around Europe to travel to the complex and venerate the relics of the saint. A recently discovered document suggests that Nicholas provided the impetus for the decoration of the building now called the "upper church"; though debate continues to surround the authorship of the murals there, they probably count among the earliest surviving works by Giotto and his workshop. Extending throughout the entire nave and transept, the paintings narrate a kind of authorized or official version of the life of St. Francis, stressing his social mission, his miracles, his Christ-like nature, and his close relations with the papacy (fig. 1.15). Proclaiming institutional approval was necessary because Francis, with his demands for radical social reform and his criticism of the wealth of the Church, had been a controversial figure during his lifetime, and some of his more extreme followers were persecuted. He was a mystic who was believed to have had the wounds of Christ, known as the stigmata, miraculously imprinted on his own body in the course of an ecstatic vision, and the cycle of paintings depicts not only the miracle itself but also its legal verification by clerics and noblemen at the time of the saint's death in 1226. Appealing to a popular audience rather than to a bookish community of monks, the murals show Francis's life unfolding in a contemporary Italian city. The scenes are populated by an array of recognizable human types – individualized clerics, merchants, and nobles – all of them performing their role in the story with dramatic gestures and vivid expressions. Such devices attested to the veracity of the biographical events depicted, encouraging visitors to identify with the feelings of astonishment and wonder that the original witnesses to the extraordinary events had experienced.

A key episode is the moment where the young Francis renounces his family and worldly possessions, to the manifest anger of his father and consternation of the people of Assisi: looking toward heaven, Francis sees the hand of God signaling approval (fig. 1.16). The bishop of Assisi, mortified that Francis has discarded even his clothes in order to return them to his father, intervenes to cover the young man. The architecture effectively registers the gulf between the secular world abandoned by Francis and the world of the Church, which now offers him protection.

Private Patronage: The Arena Chapel

Followers of saints Francis or Dominic could demonstrate their own regard for the poor through pious donations to the friars themselves, who (at least in principle) were not allowed to own property and had to beg for alms. Prominent families could also endow chapels in mendicant churches, paying for vestments, candles, liturgical vessels, and very often decoration in the form of murals, altarpieces, or stained-glass windows. In return, family members obtained the right to be buried in the chapel, thus assuring themselves of the future prayers of the friars and the faithful. (Less wealthy people settled for burial in the crypt before the altar: their carved floor tombs still give churches like Santa Croce in Florence the appearance of a cemetery.)

Giotto's most famous paintings today, in fact, are the murals that he executed in Padua beginning around 1303, for a wealthy banker's son named Enrico Scrovegni (*fl.* early 1300s). The paintings were to decorate a large chapel that Scrovegni had just built near his palace, the latter now destroyed; it is sometimes referred to as the "Arena" Chapel, after the Roman amphitheater that once occupied the same location. To build what was essentially a small, private church was to bypass the usual institutions and appeal directly to divine intercessors. At the same time, Scrovegni adopted a decorative scheme that late medieval basilicas had made familiar.

Scrovegni's builders seem to have constructed the boxlike chamber's unbroken expanses of wall, which are interrupted only minimally by windows, with paintings in mind, and Giotto has covered the walls with three rows of narrative scenes unfolding the life of the Virgin and the life of Christ; a lower tier alternates panels of simulated marble and monochrome figures of personified Virtues and Vices (fig. 1.17). Portraits of Christ and the Evangelists appear in the vault against a rich field of blue, which recurs in the background of most of the narrative scenes, giving a sense of airy spaciousness to the whole ensemble and unifying the effect. On either side of a great arch framing the altar, Giotto demonstrates his extraordinary ability to render pictorial space (fig. 1.18). The viewer sees what he or she might first take to be little chapels opening to the left and the right, but they are optical illusions. So, too, are the overhanging storeys that

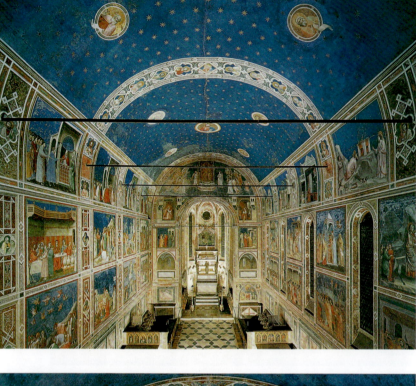

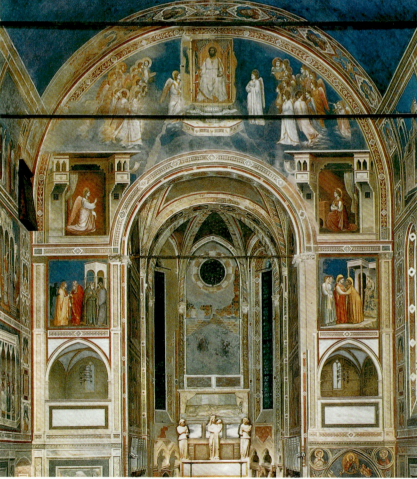

ABOVE RIGHT

1.17

Arena Chapel (also called "Scrovegni Chapel"), Padua: interior, looking toward the apse. Frescoes by Giotto, 1304–6.

RIGHT

1.18

Giotto, frescoes on the altar wall, *c.* 1303. Arena Chapel, Padua

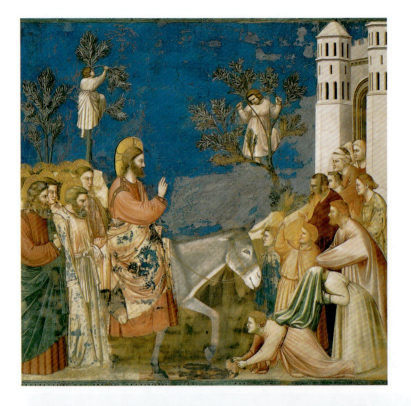

house the Annunciation, which appear to project into the real space of the chamber.

Giotto's approach here gave prominence to one of the most sacred and mysterious episodes in the entire Gospel, the moment of Christ's miraculous conception in the womb of the Virgin, when God took on human form. In the space above this scene, God the Father, surrounded by hosts of angels, charges the angel Gabriel with his mission. The figure of God is painted on a panel set into the wall, covering what may originally have been a window. Were this the case, the Holy Spirit – God's immaterial form, "incarnated" or made flesh in the womb of the Virgin – would have seemed to emerge from outside, in the form of real light. The motif would have been particularly fitting for a painter who used effects of light and shadow to lend his figures a new degree of physical presence. In the revised scheme, the use of a partly gilded panel evokes the older tradition of sacred images, appropriate for the holiest personage of all.

Giotto's narrative scenes reduce the action to essentials, concentrating on a single significant gesture or encounter. At the same time, repeated costumes and architectural settings allow the viewer to track characters

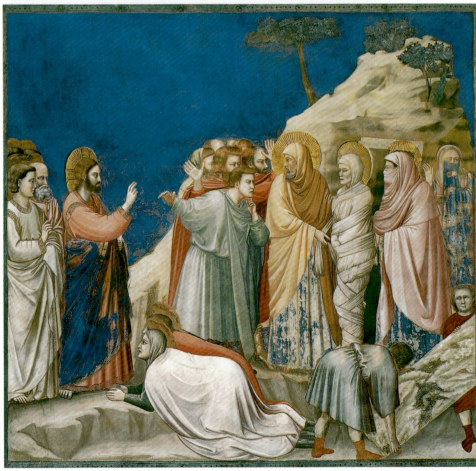

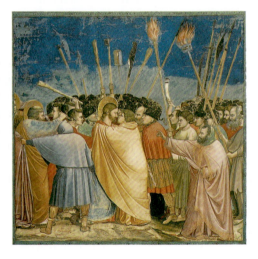

ABOVE LEFT

1.19

Giotto, *Christ Entering Jerusalem,* c. 1303. Fresco. Arena Chapel, Padua

ABOVE

1.21

Giotto, *The Betrayal of Christ,* c. 1303. Fresco. Arena Chapel, Padua

LEFT

1.20

Giotto, *The Raising of Lazarus,* c. 1303. Fresco. Arena Chapel, Padua

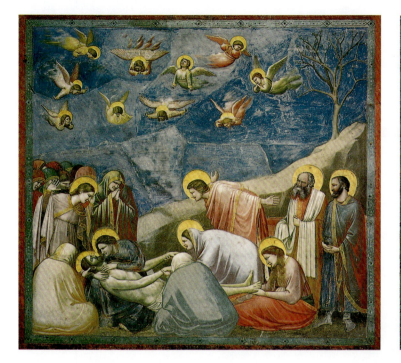

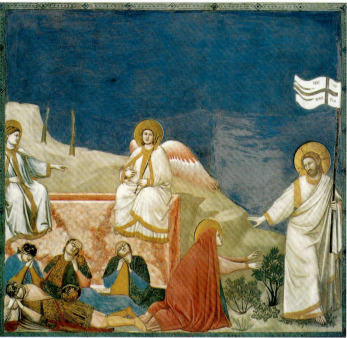

easily from one frame to the next. Once Christ enters the story, the painter usually shows him advancing in profile from left to right, his right hand raised in blessing, as in *Christ Entering Jerusalem* (fig. 1.19), or bringing about a miracle, as in *The Raising of Lazarus* (fig. 1.20). In the climactic encounter, *The Betrayal of Christ* (fig. 1.21), Judas with a kiss identifies Christ to the Jews seeking to arrest him. Enfolded in the yellow cloak that had identified Judas from his first appearance in the story, Jesus remains resolute and unperturbed: through a minimum of means, the painter signals Christ's more-than-human nature. Here and elsewhere, Giotto carefully organizes the figures so that subordinate episodes do not detract from the main event; a characteristic device is the figure viewed from the back, which crops and frames the action taking place beyond. In contrast to Byzantine painters, who generally sought to preserve the integrity of the human body, Giotto sometimes shows us only parts of figures, cropped by the frame or eclipsed by other people as they would be if the scene were unfolding in reality.

The processional motion of the narrative sequence is suspended in the scenes of the Passion, especially in *The Entombment of Christ* (fig. 1.22): here, a minimal landscape element forms a diagonal that underscores the process of descent, as the mourners lower the corpse into the lap of the Virgin, drawn by tragic gravity toward the ground. Seated figures, some of whose faces we do not see, communicate grief through the boulder-like inertia of their huddled bodies; in the sky above, angels materialize from the air to wail along with them. Giotto drew here on a long tradition of tragic Passion scenes, but his

treatment set a new standard for rendering emotions that could involve the spectator. With scenes of Christ's resurrection (fig. 1.23), Christ's onward motion assumes a triumphal character, and ultimately he ascends to heaven.

The chapel's narratives culminate with a spectacular rendering of the end of human history itself. A great painting of the Last Judgment occupies the entire surface of the western inner facade (fig. 1.24) confronting the viewer who leaves the chapel. Two angels now "roll up" the blue that elsewhere had designated historical time and space, revealing a golden eternity beyond. Christ appears as judge in a flaming nimbus, with the Apostles enthroned to his left and right – much as Pietro Cavallini had depicted them at Santa Cecilia in Rome (*see* fig. 1.14). On an axis with Christ, a massive cross serves to separate the damned from the saved. Rivers of fire from Christ's throne engulf the hellish zone to his left, where sinners not devoured (and excreted) by Satan suffer a range of graphic torments. Among them are three men who hang with moneybags, variously identified as usurers (moneylenders) and simonists (sellers of spiritual things).

The place of money in this representation of sin takes us to the heart of a conflict that accompanied the rise of commerce and private enterprise in the preceding centuries. The economic life of Italian towns, as well as the stability of governments, was sustained by banking, which entailed not only systems of credit but also lending money at interest. Preachers decried the sin that enriched so many professed Christians, but the Church was also willing to expedite salvation for those who devoted the profits of usury to charitable and pious works – such as the

ABOVE LEFT

1.22

Giotto, *The Entombment of Christ*, c. 1303. Fresco. Arena Chapel, Padua

ABOVE RIGHT

1.23

Giotto, *Noli me tangere* (scenes of Christ's resurrection), c. 1303. Fresco. Arena Chapel, Padua

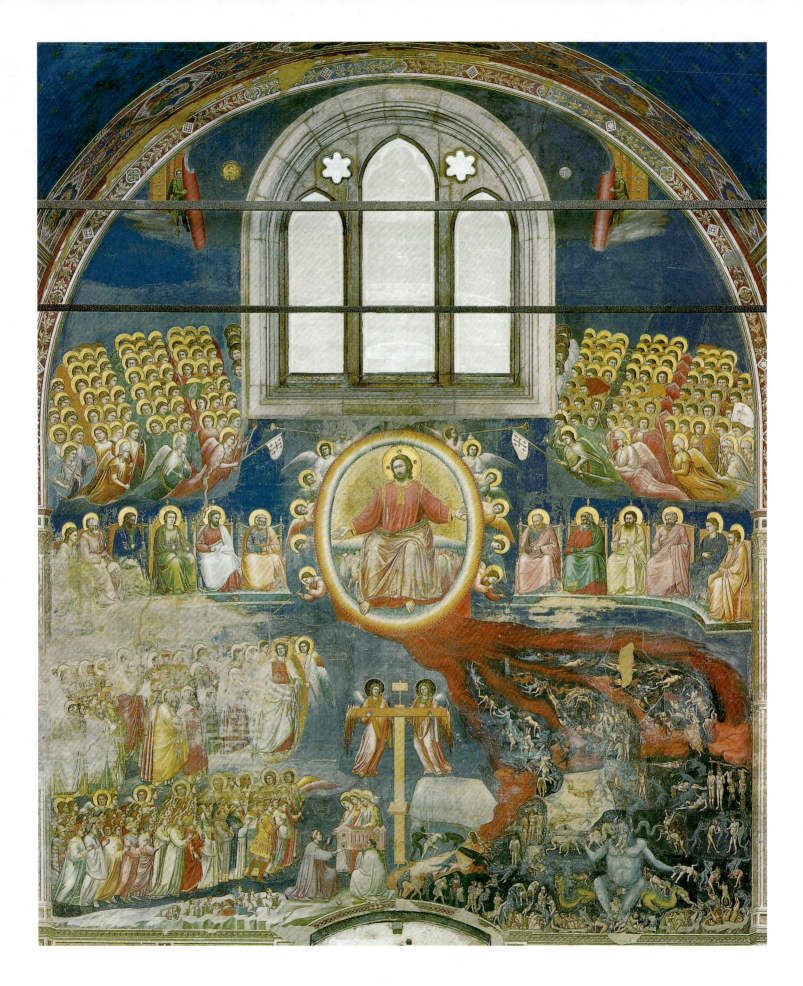

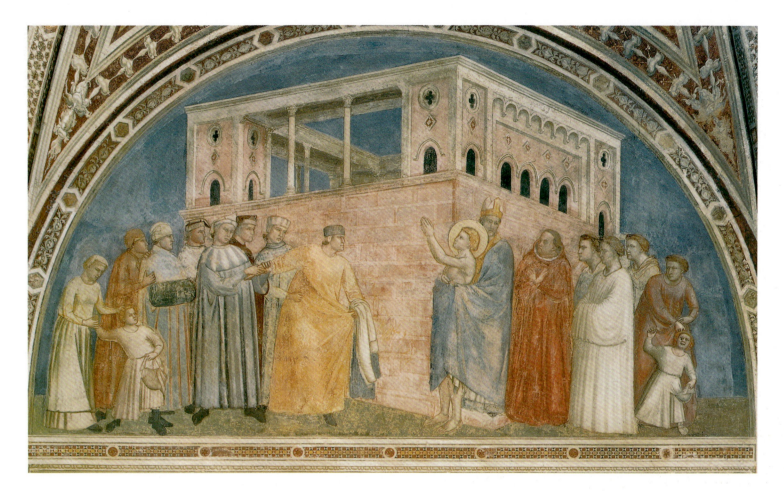

building and decoration of churches. Scrovegni, whose father was regarded as a usurer, wanted all to know that he had invested his family's wealth into his chapel: to the right of the cross, at the head of the ranks of the blessed, Giotto shows him offering the building to the Virgin Mary – a motif that would be echoed in Tino's tomb in Naples (*see* fig. 1.11) and elsewhere. The Virgin, who here also stands for the Church itself, reaches out to accept it.

We might say that Scrovegni re-dedicated an entrepreneurial initiative elsewhere. He had his eye on the rewards of the afterlife, but his investment brought a measure of worldly prominence and advertised his influence with the powerful. The local clergy were scandalized that a private chapel succeeded in drawing away worshipers from their own churches, and no wonder: the very form of Scrovegni's decorations followed the example that "public" churches were just beginning to employ.

Murals like these set the standards for vivid and emotionally convincing pictorial narrative well into the 1400s. The high premium that Ghiberti placed on effective narrative in his *Commentaries* (and, as we shall see, in his own relief sculpture) is itself part of Giotto's long legacy. The painter's influence on subsequent practice resulted not just from the unquestionable force of his art, but also from his system of workshop organization and training. Wherever Giotto took on an assignment – Florence, Padua, Naples – he put together a large team of experienced painters and apprentices who enabled the rapid completion of large-scale commissions, sometimes more than one at a time. When he departed for home or for another project, members of his team remained behind, capitalizing on their ability to execute commissions of their own in the artistic language of the master.

The Bardi Chapel

Ghiberti, whose longest and most enthusiastic pictorial descriptions in his *Commentaries* are of narrative works, would have been especially familiar with the chapel that the wealthy Bardi family commissioned in the church of Santa Croce, Florence. There, Giotto painted an abbreviated Franciscan cycle of seven episodes, including the *Stigmatization* (Francis miraculously receiving the wounds of Christ on his body), the *Funeral and Verification of the Stigmata*, and *St. Francis Renouncing His Worldly Possessions* (fig. 1.25). He heightened the drama of the hostile reaction by Francis's father – the other figures seem barely to restrain him – and added such details as the children who throw stones at Francis, the self-appointed outcast. The architecture now creates the space in which the action occurs: by contrast with the corresponding scene at Assisi, now Francis is aligned with the corner of a massive cubic building, a visual turning-point between the sacred and secular worlds.

OPPOSITE

1.24

Giotto, *The Last Judgment,* *c.* 1303. Fresco. Arena Chapel, Padua

ABOVE

1.25

Giotto, *St. Francis Renouncing His Worldly Possessions, c.* 1320. Fresco. Bardi Chapel, Santa Croce, Florence

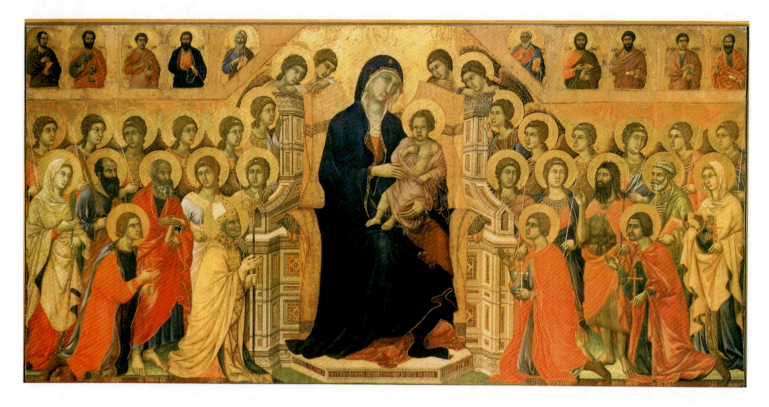

1.26

Duccio di Buoninsegna, *Virgin and Child with Saints (Maestà)*, 1308–11. Tempera on panel, main panel 7 × 13' (2.13 × 3.96 m). Museo dell'Opera del Duomo, Siena

Devotional Imagery: Siena

Duccio's *Maestà*

If Giotto represented the fountainhead of modern painting as it looked to such a Florentine as Ghiberti, the Sienese Duccio di Buoninsegna (*c.* 1255–1319) offered the most powerful contemporary alternative. Duccio left no documented murals. He painted all of his secure surviving works on panel, taking the Virgin as his primary subject in every one. This, too, has a religious context. Outside of the Mass (the rite celebrating **Eucharist**, the consecration of bread and wine, in the Roman Catholic Church), the cult of the Virgin as intercessor was the most important and widespread manifestation of Christian devotion. She was invoked both by individuals and by entire communities, often in great collective rituals involving music, incense, and processions, culminating inside a city's most important church.

It was just such solemnity that accompanied the installation in Siena Cathedral of Duccio's *Virgin and Child with Saints (Maestà)* of 1308–11 (fig. 1.26). Siena had dedicated itself to the protection of the Virgin, effectively designating her as its "Queen," in 1260. An older icon of the Virgin in the cathedral was believed to have aided the Sienese in a decisive battle against the Florentines in that year. Duccio undertook the *Maestà* when the city commissioned him in 1308 to replace the icon with a painting "far more beautiful, and more devout,

and larger." As we shall see in chapter 3, this was in many ways a typical form of request. The same eyewitness who described the work in this way also recorded a characteristic ceremony: the carrying of the work from the painter's house to the cathedral, with a great procession including the bishop, priests, and friars, the officers of the government, the most worthy citizens and women and children, following which "all that day they stood in prayer with great almsgiving for poor persons, praying God and his Mother, who is our advocate, to defend us by their infinite mercy from every adversity and all that is evil, and keep us from the hand of traitors and of the enemies of Siena."

Duccio's *Maestà* was painted on both sides, and it was to go on an altar that divided the clergy from the lay-people who gathered to watch the Mass. Many of its parts have long since left Siena, but it still makes an impact through its scale and complexity. The side that originally faced the congregation shows a continuous wide picture field with the Virgin and Child and their heavenly attendants (in Italian, *maestà* means "majesty"). Angels flank the throne as they do in the recent Florentine panels by Cimabue and Giotto (*see* figs. 1.12–1.13), but now the composition extends to the right and left to include an assembly of saints, the most prominent of whom are the four patrons of Siena – Ansanus, Savinus, Crescentius, and Victor – who kneel at the foot of the Virgin's throne so as to beg her special intercession on behalf of the city. Originally this main panel was augmented with a row of

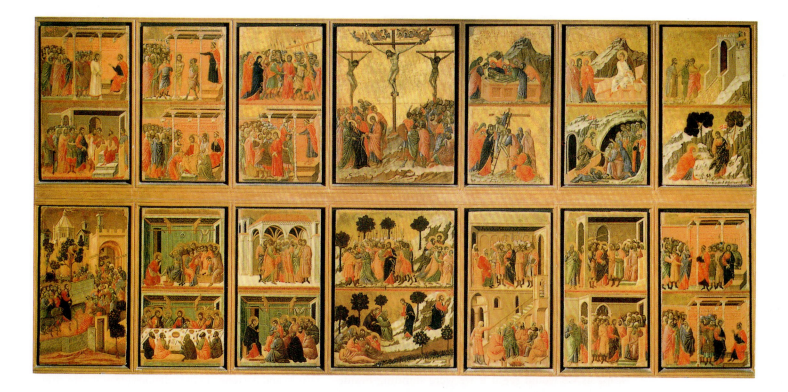

smaller panels above and below presenting episodes from the Virgin's life; the upper row was surmounted by ornate pointed pinnacles with half-length images of angels. The other side of the *Maestà* (fig. 1.27) originally faced the clergy who assembled for Mass, in a part of the cathedral known as the **choir**. This side's multiple framed panels depict forty episodes from the life of Christ, the largest and most important of which is the *Crucifixion* on the central axis. Its prominence again reflects its function, that of reminding congregants of the historical event – Christ's sacrificial and redemptive death – that the Mass itself repeatedly re-enacts.

What did the chronicler mean when he called the *Maestà* "more beautiful" and "more devout" than its predecessor? Fourteenth-century viewers would have found beauty in the visual splendor of precious materials (gold and **ultramarine** – the blue **pigment** made from ground **lapis lazuli**) given form by human skill. Duccio in fact shows off his skill by tooling the gilded surfaces in imitation of **chased** metal; he also applies paint over gold and then works it with a sharp point to suggest precious damask or embroidered fabric (fig. 1.28). His handling of the pigments themselves shows his command of the principles of light/dark modeling, though unlike Giotto, who pursued strongly **volumetric** effects in his figures, Duccio emphasizes the picture surface by a constant overall play of elegant pattern – for example, in the swinging folds of the mantles worn by the two female saints at either end of the *Maestà* scene (*see* fig. 1.26), and the sinuous

ABOVE

1.27

Duccio di Buoninsegna, *Maestà*: Scenes from the back of the main panel, 1308–11. Museo dell'Opera del Duomo, Siena

LEFT

1.28

Duccio di Buoninsegna, *Maestà* (detail): St. Catherine, 1308–11. Museo dell'Opera del Duomo, Siena

meandering golden borders of the Virgin's blue cloak and the Child's transparent garment. Duccio may have wanted his beholders to see these beautiful flowing lines as something like a personal trademark, an index of his distinctness as an artist – in a word, of his *style*. At the base of the Virgin's throne, near the swirling gold edge of the mantle, he paints in Latin the words "Holy Mother of God, be the cause of peace to Siena and of life to Duccio because he has painted thee thus."

Duccio also undertook extraordinary experiments in rendering pictorial space, especially in his narrative scenes. Occasionally, he worked with the kind of room Giotto might have included: Duccio's *Annunciation of the Death of the Virgin* (fig. 1.29), for example, takes place in a convincingly realized little architectural cell. Elsewhere, his inventiveness is evident in local touches rather than whole scenes. In the panel depicting the Temptation of Christ (fig. 1.30), where the Devil tempts Christ by showing him all the kingdoms of the world, Duccio moves in on the action, focusing on Christ and Satan in a kind of "close-up." He also "zooms" out from the mountainside to give us a panorama of the landscape as we would see it if we were standing beside

Christ – we look down at remote towns and cities bathed in clear sunshine.

The chronicler's characterization of the work as "devout," for its part, may mean no more than that it covered an encyclopedic array of Christian themes, that the artist and his patrons expended considerable money and effort on turning the Gospels and other sacred histories into pictures – and all in honor of the Virgin. It is possible, however, that this witness also wanted to highlight Duccio's strong links with older Christian art, especially the Byzantine tradition. This aspect of Duccio's work was fully apparent to Ghiberti: even though he considered the altarpiece a "marvelous thing," he regarded it as an example of the "Greek style." What for Ghiberti defined the painting's retrogressive look would, for the Sienese in 1311, have enhanced its prestige. Like their contemporaries in other cities, they believed certain older Byzantine paintings to date from the time of Christ and the Virgin themselves. These they revered as sacred relics, with miraculous properties. Duccio's Virgins, like his half-length saints and angels, refer to the long-standing traditions of the Byzantine icon, and show its ongoing relevance and currency in the religious life of Italian cities.

1.29

Duccio di Buoninsegna, *Annunciation of the Death of the Virgin*, from the back of the *Maestà*, 1308–11. Tempera and gold ground on wood, 16⅛ × 21¼" (41 × 54 cm). Museo dell'Opera del Duomo, Siena

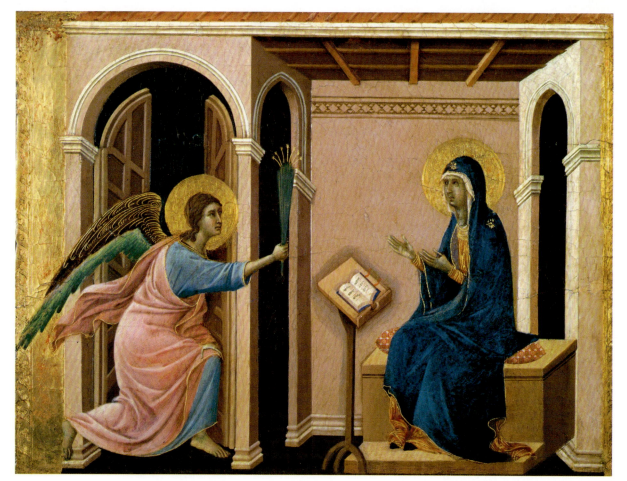

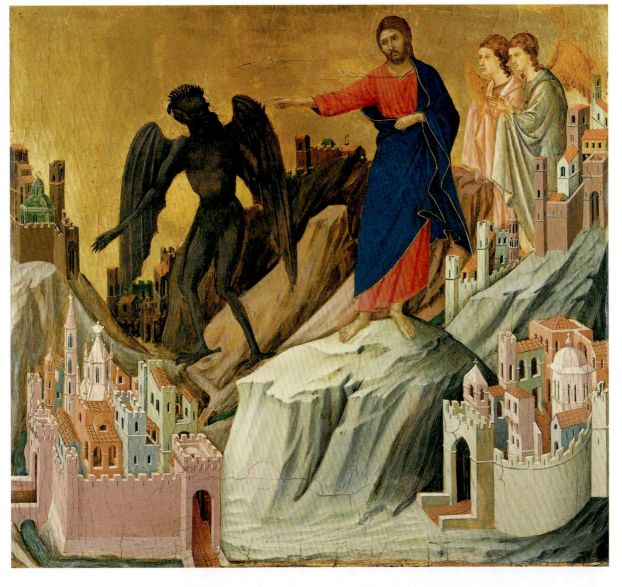

1.30

Duccio di Buoninsegna, *The Temptation of Christ on the Mountain*, from the back of the *Maestà*, 1308–11. Tempera on panel, 17 × 18⅛" (43.2 × 46 cm). Frick Collection, New York

Less apparent to Ghiberti – writing a century later – was the degree to which Duccio showed a cosmopolitan awareness of contemporary art in places outside Siena. These included not only other Tuscan cities – the crisp, curving folds of Duccio's draperies resemble those of sculptor Giovanni Pisano – but also northern Europe. Duccio's flowing line and the tendency of some figures to assume sinuous poses evoke the dominant aesthetic of French courts and cathedrals around 1300. The so-called **Gothic** style (a later and pejorative designation meaning "barbaric") also flourished at the French-speaking court of Naples, which was ruled by the House of Anjou.

Sienese Art after Duccio

Duccio was hardly the only painter to direct great attention to the Virgin Mary. On the contrary, she was the premier subject of painting in early fourteenth-century Italy, and nowhere was this truer than in Siena, where some of the peninsula's best artists turned out one representation of her after the next. Largely, such figures were bound by convention: depicted at half-length; placed against a gold background; wearing a garment painted of ultramarine, a blue pigment far more expensive than gold; and holding the infant Christ. Duccio had rendered the Virgin with an elegance that suggests he was as much concerned with beauty as with the replication of earlier types, and other artists, too, made this very conventional subject a locus of innovation.

Pietro Lorenzetti's (c. 1280/90–c. 1348) *Madonna di Monticchiello* of c. 1311 (fig. 1.31), for example, tilts her head in the same manner as Duccio's Virgin. But rather than looking out to the viewer, this Virgin fixes her eyes on her son, pulling his body close to her and

1.31
Pietro Lorenzetti,
Madonna di Monticchiello,
c. 1311. Tempera on panel,
26¾ × 18⅛" (68 × 46 cm).
Museo Diocesano, Pienza

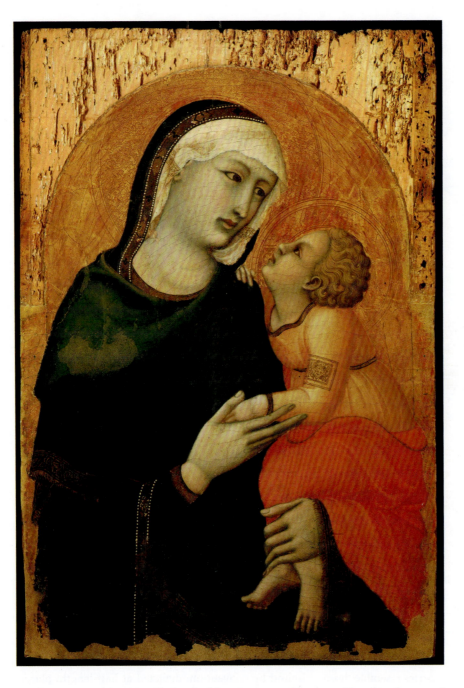

gently caressing his wrist. Christ, for his part, is not the young king presiding over the subject before him, but a believable child, who rests a hand on his mother's shoulder as he looks up to her face. When addressing prayers to the Virgin, viewers often regarded the depicted figure as truly present, as though the painting brought her into their world. Lorenzetti here does something like the opposite, taking a scene he could have witnessed anywhere, of a mother gazing fondly at her child, and using it as the basis for a devotional scene. The idea may owe something to the new culture promoted by mendicant preachers, who sought to connect religion to the natural

world and to the experience of everyday life.

A rather different transformation of the Virgin is visible in a mural painted in Siena's Palazzo Pubblico in 1315 by Simone Martini (*c.* 1284–*c.* 1344) (fig. 1.32), a local artist whom Ghiberti admired as an "elegant painter," whose pictures were "very delicately finished." The subject was the same as that of Duccio's *Maestà* from seven years earlier, the enthroned Virgin "in majesty," with an entourage of saints. As Duccio had, Simone separates Siena's four patrons from the larger group, placing them in the company of two angels. He also modifies other details to strengthen the sense of an encounter. The saints who

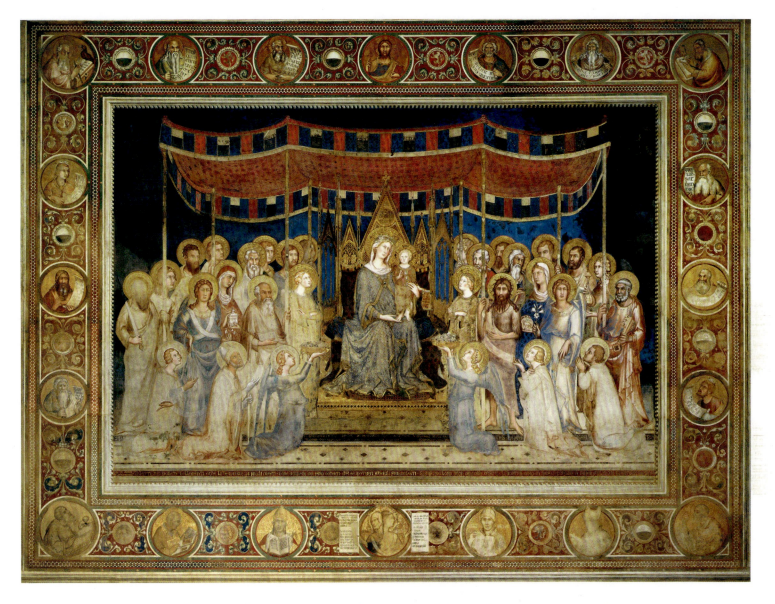

1.32

Simone Martini, *Maestà*, 1315. Fresco, 25 × 32′ (7.6 × 9.7 m). Sala del Consiglio, Palazzo Pubblico, Siena

flank the Virgin hold a materially lavish **baldachin** produced using crimson – a dye derived painstakingly from insects – and gold. For contemporary viewers, this would have evoked the presence of royalty, reminding them especially of the Angevin kings – the French dynastic family based in Naples – who had occasionally made ceremonial visits to Siena. As angels offer the Virgin baskets of flowers, the two kneeling saints behind them unroll scrolls with petitions. The Virgin's response appears in Italian words, written across the edge of the pavement and the edge of the dais, addressing the supplicants as "my beloved ones," rejecting the offered flowers and asking for "good counsel" instead, warning against "those who…scorn me and deceive my land." The depicted Virgin, meanwhile, holds the foot of Christ, inviting the viewer's kiss, while he presents the viewer with his own scroll, which reads, "Love justice, you who judge the earth."

The painting's elaborate depiction of textiles – the borders make the mural itself appear as a virtual tapestry – are typically Sienese. Also characteristic of Sienese art in the period is the paradoxical image of rule. Simone painted the *Maestà* in the Sala del Consiglio, the room in the city's council hall where its government met. This helps make sense of Christ's emphasis on justice and the Virgin's injunction to good decision-making. Yet the city was proudly Republican, with an elected government, and here was a painting that depended on contemporary imagery of the monarch. Perhaps this was a way to make the typical Christian subject of the "Queen of Heaven" and the "King of Kings" more accessible and familiar. Perhaps it was a gesture to the Angevins, with whom Siena maintained a close relationship. Yet another possibility is that the context is more poetic, in keeping with the sensibility Simone showed in his frontispiece

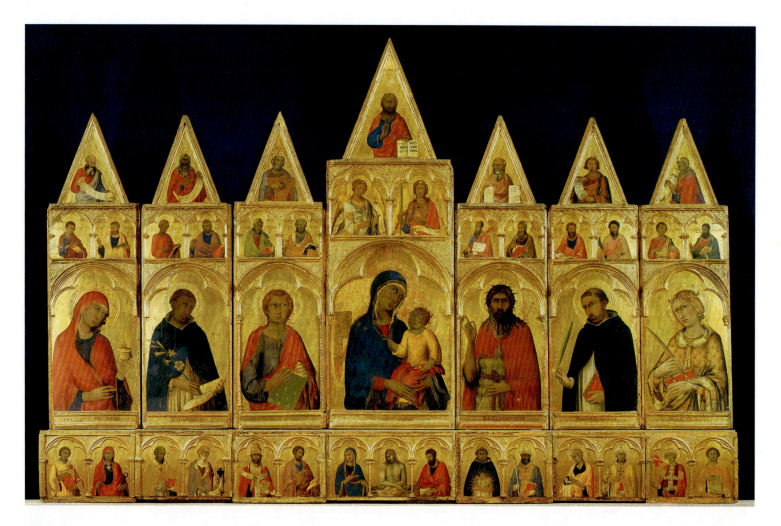

1.33

Simone Martini, polyptych for Santa Caterina, Pisa, *c.* **1320.** Tempera on panel, 3′ × 11′1″ (*c.* 95 × 339 cm). Museo Nazionale di San Matteo, Pisa

to the poet Petrarch's (1304–1374) *Virgil.* The Virgin's depicted words are in terza rima, a rhyme scheme that both Petrarch and Dante had used. In 1321, Simone went back and repainted several parts of the **fresco**, including the head of the Virgin. In revising the image, he pulled back her veil to reveal golden hair. Though no earlier Italian artist had shown the Madonna this way, Simone may well have known the French poetry honoring the beautiful blonde lady, which troubadours would perform for royal audiences.

Pietro Lorenzetti's painting may have been made for a private home; Simone's *Maestà* was for a government building. Their differences owe a lot to their intended settings. Today, Italy's local museums contain scores of painted Madonnas originally exhibited in churches, yet much is still unclear about their use within those spaces. The panel paintings made for churches, such as Giotto's *Ognissanti Madonna* (**see** fig. 1.13) were large and heavy: seeing them in museums today, it is difficult to imagine them being moved from their intended sites. Still, we have seen that even Duccio's massive *Maestà* was carried through the city in procession, and it was common

for paintings to shift locations over the years. With most surviving paintings from before 1320, no documentary evidence links them to their original function.

One development we can track, however, is the growing association of the altar with a particular form of painting: the "**polyptych.**" Long before the Renaissance, it was common for private individuals, families, and semi-private religious groups to make donations to churches that could be spent on the buildings' adornment. Beginning in the fourteenth century, however, these parties began to finance the decoration of the individual altars at which priests said Mass, notably with a large panel painting that stood behind the altar table. Though none was quite as grand as Duccio's *Maestà,* many of these were impressive, and their proliferation helped make the church interior the most important space for public art in many cities.

A revealing example, because it is known to have been placed on an altar in the church of Santa Caterina in Pisa, is another painting by Simone Martini, now reassembled in Pisa's Museo Nazionale (fig. 1.33). The painting's central panel, the Madonna holding the infant

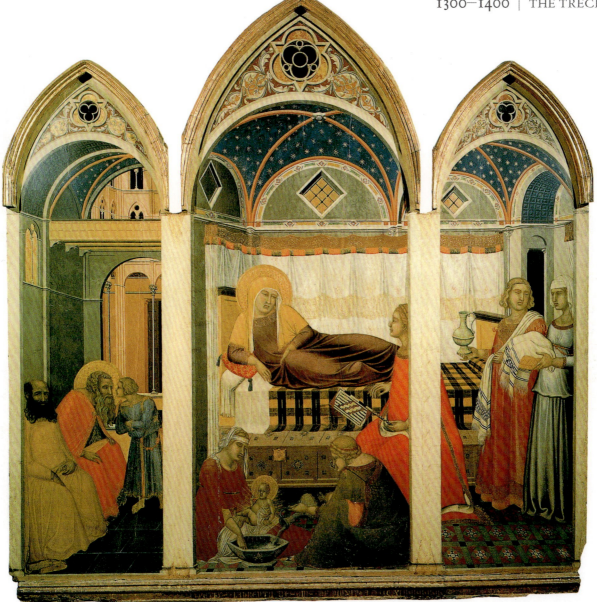

1.34
Pietro Lorenzetti, *Birth of the Virgin* (St. Savinus altarpiece), **1342.** Tempera on panel, 74 × 72" (187 × 184 cm). Museo dell'Opera del Duomo, Siena

Christ, shows the more conservative approach required by its ecclesiastical setting. While the wild-haired child looks up at the Virgin and grasps her robe, she herself would have been at home in a Byzantine icon, staring at the viewer with her hair modestly covered. More unexpected is what happens around the pair. Simone was among the Italian artists who began building outward not by creating a kind of throne room in the manner of Duccio's *Maestà*, but by expanding the half-length figures into a multipanel painting in which isolated, independently framed saints flanked (or in this case, surrounded) the Virgin. To her left and right are six other prominent saints, each identifiable from his or her face and clothes or from the object he or she holds. Above and below these figures are some three dozen additional ones, each occupying an archway supported by columns. The structure alerts us that while the friars associated with the

church preached humility and adopted uniform clothing and hairstyles, they still valued individual achievement and recognized the signs of fame, whether that be the text a predecessor had authored or the torments he or she had endured. The polyptych form drew upon ancient memory exercises, which encouraged practitioners to associate figures with architectural spaces, and it allowed for shifting attention over the course of a year, as series of holidays celebrated the various depicted saints.

The recognition that Duccio and Giotto represented alternative approaches to painting affected later altarpieces that took the Virgin as their protagonist. This can be seen, for example, in those produced around 1330 for Siena Cathedral, each dedicated to one of the city's patron saints and depicting an episode from the life of the Virgin. Pietro Lorenzetti's altar of St. Savinus, depicting the *Birth of the Virgin* (fig. 1.34), emphasizes the values

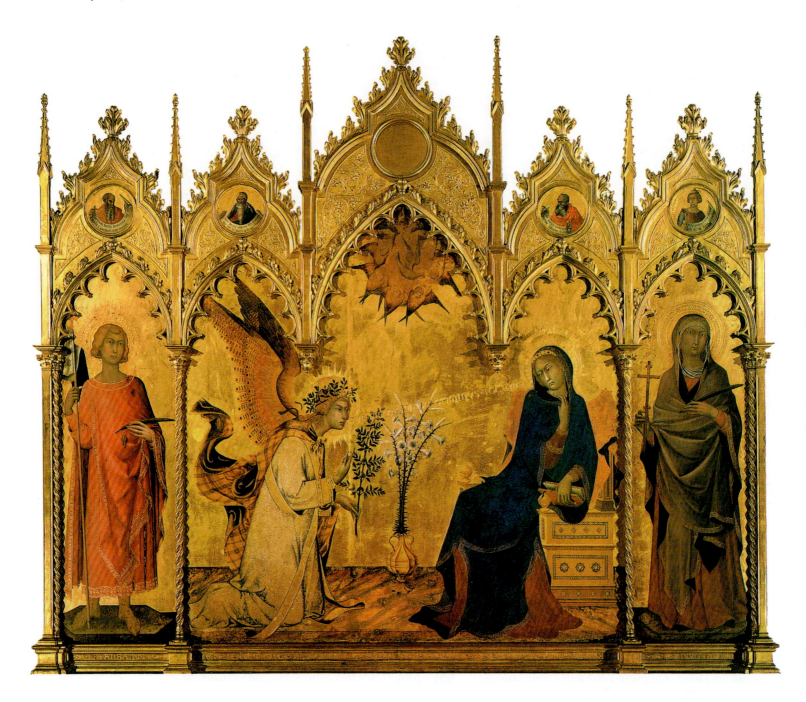

1.35

Simone Martini, *Annunciation with Two Saints, c.* 1330. Tempera on panel, 10' × 8'9" (3 × 2.67 m). Uffizi Gallery, Florence

of space and volume associated with Giotto. Lorenzetti treats the tripartite frame of the altarpiece as a three-arched screen through which we see a domestic interior – the bedchamber where St. Anne, the mother of the Virgin, reclines while the midwives bathe the infant Mary. The left panel shows an adjacent anteroom with a view onto a courtyard beyond. Treating the picture surface as an opening onto a highly realized fictional space, Lorenzetti dispensed with the gold ground commonly used in altarpiece decoration. Several of the patterned surfaces that replace it – a tiled floor, a plaid bedspread – reinforce the illusion of deep space by including straight lines

that would all converge on a common point if they were extended. (By showing us the cover hanging over the edge of the bed, Lorenzetti indicates that the lines forming its pattern are parallel lines.)

In the contemporary St. Ansanus altarpiece – devoted to the Annunciation (fig. 1.35) – by contrast, Simone Martini follows the example of his probable teacher, Duccio, conceiving the painting in terms of fluid outlines, giving his figures wiry silhouettes, elongated proportions, and pointed slender features. They bend, twist, and flex their wrists and necks in a way that enhances the calligraphic play of line. Yet there is more drama here than in Duccio:

Simone's Virgin seems to recoil at the outlandishly beautiful angel in the flowing plaid mantle, who bends his head to clear the molding of the frame. The whole composition reflects the refined behavior and stylish luxury associated with the old feudal nobility and with princely courts. By the time Simone was painting, the mercantile Republic of Siena had largely stripped the old aristocratic families of their power, yet the style associated with the French courts and the Angevin House of Naples carried considerable prestige. Simone himself was knighted by King Robert of Naples and ended his career at the court of the popes (then based in Avignon).

Art and the State

The Image of the Sovereign: Bologna and Naples

Another distinctive innovation of fourteenth-century art was portraiture. The earliest portraits all had a political context. An astonishing early example is the larger-than-lifesize statue of Pope Boniface VIII (fig. 1.36) made by the goldsmith Manno di Bandino (active around 1300) to adorn the exterior of Bologna's Palazzo Communale in 1301. Bologna at that time could claim a measure of self-rule, but it also belonged to the large area of central and northern Italy legally subject to the Pope. Under Boniface's authoritarian reign, during which the Holy See entered wars with Florence, France, and the Empire, Bologna resorted to extraordinary measures to demonstrate its loyalty, especially after the victory of a pro-papal faction in government.

Images of living rulers in public spaces were relatively uncommon, and the choice of metal rather than stone – Manno used sheets of **embossed** and gilt copper over a wooden core – was also unusual. Manno hailed from Siena, and his figure has little to do with the emotive and naturalistic sculpture associated with Giovanni Pisano and his father. Elongated and abstracted so that he resembles a gigantic chessman, the papal regalia almost indistinguishable from the forms of his body, Boniface has been turned into an image of superhuman authority. The officials who commissioned the statue would have been aware of the Pope's political self-promotion through his own effigy; in 1297, he had two statues of himself erected atop the gates of the city of Orvieto, and in 1296, his likeness was placed over the main portal of Florence Cathedral. When Boniface was finally arrested and humiliated in 1303 by an invading French army, lawyers for the French king declared the Pope to be a pagan idolator who scandalously encouraged the faithful to worship his image.

Radically different in form, but similar in its use of public portraiture to promote the authority of a regime,

1.36

Manno di Bandino, *Boniface VIII, c.* 1300. Embossed copper and bronze, height 7'6" (2.35 m). Museo Civico Medievale, Bologna

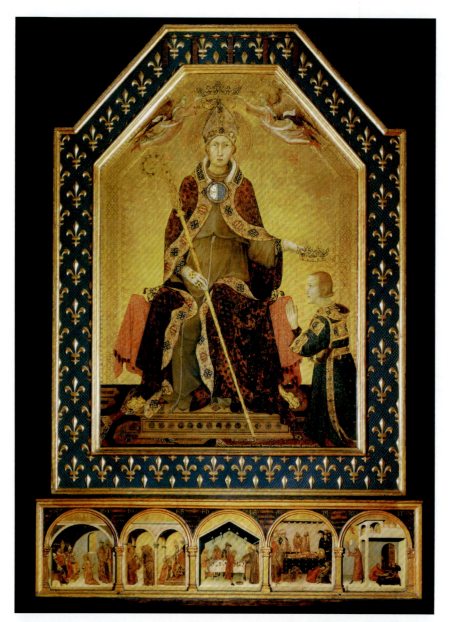

1.37

Simone Martini, *St. Louis of Toulouse Crowning His Brother, Robert of Anjou, King of Naples*, 1317.

Tempera on panel, 8'2" × 6'2" (2.5 × 1.88 m).

Museo Nazionale di Capodimonte, Naples

is actually crowned by his brother, whose status as original heir is signaled by the crown borne by angels above his bishop's miter. Louis had renounced his own claim to kingship in order to pursue a religious calling, yet had been compelled by his family to assume the far more prestigious and politically influential office of archbishop of Toulouse, a major center of Angevin territorial interests in France. Louis died in 1297, at the age of twenty-three. Simone conveys the contrasting roles of the young saint: he appears in a highly formal frontal pose, similar to that of the Virgin in earlier panel paintings, and the form of the frame itself closely resembles the central portion of Duccio's *Maestà*. The richly jeweled cope of a bishop, emblazoned with the arms of France and Hungary (Louis could claim those crowns too, through his royal parentage) nearly smothers the humble Franciscan robe; the arms of Jerusalem and Sicily appear in the great jeweled clasp (morse) on his chest; the lavish ornaments of the bishop's regalia simulate the work of contemporary goldsmiths, and gems stud the panel. The golden lily or *fleur-de-lys* of Anjou appears in the gold ground, and in wooden relief in the opulent frame. The sense of royal splendor is further enhanced by the Chinese silk draped on the throne and the Persian carpet that alone creates a sense of receding space.

Signoria and *Comune*: Verona and Siena

Apart from Naples and Rome, Italian cities typically had one of two types of government. Northern cities, such as Verona, Milan, Piacenza, Parma, Ferrara, and Rimini, in which a single sovereign and his attendants ran the show, were called *signorie* (literally, "lordships"). Central Italian cities – including Bologna, Genoa, Florence, Siena, and Pisa – had elected councils, and called themselves *comuni* (roughly, "commonwealths" or republics). Both forms could seem contingent and unstable to those that experienced them. Many *signorie* had become autocracies only after an earlier communal government had failed (an unhappy history that survived in local memory and affected commissions of artworks everywhere). But the idea of government by a town's leading citizens dated back only a century. Most republics were in fact governed by a single political party or a small group of wealthy male citizens. Neither the church nor the sovereigns with claim to the region fully recognized their legitimacy. One result of this was that even cities with elective governments could embrace images of embodied authority that were "royal" in character.

In the *signoria* of Verona, the local potentates also used portraiture to political ends, resulting in a group of the greatest sculptural monuments of the later fourteenth century. Bonino da Campione's (*fl.* 1350–1390) looming homage to Cansignorio della Scala (1340–1375; fig. 1.38)

is the altarpiece commissioned from Simone Martini (fig. 1.37) by the King of Naples, Robert the Wise of Anjou, in 1317. The altarpiece was dedicated to the recently canonized St. Louis of Toulouse, who was also the king's older brother (both are depicted on the tomb of Mary of Hungary, their mother; *see* fig. 1.11). Although its original location is not known, the altarpiece was very probably installed in the chapel of St. Louis in the Franciscan church of Santa Chiara in Naples, which served as a burial place for members of the House of Anjou ("Angevins"). The painting features the earliest surviving narrative **predella**, or sequence of narrative scenes beneath the main panel, which here tell the story of St. Louis' pious life and miracles. The king sought to draw on the charisma of the Franciscan saint to guarantee his own claim to the throne of Naples: Robert

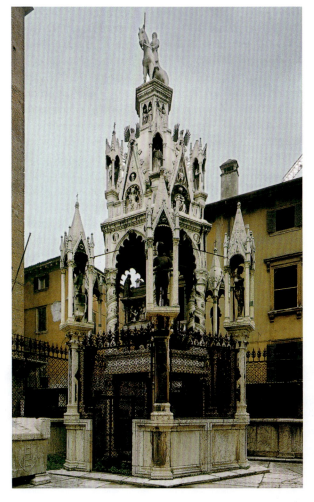

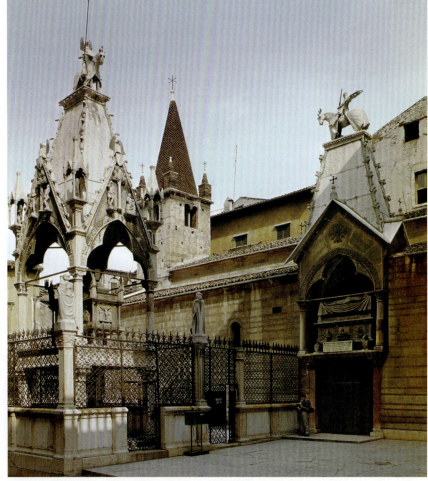

was ostensibly a tomb, and it centered on a recumbent image of the deceased local lord (*signore*). The work's primary function was to generate an image of the ruler that would last well after his death. The *baldachin* that covered it was an architectural feature elsewhere used to mark holy sites and objects, suggesting that in Verona the leader himself was worthy of adoration. Surmounting the *baldachin* was a second image of the *signore*, as a military champion on horseback: the image of knighthood lent a civilizing gloss to the arbitrary violence that characterized the signorial regime.

This structure attests to its designers' familiarity with ancient Roman triumphal forms, including the Arco dei Gavi (1st century CE; fig. 1.40) outside Verona's city walls. The Veronese *signore* had no qualms about associating himself with the ancient empire and its history of hereditary rule. What is perhaps most notable about the monument, however, is its re-creation of a more recently established architectural type: Cansignorio's predecessor Cangrande I della Scala (1291–1329) had commissioned the first **cenotaph** of this sort at the beginning of the century, and Mastino II (1308–1351), Cansignorio's father,

1.40
Arco dei Gavi, Verona. The structure, dating from the first century CE, was rebuilt in 1932.

ABOVE LEFT
1.38
Bonino da Campione, **Funerary Monument of Cansignorio della Scala**, 1376. Piazza by Santa Maria Antica, Verona

ABOVE RIGHT
1.39
Funerary monuments of (right) Cangrande I della Scala, begun after 1329, and (left) Mastino II, begun 1345. Santa Maria Antica, Verona

had created a second (fig. 1.39). Attached to the church of Santa Maria Antica, which had been a focus of family patronage, Cansignorio's undertaking would have come across above all as an attempt to legitimate his authority by associating his governance with local tradition. We can speculate on Cansignorio's own motives here: he had taken control of the *signoria* by murdering his own brother Cangrande II, and he may well have faced doubters of his claim to the title of *signore*. We can also consider the function of the Della Scala monuments as a group. Together, they assert the prerogative of a dynasty over and above that of any elected leader.

In Siena, a city the proud factions of which are evident even today, the *comune* had to position itself against such manifestations of coercive rule. The beautifully utopian murals of Ambrogio Lorenzetti (*c.* 1290–1348) produced in 1338 for the Room of the Nine Governors and Defenders of the Comune (Sala della Pace) in the Palazzo Pubblico (fig. 1.41) show the limits of the available visual language. The chamber served as the meeting place for a small group of officials (by law more than

thirty years old, members of the Guelph party, and merchants by profession) who served two-month terms on a kind of executive board for a much larger and more complex government. The "Nine," as they were called for short, lived in the palace during their tenure. The scenes under which they convened were not, like Campione's Della Scala sculptures, propagandistic so much as they were exhortative: they showed the city as it would look if the Nine ruled well, and the scenes contrasted this well-run city with its corrupt opposite (*see* fig. 1.44). A third wall of personifications (figures standing symbolically for abstract ideas) rendered the principles of "good government" in vivid and memorable form (fig. 1.42).

This third wall had two focal points, in the form of *Giustizia*, or "Justice" (as a woman because the Italian word takes the feminine pronoun), and *Ben Comune*, or "Common Good" (as a bearded man because the Italian noun *bene* is masculine). Inscriptions in Italian at the bottom ensured that the allegory in which these figures participated remained comprehensible to its viewers. Reading from left to right, the Nine would have seen that

1.41
Ambrogio Lorenzetti, murals in Sala della Pace, 1338. Fresco. Palazzo Pubblico, Siena

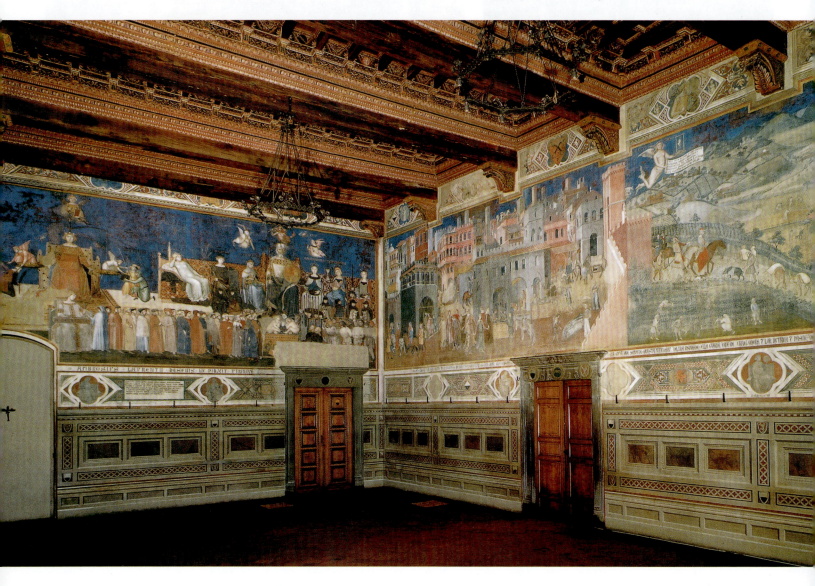

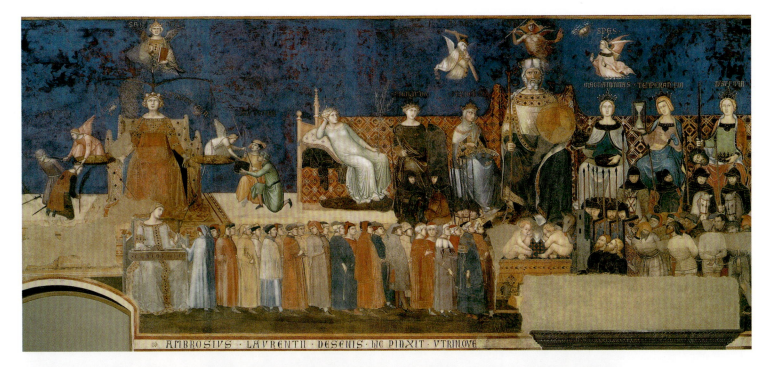

AMBROSIVS · LAVRENTII · DESENIS · HIC · PINXIT · VTRINOVE

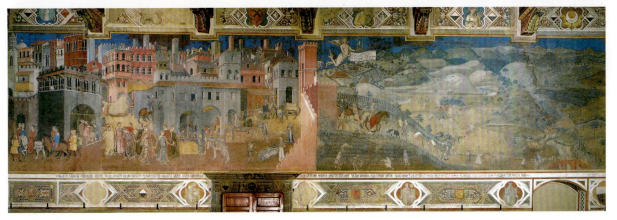

ABOVE

1.42
Ambrogio Lorenzetti,
*Allegory of Good
Government* (detail), 1338.
Fresco. Palazzo Pubblico,
Siena

LEFT

1.43
Ambrogio Lorenzetti, *Good
Government in the City and
Countryside*, 1338. Fresco.
Palazzo Pubblico, Siena.
The inscription below
reads (in part): "Look how
many goods derive from
[Justice] and how sweet
and peaceful is that life of
the city where is preserved
this virtue who outshines
any other. She guards and
defends those who honor
her, and nourishes and
feeds them. From her light
is born, both rewarding
those who do good
and giving appropriate
punishment to the wicked."

Justice controls two scales, one on each side, illustrating the notion that there are two kinds of justice: distributive, which rewards and punishes, and commutative, which mediates disputes. Descending from the vignettes that betoken this double function of the courts are two cords, which a figure of "Concord," seated below, weaves together and passes along to Siena's citizens, who proceed with it to the right, where – the inscription explains – they take Ben Comune as their "signore." Here, no less than in Simone Martini's nearby *Maestà* (*see* fig. 1.32), the image of the enthroned ruler paradoxically underwrites the values of a city that had no monarch.

Flanking the male personification are the Virtues under which the Sienese governors were expected, literally, to unite. Peace, to his far right, reclines on a suit of armor. (The significance is double-edged: political idealists might read it as a triumph of Peace over the weapons of war; hawkish realists might see it as pointing to the bedrock of military strength that literally and figuratively supports Peace.) Fortitude, to his far left, wields a sword, wears a crown, and holds a severed head, signaling the occasional necessity of severity on the part of those who rule cities. The murals, that is, by no means imply that the *comune* was somehow less violent than the *signoria*; the point is rather to deny violence to individuals and to entrust it instead to the collective state, which uses force in necessary self-defense against outlaws and warlords – like the two armed men kneeling in submission before Ben Comune's throne, with a group of bound prisoners under guard behind them.

The associated cityscape (fig. 1.43) elaborates visually on the benefits of proper government: elegant new architecture, flourishing trade, and, not least, the safety of Siena's citizens. In the well-governed city, a wedding

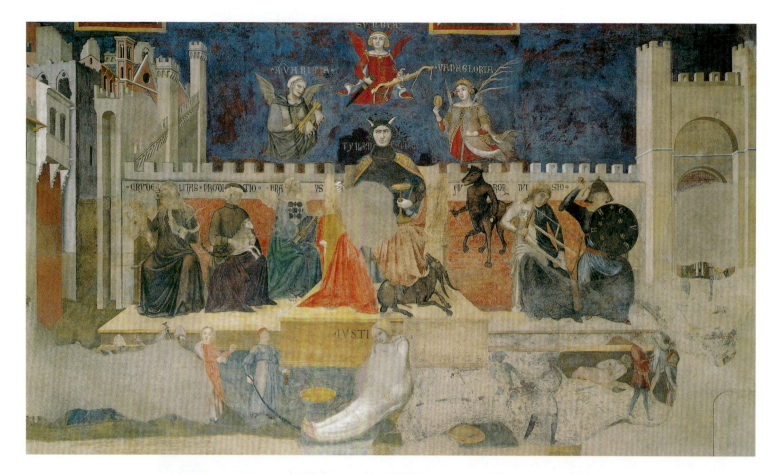

1.44

Ambrogio Lorenzetti,
*Allegory of Bad
Government* (detail), 1338.
Fresco. Palazzo Pubblico,
Siena

procession passes through the public square and a group of dancers perform in carnival costume. Such elements convey a sense of joyous festivity, but they also – like all the other activities depicted in the city – represent the areas of daily life over which the governors using the room had jurisdiction. Local laws regulated festivity as much as trade; the city set limits on how much private citizens could spend on family celebrations, and imposed fines for infringements.

The same is true of the countryside depicted outside the city gates, which provides the setting for a range of human activities that Siena protected as sources of income. In one of the first surviving landscape paintings in European art since Roman antiquity, Lorenzetti unfurled a panorama of hills and plains, extending to the sea where Siena had just annexed the port of Talamone, which was vital to its trading interests. In addition to the varieties of rural labor, he depicted a party of elegantly dressed Sienese ladies and gentlemen riding out to hunt with falcons and dogs. The impact of such an inviting world on a Renaissance observer would have been particularly powerful given the contemporary reality of the countryside. Much of the territory between cities was still barely within the rule of law; it was in large part a fearful place associated with wild animals, malarial

marshes, bandits, and the marauding armies of warlords whom Siena was actively seeking to bring under control. The principle that has rid the countryside of these terrors is represented by the angelic figure of Security, who appears overhead with a scroll: "Without fear every man may travel freely and each may till and sow, so long as this commune shall maintain this lady [Securitas] sovereign, for she has stripped the wicked of all power." Ominously, Security also bears a gallows with a hanged man: she maintains safety through the threat of punishment, including the death penalty.

Lorenzetti's image of the city might remind us that Campione's Della Scala tomb (*see* fig. 1.38), too, took security as a major theme; the warrior saints topping the columns on the monument's corners work not just as symbols of the lord's virtue but also as guardians, looking out protectively over the community as a whole. What sets the Sienese image of government apart from the Veronese ruler image, both conceptually and rhetorically, is its explicit dependence on a principle of antithesis, on the differences it directly illustrates between good government and bad. Opposite the image of the flourishing city, Lorenzetti painted a fearful picture of what might happen if the governors did not do their jobs (fig. 1.44). Buildings fall into physical ruin. No

women dance – or even walk – in the city's streets, where thugs kill those who venture outside. Presiding over all is a horrific double of Ben Comune and his advisors. Here a cross-eyed and devilishly horned figure of Tyranny takes counsel from such vices as Cruelty, who torments a child, and Treachery, who holds a sweet-looking lamb with a scorpion's tail. Division, dressed in black and white (the communal colors of Siena), literally saws herself to pieces, a chilling symbol of how a hard-won political consensus can be torn apart by factional strife. Around the head of Tyranny floats the infernal trio of Avarice, Arrogance, and Vainglory – the vices of city life that preachers most regularly denounced. Justice, Ben Comune's partner on the "good government" wall (*see* fig. 1.42), now lies bound and helpless before the throne.

When the Sienese thought of real Tyranny, they probably imagined cities very much like Verona, where a single lord presided. The communal imagery of the Lorenzetti murals, in other words, does not just differ in kind from the dynastic cenotaphs of the north – such imagery makes the very idea of the *signoria* its target. By contrast to Campione's Della Scala monuments, in which saints surround an individual, the closest thing to a central character in Lorenzetti's *Good Government* is not a person at all but a symbol of anti-individualism ("common good"). The painter might seem to give us an enthroned and stern-looking man, flanked by courtly attendants, but the arrangement also reminds us that in a republic no real person can occupy such a position, even briefly. To submit the city to the rule of an individual rather than a group, this program announced, was inherently to give the city over to conflict and destruction.

We have been focusing on figural works, but architecture, too, signaled the kind of government that operated in a city. In the very years Lorenzetti was painting, the Sienese were adding a soaring bell tower to the Palazzo Pubblico, the building in which he worked (fig. 1.45). This structure, completed in 1348, made the Sienese

1.45

Palazzo Pubblico, Siena, begun 1297. The city hall itself was begun in 1297; the tower (the "Torre della Mangia") was added after 1325.

town hall look more like its Florentine counterpart, the Palazzo dei Priori (*see* fig. 1.4), where that city's Council of Nine met. Florentines referred to their governors as the *signoria*, a designation that, like Lorenzetti's depiction of Ben Comune, drew attention to what the city avoided: the council, serving as the city's "lord," prevented such a role from falling to any individual alone.

Lorenzetti's cityscape gives us a sense of the buildings that must have stood out on Siena's fourteenth-century skyline: narrow, stone, largely windowless towers that individual clans kept for their own defense. Florence itself had by this point banned the private use of such towers, and had even required citizens who owned existing structures of the sort to level or lower them. Only one building had the right to stand above others, and that was the building representing the subordination of private interests to the collective, the Palazzo dei Priori.

Art and Devotion after Giotto

Cult Images and Devotional Life

Today we single out the work of Giotto, Duccio, or Nicola Pisano, and even of the artists who continued their workshops. In this, we follow the sensibility of such later writers as Lorenzo Ghiberti and Giorgio Vasari (1511–1574), but we should bear in mind that this way of looking went against the grain. Most Italians who encountered new images in churches, homes, and public spaces were probably indifferent to the question of who had made them and of the degree to which those works manifested artistic values and ambitions.

All Italian artists would themselves have thought carefully about the uses to which their works would be put, the requirements of those who paid for them and of those who encountered them. Few paintings and sculptures had titles – those used in this and other books mostly just describe subject matter – and early viewers would not have thought titles necessary, since the content of most artworks was so conventional. Altarpieces normally showed the Virgin and Child with saints; mural narratives related the life of the Virgin, of St. Francis, of local patron saints, and, less commonly, of Christ. Even Ambrogio Lorenzetti's inventive paintings of good and bad government in Siena's Sala della Pace (*see* figs. 1.42–1.44) had counterparts in the town halls of Florence, Perugia, and other city republics. The repetition ensured that even the uneducated could recognize the features and attributes (identifying devices) of standard characters: St. Peter, white-haired, bearded, and balding, nearly always wore blue and yellow and carried keys; John the Baptist, younger, emaciated, and often disheveled, typically sported a short vestment made of animal hair; Jerome wore the red hat and robes of a cardinal; and so forth.

For the majority of Ghiberti's Florentine contemporaries, the most important image they would have encountered was one he chose not to mention in his *Commentaries*, presumably because he took it to hold

1.46

Tuscan painter, *Annunciation*, early fourteenth century. Mural. Santissima Annunziata, Florence

little artistic value: this was the *Annunciation* (fig. 1.46) on the inner facade of a church in Florence that took its name from that very image (the Santissima Annunziata, or "Most Holy Virgin of the Annunciation"). The painting, believed to respond miraculously to prayers, had become the focus of a cult, and the faithful came from far and wide to revere it and make votive offerings – sometimes in the form of wax portraits of themselves – at the shrine protecting it or in the cloister outside. These visitors would have been told that the work did not stem from human hands: in 1252, according to the official account, a friar-artist who had fallen asleep during his work on the painting awoke to find that it had been completed by an angel. (Despite the alleged date, the present image was probably painted as much as a century later.)

Other images had an equally special status. In 1292 a mural depicting the Virgin and Child at a grain reserve in Florence called Orsanmichele began to work miraculous cures. Thousands flocked to the image with prayers and petitions, and more importantly with financial donations; some of the money paid for bread, which the overseers of the site then distributed to the poor. In 1304 a fire destroyed both the warehouse and the image. The painting was quickly replaced, with no apparent loss of efficacy, and in 1337 the *comune* began work on a new, more secure, mixed-purpose structure that could house it. The arcades on the lower storey of the building we see today (fig. 1.47) originally provided an open **loggia** facilitating the distribution of food; the new structure's primary occupants, however, belonged to a lay **confraternity**, or charitable brotherhood, devoted to the painting.

By this point, Florentines associated Orsanmichele with the protection of the *comune* as such: after uniting in 1343 to expel the French nobleman Walter of Brienne (*c.* 1304–1356) – whom the city had elected as Lord for life exactly one year earlier – it was in Orsanmichele that they erected an altar to mark the occasion. Their sense of the place no doubt owed something to the fact that the warehouse had provided an emergency food supply, though by mid century the image had become more important than the building per se. This was all the more true upon the advent of the **Black Death**, a disfiguring, lethal plague that first arrived in Italy in the late 1340s, then again, repeatedly, in the years that followed, decimating the population. The great writer Giovanni Boccaccio, living in Florence at the time, described how the disease sickened thousands a day, how the smell of putrifying bodies filled the city, how lawlessness reined as police forces dissolved, and how families turned against each other.

The plague killed the poet Petrarch's beloved, Laura, and Ambrogio Lorenzetti, as well as the painter Bernardo Daddi (*c.* 1280–1348), who had recently completed an "improved" and more stylistically up-to-date

painting for the Orsanmichele shrine (fig. 1.48). By 1348, half of the city's population was gone, and Orsanmichele's large grain reserve no longer seemed necessary. The lay confraternity responsible for the building successfully persuaded the *comune* to allow it to fill in the arches of the exterior walls. The closing of the lower floor and the subsequent addition of **tracery** windows underscored the building's religious purpose, much to the benefit of the confraternity, which became enormously wealthy through the numerous legacies that the faithful left to the Virgin of Orsanmichele in their wills. In the years following the first attack of plague, the lay brothers further embellished the cult and site, sponsoring elaborate musical performances and a new marble tabernacle to house Daddi's image (which retained the miraculous

1.47
Orsanmichele, Florence, begun 1337

powers of the original). All of this helped the confraternity maintain a steady income by encouraging a constant flow of visitors.

Lorenzo Ghiberti, who once again omits mention of the cult image, lavishes considerable praise on the new grand tabernacle it occasioned and on the painter-sculptor Andrea di Cione, known as Orcagna (*c.* 1308–*c.* 1368), who executed it: "It is a very excellent thing and quite unusual, done with the greatest diligence. He was a great architect, and he did all the scenes of that work with his own hand." The domed, pinnacled shrine would indeed have been a novelty in Florence, its richly carved surface enlivened with gilding, inlaid marble, and colored glass. A series of reliefs depicts the story of the Virgin, culminating on the back of the tabernacle in the scene of her "Assumption," her bodily acceptance into heaven at the end of her earthly life. Ghiberti, interested in the identity of artists, reported that Orcagna carved his own portrait on the shrine, but his authorship is more readily guaranteed by the signature under the Assumption. Whatever the interests of his patrons and viewers, Orcagna insisted on being remembered as the maker of this work: he was addressing a posterity that included not just the devout but also admirers of art, such as Ghiberti himself.

Painting after the Black Death

In the case of Orsanmichele, the consequences of the Black Death are unmistakable: it changed the function of the building. But could an event like this also transform the way painters conceived and executed their pictures? Attempts to answer this question have often focused on Orcagna himself, who in 1354 painted one of the great surviving panels from the period: an altarpiece for the family chapel of Tommaso di Rosello Strozzi in the Florentine church of Santa Maria Novella (fig. 1.49). The sturdy build of the figures and several of the facial profiles indicate a debt to Giotto. From Giotto, too, Orcagna derived an interest in narrative, creating a single space that extends across the altarpiece, and showing a range of interactions between the figures. Still, there is something severe, even intimidating, about the painting. We are not invited here to ask the intervention of a gentle mother; while the Virgin is still present, she has been shifted to the side and made into a far more dour figure. Ignoring the viewer, she focuses instead on recommending the Dominican St. Thomas to a grim Christ, who hands the keys to equally stern St. Peter. Saints John, Lawrence, and Paul frown from the wings, as an impassive

OPPOSITE

1.48
Andrea Orcagna, tabernacle, begun *c.* 1355. Marble, mosaic, gold, and lapis lazuli. Orsanmichele, Florence. The tabernacle frames a miracle-working panel of the *Virgin and Child*, repainted by Bernardo Daddi, *c.* 1346.

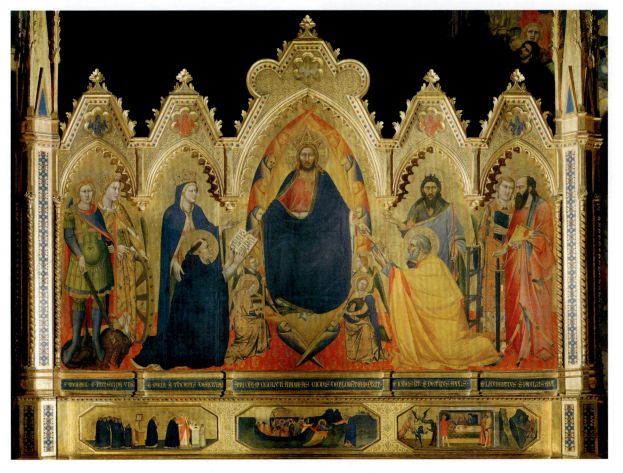

1.49
Andrea Orcagna, the Strozzi altarpiece, 1354–57. Tempera on panel, 9' × 9'9" (2.74 × 2.96 cm). Strozzi Chapel, Santa Maria Novella, Florence

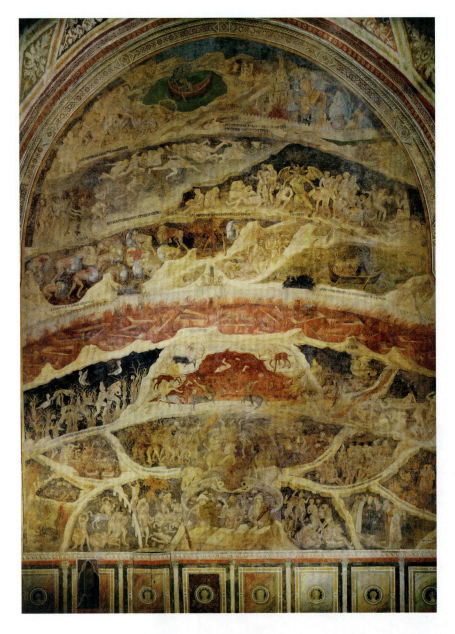

1.50
Nardo di Cione,
Hell, 1354–57. Mural.
Strozzi Chapel, Santa
Maria Novella, Florence

do merchants ceded to a more religious atmosphere. Yet such a reading of the work must be tested against the chapel to which the painting belonged.

Orcagna's brother Nardo di Cione (*c.* 1320–1366) provided designs for the stained-glass windows, which depict the standing figure of the Virgin Mary and the chapel's dedicatee, St. Thomas Aquinas. Nardo was also primarily responsible for the mural decoration, probably with the assistance of the important younger painter Giovanni del Biondo (active 1356–1399). Unlike the Bardi Chapel with its parallel bands of pictorial narrative (*see* p. 33), the three painted walls are treated as huge single fields, with scenes of the Resurrection of the Dead flanking the windows, Paradise on the west wall, and Hell to the east (fig. 1.50). Nardo was aiming for an effect similar to Giotto's monumental depiction of the Last Judgment in the Arena Chapel, painted fifty years before (*see* fig. 1.24; he would have known similar works from that period closer to home); he goes even further in suppressing effects of pictorial depth from his scenes of the world to come, while greatly multiplying the number of figures. Only in the foreground of Paradise, closest to the world of the beholder, does the figure of a deceased female Strozzi family member escorted by an angel seem to stand in a credible illusionistic space. On the facing wall, Nardo provided an alarming and highly detailed description – with captions – of the topography of hell, with different zones and punishments assigned to each category of sinner: Charon's boat brings the damned souls to hell in the uppermost register, and the castle of Limbo houses the souls of the unbaptized. The lustful and the gluttonous, tortured by the devil Cerberus, are consigned to pits of mud. Below, the misers and the spendthrifts fight a pointless eternal battle, pushing against each other with giant boulders; to the right the wrathful and the slothful are immersed in the Stygian swamp. Across the center of the fresco is the most heavily populated sector of hell: the zone of the heretics, immured in burning tombs and watched over by the Furies in the Castle of Dis. Suicides below are tormented by Harpies, while tyrants are forced by Centaurs to wallow in a lake of blood; usurers, sodomites, and blasphemers are punished together with a never-ending rain of fire. The gigantic three-headed figure of Lucifer below presides over the punishment of the worst sinners: pimps, seducers, flatterers, simoniacs (clerics guilty of bribery in return for promotion), fortune tellers, swindlers, hypocrites, thieves, bad advisers, sowers of discord, and forgers.

The decision to allocate so much wall space to a scene of damnation might make Orcagna's altarpiece look all the more harsh. It is easy to associate the whole space with a city preoccupied by death and fearful of divine punishment. Yet other explanations of Nardo's subject matter are

St. Michael holds his sword in the wound of a dragon. The absolute frontality of Christ amplifies the intensity of His gaze, humbling the viewer before Him. The upturned red-and-gold surface at the bottom of the picture reads more like a tapestry than a floor, yet there is nothing here of the elegant calligraphy or multiplication of textiles that characterized recent Sienese painting. Instead, the effect pushes the figures forward, projecting them into our own space.

Historians have sometimes been tempted to see the bleakness of the painting as a response to the plague, the most cataclysmic event of the late **Middle Ages**. They have emphasized Orcagna's differences from Giotto and his legacy, characterizing these as symptoms of an anti-modern turn, as a culture promoted by well-to-

also possible. His imagery closely follows the first part – titled Inferno – of the great poem known as the *Divine Comedy* by the Florentine Dante Alighieri, a contemporary (and admirer) of Giotto who had died as a political exile in Ravenna in 1321. The fame and prestige of Dante's poem, which combined visionary evocations of the world to come with elements of autobiography, political invective, and theological learning, had led to attempts on the part of Nardo's contemporaries to clear Dante's name in Florence, including a defense of the poet by Boccaccio in 1348. It may well be that the Strozzi and the Dominicans of Santa Maria Novella favored this imagery not because they rejected earlier values but, on the contrary, because they prized the city's literary culture and heritage. Certainly the use of his poem as the basis for a chapel's decoration elevated Dante alongside great theologians of the past, including Thomas Aquinas himself.

The most elaborate Dominican fresco cycle of the period is also at Santa Maria Novella, in the so-called "Spanish Chapel" (actually the Chapter House of the friars, a space for their formal assembly), and was executed by Andrea di Bonaiuto in 1365–67 (fig. 1. 51). Scenes of the Life of Christ – the Crucifixion, Resurrection and Ascension – signal that the space also functioned as the funerary chapel for a lay patron: one Mico di Lapo Guidalotti, according to the inscription on his tomb, was buried here in a Dominican habit. A scene in the vault derives from a work by Giotto at St. Peter's in Rome, known as the Navicella ("little ship"), the story of Christ protecting the Apostles during a storm at sea. The theme symbolized Christ's protection of the church, especially the church as led by the Pope, represented here by St. Peter.

On the wall beneath the Navicella is an allegory of Christian redemption and salvation, with a specifically Dominican emphasis. For all the supposed dogmatism and austerity of Tuscan art after the Black Death (which had struck again in 1362), the mural represents a creative encounter of poetry and theology in the wake of Dante, and the flexible adaptation of standard religious subject matter. The allegory borrows its organizational principles from the increasingly conventional image of the Last Judgment, with Christ appearing in glory in the uppermost zone. At Christ's lower right, the side associated with righteousness and salvation, we see the

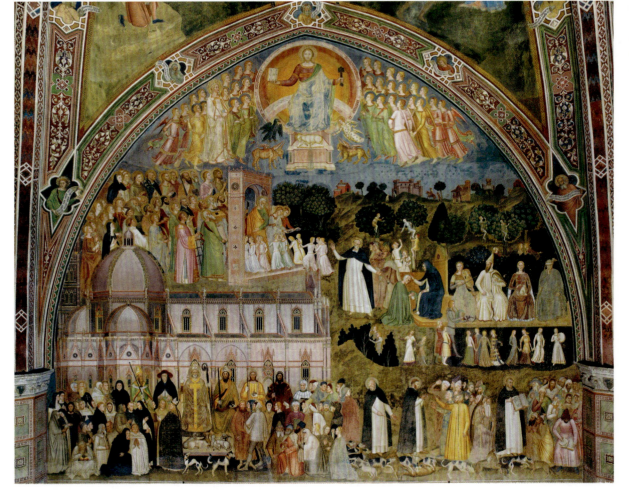

1.51
Andrea di Bonaiuto, frescoes in the Chapter House of Santa Maria Novella, Florence, 1365–67

sacred and secular powers that define the Church: a pope, an emperor, a cardinal, a king, and bishops appear enthroned, along with representatives of the religious orders, civil power, and secular learning. The unfinished fabric of Florence Cathedral, for which Andrea himself was an adviser, anchors the scene in the viewer's own world. On axis with the figure of Christ above appear commanding figures of members of the Dominican order in their black-and-white habits. In the lowest tier, these friars confront and convert heretics, Muslims, and Jews through theological disputation, yet a more coercive dimension is suggested by the metaphor of black-and-white dogs being turned by St. Dominic on a pack of wolves, a Latin pun on "domini canes" (dogs of God). St. Dominic and his order were frequently active in the Holy Inquisition established by the papacy to suppress heresy and religious non-conformism, often by violent means.

Above, it appears that the Dominicans are primary agents in the salvation of souls: a layman is blessed by a friar, while a Dominican saint conducts blessed souls – who appear in the form of children – to the gates of Paradise. What then of the activity at proper left? Seated close to the Dominican confessor is a company of elegantly dressed men and women, playing musical instruments or holding a lapdog and a falcon; women dance in the foreground, watched by two male companions; children in a garden beyond cut branches and harvest fruit from trees. This might appear to be a realm of luxury and sensory pleasures from which the friars seek to liberate penitent souls. At the same time, how we regard what is happening here very much depends on who is looking at the painting. Unlike Nardo's paintings in the Strozzi chapel, this fresco offers no guiding captions (*tituli*) to drive home the meaning; none of the activities depicted is portrayed in a negative light. It may be more prudent to regard this passage as the domain not of sin, but of secular life – even as the festive civic identity of the city of Florence – and therefore as a continuation of the evocation of the city, evoked by its outstanding architectural symbol – the **duomo** – immediately adjacent. The community of citizens found its fullest expression in the great festivals of the Florentine year, notably the May Festival (*Kalendimaggio*), when the boughs of new-flowering trees were gathered and brought into the city, while the people feasted and danced. The chronicler Giovanni Villani records one such festival in 1289, "when brigades and companies of genteel youth were formed. Dressed in new clothes, they constructed courts in several parts of the city covered with drapes and banners... women and young girls went through the city dancing in train and in pairs of women with instruments and with garlands of flowers on their heads, spending their time in games and enjoyments, in dinners and suppers."

Such displays, when the elites emulated the elegant pastimes of the courts and the old baronial aristocracy, aimed to honor the city itself. Lacking a royal or princely court of its own, the Florentines enacted one at certain exceptional times of the year. In Andrea's fresco, this is allowed to happen even under the severe scrutiny of the Dominicans.

Giotto's Legacy

If the paintings of Giotto, Duccio, Simone, and their contemporaries seem to represent a form of progress with respect to the past, marking the way to a more naturalistic or a more refined manner of making art, the middle and later years of the fourteenth century are bound to seem perplexing. It is hard to resist the impression that some artists and their promoters turned consciously against the pictorial aesthetics of an earlier generation – at least in Tuscany. Among the most impressive paintings of the 1370s, for example, is one by Orcagna's student Giovanni del Biondo. Like his master, he placed an unusual figure, this time St. Sebastian (fig. 1.52), at the center of an altarpiece. Sebastian had come to be venerated especially by those who feared or suffered from the plague, and the absurd number of arrows that pierce him hint at the anguish faced by the victims of the disease. But far more than in Orcagna's works, the unexpected subject matter corresponds to a crudeness of rendering, a disregard for space, anatomy, and emotional engagement. Giovanni's period remains the most understudied in the history of Renaissance art, perhaps because works like this fail to exemplify the qualities we tend to value: they are neither riveting nor beautiful. And the reasons for this have themselves been matters for debate. It may be that devotional changes led to a preference for paintings that evoked the supernatural rather than the human, and thus a move away from the tradition of Giotto. Or it may be that social upheaval brought about by the plague put wealth and the power to commission art into the hands of different people with different tastes. If either of these things are true, it would be possible to see painters like Giovanni del Biondo representing a conscious rejection of Giotto's work. (Benvenuto da Imola, writing around 1376, remarked the "great errors" in Giotto's paintings.) Alternatively, it may simply be that the collapse of earlier institutions diminished the demand for painting, undermining the continuity of traditional workshops, or that workshops themselves were compromised by the pandemic. It this case, what we see may be nothing more than a loss of skills.

As the century drew to a close, many Florentine painters accommodated Giottesque formulas within a plain, severe manner of painting. Some would surely have done this with a degree of historical consciousness.

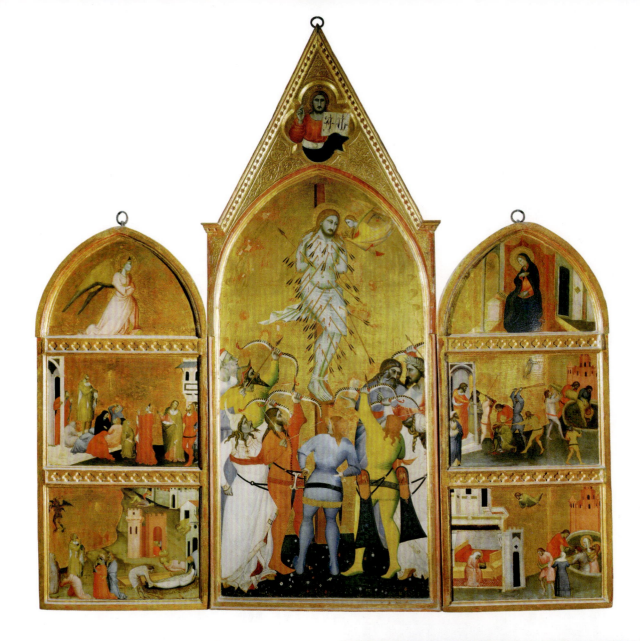

1.52
Giovanni del Biondo,
*Martyrdom of St. Sebastian
and Scenes from his Life*,
c. 1370. Tempera on panel,
7'4" × 2'11" (224 × 89 cm).
Museo dell'Opera del
Duomo, Florence

BELOW

1.53
Spinello Aretino, *Life of
St. Benedict*, 1387–88:
*Benedict leaves his family;
Benedict returns a broken
tray to a wetnurse; Benedict
reproves the warlord Totila;
Death of Benedict*. Fresco.
Sacristy, San Miniato al
Monte, Florence. The
frescoes were heavily
restored during the
nineteenth century.

A painter's adoption of Giotto's style, moreover, might well have appealed to patrons with politically conservative values. Consider Spinello Aretino's (*c.* 1350–1410) *Life of St. Benedict* (fig. 1.53) in the **sacristy** of San Miniato al Monte just outside Florence, executed for the Alberti family in 1387–88. Spinello was a pupil of Jacopo del Casentino (*c.* 1297–1358), a follower and probable pupil of Giotto, but his works seldom resemble Giotto's so emphatically as in this example. Late thirteenth-century Florentines might have been interested in Giotto and his followers for any number of reasons, but the Alberti were closely tied to the city's key governmental institutions, including the *signoria*, and a revolt in 1378 by the city's unskilled cloth workers, known as the Ciompi, had thrown these into crisis. Here, Spinello's impersonation of Giotto was a way of associating the family with tradition, civic heritage, and cultural norms.

In other cities where Giotto had worked, painters showed no reservations about following his example.

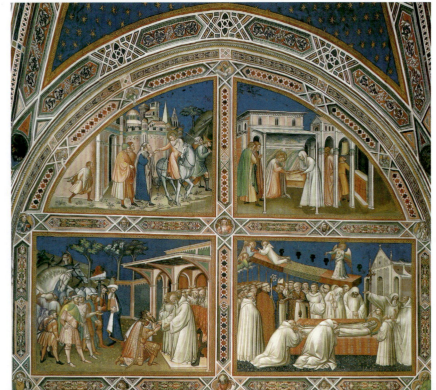

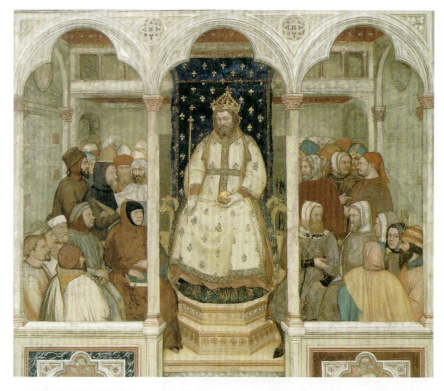

Those active in Padua, for example – including Altichiero (*c.* 1330–*c.* 1390) from Verona and the Florentine Giusto de' Menabuoi (*c.* 1320–1391) – produced narratives rich in decorative pageantry, with opulent architectural settings (fig. 1.54). Their princely audience – the Carrara family and their adherents – put a premium on display and sophisticated craftsmanship. This helps explain why painters in Padua showed less interest in lively narrative and psychological interaction, while going much further than Florentines did in the pursuit of spatial complexity, rich color, and ornamented surfaces. Characteristic are the frescoes that the nobleman Raimondino de' Lupi commissioned for the **Oratory** of St. George at the basil-

LEFT
1.54
Altichiero, *Scenes from the Life of St. James,* 1376–79. Fresco. St. James's Chapel, Basilica del Santo, Padua

BELOW
1.55
Altichiero, *Scenes from the Lives of St. George, St. Lucy, and St. Catherine,* 1378–84. Fresco. Oratory of St. George, Basilica del Santo, Padua

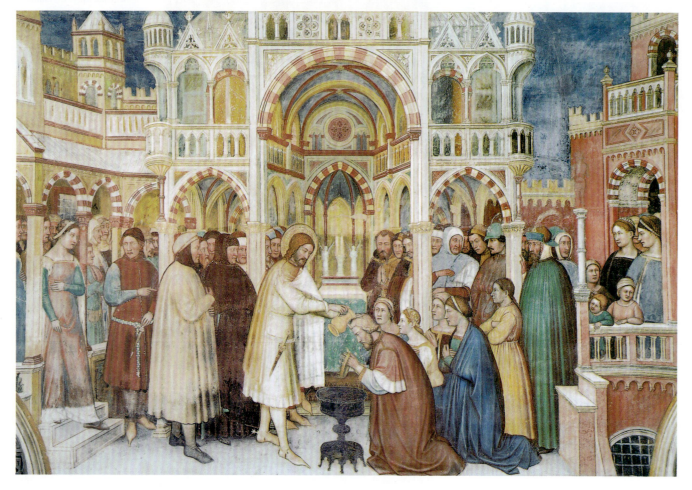

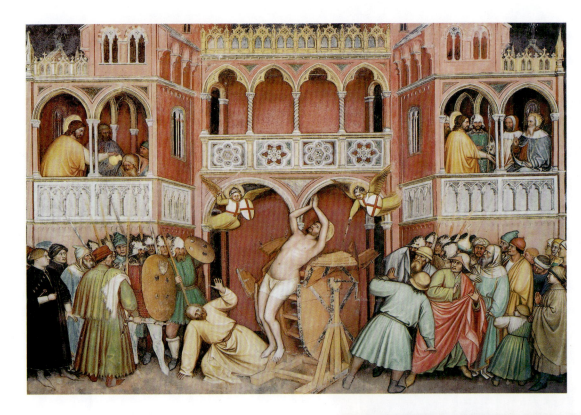

1.56
Altichiero, *Scenes from the Lives of St. George, St. Lucy, and St. Catherine,* 1378–84. Fresco. Oratory of St. George, Basilica del Santo, Padua

BELOW
1.57
Altichiero, *Scenes from the Lives of St. George, St. Lucy, and St. Catherine,* 1378–84. Fresco. Oratory of St. George, Basilica del Santo, Padua

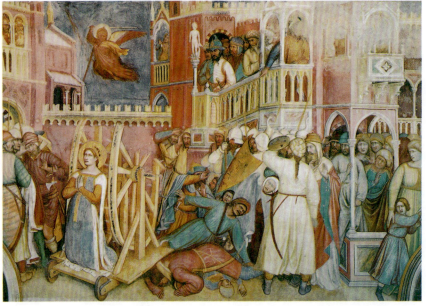

ica of the Santo, which Altichiero completed in 1378–84. The murals update Giotto's works at the Arena Chapel, which was also the architectural model for the oratory itself. As in Giotto's chapel, they include scenes from the life of Christ and the Virgin, but they add dramatic and often violent scenes from the lives of three martyr saints – including St. George (figs. 1.55–1.56), the chief saintly role-model for warrior aristocrats, such as Raimondino and his heirs. Altichiero shows George as a champion of Christianity and a dragon-slayer, surrounded by astonished pagans as he baptizes their king and queen (Petrarch here makes an appearance, dressed in red behind the saint, along with other members of the entourage of the local Carrara ruler). The Gothic basilica beyond is an idealized form of the Santo itself, with its colored bands of stone. Below, we see more conversions by St. George, and his liberation by warrior-angels from torture at the hands of pagans. The elaborate architectural setting probably alludes to the palaces and secular buildings of the Carrara dynasty, almost all subsequently destroyed; the artist, however, has avoided any analogy between the court and the pagan assembly, consciously distinguishing them with exotic costumes that identify them with the Islamic peoples of Western Asia and North Africa. This is even more the case with the scenes of the attempted martyrdom of St. Catherine (fig. 1.57), which outfit the saint's oppressors with beards, braided hair, turbans, and dark complexions.

While taking their bearings from Giotto, the muralists active in Padua created an approach to wall painting that would remain strongly independent of Florence, and would become a major point of departure for the innovations of Andrea Mantegna around 1450.

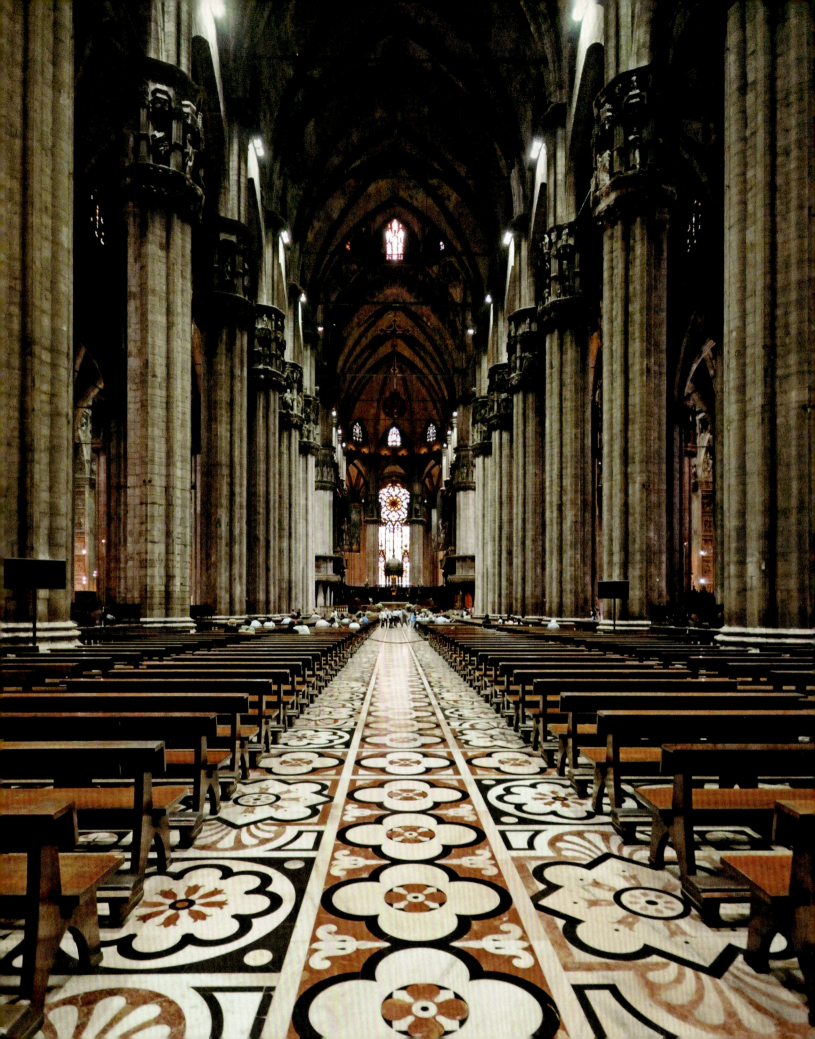

1400–1410
The Cathedral and the City 2

2

1400–1410
The Cathedral and the City

Campanilism

In 1400, Catholicism was the single Christian religion in Europe, and in principle it operated as a more centralizing organization than any European state. The head of the Church, as today, was the Pope, regarded as the successor of St. Peter, who had been given ruling authority by Christ himself. By the beginning of the fifteenth century, that authority had been damaged by a scandalous division (or "schism"), during which three separate individuals, based in different cities and supported by different European states, claimed to be Pope. The schism required localities to take sides, and provided them with an opportunity for self-assertion.

We see this, for example, in the frescoes that the government of Siena commissioned in 1407 from Spinello Aretino (fig. 2.1), the respected and prolific painter from

2.1

Spinello Aretino, *Scenes from the Life of Alexander III,* 1407. Fresco. Hall of the Priors, Palazzo Pubblico, Siena

Arezzo who had worked in Florence for the Alberti family thirty years before. It is perhaps unexpected to find an elaborate depiction of the life of a Pope in a government building. Yet the new decorations in the Palazzo Pubblico allowed the Sienese to take advantage of the Church's crisis and promoted their city by celebrating the life of a citizen, Rolando Bandinelli Paparoni (1160–1216), who had risen to be one of the most politically effective European leaders of recent centuries. Spinello depicted Paparoni's election as Pope Alexander III, his expulsion from Rome at the hands of Frederick Barbarossa's imperial troops, the Pope's subsequent collaboration with Venice to curtail the advance of imperial power in Italy, his return to Rome, and the emperor's ultimate submission: the climactic image is the spectacular, panoramic battle of Punta San Salvatore, noteworthy as a lone surviving example of the battle paintings that

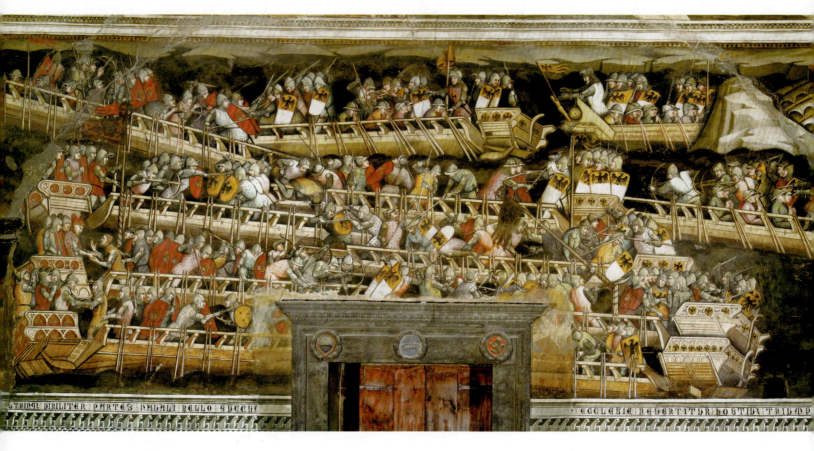

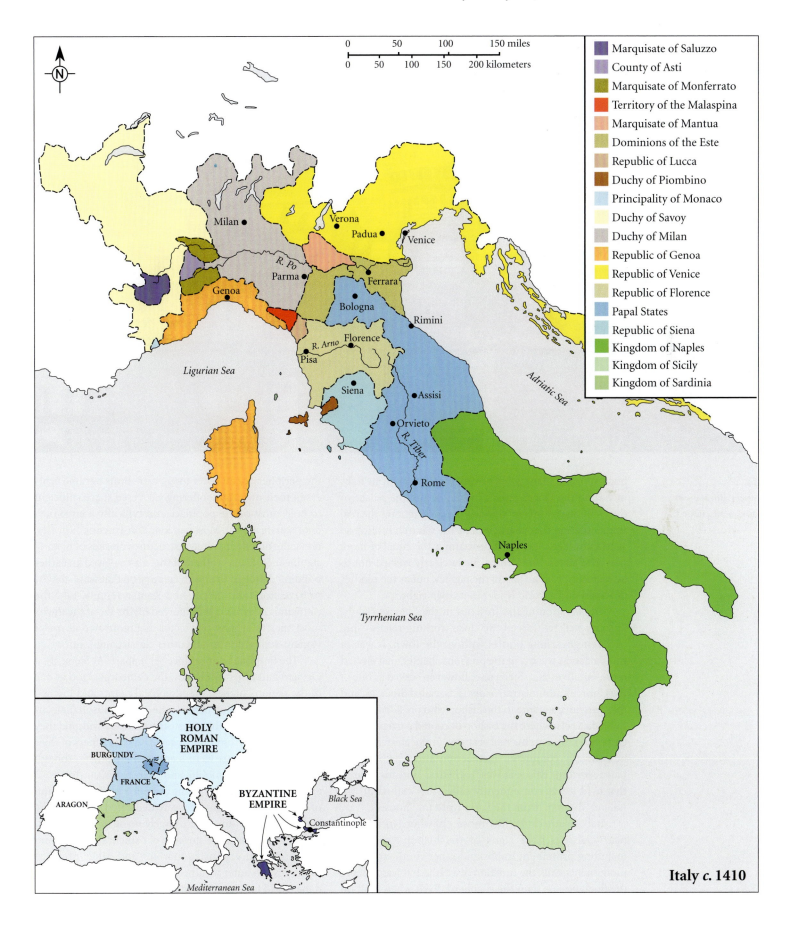

Italy c. 1410

Legend:
- Marquisate of Saluzzo
- County of Asti
- Marquisate of Monferrato
- Territory of the Malaspina
- Marquisate of Mantua
- Dominions of the Este
- Republic of Lucca
- Duchy of Piombino
- Principality of Monaco
- Duchy of Savoy
- Duchy of Milan
- Republic of Genoa
- Republic of Venice
- Republic of Florence
- Papal States
- Republic of Siena
- Kingdom of Naples
- Kingdom of Sicily
- Kingdom of Sardinia

2.2

Siena Cathedral with surrounding town

once adorned many seats of urban government in Italy, including the Doge's palace in Venice and the palace of the Della Scala lords in Verona. The cycle ignores the real fragmentation that characterized the Church in 1407 so as to exalt Siena itself and proclaim it the equal of more powerful states, like Venice. Siena clearly wished not to be seen simply as an ally of the papacy, but as the mother of Popes, and a world leader in its own right.

The location of the frescoes in the Sienese republic's city hall reinforced the close working relationship between governing bodies without the town. It was in this palace, as we saw in the previous chapter, that elected representatives met. Siena also, however, served as one of the Church's administrative districts, called dioceses, and thus provided a home to the bishop who presided over it. In Siena as elsewhere the bishop occupied a palace in the city center, though his real seat was in the church where he officially conducted instruction and worship. The Latin word for this seat was "cathedra," and the church that held it was consequently called the "cathedral" (in Italian, "duomo," from the Latin word for "house").

Italy's cathedrals, like those elsewhere in Europe, nearly always bore signs of the bishop's presence, including prominent tombs and other commemorative monuments. Still, the function of a cathedral was to serve the flock no less than the shepherd. Even when built on

the periphery of an older town, cathedrals became centers in their own right, offering a covered space sufficient to hold most of the populace and typically a large outdoor square as well. Most had long construction histories, replacing other consecrated structures on sites of historic significance; Siena's cathedral (fig. 2.2) replaced an earlier building dating to the ninth century CE that was believed to have stood on the site of a Roman temple. Like the cathedrals elsewhere, it reinforced myths about the town's most ancient origins, one factor that motivated its use of Roman-style columns and other classicizing motifs.

The building's appearance set it apart. At Siena, as at Orvieto and other hill towns, the cathedral stood at one of the region's highest topographical points and loomed over the surrounding neighborhoods. In most Italian cities, cathedrals were the tallest structures around, and they came into view from miles away. The skyscrapers of their day, such buildings were feats of engineering, though their height had symbolic and even practical functions as well, manifesting by virtue of their size the protection of the saints to whom they were dedicated. Whereas the towns' other buildings were largely made of wood, brick, and humble stone, the surfaces of cathedrals, inside and out, displayed expensive marbles and other precious materials. To enter a cathedral was to escape the mundane world for a preview of paradise. **Campanili**, or bell

towers, adjacent yet also independent, soared still higher than the cathedrals themselves, ensuring that they could not only be seen but also heard anywhere in the city.

The Cathedrals of Florence and Milan

Chapter 1 referred to some distinguishing hallmarks of seignorial and communal patronage (*see* pp. 18–26). Cathedrals, however, tend to work against such classifications, as the cases of Florence and Milan illustrate. Florence's cathedral, founded in 1296, shows that the town was fully aware of what other nearby communes were up to: Orvieto had begun building its new cathedral more than ten years earlier, in 1285, the same year that Siena furnished its duomo with a new lower facade;

Grosseto began erecting a new cathedral in 1294, the year that nearby Florence committed to building its own. In that city, **guilds** – corporate monopolies that controlled the practice of various trades and dominated city governments – oversaw construction of what all expected to serve as an image of the city; committees of townspeople made the major design decisions, turning to locals for ideas and technical expertise. The architecture of Florence's cathedral was as "democratic" as any from the period could be, and urbanistically, too, it constituted a new center, with streets radiating outward from it rather than crossing in a grid. This itself declared the building to be a place for general congregation, and its wide nave allowed it to accommodate large gatherings.

The broad communal involvement also resulted in an indecisiveness that slowed progress: seven decades after

2.3
Florence Cathedral, begun 1296 after a design by Arnolfo di Cambio. View from the south, showing to the left the campanile designed by Giotto.

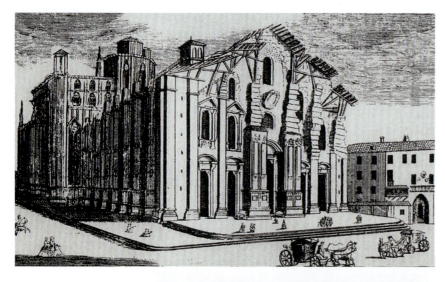

the architect and sculptor Arnolfo di Cambio (c. 1245–1301/10) laid the building's foundation stones, the structure had advanced so little that it was still possible to consider newly proposed models for its most basic design. The crawling pace of construction may help to explain why, in the intervening years, both patrons and builders directed their energies elsewhere: a colossal campanile (fig. 2.3), designed by Giotto di Bondone, was built even before the final plans for the cathedral itself were settled. At least one completed noble structure, the Florentines hoped, would impress visitors from other places.

The origins of Milan's cathedral (figs. 2.4–2.5), by contrast, date to almost a century later, in 1386, when Gian Galeazzo Visconti (1351–1402) consolidated his control of the city (he became the first Duke of Milan in 1395). In 1385 Visconti had deposed, imprisoned, and

ABOVE
2.4
Milan Cathedral, begun 1386. This engraving of *c.* 1745 by Marc' Antonio dal Re gives a sense of the building's appearance before the extensive nineteenth-century additions.

RIGHT
2.5
Interior of Milan Cathedral

FAR LEFT
2.6
Tracery windows in
Milan Cathedral

LEFT
2.7
Top of the Carelli *guglia*
of Milan Cathedral,
with statue of St. George
by Giorgio Solari,
completed 1404

ultimately poisoned the previous ruler, his uncle Bern-abò Visconti; construction on the building began one year later, under the supervision of Gian Galeazzo's cousin, Archbishop Antonio da Saluzzo. The Visconti, who wanted contemporaries to measure them by international standards, called in French and German master builders to provide designs and oversee construction, giving the church a northern European look that later additions would amplify. The relative belatedness of the building meant that all involved had seen what the Florentines were already making – an airy interior interrupted only by the massive supports necessary to hold up the vaulting and the great dome – yet the Visconti and their masons favored a different kind of building, with a series of narrow bays running from the entrance to the brightly illuminated altar wall and thinner, taller **piers** between (fig. 2.5). The windows themselves featured stained glass, framed by tracery, or decorated stonework, one of the most impressive features of northern European cathedrals, but highly unusual in the Italian peninsula (fig. 2.6). By comparison with Florence Cathedral, with its massive internal supports and broad expanses of solid wall, Milan's designers sought an effect common among the cathedrals of northern Europe, replacing large areas of wall with screens of colored glass.

The most distinctive exterior feature of Milan Cathedral in the fifteenth century was not a bell tower, but a "*guglia*," or spire (fig. 2.7), paid for by a merchant named Marco Carelli who donated funds in 1391. Supporting a statue of the warrior saint George and conceived in part as a commemorative monument, this had more in common with the Della Scala tombs in Verona (*see* p. 45) – a city Gian Galeazzo had conquered a few years before – than with Giotto's campanile in Florence. The individualist origins of the cathedral also helped shape its fate. When the plague killed Gian Galeazzo in 1402, work came largely to a halt. Nearly all the defining exterior features of the building that we see today are eighteenth- and nineteenth-century additions.

Competition at Florence Cathedral

Cathedrals provided a focus for urban artistic activities. In many cities, the cathedral works controlled the importation and distribution of marble and other materials. Sometimes a cathedral even provided workspace for artists. This situation regularly led to competition, and at several levels. Towns, as we have seen, closely watched what their neighbors were up to. Guilds strove to outdo one another in sponsoring conspicuous embellishments to the structure of their cathedral. And artists themselves, recognizing that an assignment at the cathedral was their best opportunity for public exposure, worked against others to secure commissions.

The Florentines had built their duomo, like most others in Italy, over an earlier church, in this case the eleventh-century Santa Reparata. The one ancient

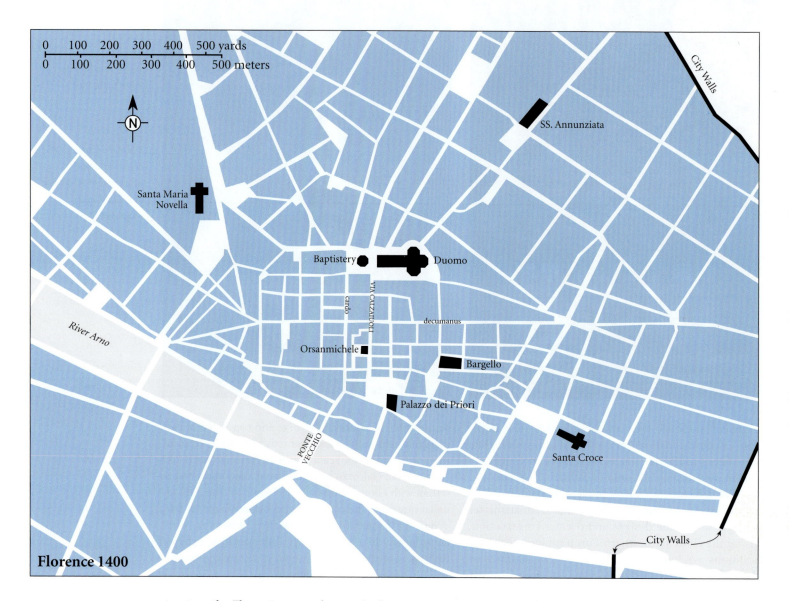

Florence 1400

RIGHT

2.8

Plan of Florence Cathedral

OPPOSITE

2.9

Baptistery (San Giovanni), Florence. The building may have been founded as early as the fourth century but was heavily renovated in the eleventh and thirteenth centuries with the addition of white and green marble revetment and columns salvaged from ancient Roman buildings (*spolia*).

structure the Florentines opted to retain, however, was the baptistery (fig. 2.9). The standing architecture of this building had been consecrated in 1059, though the Florentines believed it to be still older, originating as an ancient pagan temple dedicated to the Roman god of war, Mars. That imagined history lent it an authority to which the site's subsequent buildings nodded. Arnolfo di Cambio had proposed an octagonal crossing for the cathedral, essentially inscribing the baptistery's distinctive form into its plan, and this was one element of his design that survived subsequent reconsiderations. Giotto and his successors saw that both the campanile and the cathedral itself received a variegated skin of green and white marble **revetment** (marble facing) like that of the baptistery. And those responsible for the cathedral looked for ways to give it, too, more ancient roots.

The Republic's instructions to Giotto in 1334 were to build something "so magnificent in its height and

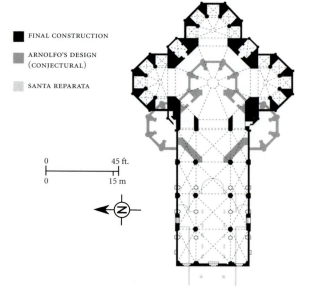

FINAL CONSTRUCTION

ARNOLFO'S DESIGN (CONJECTURAL)

SANTA REPARATA

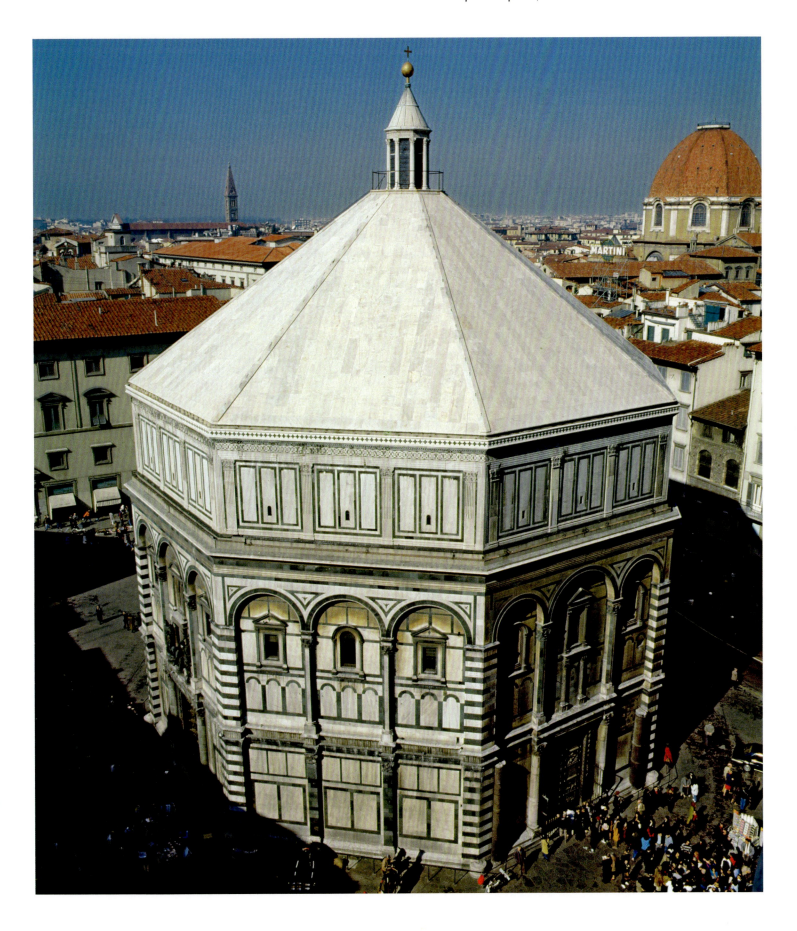

workmanship that it shall surpass anything of the kind produced by the Greeks and the Romans in the time of their greatest power." The patrons of the campanile demanded something daunting in scale, and we can assume that Arnolfo's earlier employers had the same expectations. This did not, however, preclude careful attention to ratios, and the church's dimensions, in fact, aligned it with another model. The plan of the cathedral (fig. 2.8) repeated the square that formed the crossing so as to generate a nave six units in length, a transept two units wide; the dome was three units high. This matched the dimensions of Solomon's Temple, as given in the first book of Kings (6:2): "And the house, which King Solomon built to the Lord, was threescore cubits in length, and twenty cubits in breadth, and thirty cubits in height" (i.e. 60 × 20 × 30). The reference to antiquity in this instance was not an attempt to recapture the look of ancient forms but rather to follow what contemporaries would have understood as a set of divinely sanctioned proportions, as if the cathedral were a realization of God's own design. So important were the ratios that the Flemish composer Guillaume Dufay (1397–1474) would incorporate them into the motet (a short choral composition) that he wrote for the new dedication of the building on March 25, 1436.

For all of the building's novelty, in other words, it also presented itself as the fulfillment of an earlier plan. And this way of thinking about sacred art, as an attempt to carry through something previously foreshadowed or prescribed, bears more broadly on the cathedral precinct. Catholic theologians often construed the characters and events of the Old Testament as "prefigurations" (foreshadowings) of Christ, the Virgin, and the saints who followed them, and the theme of prophecy had exceptional importance at Florence Cathedral, since John the Baptist, the great prophet to whom the baptistery itself was dedicated, was also the city's patron saint.

Lorenzo Ghiberti, Filippo Brunelleschi, and the Commission for the Baptistery Doors

The city's luxury cloth importers belonged to the "Calimala," Florence's most powerful guild, and the Calimala was charged with overseeing the baptistery's decoration. Its members recognized that the most impressive features of the building's exterior were the bronze doors that the sculptor and architect Andrea Pisano (c. 1270/90–c. 1348/49) had carried out for the east entrance between 1330 and 1336, showing scenes from the life of John the Baptist. And in 1401 the guild held a competition for the production of a sequel to what Andrea had made. Artists who wished to enter had to produce a single panel that embodied their vision for the new door. It had to show

the Sacrifice of Isaac, the episode from Genesis wherein God commands Abraham to kill his own son Isaac, then intervenes at the last moment by allowing him to slaughter a ram instead. (Catholics understood the scene to foretell God's sacrifice of his own son on the Cross.) For the sake of continuity, participants had to work with a frame of the same size and shape (a **quatrefoil**, or diamond with projecting lobes) that Andrea had used for his south-entrance panels, and to sculpt the Abraham and Isaac story within that form. The fact that two surviving competition panels include the same number of figures and very similar background elements, finally, suggests that even these things were stipulated from the outset.

As a prospective commission, the new doors would have been hard to pass up, for they would essentially guarantee the winner a decade's worth of steady work while also promising maximum visibility for his products. Seven artists ultimately submitted panels, of which two survive (figs. 2.10–2.11). Filippo Brunelleschi (1377–1446) approached the problem by designing individual characters in widely varying poses, then placing these in the subfields suggested by the assigned shape: an angel in the upper left arc, a ram in the projecting angle below that, servants at lower left and right. His attention to the challenging medieval frame manifests itself especially in such details as the pose of the horse and the contours of the cliff behind Abraham, though the artist also attempted to incorporate elements that looked to a more distant past. He sets his Isaac, for example, on an altar with a relief carved on the side; Brunelleschi may actually have seen ancient stone altars and imagined their ritual function, though here the device works also as a pedestal, making Isaac himself look like a statue. The figure at the lower left, rather than paying attention to the central event, seems preoccupied with the base of his foot. This has little to do with the central narrative, but it makes an unmistakable reference to the *Spinario* (*The Thorn Puller*) (fig. 2.12) in Rome, from the first century BCE, one of the most famous surviving statues from the ancient world.

Brunelleschi's biographer Antonio Manetti reported that the competition resulted in a draw, but that Brunelleschi refused the option of working in collaboration with his rival. Lorenzo Ghiberti himself, on the other hand, reported in his *Commentaries* that he won the contest outright. If this was indeed the case, it is easy to see why.

Brunelleschi, the son of a local notary, had entered the world of sculpture as an outsider. Ghiberti, by contrast, had trained in a typical late medieval workshop, the son and student of another goldsmith; eventually he would pass the craft on to his own sons, who remained in

the same profession. In the previous chapter, we looked at Ghiberti's enterprise as an author, which was unusual for an artist in his time. In addition to writing an important early art-historical and theoretical text, however, he also proved himself to be the most innovative metalworker of his day. Whereas Brunelleschi produced his relief by casting seven small objects, then soldering these together, Ghiberti made his scene as a single piece, attaching only Abraham's hand and a section of the rock. Thin and hollow at the back, his relief weighed less than Brunelleschi's, making it easier for the installers to handle, and it required less bronze, making it less costly. Beyond the economics, the judges of the competition may simply have liked the look of his relief better. Whereas Brunelleschi's secondary figures of animals and servants, with their vigorous and difficult poses, all jostle for our attention, Ghiberti produced a harmonious and easily legible composition organized around flowing curves. If Brunelleschi advertised his knowledge of ancient sculpture by quoting the *Spinario* in the lower margin, Ghiberti adopted the thorn puller's delicate anatomy (though not his distinctive pose) for Isaac himself; the victim here charms the viewer in a way that Brunelleschi's wretched, screaming child does not. The awarding of commissions to those who demonstrated an ability to fuse technical innovation with beauty would recur throughout the early history of the site.

ABOVE LEFT

2.10

Filippo Brunelleschi, *The Sacrifice of Isaac,* **1401–03.** Bronze with gilding, 21 × 17½" (53 × 44 cm). Museo Nazionale del Bargello, Florence

ABOVE RIGHT

2.11

Lorenzo Ghiberti, *The Sacrifice of Isaac,* **1401–03.** Bronze with gilding, 17¾ × 15" (45 × 38 cm). Museo Nazionale del Bargello, Florence

LEFT

2.12

The Thorn Puller **("***Spinario***"), first century BCE.** Bronze, height 28¾" (73 cm). Capitoline Museum, Rome

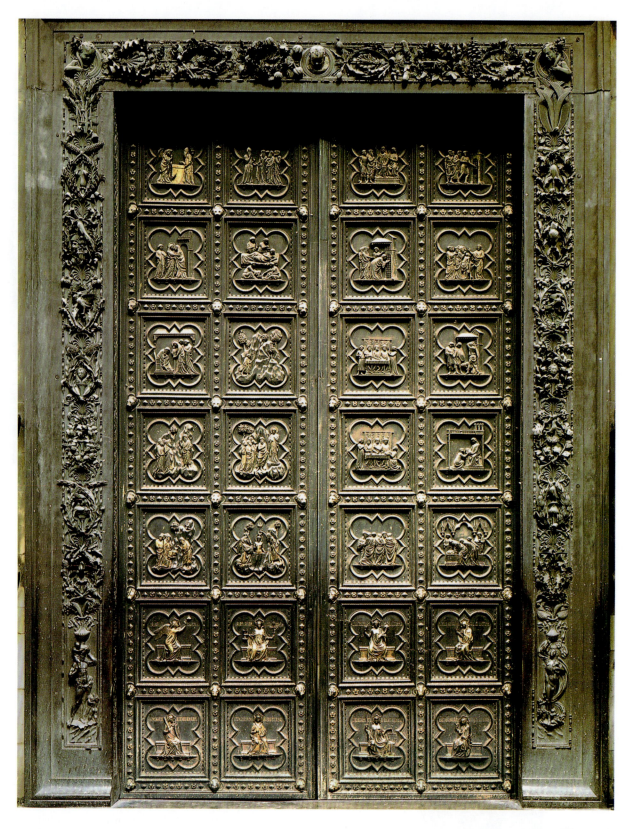

2.13
Andrea Pisano, south doors of the Florence Baptistery, 1330–36. Bronze with gilding, height 15' (4.6 m). The doors were originally made for the building's east facade.

Ghiberti's First Doors

Following the competition, the Calimala changed the program of the commission. Rather than focusing on the story of Abraham and Isaac and other episodes from the Old Testament, it would treat the New Testament, that is, the life of Christ. And rather than simply complementing Andrea Pisano's existing doors, Ghiberti's would replace them on the baptistery's east side, facing the cathedral itself. The protagonists would be the Savior whose coming John the Baptist had foretold, and Ghiberti's composition would closely follow Andrea's both in

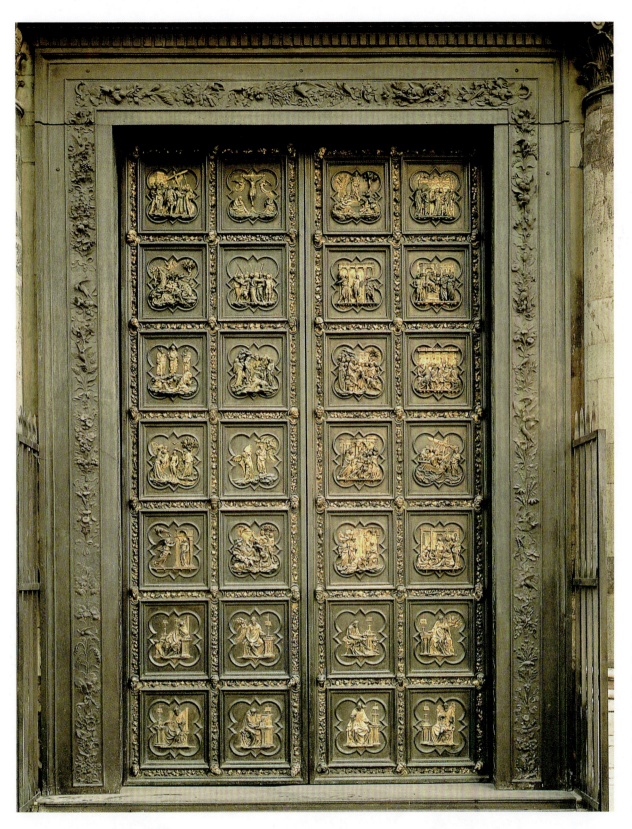

2.14

**Lorenzo Ghiberti, north
doors of the Florence
Baptistery, 1403–24.**
Bronze with gilding,
height approx. 15' (4.6 m).
The doors, installed as
replacements for the
Pisano pair in 1424, were
moved to the building's
north side in 1452.

the general arrangement of the panels and in their internal elements (figs. 2.13–2.14).

Ghiberti scaled his figures, roughly consistent in size from frame to frame, to match Andrea's. Most occupy a space defined by a ground line that runs between the middle and bottom lobes of the quatrefoil. The goldsmith kept architecture and other non-figural elements to a minimum, using only what tradition or clarity required. What set his panels most dramatically apart from those of his predecessor was his interest in figural movement. To take one telling example, Andrea's Salome (fig. 2.16) was a rigid, almost contourless figure, even though the scene in

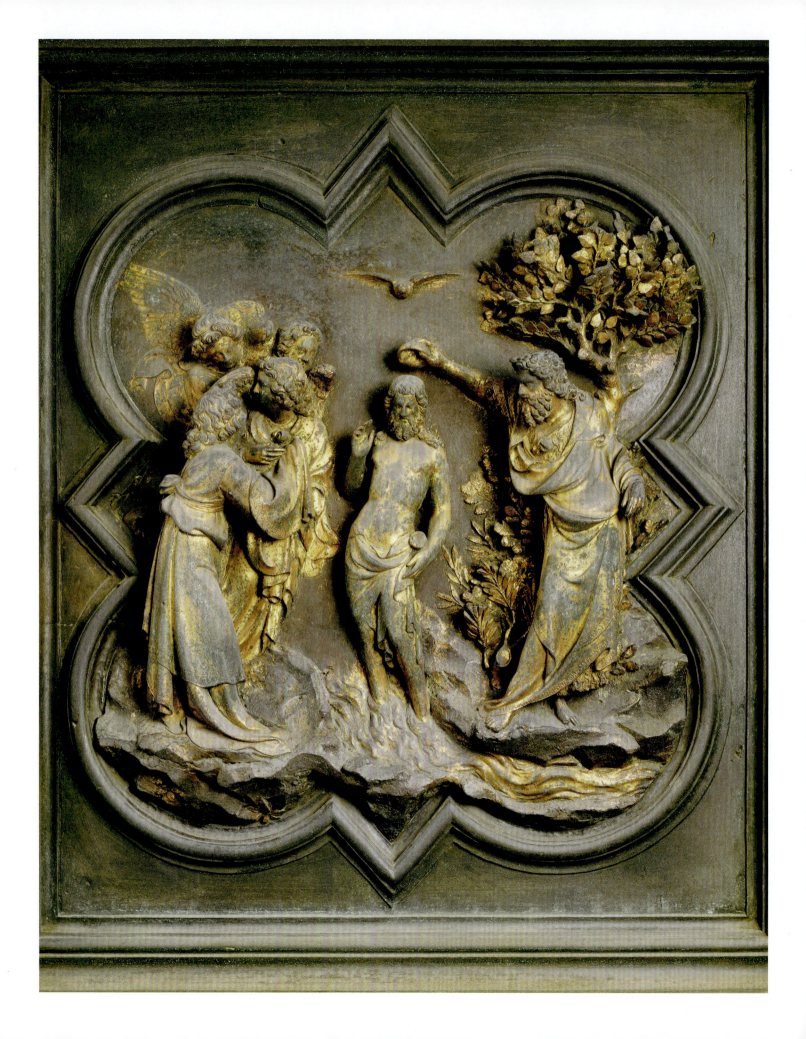

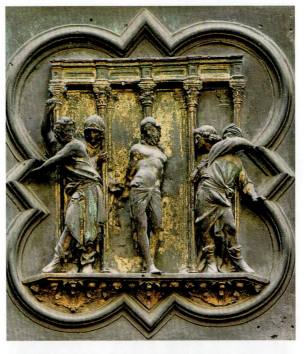

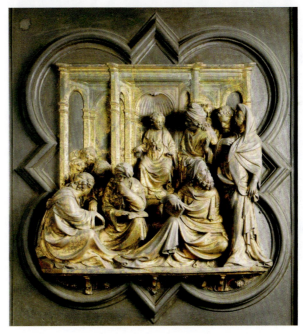

OPPOSITE

2.15

Lorenzo Ghiberti, *Baptism of Christ*, from the north doors of the Florence Baptistery, *c.* 1416–19. Bronze with gilding

FAR LEFT

2.16

Andrea Pisano, *Feast of Herod*, from the south doors of the Florence Baptistery, 1330–36. Bronze with gilding

LEFT, ABOVE

2.17

Lorenzo Ghiberti, *Flagellation of Christ*, from the north doors of the Florence Baptistery, *c.* 1416–19. Bronze with gilding

LEFT, BELOW

2.18

Lorenzo Ghiberti, *Finding of Christ in the Temple*, from the north doors of the Florence Baptistery, *c.* 1416–19. Bronze with gilding

which she starred had her dancing seductively before her stepfather. Ghiberti, by contrast, lent a graceful twist even to the suffering Christ of the *Flagellation* (fig. 2.17). In the *Baptism of Christ* (fig. 2.15), Christ's suavely curving body is symmetrically framed by sweeping arcs, formed to his right by draperies of attending angels, and on our right by John's elastically outstretched right arm and extended right leg. Posture and movement both enrich the narrative and display a modern artfulness, learned in part from the study of what the figures in ancient sculptures did. More willing than Andrea to crowd his panels, Ghiberti also set figures in different states of motion against one another, inviting the viewer to compare them (fig. 2.18). And here, as in the competition relief, Ghiberti exhibits the subtle drama of his storytelling. Mary, standing on the right, discovers the twelve-year-old Christ, who had been missing for three days, disputing with the Jewish elders in the temple. Her commanding presence disrupts the symmetrical arrangement of Christ and his interlocutors; as her gaze locks with Christ, she points to herself in a gesture of maternal reproach. It is impossible to mistake the words she is speaking: "Why have you treated us like this?" (Luke 2:48).

The baptistery doors' story of Christ's life and death runs from left to right and – more surprisingly – from bottom to top. This suggests that the viewer is to move up into the story from the panels below, which show the four Evangelists (Matthew, Mark, Luke, and John), who had authored the Gospels narrating Christ's life, and four of the chief Church Fathers who had interpreted these. The decision to give each of the quatrefoils in the lower

two rows over to a single seated figure followed Andrea's example, though Ghiberti may also have had a more integrated understanding of the overall program.

When the sculptor and architect Lorenzo Maitani (1255–1330), nearly a century before, undertook the energetic marble reliefs he made for the facade of Orvieto Cathedral (fig. 2.19), he adopted a comparable arrangement. The figures at the bottom of Maitani's picture field, which the viewer encountered at eye level, represented prophets, and the foliate motifs that grew up from them

2.19

Lorenzo Maitani, marble reliefs from the pier to the right of the main portal of Orvieto Cathedral, 1310–30

OPPOSITE

2.20

Lorenzo Ghiberti, self-portrait (detail from the north doors of the Florence Baptistery), *c.* 1416–19.
Bronze with gilding

foretell the narrative that Ghiberti fulfills with his panels. Or perhaps they simply play the part of commentators, looking around and "speaking" about what the goldsmith produced.

Among the heads Ghiberti included one of the first Italian self-portraits (fig. 2.20). The cloth covering Ghiberti's hair may simply be the normal protective gear that sculptors wore in the studio, but it also gives the artist an exotic look, as though he were from the same distant oriental lands as the characters he depicts.

Marble Sculpture for the Cathedral: Nanni di Banco and Donatello

Bronze was among the most expensive materials used for early Renaissance sculpture, and the decision to dedicate it to the production of doors shows how important such thresholds were. The decoration of the facade of Florence's cathedral under Arnolfo di Cambio had stopped soon after it began, but not before the area around the main doors had been completed (fig. 2.21). This was not only a crucial passageway between the secular world of the city and the sacred interior of the cathedral; it was also a ceremonial site in its own right, one where citizens gathered for festivals and holy days, and one that the bishop could use for public dealings with the city.

The long, straight street that terminated at the cathedral from the north, moreover, ran not up to the doors facing the baptistery, but rather up to one around the corner, colloquially called the "Porta della Mandorla" (fig. 2.22) or the "Almond Door" after the almond-shaped aureole that surrounds the Virgin in the relief above. The door itself had been under way since 1391, but in 1406 a sculptor named Nanni di Banco (1384/90–1421) was brought in to complete the ensemble that included vines, half-length angels, and a nude figure of the hero

framed the individual stories as fulfillments of what the prophets had written. Ghiberti added vegetation around his panels as well; more surprising, though, is his decision to substitute human heads for the leonine motifs that Andrea Pisano had used in his earlier doors. In making these, the goldsmith seems to have drawn on ancient portraits: one head resembles surviving figures of Socrates, another Julius Caesar. Most, however, resist naming, and seem there in order to enliven the overall composition through their mutual interaction and their engagement with the beholder rather than to depict any specific group of individuals. Do they indeed have identities at all? Some of the bearded faces follow the conventions for representing prophets. Perhaps they, like John the Baptist himself,

ABOVE LEFT
2.21
Bernardo Poccetti, facade
of Florence Cathedral,
c. 1587. Ink on paper.
Museo dell'Opera del
Duomo, Florence. The
drawing records the
appearance of the building
before the removal of the
original sculptures and the
addition of the nineteenth-
century facade.

ABOVE RIGHT
2.22
Nanni di Banco,
Assumption of the Virgin,
1414–22. Gable above the
Porta della Mandorla,
Florence Cathedral

Hercules, leaning on a club. Florentine legend made
Hercules out to be the founder of the city, and from the
late Middle Ages he had featured on the city's seal; his
presence on the door announced the building's impor-
tance as a civic no less than a religious site, and returned
to the idea of its own ancient foundations.

Working with Nanni was a twenty-year-old sculp-
tor named Donatello (*c.* 1386–1466). Nanni, like Ghiberti,
had come from a family workshop; Donatello, like Bru-
nelleschi, had entered the trade from outside. His father,
a laborer in the city's wool industry, no doubt had con-
nections to the guild that commissioned the baptistery
doors and may have helped get him into Ghiberti's stu-
dio. There the boy had probably been performing menial
tasks and studying his art when he received commissions
in 1406 to carve two small prophets for Nanni's door-
frame. Clearly he made an impression, for two years later
he secured a more significant assignment: to work with
Nanni on a series of prophets for the buttresses over the
cathedral choir.

Nanni's first contribution to that cycle was a fig-
ure that usually goes by the name *Isaiah* (fig. 2.23), the
Hebrew author of the eponymous Old Testament book.
Artists conventionally showed Isaiah holding a scroll
with the words "Behold the virgin will conceive and bear

a child," a phrase that would have linked him to the Virgin Mary and to the cathedral's dedication. Nanni's own version of the figure, nevertheless, shows a surprisingly physical writer. His swung hip nods to the graceful poses that the goldsmith Ghiberti was beginning to incorporate into his doors, but the stockier proportions immediately differentiate Nanni's invention from the goldsmith's designs. Another surprise is the relative youthfulness of the prophet: wanting nothing to do with the wrinkles and hair that marked the wisdom of age, Nanni carved a smooth, beardless face; Isaiah's clenched right hand – perhaps now missing the attribute it once held – adds to the figure's air of toughness.

Nanni must have been making his statue in co-ordination with Donatello, who in 1408 was assigned to produce a David (fig. 2.24). David's status as a prophet depended on the traditional belief that he had authored the Psalms, a group of Old Testament songs. Donatello's statue, however, holds neither the scroll that identifies the other figures in the group nor the harp a psalmist would play. The only hint, in fact, that the depicted figure produced words of any kind is his ivy crown, an ornament sometimes worn by poets, though in context this looks more like a reward for his victory over Goliath, the giant whom David slew and whose head appears at his feet. The statue, with its body-hugging leather, long neck, and apparent awareness of being seen, presages the sculptures of beautiful young men for which Donatello would become famous. Yet the figure is also swaggeringly militaristic and tough, even more explicitly so than Nanni's.

Neither Nanni's nor Donatello's statue ever reached its intended destination. The patrons eventually brought Nanni's *Isaiah* inside Florence Cathedral, where it remained until the twentieth century. Donatello's *David*, by contrast, was turned over in 1416 to the government of the city, which erected it in Florence's Palazzo dei Priori, on a pedestal bearing a dedication "to the fatherland, still struggling mightily against terrible enemies," and an invocation to "let God lend his help." The inscription seems to refer to the city's war with Milan, a context that helps explain the curious circumstances of the original commission: the patrons, in asking Nanni and Donatello to carve their figures, were moving forward with the ornamental elements surrounding the dome of Florence's cathedral even before they were quite sure how the dome itself would be constructed. Donatello's *David*, in particular, seems to have been intended for a position that faced north – in other words, toward Milan – the same direction in which the *Hercules* on the Porta della Mandorla looked. The patrons may well have hoped that the statues would have talismanic effects, channeling divine protection to the city over which they stood, though those patrons were certainly also aware that Milan had

its own cathedral under way in the same years, with its own warrior saint, George, rising high above.

Jacopo della Quercia and the Fonte Gaia

The sculptures at Florence Cathedral, conceived in competition with Milan, encouraged their own rivals elsewhere. Lorenzo Ghiberti, in the third book of his *Commentaries*, wrote that the Sienese discovered a sculpture of Venus inscribed with the name of the ancient Greek sculptor Lysippus (fourth century BCE) and placed it on top of their fountain. One citizen of the town, however, complained that the statue was encouraging idolatry and cursing the Sienese army; he convinced the city

2.24

Donatello, *David*, 1408–09. Marble, height 6'3" (1.91 m) including base. Museo Nazionale del Bargello, Florence

OPPOSITE BELOW

2.23

Nanni di Banco, *Isaiah*, 1408. Marble, height 6'4" (1.93 m). Museo dell'Opera del Duomo, Florence

council not just to take down the statue but to bury it across the border in Florentine territory, where it could bring misfortune to Siena's enemies instead. The comment reinforces the impression that Renaissance artists and patrons attributed much more power to sculpture than we do today; the idea that you could do things with sculptures that would literally advance your military prospects helps explain why the Florentines thought to position Nanni's and Donatello's prophet figures as they did. At the same time, there is perhaps a whiff of superiority in Ghiberti's story (just as there is in his account of Duccio's painting the *Maestà*; see chapter 1, p. 36), as though the ignorant Sienese could not appreciate antiquity in the way that Florentines did. He reports that he knew the statue from a drawing made of it by the "great painter" Ambrogio Lorenzetti, as though to distinguish the interests of artists from those of the superstitious. As we saw in the Introduction (*see* p. 12), moreover, Ghiberti's *Commentaries* blamed a similar fear of idols for the destruction of ancient art in the first place.

In fact, Ghiberti's actual contemporaries in Siena were nothing like those of his story. While he was at work on the north doors of Florence's baptistery, they were commissioning new sculptures for the very fountain on which, to follow Ghiberti, they had erected the fearful image of Venus. The best Sienese sculptor of the moment was Jacopo della Quercia (c. 1374–1438), a goldsmith who had entered the competition for Florence's baptistery doors in 1401, along with Ghiberti and Brunelleschi. After losing the competition to Ghiberti, Jacopo spent several years working in Ferrara, to the

north, though the Sienese probably knew him best from the tomb sculpture that Paolo Guinigi, the Lord of Lucca, had asked him to make of his wife, Ilaria del Carretto, after her death in 1405 (fig. 2.25). Originally produced for a monastery, the exquisite portrait presents Ilaria in courtly finery, her head cushioned on pillows, a dog at her feet. Jacopo's treatment combines a sense of volume comparable to the work of Donatello and Ghiberti with a delicacy of line that responded to Italian aristocratic taste for ornamental flourish and refined detail. The rest of the monument that we see today is a late nineteenth-century reconstruction, and the children bearing garlands that adorn the sarcophagus below – a self-conscious revival of the mythical figure of Eros (or Cupid, the god of love) in Roman funerary art – probably date to a later period than the effigy itself. Still, nothing suggests that the tomb ever included any explicit Christian symbolism, and the Guinigi coat of arms, added to one end of the sarcophagus, reminds viewers that houses of religion – such as monasteries (or cathedrals) – could be sites for dynastic patronage. Long after the statue was made, the Lucchese moved it into their own cathedral, where it remains today; by then it was possible to ignore the monument's political function and to celebrate it as evidence of the city's historic artistic achievement.

The Sienese, in hiring Jacopo, probably did so in the recognition that no other native of the city – and few elsewhere – had established comparable skills in marble carving. In 1408, the same city council that Ghiberti had accused of expelling the earlier idolatrous sculpture commissioned Jacopo to replace the original Fonte Gaia

2.25
Jacopo della Quercia,
tomb of Ilaria del Carretto,
1406. Marble, length
of figure 6'10" (2.1 m).
Lucca Cathedral

fountain in the **campo**, or square, before the Palazzo Pubblico in Siena, with a new group of reliefs and free-standing figures. Exposed for centuries to the elements, these have not survived well, but a drawing (fig. 2.26) of 1409 shows by Jacopo's original vision for the fountain, with Virtues flanking the Virgin and Child in fictive niches, mythical Roman figures standing on parapets, a wolf, a dog, and a monkey. Large civic fountains in this period were rare, and the technological achievement of bringing fresh water into the middle of the town surpassed anything the Florentines had achieved. Few public sculptures of any kind, moreover, featured such non-Christian subjects as the two largely nude female figures (fig. 2.27) Jacopo and his workshop produced when they finally carried out the fountain in 1416–19.

These represented Rhea Silvia, the mother of Romulus and Remus, and Acca Laurentia, the woman who raised them after Rhea's execution. (The wolf must be the animal that, to follow the myths, nursed the twins.) The ancient Roman historian Livy (59 BCE–CE 17) had represented Rhea as a descendant of the mythical Aeneas,

who, like Romulus and Remus, was also best known for his role in the founding of Rome. To place these statues before Siena's city hall was to assert Siena's connections with antiquity to the same degree that the Florentines, in tracing the origins of their baptistery, had asserted their own. The Sienese may even have aimed to bring Mars, god of war, into the dispute, since the Florentines claimed that their baptistery had been his temple and the Sienese saw Rhea as his daughter.

The Fonte Gaia, made for one of the city's great gathering places, addressed not just the local population but also the larger community of Italian states. It shows us that just as the builders of Florence Cathedral looked north to Milan, so did the Florentine products have their own centrifugal effect, shaping the sensibilities of artists who subsequently went elsewhere, as well as the goals of rival towns. Jacopo may have lost the competition for the Florence baptistery doors, but in gaining employ from Florence's enemies, he could engage a similar set of concerns and even participate in Siena's contestation of Florence's proudest claims.

ABOVE LEFT

2.26

Jacopo della Quercia, drawing for the Fonte Gaia, 1409. Pen and ink on parchment, 7⅞ × 8½" (19.9 × 21.4 cm). Metropolitan Museum of Art, New York

ABOVE RIGHT

2.27

Jacopo della Quercia, *Rhea Silvia*, from the Fonte Gaia, 1416/19. Marble, height 5'4" (1.63 m). Santa Maria Della Scala, Siena

1410–1420

Commissioning Art: Standardization, Customization, Emulation

3

1410–1420
Commissioning Art: Standardization, Customization, Emulation

Orsanmichele and Its Tabernacles

3.1

Via Calzaiuoli, looking south from the cathedral square. On the right, the east facade of Orsanmichele; at the end of the street, the Piazza della Signoria.

Look at our map of central Florence (p. 68), and you will still see clear evidence of its ancient origins. It was laid out, beginning in the first two centuries CE, following a "castrum plan," the gridded form in which the Romans arranged their garrison towns. The streets today called the Via Calimala and Via Roma were, in the city's earliest years, its *cardo*, or central north–south route. What are now the Via Strozzi and Via del Corso together constituted the *decumanus*, the main street running east–west. Stand on the Via del Corso today and look in

either direction, and you will still have views as nowhere else in the old city, a consequence of the fact that the nearly 2,000-year-old road has never been significantly impeded by later development.

In antiquity, the *cardo* and *decumanus* met in the main forum, a space that later evolved into the city's primary marketplace. It served this function until the late nineteenth century, when Florence briefly became the capital of Italy, and, in an attempt to return to the city some of its ancient grandeur, the government demolished the market and many surrounding buildings, expelling the area's Jewish occupants and carving out the square now called the Piazza Repubblica. The rest of the old city, the part inside the original Roman walls, was "centuriated," that is, divided into regular rectilinear blocks through which streets parallel to the *cardo* and *decumanus* ran. Even today, it is easy to see roughly where the medieval city grew from the Roman one, since the streets in the older sector follow the original grid, and on the whole run north–south and east–west.

Especially if we imagine away the late nineteenth-century Piazza Repubblica, every map of Florence shows the prominence of two key areas in the city: those of the cathedral and of the city hall, or Palazzo dei Priori (sometimes called the Palazzo della Signoria or Palazzo Vecchio). By the beginning of the fourteenth century, these were the centers of civic and religious life in the city. Chapter 2 showed the way that the cathedral zone emerged in competition with those in rival towns. The same was true of the area around the Palazzo dei Priori, where, as in Siena, a large public square monumentalized the building in which the city council lived and worked. This space, called the Piazza della Signoria, had been constructed through the course of the fourteenth century in an area previously occupied by family houses. There could be no clearer declaration of the city's ostensible subordination of private to public (or at least communal) interests, dispossessing families of their properties and replacing these with a large clearing that could be used for ceremonial gatherings. The structures surrounding the piazza included a tribunal (called the "Mercanzia") for the Florentine guilds, quarters for troops, and a kind of open gallery (now called the "Loggia dei Lanzi") that functioned as a sort of reviewing stand, a place for

privileged viewers to watch what happened in front of the government's main building.

The emergence of this complex, along with the contemporaneous building of the new cathedral, essentially shifted the main north–south route through Florence east by one large city block, from the old Roman *cardo* to the Via Calzaiuoli ("Cobblers' Street"), which ran from the piazza between the baptistery and the duomo to the corner of the Piazza della Signoria, where it offered the most dramatic available view of the city hall. Connecting the focal points of the city's civic and religious life, the Via Calzaiuoli brought new attention to the buildings that lined it, and none more so than Orsanmichele, the former grain warehouse that housed Orcagna's tabernacle (*see* chapter 1, p. 51).

As early as 1339, the Arte della Seta, or Silk Merchants' Guild, conceived a collaborative ornamentation to the exterior of Orsanmichele (fig. 3.1). The group's idea was that the twelve major guilds in the city, along with the Parte Guelfa, the political party that represented the city's merchants and in those years controlled its government, would add a series of tabernacles or niches with statues to the building's piers. The collective participation in the building's decoration would itself be symbolic, and the sight of statues in niches would link Orsanmichele to the "campanile," Giotto's bell tower, the one other building in Florence to be decorated in this way.

The association between Orsanmichele and the cathedral zone was underscored not just by the format of the decorations at the two sites, but also by the artists involved. The first two tabernacles to be added to the structure, those of the Wool Merchants' Guild and Silk Weavers' Guild, had both been designed by Andrea Pisano, the artist responsible for the south baptistery doors and the sculptural decorations on the campanile (*see* figs. 2.13 and 2.16). The sculptor and architect Niccolò di Piero Lamberti (*c.* 1370–1451), who made the tabernacle for the Judges and Notaries' Guild in 1405 and the statue of St. Luke in 1406 to go inside it (fig. 3.2), had likewise spent much of the previous decade engaged with cathedral projects. And around 1410, the Arte della Calimala asked Lorenzo Ghiberti to stop working on the doors that the guild had commissioned from him so that he, too, could design a niche for Orsanmichele and fill it with a statue of their own protector, St. John the Baptist (fig. 3.3).

The fact that the same artists and patrons were active at both Orsanmichele and the cathedral also meant that their attention was divided, and in the nearly seven decades that had passed between 1339, when the Guelph Party and the major Florentine guilds had agreed to take responsibility for decorating the piers of Orsanmichele with statuary, and 1407, when the Calimala officially

3.2

Niccolò di Piero Lamberti, *St. Luke,* **1406.** Height 6'10" (2.08 m). Museo Nazionale del Bargello, Florence. The statue was made for a tabernacle on the exterior of Orsanmichele but replaced in the late sixteenth century.

initiated their own project by appointing a group of supervisors, only four ensembles had been completed – those for the Wool Merchants' Guild, the Silk Weavers' Guild, the Doctors and Apothecaries' Guild, and the Judges and Notaries' Guild.

In the first decade of the fifteenth century, it was increasingly evident that competition with the cathedral works threatened to hinder the already slow progress of the decorations at Orsanmichele, and in 1406 the Florentine city government, many of whose members also

3.3

Lorenzo Ghiberti, *St. John the Baptist, c.* 1410. Bronze, height 8'4" (2.55 m). Orsanmichele, Florence. The photo shows the statue before removal from its original tabernacle.

belonged to the Orsanmichele confraternity, legislated that guilds must either complete the tabernacles meant for the spaces assigned to them within ten years or give up the rights to decorate the building at all. In the event, this decree was not strictly enforced, but it did initiate a flurry of new activity. That was the year the Judges and Notaries' Guild commissioned Lamberti to replace an older statue with an image of their patron, St. Luke; in 1407 the Calimala initiated its own project. Shortly thereafter, Filippo Brunelleschi seems to have got involved in the decorations; it is to his workshop

that most scholars attribute the St. Peter begun around 1409 for the Butchers' Guild. Suddenly, the situation at Orsanmichele looked very different than it had only a few years before. By 1410, three of the best sculptors to have competed for the baptistery door commission one decade earlier – Brunelleschi, Ghiberti, and Lamberti – had all made, or were in the process of making, what would count among the most visible large-scale figure sculptures in Florence, in a highly trafficked area and close to the ground, where they could be inspected and compared. This, as much as any law, brought the stalled project at Orsanmichele back to life. A decade later, some ten new monumental projects were either on display or nearly completed, and the building had become home to a group of the most ambitious works in the history of sculpture.

The Calimala Guild must have turned to Ghiberti in part because it wanted a work in bronze, and he had established himself as the city's best master of that material. This choice immediately set Ghiberti's statue of St. John the Baptist apart from its predecessors, since such a work would cost exponentially more than a statue in stone on the same scale. At the time the statue went up, it would have been the only over-lifesize bronze statue in all of Florence – and one of the few in Italy – and this itself announced both the wealth and power of the Calimala as a guild and the new prestige of Orsanmichele as a site. To minimize the amount of metal used, Ghiberti needed to make a hollow rather than a solid cast, employing a method called the "lost wax technique." After completing a full-scale design in clay, he would have covered this with a thin coat of wax, reworking details. To the wax surface he would have attached a series of wax rods, or "sprues," then enclosed the whole structure in a reinforced earthen mold, with a large opening at the top and metal pins running at various points into the clay form inside. Submitting this to heat would cause the wax to run out, leaving a thin empty space between the original model and its external "negative," as well as empty channels where the sprues had been. Through these, the casting team could run molten bronze into the mold. Once the mold had cooled, the sculptor and his assistants could chip away the earthen shell and saw off the (now) metal sprues, then file and polish the whole work. The artists would have completed such details as the hair, beard, and animal-hide tunic of John the Baptist with small chisels, a process called "chasing."

The laborious methods by which the bronze was made ensured that the figure appeared stylish and refined, rather than coarse. Despite the fact that Ghiberti is portraying a hermit saint who lived in the desert and wore animal skins, the overall effect of his sculpture is extraordinarily sumptuous. We are not shown much

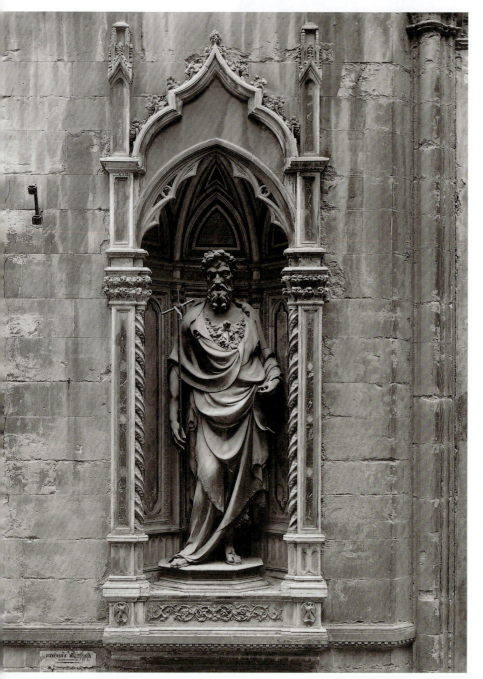

GOLDSMITHS

For much of the period this book concerns, no profession held more importance and prestige than that of the goldsmith. Goldsmiths made jewelry and tableware for wealthy households and produced the liturgical objects that the Church used for every Mass. Their workshops generated ornamental weaponry, dies for seals, and, later, medals.

To be a goldsmith required not only a set of distinctive manual skills, but also a specific knowledge and even an ethic. The goldsmith's experience with alloys and familiarity with precious gems allowed him to be called upon for appraisals. Goldsmiths commonly served as money changers and even small-scale bankers, which required them to develop bookkeeping skills. Since patrons entrusted them with precious materials, they had to maintain their reputations. Many aspired to social advancement, and they tended to have a strong sense of honor.

In Italy, goldsmithery also provided the most common path to artistic fame in other fields. Artists trained as goldsmiths – Lorenzo Ghiberti, Filippo Brunelleschi, Jacopo della Quercia, Pisanello, Masolino, and Luca della Robbia, to name just a few of the figures we shall encounter in the early chapters of this book – created some of the most innovative works of the period, none of them in precious metals. Is this mere coincidence?

Permissive guilds allowed Italian goldsmiths to experiment across fields, and skills essential to the goldsmith's trade provided foundations for other practices. All goldsmiths could draw: the patterns that masters would apply across surfaces required the mastery of designs preserved in books, and patrons expected to see a proposal for what an object would look like before committing resources. The techniques involved with the casting of gold and silver translated readily to baser metals like bronze, allowing goldsmiths to take on assignments for statuary. Casting, moreover, required goldsmiths to make models in various materials, including wood, the same thing that architects did when designing buildings.

The two centuries between 1400 and 1600 saw the reorganization of the professional landscape in Italy, at the goldsmith's expense. Artists seeking fame increasingly turned to monumental painting and sculpture. And for those who cared about enduring reputation and the longevity of their works, goldsmithery was a bad bet: too often, it was tempting for the owners of gold and silver objects to melt them down, whether to liberate gems from their settings or simply to make more up-to-date ornaments. An increasing tendency to regard the "art" or skill behind a work as more valuable than or even at odds with its materials too easily took goldsmithery as its foil.

Domenico Ghirlandaio and Andrea del Verrocchio, the teachers of Michelangelo and Leonardo respectively, were both goldsmiths by training, but their famous students showed little regard for the craft. Though Michelangelo made some designs for precious objects, he largely avoided working in metals himself. When Leonardo wrote a series of texts comparing the virtues of painting to other arts, he selected poetry, sculpture, and music, and when academies later supplanted guilds as the organizational systems for the arts, they privileged painting, sculpture, and architecture at the expense of goldsmithery. Benvenuto Cellini, largely on account of his writings, would become the most famous goldsmith in history, but already in his lifetime his specialization had been displaced as the premier artistic profession. Henceforth, goldsmiths would supply lavish and sometimes eccentric trifles to the courts, but they would not be paving the way for those in other fields.

of John's emaciated body and humble attire: he is enveloped in what appears to be a fine cloth mantle, arranged in a rhythmic pattern of folds and gathers that has little to do with the actual behavior of any fabric. The Calimala Guild represented the city's fine cloth dealers, and Ghiberti's figure deliberately recalls the taste and style of art produced for the elite clientele of the great Florentine cloth merchants throughout Europe: in France, in Bohemia, and in England, as well as in centers closer to home, such as the court of Milan. The goldsmith's ornamental handling of detail was the kind of thing expected in works on a far more intimate scale; one of his surprising achievements with this statue is his successful pursuit of such effects in a monumental figure.

The other guilds were not in a position to commission a work of such luxury, and they consequently

OPPOSITE

3.4

Nanni di Banco, *St. Philip*,

c. 1410–12. Marble,

height 6'3" (1.91 m).

Orsanmichele, Florence

welcomed statues that could be judged according to a different measure of quality, one matching Ghiberti in inventiveness rather than in material value. The mostly young artists who carried out the works added to Orsanmichele between 1410 and 1420, similarly, must have seen the commissions as an unprecedented opportunity to make works that were guaranteed prominence and attention, and they spurred one another on.

Nanni di Banco's *St. Philip*

Among the first artists to respond to the challenge the site presented was Nanni di Banco, who had been making sculptures for Florence Cathedral since 1408 (*see* figs. 2.22–2.23). Both his statue of St. Philip (fig. 3.4) for the Shoemakers' Guild and the niche it occupies are undocumented, though they have been dated on stylistic grounds to the years between 1410 and 1413. The figure, that is, was made no more than seven years after Lamberti's *St. Luke*, yet it is entirely different in conception. Lamberti's combination of statue and niche had presented redundant reminders of just who it is we are seeing. Luke holds the Gospel he authored in his left hand and the pen he used to write it in his right; the winged bull, the conventional companion that allows Luke to be distinguished from the other Evangelists (Matthew, Mark, and John), appeared as a relief at the bottom of the niche, looking up at the figure, while the saint's name ran across the plinth below. The lower corners of the niche were occupied by shields with the six-pointed star that was the heraldic symbol of the Judges and Notaries' Guild; the field of inlaid six-pointed stars behind and above the figure seemed to repeat this, even as they also suggested that the space of the niche is a heavenly one, presided over by the figure of Christ in the gable above.

The niche for *St. Philip*, with its combinations of pilaster and spiral column at the sides, its inlaid red marble and gold stars behind, and its crowning **pediment** with flanking spires, closely follows that of *St. Luke*. Its dependence on Lamberti's earlier architecture only makes the difference between the two artists' figures all the more remarkable. To begin with, Nanni gives his statue of St. Philip exaggeratedly elongated upper arms, such that its proportions only seem correct when it is viewed from below. The artist, in other words, took into account the imagined presence of a visitor to Orsanmichele, gazing at the sculpture from the street, and he engaged his figure in just the same action: the saint's turned head and sharply incised eyes, rolled up slightly in their sockets, suggest his own act of focused attention, and lend the figure a psychological existence that its predecessor, *St. Luke*, lacked. Nanni's figure overall is less columnar than Lamberti's,

and the contrast gives the impression that the earlier sculptor was working with a block that was too small and worried about wasting stone: Nanni himself does not hesitate to cut away large sections of material below both of Philip's arms and especially around the shoulders and head, freeing the figure's movements. On the body itself, additional deep cutting creates substantial folds in the garment; paradoxically, Philip's drapery seems thicker than Luke's, even as it also appears to reveal more of the body beneath it. This is because Nanni has thought about the behavior of cloth as Lamberti has not. The drapery on Luke's hip and breast, among other places, looks as if it has been folded over on itself and then ironed flat. Philip's, by contrast, seems to fall the way it does because of the positioning of the figure's arms. That Philip's clothes seem to do what they do might finally prompt us to ask just why they are as they are. Why *does* Philip seem to lift his drapery up in the air?

In answer, we might note that Philip is displaying his feet, which are clad, unlike those of Lamberti's shoeless Apostle Luke, in beautifully decorated sandals. It was for the city's cobblers, after all, that Nanni was working; just as Lamberti gave his saint a pen, the same instrument wielded by the notaries from the guild that Luke protected, and just as Ghiberti drew special attention to the cloth worn by the cloth merchants' saint, John the Baptist, Nanni found a way to associate his statue with the kind of labor for which his patrons wanted to be known. Normally, we think of the items that a sculptural figure displays as "attributes," clues primarily to the identification of the figure. These are recognizable precisely because they are the same every time that same figure appears. One of the things Nanni's first work for Orsanmichele suggested was that the identity of Philip himself could be adjusted in response to a commission, to make the sculpture of him a clearer representative and advocate of the patrons responsible for it.

Donatello's *St. Mark*

Closely related to Nanni's *St. Philip* was Donatello's *St. Mark* (fig. 3.5), produced for the "Linaiuoli," the Linen Merchants' Guild. The contract for the *St. Mark* was signed in 1411, but the statue could well have taken several years to complete. Donatello, who had until 1407 been Ghiberti's apprentice, was in 1411 still at work on a group of stone figures that he had started three years earlier, including the lifesize *David* (*see* fig. 2.24), an over-lifesize *St. John the Evangelist*, and other statues for Florence Cathedral. The absence of evidence indicating just when Donatello delivered the *St. Mark*, combined with the uncertainty surrounding the dating of the *St. Philip*, makes it impossible to say with certainty

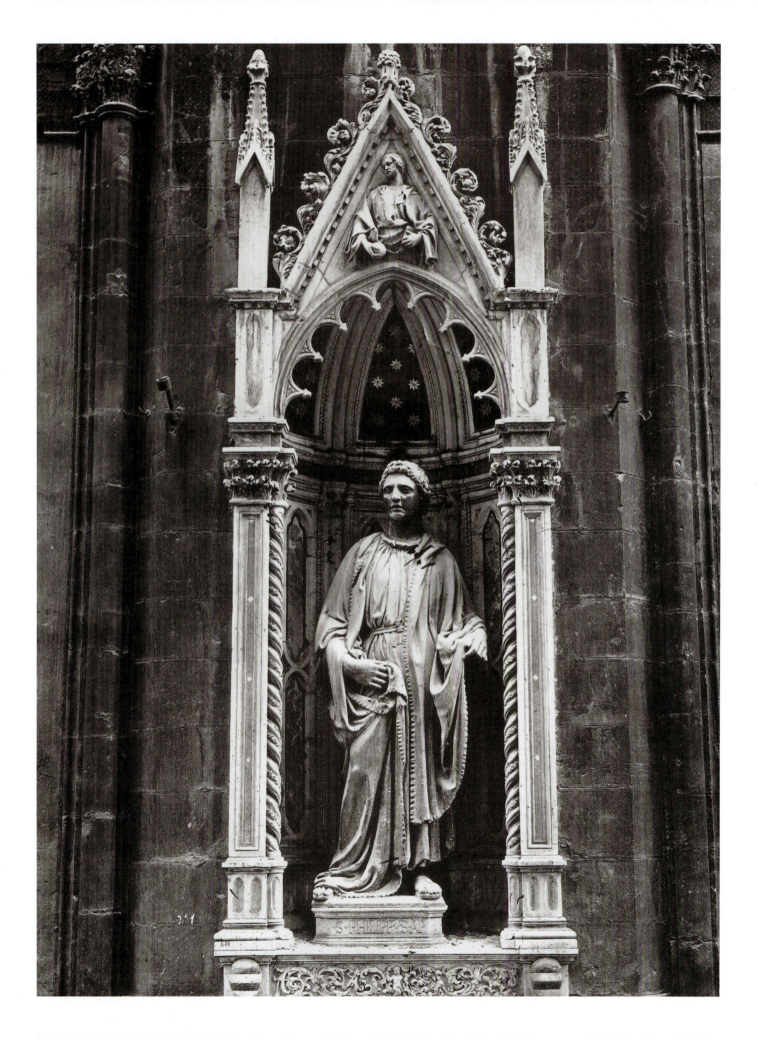

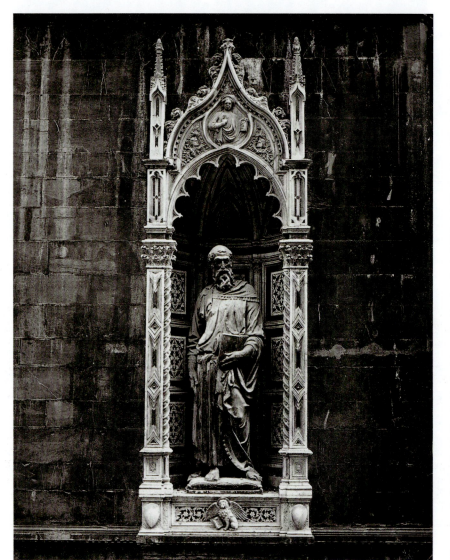

3.5
Donatello, *St. Mark*,
1411–13. Marble, height
7'9" (2.4 m). Orsanmichele,
Florence. The photo shows
the statue before removal
from its tabernacle.

The shallow block did not allow Donatello to make the deep excavations that Nanni did in order to bring folds of drapery into prominent relief. Compensating for this, Donatello relied on an array of techniques that seem more pictorial than sculptural in effect. He incises forms such as Mark's beard and the fringe of his garment in the manner almost of a drawing, and he cuts more deeply only into a few carefully chosen areas of stone – between the left sleeve and the left knee, for instance, or inside the right arm – so that the shadows created there establish the base for a tonal range that is of necessity more restricted through the rest of the work. Like Nanni, Donatello elongates his figure so that it appears correctly proportioned only when seen from below. And like Nanni, Donatello finds a clever way to allude to the group that paid for his statue, by standing his figure on a pillow. The pillow is the kind of product with which linen sellers would have been specifically associated, and it thus says more about the group that sponsored the work than it does about St. Mark himself.

At the same time, the motif must have appealed to Donatello for its contribution to his illusion, since the depression on the pillow suggests the weight of a man rather than that of a massive rock. The rendering of weight stands in contrast with the work of such older sculptors as Ghiberti, whose *St. John the Baptist* privileges grace over mass; Ghiberti had used his commission to translate an aesthetic from the decorative arts onto a greater scale. Donatello, by contrast – like Nanni – seems to have drawn especially on Roman portrait sculpture, which combined a sense of gravity (in both senses of the word) with a concern for individualized likeness.

Figure and Niche

The sculptors working at Orsanmichele in the 1410s increasingly realized that their assignments invited not only inventive references to the sponsoring guild, but also experimental connections between the figure and the niche. Nanni's *St. Philip* seems only an accidental part of its architectural environment; the niche, following the model of Lamberti's earlier design, could have housed virtually any statue made on the right scale. Later artists, however, began to use the niche to expand on the characterization of the depicted saint. Donatello's *St. Mark*, for example, follows the model of Lamberti's *St. Luke*, placing the lion that identifies the Evangelist on a panel below the figure. This single clear indication that the statue shows Mark, rather than the writer of another Gospel, frees Donatello to take more liberties with the figure's other attributes. In this respect, it is his thoughtful use of the niche that permits Donatello to place a pillow, rather than a name-tag, below his statue. Knowing

which came first, but there can be no doubt that one sculptor had seen the work of the other, since the poses of the figures are nearly mirror images of each other. One key difference between the two figures resulted from the fact that Donatello found himself working with a considerably shallower piece of marble than Nanni had. Seen from the side, in fact, the stone really appears to be more a slab than a block, and the completely unfinished back makes it clear that Donatello essentially conceived his figure as a relief rather than as a sculpture in the round. Remarkably, however, it is nearly impossible to perceive this when the statue is in its niche, not just because that environment controls the point of view from which the work can be seen, but also because of the counter-clockwise rotation of the depicted figure's torso, which gives the impression both that it has an axis on which to twist and that, were it to turn still further, there would be still more to see.

where the statue was going, and how it would be housed, affected the way he designed it.

Nanni, whose ideas for Orsanmichele so closely tracked Donatello's, clearly paid attention to this new integration of sculpture and niche, and nowhere more so than in his second work for the site, completed sometime after 1415 (fig. 3.6). This was the niche for the professional organization to which Nanni himself belonged, the Stone and Timber Masters' Guild, and he must have been particularly interested in making a strong impression. An added challenge was that the guild had a group of patron saints rather than a single protector: four early Christian sculptors who had been drowned for refusing to produce an idol for a pagan temple. The guild required Nanni to accommodate multiple figures in a confined space, and it may also have asked him to reuse an existing sculpture in the process: the conception of the second figure from the left, with its toga-like costume and the weight-shift in its pose, is decidedly similar to the designs of the prophets that had been under way since the previous decade for the exterior of the cathedral. This statue, uniquely among the four that make up the group, is finished on the back as well as the front, and it particularly stands out in light of the way Nanni otherwise approached his assignment. Like Donatello, he counted on the fact that views of the sculpture would be partially hidden. The hand that appears on the shoulder of the rightmost figure, for example, does not continue in an arm, though the viewer standing before the niche cannot see that this is the case.

The figures are made from three separate blocks of stone, the two on the right having been carved from a single piece. The approach allowed Nanni to rotate the slabs, fitting the four figures into the single niche. Pushing the blocks up against the side and back walls in this way might have had the strange effect of leaving the front, central area – precisely the space occupied by the statues in the other niches – empty. To avoid this, Nanni simply cut away that part of the niche's floor. His tabernacle is thus the first that seems actually to have been conceived with an eye to the figures it would contain, rather than the other way around. The fictive cloth that drapes the back walls further reinforces the compositional integrity of figure and niche, gathering the psychologically unconnected statues into a unified group. And if earlier sculptors had found ways to advertise the work of their guild sponsors within their sculpture, Nanni takes advantage of the newly cohesive statue and niche to do this too, displacing his own advertisement for the guild's products from the statues themselves to the relief below. Whereas Donatello and Lamberti had used this space to show attributes identifying their characters, Nanni illustrates the labors in which the guild members engaged: building a wall, carving a column, measuring a capital, and chiseling a statue. The nature of the assignment gave Nanni the unusual opportunity to draw attention to the activities at which both he and the people who paid him were most skilled: turning stone into art.

The new use that Nanni made of the vertical surface below his figures set an influential example not just for

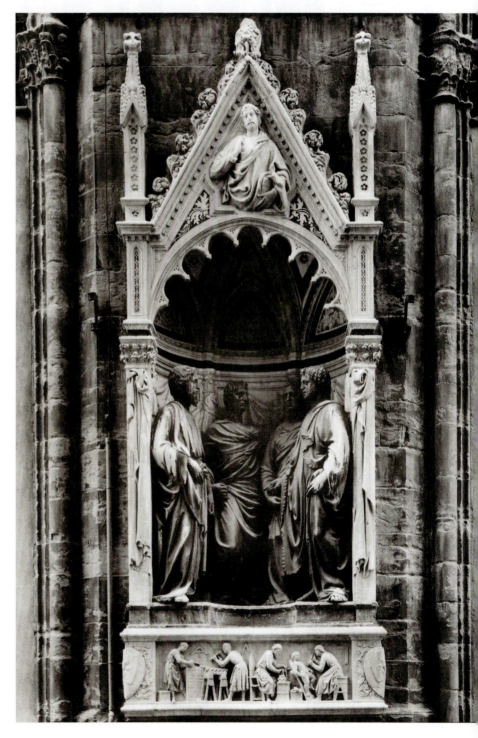

3.6

Nanni di Banco, *Four Crowned Saints, c.* 1413–14. Marble, height approx. 6' (1.83 m). Orsanmichele, Florence. The photo shows the figures before removal from their tabernacle.

3.7

Donatello, *St. George from Orsanmichele*, Florence, *c.* 1415–18. Marble, height 6'10" (2.1 m). Museo Nazionale del Bargello, Florence. The photo shows the statue and the relief below it before their removal to the Bargello.

the artists who came after him at Orsanmichele, but also for Renaissance sculptors more broadly. The first artist to respond to it, not surprisingly, was Donatello. Presumably in part on account of the impression he had made with his *St. Mark*, Donatello was commissioned around 1415 to produce a niche with a statue of St. George for the Armorers and Swordsmiths' Guild (fig. 3.7); he completed the work roughly three years later. Picking up on Nanni's idea, Donatello now used the space at the bottom of his niche for a narrative scene, one that showed the act for which George was most famous, slaying a dragon and rescuing a princess (fig. 3.8). If his *St. Mark* from around 1411 already took a pictorial approach to three-dimensional imagery, the *St. George* relief pushed that approach to its limits: a loggia at the right and a cave at the left both diminish in **perspective**, creating the effect of a deep, receding space. The regular bays of the loggia position the princess herself within an illusionistic world, such that she appears to stand slightly back from the picture plane, even though the stone from which she is made actually projects further forward in real space than the stone that represents the building beside her. What Donatello showed was that the impression of three-dimensionality could be achieved independently of the actual three-dimensionality of the stone, by employing the same devices available to painters. As if to underscore this, Donatello cut his relief as shallowly as possible, in a style that has come to be called *relievo stiacciato* (literally, "mashed" or "squashed" relief). It is hard to imagine an approach more different from that of Nanni, or indeed from that of Ghiberti, who had been Donatello's teacher just a decade earlier.

Donatello's *St. George* relief, like Nanni's image of the stoneworkers' practices in the *Four Crowned Saints* (**see** fig. 3.6), can also be seen as an illustration of the guild's tools put into action, in this case showing the sword and armor brought to a fight. At the same time, the composition, with George at the center and the princess, hands folded at her chest, in the wings, evokes that of devotional images, reminding us that this is not just any warrior we are seeing. In the relief, the inherently heroic and romantic aspect of the story runs up against the idea of George as an icon, and the same is true of the marble statue above. Nanni's *St. Philip* had already experimented with characterization, imagining the Apostle as a fresh-faced young man rather than as the wizened prophet Donatello seemed to embody with his *St. Mark*. With *St. George*, Donatello embraced the opportunity to show a beautiful young champion, placing skin-tight leather across his chest and giving him a long, sinuous neck and an expressively furrowed brow. By the middle of the sixteenth century, the work would be considered the most lovely of all Florentine marbles, the model that later painters

and sculptors should follow if they wanted to idealize the men they portrayed.

Drill marks in George's head indicate that he was at one point crowned with some form of victor's wreath; the position and arrangement of George's left hand suggest that he originally held an additional attribute there, too, presumably a bladed weapon. If this was, as is likely, a removable iron instrument, *St George* would, like Nanni's *Four Crowned Saints*, have counted among the statues on Orsanmichele that advertised the products of their guild in the materials of which those products were actually made.

The same could be said of Ghiberti's second sculpture for the building, the *St. Matthew* he began in 1419 and completed in 1423 (fig. 3.9). The space had originally been assigned to the Bakers' Guild, but as this group did not have money to spend on art, they ceded their space to the Bankers' Guild. The bankers, by contrast to the bakers, belonged to one of the wealthiest organizations in the city, and they meant to show this with their commission. Hiring Ghiberti was already an indication of their power,

and the decision to order a work in bronze rather than marble delivered much the same message. The Evangelist Matthew, like Mark and Luke, was the author of one of the Gospels, and he, like them, is portrayed with the text he wrote in his hand. Still, the ensemble departs from these earlier works (*see* figs. 3.5 and 3.2), and for that matter from all the recent compositions created for the site, in foregoing any pictorial relief below the figure. This could have been because the patrons wished to avoid ornamentation that would distract from Ghiberti's marvelous statue, limiting themselves to a pair of female figures, possibly representing sibyls, which originally stood in place of spires on the tabernacle. Given the overlaid meanings of the attributes that the earlier sculptors gave their figures, however, the reduction of forms in the case of *St. Matthew* raises the question of whether there is anything in that work, too, that refers specifically to the corporation that commissioned it. The answer may again lie in the bronze material itself, since bankers, more than any other professionals in Florence, would have been associated with precious metals.

3.8

Donatello, *St. George and the Dragon*, relief from the St. George tabernacle, *c.* 1420. Marble, 15⅜ × 47¼" (39 × 120 cm). Museo Nazionale del Bargello, Florence

3.9

Lorenzo Ghiberti, *St. Matthew*, 1419–23. Bronze figure, originally with gilded decoration, height *c.* 8'10" (2.7 m). Orsanmichele, Florence. The photo shows the statue before removal from its tabernacle.

Certainly the bankers themselves realized that their commission would stand out among the recent additions to Orsanmichele, the only work that could really compare to *St. Matthew* being Ghiberti's own earlier *St. John the Baptist* of *c.* 1410. The contract required Ghiberti to make his *St. Matthew* as large as or larger than the Calimala's *St. John* and to cast it in no more than two pieces. One way to read this is as an indication of just how competitive the atmosphere at Orsanmichele had become by 1419. At the same time, contracts with this sort of stipulation were not uncommon in the **Quattrocento**. One of the easiest ways for patrons to convey to artists what they wanted was to refer to another work; contracts themselves, that is, challenged artists to outdo their predecessors, even while imitating them. The repeated success of artists like Donatello and Ghiberti suggests that patrons prized clever responses to assignments. Still, the prime expectation was that the artist would rise to a particular standard rather than that he would do something entirely original. The question, for example, of whether Nanni's *St. Philip* preceded Donatello's *St. Mark* or vice versa is less important than the sense, evident in the proximity of the two works, that one was supposed to match the other in quality and perhaps in design. The artist was to direct his intelligence to adaptation as much as to creation, finding ways to make a highly conventionalized set of components fit together in a distinctive way.

Customizing the Altarpiece: *The Coronation of the Virgin*

In the case of Orsanmichele, it was the site itself that established the conventions in relation to which variations on the niche and statue would be conceived. Once the first niches were in place, the scale, position, and general format for future ornaments were essentially set, and the materials that could be employed were limited to a narrow range of choices: marble, bronze, and glass or mosaic elements might be inlaid within the wall of the niche. In other places, and in other media, the controls on invention were somewhat different.

A painting today in the Uffizi Gallery in Florence, showing the Coronation of the Virgin (fig. 3.10), bears the following inscription: "This panel was made for the soul of Zanobi di Ceccho della Frascha and for the souls of his family, in recompense for another panel that had been placed in this church for him." It goes on to identify the artist responsible for the painting as "Lorenzo di Giovanni, a monk of this order," and to specify that the work was completed in February 1413 (1414 by modern calendars). The painting comes from Santa Maria degli Angeli, a no-longer extant Florentine church that in the early fifteenth century was occupied by the Camaldolese, a branch of the **Benedictine Order** and one of Italy's oldest religious communities. The apparent history behind the inscription is that Zanobi di Ceccho, a banker who had died in 1375, had donated a painting that the monks at the church later wished to replace; the nature of the banker's donation required that the original painting be remembered, even after its removal. What the inscription does not tell us is that the new painting from 1414 not only took the place of the vanished panel to which it makes specific reference, but also followed the model of a second picture, a *Coronation of the Virgin* from 1407,

now in the National Gallery in London (fig. 3.11), that the same artist, Lorenzo Monaco, had made a few years earlier for another, newer Benedictine monastery, one that a group from Santa Maria degli Angeli had founded. The Camaldolese, that is, commissioned a picture in direct imitation of the one that decorated the most sacred space in a daughter church.

The Uffizi version of the *Coronation* is in every way more impressive than the one now in the National Gal-lery, London: the artist managed to accommodate more than a dozen extra attendants to the central scene, even as he made the space itself seem ampler. The figures are at once more gracefully elongated and more subtly mod-eled; the distribution of color across the picture is more complex; and the surface is worked with special dili-gence, every halo being individualized with a pattern of punched gold not repeated anywhere else in the picture. For these reasons, scholars long believed that the Uffizi

3.10

Pietro di Giovanni dalle Tovaglie, called Lorenzo Monaco, *Coronation of the Virgin*, 1414. Tempera on panel, 12′3″ × 8′ (4.5 × 3.5 m). Uffizi Gallery, Florence

3.11

Lorenzo Monaco,
Coronation of the Virgin,
1407. Tempera on panel,
6'5" × 5'1" (1.95 × 1.05 m)
(left); 7'3 × 5'3" (2.21 ×
1.15 m) (center); 6'5" × 5'
(1.97 × 1.02 m) (right).
National Gallery, London

OPPOSITE

3.12

Gentile da Fabriano,
Coronation of the Virgin,
1408–10. Tempera on
panel, 19¼ × 14¾" (48.9
× 37.8 cm) (upper); 61¾
× 31⅜" (157.2 × 79.6 cm)
(center); 46 × 15¾"
(117.5 × 40 cm) (lower).
Pinacoteca di Brera, Milan

picture must have been painted first, the London version looking like a lesser copy of this. That the opposite turns out to be true suggests something about the way that commissions themselves worked in the period: though no contract has yet been discovered, we can presume that the monks at Santa Maria degli Angeli asked Lorenzo to make something that exceeded his previous production (as the Florentine bankers had specifically asked Ghiberti regarding his *St. Matthew*). Lorenzo's second *Coronation* closely resembles his first – indeed, it includes a number of figures so similar that they could have been based on drawings the artist preserved from the earlier project. Even where improvement was welcomed, remembrance, including remembrance of things that patrons were willing to destroy, mattered more than novelty. The Camaldolese altar drew the viewer's thoughts first to the holy characters it showed: the central scene of the Virgin surrounded by celestial devotees would have reminded visitors that the church itself was dedicated to "Maria of the Angels." The painting, however, also recalled both an earlier work of its maker and the altarpiece that had been there before it.

The two altarpieces show, much as the niches and statues at Orsanmichele did, how art could, in the early Quattrocento, be generated by customizing a set of basic forms. And we bring this mode of production into still sharper relief if we compare the Lorenzo Monaco painting of 1414 with one that another painter made in roughly the same years, showing the same subject. In 1405, Chiavello Chiavelli, the Lord of the town of Fabriano in north-central Italy, ordered the rebuilding of a Benedictine church by the name of Santa Maria di Valdisasso in the hamlet of Valle Romita for a group of Franciscan friars. Although no documents survive relating to the *Coronation* altarpiece (fig. 3.12) that the painter Gentile da Fabriano (*c.* 1370–1427) made for this new church, it seems likely that Chiavelli, who wished to be buried there, commissioned the surviving picture as well, and that Gentile finished the work sometime between 1410 and 1414.

Lorenzo Monaco and Gentile da Fabriano seem to have had no contact with one another before making their paintings: Gentile had grown up in Fabriano and had spent a brief period in Perugia to the south-west, but

he made most of his important earlier works, including the *Coronation*, while in Venice; Lorenzo, for his part, was attached to the monastery of Santa Maria degli Angeli and may never have left Tuscany. And though the two paintings are almost exactly contemporary, it is easy enough to enumerate the ways in which Gentile's painting ignores Tuscan prototypes from the previous decade.

Gentile's style emphasized line and pattern, as is evident in the borders of the draperies of the Virgin and Christ; he favored rich and varied surface treatments, evoking the appearance and texture of luxurious fabric and flowering meadows. Lorenzo, by contrast, tended to more simplified and volumetric figures. Following Venetian rather than central Italian tradition, Gentile's Christ crowns his mother not with two hands but with one, holding a cruciform scepter in the other, and he is accompanied by the two other members of the Holy Trinity, with God the Father behind Christ and the Virgin, and the dove representing the Holy Spirit between. Both Gentile and Lorenzo set their scenes in a celestial realm, indicated by the starry arches below them, but Lorenzo's space is more architectonic, honoring the couple with the baldachin that canopies them, rather than floating them, as Gentile does, in spaceless gold. Whereas Lorenzo implies that the spaces of the central and side panels constitute one continuous room, Gentile insists on the sacred separateness of the area occupied by Christ and the Virgin, placing his peripheral figures on the floor of a garden resembling paradise and dividing them with the columns of the frame. More than Lorenzo, Gentile makes it clear that his saints are permitted to see what Christ and the Virgin are doing but not to join them.

3.13
Filippo Brunelleschi, Foundling Hospital (Ospedale degli Innocenti), Florence, designed 1419, built 1421–44.

Still, these striking differences should not lead us to overlook how much the pictures have in common: knowing the subject of Lorenzo's work, even a modern viewer unaccustomed to early Renaissance pictorial customs will immediately recognize that Gentile shows the same thing, with identical or closely analogous characters, in roughly the same positions relative to one another. The continuity of form between the two pictures is in large part a product of the fact that the two painters understood their assigned subject to serve the same specific function. What the patrons expected was not a painting that illustrated a particular Biblical episode, but rather one that portrayed a devotional relationship and helped them imagine their own connection to the Divine. The central scene, to the extent that it follows any text, responds to a line from the Song of Songs, a Biblical poem traditionally ascribed to King Solomon: "Come from Lebanon, my spouse, come and receive your crown." It does not, that is, represent a narrative so much as an expression of love and commitment. This gives particular importance to the characters who watch the central exchange, partaking in the same sentiment. The saints mediate between the viewer and the central characters, but they also represent a community on the model of which the monks could understand their own. It is not accidental that in the case of the two Lorenzo Monaco altars, all the depicted onlookers are male.

The Camaldolese Order was known for its strictness, and the lavish gold ornament at the center of the church must have looked especially glorious to the ascetics who lived with it. One might even understand the coronation scene as an illustration of the heavenly reward promised to those who lived like the saints in the picture. The art in an altarpiece like Gentile's or Lorenzo's consisted in making the characters in the scene as celestially beautiful as could be imagined without straying from a set of basic, almost diagrammatic expectations – expectations controlled, to a certain extent, by the physical framework to which artists continually returned. One of the reasons why early Renaissance altarpieces showing the coronation of the Virgin all look so similar is that their makers were expected to adopt the same component elements. The altars of Gentile, Lorenzo, and their contemporaries are mostly polyptychs, or multi-paneled pictures: they comprise a central arched image with the primary characters; flanking arched wings, slightly lower, with pictures of important saints; gables above; and a predella below with smaller, narrative scenes.

The overall structure of these polyptychs echoed that of the church in which such altars were placed, with what look like sections of the central nave and side aisles or chapels replicated in the pictures. In all three paintings of the Coronation of the Virgin discussed above, the position of the secondary figures illustrates a hierar-

chy of spaces – the zone featuring Christ and the Virgin being more sacred than that occupied by onlookers – and this corresponded closely to the spaces inside the actual churches where the panels stood. Attendants watching the priest perform liturgical ceremonies in front of the altar painting would, like the saints at the Coronation, have seen events that took place in an area they did not themselves enter. If, at Orsanmichele, every project started with the niche, so in the *Coronation* pictures it is architecture, as much as anything, that establishes the constant.

Filippo Brunelleschi and the Foundling Hospital

As chapter 1 suggested, most architecture in this period organized itself around nameable building types. What the comparative cases of sculpture and painting allow us to see more clearly, however, is the mechanism by which "types" developed, one driven by conventions of patronage. The most famous building in Florence, made by the most famous architect in this period, was the Ospedale degli Innocenti, or Foundling Hospital, which Brunelleschi started in 1419 (fig. 3.13). Following convention, it centered on a cloister, with a ward on one side and a church on the other. Brunelleschi himself was not responsible for the way in which the whole structure was eventually built, but he appears to have overseen laying the foundations and the construction of the basement storey. Most striking today, as in his own time, is the hospital's loggia, or **portico**, which faces the Piazza Annunziata.

This portico served a practical purpose, offering a kind of waiting room for those who could not yet be admitted to the wards. As much as it contributed to the hospital's operations, however, it also ennobled the piazza where the building stood. These two roles were not unrelated: building a hospital was an act of charity, and beautifying the city was as well; the civic function of the loggia, in this sense, was a double one. Originally, the facade above the columns included as its most prominent single ornament the coat of arms of the Silk Weavers' Guild, its patron. If building the hospital was to be a charitable act, there could be no doubt about whose act that was. Only in 1487 did Andrea della Robbia (1435–1525) fill in the concave roundels that Brunelleschi had envisioned with glazed terracotta reliefs depicting the swaddled infants for whom the hospital cared; this transformed the decoration in a way that placed more emphasis on the hospital's operations than on its sponsorship.

Today, the loggia of the Ospedale degli Innocenti is, justly, considered to be one of Brunelleschi's most defining works. Its **Corinthian** order, studied from ancient examples, and its elegant semicircular arches in crisp

3.14

Ospedale di San Matteo, Florence, begun 1385 under the direction of Romolo del Bandino and Sandro del Vinta, completed 1410.

pietra serena (a local gray limestone) together give a sense of spatial order and geometrical tidiness unlike that seen anywhere else in an early Quattrocento city. It is immediately apparent that the loggia is based on elementary geometry and simple ratios: the height of each column is the same as the interval between the columns and the distance between each column and the wall behind, resulting in a series of cubic spaces with hemispherical domes. Brunelleschi's exquisite and highly cultivated sense of design, nevertheless, should not distract us from the fact that the loggia was itself a fairly standard feature of Florentine hospitals: the hospital of San Matteo (1385–1410, fig. 3.14), among others, had a similar loggia, likewise facing a piazza, and this had been completed only nine years before for a building just one block to the west of the site of the Ospedale degli Innocenti. What is more, the contract for the San Matteo hospital survives, and it works much like the contract for Ghiberti's *St. Matthew*, requiring the hospital's builders to make their portico "in the form and manner" (*forma e modo*) of a hospital across town, in the Via San Gallo. The loggia, even one as majestic as Brunelleschi's, was not meant to be a novelty. It was added to the hospital precisely on account of its familiarity as a structural type, and because it seemed especially well suited to its circumstances.

Nowadays, in an art world shaped by assumptions of the **avant-garde**, we tend to place less emphasis on these conventional, repetitive aspects of the works we love. Renaissance art, though, depends on repetition for its legibility; the art is comprehensible only when we understand how conventional it is. What made a work "good" was not necessarily, or not only, its originality. Artists focused as much on adaptation as on creation. The masterpieces of the period are not those that break radically from the past, but rather those that fit standard parts together in a way that is at once appropriate and distinctive.

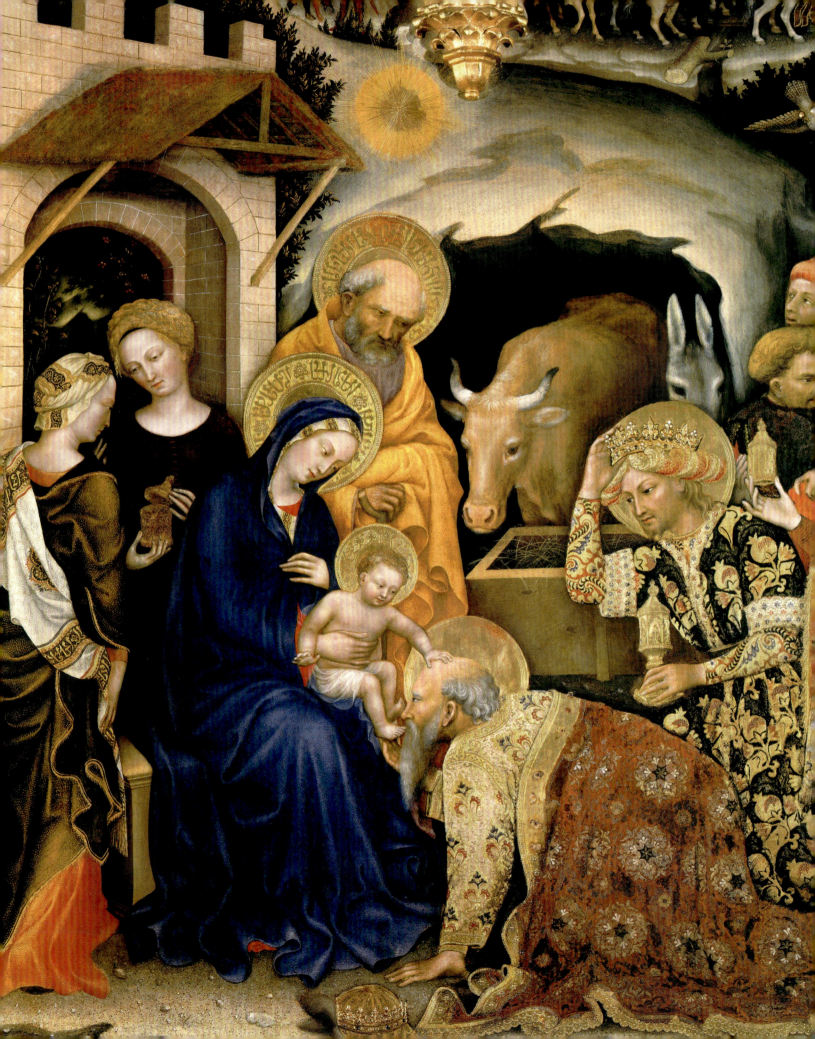

1420–1430
Perspective and Its Discontents

4

4 1420—1430
Perspective and Its Discontents

The Centrality of Florence

Histories of early Renaissance art have long presented Florence as its center, and our opening chapters have done the same. Accounts of this kind run the risk of perpetuating the prejudices of Giorgio Vasari, whose influential *Lives of the Artists* left to posterity the idea that all progressive art looked Florentine. Even a more comparative perspective, however, suggests that Florence really was, in the early 1400s, a focus of unparalleled attention. Three works from the decade 1420–1430 give some measure of this.

Cardinal Baldassare Cossa (*c.* 1370–1419) was Neapolitan by birth, and he had served as papal deputy in Bologna; in 1410 a faction of powerful clergy had assembled in Pisa and elected him as Pope in opposition to rival claimants in Avignon and in Rome itself. In many ways, however, his most important ties were to Florence. He fled there in 1410 when an invasion by King Ladislao of Naples (*r.* 1386–1414) prevented Cossa, who as Pope had taken the name John XXIII, from establishing his papacy in Rome. When the 1414 Council of Constance resolved the Schism in favor of Pope Martin V (*r.* 1417–31), Martin himself reigned initially from Florence. And when the Holy Roman Emperor Sigismund (*r.* 1433–37) imprisoned the deposed Cossa in 1418, the city of Florence paid the ransom required to free him. Cossa secured for Florence a particularly prized relic, the finger of John the Baptist, the city's patron saint. And in the 1420s, the Calimala guild (*see* p. 70) approved the burial of Cossa, as a former Pope and major ally of the city, in Florence's most prestigious setting, the baptistery. The tomb (fig. 4.1), designed by Donatello, executed with help from the bell-caster Michelozzo di Bartolomeo (1396–1472), and completed in 1431, occupied the space between two of the baptistery's existing columns, without actually modifying the venerated building's architecture. Braces hold apart an enormous fictive baldachin that drapes down from a ring above, lending the whole ensemble a ceremonial aspect while also blurring the distinction between where the building ends and the tomb begins. Low-relief figures of Virtues occupy three niches in the lower storey. Above this, three coats of arms – one of them including a papal miter – recall Cossa's worldly

RIGHT

4.1

Donatello and Michelozzo, tomb of Pope John XXIII, completed 1431. Baptistery, Florence

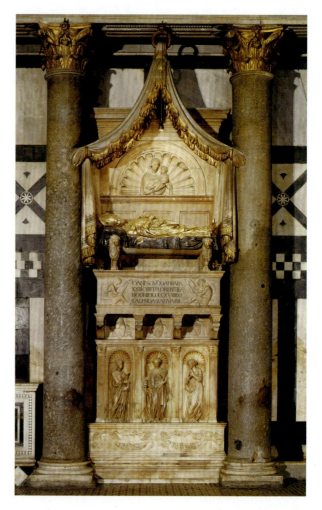

titles. The Latin inscription, which uses the papal name Johannes rather than Baldassare, refers to the deceased as "*quondam papa*" ("one-time pope"). A pair of lions, traditional symbols of Florence, supports a bier with a full-scale portrait of Cossa. The Virgin and Child appear to look down protectively over a parapet.

The Cossa tomb illustrates the close ties that Florentines cultivated to the papacy and the appeal that the city held for cultivated clerics. Such a monument, however, required not only a wealthy patron and an available site, but also a capable artistic team, and the art of the 1420s can give the sense that the city of Florence had both unmatched financial resources and a near monopoly on

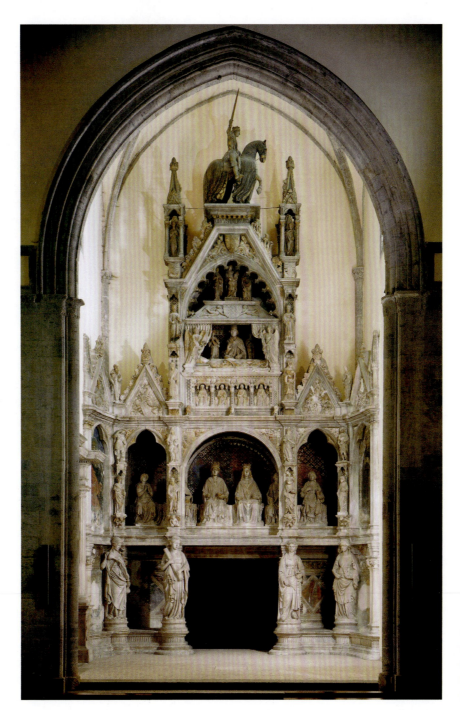

4.2
**Andrea da Firenze, tomb
of King Ladislao of Naples,
1420s.** San Giovanni in
Carbonara, Naples

the major talent. When the heirs of Cossa's former nemesis, King Ladislao, determined to build him a grand tomb as well (fig. 4.2), it was to a Florentine that they turned. The still-obscure artist behind the work goes by the name Andrea da Firenze (Andrew of Florence), though the Neapolitans seem to have called him Andrea Ciccione (Fat Andrew). He began the monument when Donatello and Michelozzo were well advanced on theirs, and Andrea adapted what he knew to his new commission. Like Donatello, the sculptor here responds thoughtfully to the architectural setting, virtually presenting the tomb as architecture itself, without really modifying the existing structure. The monument appears to unfold behind

the high altar, extending its wings to the side walls of the space to create a closed environment. Like its predecessor, Ladislao's tomb includes personifications of virtues, but the king's virtues apparently outnumbered Cossa's: four support the superstructure on their shoulders while others sit in **trilobed** arches above. Ladislao himself appears not once but three times: enthroned at the side of his sister and successor Giovanna, laid out on a sarcophagus, and on horseback with drawn sword at the top. The scale of the whole monument says much about the prerogatives of a deposed Pope relative to a conquering king, but there is also something perhaps a little too assertive about it. Pope Martin V had excommunicated Ladislao,

Gentile da Fabriano,
The Adoration of the Magi
(Strozzi altarpiece), 1423.
Tempera on panel, 9'10½"
× 9'3½" (3 × 2.8 m).
Uffizi Gallery, Florence

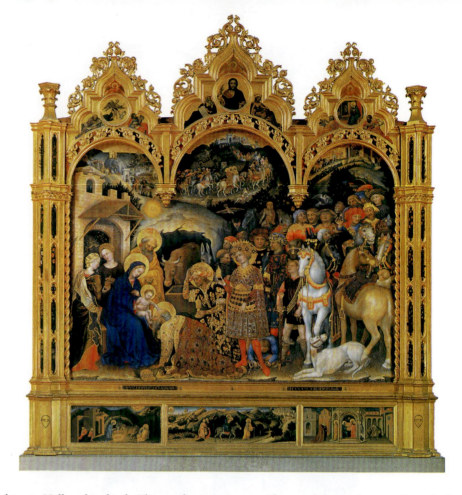

condemning him to Hell on his death. The emphasis on virtue, like the presence of the bishop and two deacons who stand over the recumbent effigy, giving it their blessing, seems calculated to undo in death what had befallen Ladislao in life.

Andrea da Firenze was a sculptor of middling abilities, and his move to Naples in the 1420s suggests not only what patrons outside Florence had to settle for, but also what limited opportunities a Florentine less gifted than Donatello or Lorenzo Ghiberti might find at home. For the best artists, conversely, the city held real allure. In 1420, Gentile da Fabriano, the most talented painter in northern Italy, chose to move his shop from Brescia to Florence. Three years later, he completed an *Adoration of the Magi* (fig. 4.3) in the sacristy of the church of Santa Trinita. The painting, like the artist's earlier *Coronation* altarpiece (*see* fig. 3.12), bears his proud signature. Its patron, Palla Strozzi (1372–1462), had been the Calimala guild's agent in the Cossa tomb commission (*see* fig. 4.1); a learned banker whose fortune helped make Florence one of the richest cities in Europe, Strozzi embodied the Republican, capitalist culture that produced the city's demand for art, sustained its intellectual life, and encouraged its eye for innovation. The highly ornate manner for which Gentile was known must have appealed to Palla; the artist, for his part, could have asked for no better subject to show off his lavish approach.

The panel shows the story from the Book of Matthew in which the three wise men (Magi), having followed a star, arrive in Bethlehem and kneel down before the newborn Christ. Following convention, Gentile rendered the Magi as crowned rulers, representatives from the East who bow to the "King of Kings." Composing a scene that involved travel, he abandoned the gold background he had employed in his earlier *Coronation* (*see* fig. 3.12) and instead adopted the panoramic landscape convention introduced in the previous century by Ambrogio Lorenzetti. The smaller relative size of the background figures indicates their distance in space, although in general here, as in his earlier picture, Gentile emphasized surface rather than depth: the sloping ground allowed him to stack rather than overlap his characters, putting a collection of individualized heads on display even as he flattened the space. Nor did the painter see any contradiction between the idea that the picture's main characters might inhabit an illusionistic world that flowed continuously across the three lobes of the **triptych** and the conviction that paintings for important sites should be physically bejewelled. Applied gold leaf did not so much depict the material of the kings' crowns and offerings as *present* it literally, along with the threads of their brocaded robes, and their animals wear gold harnesses. When it came to the rendering of such motifs as the spurs that a retainer removes from the central figure's feet, Gentile employed a technique called **pastiglia**,

physically building up the surface of the painting with molded plaster before applying the gold leaf, to create the effect of a three-dimensional gold object. This is not to say that gold always stands for gold in his painting; Gentile also experimented with the metal's luster, using it to depict the highlights in the landscape and, in the predella, to produce a moonlit Nativity scene.

All of this gilded splendor would have lent the *Adoration* altarpiece an exotic quality, as would the turbans and fine cloths that Gentile takes such delight in detailing. Yet not everything about the retinue he depicts would have seemed distantly foreign. All three of his Magi, for example, look distinctly European, different only in their ages. They are accompanied by squires, and travel on horses with dogs at their sides, as if they represented a great hunting party rather than a group of weary wanderers. The whole image is strikingly courtly, an effect that could seem out of place in a public commission by a private citizen. The subject matter, in this case, allowed artist and patron to conceive a work that would play to the former's strengths, even if it went against expectations of what Florentine art should look like. Only an artist with a north Italian background, trained to serve a clientele who expected luxuriant display, copious detail, and calligraphy-like linear pattern, could have painted this.

Lorenzo Ghiberti and Brunelleschi at the Baptistery

New Technologies

The sacristy that housed Gentile's altarpiece in the church of Santa Trinita, Florence, may have been designed by Ghiberti, who is documented as having been involved with the new woodwork being added there in the year Gentile arrived in the city. And few Florentines would have appreciated more acutely than Ghiberti the effects that Gentile was after. When the goldsmith completed his Florence baptistery doors with the *Life of Christ* in 1424, his patrons at the Calimala guild were so pleased with the result that they commissioned him to design a second set. The shift in program more than two decades earlier had left the baptistery without the scenes that Ghiberti, Brunelleschi, and their competitors had originally proposed to make (*see* p. 70), and the Calimala at first considered simply returning to the earlier plan of having Ghiberti make twenty panels showing episodes from the Old Testament and eight prophets. By 1429, though, the new doors had been completely reconceived: now they would comprise only ten panels, each significantly larger in scale than what Ghiberti had previously made, and they would combine narrative moments and

even separate stories within a single frame. The format of the panels would now resemble that of panel paintings, and Ghiberti organized most of his scenes in a way comparable to what Gentile had done, with figures disposed against a hilly landscape that allowed him to show multiple characters while also covering or decorating the entire surface of the work (fig. 4.4). When Ghiberti later boasted about his accomplishment, he wrote:

> I was permitted to execute the commission in whatever way I believed would result in the greatest perfection, the most ornamentation, and the greatest richness.... In the stories [*historie*] that called for numerous figures, I strove to imitate nature as closely as I could, and with all the perspective I could produce to have excellent compositions rich with many figures. In some scenes I placed about a hundred figures, in some less, and in some more.

The first qualities Ghiberti wanted his viewers to appreciate were "ornamentation" and "richness." As he saw it, packing a panel with as many and as great a variety of figures as possible demonstrated his virtuosity. Gentile, with his *Adoration*, could have boasted of much the same achievement.

If there is an element in Ghiberti's description of his aims that sets him apart from Gentile, and more generally from the court art of northern Italy, it is the remark that he rendered the panels for the second set of doors

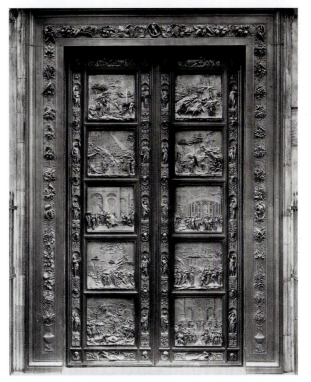

4.4
Lorenzo Ghiberti, east doors of the Florence Baptistery ("Gates of Paradise"), 1425–52. Height 15' (4.6 m)

4.5
Filippo Brunelleschi,
Crucifix, c. 1410–15.
Polychromed wood, 5'7"
× 5'7" (1.7 × 1.7 m). Santa
Maria Novella, Florence

"with all the perspective [he] could produce." These lines appear in the artist's *Commentaries*, which – along with the autobiographical, historical, and theoretical material we discussed in chapter 1 – also dealt with the science of optics. In the context of these volumes, it may not seem surprising that the artist would have been interested in perspective, though we should recognize the extent to which that interest represented a move away from Ghiberti's earlier values. The origins of his new concerns in the 1420s also reflect Ghiberti's close and continuing relationship with his rival Brunelleschi.

Brunelleschi's only Quattrocento biographer, Antonio Manetti, writes that following the competition for the baptistery doors in 1401–03, the artist went to Rome to study architecture. This may well be true, but initially, at least, Brunelleschi continued to work in Ghiberti's own primary medium of sculpture. For the Gondi Chapel in the church of Santa Maria Novella, most notably, he

produced a lifesize Crucifix in wood (fig. 4.5), a material in which Italian sculptors of the period rarely worked. The choice of medium in this case was certainly encouraged by the subject, for it allowed the artist to make an actual cross, rather than a representation of one, and facilitated the application of **polychromy** (painted-on colors) that would give the impression of Christ's presence, in the flesh. Manetti claims that Brunelleschi made the work in competition with Donatello, who produced his own lifesize wooden Crucifix for the church of Santa Croce in Florence at roughly the same time.

Brunelleschi also made the most immediately recognizable contribution to the Florence cathedral complex where Ghiberti was working: he designed the duomo's astonishing dome (fig. 4.6). Though the builders must have known for decades that the crossing of the new cathedral would have to be covered by a structure of extraordinary size, it was not until 1418 that a competition was held to determine the best way to do this. Ghiberti and Brunelleschi this time collaborated, jointly submitting a model, but after it was selected, Ghiberti withdrew from the project, leaving the supervision of the construction to Brunelleschi. Throughout the 1420s, while Ghiberti was completing his first set of doors and beginning his second, the dome was rising over the cathedral site. Structurally, it depended on a system of **ribs** – large ones springing from the corners of the octagonal **drum**, smaller ones between these – that distribute the load of the **lantern** evenly to the stone building below. No sign of this is visible from outside, since Brunelleschi built a second shell, covered with terracotta tiles, over the structure that carries the real weight. The only hint, in fact, that the dome we see contains another dome within are the marble ribs that articulate its exterior, announcing and doubling the ribs that do the work below (fig. 4.7). These features, providing the white vertical stripes that stand out so dramatically against the red brick between them, recall the **buttresses** and ribs that were the most dramatic features on Gothic churches across Europe; the dome, in fact, consists of four "medieval" pointed arches, joined at the top, where the white marble lantern disguises their peaks. Brunelleschi advertised his application of old elements to a new purpose.

Linear Perspective, Regular Space

The dome remains to this day the defining feature of the Florentine skyline, and the technological marvel it represented was not just a matter of its structure. Building the dome required other innovations, from the rigging of pulleys and the construction of a towering scaffolding system to the way in which Brunelleschi designed the laying of bricks. It is not surprising, then, that the cathedral

BELOW LEFT

4.7
Cut-away view of the dome
of Florence Cathedral,
showing the double
shell and the internal rib
structure. Diagram after
Piero Sanpaolesi

BELOW RIGHT

4.8
Brunelleschi's perspective
panel

also provided a site for Brunelleschi's other major invention of the period, a device that would transform the way that paintings and sculptures were made.

Around 1413, Brunelleschi had prepared two painted panels, one showing the Piazza della Signoria, viewed from the north-west, and the other depicting the baptistery, seen from the portal of the cathedral looking toward the entrance Ghiberti was then fitting with doors. Into each image Brunelleschi had cut a hole, so that a person could look through the back of the panel and into a mirror, seeing the painting in reflection (fig. 4.8). This simple operation had two significant effects: it eliminated the user's bifocal vision, forcing him to see with one eye only, and it established that what the viewer saw was not the thing itself but the appearance that thing had shed onto another surface. At every point, the image in the mirror intersected the lines of sight between the viewpoint and the actual thing being seen.

4.9 (1–3)
Diagrams of perspective

To follow Leon Battista Alberti's instructions of *c.* 1435 for creating a painting in perspective, the artist starts with a rectangular surface (DEFG) and draws a line parallel to the base to represent the horizon of vision. The area below the horizon will be imagined as a floor or ground and will ultimately be divided into foreshortened squares. The artist begins by designating a point (C) as a "centric point" or vanishing point, then divides the bottom edge of the plane (FG) into equal segments (B).

Next, the artist establishes the distance between the viewer's eye (E) and the picture plane (PP). It may be easiest to understand diagram 2 as though diagram 1 had been rotated ninety degrees, so that the frame DEFG is now a picture plane seen from the side (PP). The lines connecting the viewing point E to the divisions along the baseline represent optical rays that run to the viewer's eye from a series of points set ever further back in space from the picture plane. The segments (B) along the bottom of diagram 2 will be equivalent to the segments (B) along the bottom of diagram 1.

On the vertical axis, the artist marks the points where the sightlines connecting the eye to the edges of the ground modules intersect the picture plane. The intervals between these points of intersection appear to diminish the closer they get to the centric point (C).

Diagram 3 transfers these points of intersection to the side of the picture plane (HF), then uses them to establish the diminishing horizontal intervals (transversals) of the imaginary floor grid. The lines between the divisions of the baseline and the centric point (orthogonals) represent the apparent convergence of parallel lines as they run away from the viewer. Each of the boxes in the floor represents a square with sides of length B.

These were the basic principles of **linear perspective**. Writers on optics understood vision to result from straight linear rays that came from an object and converged in the eye of the observer. The meeting of the rays at a single point made it possible to render vision in a diagram as a cone or pyramid, with the eye at the apex. The crucial step from this theory to the construction of a painting in perspective was the reconception of the surface of the picture as a slice through the pyramid of rays. If things in a picture that followed this scheme

were higher or lower than one another, to one another's left or right, that was because they looked to be so positioned from a particular point of view. And if one painted thing was larger or smaller than another, that was at least in some cases registering the impression that that thing was closer to or more distant from the observer. "Perspective" literally means "seeing through"; the very word evokes the idea that the painting is a metaphorical window *through which* we see a scene. But the mechanism that Brunelleschi introduced, with its fixed point of view,

its controlled separation of observer and image, and its implication that the size of an object on the surface provides information about that object's distance beyond the surface, was really a system of **commensuration**, a way of representing things such that the dimensions of any one thing were coordinated with the dimensions of every other (fig. 4.9).

This way of thinking about a painting could only have occurred to someone with an interest in optics, that is, with a predisposition to imagine lines that extended between a point or surface inside the eye and the things seen before it. It also depended on a certain competence in geometry. In these respects, Brunelleschi's idea of painting translated his architectural interests. We have already seen how, at the Foundling Hospital, Brunelleschi allowed everything in his design to be measured against everything else (*see* fig. 3.13): the heights of the columns, their distance from the wall, their distance from one another. He followed the same principles at the building on which he worked through the 1420s, the church of San Lorenzo in Florence.

In this case, Brunelleschi was sponsored not by a guild but rather by a private patron, Giovanni de' Medici (1360–1429). A church dedicated to St. Lawrence had stood on that site since the fourth century CE, but Giovanni envisioned an entirely new building (fig. 4.10); he had Brunelleschi begin with the sacristy (fig. 4.11), the room near the altar where priests donned their vestments before conducting Mass. The lofty uncluttered grandeur of the main space results from the superimposition of the hemispherical dome upon a perfectly cubic structure; effecting the transition from the cubic to the spherical form are curved triangles known as **pendentives**. (The dome in this way differs from that of the cathedral, which rises from a polygonal drum.) As at the Innocenti, the architect built the space from simple geometrical forms that all responded proportionally to one another. The altar stands in a square cubicle, each side of which is exactly half the length and half the width of the main room; the attic zone is the same height as the lower story, and this height is also the radius of the hemispherical dome of the ceiling. Here again, Brunelleschi implied that his use of measurement was something he had recovered from antiquity: he framed the bays to either side of the altar with Corinthian **pilasters**, and gave the doorways **Ionic aedicules**. Here too, finally, he made the commensurability of elements perceptible through his choice of materials, articulating the arches, frames, and ribs in *pietra serena* and setting these against white plaster such that the geometry of the design emerged in crisp outline. (As at the hospital, the colorful reliefs in the roundels are later additions, in this case by Donatello.) The visitor has the sense that he or she has walked into a closed

ABOVE
4.10
Plan of San Lorenzo, Florence, showing the church's fifteenth-century form. The sacristy (*see* fig. 4.11) is off the south transept (to the left). The ghosted parts of the image date to a later period.

LEFT
4.11
Filippo Brunelleschi, Old Sacristy, *c.* 1418–28. San Lorenzo, Florence

109

system. Brunelleschi conceived the room, like his perspective paintings, as an autonomous space; within its frame, everything relates to everything else.

Perspective and Narrative

Donatello and Ghiberti

One artist who immediately understood the implications of what Brunelleschi was doing was Donatello. Between 1418 and 1422, he made a third statue for the facade of Orsanmichele in Florence (*see* fig. 3.1), showing St. Louis of Toulouse (fig. 4.12). His patron, the Parte Guelfa, had

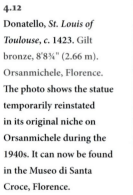

4.12

Donatello, *St. Louis of Toulouse, c.* 1423. Gilt bronze, 8'8¾" (2.66 m). Orsanmichele, Florence. The photo shows the statue temporarily reinstated in its original niche on Orsanmichele during the 1940s. It can now be found in the Museo di Santa Croce, Florence.

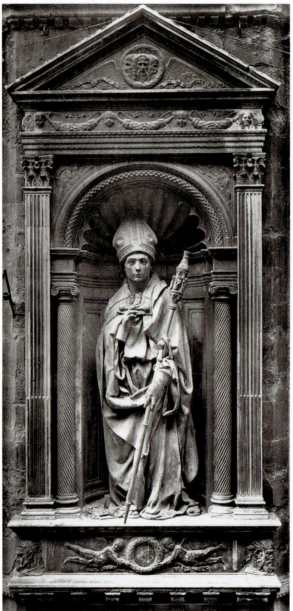

instructed him to make the figure in gilded bronze; lacking experience in metal, Donatello once again called in Michelozzo to help him with the cast. The conception of the work, nevertheless, reflects the approach Donatello had taken in his earlier contributions to the facade. Like the *St. Mark* (*see* fig. 3.5), the work depends on the assumption that the viewer would only see it from controlled angles: in fact, the "statue" consists of nothing more than a robe, a mask, and a glove held together by a hidden armature behind, even if no one studying the statue from the street would realize this. What sets the *St. Louis* apart from the *St. Mark* and from every other figure made for the building, however, are its niche and the figure's relationship to it. Whereas earlier niches look like frames from a Gothic church, with tall pointed arches, thin columns, and spires at the side, Donatello's comes off as a collection of the **classical** architectural motifs the artist knew: a Corinthian aedicule with two smaller Ionic columns set inside it, a conch above the niche itself, a **clypeus** (ornamental shield) in the lower frieze, and swags of garlands in the upper ones. Unlike the most recent additions to the building, the ornaments of the niche seem only loosely connected to the saint, yet in other ways the figure and his container are inextricably bound. For the first time, the niche is scaled precisely to the figure: the Ionic columns rise precisely to his shoulders, the **architrave** behind is at the height of his face, and the **flutes** of the conch radiate behind his head like a halo.

It was Donatello who also first demonstrated the pictorial possibilities that Brunelleschi's new perspective system might allow. The marble slab below his *St. George* on Orsanmichele (*see* fig. 3.8) had already explored the way that illusionistic devices could amplify the effect of three-dimensionality. When, in the years around 1425–27, Donatello completed a bronze relief, the *Feast of Herod* (fig. 4.13), to decorate the font at the center of Siena's baptistery, he pursued similar aims. But whereas the *St. George* had used the crystalline qualities of marble to suggest an atmospheric outdoor environment, now the artist created an interior layered with hard edges. Even as he followed the goldsmiths' convention of covering the surface with detail, he worked the wax design for the bronze as he earlier worked marble, in unusually low relief. By describing the individual bricks that make up the arcades and walls, and by diminishing those bricks in size to indicate a position further back in space, he was able to define a deep recession without having much of anything physically project forward from the picture surface.

Donatello dramatized the principle that the image represented a slice through a cone of rays by abruptly cutting off the roof beams extending toward the picture

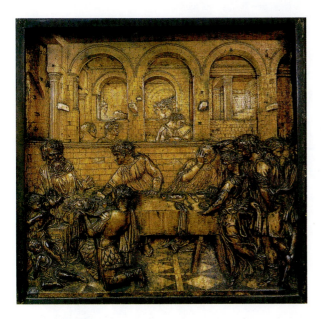

plane. He did not conceive his depicted architecture just as an exercise in optics, however, but rather used the distinctions that perspectival constructions allowed to organize his story. The viewer must explore the complex space to find the various episodes. Like earlier narrative art, Donatello's relief subordinates some events and characters to the background, arranging these in layers separated by architectural screens. In the right foreground, Salome leaps and twists, performing the dance that induced her stepfather, Herod, to give her anything she wanted; Donatello has placed the musician who accompanies her in the middle distance, in a space that resembles a singers' gallery. In the most distant scene, visible through the leftmost arch, the executioner presents the head of John the Baptist to Salome. The horrible consequence of her seductive dance is shown to the left: the entire court convulses in shock as the head is presented to the king.

Donatello's impact on Ghiberti, who had produced less inventive reliefs for the same Sienese baptistery, is most evident in the latter's second set of doors for the Florence baptistery. To begin with, the change from a quatrefoil to a square format for each of the reliefs represents a move toward geometric simplicity, but it also introduces a shape that more readily allowed for the conception of the picture as a mirror or window. What Ghiberti set within each of those frames, moreover, is far denser than anything he had made previously. Consider his version of the story of Jacob and Esau (fig. 4.14) from 1425–52. In his reliefs for the north doors, characters typically stood on a kind of shelf that projected forward from the relief ground; Ghiberti simply created real three-dimensional figures that occupied real three-dimensional space. The ground in this later work,

by contrast, appears to slope inward, and the tiles in the background, which diminish in size as they get more distant, tell us that Ghiberti has established a point of view and transformed the space according to optical principles. A kind of measure, absent before, now governs: whereas the architecture depicted in the earlier reliefs for the baptistery functioned like the niches for statues, with openings corresponding to the figures before them and with arches or roofs just slightly taller than the characters who would presumably enter them, now the structure looks like a real building. The figures establish scale, but there is no longer the sense that the function of architecture is simply to frame them. By implying that differences in the figures' sizes correspond to their relative proximity or distance from the viewer – something Ghiberti never suggested in his earlier doors – he could also imply that those figures occupy different spaces, one behind the next. Painters had used a variety of proportional diminution from the first half of the fourteenth century, and any sculptor acquainted with Gentile would have seen how this worked; only now, however, did Ghiberti and Donatello begin to move their colleagues away from a more literal-minded conception of sculptural space and toward the virtual realities of painting.

Perspective allowed Ghiberti, as it had Donatello, to employ "continuous narrative," whereby the same characters recur repeatedly in what looks like a single space. On the rooftop at the right of the *Jacob and Esau* panel, God tells the pregnant Rebecca that "Two nations are in thy womb, and two peoples shall be divided out of thy womb, and one people shall overcome the other, and the elder shall serve the younger." In the background left, Rebecca lies in bed, an allusion to the birth of her twin sons, Jacob and Esau. The two boys, now adolescents, confront each

LEFT

4.13

Donatello, *Feast of Herod,* *c. 1425–27.* Gilt bronze, 23⅛ × 23⅛" (59.7 × 59.7 cm). Baptismal font, Siena Cathedral

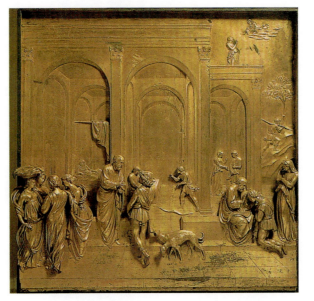

4.14

Lorenzo Ghiberti, *Jacob* *and Esau,* **panel from the** **Gates of Paradise,** 1425–52. Gilt bronze, 31¼ × 31¼" (79 × 79 cm). Museo dell'Opera del Duomo, Florence

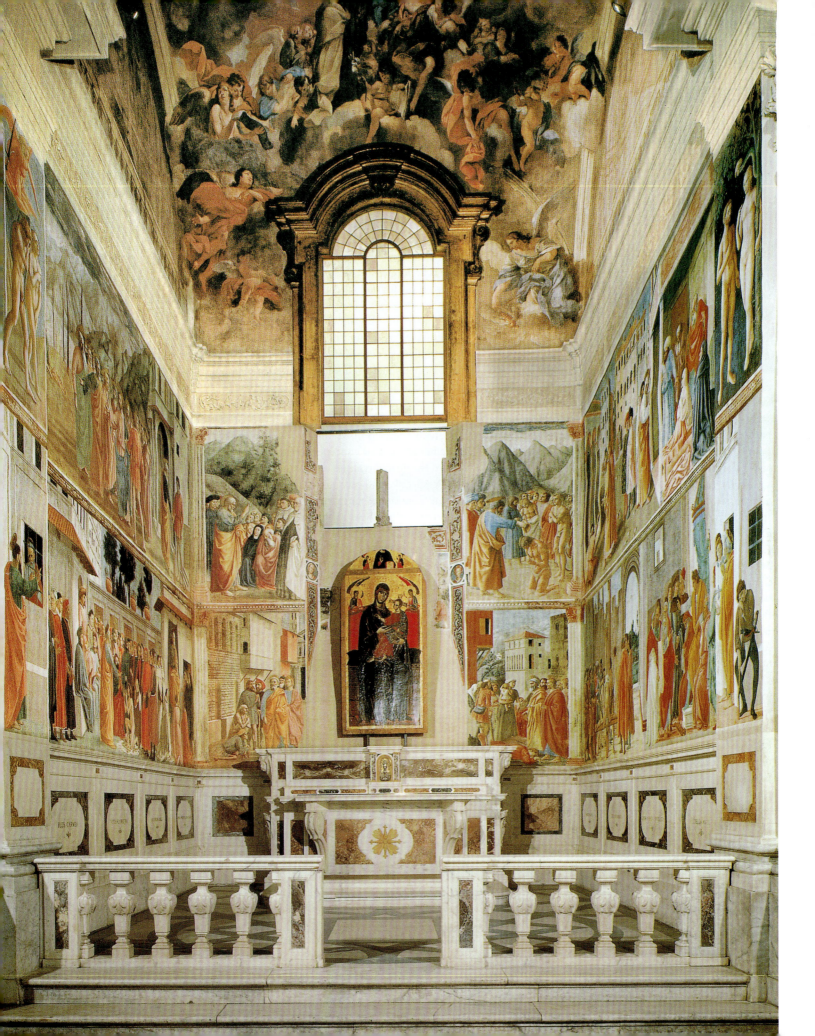

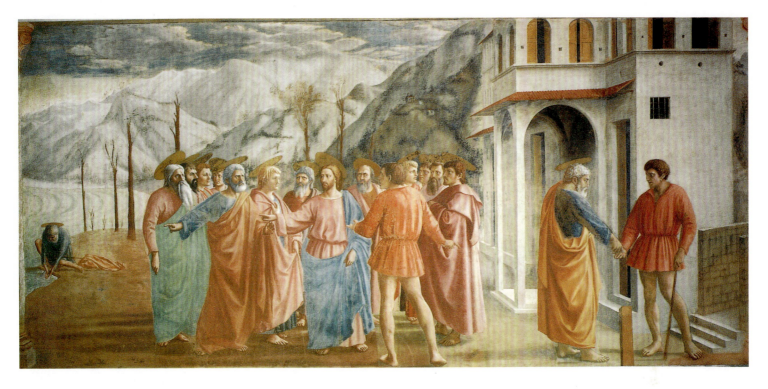

other in the central arch. In front of the building, Rebecca's husband Isaac instructs Esau to go hunting, so that he might serve meat to his father and receive a blessing. In the middle ground to the right of this, Esau's mother Rebecca conspires with Jacob to steal the blessing; he holds the meat that she will prepare for him. The theft itself happens in the same bay of the architecture, but in the foreground, where the blind Isaac blesses Jacob under Rebecca's eyes, essentially making Esau and his descendants the servants of Isaac and his. The use of architecture, scaled figures, and a gridded pavement to position the characters in the scene allows Ghiberti to show events from different chapters of Genesis in a single frame.

Masaccio, Masolino, and the Brancacci Chapel

The examples considered so far might well give the impression that it was the sculptors of Florence who made the most significant pictorial innovations in the first decades of the fifteenth century, and there is some truth to this. Painters, though, responded to what Brunelleschi, Donatello, and Ghiberti were doing as well, and none more impressively than two known as Masaccio (1401–1428) and Masolino (1383–c. 1447) – roughly, "Big Tom" and "Little Tom." The pair worked together in the church of Santa Maria del Carmine, across the river from the center of Florence, in a chapel that had been founded by Piero di Piuvichese Brancacci in 1367 (fig. 4.15). Dedicated to its founder's name saint, Peter, the paintings in the Brancacci Chapel, mostly carried out between 1424 and 1428, show scenes from that saint's life.

The romantic idea of the Renaissance artist as a heroic and solitary individual has led to a centuries-long debate about which of the chapel's scenes, even which of its figures, each of the two artists painted. The close collaboration between Masaccio and Masolino, however, should remind us that works on this scale rarely originated from a single hand. The Brancacci patrons appear first to have hired Masolino, who began painting the vault and made his way downward from there before Masaccio's arrival. The patrons may have brought Masaccio into the huge project when it was clear that Masolino's other obligations would prevent him from finishing the chapel on his own; the two worked together on the upper zone of friezes, and Masaccio painted the lower parts (some of which were modified later by Filippino Lippi) on his own. The arrangement, in any case, seems to have been a happy one all around: the two had worked together elsewhere before coming to Santa Maria del Carmine, and they would collaborate again in Rome a few years later. While they were both on the Carmine scaffolding, they did not simply divide assignments, but contributed to one another's scenes: Masaccio, for example, appears to have painted the hills in the background of Masolino's *St. Peter Preaching*, whereas Masolino painted the hills in the background of Masaccio's *St. Peter Baptizing the Neophytes*, as well as the head of Christ in Masaccio's *The Tribute Money* (fig. 4.16).

The framing of the images divides them into twelve sections, including four long friezes on the side walls. These lent themselves to a lateral disposition of figures, and the painters might simply have lined up their characters as the ancients did on their sarcophagi – Giorgio Vasari later admired what he described as the paintings' effects of "relief," and other elements, too, including various nudes, suggest close study of sculpture.

4.16

Masaccio, *The Tribute Money*, c. 1426–28. Fresco. Brancacci Chapel, Santa Maria del Carmine, Florence

OPPOSITE

4.15

Masaccio and Masolino, Brancacci Chapel, 1426–28. Santa Maria del Carmine, Florence. On the altar is a mid thirteenth-century icon called the Madonna del Popolo that was placed in the chapel in 1436. Filippino Lippi completed the Masaccio and Masolino cycle in 1481–82. The vault was reconstructed and redecorated following a fire in 1771.

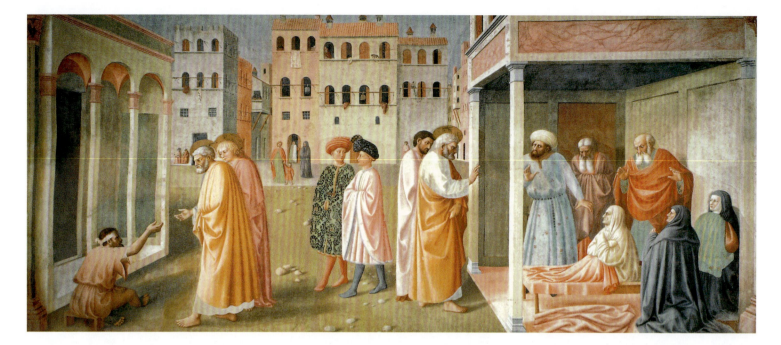

4.17
Masolino (with Masaccio),
The Raising of Tabitha,
c. 1426–28. Fresco.
Brancacci Chapel, Santa
Maria del Carmine,
Florence

Masaccio and Masolino's primary reference points, though, were not ancient so much as contemporary, a fact that becomes evident as they transpose a number of the events they depict from ancient settings to modern Florentine streets. In the main episode Masolino painted in the upper register of the west wall, for example, St. Peter appears twice, once on the left, where he heals a cripple, and again on the right, where he raises a disciple of Christ's named Tabitha from the dead (fig. 4.17). The episode took place in the city now called Jaffa, outside Tel Aviv, yet the buildings that serve as Masolino's backdrop have the tile roofs and chimneys characteristic of Italian domestic architecture in the period. The central characters wear the sort of fashionable robes and headdresses that wealthy merchants would have worn in Masolino's day; in the background, two men sit and chat beside a palace entrance, and a woman takes her child out for a walk. The paintings so capture local life, in fact, that social historians have been tempted to look at them for references to recent events, taking Masaccio's depiction of Peter paying the tribute money, opposite Masolino's *Raising of Tabitha*, as a reference to a controversial Florentine tax instituted in these years. Interpretations along such lines have not held water; the most we can say about the timeliness of the subject matter is that the Carmelites and the Brancacci alike wished to cultivate ties with the papacy in Rome, and that such a desire provided an additional reason to promote the image of St. Peter.

Masaccio's *The Tribute Money* (*see* fig. 4.16) shows a scene from the Book of Matthew in the Gospels, when Jesus tells Peter (a former fisherman) to cast a hook in the sea and open what he caught; there he would find a coin with which to pay the taxes asked of Jesus. Like Masolino on the opposite side of the chapel, Masaccio employs continuous narrative: Masaccio's story in this case pro-

ceeds from the center, where Christ gives instructions, to the left, where Peter retrieves the money from the fish, to the right, where he delivers the tribute to a tax collector. Masaccio refrained from adding much of the incidental detail that Masolino could not resist; in his relative spareness, and in the solidity of his figures, Masaccio may have been consciously modeling his work on the fourteenth-century frescoes by Giotto in Santa Croce across town. Masaccio's mural demonstrates that what these artists sought from their contemporaries, and from tradition, was a sense for how to create a three-dimensional world with a two-dimensional medium. The use of the building and the water in the paintings both to structure the composition and to separate moments in a narrative sequence follows the recent example of Donatello. What impressed early viewers even more, though, was the way Masaccio's figures seemed to *take up* space. All the characters here block the ambient light and cast strong shadows – a fact that becomes unmistakable in the nearby scene of the multitude bringing the sick into the streets in the belief that Peter's shadow will heal them (Acts 5:15).

Vasari, for his part, singled out not the shadows but the draperies, the simple folds of which give surprising volume to the bodies they wrap. Masaccio had realized "that figures who stood on tip-toe, rather than standing firmly with foreshortened feet, lacked all goodness of manner." In casting Masaccio's achievement as one of **foreshortening** – a kind of local perspective, whereby the painter reduced the dimensions of a line or surface to give the impression that they projected toward the viewer – Vasari treats it both as a technical accomplishment and as an advance in understanding. But the fact that Masaccio's depiction of his characters' feet makes it possible to infer how they are positioned relative to one another in space also points to a reconception of the picture more

OPPOSITE

4.18

Masaccio, *Trinity*, 1425–28.
Fresco. Santa Maria
Novella, Florence

generally, as a kind of container in which figures and objects occupy clearly defined places.

Masaccio's *Trinity*

Before he completed work on the Brancacci Chapel in 1428, Masaccio began painting another burial monument (fig. 4.18), this time in the church of Santa Maria Novella, across the river. The exact circumstances of its patronage, like that behind the murals in the Brancacci Chapel in Santa Maria del Carmine, remain uncertain, though a family named Berti may have been involved. What Masaccio created this time, though smaller in scale than his Brancacci paintings, was still monumental, a painting ten feet wide and twenty-two feet high. If, at the Carmine, Masaccio had used architectural settings to structure his scenes, here he turned the painting itself into a kind of architecture, using perspective to create the impression of a fictive chapel set back into the wall, with an altar table before it and a tomb below. On a ledge above and behind the table kneel two donors, representatives of the family that commissioned the painting, and just above and behind them is a Crucifixion, flanked by Mary and St. John the Evangelist. The uppermost zone centers on a medieval arrangement called the "Throne of Grace," which conventionally included a seated God the Father holding between his knees the cross bearing his son, while the Holy Spirit descended from one to the other.

Masaccio departed from the usual formula: he combined the Throne of Grace with a full-scale Crucifixion and had his God the Father stand rather than sit, but the accumulation of subsidiary figures only augments the standard meaning of the motif – God's offer of mercy in times of need. In this case, that mercy manifestly derives from Christ's sacrifice, since blood runs down the cross and out of its space onto the ledge with the donors, approaching the altar table where that same blood would have been made available to the modern celebrant in the form of the Eucharistic wine. In this case, in other words, Masaccio uses perspective not so much to structure a historical scene as to describe a series of relationships. The division of spaces maps a hierarchy of intercessions: close at hand, the donors pray for salvation (and also solicit the prayers of the living); the Virgin, in turn, conveys their prayers to the Trinity; most distantly from us, Christ's sacrifice guarantees humanity's salvation. Unlike the murals in the Brancacci Chapel (and more like Nanni di Banco's and Donatello's marble figures for Orsanmichele; *see* figs. 3.4–3.5), the perspectival construction turns on a point of view that a visitor to the church could actually occupy. Perspective now addresses a viewer. The skeleton at the bottom is not that of a specific body, buried in this

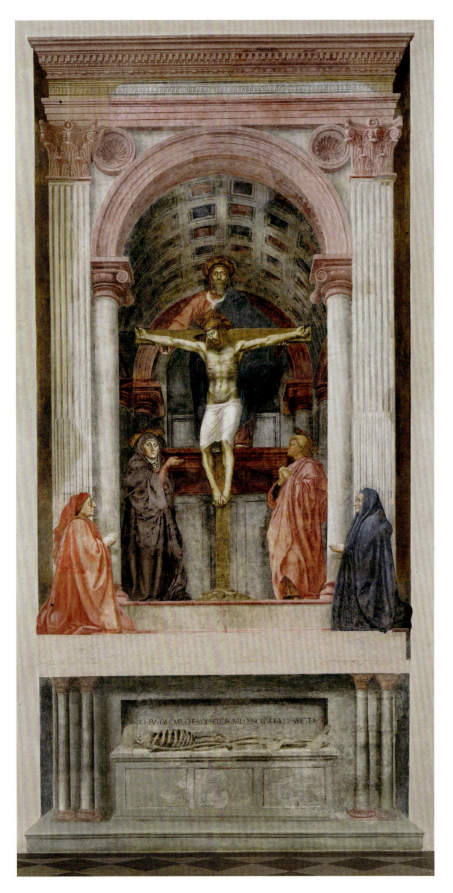

tomb, but an instance of the death that all will face, and thus a reminder of the need to follow the patrons' example and live a life of devotion. The inscription above it reads: "I was once what you are and what I am you will also be."

The Brunelleschian Model and Its Alternatives

To this point, we have been emphasizing the close connection between architecture, sculpture, and painting in the 1420s, looking especially at how the system of perspective united the means and ends of different arts. The constructions inspired by Brunelleschi, though, were a new and in many ways radical approach to picture-making, and it was hardly the case that every artist and patron embraced them without reservation. There were numerous reasons to be skeptical. Although linear perspective was based on optics, it did not capture the actual experience of seeing: it was built on the false premise that we look at the world through a single, unmoving eye, a premise that not only contradicted nature itself but also the very point of public works: simultaneously to address multiple viewers standing in various positions relative to the monument. It could be impractical to work out a rigorous perspective scheme that only looked "correct" from one position. And mural paintings, especially those such as Masaccio's, which had to cover wide surfaces, would result in ugly, distorted forms if they rigorously followed a single perspective scheme.

Nor was it always obvious that the scale of the figures should solely be a factor of their position in space, relative to other figures. In Masaccio's *Trinity* (*see* fig. 4.18), a unifying perspective scheme governs most of the com-

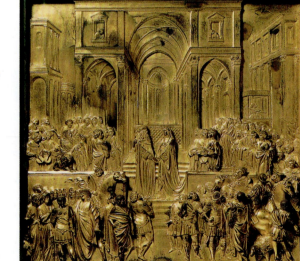

4.19
Lorenzo Ghiberti, *King Solomon and the Queen of Sheba*, panel from the Gates of Paradise, 1425–52. Gilt bronze, 31½ × 31½" (80 × 80 cm). Museo dell'Opera del Duomo, Florence

position, but the painter shifted to a higher point of view when it came time to show Christ on the Cross. In Ghiberti's *King Solomon and the Queen of Sheba* (fig. 4.19), a panel that seems to postdate his *Jacob and Esau*, the two figures at the center of the scene are larger than all the others, larger even than the soldiers in the foreground, who are closer to the viewer. The account of the queen's visit to Solomon in Kings 3:10 centers on the marvel she experienced in the presence of Solomon and his palace; rendering these two characters on a different scale from any of the others, and framing them before the main portal of a structure that resembles Florence Cathedral, conveys their nearly divine status. Comprehending how the attendants to each are positioned in space is important to understanding the scene, but violating the rules of perspective conveys more subtleties about the status of the panel's occupants.

Not all artists in Florence may fully have grasped or embraced the optical principles according to which perspective worked. Masolino, for example, seems to have had a shaky understanding of the system, or limited conviction in it, despite having Masaccio to consult. The close connection between the artists who did take up perspective made that seem a feature of one particular regional manner, the values of which could be questioned by those working in other places. Consider the case of the young painter Antonio Pisano, called "Pisanello" (*c.* 1394–1455), a sometime collaborator of Gentile da Fabriano who worked primarily in Mantua and Verona and also undertook commissions in Rome in the late 1420s. His most important surviving painting of the decade is the mural he added around a tomb commissioned by Francesco Brenzoni for the Veronese church of San Fermo Maggiore (fig. 4.20). Pisanello signed the work in 1425, which suggests his pride in what he had accomplished, and there can be little question that he was aware of the innovations happening to the south: he may have spent time in Florence while Gentile da Fabriano, his sometime artistic partner, was in the city, and on the tomb itself he worked alongside Nanni di Bartolo (*fl.* 1419–51), a Florentine sculptor who had completed commissions for the Florentine duomo and collaborated with Donatello. Pisanello's subject, showing characters interacting within and across an architectural setting, could certainly have taken up Florentine compositional devices, yet the painter evidently had little interest in this.

The central sculptural composition shows **putti** pulling back curtains to reveal the Resurrection of Christ. Pisanello framed this with a painting of the Annunciation, with the angel Gabriel in the upper left and the Virgin in the upper right. Outside this ensemble are additional painted angels and a sculpted prophet, set against a kind of pergola. Gabriel kneels and the Virgin sits; both

4.20
Pisanello, Brenzoni
Monument, 1425. Fresco.
San Fermo Maggiore,
Verona. The sculptures are
by Nanni di Bartolo.

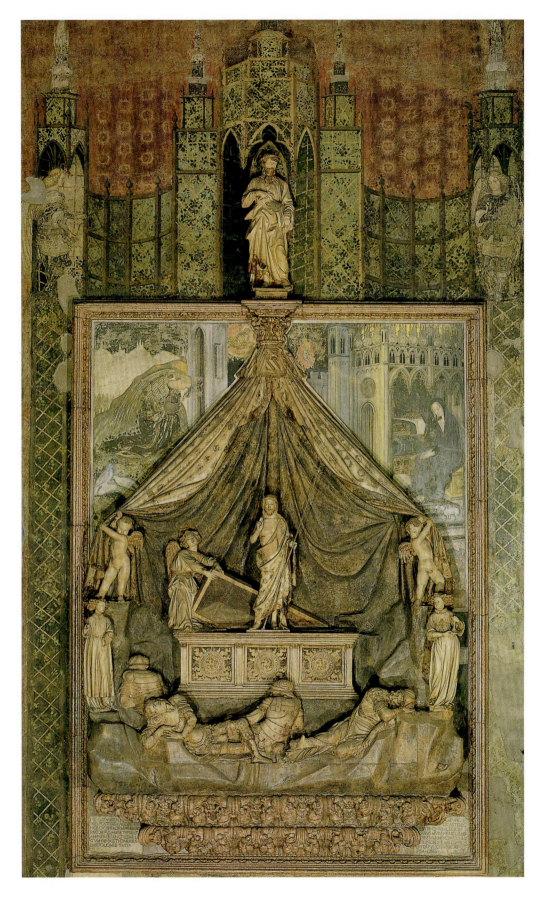

ABOVE

4.21

Sassetta, *St. Thomas Aquinas in Prayer*, panel from the Arte della Lana altarpiece, 1423–26. Tempera and gold on panel, 9¼ × 15⅜" (24 × 39 cm). Szépmüsvészeti Museum, Budapest

BELOW

4.22

Sassetta, *The Vision of St. Thomas Aquinas*, panel from the Arte della Lana altarpiece, 1423–26. Tempera and gold on panel, 9⅞ × 11⅜" (25 × 28.8 cm). Pinacoteca, Vatican

would be too tall for their buildings were they to stand. In this case, there were practical reasons for making the figures so large relative to the buildings: placed high up on the wall, it was important that they be visible, and the constraints of the frame did not leave much flexibility. In addition, the architecture here had to play a more symbolic than organizational role: it needed to designate the Virgin's bedchamber, and it needed to include the window through which the Holy Spirit passed like light – a way of conveying the idea that this woman would become a mother yet remain a virgin – but it did not have to provide different areas in which a complex story could take place. Eschewing the new Florentine manner of picture-making, Pisanello favored a flattening, decorative effect. His patrons obviously appreciated textiles – most of the sculpted monument, too, is given over to a massive polychromed canopy – and it may be that Pisanello aimed to equal a richly woven cloth. As we shall see in the next chapter, Pisanello would take much the same approach to all of his paintings, even those in formats that might lend themselves especially well to perspectival constructions. His difference from Masaccio, a near contemporary, shows the extent to which the experiments Brunelleschi inspired initially remained local ones.

Similarly, in Florence's neighboring city of Siena, artists drew not on the recent Florentine experiments in perspective but on the tradition of rendering space established by Duccio and the Lorenzetti brothers in the previous century. The painter Stefano di Giovanni, now commonly known as Sassetta (1392–1450/51), set narrative scenes in spatial interiors of considerable complexity in the predella of his altarpiece for the chapel of Siena's Wool Guild, a work dismantled and largely lost in the late eighteenth century. In the scenes of *St. Thomas Aquinas in Prayer* (fig. 4.21) and *The Vision of St. Thomas Aquinas* (fig. 4.22), Sassetta gives us glimpses into the inner spaces of a friary. From the chapel, with its gilded polyptych, we can imagine ourselves passing into the **scriptorium** to our right or the cloister garden to the left, or slipping through the foreshortened door in the left foreground. Sassetta achieved this spatial enrichment, however, without resorting to the strict new principles he would have seen demonstrated in Donatello's relief for the Siena baptistery (*see* fig. 4.13); in fact, Sassetta would probably have found the idea of the single vanishing point, with its dominance of the pictorial organization, to be a limitation.

Sassetta's compatriot Giovanni di Paolo (*c.* 1403–1482) went further, and seems even deliberately to have flouted the principles of perspective. His *Entombment* (fig. 4.23), again a predella scene from a now dismembered altarpiece for the Malavolti family in the church of San Domenico, Siena, not only drew on compositional

formulas current since the time of Duccio – the bearing of Christ's body and the gesturing women – but also looked beyond even these to the older tradition of Byzantine painting, from which he adapted the strange, jagged rock formations. Giovanni was an admirer of Gentile da Fabriano, and in particular the way Gentile employed gold to create light effects. Here, against a blaze of striated golden rays, Giovanni hauntingly rendered the shadow of the male figure who bends to lift Christ's body into the tomb. The effect is more to inspire wonder than to describe a natural phenomenon for illusionistic purposes, the way Masaccio did in his *Tribute Money* (*see* fig. 4.16). In the ensuing years, as Sienese painters increasingly registered the impact of Florentine perspective and modeling in light and dark, Giovanni became more willfully individualist, as if trying to mount a Sienese "alternative" to the Florentines. His version of Gentile's *Adoration of the Magi* (fig. 4.24) cancels every gesture toward spatial illusion on the part of the older artist, turning his composition into a decorative linear calligraphy that stresses pictorial surface over the illusion of depth.

ABOVE

4.23

Giovanni di Paolo, *Entombment*, from the Malavolti altarpiece, 1426. Tempera with gold leaf on panel. Walters Art Museum, Baltimore

LEFT

4.24

Giovanni di Paolo, *The Adoration of the Magi*, 1440–45. Tempera and oil on panel, 10⅝ × 9⅛" (27 × 23.2 cm). Cleveland Museum of Art, Cleveland

1430–1440
Practice and Theory

5

1430–1440
Practice and Theory

Painting Panels and Frescoes

The making of such a painting as the *Virgin and Child* by the artist-friar known as Fra Angelico (*c.* 1395–1455) was a laborious and intensively collaborative process (fig. 5.1). The work forms part of a small architectural structure known as a tabernacle, produced for the offices of the Linaiuoli in Florence (whom we have already seen as patrons of Donatello's *St. Mark*; *see* fig. 3.5). In fact, the guild's desire for an object that included a large wooden panel with convex frame and shutters decorated "inside and out with the finest colors," along with a carved marble casing, required separate contracts with the painter Fra Angelico, the sculptor Lorenzo Ghiberti – who assigned the carving to two assistants – and a woodworker known as Il Papero. Such teamwork had creative consequences: the lifesize saints that Fra Angelico painted on the tabernacle doors, with their slender proportions and their crisp, calligraphic draperies, consciously imitate Ghiberti's saints for Orsanmichele (*see* figs. 3.3 and 3.9). Though the sumptuous main panel recalls the work of Gentile da Fabriano in its glowing gold and its simulated silks and brocades, it also aims at the three-dimensionality of sculpture. The solidly modeled Virgin occupies an intelligible volume of space, beneath a starry vault that recedes over her head.

The wooden support for such a painting required many hours of labor even before the painter could lay his hand to the work: boards had to be prepared and joined and layers of ground built up and polished.

With the panel prepared, Fra Angelico would have applied his design in the form of an underdrawing. Most painters preferred charcoal for underdrawing, but this artist's particularly meticulous approach led him to employ pen and ink as well, and he often scored his figures into the *gesso* using a sharp point. With the underdrawing in place, his team would have then treated the areas of the panel that were to be gilded with a red, water-based glue known as **bole**, and then applied very thin squares of gold leaf. To effect the brocades and silks that give this panel its particular splendour, Fra Angelico applied paint over areas of gold. The paint medium is **tempera**: mineral or organic pigments, ground by assis-

tants to a fine powder, mixed with egg yolk. The painter would lay in colors with small, precise strokes, proceeding slowly across the surface. Within a dimly lit church interior the intense tones of the tempera would have glowed like jewels.

Paintings on walls called for a different range of techniques. All the examples we have seen so far, from Ambrogio Lorenzetti's Sala della Pace in Siena (*see*

5.1
Fra Angelico, *Virgin and Child (Linaiuoli Madonna)*, 1433–36. Marble tabernacle, tempera on panel, 9'7" × 9' (2.92 × 2.76 m) (closed). Museo di San Marco, Florence

5.2
Pisanello, *Tournament
Scene, c.* 1439–42. Fresco.
Sala del Pisanello, Palazzo
Ducale, Mantua

fig. 1.41), to Masaccio and Masolino's Brancacci Chapel in Florence (*see* figs. 4.15–4.17), are examples of fresco (literally, "fresh," or "wet"). Here, too, the artist typically started with an underdrawing, but in this case he had to cover that drawing with wet plaster and paint into this with water-based pigments before the surface dried. In fresco painting, the artist's assistants prepared the wall with an *arriccio*, a layer of rough plaster on which the painter applied his design in a red pigment known as *sinopia*. Over this drawing, the painter would spread the *intonaco*, a second, smoother layer of plaster, on which he would apply color in the form of pigments combined with a solution of water and lime. As the plaster dried, the pigments physically bonded with it, resulting in a solid and durable surface. For this to happen, however, the painter had to finish his work while the *intonaco* was still wet ("fresco"), requiring him to decide in advance how much he could get done in a given period and to proceed segment by segment: the joins between the segments typically separate the equivalent area to a day's work, and the sections themselves have thus come to be called *giornate* (singular *giornata*, after the Italian word for day, *giorno*).

If the artist wished to achieve coloristic effects on a wall using egg-based paint, he had to work *a secco*, on top of the dried (*secco*) mural. A damaged but still spectacular series of frescoes (fig. 5.2) painted between 1439 and 1441 by Pisanello in the palace of the Gonzaga rulers of Mantua, showing a scene of jousting with numerous knights in armor, illustrates the uneven durability of the different methods, fresco and *secco*. The parts of the painting that survive (discovered under layers of whitewash in the 1970s) were those painted in true fresco, though their incomplete appearance also makes it clear that they originally depended on *a secco* touches for their impact, and the armor of the knights would additionally have been completed in silver-and-gold leaf applied over the *sinopia*.

The exposed *sinopia* tells us a great deal about the role of drawing in Italian workshops in the early fifteenth century. Pisanello, an accomplished and vigorous draftsman, appears to have planned the com-

ABOVE

5.3

Pisanello, *Tournament Scene*. Detail showing *spolveri*. Fresco. Sala del Pisanello, Palazzo Ducale, Mantua

BELOW

5.4

Pisanello, *sinopia* beneath the removed *Tournament Scene* fresco. Sala del Pisanello, Palazzo Ducale, Mantua

position on the wall itself, generating a battle from a montage of figures; he made them solidly three-dimensional, but arranged them across rather than within the expansive pictorial field. The artist studied some of the more difficult figures independently on paper in advance, including those with limbs or entire bodies extended perpendicular to the picture plane. The convincing rendering of such foreshortened forms was a mark of particular skill that Pisanello proudly displayed throughout his work.

The fresco provides evidence of other uses of drawing. The outlines of the fluttering banners that form a decorative border in the upper zone, for example, are composed of minuscule dots called *spolveri* (figs. 5.3–5.4). Here Pisanello has used a paper pattern known as a **cartoon** (from the Italian word *cartone*, meaning a large sheet of paper or parchment), perforating the lines of the drawing with a stylus, then tapping or rubbing charcoal dust (called "**pounce**," or *spolvero* in Italian) through the holes to leave a dotted outline on the wall. Cartoons had allowed earlier artists to repeat decorative patterns, but painters were beginning to see new potential in them, using cartoons for entire figures and even reversing them to create figures in symmetrical pairs.

The Centrality of *Disegno*

Cennino Cennini

Young artists learned the above techniques through a system of apprenticeship. Boys often began their training at the age of twelve; in family workshops, they would start working and learning even earlier, and daughters as well as sons provided a ready labor force. Yet artists could also turn to practical handbooks on their craft, for example the manual by the Florentine Cennino Cennini (c. 1370–c. 1427), which contains an array of recipes and instructions for the numerous tasks a painter might be called upon to perform (including applying make-up to a woman's face). Cennini encouraged aspiring artists to work under a good master, and thereby learn the fundamentals of the profession: grinding pigments, preparing wood panels, making pens and brushes. Above all, though, he wanted them to draw. It was drawing, or *disegno*, that gave painting its special distinction as something more than a mechanical activity. The apprentice, Cennini wrote, should spend a year copying simple subjects on a panel coated with an erasable surface of ground bone and saliva. From here he could progress to drawing with the pen on parchment or on paper, which would "make you expert, skillful, and capable of much drawing out of your own head." Cennini recommended going out to copy figures from paintings in churches and chapels, stressing the importance of choosing a small number of good examples and learning from them alone. The last stage in one's training as a draftsman was the "triumphal gateway" of copying from nature.

Cennini had died by 1427, but the earliest surviving copies of his handbook are from the 1430s and later, indicating its ongoing usefulness to younger generations. Cennini's pages on drawing cover a wide range of media and of techniques, and they touch on an array of purposes that drawing had acquired in the Italian workshop by the middle decades of the fifteenth century. When draftsmen made drawings on parchment, they tended to produce highly finished works, combining a range of media that could include **silverpoint** (finer than **metalpoint**), pen and ink, black chalk, and watercolor. The shop might preserve these drawings for decades, using them as models for students to copy or as sources of motifs in larger paintings. Only in the 1430s did paper begin to become both more generally available and more affordable than parchment, a factor that would have significant implications for how artists would approach the practice of drawing. Fabriano, the hometown of the painter Gentile, would become the major center of paper production.

Drawing transmitted the principles of art across generations: Cennini saw himself as passing on what he had learned from a century of predecessors, going back to Giotto. The value of continuity encouraged extensive copying; at the same time, Cennini believed that it was through the very reproduction of models that artists began to manifest individual qualities or recognizable styles of their own. Copying involved what Cennini referred to as the *fantasia* (roughly, the "imagination"), the part of the mind in which images formed. His belief that even the most repetitive paintings depended on imagination spurred him to make elevated claims for the dignity and intellectual prestige of the art. Just like poets, he asserted, painters could produce figures that resembled nature or they could deviate from nature entirely, creating fantastic inventions that had no reality outside of the artist's mind. Painting by definition combined imagination and skill of hand, "in order to discover things not seen, hiding themselves under the shadow of natural objects, and to fix them with the hand, presenting to plain sight what does not actually exist." Painters, in his view, created an entirely new reality based on observation of the physical world: from the form of a man and the form of a horse, the painter could produce a synthetic fiction – the form of a centaur. Cennini accepted, but did not feel called upon to explain, the principle that painting involved both a process of reproduction and the projection of an internal image, one that bore characteristics of the artist who had formed it in his mind. By thus associating painting with the liberal art of poetry, Cennini demonstrated his awareness of the intellectual movement now known as humanism; conversely, by the 1430s, some of the key figures in that movement were paying close attention to the theory and practice of painting.

Pisanello and the Humanists

Today, we use the word "**humanists**" to refer to Renaissance scholars of the liberal arts, or *studia humanitatis* (literally, "humane studies," although corresponding roughly with the modern term "humanities"). The liberal arts – that is, arts of the free-born, undertaken for their own sake and not for money – initially comprised a group of fields based in mathematics (geometry, arithmetic, music, and astronomy) and in language (grammar, rhetoric, and logic). They might extend to written practices, such as poetry, history, and moral philosophy, but they did not include the visual arts of painting and sculpture, which traditionally fell into the category of the "mechanical" arts, worthy only of the low-born, and ranked with carpentry, butchering, and so on. The humanists followed a number of professional callings, serving as secretaries, diplomats, notaries, historians, and educators, but all were concerned with the effectiveness

of language in public life. These men modeled their writing on such ancient authors as the Roman philosopher Cicero (106–43 BCE). Many also worried about the accuracy of the texts of ancient authors then available to them, since centuries of transmission in manuscript had led to a proliferation of errors, interpolations, and even outright forgeries. It is through the efforts of humanists who scoured the old monastic libraries of Europe in order to find the oldest and most reliable manuscript versions of ancient poets, orators, and historians that we have those texts today.

By the late Middle Ages, scholars of antiquity had become aware that classical authors, such as the encyclopedist Pliny the Elder (23–79 CE), held the achievement of ancient painters, sculptors, and architects in high esteem. Petrarch, the pioneering poet and humanist whom we saw comparing Simone Martini to Virgil (*see* p. 15), also celebrated the Sienese painter in his annotations to Pliny,

comparing Simone to the ancient painter Apelles, who had been honored by Alexander the Great. Petrarch here laid the groundwork for a reconception of painting as a "liberal" rather than a "manual" art; humanists in Ferrara and Mantua bestowed similar praise on Pisanello.

In his Latin history *Of Famous Men* (*c.* 1450), the humanist Bartolomeo Facio praised Pisanello for his "poet's genius." Pisanello, in fact, received more literary tributes of this kind than any other Italian artist of the early fifteenth century; writers praised his ability to "equal nature's works," both in his copiousness of detail and in his images' astonishing lifelikeness. Such naturalism emerged primarily in the individual motif: the landscape space is largely symbolic, a flat ground on which the figures have been superimposed. As we saw in the last chapter (*see* p. 116), Pisanello certainly knew the principles of perspective; his paintings of the 1430s, however, tended to favor a more inclusive point of view.

5.5

Pisanello, *The Vision of St. Eustace, c.* **1438–41.** Tempera on panel, 21½ × 25¾" (54.8 × 65.5 cm). National Gallery, London

5.6

**Pisanello, Horse and Rider,
study for *Vision of
St. Eustace*, c. 1434–38.**
Pen and ink on red
prepared paper, 7¾ × 10¼"
(19.5 × 26 cm). Musée
du Louvre, Paris

His *Vision of St. Eustace* (fig. 5.5), for example, shows a scene one would never encounter in the real world: the encyclopedic variety of creatures that a woody landscape might contain. Here the painter assembled motifs from his own stock of drawings, or in some cases – such as the hound and the hare –from older model-books by north Italian artists. Yet Pisanello also made new drawings that appear to have been intended specially for this painting, including studies of horses, stags, and birds. Several of these, executed in pen and water-color, sometimes on tinted paper, display a much greater freedom of handling than would be characteristic of a model drawing, and show the artist working out his first thoughts (fig. 5.6). Others show the artist's skill in massing pen strokes to produce what amounts to a relief map of the head of a horse (fig. 5.7). The refined technique and sumptuous effect of the painting – for example, in the gold ornaments of the saint's costume and the *pastiglia* harnesses – indicate that the small panel was a prestige commission, probably made for a nobleman. Its subject, the miraculous apparition of the crucified Christ to the pagan knight Eustace, involved a scene of hunting, the princely sport *par excellence*, and would have appealed to courtly patrons. The variety of animals and the glamorous figure of the rider represent an

5.7

**Pisanello, Head of a Horse,
study for *Vision of
St. Eustace*, c. 1434–42.**
Pen and ink with black
chalk on paper, 10½ × 6¾"
(26.6 × 17.1 cm). Musée du
Louvre, Paris

TOP

5.8

Pisanello, three young men in magnificent dress, signed PISANUS F[ecit], *c.* **1433.** Pen, ink, and wash on parchment, 9¾ × 13¼" (24.8 × 33.8 cm). British Museum, London

ABOVE

5.9

Pisanello, design for a salt cellar in the form of a dragon, *c.***1448.** Pen, ink, and wash over chalk, 7½ × 11⅛" (19.4 × 28.3 cm). Musée du Louvre, Paris

artistic performance, a display of the repertoire at which Pisanello excelled.

We have seen that for his frescoes of an Arthurian tournament (*see* figs. 5.2–5.4), Pisanello decided to study some of the more difficult figures of warriors or horses independently on paper in advance, including those with limbs or entire bodies extended perpendicular to the picture plane. The convincing rendering of such foreshortened forms was a mark of particular skill that Pisanello proudly displayed throughout his work. His facility as a draftsman extended to making designs for production in other media, undoubtedly at the behest of one of the Italian princes he served in the course of an itinerant career between the courts. A highly finished drawing of three young men in magnificent dress, signed PISANUS F[ecit] ("Pisanello made this"), may be a demonstration of his capabilities as a designer of luxury costumes favored by courtly elites (fig. 5.8). A later drawing for a salt cellar (fig. 5.9) shows the kind of extravagant and bizarre banqueting apparatus in precious metal that painter-designers were called upon to produce. In its fantastical character it evokes the power of the artist's mind as a faculty of combination – of the real and the imagined – precisely as Cennini had envisioned it.

Leon Battista Alberti: A Humanist Theory of Painting

Inspired by the artistic achievements of his own day, the author, artist, and architect Leon Battista Alberti (1404–1472) would take the defense of painting's liberal status a good deal further than the humanists who celebrated Pisanello. Alberti came from an elite and politically ambitious Florentine family (*see* p. 57), active as patrons of the arts, that had been sent into exile at the end of the fourteenth century. This provided Alberti himself, who studied at the universities of Bologna and Padua, an opportunity to see first hand what was happening in northern Italy, and to bridge the gap between artistic events in Florence and in such towns as Verona and Mantua. In 1434, following a period of working as a secretary for the Pope in Rome, Alberti returned to Florence, where he was appointed as one of the canons (salaried resident clergy) of Florence Cathedral. One year after his arrival, he wrote a short treatise with the title *On Painting* (1435). The printing press had not yet been invented, so Alberti could not have hoped that his thoughts would find the broad audience at which later writers aimed. After completing the vernacular version of the treatise and dedicating it to Brunelleschi, however, he sent a Latin edition to Pisanello's chief patron in Mantua, Gianfrancesco Gonzaga. Alberti was a scholar, and he would later take up architecture, but when he wrote this treatise he was an amateur artist at

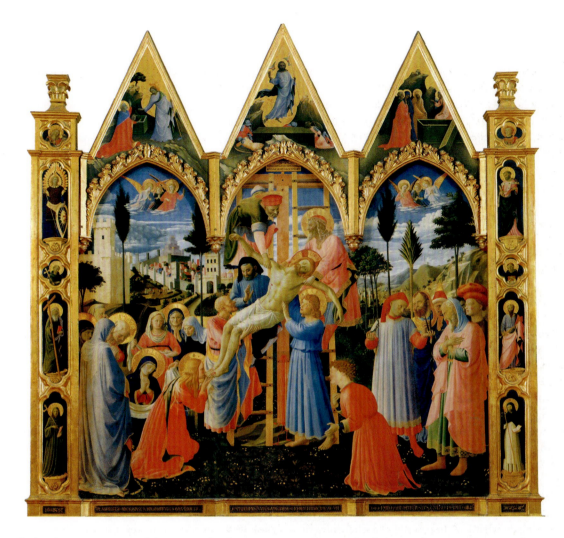

5.10
Fra Angelico, *Deposition
from the Cross*, 1432–34.
Panel painting, 69¼ × 72¾"
(176 × 185 cm). Museum of
San Marco, Florence

best. The book contains none of the practical information about preparing panels and mixing colors that Cennini sought to provide. Nevertheless, *On Painting* reads as a kind of interpretation and codification of what had been happening in Florence in the 1420s, and it offers a valuable account of the innovations we have been looking at.

The first of the treatise's three books lays out the geometry involved in putting together a painting in linear perspective (*see* p. 106), while the remainder of the text has to do with the conception of the painting more generally, and with the nature and education of the artist. While Alberti states more than once that painting is a representation of visible reality, organized on a two-dimensional surface as if seen through a window or a transparent veil, he also conceived painting as an almost literary enterprise. He referred to the work that the artist would make as a *historia*, the Italian for "story" or "history," though Alberti applied it to any image (painting, mosaic, or relief) showing figures in action: as examples, he gave a narrative mosaic, Giotto's *Navicella (Christ Walking on the Waves),* and the non-narrative mythological subject of the Three Graces. The concept, at least as Alberti employs it, has broad application, but his usage seems to follow an older distinction between *imago* – the

static icon for devotional purposes, a type of painting he does not discuss – and *historia*, a painting with a primarily didactic function, usually involving human action and expression. The categories did not need to be mutually exclusive: around the same time that Alberti was writing his book, Fra Angelico completed an altarpiece showing the Deposition of Christ from the Cross (fig. 5.10) for the Florentine banker Palla Strozzi, in which the narrative subject is composed as an iconic devotional theme. Angelico slows down the action, as if it were a solemn ritual, with the body of Christ displayed centrally and frontally, a visualization of the Eucharist celebrated daily on the altar below.

The altarpiece was commissioned to stand near Gentile da Fabriano's *Adoration of the Magi (see* fig. 4.3) in the sacristy of Santa Trinita. The assignment had initially been entrusted to Lorenzo Monaco, who by the time of his death in 1425 had completed only the decoration of the Gothic frame. Like Gentile, Angelico treats the pictorial field as a unified landscape space, but his approach, in keeping with the subject, is far more sober and simplified. He reduces the number of actors, all of them linked in their pious reaction to the central event, and adopts a more consistent arrangement of figures in space. No

longer wearing lavish golden clothes and accessories, the participants are attired simply, and in a severely limited (if still bright) array of hues. The gold ground, similarly, has been replaced by a luminous, airy landscape and a panorama of an imaginary Jerusalem. Alberti advocates very similar principles in *On Painting*: "the artist who seeks dignity above all in his *historia* ought to represent very few figures, for as paucity of words imparts majesty to a prince…so the presence of only the strictly necessary number of bodies confers dignity on a picture." The kind of painting he envisioned would manifest variety in the types of figures it included, but not so as to compromise an overall visual order: this variety should appear in a range of gestures that communicate the subject. The artist should not rely on the superficial appeal of gold.

What Alberti suggested was that the creation of the perspectival space, a space that allowed the interaction of multiple characters, impelled the painter to "stage" certain kinds of scenes. The task of the painter was not to manufacture an object or to reproduce conventionalized images, but to "compose." This cast the artist's work in distinctly literary terms, and at various points Alberti insists that what painters and writers do is closely analogous. Sometimes, the comparison guides his pedagogic views:

> I would have those who begin to learn the art of painting do what I see practiced by teachers of writing. They first teach all the signs of the alphabet separately, and then how to put syllables together, and then whole words. Our students should follow this method with painting.

Alberti's implication was that painting could aspire to be a liberal art, a practice worthy of an educated gentleman. The use of perspective already gave painting a mathematical basis that allowed comparison to arithmetic, geometry, and music, and Alberti treated painting not as a job one did for money, but as a leisure activity, for pleasure. The very art itself, he suggested, originated when Narcissus, a beautiful youth known from Greek and Roman myth, fell in love with his own image reflected in the surface of a pool: a painting, like a poem, represented its creator; its beauty was one that originated from the artist's self, one for which the painter might well feel a strong sense of possession.

It is unlikely that Angelico was guided by Alberti's book: the analogy between his work and *On Painting* arises rather from the common interests of the painter and the writer in the achievements of Masaccio and Brunelleschi. In fact, most artists would not have been able to read Alberti's Latin, and surviving manuscripts of the Italian text are rare. While the apparent aim was to raise the intellectual and social status of painting, Alberti's treatise was remote from the everyday working world of most artists.

Painters throughout the Renaissance were still, on the whole, artisans who relied on their craft to provide an income. The subject of nearly every substantial work they would undertake was dictated by a client, who expected them to execute agreed-upon content in a more or less pre-established style, sometimes following the requirements of a written contract. Much of what they were called upon to produce was precisely the kind of standardized devotional image that was not discussed in *On Painting*; few artists by this time were called upon to create works with the literary or mythological themes that Alberti recommended.

Alberti was indifferent to questions of function or context. While a painter like Angelico might have explored the possibilities of perspective to enable the clear and persuasive presentation of a subject, he did not regard his paintings as neutral surfaces to be "looked through" like windows. Often – as in the case of his *Virgin and Child* (*see* fig. 5.1) – these works were presented in highly material terms, as sacred objects, to be touched or handled as well as viewed. Sometimes Angelico's paintings served as containers for relics, or tabernacles that held holy images.

In sum, the idea of painting promoted in Alberti's book was to a certain degree a fantasy, but it marked a significant development in painting, and characterized the ambitions that many in Italy would cultivate from this point forward.

Paolo Uccello

Another artist in whose work we can observe Alberti's principles of perspective and scene-staging is the Florentine painter Paolo Uccello (1397–1475). Like his north Italian contemporary Pisanello, Uccello also painted a large-scale battle, though the world visualized in his *Battle of San Romano* (fig. 5.11) provides a striking contrast to the scenes in Pisanello's frescoes (*see* fig. 5.2). Uccello depicts a historical battle, a recent Florentine victory over Siena led by the mercenary captain Niccolò da Tolentino (the figure with the prominent red headdress charging at left), although he makes this look no more violent than Pisanello's Arthurian tournament. Uccello's Florentine patrons, like the courtiers who would have admired Pisanello's murals, were enthusiastic readers of chivalric romances, with their ritualized, even bloodless vision of war. They expected Uccello, just as Pisanello's supporters had expected him, to be attentive to the pageantry and decorative potential of his subject matter: *The Battle of*

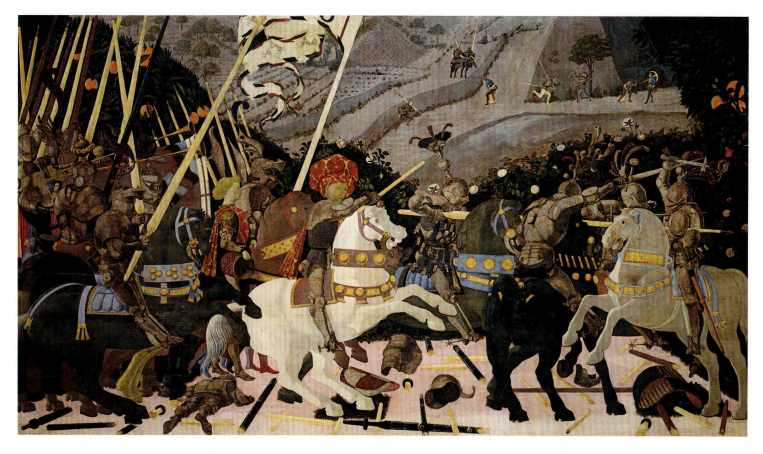

San Romano belonged to a series of three paintings that adorned a private palace. Yet whereas Pisanello organized his battle like a tapestry, spreading it across a large area of wall, Uccello composed his work with regard to the rectangular form of the panel support, emphasizing horizontals and diagonals and attempting to organize everything within a uniform pictorial space.

The engagement takes place in a stage-like space in which scattered weapons and the foreshortened bodies of fallen warriors insist on the underlying rigor of a perspectival grid. Uccello departs from the system only at the center, where he masks the recession of **orthogonal** lines toward a vanishing point with a flowering hedgerow and screen of orange trees, beyond which rolling hills, fields, and warriors observe the much older spatial convention found in Ambrogio Lorenzetti's landscapes (*see* figs. 1.41– 1.44) or Gentile's *Adoration of the Magi* (*see* fig. 4.3). Uccello's figures, already subjected to a kind of bodily abstraction through their armor, have a faceted quality, as if he has attempted to construct them by a process of geometric projection, regularizing the curved forms of nature into a schematic system of planes. Perspective here has little to do with the optical and illusionistic interests of Brunelleschi and Masaccio. Numerical order and geometric commensuration, in this case, transform visible reality more than they simulate it.

Such effects are even more apparent in the extraordinary mural (fig. 5.12) that Uccello painted in the Chiostro Verde ("Green Cloister") of Santa Maria Novella, Florence, part of a series of Old Testament scenes he began in 1431. *The Flood*, probably not completed until 1447, shows the story from Genesis of divine wrath and the salvation of Noah and his family. To the left, figures cling to the side of the ark or battle each other as they try to save themselves from the flood waters. To the right, the ark comes to rest as the waters recede, while crows pluck out the eyes of the drowned victims. Uccello here seems to have conceived of perspective as a visual puzzle or enigma for the observer, even as a vexation for the eyes. Working largely monochromatically in a greenish medium called *terra verde* (whence derives the name of the cloister), Uccello amplified the hard-edged quality of his forms. The diagonal that plunges from just left of top center suggests an orthogonal extending into depth, as though parallel with the ark's enormous base, which runs toward the same point from the lower left; only by inference, comparing the pyramidal form of the ark to the right, can the viewer see that the line is rather one of its sloping sides. Lines seem to converge relentlessly on the vanishing point, which Uccello marks with a bolt of lightning, as if it were a destructive vortex drawing the entire composition into itself. Conspicuously present throughout the picture are

5.11
Paolo Uccello, *The Battle of San Romano, c.* 1436. Tempera and silver foil on poplar, 6' × 10'5¾" (1.82 × 3.2 m). National Gallery, London

5.12
Paolo Uccello, *The Flood*,
c. 1447. Mural, painted in
tempera, later transferred
to canvas, 7'¾" × 16'8¾"
(2.15 × 5.1 m). Chiostro
Verde, Santa Maria
Novella, Florence

5.13
Paolo Uccello, perspective
study of a chalice, 1430–40.
Pen and ink on paper,
11½ × 9½" (29 × 24.1 cm).
Gabinetto Disegni
e Stampe, Uffizi
Gallery, Florence

objects associated with perspective exercises: curved barrels, and complex polygonal *mazzocchi* (wooden frames for headdresses), all of which Uccello must have studied in individual preparatory drawings.

Only a single surviving drawing (fig. 5.13) records Uccello's experiments with complex perspectives. This study of a chalice nevertheless represents another instance of the rapid transformation in the function of drawing in the 1430s and 1440s, as artists increasingly came to think of the medium as a place for experimentation. Uccello was among the first artists to use cartoons not only for intricate and repetitive patterns but also for entire figures. Traces of *spolveri* remain in the earliest of his frescoes for the Green Cloister, indicating that Uccello preferred to finalize particularly challenging poses or foreshortened anatomies on paper rather than sketching their outlines on the plaster.

The main drawback of the cartoon method was that the drawing had to be to the same scale as the figure in the painting, which was cumbersome in the case of large murals. When he came to his next large fresco assignment, consequently, Uccello devised a process of transferring his designs from drawing to painting by means of a squared grid (again using the principle of commensuration). In 1436, the *signoria* of Florence had commissioned him to paint a monumental fresco (fig. 5.14) for the newly completed cathedral, in time for its consecration by Pope Eugenius IV the same year. The commission revived a project, abandoned several decades before, to turn the cathedral into a kind of Pantheon of heroes who had served the Florentine Republic. The

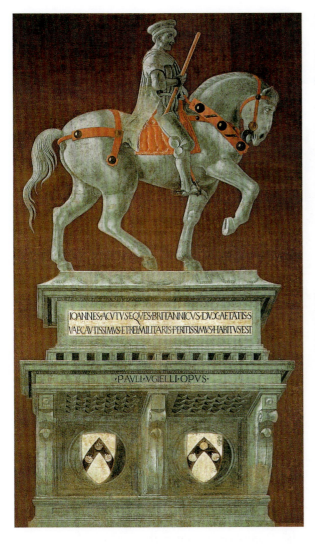

5.15
Paolo Uccello, study for
the equestrian monument
to Sir John Hawkwood,
c. 1436. Greenish wash
with white highlights
on prepared paper,
17¾ × 12⅝" (45 × 32 cm).
Gabinetto Disegni
e Stampe, Uffizi
Gallery, Florence

5.14
Paolo Uccello, *Sir John
Hawkwood*, 1436.
Fresco transferred to
canvas, 26'10" × 16'10"
(8.5 × 5.15 m).
Florence Cathedral

man Uccello honored was the fourteenth-century Eng-lish mercenary captain Sir John Hawkwood (1320–1394), whom the state had promised long before to commem-orate in the duomo, initially with a marble equestrian statue, "as much for the magnificence of the commune of Florence as for the honor and perpetual fame of the said lord John." Within a year of his death, the Republic decided to order a painted memorial instead and selected painters, though it did not immediately move forward even with this. Uccello's reputation as a perspectivist may have secured him the revived commission, though he also painted a clockface and designed stained-glass windows for the building.

Before beginning to paint this work, the artist made a detailed silverpoint drawing (fig. 5.15), which he divided into squares; he then copied the drawing square by square into a much larger grid ruled onto the cathe-dral wall. The logic of the square pervades the whole design – the base and the horse can each be circum-scribed by a square of equal dimensions, and the horse's rear right hoof touches the mid-point of one of its sides. The drawing enabled the artist to resolve in advance the demanding perspective of the base, which he projected as if seen by a beholder standing below (the fresco, detached in 1842, would originally have been much higher on the wall). The vanishing point thus falls below the lower edge of the border, creating a "worm's eye", or *sotto in su* (literally, "from below, looking up"), perspective. Much as Masaccio had done with the figure of Christ in his *Trinity* (*see* fig. 4.18), however, Uccello shifted the per-spective for the horse and rider, depicting them as if seen by an observer standing on the same level. He more than likely realized that if he used the same point of view as for the base, he would show a heavily foreshortened figure of Hawkwood and a great deal of the horse's underside. For reasons unknown, a first version of the fresco, completed in 1436, failed to satisfy the *signoria* and had to be entirely repainted. Could this be because a too rigorous applica-tion of perspective resulted in a less than flattering image of the commander?

CONDOTTIERI

The most powerful Italian states – Milan, Florence, Venice, Naples, and the Holy See – did not allow their citizens to bear arms. From the late 1200s, governments waged war by hiring mercenary companies led by captains known as **condottieri** (from the word *condotta*, the term for an assignment given to one of these warlords). Most were soldiers of non-noble origin, some were landless sons of nobles, and one or two were renegade friars; in the 1400s the princely rulers of smaller territories – Urbino, Rimini, Ferrara, and Mantua – all signed *condotte* with the more powerful states. *Condottieri* were regarded with fear and suspicion. Some, like Cangrande della Scala in 1311 and Francesco Sforza in 1450, staged coups against their employers and established dynastic rule over former republics. Others, like Sigismondo Malatesta of Rimini, became notorious for breaking faith with successive employers. The armies of Niccolò Piccinino (1386–1444) and John Hawkwood were known for lawlessness and rapacity during periods when they were not employed.

Equestrian monuments in the tradition of those made for the Della Scala in Verona (*see* figs. 1.38 and 1.39) became the most characteristic form associated with the warlords. Although some princely *condottieri* commissioned equestrian statues of themselves or their fathers – the Este of Ferrara in 1450 and 1499, the Sforza of Milan (employing Leonardo da Vinci for the purpose) – the most prominent of these memorials were erected (or painted) in the Republican territory of Venice and Florence, the cities that had engaged their services. Given the association of the form with despotic rulers and usurpers, this might seem surprising. Yet placed on the walls of the cathedral, Uccello's painted monument to John Hawkwood (*see* fig. 5.14) and Andrea del Castagno's pendant for Niccolò da Tolentino look less like glorifications of the individual than heroic masculine symbols of the Republic itself, the forces of violence contained and put to productive use.

Several fifteenth-century *condottieri* are noted for their patronage of art and learning. Some of them may have responded to the widely shared belief, articulated by the new humanist philosophers no less than the older poets of chivalry, that military achievement represented only one kind of virtue, and needed to be balanced with cultivation. Others, recognizing that the commercial

5.16
Giovan Antonio Amadeo, Colleoni Chapel, Bergamo, 1472–75. Interior, showing the tomb of Bartolomeo Colleoni

interests that drove their profession also undermined its respectability, saw art as a way of restoring their honor. Some, especially with age, may simply have found the life associated with the palace more comfortable than that of the field. All, having achieved fame in their time, wished to leave some lasting memorial to themselves.

Bartolomeo Colleoni (*see* fig. 10.23) is an example of how innovative *condottiere* patronage strategies could be, especially in the case of warriors aspiring to princely authority. Colleoni ruled only a small fiefdom, but assembled a refined court at his castle of Malpaga in Lombardy and commissioned works on a princely scale. His spectacular funerary chapel in nearby Bergamo, richly polychromed and built to a centralized design by Giovanni Antonio Amadeo in 1472–75, stood on property seized from a local confraternity. The exterior, with its imperial busts and despoiled marbles, suggests the cultivation of an antiquarian sensibility, even as it strikes a belligerent tone. The interior is dominated by the general's highly distinctive tomb (fig. 5.16): an equestrian statue of Colleoni in gilded wood surmounts a marble sarcophagus with reliefs of the life of Christ, the whole enclosed in a triumphal arch with roundels based on Roman imperial coins.

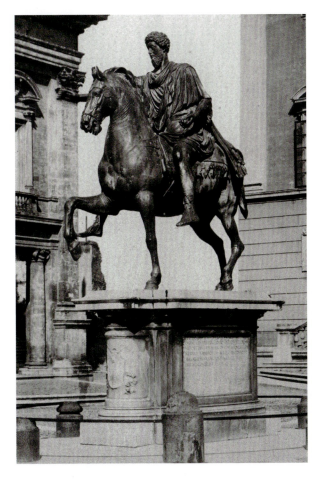

FAR LEFT

5.17
Equestrian monument
of Marcus Aurelius,
161–180 CE.
Campidoglio, Rome

LEFT

5.18 and 5.19
Pisanello, *John VIII
Palaiologus, Emperor of
Constantinople*, obverse
(top) and reverse (bottom),
1438–39. Cast bronze,
diameter 4" (10.3 cm).
British Museum, London

Inventing Antiquity

An Emperor in Italy

Uccello's work is important not only because it applied strict geometry to the making of a painted surrogate for sculpture, but also because it explicitly revived a classical sculptural type associated with empire and domination: the equestrian monument, best typified by the sculpture of the emperor Marcus Aurelius (fig. 5.17), then at the Lateran Palace in Rome and widely regarded as a portrait of Constantine, the first Christian emperor. The classical character of Uccello's fresco is underscored by the inscription in elegant humanist Latin, praising the commander for his military skill and for his great caution. The mural was just one of the influential adaptations of ancient forms to modern artistic and political ends to occur in the 1430s.

In 1438, a great council of the Western and Eastern Christian Churches convened at Ferrara, then transferred after several months to Florence. The aim of the council was to reconcile the theological and administrative rifts that had long split Christianity into two observances, one centered on the papacy in Rome, the other on the Orthodox Church in Constantinople. The council's sponsors included not only Pope Eugenius IV and the Holy Roman Emperor Sigismund but also the Byzantine Emperor John VIII Palaiologos, who attended the council in person with seven hundred members of his entourage. The presence of the Byzantine emperor, a near-legendary figure who belonged to an imperial succession that went back to the ancient Caesars, caused a sensation. Among the retinues of the Italian princes who went to pay court to Palaiologos was Pisanello, who made rapid on-site pen studies of the Byzantines, their exotic weapons and their costumes. He also made a detailed portrait drawing of John himself, which became the basis for the first Renaissance portrait medal (figs. 5.18–5.19).

Here Pisanello adapted the numismatic images of Roman and Hellenistic rulers to create a cast-bronze likeness, which survives in multiple versions and which circulated widely in the form of diplomatic gifts or as collectable objects. (Italian princes rapidly followed suit in commissioning medals of their own.) On one side (*see* fig. 5.18), the medal bears the profile of the emperor with an inscription in Latin and Greek, "John Palaiologos, King and Emperor of the Romans." The reverse (*see* fig. 5.19) presents a composition very similar to the

5.20

Pisanello, studies from a
sarcophagus of Jason and
Medea, *c.* 1431–32. Pen and
ink and brown wash over
metalpoint on parchment,
8⅜ × 6⅛" (21.2 × 15.6 cm).
Museum Boymans van
Beuningen, Rotterdam

5.21

Pisanello, *Nude Woman,
the Annunciation, c.* 1430?
Pen and ink on parchment,
8⅜ × 6½" (21.1 × 16.5 cm).
Museum Boymans van
Beuningen, Rotterdam

artist's *St. Eustace* panel (*see* fig. 5.5): the emperor, shown hunting or possibly as a pilgrim, pauses to make a sign of reverence before a cross. The image presents John as the pious defender of Church unity, all the more so since the equestrian portrait made reference to the statue believed to be of Constantine (*see* fig. 5.17), who had presided over a consolidated Christian realm.

Drawing was the means by which ancient art entered the repertoire of the fifteenth-century artist, who used it to transpose and adapt older forms. Pisanello's surviving drawings show numerous motifs copied or freely adapted from ancient relief sculpture. An aspect of ancient art that particularly appealed to him was its depiction of the human figure in motion. If in the Trecento Nicola Pisano and his followers (*see* chapter 1, p. 24) paid particular attention to posed figures, Pisanello and his contemporaries looked more at

the dynamic movement on a mythological sarcophagus (fig. 5.20). By 1440, correspondingly, the representation of the moving body, nude or with clinging drapery, had become the quintessential sign of an artistic allegiance to antiquity. A group of remarkable drawings by Pisanello of a dancing woman (fig. 5.21), *c.* 1430, rendered on the same parchment sheet as a modelbook Annunciation, shows that he was looking at an actual nude model rather than a sculpture: nothing from antiquity showed such a depiction of sequential acts. Her fluid, graceful gestures, and the tumbling hair she unbinds, however, all suggest an attempt to evoke the most distinguishing characteristics of the body in ancient art – its dynamism. When Pisanello turned to the art of his own time, and drew from reliefs of putti by Donatello, he probably regarded them as works that possessed the very virtues that he admired in ancient art.

The *cantorie* of Donatello and Luca della Robbia

Donatello himself explored the theme of the dancing figure in a major commission from the 1430s: the *cantoria* (fig. 5.22), or singing gallery, that he produced for Florence Cathedral from 1433 to 1438. The gallery was one of a pair that supported the musicians and singers indispensable to the ceremonial life of the cathedral, where the Mass and other liturgies would have been sung (we have already referred to Guillaume Dufay's motet

5.22
Donatello, *Cantoria*,
1433–38. Marble and
mosaic, length 18'8"
(5.7 m). Museo dell'Opera
del Duomo, Florence

5.23
Luca della Robbia,
Cantoria, 1431/32–38.
Marble, length 18'4"
(5.6 m). Museo dell'Opera
del Duomo, Florence

performed at the consecration in 1436, an instance of the duomo's flourishing musical life). Donatello's singing gallery seems to have housed a small organ as well as singers: the main organ was located in the other *cantoria* already commissioned in 1431 from Luca della Robbia (1400–1482; fig. 5.23). Both commissions sought to enhance the fame and prestige of their chief religious center by promoting the best of Florentine art and music.

Thus Donatello's *Cantoria* participates in a dialogue with ancient relief sculpture as well as with the work of a Florentine contemporary. Luca's gallery had drawn heavily on the principles of Brunelleschi's architectural design. Paired Corinthian pilasters provide a supporting frame for six square reliefs, while four more appear between the consoles beneath. Each panel depicts a throng of boy musicians and others who sing and dance, illustrating the verses from Psalm 150 that appear inscribed in the frieze: "... Praise [God] with the sound of the trumpet; praise him with the psaltery and harp. Praise him with the timbrel and dance: praise him with stringed instruments and organs. Praise him upon the loud cymbals; praise him upon the high-sounding cymbals." Luca has composed his figure groups in harmony with the architectural forms. The tallest children in each relief wear gowns that fall in long straight folds, echoing the fluting in the pilasters even as they sway gently to the music. Yet while the architecture determines the orderly form of the composition, the words of the psalm – which call for God to be worshiped with movement and sound – enabled Luca to introduce several smaller infants, some naked and some grinning, who leap and kick their legs with an abandon that is entirely uncharacteristic of earlier Christian art. Luca probably looked at the same kind of sarcophagus that Pisanello drew (*see* fig. 5.20), transposing the figures from a pagan to a Christian context. Ancient relief has become the vehicle through which Luca explores the bodily motion and emotion produced by music.

Donatello echoes the format and the content of Luca's relief, but produces something different in every respect. Conspicuously avoiding the architectural vocabulary both of Brunelleschi and Luca here, he instead employs a bold ornamentation with shells and bizarre faces as well as vase and **acanthus** patterns, covering most of the surfaces with an inlay of tiny colored stone roundels. It is almost as if Donatello were trying to produce a sculptural equivalent for the musical **polyphony** newly in vogue at the cathedral, in which voices simultaneously sang material with overlaid texts and rhythms, sometimes even incorporating profane song. Unlike Luca's reliefs, moreover, Donatello's do not read as a series of square "pictures" framed by columns. The architectural order now forms a screen behind which a tumultuous crowd of dancers move freely along the length of the structure – in fact, they dance in a circle, the figures in lower relief set back further in space. The infant dancers, more riotous and uncouth, the laughter of some more reminiscent of snarls and grimaces, defy containment. And who are these figures? Rather than depicting angels, it appears that Donatello has sought to portray the little spirits (*spiritelli*) that the Greek philosopher Aristotle (384–322 BCE) and his later commentators believed to

inhabit the air, demons whose motions are stirred up by music. They literally embody the disturbances of the air brought about through sound, movement that excites a response from listeners.

Jacopo Bellini and the Transformation of the Modelbook

The drawings of Uccello and Pisanello may have been treasured by their heirs, even admired in themselves, but they always served the ends of painting. It is by no means certain, however, that we can say this about those painters' great Venetian contemporary Jacopo Bellini (*c.* 1395–*c.* 1471), who between about 1430 and his death produced a body of remarkable drawings preserved in two books. He executed the earlier of the two, now in the Louvre, Paris, in **leadpoint** on parchment, with the outlines reworked in pen; for the second book, now in the British Museum, London, he worked in leadpoint on paper. Bellini probably began the volumes as modelbooks, a store of stock designs for flowers, drapery, and architectural ornament, as well as versions of such common **iconographic** themes as the Virgin and Child. In addition, he recorded inscriptions and epitaphs from Roman tombs in the Veneto, sometimes framing them with an entirely invented classical architecture. Then, at a certain point, Bellini began to embellish his pattern-like renderings of familiar sacred subjects. On one page of the Louvre drawing book (fig. 5.24), for example, he took up the theme of the Man of Sorrows, a common devotional subject at the time. Conventional renderings of the theme centered on a dead Christ in an upright position, sometimes in a tomb and supported by lamenting angels, but Jacopo framed the iconic group with a gathering of the mourners, including the Virgin, Mary Magdalene (a penitent prostitute who became one of Christ's most devoted followers), and Joseph of Arimathea (a disciple who gave Christ his own tomb); these three conventionally appear only in treatments of Christ's Entombment, a more narrative scene involving the carrying of Christ to his place of burial. Bellini further elaborated the subject by extending it onto the facing page and adding a rocky landscape with the three crosses. The drawing thus spread into something that exceeded its function as a pattern or source for a painting, since no painter would have treated this or any Biblical subject in such a radically asymmetrical manner.

Bellini went on to invent dozens more original compositions, their format determined entirely by the expanses of the drawing surface rather than by the convention of painting. On many occasions a landscape or architectural setting dwarfs the narrative subject; else-

5.24

Jacopo Bellini,

Lamentation/Entombment.

Metalpoint with pen and

ink on parchment,

15⅜ × 11½" (39 × 29 cm).

Musée du Louvre, Paris:

Département des Arts

Graphiques, RF 1521 67–68

where the imaginary architecture itself becomes the subject. Only when we explore the courtyards and porticos of these complex architectural spaces do we recognize that something more is happening than we first expected: we stumble upon the flagellation of Christ, or the Feast of Herod (fig. 5.25), hidden in the grandiose buildings.

As an apprentice to Gentile da Fabriano, Jacopo Bellini had been to Florence in the 1420s (there is a record of his arrest in that city following a street fight), and he could have become acquainted with the principles of Brunelleschi's perspective at first hand. Yet in the drawing books, he uses perspective as no Florentine artist would, generating entirely original kinds of composition characterized by spatial complexity and the priority of the architectural environment over the events taking place within it. Perspective here creates a new mode of relation between the beholder and the subject: the religious subject no longer engages primarily with the viewer through its familiarity or emotional drama, but by its objective presentation as one visual fact among others in a complete virtual world. In this respect Bellini bears out Cennini's claim that artists do not simply copy reality, but remake it through an imaginative process aptly compared to poetry.

Jacopo Bellini's two books also suggest the centrality of drawing in the practice of architecture, which is especially significant in the absence of surviving examples of working architectural drawings from before the late fifteenth century. Bellini seems never to have built anything himself, but he demonstrates a thorough command of the principles of architectural design. Buildings of all kinds, and the elaborate urban environments they create, are as important as narrative compositions in demonstrating his powers of *fantasia*. Mostly, Bellini invents a kind of avant-garde architecture of the imagination; he incorporates in his drawings colossal reworkings of antique ruins from the Veneto, and embellishes the facades of his buildings with carvings of nude gods and heroes adapted from classical reliefs and from coins. Some of the buildings in

5.25

Jacopo Bellini, *Feast of Herod.* Metalpoint with pen and ink on parchment, 15⅜ × 11½" (39 × 29 cm). Musée du Louvre, Paris: Département des Arts Graphiques, RF 1484 13, drawing book 16v. 17

his drawings, however, do evoke the city of Venice, with ornate **Gothic** pinnacles, tracery, and pointed arches, Byzantine domes and arcades, and touches of the new Florentine architecture of Brunelleschi.

More significantly, Bellini's interests in many ways align with the actual practice of architecture in the Venice of his day. Brunelleschi in Florence had worked largely within a local idiom: his knowledge of the architecture of antiquity derived mainly from medieval Tuscan buildings, such as the baptistery, which itself drew on classical forms. Venice, however, was a cosmopolitan artistic culture; just as its basilica of San Marco displayed precious colored stones and architectural spoils imported or looted from throughout the Mediterranean world, so too did the architectural language of public buildings like the adjacent Doge's Palace combine elements of north Italian Gothic (the loggia and tabernacles) with Arabic architecture (the pointed **crenellations** at roof level and the patterns of colored tile; fig. 5.26). Venice was thus symbolically situated as a "center" between the Mediterranean sea and the European mainland.

The exterior of the Doge's Palace was nearing completion by the 1430s, and one of the last sections to be designed was the so-called Porta della Carta (Gate of the Charter), commissioned from Giovanni Bon (1355–1443) and his son Bartolomeo Bon (1421–1464) in 1438 (fig. 5.27). The contract required the sculptor-architects to follow a detailed drawing, now lost, which specified the inclusion of a figure of Justice and another of St. Mark "in the form of a lion," along with nude infants and foliate ornament. As was the case with Jacopo della Quercia's Fonte Gaia in Siena (*see* figs. 2.26–2.27), however, the contract drawing provided only a starting point for greater elaboration, revisions that probably required the preparation of new drawings. As constructed, consequently, the Porta della Carta included significant elements not named in the original contract, among them four additional figures of Virtues in the **jambs** and a lifesize portrait of the reigning Doge, Francesco Foscari (1373–1457), kneeling before the Lion of St. Mark. The florid Gothic of the pinnacles and the gable on which Justice sits enthroned feature Cupid-like infants – intruders from classical art – who bear shields or clamber through the curly acanthus. Two angels, meanwhile, bear a *tondo*, with yet another image of Mark, the city's patron saint, this time in the form of a portrait. The impressive ensemble shows little overall concern with commensuration, although a consistent proportional system guided the design of the tracery and the framing jambs with pinnacles. It was the reliance on drawing – from patterns for individual sections of tracery to more comprehensive designs governing the overall appearance of the Porta – that would have guaranteed the coordination of the overall project, the relation of the parts to the whole.

5.26
The Doge's Palace, Venice, from the Grand Canal

5.27
Giovanni and Bartolomeo Bon, Porta della Carta, Doge's Palace, Venice, 1438–42. Red and white marble and Istrian stone

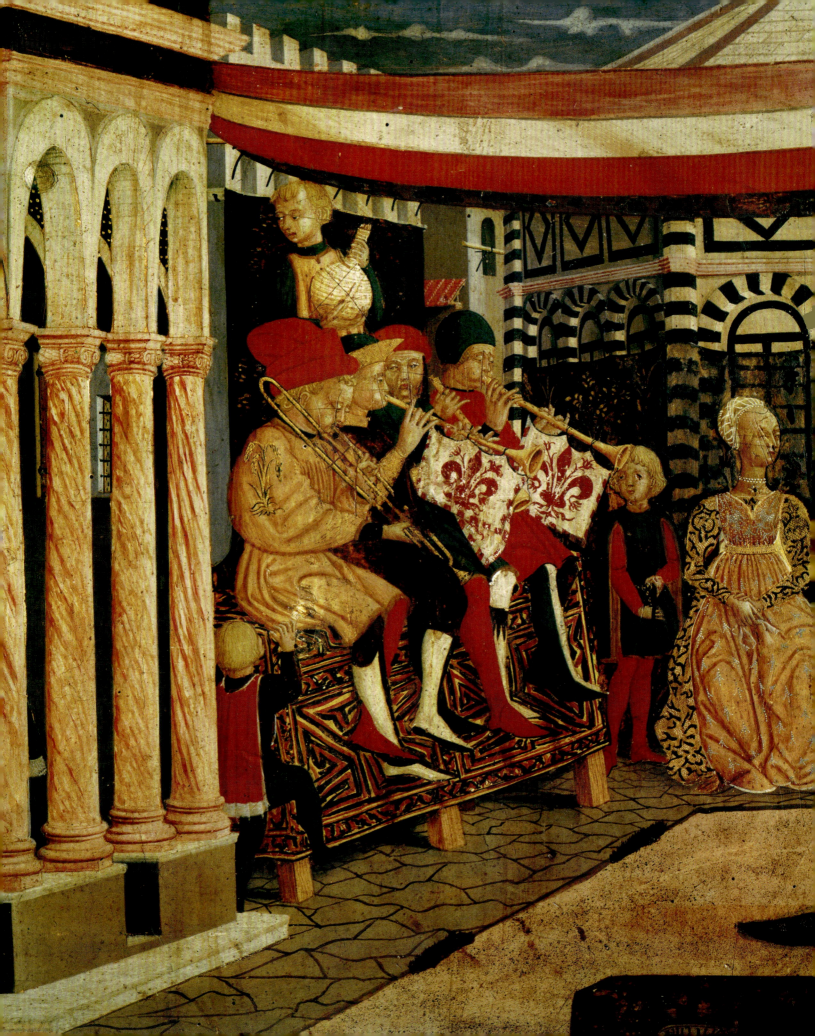

1440–1450
Palace and Church

The Sacred and the Profane

"Painters...are to be reprimanded when they paint things contrary to the faith," wrote the Dominican friar Antonino Pierozzi (1389–1459) in his theological textbook known as the *Summa theologica*. Fra Antonino, who became archbishop of Florence in 1446, had strong views about the spiritual purpose of art and was highly critical of many tendencies in the art of his time: "[painters] commit an offense," he wrote, "when they create images provoking desire, not through beauty, but through their poses, as of naked women and the like." He further objected to what he called "curiosities," things that incited laughter rather than devotion, giving as examples monkeys, dogs chasing hares, and "vain adornments of clothing." Reading such remarks, it is hard not to think of the opulent works of Pisanello, probably the most fashionable artist of the era, or of Gentile da Fabriano, who had an avid following in Florence. Such painters, in the eyes of a viewer like the archbishop, had crossed a line when they embellished Christian subjects with "curiosities" – gorgeous ornaments and eye-catching details – or demonstrated their skill in the rendering of figures and animals, and the simulation of costly fabrics. If these artists appeared to be going astray them-

6.1

Aerial view of San Lorenzo, Florence. The Medici Palace is just outside the frame at lower right.

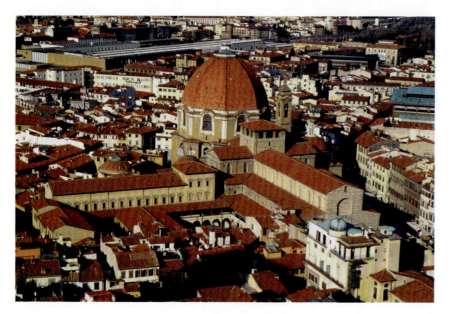

selves, then they were likely to lead their viewers to think of worldly pleasures rather than enable them to pray or meditate.

Most painters working around mid century, like the wealthy lay people who paid for their works, would have been surprised by such a reaction from their archbishop. For them, the embellishment of a religious painting with all the trappings of aristocratic display, the evocation of civilized manners and tastes, served the same ends as the use of such expensive materials as gold or ultramarine: the purpose was to show honor to the depicted holy figures and to secure honor for the families of the clients who paid for the work. If a lavishly decorated private chapel proclaimed the status of a Cosimo de' Medici or a Palla Strozzi (*see* p. 104), such men were only fulfilling their duties to their family and city. They would hardly have distinguished such a motive from the more recognizably spiritual ones of expiating sins through charitable giving to churches and convents, or of reminding generations who came after them to pray for their souls.

Fifteenth-century Europeans would have accepted that there was, in general, a difference between the domain of the sacred on the one hand and the secular, or "profane," on the other. The distinction was basic to civic as well as to private life: certain times, and certain spaces, were set aside for God, the immortal and the eternal. Yet in lived experience the sacred and the profane overlapped to such an extent as to be indistinguishable. Even lay people measured time through regular moments of daily prayer (the most common form of prayer book is known as a "Book of Hours") and the Church's recurring annual feast days. In Florence, priests and friars participated in the political process, as overseers who ensured the fair casting and counting of votes. The cathedral of Florence was the center of religious life, but as in several other Italian cities, it was administered by a secular bureaucracy appointed by the Florentine government, and it served as a principal space for civic ceremony.

Donatello's Doors for San Lorenzo

When in 1442 Cosimo de' Medici assumed responsibility for the rebuilding of Florence's basilica of San Lorenzo (fig. 6.1), he increased his influence over the religious life

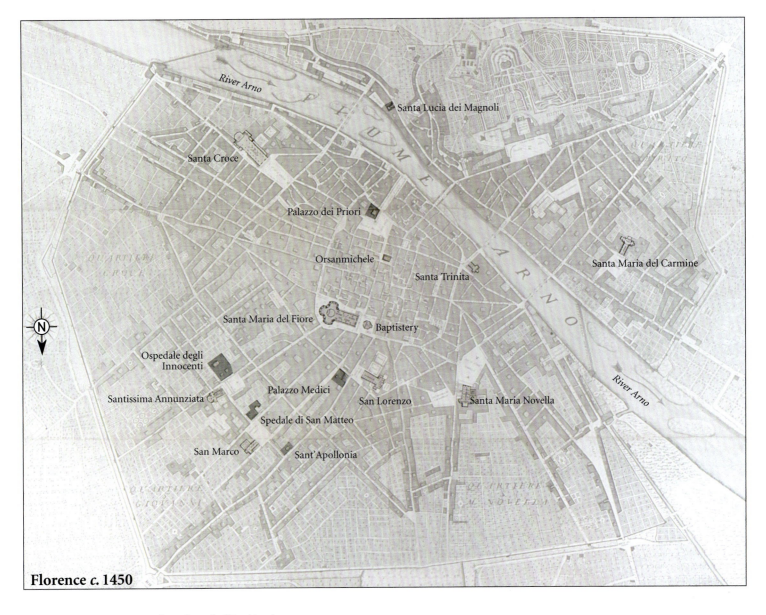

Florence *c.* 1450

This map, based on an engraving (here ghosted) of Zocchi and
Magnelli's map of 1783, highlights some of the major sites of early
Renaissance artistic activity in Florence.

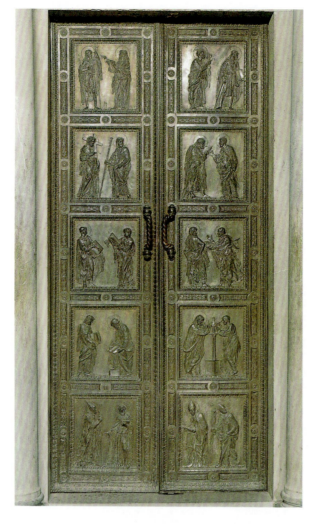

6.2

Donatello, doors to the right of the altar with figures of Apostles and the Doctors of the Church, 1440–43. Bronze, 7'8½" × 3'7" (2.35 × 1.09 m). Old Sacristy, San Lorenzo, Florence

figures gripped by an evangelical fervor or intellectual combativeness that registers in their faces and bodily gestures as they brandish books, martyrs' palms, and other attributes. St. Peter jabs his finger at a haggard St. Paul, who starts back in astonishment or defiance; other saints more difficult to identify write urgently in books balanced on their knees or raised on lecterns. By conceiving theological authority as a set of disputes or acts of inspired writing, Donatello avoided monotony and created a constantly varying choreography of moving figures. Yet not everyone, as we shall see, thought that Donatello's conception of the saints and martyrs was appropriate.

San Marco

In addition to San Lorenzo, the most significant institutional beneficiary of Medici largesse was the convent of San Marco. Since 1417 the convent had been the focus of lavish public celebrations of the Feast of the Epiphany, when a confraternity based there re-enacted the journey of the Magi with a great procession through the Florentine streets. Several Medici belonged to this confraternity and participated in the festival. In 1436 Cosimo sponsored the transfer from Fiesole, a small town just outside the city, to San Marco of a community of **Observant** Dominican friars. The Observants followed a stricter version of the Dominican rule than the "**Conventual**" Dominicans at Santa Maria Novella, and their piety made them especially attractive intercessors for a rich donor anxious about his salvation. Cosimo used his influence with the Pope to secure the eviction of the religious Order previously occupying the site. He undertook the entire expense of rebuilding and redecorating the convent, as well the costs of books, clothing, food, and other necessities for the community. By the 1440s San Marco housed one of the most important collections of classical and theological texts in existence. The San Marco library (fig. 6.3), designed by Donatello's former collaborator Michelozzo, adopted a simplified version of the architecture of Filippo Brunelleschi's Foundling Hospital (*see* fig. 3.13). The library's system of **groin-vaulted** bays rising from Ionic columns made it one of the few parts of the convent not to have a flat wooden ceiling; the choice spoke to the importance of the space but also brought the advantage of reducing the risk of fire.

Fra Angelico and the Invention of the Unified Altarpiece

In his dealings with the friars, Cosimo would have consulted closely with the prior, Fra Antonino. Despite the Dominican Order's commitment to poverty, the prior

of the city. This, too, testifies to the interdependency of the world of the cloister and that of the marketplace. The clergy needed the rich to provide them with material support for their life of prayer and contemplation; the rich needed the clergy in order to obtain salvation. This was especially true of bankers like Cosimo, since the Church regarded the raising of profits through usury (moneylending) as a sin: Pope Eugenius IV (1431–47) personally advised Cosimo about how much of his income he should devote to what the banker called "God's Account." The result was that Cosimo was the single greatest individual Church benefactor not only in Florence but also in all of Italy.

In 1443, the Medici sacristy at San Lorenzo received two pairs of bronze doors (fig. 6.2) designed by Donatello. Only Florence's baptistery could boast an equivalently expensive form of embellishment (*see* figs. 2.13–2.14 and 4.4). Each of Donatello's doors consists of ten low-relief panels in which pairs of saints communicate in a lively and highly physical manner. The artist represented acts of speech and writing by non-verbal means: he showed

accepted and justified the benefactions of the richest man in Florence. Perhaps it was Antonino's awareness that he was compromising the Observant commitment to voluntary poverty that prompted his comments on art, his insistence that at least church paintings clarify and preserve a differentiation of sacred from secular interests. Among his colleagues at San Marco was Fra Giovanni da Fiesole, known to posterity as Fra Angelico, whose labors as an artist provided an important source of income to his Order. By 1440, the friar was one of the leading painters of Florence, producing altarpieces and devotional pictures for a broad network of lay patrons, including, as we have seen, guilds like the Linaiuoli. In 1441, Fra Angelico took on the decoration of his own convent, forcing him to confront the question of what kind of art was suitable for a religious community professing the highest standards of purity and unworldliness. How could an Order that rejected luxury be represented by a painter who specialized in the making of luxury products?

Fra Angelico's status may have helped him attract a secular clientele, but he was also accustomed to painting according to the expectations of such customers. His stylistic choices in this regard are significant: he learned a great deal from the work of Masaccio and Donatello, yet he showed far greater allegiance to the decorative color, rich detailing, and aristocratically refined figures

6.3

Michelozzo, Library, begun 1437. San Marco, Florence. The books were removed and the walls, originally green, were painted white after the suppression of the convent in the nineteenth century.

6.4
Fra Angelico, *Virgin and Child with Saints* (San Marco altarpiece), **1438–43.** Tempera on panel, 7'2⅝" × 7'5⅜" (2.2 × 2.27 m). Museo di San Marco, Florence

of Gentile da Fabriano. Fra Angelico was certainly aware that the vanguard of Florentine art in his generation had created a mode of expression that pursued emotional conviction and rejected ornamental finesse – think of the rugged, vagabond saints and patriarchs of Donatello, Masaccio and Uccello – yet this is not the route that he himself pursued.

The altarpiece (fig. 6.4) for the rebuilt convent church of San Marco is a spectacular application of the new pictorial science of Brunelleschi and Alberti. It shows Fra Angelico to be a master of perspective; few others working around 1440 could set their figures so convincingly in a luminous and geometrically ordered space. One of the painter's most significant modern gestures was the rejection of the traditional polyptych in favor of a simple rectangular format. This simplification of shape

responded to the principle of commensuration that Michelozzo's architecture in the library (*see* fig. 6.3) had already adopted. Fra Angelico conceived his panel simultaneously as a window onto an outdoor world – in this case a garden in which tapestries and a Brunelleschian tabernacle form an enclosure – and as a lavishly decorated surface, one that emulates the crafts of weaving, metalwork, and embroidery. Perspective comes across here as another technique of enrichment. Yet it also focuses and directs our attention to the Virgin, who in turn indicates the blessing Child; he holds the orb of the earth, a sign of universal kingship. The play between decorative surface and proportional recession is especially striking in the Anatolian carpet, with its foreshortening of the animal and abstract designs. Hovering in front of the carpet is a painting-within-a-painting, a *Crucifixion* that evokes the

older tradition of the gold-ground religious icon. This *Crucifixion* further dramatizes the play between flatness and illusionistic depth. It marks the threshold between the tantalizingly close heavenly "other world" of the painting and the actual world of the beholder: the altar table would have extended just below and in front of this, and the Eucharist upon it would have doubled the body of Christ on the cross.

Cosimo de' Medici the patron is discreetly but unmistakably present, not as a donor portrait but through the proxy of his name saint, Cosmas. Cosmas looks out of the painting as if soliciting the attention of beholders and presenting them to the heavenly court. His brother Damian looks inward toward the Christ Child; they are the primary recipients of the Child's blessing, but they are also heavenly intercessors who obtain the benefits of that blessing for those on our side of the painting. Scholars have traditionally referred to this kind of arrangement as a *sacra conversazione*, literally "holy conversation," as though the picture showed a kind of social gathering. What really structures the picture, though, is a social hierarchy: the humble might seek help from the Medici and their associates just as the devout might peti-tion the advocates at the Virgin's side to put in a good word that she might then pass on to Christ. The saints in the picture have their own rank, one reflected in their relative positions and in their proximity to their betters. Near Cosmas and Damian, and equally responsive to the implied beholder, is the other great Medici patron, St. Lawrence. St. John the Evangelist, in profile, is pre-sent as the name saint of Cosimo's father and his brother, both called Giovanni; he is in conversation with his fellow evangelist St. Mark, the patron of the convent. To the Virgin's left (the place of lesser honor) are the prin-cipal saints of Dominican and Mendicant observance: St. Dominic, St. Francis, and St. Peter Martyr, the last also the name saint of Cosimo's eldest son.

For all of its distinctive format, Fra Angelico's altarpiece originally included a predella, which set the actionless protagonists from the painting above it into the narratives most closely associated with them. Here, Cosmas and Damian, who were also doctors (*medici* in Italian), appear in a lively series of scenes displaying a variety of landscape and perspective inventions: several illustrate a series of attempts to martyr them through burning, crucifixion, and decapitation. A posthumous

6.5

Fra Angelico, *Cosmas and Damian Healing a Lame Man,* predella panel from the San Marco altarpiece, *c.* 1438–40. Tempera and gold on panel, 15 × 18¾" (38.1 × 47.5 cm). Museo di San Marco, Florence

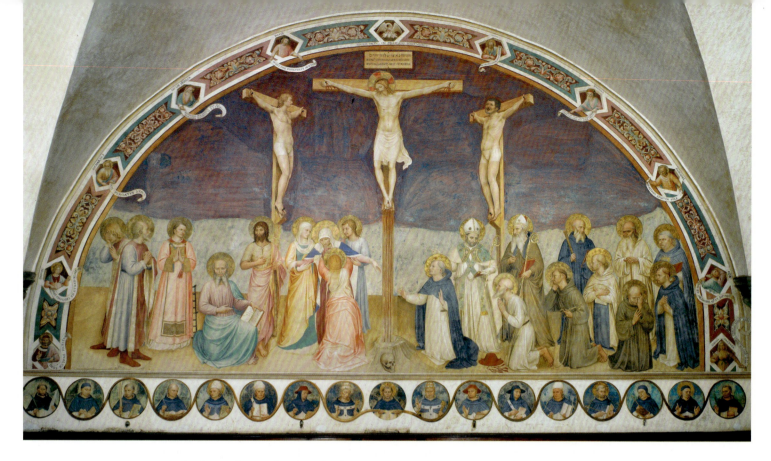

6.6

Fra Angelico, *Crucifixion
with the Virgin,
Mary Magdalene and
St. Dominic, c.* 1441–42.
Fresco. Chapter house,
San Marco, Florence

miracle shows the two brothers healing an amputee by substituting the leg of a black man (fig. 6.5). The effect is to produce a sense of wonder that underscores the impact of the altarpiece as a whole.

The altarpiece includes several legible texts. St. Mark shows St. John the sixth chapter of his Gospel, in which Christ sends out the Apostles two by two to preach and to live in poverty. The detail relates the mission of the Apostles with that of the Dominican Order itself, but the reference to saints acting in pairs also points to the brother saints Cosmas and Damian, as well as to the Medici brothers Cosimo and Giovanni.

The text is legible at close range, but we might wonder who, apart from the priest, ever got close enough to the altarpiece to be able to read it. The same goes for another inscription, from the book of Ecclesiasticus, on the mantle of the Virgin: "I am the mother of beautiful love…and of holy hope"; "Like a vine I caused loveliness to bud, and my blossoms became glorious and abundant fruit." Perhaps some of the devout brethren's interaction with the painting did involve poring over its surface, but it should not be ruled out that such inscriptions were placed there by Fra Angelico as memos to himself, making the act of painting into a pious meditation on its imagery and even on its aesthetic effect. The passage from Ecclesiasticus underlies the paradisical splendor of the altarpiece, affirming the artistic idiom of sensory richness and marvel. Fra Angelico might have had cause to wonder whether such effects had their limits in sacred art, and how those limits were to be determined.

Fra Angelico's Frescoes

Such scruples were clearly operative in the decoration of the convent's communal spaces and the friars' cells. The altarpiece addressed the secular world and presented the Order to outsiders who could enter the convent church (although they probably only saw the painting at a distance, through the doors of the masonry screen that originally separated the choir from the nave of the church). In the chapter house, a space for community assembly and for the reception of visitors, Fra Angelico's great mural of the Crucifixion (fig. 6.6) served both to represent the Dominicans and to address the brethren themselves. The nucleus of the composition is the crucified Christ contemplated by St. Dominic, a theme repeated numerous times by Fra Angelico and his assistants throughout the convent (it appears in every one of the novices' cells). Amplifying this is the group with the fainting Virgin, her outstretched arms manifesting her mimetic identification with the suffering Christ (known as the Virgin's *compassio*). Dominic heads a phalanx of kneeling and standing saints, all of them associated with the foundation of religious Orders. By contrast, the group near the Virgin represents the sphere of Florentine civic life, which centered on the cult of the Virgin at the cathedral of Santa Maria del Fiore. Nearby is a pointing St. John, the city's patron saint, the convent's patron St. Mark, and the three Medici saints Cosmas, Damian, and Lawrence. Fra Angelico frescoed the lunette with the full palette of Florentine Trecento painting, in bright

contrasting primary and secondary colors. There are discreet touches of luxury in the use of ultramarine for the Virgin's regal ermine-lined mantle, and in the *a secco* patterning of the garments of the Medici saints. By contrast, the founder saints to the left of Christ wear sober blue-black, white, and browns, rendered in less expensive pigments. The fresco, in other words, illustrates the harmonious confrontation of city and cloister around the collective act of venerating the Cross.

The fresco also had a prescriptive function for the Dominican brothers. Its model of a prayerful comportment directed the friars to internalize the image of the dead Christ, to maintain a penitential state of mind by meditating upon it. The chapter house also served as the setting for the daily "Chapter of Faults," in which friars would confess to infringements of the Dominican Rule and subject themselves to penitence, including self-flagellation. The mural paintings in the convent's inner spaces maintain a similar disciplinary function. An inscription on the large *Annunciation* (fig. 6.7) at the head of the stairs bids the beholder: "When you come before the image of the Ever-Virgin, take care that you do not neglect to say an 'Ave.'" The painting is pointedly austere: the angel's variegated wing contains the four principal colors to which Fra Angelico has limited his palette: ocher, vermilion, grayish blue, and blue-green. The strong clear light, originally reinforced by a single window in the corridor to the left, gives the figures a powerful sense of presence and sharpens the contours of the architectural setting. This illumination, however, is not consistent; having earlier evoked all the codes of Florentine painting in the wake of Masaccio, Fra Angelico has now resolved deliberately to undermine the principles of spatial coherence. The solid-looking angel casts no shadow; the vaulting above the angel responds to no system of consoles like those visible behind the Virgin, and the capitals of the arcade switch from **Composite** to Ionic in the section of loggia that recedes in space. It is as if Fra Angelico wanted to signify the miraculous and mysterious nature of the Incarnation by conceiving it as something literally "incommensurable" with the optical cues by which we make sense of the world.

The version of the Annunciation that Fra Angelico painted for one of the friar's cells (fig. 6.8) is yet more austere. The event takes place under a loggia strongly reminiscent of the little room in which the painting is located: the whitewashed wall of the cell provides the dominant color of the painted architectural setting. Expensive colors, such as ultramarine, are conspicuously absent, a fact to which Fra Angelico draws attention by leaving the figure of the Virgin unfinished. The underpainting of her robe and its modeling in red wash seem to await a customary final layer of blue pigment that the painter never intended to supply, deliberately "impoverishing" his own image. Fra Angelico had found a way of painting that reflected its primary audience, friars who rejected worldly goods; the image includes the figure of a Dominican, St. Peter Martyr, who provided the cell's inhabitant with a proper example of prayerful contemplation.

Such a manner of painting reinforced the extraordinary posthumous myth of the "angelic" painter, who redeemed the practice of art through a near saintly degree

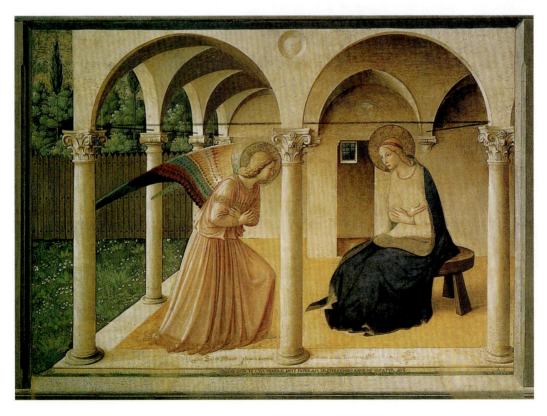

6.7
Fra Angelico,
Annunciation, 1438–45.
Fresco. Upper corridor,
San Marco, Florence

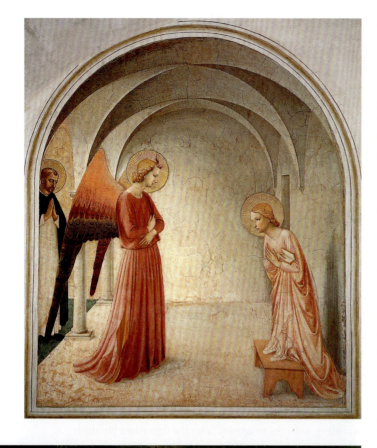

of personal piety. As early as 1450 the Dominican poet Fra Domenico da Corella wrote with regard to a set of cabinet doors that Fra Angelico had painted for the church of the Annunziata in Florence, that the artist was "rich in skill and unerring in religion," possessed of the necessary grace to paint the Virgin. The poet associated Fra Angelico with the founding miracle of the **Servite** Order and the celebrated miracle-working icon (*see* fig. 1.48) in the church, itself brought to completion not by the tricks of human art, but by the intervention of an angel. Following Corella, writers would regularly refer to "Fra Giovanni" as a *pictor angelicus*, thereby recognizing the unique harmony of an absolute unalloyed orthodox Christian faith combined with the potentially specious splendors of human artifice, illusion, and craft. In his artists' biographies of 1550 and 1568, Giorgio Vasari would immortalize such stories as "Fra Giovanni" weeping when he painted a *Crucifixion*, and the Pope's plan to appoint him archbishop of Florence. Pope John Paul II did in fact beatify the artist in 1984, pronouncing him a step closer to sainthood, and artists are now encouraged to pray to Fra Angelico for his intercession. The myths surrounding Fra Angelico deal with much the same anxieties as those brought on by the remarks of Antonino at the beginning of this chapter (*see* p. 144), namely, about the surrender of art to secularizing impulses, which were concerns (as we shall see) that came to a climax during Vasari's own lifetime.

The Florentine Altarpiece after 1440

Fra Filippo Lippi

Another friar painter who responded rapidly to the new unified altarpiece format was Fra Filippo Lippi (c. 1406–1469) of the Carmelite Order, who was also closely associated with the Medici and their supporters. Lippi would become as famous for his scandalous personal life as Fra Angelico would for his piety, yet like the Dominican friar his painting mediated the concerns of the cloister and the city. Even while living and working in the secular world after 1432 and fathering a child by the nun Lucrezia Buti, Lippi never renounced his vows or broke off contact with the **Carmine**. In 1445 he completed the single-panel altarpiece (*pala* in Italian; fig. 6.9) for the chapel of the Franciscan novitiate at Santa Croce in Florence, which had been built and decorated under the patronage of Cosimo de' Medici and dedicated to Cosmas and Damian. Like Fra Angelico in the San Marco altarpiece, Lippi places the Virgin and Child in a unified space with a company of saints: Francis and Anthony of Padua represent the Order, Cosmas and Damian its Medici patrons. Damian arrests the attention of the

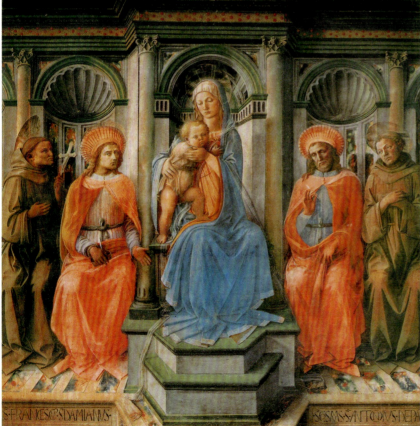

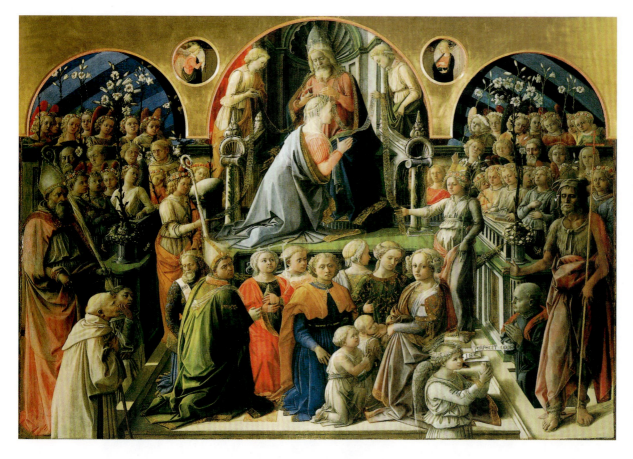

OPPOSITE, ABOVE
6.8
Fra Angelico,
Annunciation, 1440–45.
Fresco. Friar's cell,
San Marco, Florence

OPPOSITE, BELOW
6.9
Fra Filippo Lippi, *Madonna
and Child Enthroned with
Saints Francis, Cosmas,
Damian, and Anthony*,
1445. Tempera on panel,
6'5" × 6'5" (1.96 × 1.96 m).
Uffizi Gallery, Florence

LEFT
6.10
Fra Filippo Lippi,
Coronation of the Virgin,
1441–47. Tempera on
panel, 6'7" × 9'5"
(2 × 2.87 m). Uffizi
Gallery, Florence

beholder, directing him to the Virgin and Child. The shallow architectural setting, decorated in the frieze with the *palle* (balls) that the Medici used as family symbols, would have looked like a more magnificent version of the novitiate chapel itself (built, once again, by Michelozzo). Lippi's saints seem capable of vigorous movement, and the Child, reminiscent of the *spiritelli* on Donatello's *Cantoria* (see fig. 5.22), leaps in the Virgin's lap. Clasping his mother's breast, the infant confronts the viewer with his stare, as though to indicate that the Virgin's milk is not for him alone. Clerics often understood the milk of the Virgin to be a symbol of the nourishing power of religious doctrine, but Lippi delivers a more emotional charge: he provided the teenage novices, some of them orphans, some recently removed from the care of their parents and from family, with the compensating assurance of the Virgin's nurturing motherhood.

Lippi's emotive presentation seems more rooted in the physical world than Fra Angelico's painting, yet Lippi, too, undermines the idea of a pictorial space that extends our own. The benches on which the Medici saints sit recede to a two-point perspective that is not consistent with that of the Virgin's throne or the marble tiles in the floor. Once noticed, the effect is jarring, as is the not quite measurable or comprehensible relationship of the four

flanking saints to the niches and columns behind them. The hints of incoherence as well as the tripartite division of the architecture read as a throwback to the format of the polyptych, where Virgin and saints seemed to coexist in demarcated worlds, separated by frames.

Lippi and his patrons seem on other occasions to have preferred the older multi-paneled altarpiece: the one he made between 1441 and 1447 for the church of Sant'Ambrogio, Florence, effectively combines the possibilities of the polyptych with the more modern unified format (fig. 6.10). Here the three-arched frame recalls the subdivisions of older altarpieces; dividing and prioritizing visual information, it also serves as a screen behind which figures move in a coherent inner space. The perspective construction of the great throne serves deliberately to misalign its architecture with the divisions of the frame, enhancing the sense of a spatial volume extending beyond the arches and even in front of them: on the "far" side, a court of angels attends on the Virgin's coronation. Lippi places these figures higher in the painting than the foreground group of saints and other figures, who seem rather to be on "our" side of the arcade.

Lippi's altarpiece creates a gradual transition from sacred to secular spheres. Once again, the artist's conception can be related to the dual nature of the congregation

6.11

Domenico Veneziano,
St. Lucy altarpiece, 1445–47.
Tempera on panel,
6'10" × 7' (2.09 × 2.19 m),
Uffizi Gallery, Florence

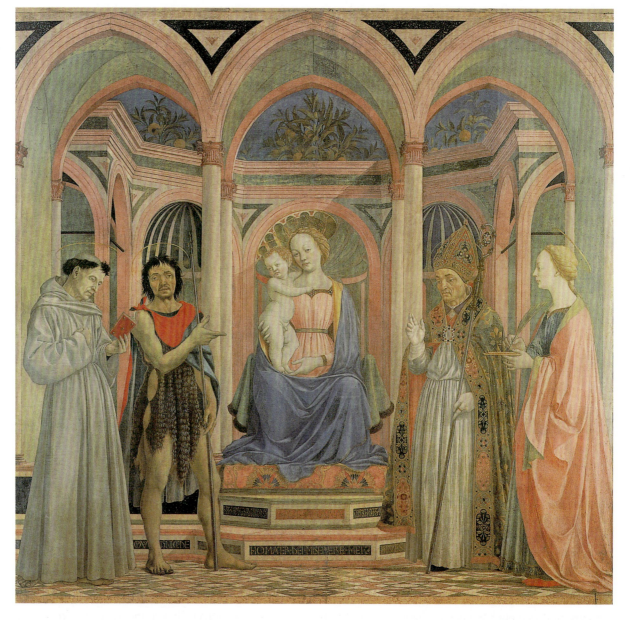

addressed by the work. On the one hand the Benedictine foundation of Sant'Ambrogio housed a community of nuns who maintained strict vows of seclusion from the secular world; they participated in the Mass and other services from a separate enclosure in the choir. The nuns would have specially identified with, and been represented by, the figure of the Virgin, whose coronation, like the nuns' own profession of vows, constituted a spiritual marriage with Christ. Yet Sant'Ambrogio was also a parish church; it housed confraternities that drew lay membership from across the city, and a diverse community of Florentines venerated its relic of the blood of Christ. The relation of church and city is represented in the altarpiece by the commanding figures of St. John the Baptist and St. Ambrose, who dominate the right and left of the composition respectively. John's gesture designates the Virgin, but it also draws attention to the portrait of the patron, Francesco Maringhi, who seems to rise from his tomb beneath the arm of the Baptist. At the threshold of the painting an angel holds a scroll, which reads "ISTE PERFECIT OPUS" ("He it was who brought the work into being"): the words present the patron as the "author" of the work. Directly opposite are two white-robed figures. The one with the staff is probably St. Benedict; the adjacent figure leaning his head on his hand has no discernible identity, and it is likely that here Lippi took the unusual step of portraying himself, in his Carmelite habit. An image of the friar-painter, in the place of greater honor at God's right, provides a counterpart for the portrait of a donor from the secular world.

At center foreground, the gazes of three saints confront the congregation: the bishop St. Martin and the husband and wife martyrs Eustace and Theopista, shown with their two children. The image of the saintly family presents itself for emulation by Florentine households, although there seems to be very little of the otherworldly or the ascetic in Lippi's view of saintliness. In fact, the lavish attire of the demurely staring Theopista, with her jeweled brocades and elaborately styled hair, touched a point of long-standing tension in the Renaissance city, namely, between the private citizens who sought honor through luxurious adornment, and the government regulators and mendicant preachers who sought to restrain such displays. (Fra Antonino had written a pamphlet against excess in women's fashions in 1440, but his views were generally more moderate than those of Franciscan preachers.)

So what does it mean for a female saint to be dressed in a manner that could invite censure in the case of actual Florentine women? One answer is that there was a different standard for saints: these were superior and non-worldly beings who deserved to be represented with more honor, and thus a greater degree of ornament – especially when the setting was clearly not of this world. Yet perhaps in the eyes of Florentine lay beholders, Theopista would also have quietly affirmed their own worldly pursuit of distinction through expensive adornment.

Domenico Veneziano

Around 1447, across the River Arno, the **Olivetan** Benedictines of Santa Lucia dei Magnoli received an altarpiece (fig. 6.11) by Domenico Veneziano (c. 1410–1461), a Venetian who appears to have trained in Florence and Rome with Gentile da Fabriano and Pisanello. The rectangular painting shows that Domenico had carefully studied Fra Angelico's San Marco panel (*see* fig. 6.4), and reconciled the geometry of receding, perspectival, architectural space with simple proportional divisions of the surface. Now the tripartite loggia inside the painting retains the organizing principles of the older multi-panel format. Below the **cornice** of the frame, the painted architecture, flush with the surface, behaves like a traditional triptych, yet the supporting members rise from a point much further back in the pictorial space. While the Virgin and Child are set back in depth and framed by columns, the four saints occupy a common foreground zone closer to the beholder's space. At the same time, the arches and niches of the architectural enclosure echo the containing and compartmentalizing effect of the polyptych frame, emphasizing the status of each saint as an individual focus of devotion. And once again, the panel instructs the viewer who considers it closely not to take the prin-

ciples of regular spatial recession too literally: the more distant Virgin and Child are apparently exempt from the law of proportional diminution, according to which they would in fact be larger than the figures in the foreground.

Domenico's major achievement in the panel is the realization of light effects, and it is he who most fully developed that aspect of Masaccio's work. The surface of the painting was damaged by overcleaning in 1862, but it is still possible to see how the reflected light plays across the inner surfaces of the vaults, giving the pink, white, and green of the architecture – a reference to the colors of the marble on Florence Cathedral – a sunlit radiance. Compare the indirect illumination of the Virgin beneath the loggia with the intense light falling on Lucy, the saint in the right foreground holding a plate with the eyes her torturers removed. Domenico has coordinated the rendering of optical phenomena with religious meaning: the very name "Lucy" derives from the Latin word for "light." At the same time, the altarpiece implies that physical light, the medium by which things are seen, constitutes only a limited and partial form of spiritual illumination and insight. The Virgin's throne bears a condensed version of a text from Luke 8:10: "Unto you it is given to know the mysteries of the kingdom of God: but to others in parables, that seeing they may not see."

Light assumes an important dramatic role in Domenico's five predella panels below, each devoted to an episode in the lives of the four saints and the Virgin above. The artist scored the rays of miraculous light in *St. Francis Receiving the Stigmata* (fig. 6.12) directly into the panel. In the *Annunciation*, diagonal beams fall across the pavement of a closed courtyard, also scored into the surface, and separate the supernatural domain of the angel from that of the mortal Virgin. (As we saw with Pisanello's Brenzoni monument (*see* fig. 4.20), Catholics regarded the action of light as a metaphor for the

6.12
Domenico Veneziano, *St. Francis Receiving the Stigmata*, predella panel from the St. Lucy altarpiece, *c.* 1445. 10⅞ × 12" (26.7 × 30.5 cm). National Gallery of Art, Washington, D.C.

6.13
Domenico Veneziano, *The Martyrdom of St. Lucy*, predella panel from the St. Lucy altarpiece, c.1445–48. 10⅝ × 11⅞" (27 × 30 cm). Staatliche Museen, Berlin

Incarnation; some, including Antonino, even understood light to be the medium by which the Incarnation took place.) The plunging orthogonals and the vector of a tyrant's scepter, which follow the same path as the light rays that provided the premise for Alberti's explanation of perspective, seem to converge at the point where an executioner's knife enters the neck of the martyred St. Lucy (fig. 6.13). Stark white light striking a pavement dramatically silhouettes the screaming mother of a dead child resurrected by St. Zenobius (fig. 6.14). Finally, as if signaling a drama of conversion, light bathes both the harsh rocks and vulnerable nude body of the young St. John the Baptist (fig. 6.15), who sets aside his worldly clothes for his hermit's animal hide. The gnarled, Donatellesque older saint in the main panel shows the same young man transformed by years of life in the wilderness.

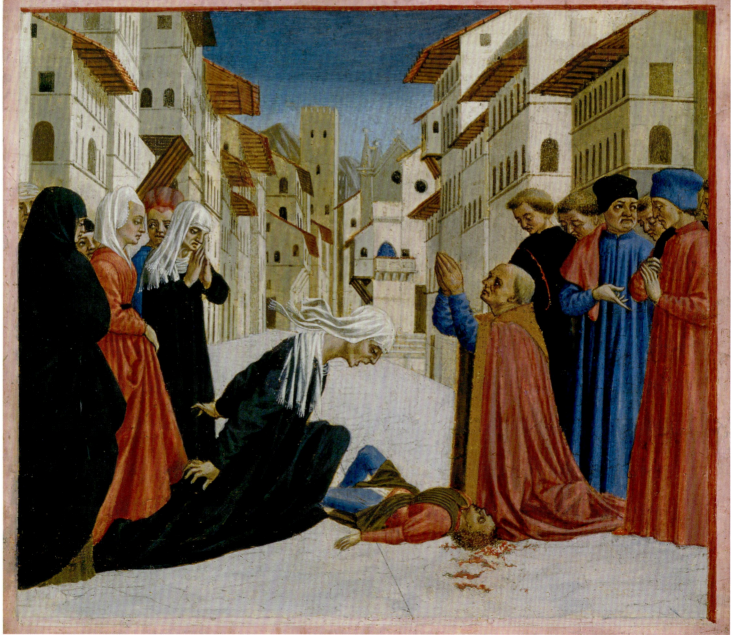

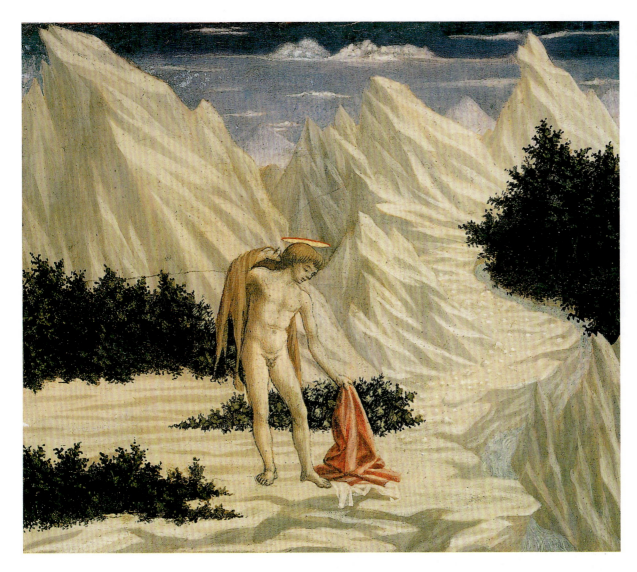

6.15
Domenico Veneziano, *St. John the Baptist in the Wilderness*, predella panel from the St. Lucy altarpiece, *c.* 1445–48. 11¼ × 12¾" (28.4 × 31.8 cm). National Gallery of Art, Washington, D.C.

Andrea del Castagno and the Convent of Sant'Apollonia

In the same years that Domenico Veneziano was working for the community at Santa Lucia, another Benedictine community across the River Arno, the convent of Sant'Apollonia, hired the Florentine native Andrea del Castagno (*c.* 1419–1457) to decorate its refectory. This was the room where the nuns dined, and Castagno responded to that function by painting a monumental *Last Supper* (fig. 6.16) along with other scenes from Christ's Passion. Compared with Fra Angelico in San Marco, Castagno's pictures are more assertive in their virtuoso illusionism and confident in the splendor of their color and ornament. The virtual room that houses the *Last Supper* seems to project from the wall rather than receding into it; the fictional interior is sumptuously adorned with panels of multicolored marble, figured textile hangings, and

carved sphinxes. The floor and ceiling tiles, in stark foreshortening, form a shimmering pattern. Castagno had recently worked in Padua and designed mosaics for San Marco in Venice, and so was attuned to the impact of colored-stone wall treatments. In the now severely damaged scenes overhead, figures around the crucified Christ gesticulate with an emotionalism that demonstrates that Castagno had studied the work of Donatello, while the resurrected Christ directs his triumphant blessing toward the occupants of the refectory below.

The sumptuousness of the painted architecture and the conspicuous demonstration of illusionistic artifice relate to the privileged status of Sant'Apollonia, the largest and the richest female cloister in Florence. The city's great families were represented among the nuns, who would often bring with them a substantial dowry when they joined the Order. At the same time, the rigorous discipline of the house, especially the maintenance of the community in complete isolation from the outside

OPPOSITE, BELOW
6.14
Domenico Veneziano, *A Miracle of St. Zenobius*, predella panel from the St. Lucy altarpiece, *c.* 1445–48. Tempera on panel, 11¼ × 12⅞" (28.6 × 32.5 cm). Fitzwilliam Museum, University of Cambridge

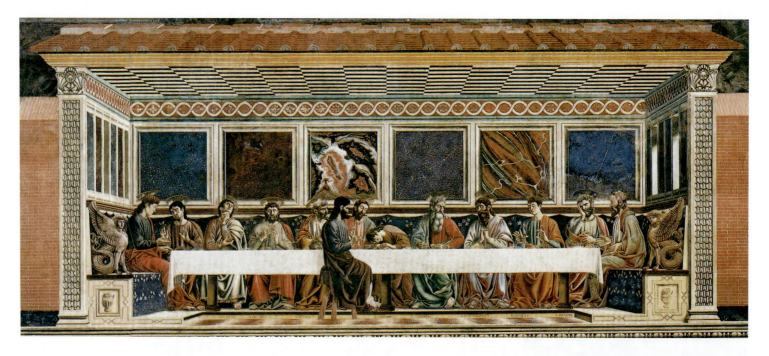

6.16

Andrea del Castagno, *The Last Supper*, *c.* 1445–50. Fresco. Sant'Apollonia, Florence

world, earned it the special favor and protection of the Pope, Archbishop Antonino, and the Medici. Castagno, that is, did not produce splendor and magnificence for its own sake. Archbishop Antonino (among the few male Florentines who would have had access to the painting, during pastoral visits) would have been unlikely to fault its effects as arbitrary curiosities. The whole scheme has a cerebral quality, supporting the meditation of the sisters in the room. There is after all something rather funereal about the marble-clad space in which Christ celebrates his last Passover with the Apostles; the precious **porphyry** and **serpentine** recall the adornment of Roman funerary monuments being revived in just these years. The sense of tomb-like enclosure might have resonated with women confined for life behind the high walls of Sant'Apollonia.

At the same time, Castagno's painted marble interior presents a kind of visual enigma, a sign of reality itself being transfigured. As Christ institutes the Eucharist, telling his followers to eat of his flesh and drink of his blood, a violent efflorescence of colored marble seems to break forth over the main characters in the story – Christ, Peter, John, and Judas. The six marble panels of the rear wall are matched by six panels on each foreshortened side wall, which tells us that the room is square in form. With sufficient patience, you can determine that the ceiling has fourteen panels to each side. Yet if you count the loops on the circular meander pattern in the frieze, you find that there are exactly twice the number in the section on the rear wall as appear on either of the side walls. Castagno is challenging us to notice the inconsistency, departing from the rules of perspective to create

a paradoxical space that signals the mind-boggling mystery that is the subject of the narrative. A literate beholder might recall that sphinxes are symbols of enigma, and that in John's account of the Last Supper, the Apostles expressed perplexity at Christ's mysterious words. At John 16:25, moreover, Christ remarks: "I have said this to you in figures; the hour is coming when I shall no longer speak to you in figures but tell you plainly of the father." The beholder might note that John is placed at dead center, directly on an axis with the Crucifixion above, which would inform her that it is John's account of the Passion that is at stake.

The *all'antica* Tomb

Like Florence's cathedral, the great mendicant churches, such as Santa Maria Novella and Santa Croce, received funding from the state, and locals regarded them as civic foundations. In 1444 the *signoria* designated Santa Croce, long established as the burial place of numerous affluent Florentine families, to be the site of a public monument to the late chancellor Leonardo Bruni (1369–1444). Bruni had wanted to be buried there under a plain marble slab, but the state pre-empted family initiative, producing a monument (fig. 6.17) on the scale of the one that Donatello had made in the 1420s for the antipope John XXIII in the baptistery (*see* fig. 4.1). This gesture on behalf of the public interest competed with the territorial strategies of such families as the Alberti, the Bardi, and the Baroncelli, all of whom had ostentatious private burial chapels in the same church. The inscription commemorates

the humanist simply as Leonardus, without using his family name.

Bernardo Rossellino (c. 1409–1464) carved the effigy of the deceased Bruni as he had been laid out at his state funeral, crowned with laurel and holding his most prominent work, the Latin *History of the Florentine People*. The eagles supporting the bier are a funerary symbol imported from ancient Roman practice, echoing the staging of the funeral itself, which re-created a Roman ritual. Though the Virgin and Child in the *tondo* (round image) above refer to the salvation of Bruni's soul, the epitaph on the tomb itself refers not to Bruni's piety but to his intellectual accomplishments, stressing the world's loss at his passing: "history is in mourning and eloquence is dumb, and the Muses, Greek and Latin alike, cannot restrain their tears." This is a tomb that looks back on a lost life more than it looks forward to an eternity in heaven. The ideals of fame and glory were part and parcel of its classical themes, no less than the richly carved Corinthian piers supporting a palmette frieze that surround and con-

tain the effigy. The *tondo* is echoed by the coat of arms outside the arch, originally decorated with blue and gold, and held by angels that resemble the Eros figures in classical funerary monuments. Conveniently, however, the lion on Bruni's coat of arms corresponded with the lion symbol of Florence, known as the Marzocco: the installation honored the city as much as the individual.

Subsequent patrons and sculptors widely imitated Rossellino's composition. Only a few years later, a follower of Donatello named Desiderio da Settignano (c. 1430–1464) completed a similarly conceived monument for Bruni's successor and fellow humanist Carlo Marsuppini, directly opposite Bruni's in the same church. Marsuppini's tomb (fig. 6.18) exceeds Bruni's in the lavishness of its classical ornament; its disembodied wings, lion paws, and bristling foliage have an uncanny liveliness, and the virtuoso carving suggests a bid by Desiderio to outdo Rossellino. Whereas the relative severity and gravity of the Bruni tomb might seem to exemplify ideas of the "antique" in the fifteenth century, Desiderio's

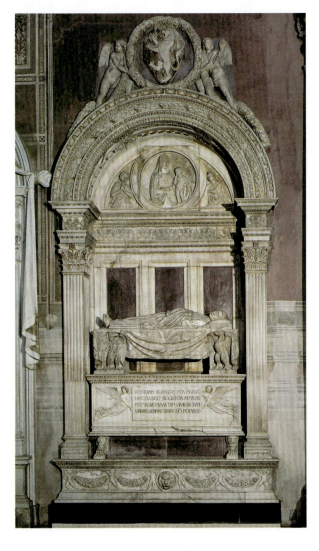

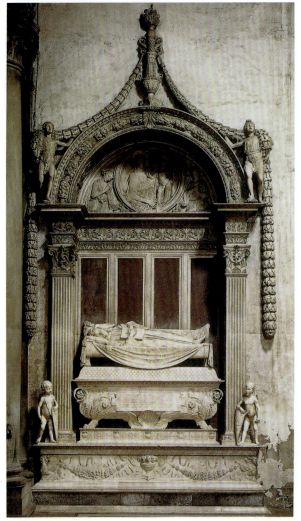

FAR LEFT

6.17

Bernardo Rossellino, tomb of Leonardo Bruni. 1444–50. Marble, height 20' (6.1 m) to top of arch. Santa Croce, Florence

LEFT

6.18

Desiderio da Settignano, tomb of Carlo Marsuppini, begun c. 1453–64. Marble, originally with gilding and green and red paint, height 20' (6.1 m) to top of arch. Santa Croce, Florence

response indicates that *all'antica* works could alternatively embrace a fantastic inventiveness: following the ancients did not always mean "adhering to the rules"; it could also amount to the adoption of a concept of license. Together, the two monuments formulated the principles of what is sometimes called the "humanist tomb," although such tombs would most often be used for the burial of cardinals, popes, and powerful clerics.

The Private Palace

Ambitious Building in Florence and Venice

During his exile in Padua in 1433–34, Cosimo de' Medici must have traveled to Venice, where he would have seen the way that prominent merchants in another republic lived. In just those years, for example, Marino Contarini was adding new windows to the facade of his home (fig. 6.19) on the Grand Canal. Completed in 1440 after nineteen years of construction, the palace – which is now known as the Ca' d'Oro ("Golden House") – indulged in a splendor normally reserved for religious structures. The

6.19
Giovanni and Bartolomeo Bon, Matteo Raverti, and others, Ca' d'Oro (Palazzo Contarini), Venice, 1421–40

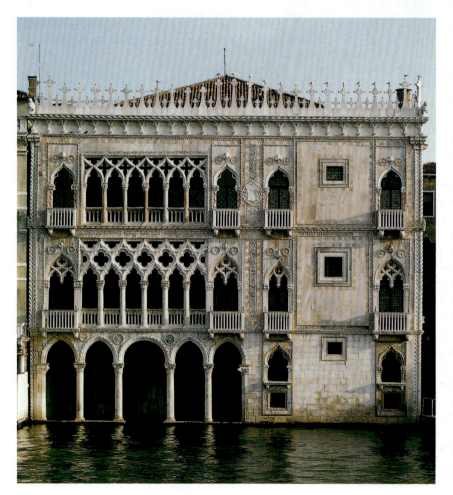

arcaded lower storey on the left half of the asymmetrical building provided easy access to boats, while the rows of windows above, outlined with delicate tracery – some of it by Matteo Raverti (*fl.* 1398–1436), who had worked on Milan Cathedral – ensured both bright illumination and an ever-changing play of shadows in the rooms behind. The thin columns separating these were each made of a different imported stone; originally, highlights in gold and even ultramarine ornamented some of the carving. The right-hand side of the palace involved less intricate detailing, though workers applied varnish to the red marble and polychromy to the **Istrian** stone so that even the revetment there sparkled in the sun.

The Florentine palace for the Medici (fig. 6.20), that Cosimo began constructing in 1444, seems by comparison both more assertive and more controlled. This occupied a no less significant site along the Via Larga, a street that ran from a point not far north of the baptistery toward San Marco. The family already owned a residence and several other properties there; for several decades they had been acquiring real estate, and when they finally cleared ground, they made room for a palace significantly larger than the Ca' d'Oro. Such conspicuous building by private individuals might have aroused suspicion of the kind that had driven Cosimo into exile in Padua in 1433, yet with his triumphant return in 1434 he was able to banish or thwart the political enemies who feared his growing influence. (Palla Strozzi was among those banished, largely on account of the envy aroused by his conspicuous display of wealth.) By 1444, then, Cosimo had little reason to worry about his political or financial security, and his friend Antonino was ready to justify grandiose acts, conceiving them as a form of public duty that served the common good rather than the self-interest of a patron. The effect of sobriety, a typical Florentine aspiration to ancient Roman gravity, is certainly calculated, yet every contemporary Florentine observer would have understood the extraordinary costs incurred not just by the scale of the undertaking but also by the treatment of the two street facades. The one conspicuously classical element in the design is the colossal overhanging cornice; for the rest, Cosimo favored a design that looked back to the thirteenth-century Palazzo dei Priori (*see* fig. 1.4). The rough rustication characteristic of the earlier building occurs only on the ground floor, however, and gives way to smooth-faced stones arranged in diminishing courses on the second storey (the principal floor, or *piano nobile*) and then to the seamless surface above. Like the Ca' d'Oro, the palace would originally have been open on the ground floor, with large arches forming a loggia. A Medici device, the diamond ring, appears in the spandrels of the windows, and the corner of the building bears the family coat of arms, with the *palle*.

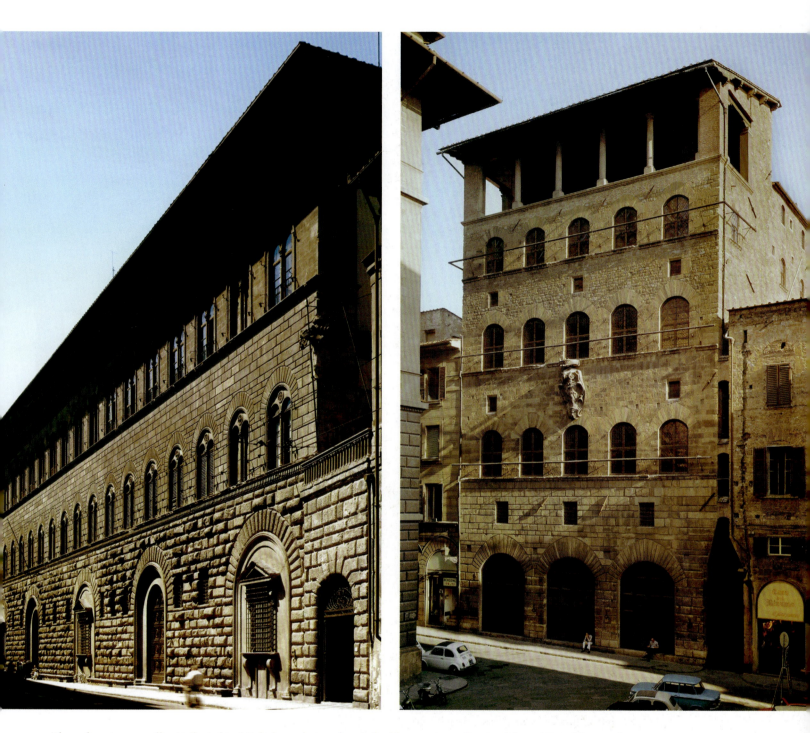

The palace is generally attributed to Michelozzo but may reflect an earlier design by Brunelleschi. In its references to public architecture, it departs no less strikingly from the conventions of Florentine domestic buildings (compare it with the mid fourteenth-century Palazzo Davanzati, fig. 6.21) than did the Ca' d'Oro in Venice. Both buildings centered on an open courtyard; entering the courtyard of the Medici Palace, however (fig. 6.22), would have reminded Florentines of Brunelleschi's Foundling Hospital (*see* fig. 3.13). It is as if the latter's loggia had been wrapped around four sides of the *cortile* (courtyard), the *tondi* now replaced with the Medici *palle* or with enlarged reproductions of mythological scenes from famous classical carved gems, some already owned by the Medici and others acquired in the decades after the palace was complete.

The house of a wealthy, visible family like the Medici was never truly a "private space" in our modern sense. The palace continued a series of neighborhood interventions that extended from the immediately adjacent

ABOVE LEFT

6.20

Michelozzo, Medici Palace, begun 1444. Florence

ABOVE RIGHT

6.21

Palazzo Davanzati, mid fourteenth century. Florence

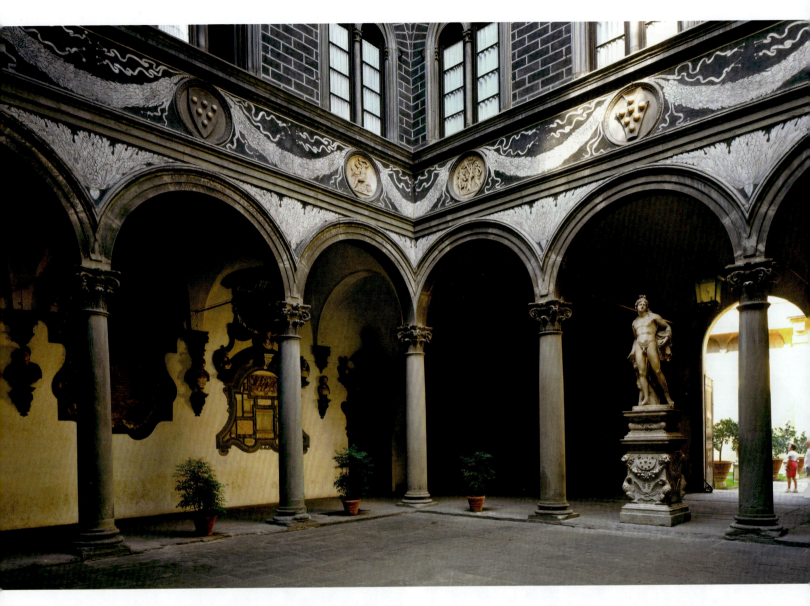

6.22

Michelozzo, Medici Palace, courtyard, Florence

church of San Lorenzo to San Marco up the street, making no distinction between the secular and religious spheres. The building itself, moreover, was a place of business, sociability, and political deal-making, a place where the concerns of a family merged with those of public life. During public festivals as well as family weddings and christenings, large numbers of Florentine citizens came into both the inner and outer loggias for musical entertainments and lavish meals. Still today, passers-by take advantage of the protection the cornice provides from rain and sun, or pause to rest on the benches built into the exterior walls. In both its architecture and its function, the Medici Palace inserted itself into the wider world of civic concerns. Perhaps the most audacious aspect of the Medici appropriation and adaptation of public forms and symbols is the statue that once stood on a richly carved marble plinth in the center of the courtyard.

Luxury and Humility: Donatello's Statues for the Medici Palace

Cosimo appears to have commissioned the lifesize bronze *David* (fig. 6.23) from Donatello after the patriarch's return from exile in 1434; it was very probably in the courtyard by the early 1450s. A Florentine visitor might have recognized the image of the Biblical hero as an adopted symbol of the city, since the same artist's earlier marble *David* had stood in the Palazzo dei Priori since 1416; such a visitor, though, could not have failed to be curious about some of the more novel features of the statue. There is slender scriptural support (I Samuel 17) and no visual tradition for representing David naked. Contemporaries could have compared the work to the nude Hercules on the city seal or on the Porta della Mandorla, but they would have been struck

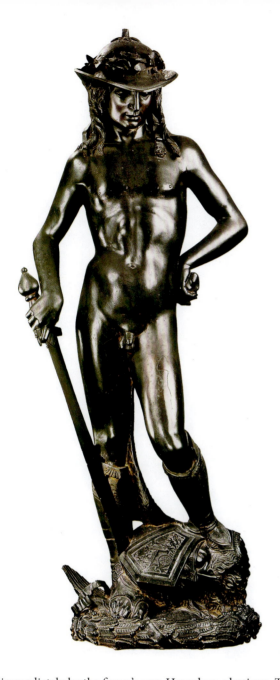

Medici may have had reason to worry that the image contradicted the spirit of reserve that the Republican city expected. Perhaps it was these concerns that prompted them eventually to add an epigram to the base of the work: *The victor is whoever defends the fatherland. God crushes the wrath of an enormous foe. Behold! A boy overcame a great tyrant. Conquer, O citizens!* The lines speak to the general Florentine preoccupation with patriotism and civic duty, but they also promise viewers that Cosimo de' Medici, for all of his far-reaching powers, would be the very enemy of "tyranny."

David was useful because the Biblical account also emphasizes his youthful lack of heroism, his humility and utter powerlessness except when aided by God. Donatello and his audience were probably also aware that the Scriptures speak of David's physical beauty. Psalm 44 refers to him as "most beautiful among the sons of men," and the great exegete St. Jerome interpreted the name "David" as meaning both "strong of hand" and "desirable." In the eyes of the Florentine patriarchy, handsomeness and obedience were also desirable qualities in youthful males; Domenico Veneziano's young *St. John* (*see* fig. 6.15) and Ghiberti's *Isaac* (*see* fig. 2.11) are characteristically Florentine in this respect. In fact, the beauty and even the sexual appeal of male adolescents was a deeply rooted obsession of Florentines in general: the preachers decried their fascination with youth as a sinful perversion, and even accused parents of dressing up their sons to make them more attractive to adults. Donatello's *David*, his exposed body set off by contemporary hat and boots, plays upon such preoccupations: the boy's expression suggests erotic enticement, and the feather on Goliath's helmet sensuously caresses his inner thigh. That Donatello thought of his *David* in this way is suggested by the fact that he adorned the helmet of Goliath (fig. 6.24) with a replica

6.23

Donatello, *David*, *c.* 1440–43. Bronze, height 5'2¼" (1.58 m). Museo Nazionale del Bargello, Florence

6.24

Donatello, *David* (detail): Helmet of Goliath. Museo Nazionale del Bargello, Florence

immediately by the figure's non-Herculean physique. To some it would have suggested the medieval convention of representing pagan cults through the motif of the "idol," usually a nude figure on a column. Donatello himself may have designed the work with an eye to the *Spinario* (*see* fig. 2.12), the bronze statue at the Lateran in Rome that had earlier been so important as a model for Brunelleschi and Ghiberti; *David* resembles the *Spinario* not only in its medium but also in its nudity, age, physiognomic type, and long flowing hair. The likeness pushes the statue further from the realm of the sacred into the world of profane and worldly concerns, as does the fact that the boy's cap, boots, and sword make no attempt to evoke the world of Biblical antiquity, following contemporary fashion.

No other family in the city could have afforded so costly and extravagant a work in precious metal, and the

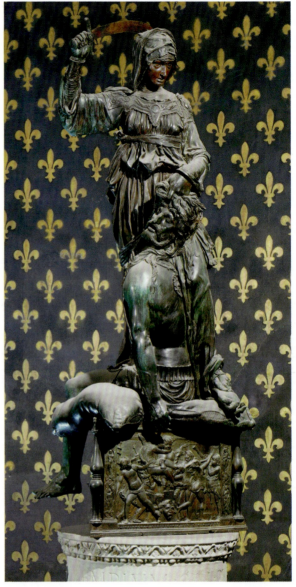

6.25

Donatello, *Judith and Holofernes, c.* 1455. Bronze with gilding, 7′9″ (2.36 m). Palazzo Vecchio, Florence

of a classical cameo showing Eros, or Cupid, riding a chariot. Love, in other words, is in control here – perhaps it is love that has conquered Goliath. Such a detail would not have been visible from the ground, belonging in the sphere of private or restricted meanings known only to the artist and client. On the one hand – in their collaboration with Antonino and patronage of churches and monasteries – the Medici were careful to maintain the role of Christian pillars of society. On the other, they signaled their power through an ability to question the boundaries and limits of what was permissible in Christian art.

Some visitors to the Medici Palace would have been allowed to proceed farther from the courtyard into the walled garden beyond, a space one could only glimpse from the street. At some point, probably during the second half of the 1450s, the Medici placed over a fountain in the garden a second bronze statue by Donatello, the two-figure group of *Judith and Holofernes* (fig. 6.25). As a Biblical heroine and exemplar of virtue, Judith formed an apt companion piece to David; she, too, saved her homeland by decapitating an enemy leader (after first getting him drunk). Although she has the same downcast glance as David, however, this now reads as the sign not of allure but of baleful intent. Judith's action contrasts with David's repose, and just as Donatello displayed his masterful depiction of the nude body in the earlier sculpture, so in the later he shows his skill in rendering drapery. The bunched and gathered folds of cloth richly articulate the statue with light and shade. Holofernes, by contrast – struck once already by Judith's sword – drapes over the base in an ungainly and disfigured pose. As with Goliath, Donatello insinuates more about the cause of the figure's undoing. The three sides of the base (fig. 6.26) recapitulate the riotous *spiritelli* (little spirits) of his *cantoria* (*see* fig. 5.22), except that here they are very explicitly the

6.26

Donatello, *Judith and Holofernes* (detail): Relief from base. Palazzo Vecchio, Florence

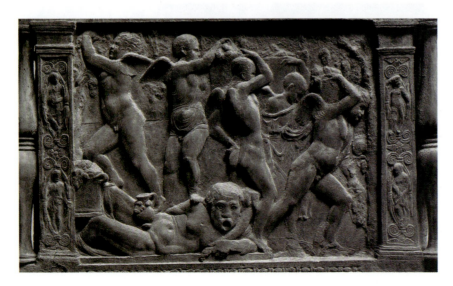

"vital spirits" of wine who have overpowered the warlord, and who cavort as they make and consume the liquor that intoxicates them. Two of Donatello's fountain spouts takes the form of vomiting faces. One of the more mature spirits, viewed from behind, strikes the pose of the *David*, as if to underscore that figure's scarcely concealed pagan and sensual nature.

The Medici family gave the *Judith*, like the *David*, a self-serving moral meaning in the form of a patriotic inscription: *Kingdoms fall through luxury, cities rise through virtues; behold the neck of pride severed by the hand of humility*. And even more than with the *David*, the lines contain a certain irony: they designate the statue as a triumph of virtue over luxury, yet that statue decorated the most luxurious private residence ever to rise in the city of Florence.

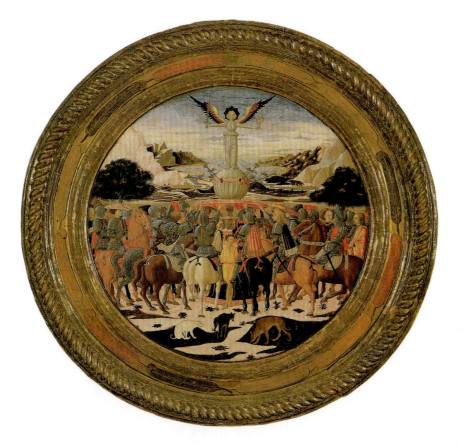

LEFT

6.27

Giovanni di ser Giovanni Guidi (called Lo Scheggia), birth salver (*Desco da parto*) of Lorenzo de' Medici. Obverse: *The Triumph of Fame, c.* 1449. Tempera, silver, and gold on wood: overall with engaged frame, diameter 36½" (92.7 cm); painted surface, diameter 24⅝" (62.5 cm). Metropolitan Museum of Art, New York

BELOW

6.28

Lo Scheggia, birth salver of Lorenzo de' Medici, *c.* 1449. Reverse: the Medici device of the *diamante* (diamond ring with feathers). Metropolitan Museum of Art, New York

Inside the Florentine Palace

The large rooms of the Medici Palace would have appeared sparsely furnished and decorated to modern eyes. Rooms were flexible in function, sometimes serving at different times for sleeping, for receiving guests, and for conducting business. In Cosimo de' Medici's time, paintings, many of them apparently rather modest images of the Virgin or Christ, decorated a few walls, though the murals that featured frequently in older elite dwellings were largely absent. Some of the more important spaces were decorated to shoulder level with inlaid wooden paneling. Among the most noteworthy works from the 1440s is the decorated salver, or formal tray, called *The Triumph of Fame* (figs. 6.27–6.28), commissioned to mark the birth of Cosimo's grandson Lorenzo on 1 January 1449. The painter, known as Lo Scheggia ("The Splinter"), was the brother of Masaccio, but rather than following his sibling in the making of altarpieces and frescoes, he specialized in painted wooden artifacts associated with the Florentine domestic interior. This childbirth tray he made for the Medici is the largest and most splendid surviving example of one of the most characteristic objects that Florentines had in their home. Most of the salvers in its genre were humble objects purchased as readymades on the occasion of the birth of a child and probably used for the presentation of gifts after a birth. Some examples were

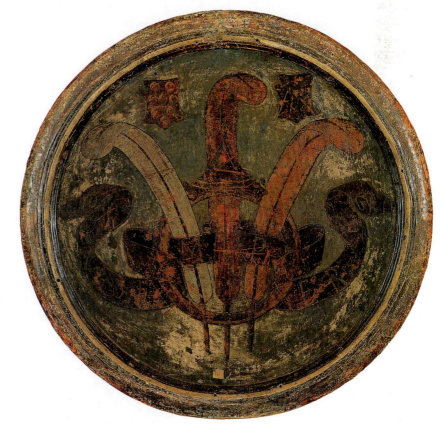

then displayed on walls like small devotional paintings. When decorated, the trays often showed scenes of childbirth and images of one or more male infants wrestling, playing, or urinating – themes associated with fertility and believed to bring good fortune. Wealthier families like the Medici could have the salvers marking their own births made to order with their coat of arms on one side and with imagery drawn from literary classics on the other, as in the present case.

The coats of arms of the Medici and of the Tornabuoni – the family from which Lucrezia, the mother of Lorenzo and the wife of his father Piero, came – appear on the salver's reverse (*see* fig. 6.28), while the inner rim is decorated with green, white, and red feathers, a personal symbol used by Piero that signified the three theological virtues of Faith, Hope, and Charity. The *Triumph of Fame* augurs the future glory of the Medici child, Lorenzo. Its imagery derives from the *Triumphs*, an allegorical dream vision by the great Tuscan poet Petrarch (1304–1374), describing a procession of festive parade floats devoted successively to personifications of Love, Chastity, Death, Fame, Time, and Eternity.

6.29
Domenico Veneziano,
The Adoration of the Magi,
1440–43. Diameter
33½" (84 cm). Staatliche
Museen, Berlin

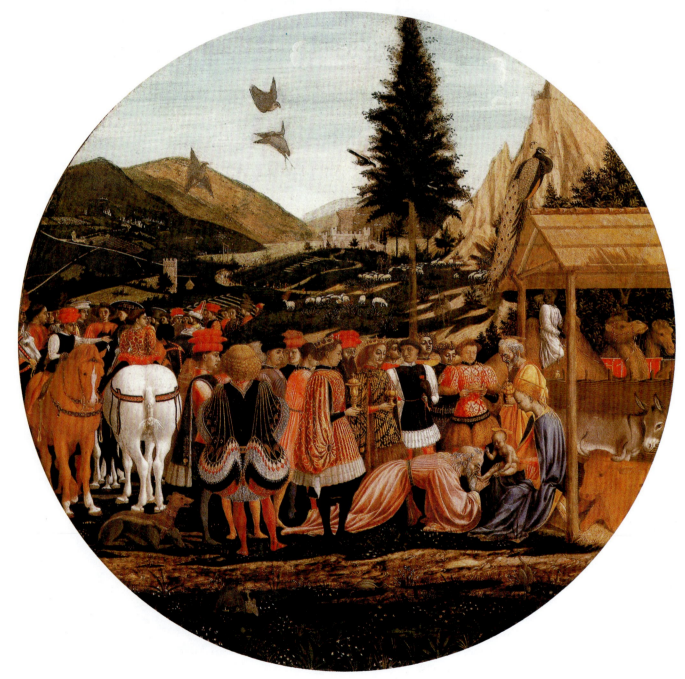

6.30
**Plate with the arms of
the Soderini family
of Florence. Produced in
Valencia (Spain),**
c. 1400–70. Majolica
(tin glazed ceramic).
British Museum, London

Accompanying Lo Scheggia's *Triumph of Fame* are great men of the classical and chivalric past, although the artist does not make their identities clear. Rather than depicting Fame in a chariot, he places her on top of an elaborate fountain-like structure, manifesting once again the powerful significance of the figure raised on a pedestal in Florentine culture, and at the Medici Palace in particular. The style is a simplification of the manner of Gentile da Fabriano and Uccello, prioritizing decorative effects with its symmetry and repetition of forms.

Related in format to the childbirth tray, although more varied in function and location, is the round religious painting known as the *tondo*, which became fashionable in the 1440s. We have already seen one example, the relief of the Virgin and Child on Rossellino's tomb of Leonardo Bruni (*see* fig. 6.17), but paintings of related subjects were more common. Domenico Veneziano produced a splendid example, possibly for the Medici, around 1440–43, depicting the Adoration of the Magi (fig. 6.29). The pageantry of gorgeous costumes and the depiction of animals make this painting the closest that any local artist ever came to the work of Pisanello, with whom Domenico shows evident familiarity, although he

locates these features in the kind of spacious landscape more characteristic of his own generation of Florentines.

What other kinds of artifacts could be found in a Florentine private palace? Painted majolica (fig. 6.30), imported or produced in the Central Italian towns of Deruta or Faenza, was a highly prized commodity. Panel paintings portraying individuals were becoming more common: those that survive from before 1450 are almost always of male sitters depicted in profile, in response to the convention familiar from ancient coins and the more recent portrait medals of Pisanello (*see* figs 5.18–19): the portrait of Matteo Olivieri, probably painted by Domenico Veneziano around 1440 (fig. 6.31), is a characteristic example. More unusual is the female profile painted by Lippi around 1444 (fig. 6.32). The painting does more in this case than record a likeness: the unknown woman wears sumptuous velvet brocade with a saddle-shaped headdress and jewels, apparel frequently censured or even banned in public. She is placed in an interior and engaged in a mysterious transaction with a male figure whose profile appears at a window casement. The motto LEALTA ('loyalty') appears on her red sleeve. To whom is such loyalty being professed? To the man who engages

6.31
Domenico Veneziano (or copy after?), *Matteo Olivieri, c.* **1440.** Tempera on fabric transferred from wood, 18⅞ × 13¼" (47.95 × 34.14 cm). National Gallery of Art, Washington, D.C.

MATHEVS OLIVIERI DÑI IOANNI FILI

her by the window – or to another, whose wife she has become? In fact, it is now uncertain (and probably always was) whether the woman is a portrait or a creation of poetic fantasy. Lippi's image constructs the domestic interior as not only a private but also a female space, one where luxury could not easily be regulated by law and where secret thoughts and fantasies could be entertained. The "portrait," however, also imagines the permeability of this confined female world: women did display themselves at windows, where they could attract the gazes of passers-by, and they paid more than slight attention to the world outside the palace walls.

The wooden furnishings of important rooms often incorporated painted panels as an integral part of the decoration. Horizontal panel paintings adorned the splendidly decorated *cassoni*, chests that accompanied a wealthy bride to her new home. The chests contained the precious textiles that formed the bride's provision from her own family. (Titian shows such a chest in the background of his later *Venus of Urbino*; **see** fig. 15.3.) The main surface was often painted all over with narrative scenes, including a dozen or more episodes of a story from ancient history or mythology, with hundreds of figures. Sometimes the inner lids of the *cassoni* were

6.32
Fra Filippo Lippi,
*Portrait of a Woman and
a Man at a Casement,
c.* 1444. Tempera on
panel, 25¼ × 16½"
(64.1 × 41.9 cm).
Metropolitan Museum
of Art, New York

painted with sensuous reclining nude male or female figures (fig. 6.33), in the belief that the very sight of beautiful bodies could enable pregnant women to conceive and deliver healthy and handsome children. The so-called "Adimari Cassone" (fig. 6.34) by Lo Scheggia from the 1440s is not a *cassone* (nor was it made for the Adimari family) but is rather likely to be a **spalliera** panel, set into a wooden surround at shoulder level (*spalla* is Italian for "shoulder"). The panel is especially remarkable in that it depicts a contemporary Florentine celebration, possibly of a marriage or of the Feast of St. John on 24 June: the latter possibility would explain why the Florence baptistery appears so prominently. Splendidly dressed couples dance in formation under awnings outside a palace; a group of wind players, depicting the ensign of the *signoria* who normally employed them, provide the accompaniment. Festivities like this provided an occasion for the display of private wealth, and the painting shows that the display could occur in the city streets, and

with conspicuous civic symbols. The Florentine elite justified their lavish expenditure on weddings, christenings, and funerals with the rationale that these added to the glory of the city.

Such conspicuous luxury, whether in the form of ephemeral celebrations or of monumental building, was not without an element of competition or rivalry. Although the authority of the Medici was well established in Florence by the 1440s, a number of other wealthy families quietly resented their prominence, and challenged it in their own equally visible commissions. Among these were the Pazzi, who like the Medici ran an important international bank. Seeing the Medici use the sacristy of San Lorenzo as a burial chapel, the Pazzi in 1442 commissioned Filippo Brunelleschi to design theirs (fig. 6.35) as the chapter house of Santa Croce, where it opens off one of the main cloisters. Its wall treatments, with Corinthian pilasters and evocations of Roman triumphal arches, represent both a variation on and an enrichment of the Old

RIGHT

6.33

Paolo Schiavo, *cassone*, opened to show nude from interior, 1440s. Statens Museum for Kunst, Copenhagen

BELOW

6.34

Lo Scheggia, *spalliera* with scene of a public festival ("Adimari Cassone"), 1440s. Accademia, Florence

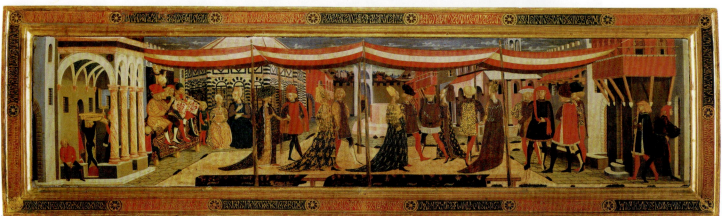

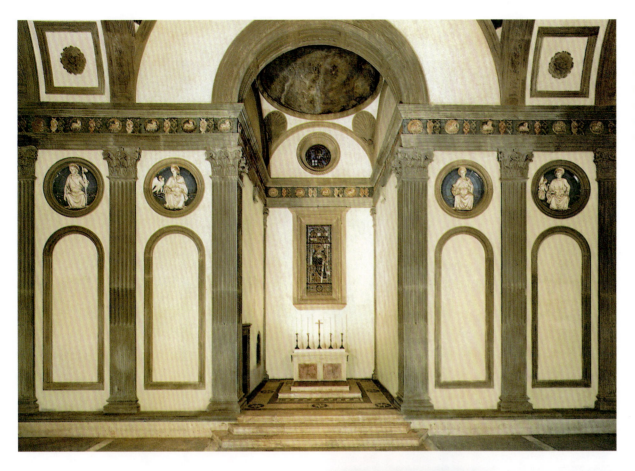

Sacristy (*see* fig. 4.12); the bays are adorned with *tondi* of the twelve Apostles by Luca della Robbia, and the pendentives of the dome present richly colored figures of the Evangelists, a deliberate contrast with the sober white, gray, and blue of the lower parts of the chapel. In the 1460s the Pazzi would also commission their own palace (fig. 6.36), from Giuliano da Maiano (1432–1490). It had a **rusticated** lower storey, though the smaller scale of the stones and the plain **stucco**-work of the upper facade make the whole building less overbearing than the Medici building that had spurred them to commission it.

Civic Patronage and the Church: Venice and Padua

The use of art to mediate between the sacred and the profane, as well as between the public and the private, was not unique to Florence. We have already seen one example of a private Venetian palace, the Ca' d'Oro (*see* fig. 6.19), employing imported revetment, gold, and tracery decorations, all ornaments we might sooner associate with churches. Its combination of white Istrian stone and red marble, meanwhile, made the same kind of reference to public architecture that the Medici Palace in Florence did, in this case to Venice's Palazzo Ducale, or Doge's Palace (*see* fig. 5.26), the large complex adjacent

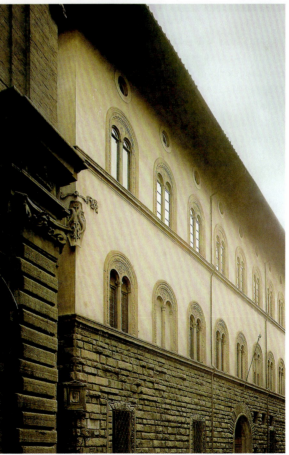

6.37

Antonio Vivarini and Giovanni d'Allemagna, *Virgin and Child with Saints,* 1446. Oil on canvas, 11'3½" × 15'7¾" (3.44 × 4.77 m). Galleria dell'Accademia, Venice

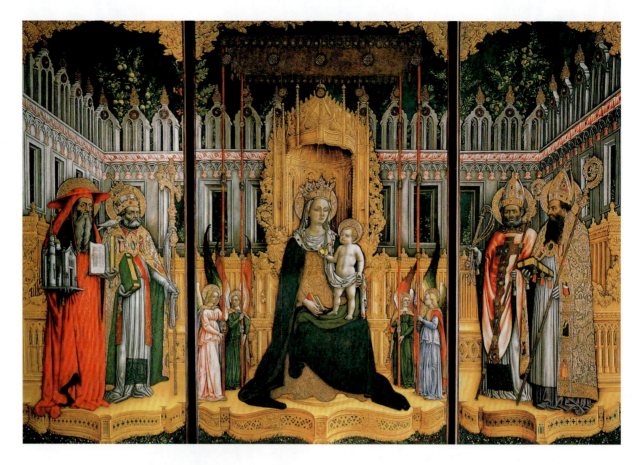

to San Marco where the Doge resided and the city's Great Council met. Giovanni Bon, one of the stonemasons who oversaw work on the Ca' d'Oro, moved on to work at the Doge's Palace, for which he and his son Bartolomeo provided the Porta della Carta (*see* fig. 5.27), completed in 1442. Part of the function of the Porta was to unify the adjacent worlds of church and palace, of sacred space – the basilica of San Marco – with the building that housed the Venetian government and elected ruler.

As in Florence, moreover, patronage by private individuals and families in Venice was less conspicuous than initiatives by the state and by corporations. The most important Venetian corporations were not the guilds, as in Florence, but confraternities known as *scuole*. Most *scuole* were groups of lay people who gathered for prayer before specially designated altars in parish churches, but the great *scuole*, or "Scuole Grandi," were elite organizations, their membership drawn from the highest class of *cittadini,* or non-nobles, who constructed palatial buildings to house their meetings, charitable activities, and communal devotions. The boardroom of the Scuola della Carità was decorated with a great triptych on canvas, *Virgin and Child with Saints* (fig. 6.37), painted in 1446 by the workshop of Antonio Vivarini and Giovanni d'Allemagna. Depicting the Virgin and Child with a group of saints in a splendid Gothic architectural setting, it served as an image for communal devotion while also representing the confraternity and its members. The *scuola* was devoted to acts of charity, and in this picture, St. Jerome holds a book open to a passage exhorting beholders to despise riches and give to the poor. The staggering splendor of the golden throne and stalls, the gilded fruit and foliate ornament that echo the real vegetation in the garden beyond, the simulated brocades and crowns in raised patterns, the expensive colors, including **indigo** and ultramarine: all of this might today seem contrary to the work's basic point, but to a contemporary audience it would have asserted that the only true wealth was to be found in heaven.

Venetians had long regarded the Virgin Mary (as the Florentines regarded John the Baptist and the Romans Saints Peter and Paul) as a symbol and protector of their state. Beyond its inclusion of the image of the Virgin, the style in which the work was painted also signaled the patriotic identity of the *scuola*: the elaborate Gothic ornament of the setting would have evoked the rich architectural ornament of the Doge's Palace, the residence of the Republic's elected prince and the city's other governors. By casting the triptych format as a continuous space, Vivarini and his partner showed their consciousness of recent Florentine innovations – the Florentine Filippo Lippi had painted such a unified triptych in Venice's subject city of Padua in the previous decade – though as

ABOVE

6.38

Andrea del Castagno, *Benedictine Fathers and Apostles*, from the vault of the apse in the chapel of San Tarasio, 1442. Fresco. San Zaccaria, Venice

RIGHT

6.39

Andrea del Castagno (designer), *The Death of the Virgin*, *c.* 1430–50. Mosaic. Mascoli Chapel, San Marco, Venice

in Jacopo Bellini's drawings (*see* figs. 5.24–5.25), the relation to Florentine art is anything but complacent. In an adaptive fashion characteristic of Venetian artistic culture, the artists transform and translate the imported format.

A number of Florentine artists were active in Venice and the Veneto during this decade, their presence sometimes the result of Medici diplomacy: Cosimo had temporarily moved the Medici bank from Florence to Padua while exiled there in 1433–34, and his authority was still strong in the region. For the Observant Benedictine nuns of San Zaccaria in Venice, Castagno in 1442 painted a series of his characteristically sinewy and vigorous saints (fig. 6.38), in the Gothic vaults of the sacristy. Around the same time he designed a mosaic of the *Death of the Virgin* (fig. 6.39) for a chapel in the basilica of San Marco in Venice, though his designs were probably only executed

OPPOSITE

6.40

Jacopo Bellini (designer),
Visitation, c. 1450.
Mosaic. Mascoli Chapel,
San Marco, Venice

LEFT

6.41

Donatello, Santo altar,
1447–50. General view
of present installation.
Basilica del Santo, Padua

later in the decade and even modified by other artists. Castagno's contribution consists of the group of Apostles, the Virgin on her bier, and Christ appearing overhead in a **mandorla**. The architectural elements behind appear to have been added subsequently to the figure composition: Castagno, as we have seen, was generally more adept at locating his figures within painted architecture. Moreover, the style of the architecture is closer to the monumental and richly adorned buildings that appear in the drawing books of Jacopo Bellini (*see* figs. 5.24–5.25). In the same chapel Bellini designed the flanking scene of the *Visitation* (fig. 6.40), where the figures are, again by contrast, located within the pictorial space, and it was probably he who supplied the background for Castagno's composition.

Donatello in Padua

In the period he was working on the *David* and the *Judith*, Donatello found himself drawn between palace and church commissions. He spent roughly a decade (1443–53) working in Padua, notably at the great Franciscan pilgrimage church of St. Anthony – known as the Santo – where he carried out a massive altarpiece with seven near-lifesize figures in bronze and more than a dozen bronze reliefs depicting angels and episodes from the life of St. Anthony, together with a marble relief of the Entombment of Christ (fig. 6.41). The ensemble was dismantled in 1579 and the present reconstruction dating from 1895 bears little relation to Donatello's installation in 1450. It is necessary to imagine a temple-like

6.42

Donatello, *The Miracle
of the Newborn Child,*
1447–50. Bronze with
gilding, 22½ × 48½"
(57 × 123 cm). Basilica del
Santo, Padua

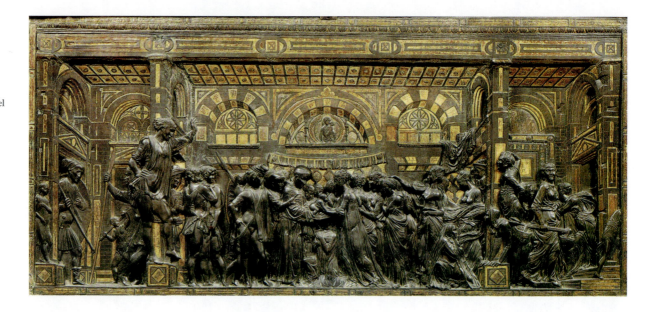

structure housing the Virgin in the company of three saints representing the Franciscan Order (Francis, Anthony, and Louis of Toulouse), and three others from the city of Padua (Prosdocimus, in bishop's vestments; Giustina, crowned; and Daniel, holding a model of the city). The great Crucifix pertains to an independent commission by Donatello and was not originally part of the altarpiece.

The exact original disposition of the other parts, moreover, remains uncertain, and possible reconstructions produce strikingly different effects. Did the gestures of Giustina and Daniel originally designate and acknowledge the congregation, beckoning pilgrims to approach the altar, as they do now? Or were their positions switched, such that their gestures rather directed the beholder toward the Virgin and Child – much like the attitudes of St. John in Domenico Veneziano's St. Lucy altarpiece (*see* fig. 6.11) or Cosmas in Fra Angelico's San Marco panel (*see* fig. 6.5)? Slightly rearranged, the altarpiece becomes more introspective and self-enclosed in character, like Vivarini and Giovanni d'Allemagna's *Virgin and Child with Saints* (*see* fig. 6.37): the saints become contemplatives in a state of otherworldly beatitude. The viewer would in that case relate to the altar primarily through the confrontational pose and penetrating stare of the Virgin, austerely frontal and symmetric as she holds the child directly before her (fig. 6.42). Donatello surrounds his Christ with a mandorla of drapery that makes the Child appear to emerge from her body. The composition derives from an older icon of the Virgin and Child, yet with his frown and urgent gesture of blessing, Christ seems more human than the otherworldly Virgin, a disquieting composite of ancient statuary and pagan motifs: her head is reminiscent of a Roman or Hellenistic

goddess, but crowned by "living" cherubim; the throne is composed of lion claws with human heads, probably designating sphinxes that (as we saw with Castagno, *see* fig. 6.16) served as a symbol of enigma.

The four rectangular bronze reliefs recount miracles attesting to the sainthood of Anthony. Like the narrative paintings of Fra Angelico and Domenico Veneziano (*see* figs. 6.5–6.8, and 6.11–6.15), these aimed to produce marvel and wonder. With an eye on Ghiberti's second set of baptistery doors, Donatello crowded his compositions with a throng of figures who react to what they see with passionate astonishment: through the saint's agency, a newborn infant speaks in defense of his mother's chastity; a self-mutilating penitent has his severed leg reattached; a donkey converts a skeptic by kneeling in reverence before the Eucharist; and an autopsy on a miser reveals his heart not to be in his chest but in his money box.

Donatello uses perspective to enrich and complicate the space in which the action unfolds, superimposing screens of architectural elements as he did in his earlier *Feast of Herod* for Siena (*see* fig. 4.13), though the illusionistic architecture now has a vastness and monumentality with little precedent in Florentine art. This has to do in part with the scope afforded by the extended horizontal relief format, but it also suggests that Donatello was in touch with Jacopo Bellini and knew that artist's drawing books with their panoramic landscapes and architecture (*see* figs. 5.24–5.25). *The Miracle of the Irascible Son* (fig. 6.43) uses the architecture of a stadium to magnify the diminution between the main figures in the foreground plane and the smaller figures that appear to watch from the far distance. The monumental three-naved basilica in *The Miracle of the Ass* (fig. 6.44) uses architectural motifs also found in Bellini's drawings. The

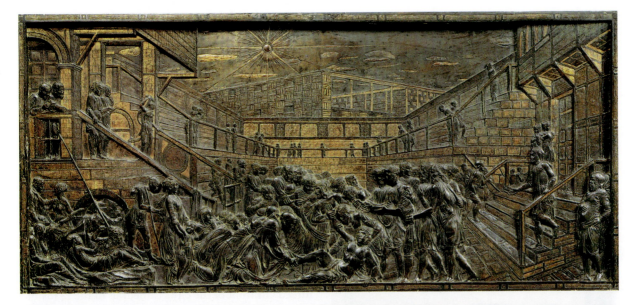

6.43
Donatello, *The Miracle of the Irascible Son*, relief from the Santo altar, 1447–50. Bronze with gilding, 22½ × 48½" (57 × 123 cm). Basilica del Santo, Padua

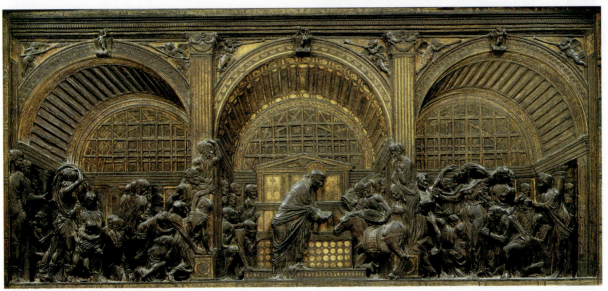

6.44
Donatello, *The Miracle of the Ass*, relief from the Santo altar, 1447–50. Bronze with gilding, 22½ × 48½" (57 × 123 cm). Basilica del Santo, Padua

gold highlights in *The Irascible Son* suggest the effects of the blazing sun (which appears overhead), but as with all the architectural settings in the Santo series, they also evoke the shimmering, mosaic-clad interiors of the basilica of San Marco.

Siena: Civic and Sacred Space

In Siena as in Florence and elsewhere, the public space adjacent to major public buildings like the Palazzo Pubblico was always potentially sacred space. Just as the city palace contained chapels and altars, so too did the great piazza outside. Close to the outdoor altar of the palace, preachers mounted temporary pulpits to address the assembled populace in lengthy yet colorful sermons.

In 1444 the great Franciscan preacher Bernardino of Siena died and instantly became the focus of a popular cult, especially in his native city. In 1445, even before he was officially canonized, a Sienese confraternity known as the Company of the Virgin commissioned an altarpiece from Sano di Pietro (1406–1481) with Bernardino as its protagonist (figs. 6.45–6.46). Sano and his fellow artists effectively had to invent the iconography of a new saint. The central panel most likely showed a single figure of Bernardino, possibly in carved wood.

The most remarkable features of the altarpiece, however, are the two panels that originally flanked this. These depict the saint's most characteristic activity: his delivery of sensational, witty, and badgering sermons before huge outdoor crowds at the city's town hall and at its most important churches. On one wing of the original

altarpiece, Bernardino preaches about the Crucifix in the square before the cathedral of Siena, while on the other he displays the IHS monogram (an abbreviation for the name "Jesus" in Latin) to a crowd – segregated by gender – in the Piazza del Campo. Bernardino promoted the IHS monogram as a kind of verbal icon and as the focus of a devotional cult. Along with the saint's toothless, sunken-cheeked visage (probably based on a death mask), the monogram would become an indispensable aspect of future Bernardine iconography. The panel, unprecedented in its rendering of contemporary urban topography, shows that the city of Siena had already taken up the IHS as a civic motif – it is emblazoned on the walls of the Palazzo Pubblico.

The altarpiece was eventually installed in a public building: the renowned Sienese hospital of Santa Maria della Scala, a major focus of civic patronage located directly in front of the city's cathedral. In the 1440s the city commissioned a monumental program of frescoes for the male dormitory there, depicting the foundation's

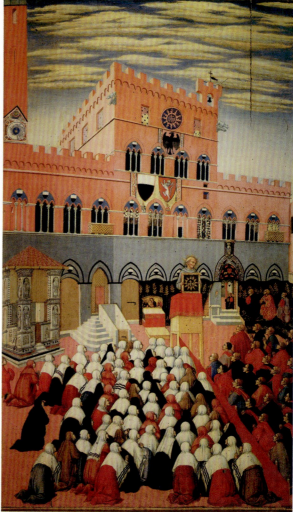

6.45
Sano di Pietro,
St. Bernardino Preaching at the Siena Duomo, 1445–47.
Museo dell'Opera del Duomo, Siena

6.46
Sano di Pietro,
St. Bernardino Preaching in the Campo, 1445–47.
Tempera on panel, 63¾ × 40" (162 × 101.5 cm).
Chapter house, Siena Cathedral

history and its range of charitable and medical services. Domenico di Bartolo's (*c.* 1400–*c.* 1447) *Care of the Sick* (fig. 6.47) is a rare surviving example of a public commission made to record an activity of contemporary urban life, and it gives a remarkable degree of attention to documentary and anecdotal detail: the artist does not use perspective to construct an abstract, geometrically perfect space but to depict a contemporary institutional interior. To the left a physician examines a flask of urine while an orderly cradles an emaciated patient; a surgeon examines a shivering nude youth with a wounded thigh who bathes his legs in a copper basin; a corpulent friar hears the last confession of a dying man while a dog and cat (maintained as a form of pest control) square off in a noisy confrontation. Domenico lavishes attention on the still life of bottles and jars over the bed of the confessing patient, the boy's submerged foot, and the shadow of a candelabrum on the terracotta tiles. Above all, the fresco proudly displays what would at the time have been considered exemplary standards for the care of the sick. Such self-celebration by a public institution in such an innovative idiom of matter-of-fact description has no obvious parallel elsewhere in Italy at this time.

Sienese artists were in demand in the smaller towns of southern and eastern Tuscany, although in such locations they were expected to work in a more abstract idiom consistent with art from the time of Duccio. In 1444 Sassetta), the city's longest-established and most successful artist, completed a large double-sided polyptych for the Franciscan church in Borgo San Sepolcro, a town in the mountainous eastern frontier of Tuscany. The front of the altarpiece (fig. 6.48) depicted the Virgin and Child with a court of angels, an iconography reminiscent of Duccio's similarly double-sided *Maestà* (*see* figs. 1.26–1.28); saints Anthony of Padua, John the Evangelist, Augustine, and the local *beato* Rainiero originally appeared on flanking panels. The gold ground and linear flattening of three-dimensional forms to assert the picture surface likewise proclaim the vitality and authority of the tradition of Duccio. Yet such conservatism could also be a stimulus to innovation, especially at the level of pictorial meaning.

RIGHT, ABOVE
6.47
Domenico di Bartolo,
Care of the Sick, **1440–47.**
Fresco. Pellegrinaio,
Hospital of Santa Maria
della Scala, Siena

RIGHT
6.48
Sassetta, *Virgin and Child*
with Angels **(main tier front**
of San Sepolcro altarpiece).
6'9" × 3'10" (2.05 × 1.19 m)
(original panel 2.02 ×
1.19 m). Musée du
Louvre, Paris

ROMAN PILGRIMAGE IN THE HOLY YEAR OF 1450

In the Holy Year of 1450, most European pilgrims approached Rome from the north, on the ancient Roman road known as the Via Flaminia. They entered at the fortified gate by the eleventh-century church of Santa Maria del Popolo, and from there could continue into the heart of the old city along the Via Lata (now known as the Corso). The Via Lata ran as far as the Capitoline Hill, the seat of Rome's municipal government; a building housing the magistrates known as the Conservators and another that served as a palace for an officer called the Senator were in 1450 being restored at the initiative of Pope Nicolas V himself. The pilgrims' principal objective was to obtain spiritual benefit in the form of **indulgences** (remission of sins and the punishment due to them in **Purgatory**) by visiting sacred sites, mostly associated with the great Early Christian churches (known as basilicas) founded under the first Christian emperor, Constantine; there were numerous other holy sites and "marvels" of the ancient city to see along the route. To visit San Lorenzo fuori le Mura ("outside the walls") to the east, or San Paolo fuori le Mura to the south, pilgrims had to pass through vast uninhabited tracts, neighborhoods from the ancient city that had in the Middle Ages been given over to farming or turned into feudal strongholds of Rome's baronial families. A body of early guidebooks known as "Marvels of Rome" relayed the experience through pilgrims' eyes. These sources described the various saints' relics and miracles of Christian Rome along with popular stories conveying the mixed fear and admiration that still attached to the remains of the pagan city.

Following its return to Rome in 1420, the papacy had collaborated with the civic government to improve the city's tattered infrastructure and to restore its venerable churches. In 1450, however, most of Rome's streets were still haphazard passages between buildings erected randomly over the centuries. The ancient Via Lata was one of very few streets that was both straight and paved. Another was the Via Recta, which ran west toward the Tiber and to one of the few means of crossing it, the Ponte Sant'Angelo. Passing the fortress of Sant'Angelo, originally the mausoleum of Emperor Hadrian, the pilgrim traversed the neighborhood known as the Borgo and reached the Vatican and the basilica of St. Peter's,

6.49
Masolino, *Founding of Santa Maria Maggiore,* c. 1425–28. Panel, 57 × 30" (144.5 × 76 cm). Capodimonte Museum, Naples

recently the focus of the Pope's most ambitious renovation projects, and the main seat of papal ceremony – pilgrims would have sought to attend a papal blessing, as they do today. To the south, near the site of St. Peter's martyrdom at San Pietro in Montorio, was the basilica of Santa Maria in Trastevere, embellished with spectacular mosaics in the late thirteenth century. Heading back north and across the river, visitors could take the so-called Via Papalis or, further on, the Via del Pellegrino, which led to the lively downtown market area known as the Campo dei Fiori. Passing the old Forum, used as a grazing ground for cattle, and the Colosseum, then venturing further to the south east, they could visit the basilica of Santa Croce in Gerusalemme, founded by St. Helen, the mother of Constantine: it preserved relics of blood-soaked earth from the Holy Land and a miraculous mosaic of the Dead Christ commemorating a vision of Pope Gregory the Great.

Perhaps the most important site along the route was St. John Lateran, officially the cathedral of the city of Rome and the symbol of the transfer of authority from the empire to the papacy. The Lateran basilica, built on the site of an imperial palace, was also the site of the "Holy of Holies," a chapel containing some of the most sacred relics in Christendom, including the Acheiropoeta, a miraculous portrait of Christ "not made by human hand." Many of the relics were supposed to have been brought to Rome by Emperor Titus following his destruction of the Jerusalem Temple in 70 CE. Like Santa Croce, the chapel represented Rome's claim to have surpassed Jerusalem as the holiest city on earth. In the Lateran Baptistery pilgrims could visit a porphyry basin in which Constantine himself was allegedly baptized. Nearby, raised on columns and plinths, were an assortment of ancient sculptures that commemorated the pagan and imperial origins of the city and its surrender to Christianity: among these were fragments of a colossal statue of Constantine; a bronze equestrian statue of Marcus Aurelius believed to represent the first Christian emperor (*see* fig. 5.17); a bronze she-wolf associated with the twins Romulus and Remus, founders of Rome who were raised by a wolf in the wilds; and the *Spinario*, or "Thorn Puller" (*see* fig. 2.12), described in *The Marvels* as an idol.

St. John Lateran was still a focus for a great procession every Holy Thursday expressing the unity of the papacy with Rome's clergy and its people; although restored under Martin V, since the return of the papacy the Lateran had been eclipsed as a focus of papal patronage by St. Peter's, and by Santa Maria Maggiore to the north. This church, especially promoted by Martin's family, the Colonna, was the most important in Christendom dedicated to the Virgin Mary: among its chief relics were the cradle of the Christ Child and an icon known as the Salus Populi Romani ("Welfare of the Roman People"), expressing the privileged relation of the city of Rome to the Virgin (fig. 6.50). In 1427 the Colonna invited Masaccio and Masolino from Florence to execute a double-sided altarpiece showing the *Assumption of the Virgin* on one face, with the basilica's foundation legend on the other (fig. 6.49): a miraculous fall of snow in August, sent by the Virgin in 352 CE to indicate to Pope Liberius the site of the new basilica in her honor.

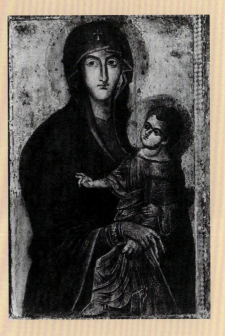

6.50
Icon of the Salus Populi Romani, fifth century CE (?). Santa Maria Maggiore, Rome

6.51
Sassetta, *St. Francis in Ecstasy*, 1437–44. Tempera on panel, 80¾ × 48" (179 × 58 cm). Berenson Collection, Villa i Tatti, Florence

On the side facing the choir (fig. 6.51), primarily visible to the Franciscan friars, Sassetta painted a remarkable image of St. Francis in ecstasy, levitating over a lake as he tramples on the Vices of Luxury (a woman with a mirror reclining on a pig), Vainglory (a warrior with a lion), and Avarice (a nun squeezing a purse in a vice). The virtuous counterparts of these vices appear around Francis's head: Chastity (in white), Obedience (with a yoke), and Poverty (in a patched Franciscan habit). The rigorous symmetry of the saint in a mandorla of seraphim (a symbol normally used only for Christ and the Virgin) and the almost circular geometry of his head, surrounded by a flaming halo, blatantly assert Francis's divine and messianic nature. This reinforces a controversial claim maintained by some members of the Order that Francis, more than any other saint, was an "alter Christus," another Christ. The complex was dismembered in 1752, but a widely accepted reconstruction places the depiction of Christ's Passion in a series of predella panels below, underscoring the identification. Flanking the central altar panel were eight scenes of the life of St. Francis, arranged in two tiers (again in a format similar to one that Duccio had employed). Yet in these narrative scenes Sassetta adopts an idiom more reminiscent of Fra Angelico or Pisanello: in its handling of space and consistent fall of light, his *Stigmatization of St. Francis* (fig. 6.52) bears comparison with Domenico Veneziano's contemporary version in the St. Lucy altarpiece (*see* fig. 6.12).

Palermo: from Palace to Hospital

Renaissance private palaces were capacious structures that to this day have regularly been adapted for new uses. Such was the case with the palace of the Sclafani counts in Palermo, Sicily; in 1435, with the last member of the family re-established in Spain, King Alfonso I of Aragon and Sicily authorized the conversion of the large palace into a new central hospital for the city, at the time subject to frequent outbreaks of plague. Around 1445, as the Pope was granting special benefits to the new foundation, a large mural (fig. 6.53) was commissioned for the wall of the courtyard. The alarming image contrasts sharply with the reassuring portrayal of administrative order we saw in the contemporary murals for Siena's chief hospital (*see* fig. 6.47). A festive gathering of splendidly attired and bejewelled aristocrats is under attack by a horrifying skeletal figure on a massive cadaverous horse. This is Death, who has laid waste to the company with his arrows. Although a few of the women make gestures of dismay, most of the assembled people are too absorbed in their elegant pastimes – playing music,

6.53

Unknown artist, *Triumph of Death*, 1445. Fresco from Palazzo Sclafani; now in the Gallery of Regional Art at Palazzo Abatellis, Palermo, Sicily

conversing by a fountain, preparing for a hunting expedition – to notice that their companions have suddenly met their end. Even more illustrious victims pile up beneath the horse: friars, two popes, a cardinal, and a turbaned ruler (perhaps a ruler of Tunis, not far to the south). To the left, a group of poor men and women appear to regret that Death has passed them by, since only he could have put a stop to their sufferings – a theme with a special charge in an institution devoted to the care of the

dying. Two figures in this group appeal directly to the beholder. One of them, holding a maul stick and brush, is clearly the painter; the man to his right could conceivably be the hospital official or donor who commissioned the fresco as a work of piety and charity. The artist's pose and address to the viewer parallel those of the solemn musician on the far right, as if raising questions about the status of his profession: is painting a liberal art (*see* p. 125), like music? And, if so, is it implicated in the world

of ephemeral concerns being swept away here by Death, or does it have a more positive capacity to reveal truth and teach the values of a virtuous life?

The identity of the artist and his origin are much debated: it has been proposed that he is Catalan, or Aragonese, or Burgundian, or Lombard, or Ferrarese, or Neapolitan. That ambiguity is itself an index of the cultural diversity of maritime Italy, especially in the south. By 1445, Sicily was part of a polyglot kingdom that included the Spanish territories of King Alfonso, together with the Kingdom of Naples, which he had conquered in 1442. He ruled over the largest territorial state in the Mediterranean, and artists with diverse origins and training worked throughout his dominions.

The Vatican Papacy and the Embellishment of St. Peter's

Rome in the 1440s was a politically troubled city, and Pope Eugenius IV spent little time there. Nonetheless, he followed his predecessor Martin V's example by residing primarily at the Vatican palace, and by his embellishment of St. Peter's, where he was crowned and eventually buried. The relation of St. Peter's and the Vatican – a ruler's residence with a great pilgrimage church attached – paralleled that of the Doge's Palace and San Marco in Venice, and established a model for the Medici in their coupling of family palace with a major sacred site: Eugenius was well aware of what the Medici were doing at San Lorenzo. In 1438 he ordained that St. Peter's should have its own set of monumental bronze doors (fig. 6.54), a commission that was to take twelve years to complete. Romans and visitors alike would have seen the doors as an emulation of those on the Pantheon, an ancient temple that had come to serve as a Christian church. The sculptor, known as Filarete (c. 1400–1469), was a Florentine, and he would have known the contemporary works of Ghiberti and Donatello. He seems to have resisted making anything that would resemble the doors of Florence's baptistery or the San Lorenzo sacristy, however. Filarete combined different forms of relief to create a hierarchy of visual information. Four large panels present Christ, the Virgin, and Saints Peter and Paul. At top right Peter gives the keys of the Church – designating supreme authority – to Eugenius, a charged theme in a period when councils of clergy and Roman political factions defied the Pope's decrees and sought to depose him. Two square panels below depict the martyrdoms of Peter and Paul, Rome's patron saints. The smaller reliefs between these panels depict the recent diplomatic and political successes of Eugenius's fragile papacy, including the Council of Ferrara-Florence

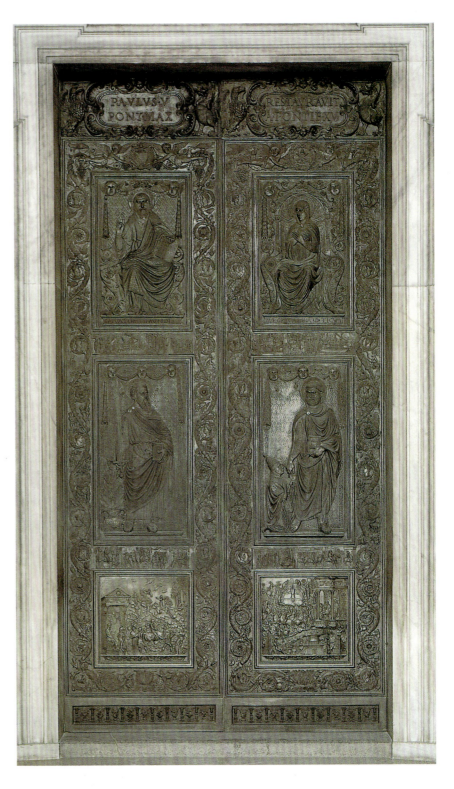

6.54
Filarete, doors of Old St. Peter's, completed 1445. Silver-gilt bronze, 20'8" × 11'9" (6.3 × 3.58 m). St. Peter's, Rome

FLORENTIE

6.55
Filarete, doors of
Old St. Peter's, detail:
Martyrdom of St. Peter

in 1439 and the Pope's crowning of Emperor Sigismund in 1433.

The frontally displayed figures in the largest panels are rigid and utterly devoid of the weight shift characteristic of Donatello's figurative sculpture; Filarete seems to be evoking a style from eras past, that visible in early Christian sarcophagi and Byzantine ivories. The narrative reliefs (fig. 6.55) are notable for their avoidance of linear perspective, arranging elements of the story across the panel without regard for disparity of scale. If there is a principle of unity, it is more topographic than illusionistic. Peter was said to have been crucified "inter duas metas," that is, between the pyramid of Gaius Cestius and another pyramid that no longer survives. Filarete placed

depictions of the two monuments in the lower corners and the Crucifixion itself on a hill between and above these, across the River Tiber – almost certainly the site on the Janiculum marked by the church of San Pietro in Montorio. The mode of rendering itself derives from surviving ancient reliefs, such as those on the Column of Trajan. Filarete deliberately created a Roman style, drawing on the traditions of art in the city, and appropriate for a sacred site like St. Peter's.

In a treatise on architecture he would write some years later, Filarete proved highly critical of Donatello: "If you have apostles to do, don't make them seem like fencers, as Donatello did in San Lorenzo in Florence, that is, in the sacristy in the bronze doors." As Filarete saw it, Donatello had sought to display his own art before thinking about the appropriateness of his sculpture to its place. It is a critique that parallels the attack on "curiosities" by Fra Antonino with which we began this chapter: Filarete had an artist's sense of style as a communicative and expressive instrument, but was clearly concerned by the degree to which meaning can be perverted by the pursuit of novelty and the demonstration of virtuosity. For all of this, "curiosities" have an assigned place in Filarete's doors: visitors to St. Peter's who looked closely at the rich acanthus borders that surround the reliefs might have been surprised to discover figures from the pagan fables of the Roman poet Ovid (43 BCE–17 CE) and other poets, frequently erotic and violent in character (fig. 6.56): Europa, Hercules, Ganymede, Narcissus, Jason and Medea, Pan and Syrinx. Once again, the very nature of the sacred and the profane emerges through their juxtaposition – as if the integrity of each as a category was necessitated by the proximity of the other.

6.56
Filarete, doors of Old St. Peter's, detail: *Abductions of Europa and Proserpina*

1450–1460
Rome and Other Romes

7

7 1450–1460
Rome and Other Romes

The Model City

In 1411, the Byzantine scholar Manuel Chrysoloras wrote an extended comparison between the city of Rome, where Emperor John VIII had sent him on a diplomatic mission, and Constantinople, the capital of the Byzantine empire. His lively verbal portrait of the papal city concentrates on its famous pagan and Christian sites, its status as a living witness to the staggering military power and cultural authority of the ancient Romans, and its testimony to the ultimate triumph of Christianity over paganism. Proceeding in this vein, Manuel prepared his reader for the real point of his oration. "I think that our city is superior," he wrote, "for many things were made, and still exist, in Constantinople, that Rome does not have." While Rome had no real predecessors and satisfied itself by outdoing other cities:

> Constantinople looked at this model as an archetype (for that is how Rome is correctly seen), brought many things to greater perfection and splendor. The works of men competing with others can progress to greater beauty.

Unlike many of his Italian contemporaries, Manuel believed that the preceding centuries had witnessed a history of progress and innovation rather than one of decline and decay. Whereas the ruins of Rome filled such Italians as the poets Petrarch and Dante with despair, since they were a reminder of an Italian greatness that could never exist again, Manuel saw Rome as an "archetype," a model to be imitated and surpassed.

To Manuel, "Rome" was as much an idea as an actual place. It signified the idea of the Center, the nucleus of a well-ordered, disciplined, and hierarchically organized authority. If the world could be conceived as a body, then Rome was its head, the *caput mundi*. That role, however, did not need to be played by the actual city of the Colosseum and the Pantheon. Like the so-called Holy Roman emperors of northern Europe, the Byzantine emperors claimed to be the true heirs of the authority of the Caesars, and they regarded the place where they resided as the true *caput mundi*, the "new Rome."

Manuel wrote during the Schism, when rulers in different cities claimed to be Pope. After Martin V had established Rome as the papacy's uncontested seat in 1420, he and his successors began seriously to pursue the objective of restoring that city to a state that would physically embody its status. Inspired in part by Petrarch, who had given voice to the hope that the depopulated and disorderly shadow of the universal capital might rise again to a semblance of its former glory, the popes' rhetoricians and image-makers portrayed them as natural successors of the Caesars. The reasons were practical as well as symbolic: thousands of pilgrims converged on Rome every year to revere the relics (miracle-working remains) of St. Peter, the Apostles, and countless other saints. The Pope's authority rested on his being clearly associated with the means by which Christians obtained their salvation, and the Rome pilgrimage and its related rituals were of key importance. By staying in Rome, the popes could cultivate their association with St. Peter, to whom, they maintained, Christ had passed authority to oversee all of Christianity. They could also advance claims founded on the legend of the Donation of Constantine, which asserted that the first Christian emperor (*r.* 306–37) had divided imperial power with the popes, leaving them in possession of Rome and the West when he withdrew to the Eastern capital he founded and named after himself.

These pursuits were not uncomplicated. In 1440, the Italian humanist Lorenzo Valla (1406–1457) had proved, sensationally, that the key historical document attesting to the Donation was a forgery. This discovery, presented to the world in the form of a passionate treatise that became a model of modern **philology**, threatened the papacy's temporal claims. Then there was the city of Rome itself, which presented its own obstacles to the exercise of papal authority. Crowded with pilgrims and lacking an adequate infrastructure of paved roads, water, and bridges, Rome was chaotic, squalid, and difficult to govern. It was dominated by aristocratic factions that entered frequently into open conflict with one another, refusing to acknowledge papal overlordship and seeking to control papal elections through family members in the College of Cardinals. Opponents of papal rule saw in cities like Florence or Venice a living example of

Rome c. 1450

Rome c. 1450, including the projects commissioned by Nicholas V

Republicanism, the form of popular government that had operated in Rome itself before Augustus established the first imperial dynasty at the end of the first century BCE. This inspired humanistically trained militants, such as Stefano Porcari, who led an uprising against Pope Nicholas V in 1453.

In theory, the territories directly subject to the papacy included not only the city but also a large portion of the central Italian peninsula. Over the preceding two centuries, however, the real reach of papal authority had been compromised by the feudal practice of appointing "Papal Vicars" among the local aristocracy, several of whom, such as the Malatesta of Rimini, the Montefeltro of Urbino, and the Este of Ferrara, succeeded in establishing dynasties with the prerogatives of ruling princes, who acknowledged only the nominal sovereignty of the papacy. South of the Papal States, the vast Kingdom of Naples had been conquered by the Spaniard King Alfonso of Aragon in 1443. Although he posed as a defender of the Church and maintained an uneasy

alliance with the papacy, Alfonso intended to extend his rule throughout central Italy and into Lombardy.

Architecture and Urbanism under Nicholas V

This situation lay behind Pope Nicholas V's determination to make the refurbishment of Rome an official aspect of papal policy. Nicholas (r. 1447–55) declared 1450 to be a Holy Year or Jubilee – a time in which pilgrims to Rome could secure special "indulgences". The prospect of as many as one million pilgrims – more than ten times the native population of the city – descending on Rome from all over Europe served as a stimulus to development, not least because it exposed the disparity between Rome's spiritual and historical importance and its actual conditions. In consultation with city officials and with such architects as the Florentine Bernardo Rossellino, Nicholas conceived an ambitious series of renovation projects. Newly paved roads and squares would improve circulation in the city. The main arterial streets, the Via

7.1

Basilica of Maxentius (Basilica of Constantine), Rome, 308–12 CE. View showing concrete vaulting

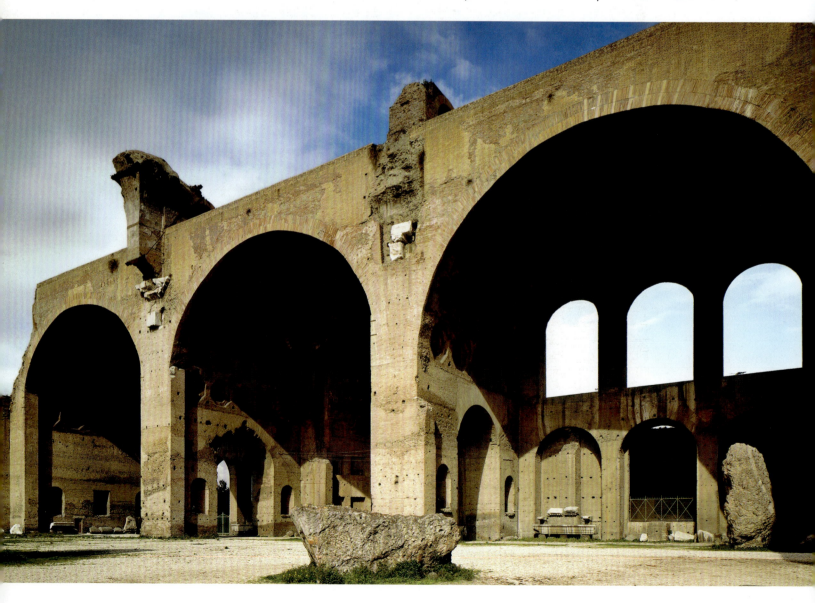

del Pellegrino ("Pilgrim's Way") and Via Papalis ("Papal Way"), would culminate in a new square at the River Tiber, where a refurbished bridge (Ponte Sant'Angelo) would conduct travelers to the papal fortress of Castel Sant'Angelo. The network of streets would facilitate access by pilgrims, while also making the tangle of ruins and haphazard medieval construction more penetrable by the forces of law and order. The densely populated neighborhood between the Castel and St. Peter's, known as the Borgo, was to be razed and rebuilt. Three broad, straight new streets lined by elegant porticos would afford access to St. Peter's and the Vatican Palace, expressing at the same time the social hierarchy of the Roman mercantile community: the bankers and luxury cloth merchants would have the central street, while artisans of the "middling" and "lowest" condition would each have one of the others. By collaborating with Roman civic officials, Nicholas hoped to persuade the Romans of the benefits of papal overlordship.

Nicholas, like several other fifteenth-century rulers, may have had some expertise as an architect, and he is credited with rebuilding his own palace when he served as bishop of Bologna. In Rome he devoted particular attention to St. Peter's (*see* fig. 1.5), the home of the relics of the first Pope and the site at which the popes had one of their two main residences. The worn fabric of St. Peter's itself was to be restored and partly rebuilt to accommodate greater numbers of pilgrims and Rome's enormous population of clergy during its ceremonies. It would have a new deep choir behind the main altar and an extended transept, with a central dome over the tomb of the Apostle; round windows, or oculi, in the dome would admit a flood of light to the transept and choir, evoking the glory of God. All of this would necessitate the replacement of St. Peter's wooden ceiling with masonry vaults, a transformation that would make the building even more lofty and imposing, recalling surviving ancient imperial structures, such as the basilica of Maxentius (fig. 7.1) and the Pantheon (fig. 7.2). A new piazza in front of the basilica was to be adorned with an obelisk, originally erected by Augustus at a site further to the west, accompanied by bronze statues of Christ and the Four Evangelists. The papal secretary Gianozzo Manetti, our source for much of this information, compared the St. Peter's project to the Ark of Noah, since it was similarly intended as a vessel of human salvation, as well as to the Temple of Solomon, the Parthenon, and the Seven Wonders of the ancient world.

Nicholas was aware that in undertaking such works, he ran the risk of violating the moralizing strictures against vainglory that had long been a staple of meditations on the ruins of Rome. Manetti ascribed to the Pope a long deathbed speech that justified his policy of conspicuous display:

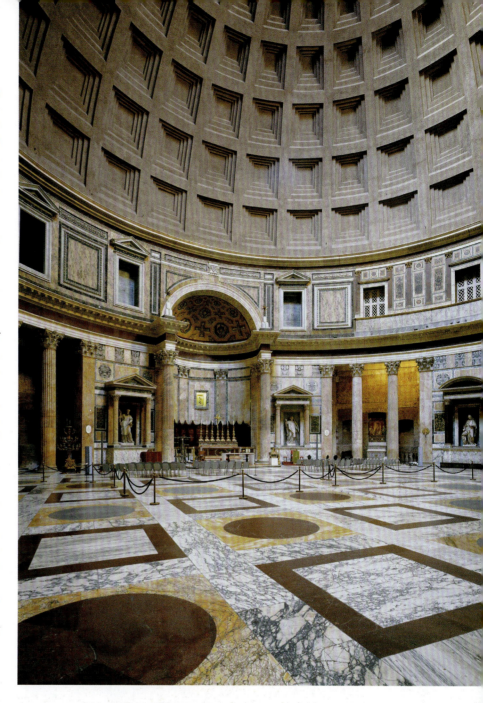

To create solid and stable convictions in the minds of the uncultured masses, there must be something that appeals to the eye: a popular faith, sustained only by doctrines, will never be anything but feeble and vacillating. But if the authority of the Holy See were visibly displayed in majestic buildings, imperishable memorials and witnesses seemingly planted by the hand of god Himself, belief would grow and strengthen like a tradition from one generation to another, and all the world would accept and revere it. Noble edifices combining taste and beauty with imposing proportions would immensely conduce to the exaltation of the chair of St. Peter.

If we had been able to accomplish all that we wished, our successors would find themselves more

7.2

The Pantheon, Rome, 126 CE. Interior. The figures in the tabernacles and some of the surface features were added after 1500.

respected by all Christian nations, and would be able to dwell in Rome with greater security from internal and external foes. Thus [we do this] not out of ostentation, or ambition, nor a vainglorious desire of immortalizing our name, but for the exaltation of the power of the Holy See throughout Christendom, and in order that future Popes should no longer be in danger of being driven away, taken prisoner, and besieged, and otherwise oppressed.

7.3

Fra Angelico, *The Legends of St. Stephen and St. Lawrence: Ordination of St. Lawrence*, completed 1448. Fresco. Chapel of Nicholas V, Vatican Palace

As the speech suggests, this was a crisis-ridden decade. The later years of Nicholas V's papacy were beset by a series of disasters, the most traumatic of which was the fall of Constantinople to the Ottoman Turks in 1453. In the wake of this, the goal of giving Rome the appearance of splendor and permanence acquired a kind of sacred

and moral urgency. The preservation and embellishment of Rome was a response to a new awareness of the fragility of what had seemed permanent and timeless.

Nicholas's resources did not match his ambitions. He was, very deliberately, planning and building on an imperial scale, and he gave less attention to practical considerations than to the calculation of a magnificent effect. Only a few of his initiatives were carried out. At a corner in Rome known as the "trivium" (literally, "the crossing of three streets"), he built a fountain in the form of a triumphal arch. This addition, the "Trevi" fountain, replaced in the eighteenth century by Nicola Salvi's crowd pleaser, was one of the first new public waterworks introduced into Rome since antiquity. At the center of the city, Nicholas contributed to the restoration of the government buildings on the Capitoline Hill. Reinforcing the city's Christian as well as pagan past, the Pope additionally restored churches associated with the early martyrs, including Santo Stefano Rotondo and San Lorenzo fuori le Mura.

At St. Peter's, Nicholas saw the start of the work, though his modifications were swept away by later popes with grander ideas. More lasting were his additions to the Vatican, the neighboring residence of the papal court. Here Nicholas provided new gardens and courtyards and a three-storey residential wing; he also took care to extend the palace's defensive fortifications. After the fall of Constantinople in 1453, finally, Nicholas made an urgent effort to save the cultural heritage of Greek and Latin Europe from obliteration. He charged the scholars in his employment with the salvaging of Greek books that had been dispersed by plunderers or by refugees, many of whom were arriving in Italy, and he thus founded the Vatican Library, still today one of the world's great research libraries.

Fra Angelico at the Vatican

As a scholar, Nicholas was committed to assessing the validity of textual sources and historical evidence. He was particularly interested in the cult of the saints, and sponsored a movement in the Church to rewrite their lives according to the criteria of classical historians. In contrast to *The Golden Legend*, an enormously popular late thirteenth-century anthology featuring gruesome sufferings and outlandish miracles, the humanist writers whom Nicholas supported treated the saints above all as inspiring examples of virtue. His role as a patron of literature was in this respect closely related to his other enterprises. The chief surviving figural work commissioned by Nicholas is the cycle of frescoes devoted to the lives of St. Stephen and St. Lawrence that Fra Angelico executed for the Pope's new chapel in the Vatican between 1448 and

Here, Lawrence epitomizes the virtue of Charity: his scarlet mantle is adorned with golden tongues of flame, alluding to the fires of Charity as well as to his impending martyrdom. Interrogated by Valerian, who insists on his handing over the treasure, Lawrence retorts with pious wit that the people are the treasures of the Church. He is imprisoned (his halo gleams in the dark of the prison as he converts his jailor) and then put to death by being roasted alive on a grill.

What most distinguishes these frescoes from Fra Angelico's earlier work at the convent church of San Marco in Florence (*see* figs. 6.4–6.8) is the importance of the architectural settings, which offer a symbolic commentary on the action and anticipate the antique splendor that Nicholas hoped to restore to Rome's sacred sites. These settings work to invest the early Christian buildings of the city as sites of memory, even as tangible links to the heroes of Christian antiquity that those buildings commemorate. Although the historical epi-

7.4

Fra Angelico, *The Legends of St. Stephen and St. Lawrence: Pope Sixtus Entrusts Lawrence with the Treasures of the Church*, completed 1450. Fresco. Chapel of Nicholas V, Vatican Palace

7.5

Fra Angelico, *The Legends of St. Stephen and St. Lawrence: Distribution of the Treasures*, completed 1450. Fresco. Chapel of Nicholas V, Vatican Palace

1450 (figs. 7.3–7.6). The two saints were objects of particular scholarly and devotional interest to Nicholas. In 1447, he had ordered an inquiry into the authenticity of relics, purported to be the remains of Stephen and Lawrence (the patron saints, respectively, of architects and of libraries), in the basilica of San Lorenzo fuori le Mura; he also renovated the main Roman churches dedicated to both of these saints.

Fra Angelico, in his mid fifties and with only a few more years to live, appealed to the Pope for several reasons: he represented the very best qualities of modern Florentine painting, his services were in high demand throughout central Italy, and he was in addition a Dominican friar, acquainted with the principles of theology and preaching. He had already decorated a chapel in the Vatican for the previous Pope, Eugenius IV, with scenes of the Last Judgment. Fra Angelico tells the stories of Lawrence and Stephen through episodes selected to emphasize a particular virtue, either of the saint himself or of the early Christian Church – concerns that were close to Nicholas. The Lawrence cycle begins with his ordination as deacon by Pope Sixtus II (*see* fig. 7.3). The following scene (*see* fig. 7.4) shows the Pope consigning the treasures of the Church to Lawrence as the soldiers of the pagan Roman emperor Valerian prepare to break down the door. In the next scene (*see* fig. 7.5), Lawrence distributes the treasure to the poor of Rome (thus implying that the Church, as a temporal power ruled by just government, provides for the needs of its population).

sodes themselves took place in Jerusalem, Fra Angelico's St. Peter ordains the deacon Stephen in a structure clearly supposed to evoke the basilica later founded in his name by Constantine, a church that Nicholas had rebuilt. The soldiers who come to arrest Lawrence gather at the door of the Lateran (*see* fig. 7.4), a papal residence built long after the saint's time; the soldiers' actions probably refer to the ceremonial opening of a bricked-up door at the basilica during a Holy Year. In the *Distribution of the Treasures* (*see* fig. 7.5), Lawrence is pointedly aligned with the apse and altar of another Christian basilica, which stands for the Church in general but more specifically evokes the basilica of San Lorenzo fuori le Mura. The message of these frescoes is about the special relation between saints and sites that operates in the city of Rome, whereby relics sanctify the structures that house them.

Another important theme of the two saints' lives as conceived by Fra Angelico and Nicholas is the power of oration and its impact on the hearer. Much of the very restrained action depicted in the scenes is a rendering of speech through gestures of the hands and the expres-sions of speakers and listeners. The paintings dwell on the various ways in which words can constitute actions: it is through the pronouncement of words, for instance, that the boys Stephen and Lawrence are raised to a junior level of the priesthood. Lawrence, famed for his verbal dexterity, taunts Emperor Valerian over his hunger for material treasure. As a preacher, Stephen commands the power of language to spread the Christian faith (fig. 7.6). Before his martyrdom by stoning, he rebukes the Jewish elders for their idolatrous faith in the material fabric of the temple: "Howbeit the most High dwelleth not in temples made with hands, as saith the prophet. Heaven is my throne, and earth is my footstool: what house will you build me? Saith the Lord" (Acts 7:48–49). Given Nicholas's investment in building, this might seem heavily ironic. Contemporary viewers, however, would have understood the magnificent buildings of Christian Rome as sites of sacred memory, not theaters of worldly pomp. And as we have seen, Nicholas in his deathbed speech ultimately articulated a more pragmatic justification for his undertakings.

The Courts of Naples and Rimini

Rulers beyond Rome, who saw the Pope's temporal power as encroaching on or compromising their own, found means of expressing resistance. While it might look like an expression of conformity with papal example, the visual style of the princely regimes conveyed strikingly different ambitions. Works of art that symbolized loyalty to an idea of Rome, to the central authority of the Pope or the emperor, could also signify the desire to replace that authority. Rulers like Sigismondo Malatesta of Rimini and King Alfonso of Naples could appropriate the image of Rome for their own ends, even to the extent of challenging the papacy's bid to reserve the image of "Rome" for itself.

Alfonso Looks North

The Kingdom of Naples had been ruled since 1250 by a French royal dynasty, the House of Anjou (collectively, the Angevins), but in 1443, after nearly a decade of war, Alfonso V, King of Aragon and Sicily, took control. Alfonso, who settled permanently in his new territory, was then faced with the problems of all conquering powers: the need to implant a new bureaucracy and military loyal to him, while convincing his new subjects and the older aristocracy, through justice as well as force, of his legitimacy. Despite massive expenditure on armies, fortresses, and public works, Alfonso and his successors never fully achieved this. The most powerful figures around the new king were Spanish-speaking Aragonese, while the French and Italian barons, who ruled over virtually autonomous rural fiefdoms throughout the kingdom, remained for the most part uninvolved and uncooperative.

The other Italian powers were unnerved by Alfonso's imperial ambitions, which became apparent when he attempted to annex Milan during its brief Republican regime of 1447–50, and when he went to war with Milan's new ruler, Francesco Sforza, in 1450–53. The Este princes of Ferrara moved quickly to recognize Alfonso's rule and to ally themselves with him. The marquess Leonello d'Este married Alfonso's illegitimate daughter Maria of Aragon in 1444, an occasion commemorated in a medal by Pisanello (figs. 7.7–7.8) bearing the legend GE R AR (*gener regis aragonensis*, "son-in-law of the King of Aragon"), a somewhat muted recognition of Alfonso's status. Pope Nicholas V also cultivated Alfonso, as finally did the Florentines after 1450.

Aware that Italian rulers now routinely employed humanists as secretaries, diplomats, and literary apologists, Alfonso sought to outdo all others in his patronage of men of letters: among those on his payroll was the humanist Lorenzo Valla (*see* p. 190), which signaled a far from complacent relation to the authority of the Pope. The various Latin biographies of Alfonso, commissioned as propaganda for Aragonese rule, were modeled on the lives of Roman emperors, especially Hadrian and Trajan, who had been born in Spain. These biographies emphasize Alfonso's prodigious gifts to followers and to men of letters, along with the king's rather theatrical piety, his preference for dressing in sober black clothing, and his seeming aversion to extravagant display. Alfonso's scattering of money was supposed to win support and to convince the world of his unlimited wealth, but the king seemed to present it almost in terms of a Christian contempt for the goods of fortune. A reputation for luxury could damage the image of a ruler like Alfonso: wealth and spending needed to be justified.

FAR LEFT

7.7

Pisanello, Portrait medal of Leonello d'Este, obverse, 1444. Bronze, diameter 4" (10.1 cm). Victoria and Albert Museum, London

LEFT

7.8

Pisanello, Portrait medal of Leonello d'Este, reverse, 1444. Bronze, diameter 4" (10.1 cm). Victoria and Albert Museum, London. The lion, representing Leonello, is taught to sing by Cupid. Leonello, in other words, cultivates civilized art like poetry, through love of the Neapolitan princess he married in 1444. Leonello did in fact write love poetry.

RIGHT TOP AND CENTER

7.9 and 7.10
Pisanello, medal of Alfonso
of Aragon, obverse (top)
and reverse (center), 1449.
Cast bronze, diameter
4⅜" (11 cm). Victoria and
Albert Museum, London

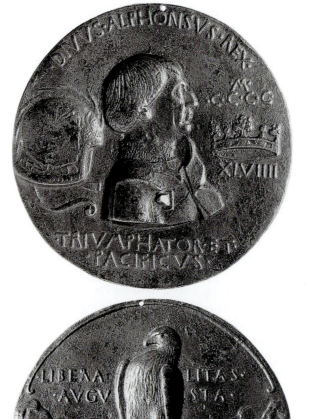

FAR RIGHT

7.11
Workshop of Pisanello,
design, probably for the
entrance facade of the
Castel Nuovo, Naples,
c. 1450. Pen and ink and
brown wash over black
chalk on parchment, 12¼
× 6⅜" (31.1 × 16.2 cm).
Museum Boymans van
Beuningen, Rotterdam

By commissioning bronze medals, Alfonso was imi-
tating the patronage of his son-in-law Leonello d'Este
and other Italian princes. The king's medals, however,
were much larger in format and conveyed much grander
political ambitions. In one example from 1449, Alfon-
so's portrait (fig. 7.9), flanked by a helmet and a crown, is
captioned at the base *Triumphator et Pacificus* ("the con-
queror and the bringer of peace"). Another inscription, at
the top, associates Alfonso's name with the epithet *divus*,
which in antiquity had been reserved for deified Roman
emperors. The imperial theme also dominates the reverse
(fig. 7.10): here, Alfonso's aquiline profile is echoed by an
eagle, which takes up an idea from the ancient Roman
encyclopedist Pliny the Elder: the eagle proved its nobil-
ity and its regal supremacy among other birds by offering
its prey to them. The caption in this case reads *Liberalitas*

Alfonso's artistic patronage suggests a policy of emu-
lating Italian rulers to the north, while at the same time
displaying the wider European reaches of his power.
Tapestries, paintings, and other valuable objects from
France, Burgundy, Provence, and the Spanish kingdoms,
including panel paintings by Jan Van Eyck and hangings
designed by Rogier Van der Weyden, flooded into Naples.
The court supported some of the earliest Italian artists to
work with oil-based paints; Niccolò Colantonio (*c.* 1420–
c. 1470) was the most noted exponent. Artists worked on
Alfonso's behalf to promote Naples as the center of a Med-
iterranean empire. The Medici sent a triptych by Fra Fil-
ippo Lippi in 1457; Pisanello, drawn by one of the largest
salaries yet paid to an artist, left the courts of northern
Italy to work for Alfonso in 1448–49. He may have been
based primarily in Naples until his death in Rome in 1455.

OPPOSITE

7.12
Pietro da Milano,
Francesco Laurana, and
others, triumphal arch at
entrance of Castel Nuovo,
1453–58 and 1465–71.
Castel Nuovo, Naples

Augusta ("imperial generosity"). By adopting an eagle as a device on the reverse of a medal, Alfonso was explicitly evoking the heraldic eagle on the coinage of the modern Holy Roman Emperors.

Pisanello appears to have been a consultant on Alfonso's most important architectural project. A design for a triumphal entry way (fig. 7.11), originating from the artist's workshop, probably served as an early project for the entrance facade of the Castel Nuovo. Alfonso had almost entirely rebuilt the castle, an Angevin foundation, as a state-of-the-art fortress designed to withstand artillery fire, possibly sacrificing a chapel decorated by Giotto in the process. Inside, Spanish masons, working in a rich Gothic style, outfitted magnificent chambers, most notably the Hall of the Barons, the star-shaped rib vault of which covered a 90-foot span. While these spaces followed the style of the Spanish courts, the entrance facade, which was built under the direction of the Lombard mason Pietro da Milano, was a hybrid response to Italian practice. The Pisanello project resembles a Roman triumphal arch (*see* fig. 1.40) that has been translated into the language of Gothic. Classical pilasters jostle with spiky pinnacles and heraldic displays of arms; fragile-looking paired spiral colonnettes replace the columns that support the projecting **entablature** blocks on most Roman arches, and the arch itself is pointed. The effect is that of a temporary structure erected for a tournament. The Gothic elements would have reminded Alfonso's subjects of the local monuments of the House of Anjou, emphasizing the continuity between the Angevin and Aragonese regimes. The vertical structure of the arch, with the climactic equestrian statue of the king, would in particular have recalled the tomb of Ladislao IV (*see* fig. 4.2).

The final built version of the arch (mostly constructed 1453–58, completed 1465–71) abandons the encrusted Gothic ornament for elements much more in line with contemporary architecture in Rome and Florence, again pointing to Alfonso's emulation of rulers to the north (fig. 7.12). The result, however, is utterly unique, as noteworthy for its differences from as for its similarities to Roman architecture. The paired river gods in the uppermost pediment evoke a famous pair in Rome on the Quirinal Hill, thus referring to the center of the empire and the fountainhead of its authority (Michelangelo would move them to the Capitol). The frieze showing Alfonso entering the city of Naples as conqueror (fig. 7.13), similarly, alludes to the well-known ancient triumphal relief on the Arch of Titus. Yet the sculptors have produced no complacent evocation of this. In the Naples relief, unlike its prototype in Rome, the figures under the pedimented arches move along the axis of depth and against the plane of the relief, evoking an imaginary procession through the Aragonese arch itself.

7.13

The Triumphal Cortege
(detail from the triumphal
arch at entrance of Castel
Nuovo), 1455–58.
Castel Nuovo, Naples

7.14

Leon Battista Alberti,
Matteo de' Pasti, and
others, San Francesco
("Tempio Malatestiano"),
Rimini, exterior, 1447–60,
facade designed 1450. The
present building, heavily
damaged by bombing
in 1944, is largely a
reconstruction.

The frieze, moreover, casts in permanent form the actual triumph held for Alfonso in Naples in 1443, in which an actor playing Julius Caesar appeared as an archetype of the imperial victor, implicitly welcoming the king as his successor. The procession, finally, has a distinctly courtly quality, inasmuch as it draws not only on Roman imperial themes but also on the medieval legends of King Arthur. Its image of a flaming throne refers to the magical Siege Perilous, a chair at the Round Table destined to be occupied by Sir Galahad, the purest of Christian Knights: the throne consumed in flames all others who sat on it. Galahad was the discoverer of the Holy Grail, the cup used by Christ at the Last Supper and long sought by Arthur's knights. Alfonso claimed to own this legendary treasure, which he kept in its own chapel in faraway Valencia. As a Caesar-Galahad, Alfonso asserted a sacred charisma and divine authority rivaling that claimed by any modern Pope or emperor.

The "Tempio" of Rimini

A comparably courtly appropriation of Rome emerged around the warrior prince Sigismondo Malatesta (1417–1468) of Rimini, whose ambitious personal imagery and lavish building seems far more vastly out of proportion to his actual power. Alfonso and Malatesta were in fact enemies, since Malatesta had broken his contracted service with the king in the war against Milan in 1447 and joined forces with Venice. Having distinguished himself as a general in the field against Alfonso, Sigismondo in 1450 received special privileges from Pope Nicholas, among them the legitimation of his children by his mistress Isotta, and confirmation of his Papal Vicariate. This is the reason he had the year 1450 inscribed on the most distinctive monument of his patronage, the church of San Francesco of Rimini (fig. 7.14) – also known, following the inscription on the foundation medal, as the "temple" of Rimini or "Tempio Malatestiano" (fig. 7.16). In recognition of Sigismondo's service as captain general of the Church, in 1452 Nicholas V granted an indulgence to all those who visited the Chapel of St. Sigismund in San Francesco, and he endowed the chapel with "innumerable relics and privileges."

Only a few years later, Sigismondo secured the undying hatred of another Pope, Pius II (1458–1464), who excommunicated him in 1459 and had him burned in

effigy in Rome. In his memoirs, Pius conveyed a grudging regard for the prince's military skill and intelligence, but complained about his faithlessness and his personal excesses. Sigismondo, Pius wrote, was "the worst scoundrel, the disgrace of Italy, and the infamy of our times." "As a *condottiere* he broke his word to everybody – the Milanese, the Sienese, the Papacy, and Alfonso of Aragon – who waged a long and devastating war against him." "He had a thorough knowledge of history and no slight acquaintance with philosophy. Whatever he attempted he seemed born for, but the evil part of his character had the upper hand. He was such a slave to avarice that he was ready not only to plunder but also to steal. His lust was so unbridled that he violated his own daughters and his sons in law. He outdid all barbarians in cruelty."

In 1462 Sigismondo obtained from Pius the rare distinction of being "canonized to hell." This extraordinary defamation helped give rise to a romantic myth of Sigismondo as a warrior-aesthete, sensual and cruel, who lived to gratify his lusts and ambitions, even to the extent of defying the political status quo and religious orthodoxy. Pius's comments on the restoration of San Francesco, which he took as further confirmation of Malatesta's depravity, have left us with the image of a Renaissance neo-pagan: "He built the noble temple of Rimini in honor of St. Francis, although it looks much more like a pagan work erected not for Christians but for the cult of infidel demons. And in this he erected the tomb of his concubine with gorgeous marble and workmanship, adding the inscription in the pagan manner: DIVE ISOTTE SACRUM ['sacred to holy Isotta' or 'to the goddess Isotta']." Pius was evidently well informed about Sigismondo's patronage, though this highly negative image requires qualification. In the fifteenth century, orthodoxy in religious belief was far less rigid than it became a century later, and there were few fixed rules or principles regarding how a Christian church ought to look. There are, to be sure, signs that even by the standards of the time Sigismondo may have overstepped a limit. His transgression, however, had a good deal to do with his implicit challenge to the idea of Papal Rome as a universal authority. Sigismondo liked to identify himself with Scipio Africanus (235–183 BCE), the great Roman general who defended Rome against the Carthaginian forces led by Hannibal. Yet the elephants that appear throughout the church of San Francesco as a symbol of Fortitude also invite the opposite reading: that Sigismondo really was a kind of Hannibal. The Roman historian Livy tells us that this most formidable adversary of Rome advanced with his army on the backs of African elephants.

The church of San Francesco was the traditional burial site of the Malatesta family. Sigismondo had begun a new chapel dedicated to his name saint,

St. Sigismund, in 1447, while Isotta obtained papal authorization to renovate the flanking Chapel of the Angels. By 1449, Sigismondo had conceived a grand project for the exterior transformation of San Francesco, literally encasing the older Gothic structure in new facades of white marble, imitating Roman architecture. For this, Sigismondo consulted with Leon Battista Alberti, who supplied designs and advice from Rome. On site, the sculptor Matteo de'Pasti directed building operations, while the Florentine Agostino di Duccio (1418–*c.* 1481), a former pupil of Donatello, provided much of the extraordinary interior sculptural decoration.

The design drew attention to the idea of renovation or renewal: Gothic tracery windows are still visible through the classical arcades of the facades to the north and south (fig. 7.15). The arched openings form deep recesses containing sepulchers for distinguished members of the Malatesta court (or in one controversial case, of the Greek humanist and neo-pagan Gemisthos Plethon, who had revived the worship of the ancient gods on the island of Mistra). The incomplete main facade takes its tripartite organization from the triumphal arches of imperial Rome, which Alberti knew to have been erected in honor of the emperor's victories. Such elements as the massive triangular pediment that dominates the horizontal organization of the facade, along with the engaged Corinthian columns placed on a raised base, the entablature projecting over each column, and the medallions, were adopted from a Roman source much closer at hand: the so-called Arch of Augustus in the town of Rimini itself. The foundation medal (*see* fig. 7.16) also informs us that the original plan of San Francesco called for a massive dome over the crossing, a form that might have looked modern to those who knew Florence Cathedral, but one that would also have invariably recalled the Pantheon in Rome. Apart from the

7.16
Matteo dei Pasti,
**Foundation Medal for San
Francesco, Rimini**, 1450.
Bronze, diameter 1⅝"
(4 cm). British
Museum, London

cherub heads in the Corinthian capitals, there is little to tell us that we are looking at a Christian church here: the triumphal arch and Pantheon references, along with the classically styled sepulchers on the other facades, evoke worldly ideas of fame, as does the inscription in honor of Sigismondo himself. He had plundered the porphyry and serpentine used for revetment from the early Christian basilica of Sant'Apollinare in Classe near Ravenna, as its abbot complained in August 1450.

For all of this, devotional considerations seem to have determined the form of San Francesco's facade. The

7.17
Piero della Francesca,
*St. Sigismund Venerated
by Sigismondo Malatesta*,
1451. Detached fresco
and tempera, 8'5⅝" ×
11'4⅜" (2.5 × 3.4 m).
San Francesco, Rimini

arch above the central portal was conceived to hold the remains of a saintly member of the Malatesta family – the pious Galeotto Roberto, brother of Sigismondo (his name is the Italian form of "Galahad"). As a final act of humility, Galeotto Roberto had requested that he be interred in the ground outside the church. His tomb soon became a place of local pilgrimage and a site of miracles. Alberti's new design for the facade elevated Galeotto Roberto's remains to a new and more prominent location, thus protecting and glorifying the relics while respecting his wish to be buried outside the church. The arrangement then became the generating principle for the remainder of the entire exterior design, with its series of sepulchers under arches.

The church has not abandoned the sacred. Rather, as in Rome itself, the sacred has been made to work very pointedly on behalf of the local ruler. This is especially apparent in the Chapel of St. Sigismund. This chapel contained holy relics, and an indulgence was granted to those who visited them. Its reuse of materials from the "most holy" fabric of Sant'Apollinare in Classe added to the chapel's accumulation of sacred capital. In 1451, the painter Piero della Francesca (c. 1415–1492), then working as an itinerant master, added a monumental fresco to the wall (fig. 7.17). In it, Sigismondo kneels before his name saint, the seventh-century Burgundian king St. Sigismund. The arrangement recorded the patron's devotion and obligation to heavenly authority, but it also had political implications: Malatesta had received the saint's name only in 1433, when he added the syllable "Si" to his own name of Gismondo, thereby also identifying himself with the Holy Roman Emperor Sigismund, who in that year had conferred on him a knighthood. The knighthood gave him a legitimacy he did not have by birth, but it also made him an imperial vassal, loosening the feudal ties that bound him exclusively to the Holy See. It is thus not accidental that St. Sigismund here bears the features of the late emperor himself.

Sigismondo is shown as subordinate to the saint, but he is nonetheless centrally placed, his back aligned with the axis of the pictorial field. His centrality is underlined by the fact that a third "Sigismund" appears in the painting: the roundel shows the great fortress known as the Castel Sismondo. Paired greyhounds and paired pilasters, together with the receding marble panels of the floor, convey a sense of lucid symmetry and timeless monumental order. These are qualities specially associated with Piero della Francesca, but the fresco would once have testified to qualities that are less appreciated in this artist's work: in its original, undamaged state, it was among Piero's most sumptuous paintings. The rich colors and ornamental detail of the tapestry hangings in the background, together with the gilded embroideries of Sigismondo's cape, would have provided an effect

of splendor unequaled in Piero's other paintings, and a glimpse of the luxury of Sigismondo's court.

Agostino di Duccio and the Sculptural Decoration of the Tempio

The chapel was but one of a series newly outfitted for the interior of San Francesco. Together they boast an elaborate sculptural program that is unique in Renaissance architecture (fig. 7.18). Magnificent coats of arms with simulated hangings painted in blue and gold adorn the sarcophagi of Isotta and the Malatesta ancestors, while spectacular reliefs by Agostino di Duccio and his shop divide the pilasters of each chapel's arched entrance. Each chapel is dedicated to a saint, yet has its own theme devoted to a different area of secular knowledge: one of Sigismondo's goals was to put the erudite culture of the Riminese court on display, and in an appropriate "antique" style. Some chapel decorations were the product of humanist research. In determining how to represent sibyls (ancient pagan prophetesses) in the Chapel of the Madonna dell'Aqua, the poet Basinio da Parma wrote to Rome enquiring about the painted cycle of the sibyls in the palace of Cardinal Orsini. The Nine Muses in the Chapel of St. Augustine were based on a learned program drawn up by the humanist Guarino of Verona in 1447, to guide painters decorating the study of Leonello d'Este

7.19
Matteo de'Pasti (architecture) and Agostino di Duccio (sculptures), relief representing the moon. Chapel of St. Jerome (Chapel of the Planets), San Francesco, Rimini

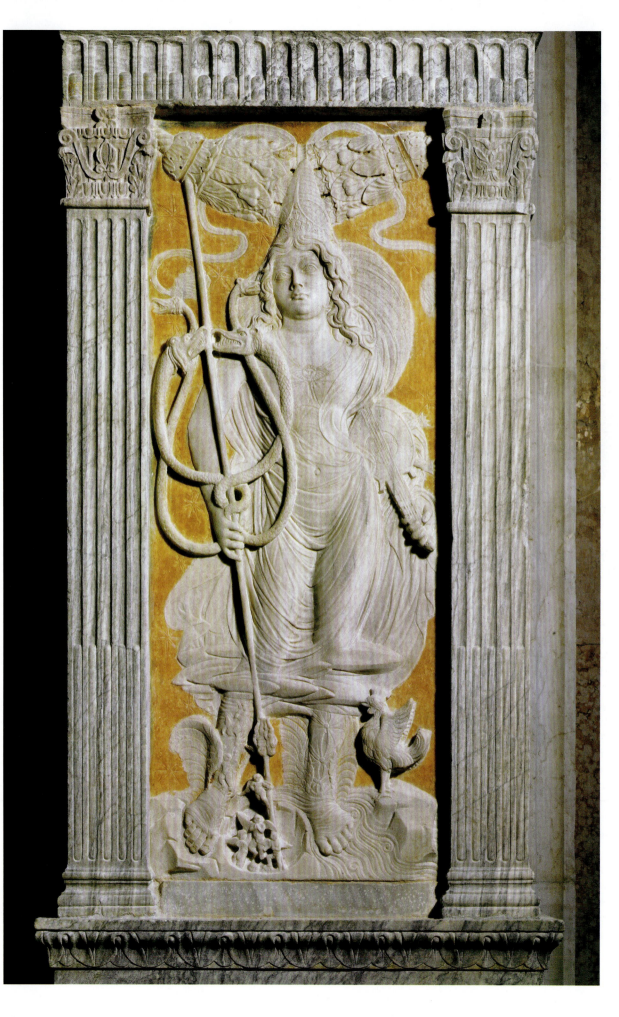

7.20
Agostino di Duccio,
Mercury, 1450s. Marble
relief. Chapel of St. Jerome,
San Francesco, Rimini

(*see* p. 218). The Chapel of St. Jerome (fig. 7.19), now often called Chapel of the Planets on account of its representations of planetary gods and signs of the Zodiac, gives a good example of the way the design process worked.

Over the previous centuries, the conventions for representing the ancient gods in Greek and Roman art had largely been forgotten. Medieval artists, when they wished to depict ancient deities, showed them in contemporary dress, or they turned to handbooks by Christian writers who described gods without reference to ancient art, and in terms that no ancient Greek or Roman would have recognized. To be sure, the figures that Agostino carved in the Chapel of St. Jerome still have little to do with ancient images of the same characters. For these, though, Basinio, who had composed a Latin poem on astrology, informed himself by reading an eclectic array of ancient and medieval sources. In the case of *Mercury* (fig. 7.20), Basinio was careful to base his description on a true classical source: the *Aeneid* (Bk. IV, ll. 238–46) of Virgil, which describes the god putting on his "golden shoes, which carry him upborne on wings over seas and land, swift as the gale. [With his wand] he calls pale ghosts from Orcus and sends others down to gloomy Tartarus, gives or takes away sleep or seals eyes in death; relying on this, he drives the winds and skims the stormy clouds." The lute and the cockerel in the relief come from a medieval source, but the Virgilian details are all here as well. Agostino himself, moreover, has clearly studied surviving examples of Roman relief sculpture. His mitered and androgynous figure of Mercury suggests that he may have based his figure on images of Egyptian or Persian divinities who were worshiped in late imperial Rome, such as Serapis or Mithras.

Part of Agostino's achievement was his translation of the sometimes cumbersome directions he received into harmonious, flowing forms, making the highly literary and abstruse figures intelligible and memorable. The billowing lines of transparent drapery and hair and the delicate silhouettes infuse each figure with a pulsing energy. The effects of airy transparency and flowing movement, which have been compared to the look of water flowing over stone, suggest that Agostino was attempting to portray a kind of immaterial being. (The sibyls, being mortal women, have far greater three-dimensional presence.) The images remind us that the planet gods were sometimes conceived in terms of airy spirits or demons who could influence persons and things on earth. They visualize the art of antiquity in terms very different from what is often conceived as "the classical": forms like those of Nicola Pisano or Masaccio, which emphasize qualities of gravity and weighty monumentality. What the Tempio as a whole offers is a kind of alternative version of antiquity, one that consciously differed from the kinds of antique revival being promoted in Florence (for example, in Rossellino's Leonardo Bruni tomb, *see* fig. 6.17), the city from which Agostino hailed.

Padua

Andrea Mantegna's Beginnings

The reinvention of Rome in different centers of Italy advanced local claims and participated in larger political conflicts, but it also served the interests of the artist. One of the period's most influential inventions of antiquity was dramatically unveiled by a young painter, Andrea Mantegna (*c.* 1431–1506), in Padua around 1457, in the church of the Augustinian Hermits (*Eremitani*). Mantegna had begun work on the funerary chapel of the wealthy Antonio Ovetari as part of a team assigned to produce frescoes devoted to two martyr saints, St. James and St. Christopher. With the death of two of the other painters (Mantegna's bitter rival Niccolo Pizzolo and the Venetian-based Giovanni d'Allemagna, who had been hired with his partner Antonio Vivarini), he emerged as the dominant personality on the commission, able to impose his style on the artists who remained. The frescoes would set a powerful new standard for a modern art that claimed to imitate or to revive the art of the ancients, one that artists of the later fifteenth century would have to reckon with.

7.21
Andrea Mantegna, *The Trial of St. James*, 1455. Ovetari Chapel, Church of the Eremitani, Padua. Destroyed 1944

By comparison with Fra Angelico's Roman frescoes (*see* figs. 7.3–7.6), which also presented martyr saints in settings that drew from contemporary revivals of antiquity, Mantegna's architecture towers over the human figures. While Fra Angelico's backdrops recall the Florentine architecture of Brunelleschi, Mantegna aimed to represent more plausible ancient buildings: *The Trial of St. James* (fig. 7.21) takes place against a very Roman-looking triumphal arch, while the great arched gateway in *St. James Led to His Execution* (fig. 7.22) shows Mantegna's study of the ancient arch in Verona widely believed to have been the work of Vitruvius (*see* fig. 1.40). The painted arch is no slavish copy of the heavily damaged stone structure; it comes across rather as a restoration or even improvement of the original. Mantegna has carefully incorporated elements from other ancient monuments, such as a Roman arch at Pula in Istria, which he could have studied in drawings belonging to his father-in-law,

the Venetian painter Jacopo Bellini. The proportions and the poses of Mantegna's figures, along with their grim expressions, evoke ancient statuary and sculptural relief – he also made a conspicuous homage to Donatello's *St. George* (*see* fig. 3.7) in *St. James Led to His Execution* – and he attempted to provide a historically convincing depiction of costume, weapons, and armor. Mantegna visualizes antiquity in emphatically martial terms, as dominion established through overwhelming military power. The central drama in his treatment of the subject is the ultimate triumph of the Christian martyrs despite the crushing force of empire. In the *Trial*, the arch frames the defiant saint and alludes to his own impending exaltation, just as the relief with the scene of sacrifice evokes the greater self-sacrifice of martyrdom (*see* fig. 7.21). As in the case of Fra Angelico's martyr cycle (*see* figs. 7.3–7.6), architecture serves as a kind of commentary on the story; but whereas Fra Angelico's buildings stood for the

LEFT

7.22

Andrea Mantegna,
*St. James Led to His
Execution*, 1455. Fresco.
Ovetari Chapel, Church
of the Eremitani, Padua.
Destroyed 1944

ABOVE

7.23

Andrea Mantegna, *The
Martyrdom of St. James*,
1455. Fresco. Ovetari
Chapel, Church of
the Eremitani, Padua.
Destroyed 1944

martyrs themselves and their future cults in the churches of Rome, Mantegna drew out the tension between the pagan splendors of antiquity and the spiritual triumph of early Christianity. Mantegna seeks here to establish his reputation through his superior command of an antique style, one that surpasses the surviving works of antiquity itself. The antiquity Mantegna creates, however, looks repressive and threatening.

Although Mantegna's figures are restrained and full of gravitas, the treatment of space invests the narrative with tragedy and terror. In *St. James Led to His Execution*, the painter employs a worm's-eye, or *sotto in su*, perspective, so that we appear to witness the action from a point of view below the figure's feet; the architecture looms dizzyingly over our heads. In *The Martyrdom of St. James* (fig. 7.23), Mantegna foreshortens the figure of the saint so that it appears, horrifyingly, that his head will drop into our space. The ancient city in the background incorporates ruins from a previous era, as if pointing to the fact that this material splendor will itself one day pass away.

Donatello's *Gattamelata*

Mantegna's impressive antique style, with its archeological references and its tragic or epic character, would have had a particular impact in fifteenth-century Padua. Not only was the city proud of its Roman heritage, but it also promoted the legend that it had been founded by the Trojan general Antenor, a story that made Padua out to be even older than Rome. Padua was the birthplace of Livy, the premier Roman historian, and there was great excitement when his bones were allegedly rediscovered there in 1413. The city supported one of the oldest and most distinguished universities in Europe, and Petrarch had resided in and near Padua in his later years. Yet Padua had also been made subject to a modern imperialist power from 1404, when the Venetian state drove out the last ruler of the Carrara dynasty and occupied the city; Venetians occupied most of the important administrative positions in the civic government and in the clergy.

Among the visible signs of Venetian rule was one of the great masterpieces of early Renaissance sculpture, Donatello's equestrian monument to the mercenary Erasmo da Narni (1370–1443), nicknamed Gattamelata ("Honeyed Cat") (fig. 7.24). Gattamelata had been the Paduan commander of the forces carving out a Venetian territorial empire as the Ottomans advanced and the city's overseas influence dwindled. As a general, he fell far short of his employers' expectations, but following his death he became useful as a symbol. The statue, executed between 1447 and 1453, originated as a private commission by Gattamelata's widow and son, but the prominent location outside the great Franciscan pilgrimage church

of the Santo required the approval of the Venetian state. The statue to some extent followed a local funerary type, echoing for example the Della Scala tombs in Verona (*see* fig. 1.39). More explicitly, it re-created the Marcus Aurelius statue in Rome, then generally believed to depict the Emperor Constantine (*see* fig. 5.17). The *Gattamelata* would thus have worked not only as a cenotaph, but also as an embodiment of Venetian statehood and imperial aspirations. Along with the idea of empire, the sculpture also expresses "Venice." The best-known monumental bronzes in all of northern Italy were the horses taken as spoils during the Sack of Constantinople in 1204 and displayed subsequently on the facade of the Venetian basilica of San Marco as victory trophies.

Donatello conceived the warrior's lion-like features and grim expression so that they would be legible from the piazza below. The armor, a fantastic hybrid of modern and Roman military dress, bristles with decorative reliefs in the form of winged spirits, a Medusa head, and cat faces (a pun on Gattamelata's name), enabling the statue to be read as both ancient and modern: on the one hand,

7.24

Donatello, Equestrian Monument to Gattamelata, 1447–53. Bronze, *c.* 11′ (3.4 m). Piazza del Santo, Padua

ABOVE

7.25

Francesco del Borgo, Benediction Loggia, Old St. Peter's, 1460s, as shown at the left in a drawing of *c*. 1533 by Maerten van Heemskerck.

Graphische Sammlung Albertina, Vienna

RIGHT

7.26

The Colosseum, Rome, 80 CE

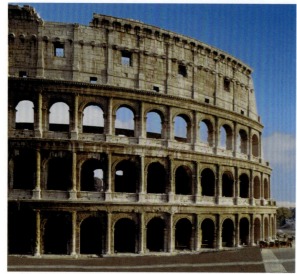

the warrior exemplified the military virtue of fortitude; on the other, he offered a sober warning about recent history, as well as an assertion that Paduan talent and virtue now contributed to the might of Venice.

Pius II: Rome and Pienza

Renaissance popes were of course aware that other powers in Italy were using art and architecture to produce competing claims to be the Center, to become the new Rome despite their limited power or resources. By the end of the 1450s, the papacy began responding to the

creation of alternative Romes in Rimini, Naples, Padua, Florence, and elsewhere. During the short reign of the Spanish Pope Calixtus III (*r*. 1455–58), the architectural projects of his predecessor Nicholas V had been suspended, and all papal energies and revenues were invested in the cause of a crusade against the Ottomans. Pius II, however, resurrected the project to renovate St. Peter's. His architect Francesco del Borgo (*c*. 1425–1468) added the Benediction Loggia to the main facade, along with a new piazza in front of the basilica and a flight of marble steps (fig. 7.25). The Benediction Loggia was conceived as a magnificent setting for the papal blessing that pilgrims assembled in the piazza received on important feast days. Its design, with three arcaded storeys, is particularly significant as an adaptation of Roman imperial architecture to the ceremonial and ideological needs of the church. The source of the design is the Roman Colosseum (fig. 7.26), the lower three storeys of which likewise featured arcades, each articulated by a different **classical order**: plain and solid Doric on the lowest level, followed by the more ornamental Ionic and climaxing with Corinthian, the richest order of all.

Pius built more ambitiously outside of Rome, where he spent a great deal of his pontificate, especially in the hill town of Corsignano near Siena. The Pope, in collaboration with the sculptor-architect Bernardo Rossellino, conceived a plan to transform the city where he had been born, imposing symmetry and hierarchy onto a tangled, rambling medieval settlement and renaming the city Pienza in honor of himself (fig. 7.27). An area of level ground was cleared for the central piazza and the most

important buildings, the irregularities of the uneven hilltop site determining its trapezoidal plan. The inlaid pavement focused attention on the new cathedral, dramatically located at the edge of a cliff by the open sky. To the right was Palazzo Piccolomini, for the Pope's family (fig. 7.28). The bishop's palace is to the left, while the palace of the Podestà (the magistrate in charge of law and order) closes off the cathedral.

To a certain extent the Palazzo Piccolomini represents an extension of the architecture that the Pope had commissioned in Rome. Its three storeys are articulated by the sequence of classical orders as they appeared on the facade of the Colosseum and in the Benediction Loggia (*see* fig. 7.25). The building seems entirely Roman in spirit – even down to the decoration of its basement with a kind of *opus reticulatum* (a diamond pattern of brickwork that the ancients had used) – and a marked departure from the kind of modern palace design that Michelozzo was producing in Florence (*see* figs. 6.20 and 6.22). Around the same time, however – the exact dating is uncertain – the merchant Giovanni Rucellai was

ABOVE

7.27

Plan of the cathedral square in Pienza (Corsignano), as redesigned by Bernardo Rossellino, 1459–62

LEFT

7.28

Bernardo Rossellino, Palazzo Piccolomini, Pienza, 1459–62

7.29
Leon Battista Alberti,
Palazzo Rucellai,
Florence, 1460s

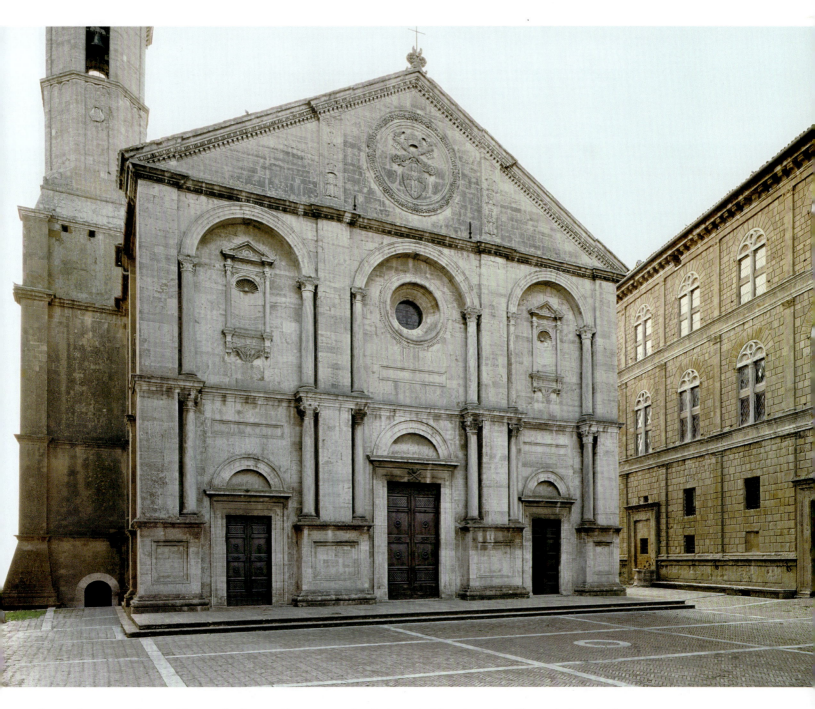

having his own palace in Florence built according to a nearly identical design (fig. 7.29), probably under the direction of Alberti. So which came first? Scholars disagree, but it seems unlikely that Pius II, who viewed the Florentines with condescension and suspicion, would have settled for a mere copy of a merchant's dwelling. The Rucellai palace, furthermore, looks like a more refined or improved version of the Pienza design, relieving the over-all rustication with smooth pilaster strips.

Pienza Cathedral is also markedly different from previous fifteenth-century church designs. Although the

facade is vertical in orientation (fig. 7.30), there is also a subtle horizontal division into three parts, and here again we find the "Colosseum theme." More striking, though, is the fact that its three interior divisions are all of the same height (fig. 7.31), such that the facade also seems to respond to the proportions of a square. Similar proportions are apparent in the facade of Santa Maria Novella in Florence, also designed by Alberti for Rucellai and begun in 1458 (fig. 7.32). This departs from the same artist's design for San Francesco at Rimini (*see* fig. 7.14), which gave greater emphasis to the higher central element

7.30
Bernardo Rossellino, facade of Pienza Cathedral, 1459–62

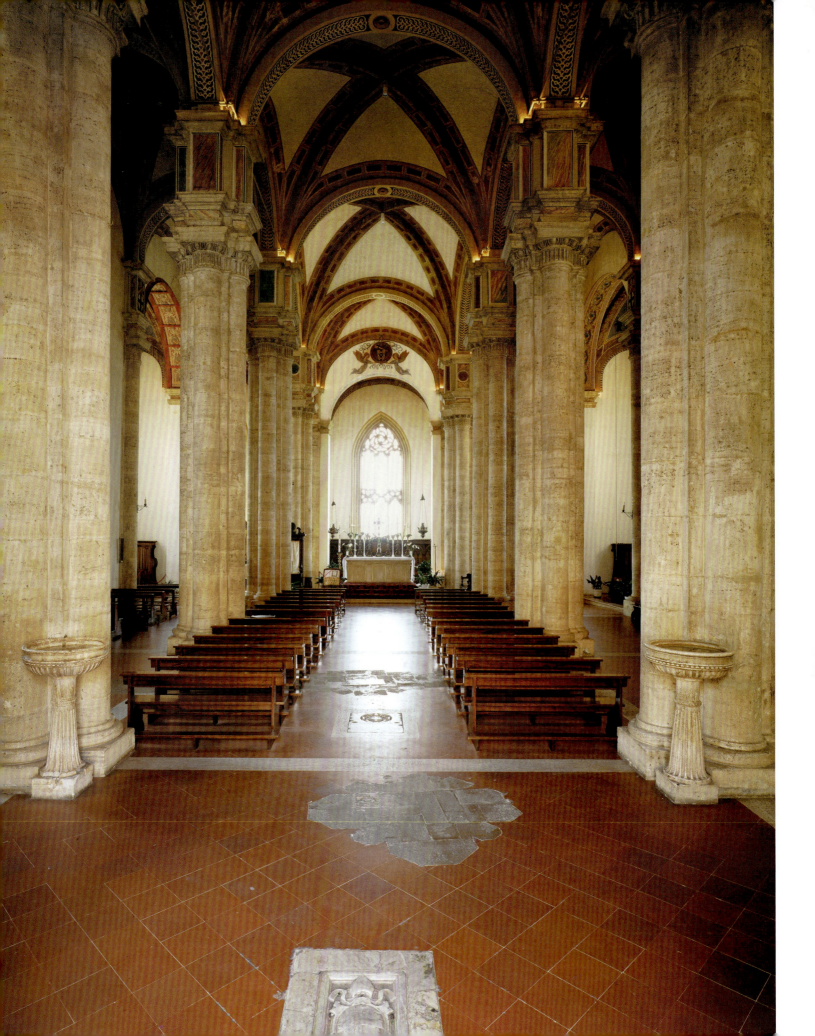

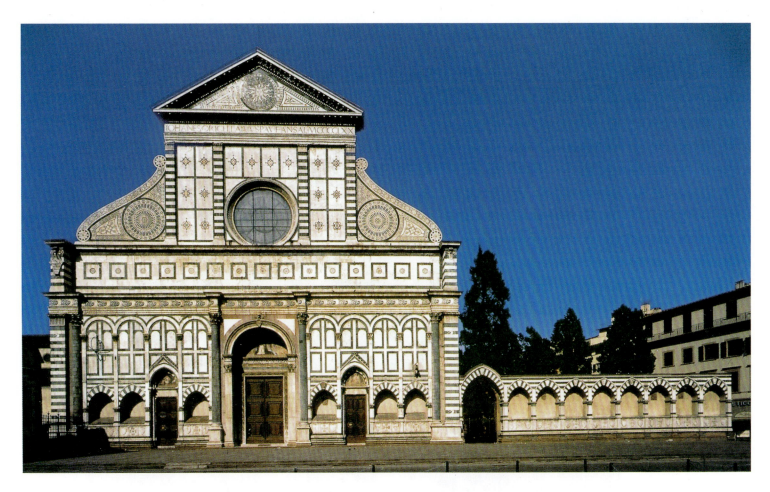

corresponding to the nave. The squaring of the facade allows a more thorough amalgamation of the two components of classical architecture most favored by all the patrons we have been considering – the pedimented temple front and the triumphal arch.

As at Rimini, so in Pienza, there is little sense that we are looking at the facade of a church. Rather than indicating the holy figure to whom the church is dedicated, the pediment bears only the coat of arms of Pius II himself. As it happens, Pius wrote about his intentions, informing us that when he planned a building with the aisles and nave all of the same height he had a specific type of Christian architecture in mind: the so-called "hall churches" he had seen in central Europe during his years as ambassador at the imperial court in Vienna. The lofty and light-filled interior uses a Gothic system of rib vaults springing from piers, and the pointed windows have Gothic tracery, which by the 1450s was more characteristic of northern than of central Italian architecture. "As you enter the middle door," Pius wrote:

the entire church with its chapels and altars is visible and remarkable for the clarity and brilliance of the whole edifice. There are three naves [*navati centrale*], as they are called. The middle one is wider. All are the same height…. It makes the church more graceful and lighter…. Every chapel has a high and broad

window cunningly wrought with little columns and stone flowers and filled with the glass called crystal. At the ends of the naves are four similar windows which, when the sun shines, admit so much light that the worshipers think they are not in a house of stone but of glass.

Was Pius II here deliberately insisting on the "Christian" character of his building, as distinct from the "pagan" look of his enemy Sigismondo Malatesta's church of San Francesco in Rimini? Certainly the four altarpieces that Pius commissioned from the leading artists of Siena are archaic in character by Florentine standards: although they employ the Brunelleschian rectangular support and all'antica pedimented frame, the gold leaf and the emphasis on surface pattern over illusionistic space evoke the great tradition of Sienese religious art (fig. 7.33). The Pope must have liked their otherworldly character and mystical effect.

Alberti on Architecture

Many of the buildings discussed in this chapter have been connected with the influence of Alberti, even if his direct involvement can be established only in the cases of San Francesco in Rimini and Santa Maria Novella in

7.32
Leon Battista Alberti, facade of Santa Maria Novella, Florence, begun 1458. Alberti worked with the existing facade, retaining the Gothic pointed arches in the ground storey as well as the rose window above, and adopting the building's scheme of green and white marble revetment for his own additions.

OPPOSITE
7.31
Bernardo Rossellino, Pienza Cathedral, 1459–62. Interior

7.33
Matteo di Giovanni, *Virgin and Child with Saints*, altarpiece for Pienza Cathedral, *c.* 1460

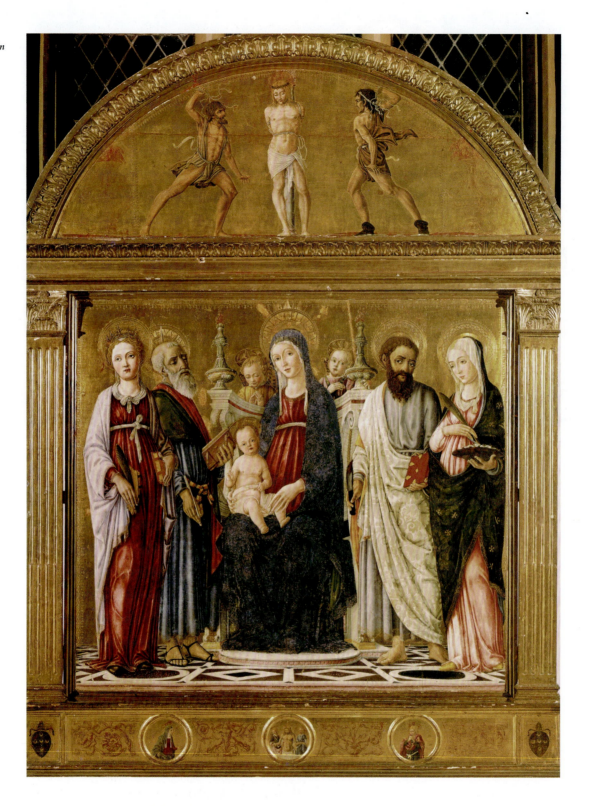

Florence. It is often stated that Alberti's treatise *On Architecture* (completed 1452), which would become one of his most widely read works, was produced for Nicholas V as part of the project to restore and embellish the city of Rome, and some passages do indeed seem informed by the place in which Alberti was living and working: he refers, for instance, to the difficulty of governing a city built on hills, divided by a river. Alberti himself, however, stated that he wrote the treatise at the behest of Meliaduse d'Este, the brother of Prince Leonello d'Este

of Ferrara. It was not the Pope himself, but the cultivated minor princes of Italy, with their passion for antiquity and their emulation of Rome, that Alberti had in mind. Like the building projects of poets and princes, Alberti's treatise reminds us that the revival of Roman architecture was about more than antiquarian taste: it represented a will to shape consciousness, to make the ascent of certain political interests seem natural, that anticipates the modern concept of ideology: "Thucydides did well to praise the ancients who had the vision to adorn the cities with such a rich variety of buildings as to give the impression of having far greater power than they really had."

When Alberti demanded that the social order be articulated through building and through planning, and that private building enterprises be subordinate to those of the ruler, he was expressing something that the papacy and most other governing powers in Italy took for granted: Alberti did not so much present a new vision for architecture as provide an elegant and systematic formulation of these ideas. There should be "no arches, no towers should stand along the roads through the town." The whole town should be planned "to give the one with supreme power sole possession of all the highest structures." Perhaps the most striking aspect of the treatise, especially in light of the papal projects in Rome and Pienza, is its emphasis on the total environment of the city, an organic composition where individual parts would relate to one another: the citadel should adjoin the palace; the senators should be downtown, near the main religious sites. Private houses and palaces should relate to public space through the provision of a portico. Alberti even extends the principles of centralized town planning into the private sphere, comparing the family house to the organization of the wider urban fabric. Just as noisy and malodorous trades, such as butchering, should be kept away from the homes of the rich, so in a house "the prattling and noisy hordes of children and housemaids should be kept well away from the men, as should the servants with their uncleanliness."

Alberti's systematic approach to ancient principles of design in the form of the classical orders also seems to respond to current trends. For the most part, his interests were practical and archeological, governed by his concern to understand the scarcely intelligible technical vocabulary in the treatise on architecture by the Roman architect and engineer Vitruvius (c. 80–c. 15 BCE), "an author of unquestioned experience, but one whose writings have been so corrupted by time that there are many omissions and many shortcomings." In this task, ancient buildings acquired the same kind of authority as ancient texts: "No building of the ancients attracted praise, wherever it might be, but I immediately examined it carefully, to see what I could learn from it." Such study is reflected

in San Francesco in Rimini, which draws on elements of a local Roman arch, and at Santa Maria Novella, where the main portal is modeled on the Pantheon. Alberti adheres for the most part to a typology of ancient buildings, even when no clear counterpart existed in the present. He provided instructions for "temples," which clearly correspond to modern churches, but also prescriptions for basilicas, amphitheaters, and circuses. He called for the hierarchy and distinction of building types to be articulated through appropriate ornament, which usually means the classical orders; "temples dedicated to Venus, Diana, the Muses, Nymphs, and other more delicate goddess must take on the slenderness of a virgin and the flowery tenderness of youth...buildings to Hercules, Mars, and other great gods must impose authority by their solemnity, rather than charm by their grace."

More strangely, Alberti suggests that images of male "gods" (or saints) might not be appropriate in "temples" to female "gods." Here, Alberti's concern with consistency and decorum exhibits a degree of authoritarian control at the most minute level of detail. On the other hand, his ideas of what is appropriate derive from pagan antiquity, and he believed that the imagery of the ancient gods could find a legitimate place even in a Christian sacred space. Such values clearly underlie the design of San Francesco in Rimini, as does his judgment that sculptural reliefs and detached panel paintings are preferable to fresco paintings on the walls of churches. The function of images in "temples," according to Alberti, is primarily to inspire respect and awe, and to this end he also maintained that churches were legitimate sites for displaying images of famous men: "effigies of those worthy of mankind's praise, and deserving to be commemorated along with the gods, should be set up and displayed in sacred places, so that future generations, when paying their respects, might, in their zest for glory, be incited to follow such example." The comments recall the rise of such secular memorials as Uccello's Hawkwood Monument (*see* fig. 5.14) and Rossellino's Bruni tomb (*see* fig. 6.17), as well as several works we have seen in this chapter: for example, Donatello's *Gattamelata* (*see* fig. 7.24), and Piero's votive fresco of Sigismondo Malatesta (*see* fig. 7.17). Yet Alberti's remarks also apply to the new use of saints' lives to provide inspiring examples of virtue, such as Fra Angelico's Vatican cycle for Nicholas V (*see* figs. 7.3–7.6) and Mantegna's Padua frescoes (*see* figs. 7.21–7.23). For Alberti, as for many of the rulers examined in this chapter, Rome and its art offered a reproducible experience of classical form and social order, realizable in pagan or in Christianized terms, and to a degree that might outstrip any ancient precedent.

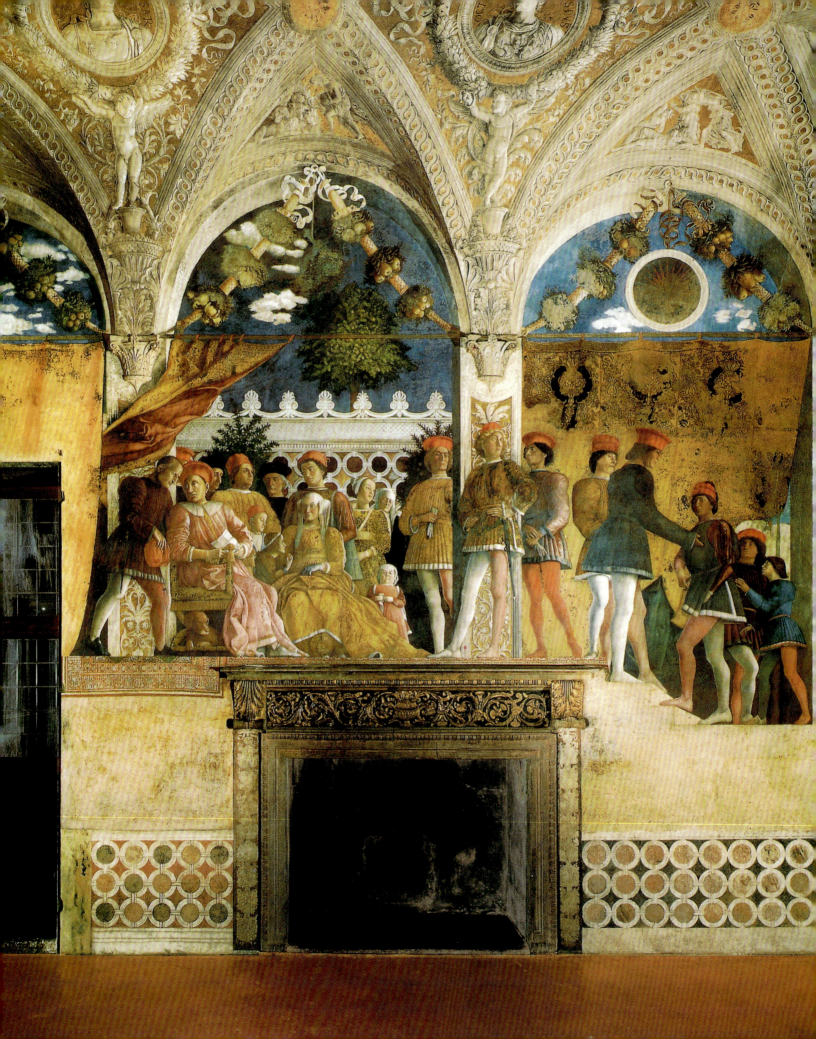

1460–1470
Courtly Values

1460–1470
Courtly Values

What Is Court Art?

The first chapter of this book distinguished the art that characterized *signorie*, governments run by a local lord, from that sponsored by *comuni*, or Republican towns. The distinction helps introduce another category that is essential for understanding both patterns of patronage and the aspirations of artists themselves in and after the later fifteenth century: the art of the courts. When we refer to "court art," we mean the distinctive objects and media, typical subject matter, and modes of production associated with princely households. In this context, painting and sculpture become but two relatively modest forms of luxury expenditure, alongside tapestry and embroidered textile hangings (usually imported), objects fashioned from ivory and precious metal, fine ceramics and glassware, engraved gems both ancient and modern, and illuminated books. And referring to "court art" is also a way of escaping the temptation of looking for a particular *style* characteristic of courts in general as opposed to such city republics as Florence or Venice. If anything, the courts of fifteenth-century Italy shared a desire to have the best of everything, which meant art in a range of styles, whether Florentine, Venetian, French, or Netherlandish.

In some respects, it might seem that such an artist as Pisanello (*see* chapters 5 and 7), who moved between the courts of Ferrara, Mantua, Rimini, and Naples, responded to a particularly courtly predilection for splendid materials, virtuoso workmanship, and an overall emphasis on the decorative, just as his typical subject matter (chivalric legends, warrior saints, the devices on his portrait medals) reflected an aristocratic interest in heraldry and the warrior ethics of chivalry and antiquity. Yet the courts were interested also in artistic qualities often assumed to be distinctively "Florentine." One of the pre-eminent court artists of the mid fifteenth century was Piero della Francesca, who worked in Rimini (*see* fig. 7.17), Urbino, and Ferrara (see below). Piero's command of geometry, perspective, and the architectural vocabulary of Filippo Brunelleschi and Leon Battista Alberti seems if anything more Florentine than the interests of his contemporaries working in that city. Many of the leading Florentine, Sienese, and Venetian artists supplied art for courts. And while the paintings and sculptures of Brunelleschi, Masaccio, and Donatello have sometimes been seen as patriotic Florentine reactions to the internationalism (and hence also the courtly connections) of Lorenzo Ghiberti and Gentile da Fabriano, Florentine patrons continued to demand the rich ornament, naturalistic detail, and idealized figures characteristic of art produced in Paris, Prague, Bruges, or Naples, along with imported luxuries, such as tapestry. This is true of the Medici in particular: Piero de' Medici ordered a set of tapestries from Antwerp in 1448, while also acquiring Netherlandish oil paintings and commissioning luxurious illuminated manuscripts.

Ferrara and the Court of Borso d'Este

Ferrara is a good example of a princely court that recruited non-local artists – Pisanello among them – as well as selectively encouraging native talent. The ruling family, the Este, had come to power as a warlord clan in the early fourteenth century, and in the 1400s two of its rulers served as *condottieri* for larger states. However, Leonello d'Este (1407–1450), who ruled from 1441 to 1450, and his half-brother Borso (1413–1471), who succeeded him, sought to promote the family through diplomacy and through the beautification of the city, spending lavishly on building. Piero della Francesca's work at Ferrara is known only from a mention by Giorgio Vasari: the very sparse account indicates that the artist decorated "many chambers" in the palace of the Este rulers, as well as a chapel in the church of Sant'Agostino, during the reign of Borso d'Este. Unfortunately, not a trace of either project survives (two later panels from the mid sixteenth century now in London's National Gallery and Baltimore's Walters Art Museum are sometimes identified as partial copies of the palace frescoes). There is, however, independent evidence for the impact of Piero's work in Ferrara, in the form of a panel now preserved in Berlin (fig. 8.1). The figure of a standing woman with foot extended and a hoe over her shoulder is characteristic of Piero; a slightly later example from his work is the similarly posed male figure in his Arezzo frescoes from *c.* 1455–60 (*see* fig. 8.34).

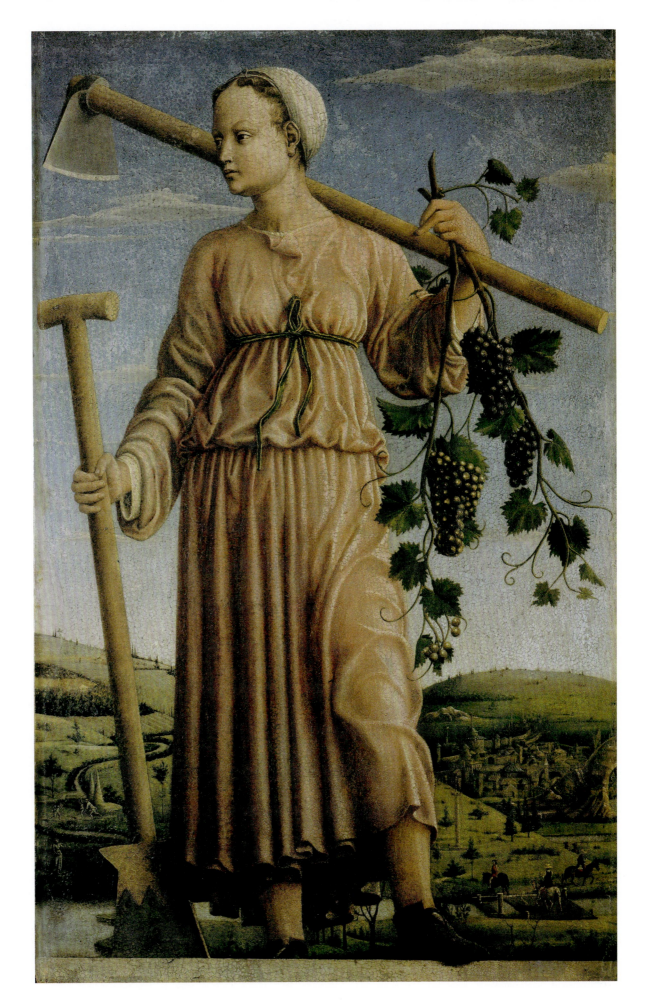

8.1
Angelo of Siena (?), *The Muse Polyhymnia*, 1450. Oil and tempera on panel, 46 × 27¾" (116.5 × 70.5 cm). Gemäldegalerie, Staatliche Museen, Berlin

Perhaps surprisingly, the figure represents Polyhymnia, one of the nine Muses venerated in antiquity as goddesses of the arts. Most classical authorities considered Polyhymnia to be the Muse of sacred song; her conversion into a gardener was the doing of the court humanist Guarino of Verona (1374–1460), the pre-eminent classical scholar of northern Italy, who ran a Latin prep school at Ferrara and taught at its university. Like his humanist colleagues in Florence and elsewhere, Guarino's approach to classical literature was governed by a sense of its universal value, its status as a precious survivor from a lost civilization vastly superior to the present in which he lived. At the same time Guarino recognized that the classical era itself had a history with its own upheavals and declines, and that ancient authorities did not speak with one voice. The very multiplicity of the ancient world meant that moderns were not bound to one single way of reading or understanding or indeed of imitating the culture of antiquity. When in 1447 Guarino drew up a list of instructions for Leonello d'Este on how the nine Muses should be painted, he insisted that there was more than one option and adapted his recommendation to the needs of the present: Guarino had studied Greek with Manuel Chrysoloras (c. 1350–1415) in Constantinople, and he knew that one late antique tradition of Greek scholarship had understood several of the Muses to be not just representatives of poetry, music, and the liberal arts, but also as the principals of agriculture and the cultivation of gardens. Leonello, a passionate reader and writer of poetry, would have welcomed this demonstration that the goddesses of poetry could des-

ignate such useful knowledge, especially since the Este were engaged in large-scale projects to drain the marshes of the Po valley, making it fertile and productive.

Painters of *cassoni* and *spalliere* sometimes illustrated stories from the ancient Roman poet Ovid, but Guarino's intervention resulted in the first humanist mythological paintings – the first paintings, that is, with new poetic inventions informed by the most advanced scholarship. Alberti in the 1430s had called for painters to take directions from literary men and recommended several learned and elegant mythological subjects, but the Muses of Ferrara are the earliest to be documented and the earliest to survive, at least in part. The panels (*see* fig. 8.1) were initially to be executed by Angelo da Siena (?–1456), who enjoyed a professional role more typical of artists at courts than in such cities as Florence. Angelo was more than a contracted employee receiving a one-off commission. He had a special status as the favored artist of the prince, a relationship governed by ritual protocols of devoted service. Borso d'Este, who, as noted, succeeded his half-brother Leonello in 1450, undertook to pay Angelo's living expenses in return for an annual gift of a painted flower.

Angelo's death in 1456 required the Este to find other talent. Rather than following their former practice of engaging a nomadic celebrity, such as Pisanello, from elsewhere, they now favored the local painter Cosmè Tura (1429–1495), giving him numerous commissions over the following thirty years. Tura would soon have a considerable reputation, more than likely enhanced by a special standing with the Este. Contemporary writers

8.2

After Cosmè Tura, *Lamentation, c. 1475.* Tapestry, 3'5" × 6'6½" (9.8 × 1.92 m). Cleveland Museum of Art, Cleveland

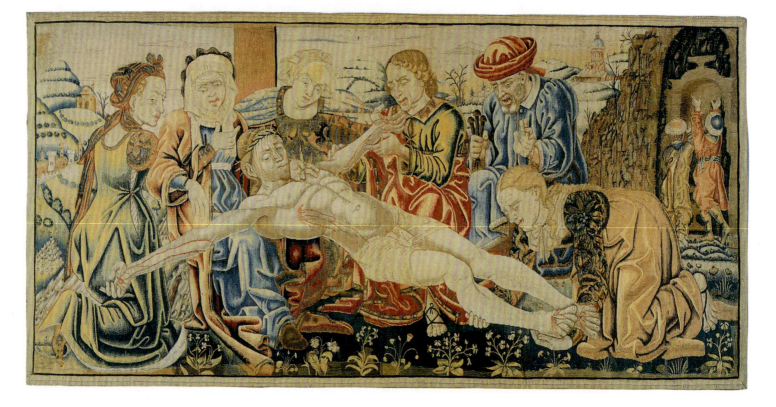

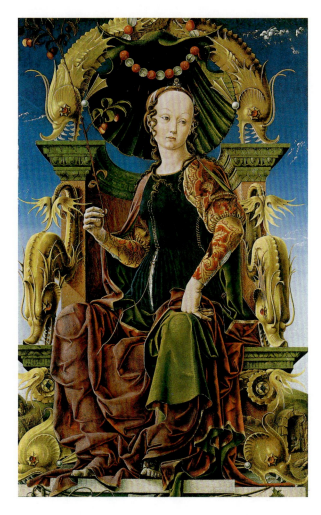

referred to him repeatedly as "extremely noble," a highly unusual designation for an artist whose father was a shoemaker, and an indication that even in such an aristocratic environment nobility could in a few cases be grounded in merit rather than lineage.

Tura completed (and partially repainted) the cycle of Muses begun by Angelo da Siena, which was to adorn a study in the suburban palace of Belfiore. Around 1470, he also headed a team of artists who decorated a sumptuous domed chapel for Borso d'Este in another residence, of which no trace survives. Beyond these two commissions and several portraits, however, Tura made no documented, surviving paintings for the court. (His altarpieces, in every case where the patron is known, were made for other clients in the city.) This suggests that Tura's more important function at court was to coordinate a "house style" in everything from metalwork to embroidery to wall painting, supplying drawings and overseeing their realization: an example is the tapestry altar frontal of the *Lamentation* (fig. 8.2), preserved in two versions that point to a single original design. In such works as this, Tura employed a sculptural hardness and an emphatic

linearity, ideal for translation into patterns for decorative arts. A flowing, sometimes jagged contour describes wiry and elegantly emaciated bodies, as well as complex and fanciful drapery that clings to the figures like glittering metal foil. A fantastic golden table service made in Venice from Tura's designs does not survive, but its appearance might be imagined from the best-preserved of the Muse panels he completed for Borso. *Calliope* (fig. 8.3) sits on a throne adorned with three pairs of dragon-like golden dolphins studded with rubies and pearls. The Muse herself designates poetry through an unrelenting emphasis on the principle of artifice – in the elaborate textiles of her costume, in the cosmetic effects of her curled hair and plucked eyebrows, and in the calculated mannerisms of her posture and averted gaze.

Borso, who adorned himself and his retinue (male as well as female) to similarly dazzling effect, must have had a taste for such luxurious display. At the same time, the ornamental profusion and even the eroticism of Tura's figure conform with the ideas of contemporary humanists, who did not imagine the ancient world as a place of sober, Ciceronian restraint, but as one where knowledge and linguistic sophistication might be linked to pleasure. The ancients allowed experiences that the Judaeo-Christian tradition regarded as worldly and corrupting. Guarino's younger followers were particularly distinguished for their imitations of the explicitly erotic and sometimes outrightly provocative Latin love lyrics of Ovid, Catullus, and Propertius.

Astrological Imagery in the Palazzo Schifanoia

The so-called Hall of the Months in the Palazzo Schifanoia (figs. 8.4–8.6) illustrated similar interests on a monumental scale. The most sophisticated of the painters involved with this cycle of murals was Francesco del

8.3

Cosmè Tura, *The Muse Calliope*, 1460. Oil and tempera on panel, 46 × 28" (116.2 × 71.1 cm). National Gallery, London

8.4

Hall of the Months, Palazzo Schifanoia, Ferrara, with frescoes by Francesco del Cossa and others

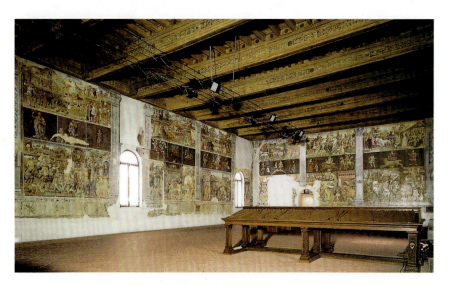

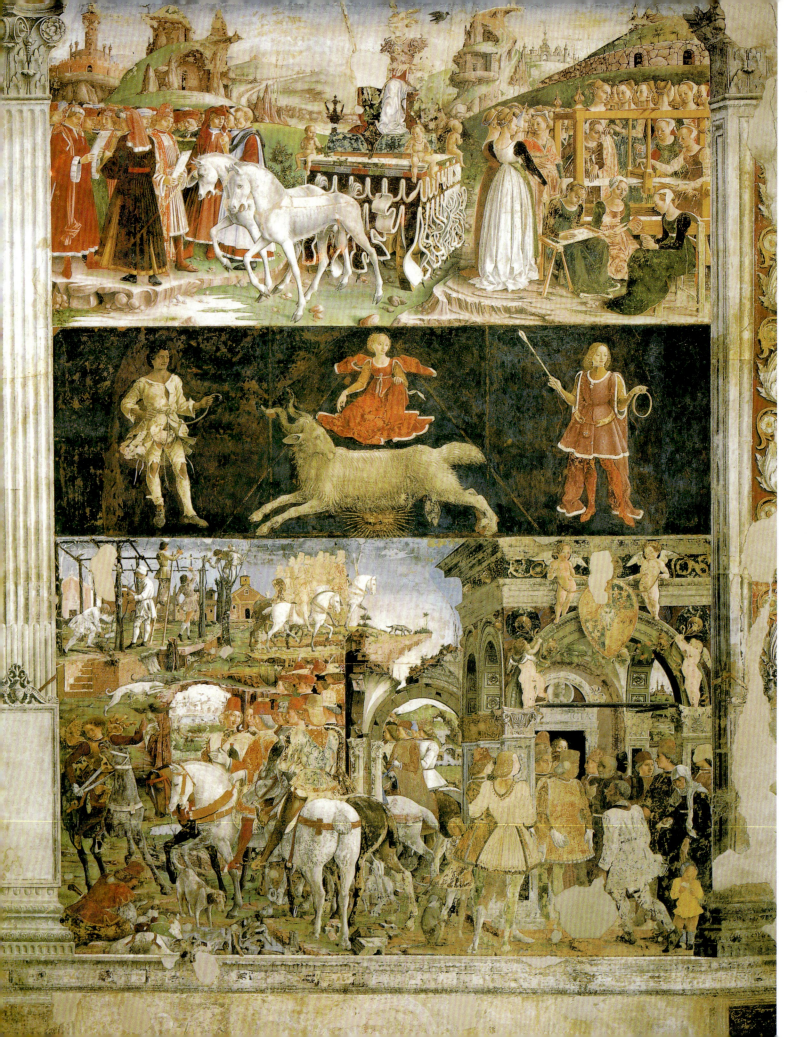

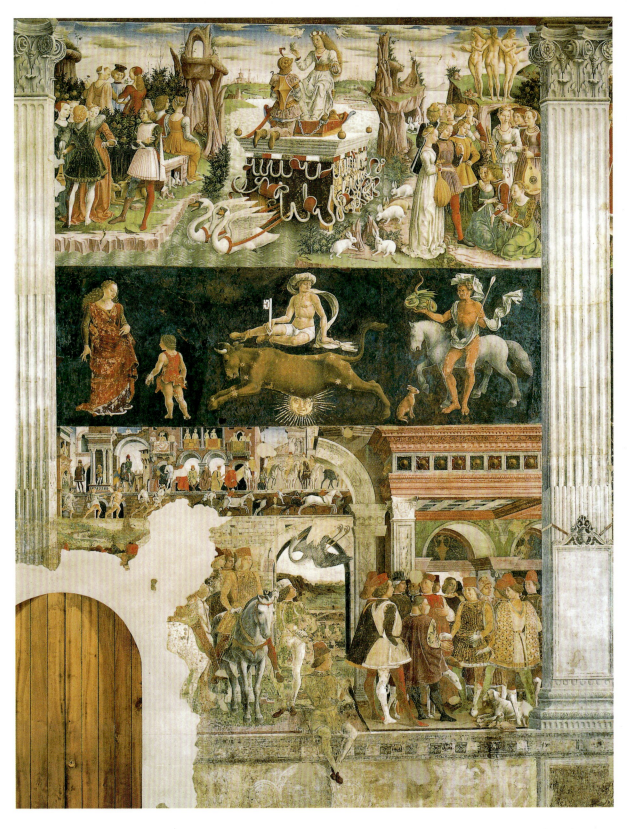

OPPOSITE

8.5

Francesco del Cossa, Aries (the month of March), 1469. Fresco. Hall of the Months, Palazzo Schifanoia, Ferrara

LEFT

8.6

Francesco del Cossa, Taurus (the month of April), 1469. Fresco. Hall of the Months, Palazzo Schifanoia, Ferrara

Cossa (1436–1478), who complained in a letter to Borso about receiving the same flat fee as the other less diligent and talented painters working by his side. It may be that the artists were all expected to follow designs that Tura, the court's chief painter, had provided: this would explain the wage structure. Most of the painters – but not Cossa – worked in a simpler version of Tura's craggy linear manner.

These frescoes are the oldest surviving decorative cycle devoted to the occupations of a prince and his court, although they constitute only a tiny fragment of the extensive frescoed interiors that the Este rulers

8.7
Cosmè Tura, *Annunciation*, 1468. Oil and tempera on panel, each panel 13'6" × 5'6½" (4.13 × 1.69 m). Museo del Opera del Duomo, Ferrara

commissioned from the fourteenth century onward. (Most of them were destroyed by an earthquake in 1570 or by the papal government that ran the city from 1598.) Scenes of court life, each framed by Corinthian pilasters and devoted to a month of the year, appear in the lower zones of twelve bays. The upper zones depict the zodiac sign for the month, and a pagan god associated with the sign. Borso adheres more or less to the same routine in each month: holding audience, dispensing justice, or rewarding followers (including a figure thought to represent a court jester). His entourage consists of individuals evidently portrayed from life, but now no longer

identifiable. Each scene takes place in a palace or loggia that opens onto a landscape, where we see Borso for a second (and sometimes a third) time, riding from the palace or city into the country, engaging in the courtly pastime of hunting while peasants till the land or tend the vines. Throughout the twelve bays, some of the profile images of Borso derive from the same cartoon, which ensures his recognizability and reinforces the sense that he is ubiquitous – and hence all-powerful – throughout his dominions. The room served as a large antechamber where petitioners and ambassadors would have waited for audience with the prince, and it presented the duke

not just as a willful human being with luxurious tastes, but also as the embodiment of the virtues necessary for governing states: in the court scene for March (*see* fig. 8.5), he appears on the right under a profile portrait of himself, inscribed with the word IUSTICIA (Justice).

Borso, indeed, had his image transmitted and repeated like a religious icon throughout Ferrara. Citizens professed their loyalty by erecting a bronze statue of the prince in the main square of the city; a nearby gallows underscored his identification with Justice. Pope Pius II disdainfully remarked of Borso that "the Ferrarese worship him almost as a god" and clearly regarded the ruler cult as a form of idolatry. His long attack on Borso in his memoirs (the same text in which he condemned Sigismondo Malatesta in Rimini) criticizes him particularly for his vainglorious self-presentation, his reliance on astrology, and his predilection for hunting – all the aspects of Borso that the frescoes emphasize. Yet his self-imaging made a better impression on Pius's successor Paul II, who appointed Borso the first Duke of Ferrara in 1471 (following the payment of a hefty fee).

The upper tier of each bay of the Hall of Months shows a landscape with a triumphal car. All twelve gods of Olympus appear in triumph, and the figures in the surrounding landscape provide a "court" for each god, consisting of those whom the divinity specially protects, or figures from myths in which he or she appears. Sometimes there are parallels between the heavenly court and the earthly court of Borso: unicorns, the symbols of chastity and a device of the allegedly celibate prince, draw the chariot of Minerva (*see* fig. 8.5, central band). Venus subjugates the warrior Mars, who kneels before her in chains (*see* fig. 8.6), a reminder that Borso styled himself as the promoter of peace between the Italian powers.

The pagan gods appear here, as they often had elsewhere, as courtly knights and ladies, yet their features are also fully in line with contemporary classical scholarship. The humanist Pellegrino Prisciani (1435–1510) based the program on a Latin astrological poem, the *Astronomicon* by the Roman Marcus Manilius (*fl.* first century CE), which uniquely associated the gods of the Greco-Roman Pantheon with the months of the year; this is why Vulcan, Hestia, Ceres, and Minerva, who are not planet gods, all appear. Each sign of the zodiac constitutes thirty degrees of a circular band of stars known as the "encliptic." Stellar demons known as "decans" governed subordinate regions of ten degrees. Under Aries, the dark-skinned man in white torn garments is a decan (*see* fig. 8.5). One medieval source, a text on magic and astrology known as *Picatrix*, describes this as "the form of a black man, agitated and large of body with red eyes and holding a cutting axe in his hand, girded about with white cloth . . . And this is a [heavenly] sign of strength, high rank, and

wealth without difference." The same text describes the first decan of Taurus (April) as "A woman with curly hair, with a single child dressed in clothes resembling flame, and she is dressed in similar clothes. And this is a sign for plowing and working the earth, for sciences, geometry, sowing seeds, and making things." The frescoes represent an attempt to create images according to what was believed to be the most ancient form of knowledge, the magical science of the heavens.

The pagan gods appear elsewhere in Ferrarese art in the 1460s, and sometimes in a form more directly reminiscent of their appearance in ancient art. In the background of an *Annunciation* painted by Tura in 1468 on the canvas shutters for the organ of the cathedral (fig. 8.7), gods representing the eight planetary spheres appear as dynamic nudes, reacting to the incarnation of the true god with animated dismay. Here Tura imitates the art of antiquity, which for him entailed an inventive rendering of the body in terms of weight shift; the style of the classical figures contrasts pointedly with that chosen for the Virgin and the angel. Venus, who adopts a spiraling double twist, appears to snarl down at the Virgin, herself completely absorbed in a book as the Holy Spirit hovers at her ear. It is not clear that she even sees Gabriel, whose form is mysteriously echoed in the sphinx-like rock formation in the landscape beyond, just as his gesture of greeting repeats that of the pagan messenger god Mercury in the left-hand relief almost completely eclipsed by his wing. The gods of paganism here represent the antithesis of the Christian religion. Yet as planet gods, they are also able to signify the will of the supreme god, heralding the very event that brings about their downfall.

Borso's Bible

Borso's most distinguished commission was his illuminated Bible, a massive two-volume set with jeweled covers that accompanied him on state visits and was shown to guests at his court. He sought to have the most beautiful and magnificent book imaginable; the expenditure that went into it amounted to more than twice the cost of the frescoes in Palazzo Schifanoia. Between 1455 and 1461, a team headed by Taddeo Crivelli and Francesco de' Rossi illuminated the more than six hundred leaves with remarkably varied combinations of text, framed miniatures, and decorative borders. Among the most elaborate are the openings for Genesis (fig. 8.8), where the episodes of Creation appear among the unfurling leaves of a magical vine that springs from an urn precariously supported by golden putti over a baptismal font. The font was one of Borso's heraldic devices; other emblems, among them the *diamante* (diamond) and the unicorn, appear along

8.8

Taddeo Crivelli, opening
of Genesis, Bible of Borso
d'Este. Each folio 14¾ ×
10½" (37.5 × 26.5 cm).
Biblioteca Estense, Modena

with Este coats of arms on the inner borders. The com-
binations of flora and fauna, like the whimsical dragons
and acrobatic nudes, manifest an exuberant creative
energy, reinforcing the scriptural text where the spoken
word of God gives rise to the profusion of the world and
the cosmos.

The Sforza Court in Milan

Filarete

It was easy to idealize the role of the court artist. The
position normally entailed the receipt of a salary and
other benefits from a prince, and some measure of sta-
tus – an artist might be designated a "familiar" of a ruler,
part of an inner household of specially favored courti-
ers and servants. The architect and sculptor Filarete (*see*
p. 185), who took up residence in Milan in 1451 following
an inglorious end to his Roman career (he was banished
for trying to steal relics in 1447), made a self-portrait
medal around 1460 to create the impression that he had

a privileged relation to Duke Francesco Sforza (figs. 8.9–
8.10). The reverse, inscribed *Ut sol auget apes sic nobis
comoda princeps* ("As the sun helps the bee, so to us is the
favor of the prince"), shows the sculptor at work beside
a beehive in a hollow tree, from which a stream of honey
flows. In actuality, Filarete was one of many court art-
ists who found that princely service was all too often its
own reward. Princes could be unpredictable, or exces-
sively demanding; they were also notoriously dismissive
of the obligations that went with the mercantile world of
the contract and the market, and often neglected to set-
tle their bills. They frequently viewed what compensation
they did offer as a gift rather than an obligation. (When
Francesco del Cossa pressed Borso d'Este for an addi-
tional payment toward his part of the Hall of the Months
frescoes, he diplomatically suggested that he would
regard this as a gift and not as the settling of a debt.)

The Sforza, newly established as the ruling family of
Milan, were often casual in their treatment of employees.
Members of the family did take an interest in individual
artists, sending one to Bruges to study with Rogier van
der Weyden (1399/1400–1464) and another to learn from

8.9 and 8.10
Filarete, self-portrait
medal, obverse (above) and
reverse (below). Gabinetto
Numismatico, Milan

TOP AND ABOVE
8.11
Filarete, Ospedale
Maggiore, from *Treatise on
Architecture*, 1465. Pen and
ink on paper. Biblioteca
Nazionale, Florence. The
illustration shows drawings
from Book XI, fol. 82v
(top) and fol. 83v (bottom).

Tura in Ferrara, but most artists at the Milanese court enjoyed little distinction and less financial reward. They usually joined teams engaged to work quickly, and with scant recognition of individual merits. Filarete's move to Milan happened largely at the instigation of Piero de' Medici; the appointment allowed the Sforza and Medici to express close ties of alliance, while serving a larger Medici policy of promoting Florentine artistic expertise abroad. Filarete himself cultivated the role of the learned architect able to guide the prince in the principles of building in the new Florentine style. In his *Treatise on Architecture*, composed for the Sforza but ultimately dedicated to Piero de' Medici in 1465, he wrote proudly of the dependency of princes on their architects. Much of the work consists of fictional dialogues between Francesco Sforza and Filarete, emphasizing their intimacy. The book envisions the building of an ideal city in completely centralized form, named Sforzinda in honor of the prince, with buildings based on projects that Filarete had conceived for the Sforza. Chief among these was the Great Hospital (Ospedale Maggiore) of Milan, on which Filarete worked from 1456 to 1465. The corresponding drawings

in Filarete's treatise (fig. 8.11) show a colossal three-storey building, its horizontal expanse divided by pavilions and with a domed and towered church at its center. The modular plan repeats a basic element, organizing a 5 × 2 grid of identical squares into two Greek crosses (crosses with arms of equal length) on either side of a central block. The arms of the cross house the hospital wards, and the intervening spaces form a series of courtyards, with abundant provision of water to the rear of the building.

Although the hospital draws from such Tuscan models as Brunelleschi's Foundling Hospital (Ospedale degli Innocenti) (*see* fig. 3.13), the design and the principles of functional organization it represents are unprecedented. For centuries, hospitals opened their doors both to those needing medical care and to the homeless, the elderly, orphans, and war refugees, who were often housed together regardless of their particular needs. The Milan hospital classified and separated its patients, with different accommodations for males and females, young and old, and further segregation of patients with infectious illnesses. Laundry rooms, latrines, and internal plumbing manifested a new emphasis on hygiene.

ABOVE

8.12

Filarete, Ospedale

Maggiore, Milan

(fifteenth-century portion)

Only the plan and first storey were built according to Filarete's directions. A board of overseers, divided by political factionalism, constantly challenged and subverted ducal authority. In 1461, with construction under way, local experts and their noble patrons criticized Filarete's design. The architect was dropped from the works and not even Sforza's intervention could reinstate him. Filarete's architecture seems also to have met resistance for its foreign character. The facade as finally built (fig. 8.12) features the kind of Gothic ornament that Filarete openly disparaged in his treatise, where he attributed it to the influence of goldsmiths on architectural design: "They made buildings in this same manner, because these forms seemed beautiful in their own work, but they also have more to do with their own work than with architecture." In a remark that would have gone over much better in Florence than in Milan, he added that such

"modes and customs" came "from across the Alps, from the Germans and the French," and that "for this reason ancient usage was lost." Such comments represent a kind of stylistic absolutism, one that showed Filarete's friction with the local culture. He wrote that the Medici Bank in Milan (fig. 8.13) was "not in the Milanese manner but as is used today in Florence, that is, in the antique style." It is true that the bank (*c.* 1463), now known only from a surviving portal and from Filarete's drawing, incorporates elements of the "Florentine" style used by Brunelleschi, Michelozzo, and Rossellino. The basic form of the building echoes Michelozzo's design for the Medici Palace (*see* figs. 6.20 and 6.22). Yet the bank is a hybrid, its facade encrusted with tracery and its windows topped with the cusped arches that Filarete associated with the over-precious "little tabernacles and incense boats" of the Gothic style. The portal (fig. 8.14) has an elegant

8.13
Medici Bank, Milan, facade, *c.* 1465, as shown in Filarete, *Treatise on Architecture*. Pen and ink on paper. Biblioteca Nazionale, Florence. Detail from Book XXV, fol. 192r.

8.14
Unknown architect, portal from the Medici Bank in Milan. Castello Sforzesco, Milan

Corinthian order framing an arch, yet the richly carved spandrels with their portraits of Duke Francesco Sforza and his wife Bianca Maria Visconti, and the ostentatious frieze with putti bearing the Sforza-Visconti coat of arms, signal a Milanese adaptation or translation of the Florentine-Roman vocabulary. The vertical tiers of figurative sculpture framing the door, with putti, cornucopia, female Virtues, and warrior figures, might recall Florentine humanist tombs by Rossellino and others, but they would never have appeared in a Florentine civic or commercial context. The Medici Bank of Milan, then, signals not so much an imposition of Florentine taste on local norms as an attempt to produce a work that is both Florentine and Milanese, both Medici and Sforza.

The Portinari Chapel

The bank's manager, the Florentine Pigello Portinari, was aware of the power of art to forge cultural bridges. His own funerary chapel at the Milanese church of Sant'Eustorgio (fig. 8.15), adapted from the design of Brunelleschi's Old Sacristy (*see* fig. 4.11), is no simple gesture of "Florentinization"; like the bank, it signals a process of translation and adaptation. Once again, Gothic tracery appears in the windows, instead of the Old Sacristy's severe arches. The umbrella dome is raised now upon a drum, on which a frieze of stucco angels bearing garlands and cornucopia designates the "heavenly" zone of the chapel.

Unlike the plain expanses of wall in its Florentine model, the zones above the Corinthian frieze in the Portinari Chapel are decorated with richly colored frescoes of the Life of St. Peter Martyr (the Dominican saint whose remains are preserved in the church) by the Brescian painter Vincenzo Foppa (*c.* 1430–*c.* 1515). Foppa, an accomplished perspectivist, used painted architecture to extend the space of the chapel with elaborate urban vistas. The approach recalls other north Italian practitioners of the modern manner, such as Jacopo Bellini (*see* p. 138), who had himself worked in Foppa's home town of Brescia. The roundels in the spandrels, depicting the four Doctors of the Church, draw not on Donatello's stucco *tondi* in the Old Sacristy but on the treatment of the same subject by the rivals Andrea Mantegna and Niccolò Pizzolo in the Ovetari Chapel in Padua, from the previous decade (*see* figs. 7.21–7.23). In addition, illusion is a thematic concern of the frescoes: in one scene by Foppa (fig. 8.16), the saint exorcizes a demonically animated statue of the Virgin that had been working spurious miracles. The "inauthentic" manifestation of the Virgin here contrasts with the accompanying scenes of the Annunciation on the chancel arch and the Assumption on the facing wall.

ABOVE

8.15

Portinari Chapel,
Sant'Eustorgio, Milan,
c. 1468. Interior

OPPOSITE

8.16

Vincenzo Foppa, *St. Peter
Martyr and the Idol*, 1468.
Fresco. Portinari Chapel,
Sant'Eustorgio, Milan

Courtly Imitation

Through Portinari's influence, Foppa was appointed "familiar" in the household of Duke Francesco's successor Galeazzo Maria Sforza, yet none of his major surviving works can be connected with the court. There instead we find him working in partnership with other painters on large-scale projects where the priorities were speedy execution and stylistic uniformity. Foppa belonged to the team of artists that produced a massive reliquary altarpiece for the chapel in the new Sforza castle of Milan. Most of the castle's rooms repeated Sforza and Visconti heraldic motifs in gold and azure. Insistence on continuity with the Visconti regime was a matter of some urgency to Francesco, since his own claim to succession depended on his marriage to an illegitimate daughter of the last duke. When Francesco's successor Galeazzo Maria had the castle chapel decorated a few years later by another group of artists headed by Bonifacio Bembo (*fl.* 1447–77), the style employed (fig. 8.17) emphasized continuity with the Visconti era in its deliberate avoidance of Foppa's characteristic manner. Here we are still in the world of Pisanello and Gentile da Fabriano, with its simulation of rich materials, its emphasis on decorated surfaces, and its suspension of spatial illusion. The entire scheme probably imitated an earlier fifteenth-century decoration in a Visconti residence.

Galeazzo provides a striking example of the power of court painting to govern even social conduct and manners. Not only did he commission elaborate frescoes depicting himself and his courtiers hunting and feasting, just as the Visconti court had in decorations from the late

8.17
Bonifacio Bembo and others, ceiling frescoes in the Chapel of Castello Sforzesco, Milan, 1473

1300s; but he also compelled the men and women of his court to adopt the hairstyles and forms of dress featured in these earlier paintings. According to one Florentine ambassador's report from 1470, "A wild passion for greyhounds has come over the Duke and he thinks of nothing else.... He has painted the Duke Giovan Galeaz [Visconti] with greyhounds around him in every *storia* in the *sala* of the Castle here, and he continues to imitate it, and from this I believe comes his desire." The perception was that Galeazzo Maria's very enthusiasm for hunting followed a logic of ritual imitation, one guaranteed by the pictures on his walls.

Mantegna, Alberti, and the Gonzaga Court

In one remarkable decorated chamber in the castle of the Prince of Mantua, Andrea Mantegna not only concentrated and intensified all the features of courtly secular painting we have seen in the much larger cycles in Ferrara and Milan, but he also produced a meditation on the principles of "Renaissance" painting itself.

Mantegna had come to Mantua from Padua in 1460 after a prolonged period of wrangling about his salary and his prospective status as an employee of the ruling Gonzaga family. One of the delays was due to an uncompleted commission (also in 1460) for a monumental altarpiece for the abbey church of San Zeno in Verona (fig. 8.18), ordered by the abbey's Venetian administrator, Gregorio Correr. The work is often compared to Donatello's Santo altarpiece in Padua (*see* fig. 6.41), which Mantegna certainly knew well: the frame of the San Zeno altarpiece, a triple-arched portico, gives illusionistic access to a continuous architectural space, viewed from below, that recedes into depth. The Virgin and Child with a heavenly court of contemplative saints occupy a classical temple, which is otherwise strangely free of Christian imagery. Adorning it are reliefs of cupids with garlands and *tondi*, along with roundels showing subjects from pagan mythology. In the three meticulously rendered panels that form the predella, Mantegna created an imaginary itinerary around the city of Jerusalem. His landscape panoramas with shifting views of Jerusalem reflect his close study of paintings imported from the Netherlands.

By now established as one of the most renowned painters in Italy, Mantegna could command the best terms. He held out for nothing less than aristocratic honors from the Gonzaga. In addition to a salary, a house, and living expenses for six people, he received a coat of arms, with the promise that "these are the least of the rewards you will get from us." In 1468 Mantegna traveled

8.18

Andrea Mantegna, San Zeno altarpiece, 1460.

Tempera on panel, height 7'2½" (2.2 m).

San Zeno, Verona

to Ferrara, where Borso d'Este was entertaining the Emperor Frederick III, and purchased the title of Count Palatine. In many respects, the Gonzaga needed Mantegna as much as he needed them: the ruler Ludovico (r. 1444–78), raised as a professional soldier, had obtained several commissions in the service of the Sforza of Milan. Yet Gonzaga had also received a humanist education and was fully aware that culture would enhance the reputation of his small state as much as soldiering.

Mantegna's Camera Picta

According to the terms of his employment, Mantegna would work exclusively for the prince. If other elite clients wanted a painting by Mantegna, they had to petition Ludovico. Few such requests met with success, however, given Mantegna's insistence on working at his own pace, and his unwillingness to satisfy any but the most important clients – such as the Pope and Lorenzo de' Medici. Mantegna also managed to avoid many of the more mundane duties of court artists, such as the painting of shields and parade banners and the decoration of furniture and

statuary. By 1465, it had been determined that the artist would invest his energies in a single great work that would show his skills to their best advantage. This was the decoration of a cube-shaped room in the prince's apartment: located in a restricted and private part of the castle at Mantua, it combined the functions of a bedchamber, a private study, and a reception space. A group portrait of the Marquess Ludovico, his wife Barbara of Brandenburg, their children, and various members of the court appears above our eye level on the fireplace wall (fig. 8.19). On the adjacent wall, male members of the Gonzaga family gather with other princes in an open-air setting, the horses and dogs evoking the hunting scenes that are so characteristic of this kind of palace decoration (*see* figs. 8.5–8.6). Yet we encounter these scenes through a painted arcade adorned by swags, and with curtains that flutter in the open air: it is as if Mantegna has placed us inside the temple-like space of his San Zeno altarpiece. An exquisitely decorated vault rises from the painted pilasters, with illusionistic stucco decorations of cupids holding garlands around portraits of the first eight Roman emperors: an oculus opens above our heads with a glimpse of blue sky, while "live" cupids besport themselves on the ledge (fig. 8.20).

In one sense, the Camera Picta (Painted Chamber) belongs to the same genre as the portraits that filled the residences of the Este and the Sforza. Yet Mantegna concentrated resources, working slowly and meticulously, rendering the portraits with astonishing descriptive naturalism and adding intricate patterns to the vault. (He used a slow-drying, oil-based technique rather than traditional *fresco*.) The room draws attention to the unique abilities of the individual who made it, and Mantegna, in fact, proclaimed his authorship in a Latin inscription above one of the doorways: "For the illustrious Ludovico, second marquis of Mantua, a prince most excellent and of a faith most unbroken, and for the illustrious Barbara, his spouse, glory beyond compare of women, their Andrea Mantegna of Padua completed this poor work to do them honor in the year 1474." The Gonzaga residences contained many "painted chambers," but only this one was simply designated as "*the* Painted Chamber," as if it were the last word in decorations of its kind. For Ludovico Gonzaga, Mantegna's performance offered an alternative to an endless repetitive display of the princely image throughout the castle: this room, made marvelous by art, is privileged and distinguished as the space of the prince's image. The fresco enacts the idea of restricted access to the prince, of "insiders" and "outsiders," by separating the zone with the Gonzaga family from that of the stairway, where two courtiers delay the admission of others (fig. 8.19). Ludovico himself used the space in an almost ritualistic way, receiving the most important guests while seated in front of his own portrait on the wall, on at least one occasion in the company of his wife and daughters. Such staged appearances can be seen as a profession of sincerity and trustworthiness: visitors, seeing that the frescoes showed the Gonzaga without flattery, would have had visual evidence of the family's good faith.

8.19
Andrea Mantegna, Camera Picta, 1466–75. Castello San Giorgio, Mantua

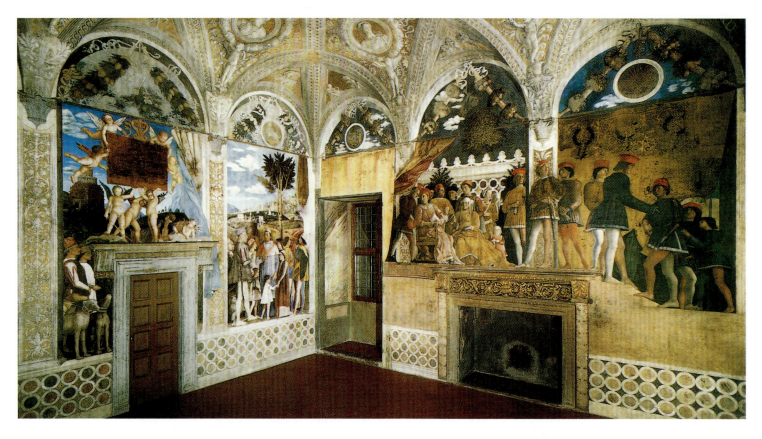

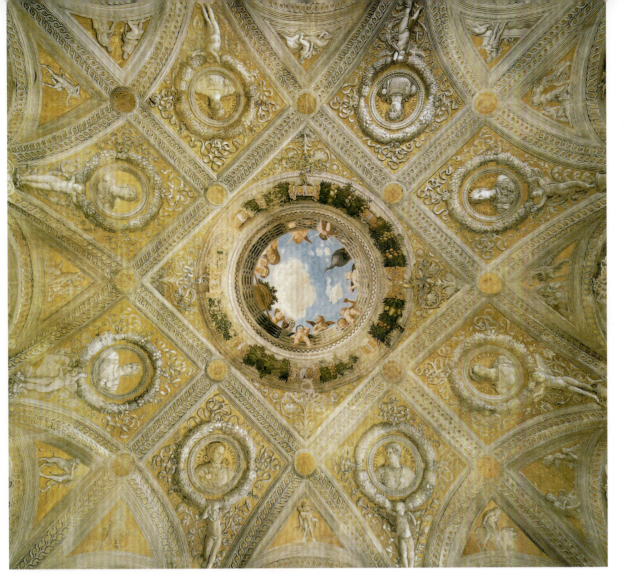

8.20

Andrea Mantegna, Camera Picta: vault. Castello San Giorgio, Mantua

What is especially new about the Camera is the way in which the entire decoration responds to the presence of a beholder. In the court scene (*see* fig. 8.19), Ludovico – having evidently just read a letter – turns to address a servant or secretary. Ludovico is clearly transacting business, but an outsider cannot determine whether he is attending to routine affairs of state or whether something more momentous has happened. The Gonzaga seem to act with reserve, both toward one another and the viewer. Yet this reinforces the sense that they are conscious of being looked at, doing their utmost to avoid our gaze. Only the female dwarf haughtily glowers down at us, as if to insinuate that we are hardly worth their attention. And then, looking up, this uneasy feeling of being excluded assumes a more mischievous dimension. From the oculus several ladies smile down knowingly, as if a humiliating joke is about to occur at our expense. One of the foreshortened cupids dangles a piece of fruit over our heads, while one of the women rests her hand on a beam that barely supports a planter containing an orange tree.

The Camera is a work of political art: it documents the status and ambitions of the Gonzaga family. The pic-ture excluded Duke Galeazzo Maria Sforza, a potentially serious breach of protocol since the Sforza were the chief employers of the Gonzaga military forces, and the duke noted with displeasure that while leaving out his portrait, the artist had included the Holy Roman Emperor and the King of Denmark, "two of the worst men in the world." These sovereigns, who represented more honorable and ennobling connections than the upstart Sforza dynasty, turn up in the scene that has come to be called *The Meeting*, where Ludovico greets his son Francesco, who had been made a cardinal in 1461 at the age of seventeen (fig. 8.21). Francesco, embodying a highly advantageous connection to the papal court, receives special distinction here as the only full-length figure represented frontally. He stands amidst an array of princely profiles, reminiscent of the official likenesses on portrait medals, with his father Ludovico to his right and his eldest brother Federico to the far left, while he holds his younger brother (also called Ludovico) by the hand. Yet the illustrious political connections from beyond the Alps, the king (the man in black to Federico's right) and emperor (facing Federico, in profile), would have been

235

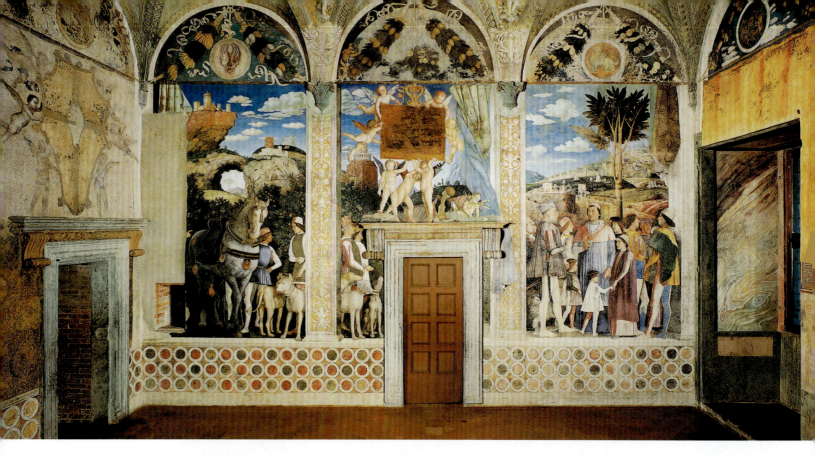

8.21
Andrea Mantegna,
dedicatory inscription
and *The Meeting*. Fresco.
Camera Picta, Castello
San Giorgio, Mantua

RIGHT
8.22
Leon Battista Alberti,
facade of Sant'Andrea,
Mantua, begun 1470

identifiable only from their portraits; they are given no special prominence through royal or imperial insignia. It is as if "vertical" connections of feudal dependency have become "horizontal" connections of family and friendship. (Ludovico could claim kinship with both monarchs through his noble German wife.) Thus the landscape representing the city of Rome in the meeting scene, like the roundels with the portraits of emperors, is deliberately ambiguous in its reference: it could show the Gonzaga to be feudal subjects of the Holy Roman Emperor, the new Caesar, or it could represent the Gonzaga connection to papal Rome through the cardinal. Finally, however, it could represent the fantasy of imperial status on the part of the Gonzaga themselves, where Mantua – through the cultural and military distinction won by its rulers – becomes a "New Rome." One tiny but important detail reinforces this insinuation: over the gate to the "Rome" in the background of the "Meeting" appears the same Gonzaga coat of arms that adorns the overdoor on the facing wall in the Camera Picta.

Alberti in Mantua

The Gonzaga additionally emulated Rome through the services of another important connection: Leon Battista Alberti. In the previous decade Ludovico had commissioned Alberti to add a monumental circular choir to the church of Santissima Annunziata in Florence as a votive offering on a princely scale to the church's miraculous image. The gesture was also a clear bid to secure Gonzaga

recognition abroad, and an expression of friendship with the Medici. Of two churches built by Alberti in Mantua, the more notable is Sant'Andrea, designed in 1470 to provide a magnificent and capacious setting for a highly important relic, the blood of Christ. As had been the case

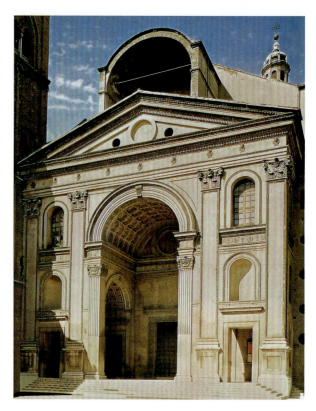

Urbino: The Palace of Federico da Montefeltro

8.23

Leon Battista Alberti and Luca Fancelli, Sant'Andrea, Mantua, begun 1470.

Interior

with the church of San Francesco in Rimini (*see* figs. 7.14–7.15), Alberti mainly supplied designs and advice from Rome, while the Gonzaga architect Luca Fancelli directed the building work on site.

Alberti here truly brought Rome to Mantua, in a building without equal elsewhere in Italy for its inventive adaptation of ancient types. The facade (fig. 8.22), like those of Pienza Cathedral (*see* fig. 7.30) and Santa Maria Novella in Florence, combines the triumphal arch with the temple front, now with much greater emphasis on the arch: the colossal Corinthian pilasters on bases recall the engaged columns on the arches of Septimius Severus or Constantine in Rome. The great central arch, with its deep recession and its **coffering**, offers a bold sculptural contrast to the more delicate and relief-like treatment of the facade. The facade's tripartite form, moreover, announces the organization of the interior (fig. 8.23). Unusually, Alberti's church has no aisles: the vault is supported on massive piers, between which is a series of chapels mostly with their own coffered **barrel vaulting**. Again, Alberti has unified interior and exterior by repeating the triumphal arch theme of the main facade – Corinthian pilasters and three-storey minor bays with smaller doorways frame the large coffered recesses of the chapels. The design recalls the ancient basilicas and baths of Rome: the huge (60-foot) barrel vault (with fake coffering) is the largest constructed in Italy since the fourth century CE. Alberti appears also to have designed a dome for the church, though the brightly illuminated crossing we encounter today depends on an eighteenth-century modification.

The Este, the Gonzaga, and the Malatesta (*see* p. 196) dynasties all owed their political good fortune and economic survival to the profession of soldiering. Princes who fought for money took special pains to assume the trappings of chivalry and noble martial arts; many professed a sincere interest in the military heroes of antiquity, such as Scipio Africanus and Julius Caesar, and took up the study of Roman history. The fathers of Ludovico Gonzaga and Borso d'Este ensured that their sons were not just good soldiers but also gained a solid humanist education: this would have meant at least the ability to read Latin, although Ludovico had deeper scholarly interests and wrote Latin poetry. One of Ludovico's boyhood classmates in Mantua was a young prince of the Montefeltro family, papal vicars of a mountainous and largely barren fief in the eastern Papal States, centered on the town of Urbino. Federico da Montefeltro (1422–1482) would soon prove to be the most renowned captain of his age, combining fearsome efficiency with a reputation for loyalty and dependability – qualities his arch-rival and neighbor Sigismondo Malatesta (1417–1468) notoriously lacked. Since most of the Italian powers finally found it expedient to pay Montefeltro not to fight, he rapidly amassed vast wealth, which he invested in the architectural embellishment of his small state.

Contemporaries regarded the palace of Urbino, begun in 1447 and mostly completed in the 1470s, as one of the wonders of Italy: they admired its engineering, its noble architecture, and the refinement of the scholars and nobles found there. They credited Federico himself with a substantial role in the design, though a document of 1468 records that he had given a Dalmatian architect named Luciano Laurana (*c.* 1420–1479) full authority to direct building operations. The palace, which straddles an entire hillside (figs. 8.24 and 8.26), dominated the view of Urbino from the western approach road. The turreted central element suggests a fortress, but the defensive theme is more symbolic than actual. Two delicate towers framing a four-storey, single-bay loggia designate the core of the palace, the apartment of Count Federico (he would be made Duke of Urbino in 1474), containing his chapel, his studiolo, and, in emulation of the Este, a little Temple of the Muses. The tower and loggia theme recalls the Arca Aragonese of the Castel Nuovo in Naples (*see* fig. 7.12), but its main function is to afford views of the valley; there is no access to the palace from here. The building is entered on the town side, which presents a facade reminiscent of the recently built palaces of Florence and Rome (*see* fig. 7.29). The central portal leads

to Laurana's great courtyard (fig. 8.25), which in its breadth and luminous elegance suggests a grand urban space rather than its closed-in, shaft-like counterparts in Florence (*see* fig. 6.22). Laurana certainly knew Florentine architecture: the loggia is a variant on Brunelleschi's Ospedale degli Innocenti (*see* fig. 3.13), adapted with an eye to visual refinement. Whereas Michelozzo, for instance, had merely wrapped a copy of the Innocenti loggia around four sides of a square (*see* fig. 6.22), Laurana devoted special attention to the corners, here replacing columns with L-shaped piers, thus providing a sense of containment and stability to each of the four facades. An inscription in elegant Latin majuscules runs around the frieze: "Federico, Duke of Urbino, Count of Montefeltro and Castel Durante, builder of the palace, undefeated in war, the just, clement and liberal prince."

The courtyard provided access to Federico's famous library, a collection of nearly one thousand sumptuously bound and illuminated manuscripts, some of them produced in Florence and others in a local scriptorium. Federico's ambition was to equal or even surpass the great libraries of the world, and his envoys requested

TOP LEFT
8.24
Luciano Laurana,
Francesco di Giorgio,
and others, Ducal Palace,
Urbino, 1450s–80s. View
from western approach

ABOVE
8.26
Luciano Laurana,
Francesco di Giorgio,
and others, Ducal Palace,
Urbino. Plan

LEFT
8.25
Luciano Laurana,
courtyard, Ducal Palace,
Urbino, 1465–79

8.27

Francesco de' Russi (?), opening of the Gospel according to St. Luke, 1474–82. Manuscript on parchment, 16 × 10" (40.5 × 25.6 cm). Vatican Library

da Bisticci. More generally, the palace of Urbino became the exemplary princely dwelling: it provided the basis for the ambitious new palaces of Ercole d'Este (Borso's successor as Duke of Ferrara in 1471), and both Lorenzo de' Medici, and Ludovico Gonzaga's heir, Federico, wrote to request drawings of the building. Decades later, in 1518, the highly influential *Book of the Courtier* by the Mantuan nobleman Baldassare Castiglione still celebrated not only the palace but also the brilliant circle of gentlemen and ladies, artists, and musicians that the Montefeltro family entertained there. Long after the 1470s, as a consequence, Urbino's elegant, witty, and humane courtly society remained the model for civilized manners and behavior for the whole of Europe.

Courtly Values in Cities without Courts

Florence: Chapel Decorations in the Medici Palace

A court was not just a political institution, the household and administration of a prince. The word "court" and its derivatives in English to this day – "courteous," "courtship," even "court of law" – connote virtuous and gracious conduct, of an authority founded on manners and the observance of ceremonial protocols. The aesthetic and moral ideals of Dante, Petrarch, and Boccaccio were those of the courts where the three great poets spent much of their time, even as the ideologues of Florentine Republicanism tried to reground those ideals in the classical authority of the Roman philosopher, statesman, and political theorist Cicero. Courts defined an essence of civilization to which republics were still beholden, and the Medici sought to manifest that essence.

We have seen that the Medici family, though not nobles themselves, erected buildings and decorated chapels of an expense that the princely rulers of Europe hardly rivaled. The patrons and artists may both have associated the proportionality, clearly ordered composition, and ornamental restraint in these works with particular social values: gravity, dignity, the cultivation of ancient virtue, and "Tuscan" simplicity. Yet when Piero de' Medici (1416–1469; r. 1464–69) became head of the family in Florence, and commissioned Fra Angelico's assistant Benozzo Gozzoli (c. 1421–1497) to decorate the chapel of the family palace in 1459, the family adopted an art of luxurious display that deliberately echoed the work of Gentile da Fabriano a generation earlier (*see* fig. 4.3), as well as recent work by Pisanello (*see* fig. 5.2).

The east and west walls of the chapel show the procession of the Magi in a landscape that rises up the wall as much as it recedes in depth, recalling the tapestry effect

catalogues from the Vatican, the Medici Palace, and Oxford University, among other collections. This was very much a humanist library, with most of the volumes in Latin, Greek, and Hebrew, and only about seventy in the vernacular. Although they represented most of the great theologians, the majority of the books concern philosophy, history, and poetry. Two massive Bibles decorated by Florentine and Ferrarese illuminators were clearly intended to rival that of Borso d'Este in Ferrara; the *St. Luke* (fig. 8.27) strongly recalls the style of Cosmè Tura (*see* fig. 8.3). By contrast with the Ferrarese Bible, however, the Montefeltro volumes employ a form of italic script devised for the transcription of classical Latin texts.

Given the importance of fresco decoration at Milan, Ferrara, and Mantua, it is striking that Federico seems not to have commissioned any for his own palace at Urbino. Simple white walls offset the marble framed portals with *intarsia* doors. Federico did occasionally have the walls hung with tapestries, the most princely of media: in 1476, he would commission a set of eleven pieces from Jean Grenier of Tournai representing the war of Troy. Isabella d'Este, the Marchioness of Mantua and the great arbiter of aristocratic taste, singled out Federico's tapestries and embroidered hangings for particular praise, as did Federico's Florentine biographer and book supplier Vespasiano

8.28

Benozzo Gozzoli, *Procession of the Magi* (detail), 1459. Fresco. Chapel of the Medici Palace, Florence. Among the Magi and their entourage are portraits of the principal male members of the Medici family and several of their allies from the princely families of Italy.

of Pisanello's Arthurian cycle; huntsmen pursue deer with their dogs and leopards, details reminiscent of Pisanello's "modelbook" naturalism (*see* p. 127). While the procession winds its way through the highly artificial-looking rock formations, the majority of the figures are packed into the foreground and stacked so that every face is visible (figs. 8.28–8.29). For the Medici and their entourage in 1460, these faces were undoubtedly there to be recognized. Gozzoli portrayed himself near the apex of the left-hand group, his name emblazoned in gold letters on his red cap. Cosimo, the white-haired elder in black, rides a mule, a mount he favored in real life as a calculated sign of humility. His son Piero, the patron of the cycle, appears to his left in black and gold brocade, and the black bowman who walks alongside Cosimo may also be a historical person. The young man on the white horse nearby is the young heir to the Dukedom of Milan, Galeazzo Maria Sforza, who had made a state visit to Florence in 1459. Directly to Galeazzo's right is Sigismondo Malatesta of

Rimini, who had last been to Florence in 1436, when the members of the great houses of Italy had assembled for the papal consecration of the cathedral. In the picture the Medici escort real princes in the train of one Magus, the crowned youth on the white horse who turns his head to look in the direction of the viewer. Though he may not physically resemble any living being, that figure is an idealized representation of Piero's son Lorenzo, only ten years old in 1459 but already being groomed as future head of the family. The laurel that frames his head and the orange that appears nearby (*lauro* and *arancio*) pun on the name "Lorenzo" (*Laurentius* in Latin).

The frescoes reflect the Medici's sense of themselves as both Florentine citizens and implicit dynastic rulers, peers to the princes of Italy. The Malatesta and the Sforza had been important military allies of both the city and the Medici family, while in addition Piero nurtured good relations with the Este of Ferrara and the Gonzaga of Mantua. The man with the dagger walking

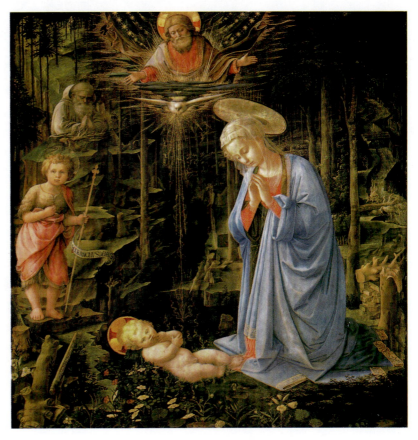

the Baptist and the twelfth-century French saint Bernard of Clairvaux. Both John and Bernard contemplate the human and divine generation of Christ, the subject of many of Bernard's sermons. Heavenly light rendered in gold passes from God through the Holy Spirit to the Child who lies on the ground, while the figure of the Virgin nearby makes clear that the incarnation of Christ occurred through the flesh of the Virgin no less than through the procession of the Spirit.

The two saints, popular throughout the Christian world, carried a particularly Florentine resonance: the government of Florence observed Bernard's feast day, 20 August, and Bernard himself figured in the pre-eminent Florentine literary classic, the *Divine Comedy* (1308–21) of Dante; in the final canto, he presents the poet to the vision of the Virgin herself. John the Baptist was the city's patron saint. Here, he appears not as the bearded hermit that Lorenzo Ghiberti had cast for the city's baptistery in *c.* 1410 (*see* fig. 3.3), but as a child, a change that reflected the devotional interest of Lucrezia Tornabuoni, Piero de' Medici's wife. Like Gozzoli, that is, Lippi appropriated themes and images from the cultural and religious life of the city but gave them a distinctive Medici cast. The altarpiece in particular became a kind of Medici icon, and gave rise to a host of imitations and direct copies by other artists, some of them produced using cartoons

in front of Piero's horse wears a tunic adorned with the *diamante*. A play on the words for "lover of God," as well as "diamond," the *diamante* was a princely heraldic sign that Piero shared with the Este rulers of Ferrara, who had granted him the right to use the device. As we have seen, the Medici also participated in the annual Epiphany procession of the Magi, a ritual that this cycle of frescoes clearly commemorates. Yet the destination of this procession is not the convent of San Marco with its representation of the Nativity, but the altar in the chapel of the Medici Palace itself.

There could be no clearer expression of the connections between palace and church that we explored in the last chapter than the spectacle of priests saying Mass in this private home. In 1460 Fra Filippo Lippi supplied the altarpiece (fig. 8.30), which has to do less with the Epiphany in Luke's Gospel than with the manifestation of the Divine in the local world. Gozzoli painted a host of adoring angels in a paradise-like landscape on the walls adjacent to the altarpiece. In the latter, however, the setting has shifted to the heart of a woodland, a solitary clearing with rocks and tree stumps. The artist's signature appears on the handle of an axe, in sharp foreshortening in the left foreground. And rather than depicting St. Joseph and the ox and ass from the stable of Bethlehem, Lippi includes the young hermit St. John

8.29
Benozzo Gozzoli, *Procession of the Magi*, chapel of the Medici Palace, Florence, 1459. Fresco

8.30
Fra Filippo Lippi, *Adoration of the Christ Child*, 1460. Tempera on panel, 50 × 45⅝" (1.27 × 1.16 m), Gemäldegalerie, Staatliche Museen, Berlin. A replica now occupies the original site of the painting, on the altar of the chapel in the Medici Palace.

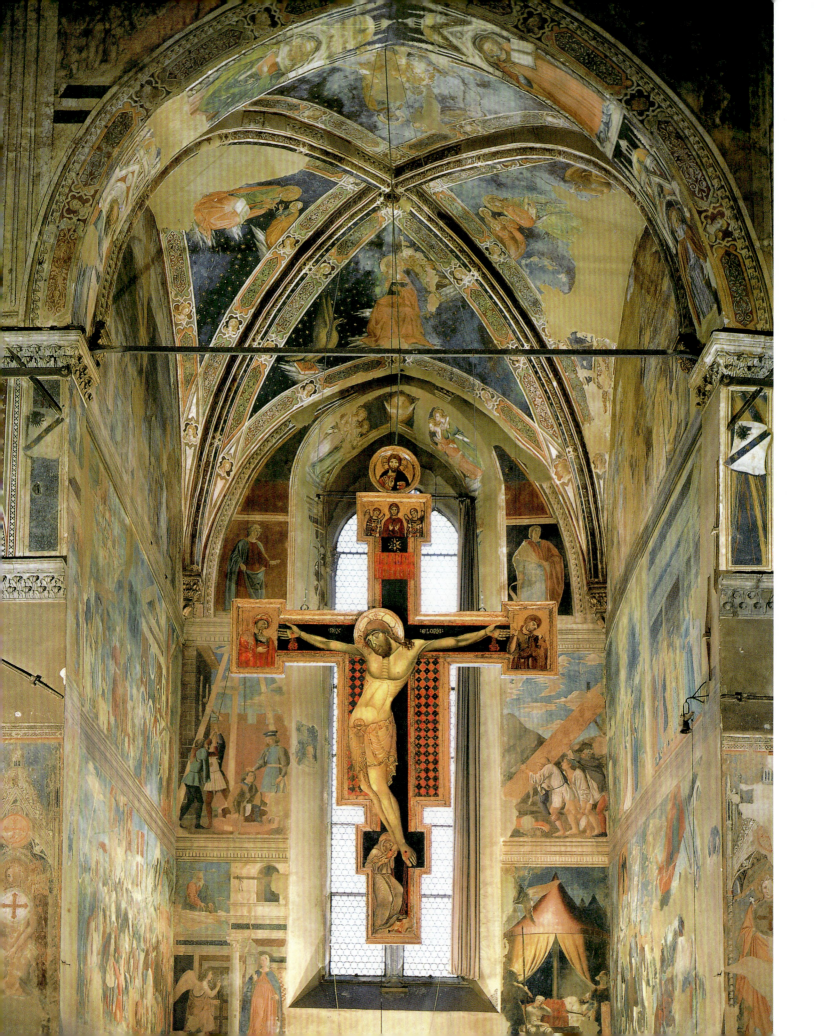

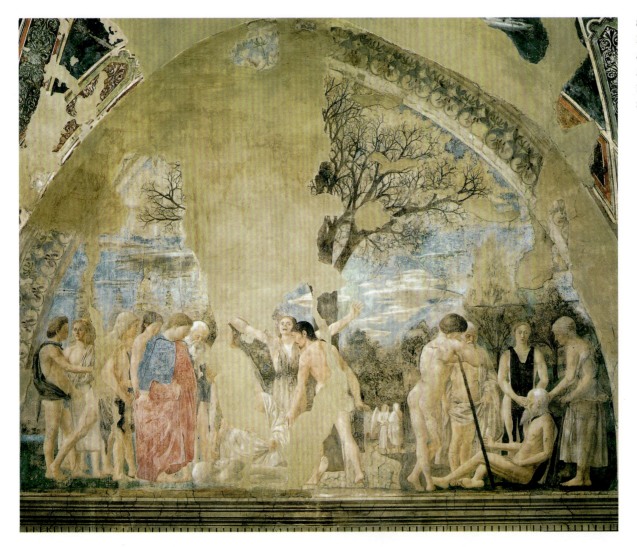

8.32
Piero della Francesca,
Story of the True Cross: The Death of Adam, c. 1455–60.
Fresco. Cappella Maggiore,
San Francesco, Arezzo

traced from the original. In this use of art to connect the private and public spheres, the Medici resemble their allies at the courts of Italy.

The Medici never overtly claimed to be dynastic rulers, which would have been risky in a republic that had sent families, such as the Alberti and the Strozzi, into exile for their alleged princely aspirations. Still, their authority in Florence and their recognition as favored courtiers or even peers by princes elsewhere made their house and retinue hard to distinguish from any other Italian court. Especially when conducting business away from home, the Medici could quietly count on equal or greater political and financial authority with those princes at whose "service" they placed themselves. Yet circumspection was necessary: when Galeazzo Maria Sforza made a return visit to Florence in 1471, now as Duke of Milan, and headed a retinue of one thousand courtiers adorned in velvet and cloth of gold, with many bearing falcons on their wrists, Florentines were both astonished and appalled.

Arezzo: Piero della Francesca's *Story of the True Cross*

The frescoes that Piero della Francesca completed around 1460 in the Florentine subject city of Arezzo (fig. 8.31) further exemplify the centrality of the court as an imaginary social ideal even in a non-courtly context: the artist who had worked for Italian princes now produced a romantic evocation of the kings, knights, and chivalry for a non-princely patron. The cycle, commissioned by a member of the Bacci family for the choir of the town's Franciscan church, is based on episodes from one of the most colorful sections of Jacopo da Voragine's *Golden Legend* (*see* p. 80), although amplified, in humanist fashion, with the inclusion of material from more authoritative late antique historians. The "Story of the True Cross" features many royal figures from the Bible and from Christian history: wonders and feats of chivalry abound, and Christian kings and knights do battle with pagans and heretical eastern rulers. Though set in the distant past, the story

OPPOSITE
8.31
Piero della Francesca,
Story of the True Cross,
fresco cycle, c. 1455–60.
Cappella Maggiore, San
Francesco, Arezzo

8.33
Piero della Francesca,
Story of the True Cross: The
Queen of Sheba Adoring
the True Cross and Meeting
with Solomon, c. 1455–60.
Fresco. Cappella Maggiore,
San Francesco, Arezzo

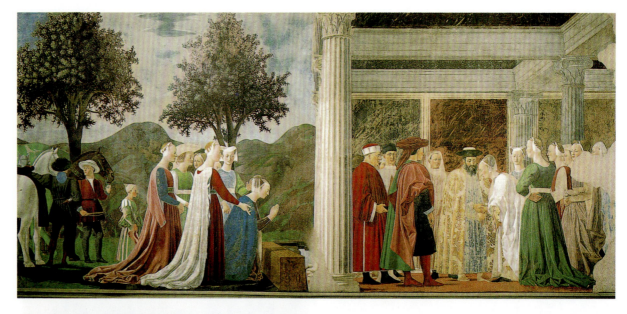

8.34
Piero della Francesca, *Story*
of the True Cross: Vision of
Constantine, c. 1455–60.
Fresco. Cappella Maggiore,
San Francesco, Arezzo

is permeated with references to crusade, a cause long
preached by the Franciscans and the focus of renewed
discussion with the fall of Constantinople to the Otto-
man Turks in 1453. The narrative begins with the death
of Adam amongst his numerous kin (*see* fig. 8.32). From
his grave springs the tree from which the wood of Christ's
cross will be drawn. Long before the Crucifixion, however,
King Solomon attempted to use the tree as material for his
palace: the wood miraculously changed its size, refusing
to be incorporated into the architecture, so Solomon cast
it across the river to serve as a bridge. Piero depicts the
episode where the wise Queen of Sheba, en route to visit
Solomon, recognizes that the wood is holy, and refuses
to place her foot upon it, kneeling down to venerate it
instead (fig. 8.33). On the right, in a separate scene, the
same queen bows before Solomon himself. Piero lends a
ritualistic formality to the event, in part through calcu-
lated repetitions. One female figure rendered in profile
appears in three different incarnations: Piero used the
same cartoon twice in the left-hand scene, flipping it for
the corresponding figure in the scene on the right. Subse-
quent scenes from the Christian era show the conversion
of the Roman emperor Constantine (fig. 8.34), greatest
of all Christian rulers, through a vision of the cross, his
victory over his rival Maxentius, and his mother Helena's
retrieval and authentication of the relic (fig. 8.35) after its
concealment by the Jews (a Jew named Judas reveals the
hiding place under torture). The authentication scene the-
matically and compositionally echoes that of Sheba on
the opposite wall. Helena, to the left, looks on as three
crosses – that of Jesus and those of the thieves crucified at
his side – emerge from the ground; to the right, the true
cross miraculously identifies itself by resurrecting a dead
man. Viewed from the rear with arms extended, the nude

8.35
Piero della Francesca,
*Story of the True Cross:
The Discovery and
Authentication of the True
Cross, c.* 1460. Fresco.
Cappella Maggiore, San
Francesco, Arezzo

8.36
Piero della Francesca,
*Story of the True Cross:
Battle of Heraclius and
Chosroes,* 1460. Fresco.
Cappella Maggiore, San
Francesco, Arezzo

figure of the resurrected man completes Piero's circular formation of figures before a basilica, strongly reminiscent of the cathedral recently erected in nearby Pienza.

Piero repeats the cross in various scenes throughout the cycle, foreshortening it at a range of angles in relation to the picture plane. Even when the cross itself does not appear, the painter constantly places stress on cross-like vertical elements – the supporting post of Constantine's tent, the scaffold on which Judas is tortured, the banners and weapons that appear in the climactic battle scenes on each wall: Constantine's defeat of Maxentius and the Byzantine emperor Heraclius's defeat of the Persian king Chosroes (fig. 8.36). The violence of the scene, in which a semi-nude warrior engages in combat alongside others in fifteenth-century armor, is implied but curiously

understated. Like Paolo Uccello's battle scenes from thirty years earlier (*see* fig. 5.11), the concern with geometry and perspective has instilled a paradoxical sense of order, as if this were a ritual rather than an episode from history. The chivalric accents of the banners, and the invocation of Christian sovereignty, may have carried a political undertone: before its domination by Florence, which annexed the city in 1384, Arezzo had long placed itself under the protection of the Holy Roman Emperor. The scene of King Chosroes's decapitation would inevitably have prompted beholders to consider the distinctions between just and unjust rulers, and the merits of a political order centered on the rule of a virtuous and heroic individual. Such a manipulation of the symbols of imperial authority was a constant theme in the imagery of the courts.

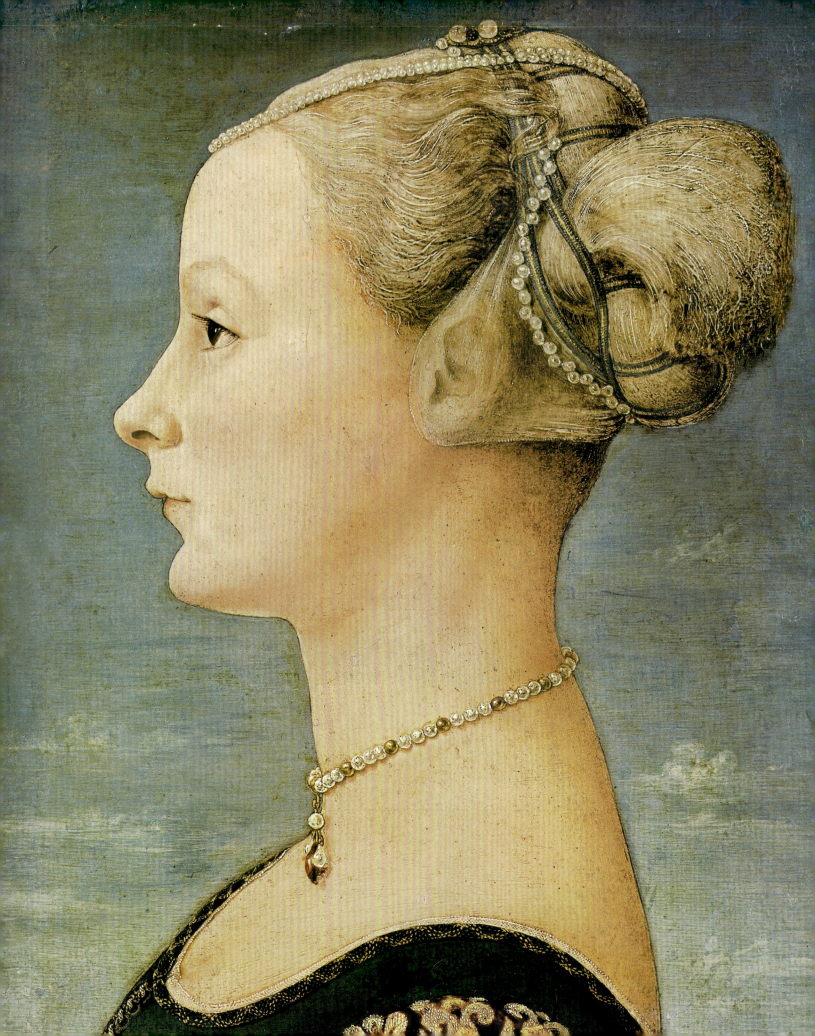

1470–1480
What Is Naturalism?

1470–1480
What Is Naturalism?

A fifteenth-century painter or sculptor, asked to identify the primary achievement of the art of his time, would probably have pointed to his contemporaries' new ability to describe the visible world. Part of the appeal of linear perspective, for example, was its promise to capture how objects looked from a given point of view. Drawings allowed artists to import things they had witnessed in the out-of-doors into panels and frescoes. And the newly popular genre of the portrait called on artists to render specific faces that they saw before them. In their writings on art, Leon Battista Alberti and Cennino Cennini both encouraged painters to "follow nature," and fifteenth-

century paintings and sculptures are still commonly characterized as signaling an interest in "naturalism." But what exactly does it mean to say that an artwork from this moment is "naturalistic"? Was this, as Giorgio Vasari presented it later, primarily an advance in understanding, artists having arrived at "a more beautiful knowledge of muscles, better proportion, and more judgment"? Was "nature" a factor of subject matter itself, as exemplified for example in Pisanello's horses, dogs, and birds? Or was it a reflection of a broader mentality, as the historian Jakob Burckhardt suggested 150 years ago when writing of the Renaissance "discovery of the world and of man," a discovery characterized by a new objective investigation of human and physical nature, which led learned elites to assemble rare plant collections in gardens and exotic animals in menageries? Today, it is not easy to imagine what naturalism looked like in a pre-photographic world, what its hallmarks were, what qualities might have competed to earn that label. But by the 1470s the world of art offered a number of possible answers.

The Flemish Manner

The Portuguese artist and writer Francisco de Holanda attributed to Michelangelo the view that "in Flanders," a collection of territories subsequently absorbed into what is now Belgium and northern France:

> they paint with a view to external exactness…they paint stuffs and masonry, the green grass of the fields, the shadow of trees, and rivers and bridges, which they call landscapes, with many figures on this side and many on that.

For Holanda (who purported to represent Michelangelo's own thoughts), it was possible to associate the pictorial qualities that seemed most to mark an interest in nature with a regional manner, rather than simply with an eye for detail or a skill in rendering it. Holanda's remarks, written in the middle years of the sixteenth century, may well have seemed outdated to his contemporaries: by that point, the most ambitious Flemings, and Holanda himself, were journeying to Rome, studying antiquities, and

9.1

Rogier van der Weyden,
Entombment, c. 1450.
Oil on panel, 43⅜ × 37⅞"
(110 × 96 cm). Uffizi
Gallery, Florence

trying to learn the methods of modern Italians. Still, the remark preserves what must long have seemed both to Flemish and Italian artists a basic difference between the two cultures' pictorial approaches to the world.

The confrontation, of course, depended on contact, and this had been occasioned by the economic, professional, and familial networks that had come to bind the Italian peninsula with the Flemish provinces. The Burgundian court had long provided a model for its central and north Italian counterparts, and *condottieri* who sought to refashion themselves as chivalrous and cultivated princes sponsored pageants and surrounded themselves with trappings that imitated those of the north. One consequence of the invention of the printing press around 1450 was an increased demand for, and soon an increased supply of, paper; with this, drawings began to circulate in greater numbers. Ambassadors brought gifts between the regions: Florence and Venice were major early production sites for illustrated books, while Flanders was Europe's center for tapestry production. Eventually these patterns of exchange allowed for collaborative undertakings. From at least the middle of the fifteenth century, Italian artists were sending designs north to weavers, who would send back the expensive and highly treasured finished hangings. Artists began to travel, too; as we saw in chapter 8, the Sforza of Milan sent one of theirs to study with Rogier van der Weyden in Brussels. Rogier himself seems to have come to Rome for the jubilee of 1450; certainly works by him were to be seen at Ferrara and elsewhere. Among these is the *Entombment* (fig. 9.1), now in the Uffizi; the early history of the painting remains obscure, but by 1492 it was on the altar of the chapel of the Medici Villa at Careggi, near Florence.

The Medici and Bruges

That Milan and Ferrara had close connections to the north reflects the internationalism of the court circuit. Yet republics, too, could cultivate broad geographical networks. The Flemish city of Bruges, for example, was home to a major branch of the Medici bank, and this required the presence of Italian agents who could oversee it. One of these, a supervisor named Angelo Tani, commissioned a grand *Last Judgment* from the esteemed local painter Hans Memling (*c.* 1435–1494) and attempted to send it to Florence by ship in 1473. The ship was attacked by pirates, who made off with the painting; today it hangs in a gallery in Gdansk, Poland. Better fortunes befell a series of works commissioned by the chief of the Medici bank in Bruges, Tommaso Portinari, who had Hugo van der Goes (*c.* 1440–1482) paint a colossal triptych showing the Adoration of the Shepherds (fig. 9.2), as well as some portraits of his family. When the Portinari returned to Florence, the works were given to Santa Maria Nuova, a hospital founded by one of Portinari's ancestors.

The folding triptych form is characteristically northern: Italian clients imported them (usually smaller examples) but Italian artists almost never attempted the format. In the wings of the triptych, members of the donor's family kneel before their patron saints; the differences in the figures' scale show that Hugo and his patron preferred to indicate the relative importance of the characters rather than their relative positions in space. Some Florentines must have found the central panel, in which the Virgin and Joseph adore the Christ Child in the company of angels and shepherds, to be surprisingly disjunctive: the wooden structure at the right

9.2

Hugo van der Goes, Portinari altarpiece (open), *c.* 1476. Oil on panel, center 8'3½" × 10' (2.5 × 3.1 m), wings each 8'3½" × 4'7½" (2.5 × 1.4 m). Uffizi Gallery, Florence

seems too small to hold those who kneel below it; the massive Corinthian column, a traditional symbol of the Virgin, has nothing to do with the rest of the rustic architecture; and the flowers at the center bottom do not quite seem to follow the steep incline of the ground, as if they have been placed on the frame as offerings rather than into the virtual space. Whereas Alberti would have had the painter standardize a system of internal measure, and then compose the *historia*, Hugo seems to work from the detail outward, and it is easy to imagine that Tommaso Portinari would have appreciated the painter's specificity in rendering the golden threads of the cloths the angels wear, the straw on the ground, and the stonework on the out-of-place modern building (presumably a church) in the background. The point of the painting is its characters' exemplary absorption in the sight of the Christ Child, and the artist rewards viewers who observe his painting with the same attentiveness that its characters employ when looking at the object of their own affection.

9.3

Joos van Ghent, *The Institution of the Eucharist*, 1474. Oil on panel, 10'2" × 10'11¾" (3.1 × 3.35 m). Galleria Nazionale delle Marche, Urbino

The Court of Urbino

Italian patrons preferred to import works by Netherlandish artists: only a few actually offered long-term employment in Italy itself. Perhaps the most notable example of a successful arrangement of this kind was

Joos van Ghent's (*c.* 1410– *c.* 1480) stay from 1473 to 1475 at the court of Urbino, the center of a small state ruled by Duke Federico II da Montefeltro (*see* p. 237). Joos's single documented work in the city is the 1473–74 altarpiece he painted for the subsequently destroyed church of Corpus Domini, showing the Communion of the Apostles (fig. 9.3).

The church was dedicated to the Eucharist, the wine and wafer consumed during the ceremony of communion, and Joos's altarpiece shows the institution of that sacrament, when Christ, anticipating his impending death, gave his followers bread, saying "Take and eat; this is my body." In the picture, eleven of the Apostles prepare to consume the wafer; Judas is singled out by his near exclusion at the back left, by the bag of money he holds, and by his yellow garment (Jews were forced to wear this color in many parts of Quattrocento Europe). Already these details suggest that the picture does not aim just to capture a historical scene, and the setting suggests different temporal registers. The curved colonnaded wall in the background identifies the depicted space as the apse end of a church, and this implies that the table occupies the space of the altar itself. What the picture actually shows, that is, is Christ's introduction of the very ritual that would have been repeated at the altar tables that would have stood in front of Joos's painting, illuminated by candles like the one held by an Apostle. The dress of the characters at the back right identifies them as Joos's contemporaries, and the man in profile with the red sash is recognizable as Duke Federico. The fact that the duke places his hand on the arm of the bearded man to his right suggests that that figure, too, is a contemporary. The turban has led most scholars to conclude he is a visitor from the east, and it has been plausibly suggested that he represents a Spanish Jew named Isaac who converted to Christianity while on a diplomatic mission to Rome from the ruler of Persia in 1472, during which he visited Urbino.

The real protagonist of the altarpiece is not any of these characters, though, but the host (consecrated bread) itself. This was already the subject of a predella that Paolo Uccello had painted in the previous decade, over which Joos's altar was to be placed. Its panels showed a sequence of episodes relating to a Jewish pawnbroker who promises to return the items a Christian woman has given up in his shop in exchange for a consecrated host (fig. 9.4). The Jew, having persuaded the woman to collaborate, then tries in vain to destroy the host by cooking it, at which point it bleeds (fig. 9.5), the Jew is arrested, and he and his entire family are burned at the stake. The Christian woman, by contrast, is freed through divine intervention, and in Uccello's final panel receives communion just before her death.

9.4

Paolo Uccello, predella to Joos van Ghent, *Institution of the Eucharist*, 1467–68. Tempera on panel, 16⅝" × 142" (42 × 361 cm). Galleria Nazionale delle Marche, Urbino. The sequence shows: a woman selling the Host to a Jewish merchant; the Host miraculously beginning to bleed as the Jew attempts to burn it and townspeople attack his door; the reconsecration of the recovered Host; an angelic apparition as the thief is about to be put to death; the Jewish merchant and his family burnt at the stake; angels and demons contesting possession of the woman's soul.

9.5

Paolo Uccello, *Miracle of the Desecrated Host*. Detail of predella. Tempera on panel. Galleria Nazionale delle Marche, Urbino

Joos's approach to the altarpiece resonated in various ways with Uccello's scenes. Giving Judas a bag of money accords with the predella's own anti-Semitic stereotype; there the pawnbroker is portrayed as a usurer, while in the altarpiece Joos reminds viewers that Judas was willing to sell out Christ himself. In the predella, a procession celebrates the host's survival and precedes the Jewish family's execution; Urbino's own annual procession of the host was a primary responsibility of the confraternity associated with the church. The presence of Isaac, whom Duke Federico directs to the altar, would have underscored both the continuing redemptive power of the Eucharist and the continuing religious conflicts between the Christian world and its neighbors. It was on the day of Corpus Christi (the feast honoring the Eucharist) in 1472 that Pope Sixtus IV

had launched the latest crusade against the Turks, with Urbino's support and with the Persian Sultan as an ally.

The close thematic connections between the altarpiece and the predella, though, might also make it seem surprising that it was to Joos, of all painters, that the confraternity of Corpus Domini turned for its commission. The square format of the panel followed the modern Italian preference; like Hugo, Joos covered the large surface (now damaged) using an exactingly detailed oil technique. And although for recent Italian viewers the regular shape would have reinforced Alberti's idea of the picture as a window through which the beholder looked at a virtual space, unified in measure, and whereas Uccello took every opportunity to display his skills at rendering complicated perspective schemes (*see* figs. 5.11 and 5.13), Joos ignored

9.6

Piero della Francesca,
Diptych with portraits
of Battista Sforza and
Federico da Montefeltro,
c. 1472. Oil on panel,
each panel 18⅝ × 13⅛"
(47 × 33 cm). Uffizi
Gallery, Florence

these conventions. The characters are not scaled in a way that lets their relative placement in the room be easily read. Drapery, rather than indicating an anatomy beneath, gathers in bunches to decorative effect. The orthogonals do not converge consistently. The painter does not submit bodies to any kind of canon, and even the architecture seems measureless, with modern round arches accompanying slim Gothic columns, stacked, against all the classical rules, directly on top of one another.

The patrons could presumably have found someone to paint them an altarpiece in the manner of Uccello, had they wanted one; apparently, they did not. The kind of naturalism that had guided Italian painting for the previous two decades, one grounded in the laws of optics, was less useful to their purposes than what a Flemish painter could now distinctively offer. Joos did not focus his efforts on rendering volumes, but he was a master at capturing the varying qualities of precious materials: the gilded bronze **paten** (plate for the host) that Christ holds just below the site where a spear would soon pierce his side ("this is my body"); the chalice and the carafe for wine on the table; the ewer and basin on the ground for the washing of feet. Though the duke and the ambassador are confined to the background, the fine clothes they wear manifest their importance. And though the space itself does not cohere geometrically, the colored marbles

of the columns at the back and the finely described glass panes of the windows between them lend the interior an otherworldly aura.

Italian Responses: Piero della Francesca

Urbino is a relatively isolated hill town, and as such the impact of Joos's painting would have been limited. A number of Italians, however, seem to have picked up immediately on the attractions of these new Flemish models. In the very years Joos worked for Duke Federico da Montefeltro, Piero della Francesca carried out a diptych portrait of the duke and duchess (fig. 9.6). Both the subtle modeling of Duke Federico's face and the rendering of the lustrous jewels in the portrait of his duchess, Battista Sforza, show an attempt to replicate the effects Piero could witness in pictures like Joos's. Even the combination of a profile view with a panoramic landscape depended on a format that had been developed recently by painters in Bruges: Piero could have studied a panel by Jan Van Eyck (*c.* 1389–1441) at the court of Urbino, which according to the humanist Bartolomeo Facio showed a bathing woman with a panoramic landscape including "minute figures of men, groves, hamlets, and castles carried out with such skill you would believe one was fifty miles distant from another."

Piero also painted a great altarpiece for the same patron, showing Federico in prayer before the Virgin and saints (fig. 9.7). As a Fleming would, he made a point of capturing the gleaming armor of the warrior duke and the gold and scarlet brocade of the Virgin's gown; the duke's hands, moreover, are rendered with a descriptive finesse never equaled in Piero's other paintings, indicating that for this passage Piero went so far as to seek the intervention of another artist trained in Flanders. The Montefeltro altarpiece would never be mistaken for a Flemish panel, however: the lightness of the palette and the play of brilliant light across white marble recall the painting of Piero's teacher Domenico Veneziano. Piero's interest in perspective and ideal geometry are manifest in the carefully planned architecture (reminiscent of Rossellino's tomb of Leonardo Bruni; *see* fig. 6.17) and the geometric abstraction of the figures. The heads of the Virgin and the angels echo the form of the ostrich egg (a symbol of resurrection) suspended in the apse. With a calculated ambiguity reminiscent of Andrea del Castagno at Sant'Apollonia in Florence (*see* fig. 6.16), Piero initially invites us to think that the group is positioned in the apse; closer inspection of the shift in floor level (and indeed the proportions of the egg) indicates in fact that the Virgin, saints, and donor are in the crossing of a church with light streaming from a dome overhead. The ambiguity creates mystery, a suspicion that all is not what it seems. If this is naturalism, it is of a higher order, and not limited to the rendering of appearances.

Oil Painting

Joos's and Hugo's paintings differed from most of those made by their central Italian contemporaries in the early 1470s in that both were painted in oil. A century later, oil was the standard medium of Italian painting, though even then the historically minded would have associated it with Flemish origins. According to Vasari's influential account, oil painting had been invented accidentally by Jan Van Eyck, who was looking for a new kind of varnish. Florentine merchants then sent one of Van Eyck's paintings to Naples, where it was seen by the Sicilian painter Antonello da Messina (*c.* 1430–1479). Antonello was so impressed that he traveled to Flanders in order to study directly with Van Eyck. Having learned the technique, Antonello returned first to Messina then to Venice, where he introduced the method to other painters, notably Domenico Veneziano.

As it turns out, virtually all of these assertions were wrong: Van Eyck used oils to particularly impressive effect, but he was not the first to paint with the medium and cannot be credited with its invention. Antonello

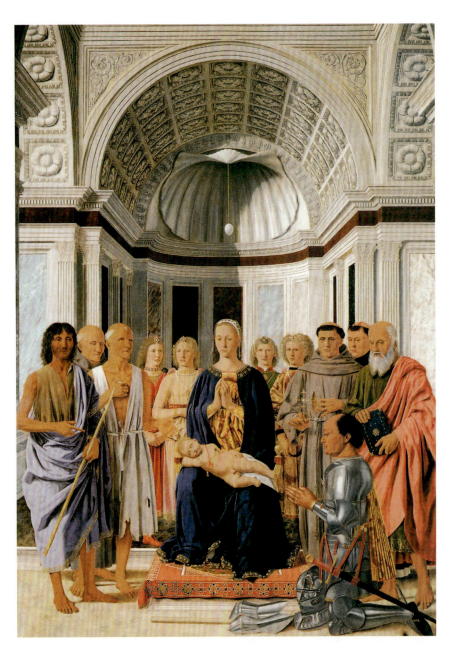

could not have studied with Van Eyck, who had died in 1441 when the Sicilian was only about eleven, and painters in Venice were using oil before Antonello's stay there in 1475–76. Still, the myth does point to a number of underlying truths. The presence of Flemish paintings was a significant factor in the spread of oil painting in Italy. Naples did indeed play an important role in the transmission, and one of the earliest experimenters there, Niccolò Colantonio, was Antonello da Messina's teacher. Though a number of Italian painters had painted with oil as early as the 1450s – Cosmè Tura's *Calliope* (*see* fig. 8.3) employs oil, as does Filippo Lippi's altarpiece for the Medici Chapel (*see* fig. 6.9), and Piero della Francesca had been combining tempera painting with oil glazes – the

9.7
Piero della Francesca, *Madonna and Child with Saints, Angels, and Federico da Montefeltro* (Montefeltro altarpiece), 1474. Oil and tempera on panel, *c.* 8'2" × 5'7" (2.5 × 1.72 m). Pinacoteca di Brera, Milan

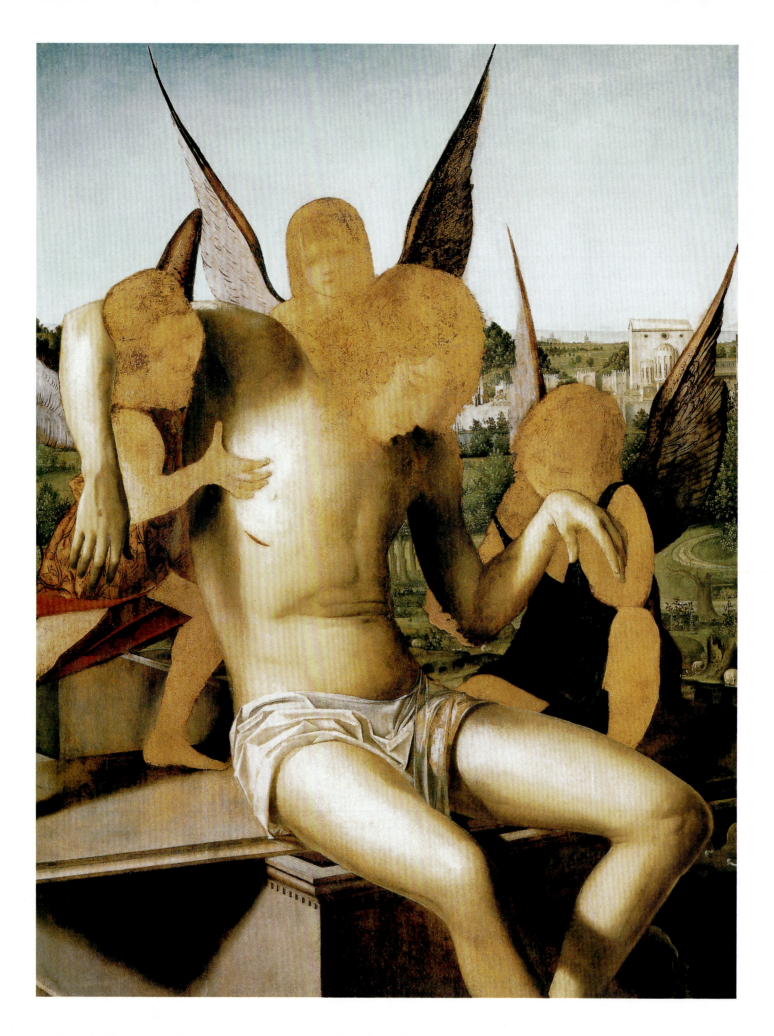

activities of Antonello in Venice and of Joos in Urbino, as well as the arrival of the Hugo paintings in Florence, made the 1470s and 1480s a watershed for the peninsula.

By the end of the century, there were few painters who had not mastered the oil technique, with Venetians in particular demonstrating all that it could do. Oil offered a number of advantages over tempera, the egg-based medium that it supplanted. Egg dries quickly, and as a binder for pigments it does not lend itself to broad application. Painters who used tempera made their pictures in much the way they made drawings, placing tight, regular parallel **hatchings** on a surface of *gesso* that had been smoothed to a glassy finish; they modeled forms by gradually shifting through a range of tones in neighboring strokes. Because the medium has to be applied thinly and evenly, paintings in tempera have a regular, flat surface; because tempera is opaque, painters applied colors next to, rather than on top of, one another. One consequence of this was that tempera pigments remained largely true to the mineral powders from which they were derived, lending the pictures made from them a brightness that ensured their legibility in candle-lit church and palace interiors.

Oil, by contrast, took hours, even days, to dry. This made it possible to lay in one color and then, while it was still wet, work with another beside the first, or to blend the two together. It was an approach that increased the chromatic range of the picture; whereas tempera painters were restricted to what they had mixed and laid out on the palette in advance, oil painters could create new tones on the palette or even directly on the surface of the picture. Tonal fields did not need to remain separate, so transitions between represented forms could be much more gradual. Because oil is translucent, it also allowed what was beneath it to show through, and thin glazes, laid one atop the other, could produce a new variety of coloristic effects. Because the consistency of the medium was itself adjustable, finally, painters in oil had more control over the application per se, and they could vary the size and movements of their brushes depending on the look they wished to achieve. Tempera paintings tend to have smooth, even skins, but oil could give texture to the surface of a painting.

Antonello da Messina and Giovanni Bellini: Light as Actor

Antonello's *Pietà* (fig. 9.8) in the Museo Correr, Venice, probably painted *c.* 1475 while the artist was in that city, has lost much of its original surface and thus provides unintended insight into the way an artist might work with oil. Brown underpainting laid in the light and dark areas – the contrast, for example, between the

enshadowed right shoulder of Christ and the brighter face of the angel beside it. In the same tones, the artist might establish the initial modeling of other forms. Onto this, the painter would add other layers of pigment, usually building from dark grounds to bright highlights, as visible in the sky that shifts from blue to white toward the horizon, or in the right side of Christ's torso and right arm, where a raking light brings out the contours of his skin, stretched over bones, muscles, and veins. Individual brushstrokes throughout illustrate how the artist might change the way he handles his instrument when describing the feather on a wing as opposed to the leaf on a distant tree. And even in its damaged condition, the painting shows Antonello's overriding interest in light's role as the primary condition for visibility.

These interests are still more evident in Antonello's *Annunciate Virgin* (fig. 9.9), painted in Sicily *c.* 1476 in the years immediately before or after his trip to Venice. Conventionally, images of the Annunciation showed an angel arriving from the left to greet the Virgin seen in profile or three-quarter view. In Antonello's picture, by contrast, the only indications that it is in fact the Annunciation that we see are the setting, the Virgin's attributes – Gabriel nearly always finds her reading a devotional book at a lectern – and her gesture. In more conventional versions of the scene, the Virgin's movements convey fear at the miraculous event that has overtaken her, or humble devotion before God; here, her

OPPOSITE
9.8
Antonello da Messina,
Angel Pietà (Dead Christ with Angels), c. 1475.
Oil on panel, 57 × 33½"
(145 × 85 cm). Museo
Correr, Venice

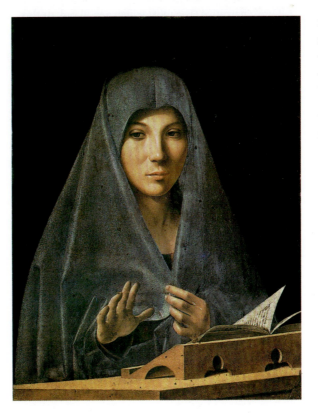

LEFT
9.9
Antonello da Messina,
Annunciate Virgin, c. 1476.
Oil on panel, 17¾ × 13⅝"
(45 × 34.5 cm). Galleria
Nazionale della
Sicilia, Palermo

ICON AND NARRATIVE

Medieval commentators distinguished between two categories of picture: "*historiae* to learn from and *imagines* to adore," in the words of Pope Gregory the Great. *Imagines*, or icons, provided for devotional focus, placing Christ, the Virgin, or a saint at the center of the picture, facing the beholder, to facilitate the reception of prayer and suggest readiness for response. They did not on the whole correspond to Biblical or other texts but instead duplicated earlier, prototypical pictures, some of which were believed to have miraculous origins. *Historiae* generally consisted of multi-figure compositions, usually narrative, and were familiar from manuscript illuminations, murals, and other artworks that related sacred stories and saints' lives.

By the fifteenth century, changes in the private devotional lives of Italian patrons and collectors placed new pressures on the boundary between the iconic and the narrative. The most widely read book in this period, after the Bible itself, was the *Imitation of Christ* (*c.* 1418) by the Flemish theologian Thomas à Kempis. Thomas encouraged his readers not to look for sophisticated symbolism in religious narratives, but to practice what came to be called the *devotio moderna* (literally, "modern devotion"), immersing themselves emotionally in the stories and connecting imaginatively with the protagonists. In Italy, the Venetian cleric Ludovico Barbo in his *Method of Prayer and Meditation* from around 1440 and Niccolo d'Osimo in his *Garden of Prayer* of 1454, followed Thomas's example and similarly directed readers to envision themselves participating in sacred narratives. Meditative practices of this sort eroded the boundary between relational images of venerated individuals and mere illustrations; interactions between the two categories became an engine for pictorial novelty. Formerly iconic subjects, such as the Virgin and Child, became a basis for inventive variations, as painters and sculptors rethought the ways in which a mother and child might interact, or placed the pair in new settings. In the other direction, artists "zoomed in" on the actors from traditional narrative subjects, inviting close attention to a character in particular dramatic circumstances. With Antonello da Messina's *Annunciate Virgin*, we seem not to be watching a repeat performance of Gabriel's arrival but to enter into Mary's bedchamber ourselves, at the very moment of Christ's conception. And even in a public work, such as the crowning image of Giovanni Bellini's *Coronation* altarpiece (fig. 9.10), the *Pièta* ceases to be a formal exhibition of Christ's body and instead makes the viewer part of the grief-stricken circle that surrounds the dead savior.

expression is more reflective and her thought harder to infer, though the gesture reads as a *reaction*, her lifted right hand acknowledging something happening before her, her eyes turned modestly away. What Antonello has done, in short, is rotated the conventional composition by ninety degrees, not just showing the Virgin from the front but also implying that the angel stands before her, in the company of the painting's viewer and probably slightly to his or her left; or so, at least, the illumination would seem to imply, shining onto Mary from somewhere in front of the picture.

If, with earlier Annunciations, we seem to be watching a performance, Antonello puts us in Mary's bedchamber, at the very moment when Christ was conceived. It is a remarkable change, one that depends on the alignment of a new spirituality and a new technology – the subject all but depends upon the new oil medium, for it is the use of oil that allows the light to be so specific, the figure to be so present. Only with oil could Antonello so gradually have modeled from the deep blue of the drapery up to the white highlights, these applied by dragging a nearly dry brush down along the folds, blending pigments to allow the

dramatic transition from the shadow around the Virgin's left cheek to the reflection on the tip of her nose.

That Vasari was not completely wrong about the impact Antonello had in Venice is most immediately discernible in the work of Giovanni Bellini (*after* 1430–1516). The son of Jacopo Bellini and the brother-in-law of Andrea Mantegna, Giovanni would have been attuned to the most modern trends around him; even before Antonello's arrival in the city he was experimenting with oil, and with the single-panel **pala**. A spectacular early example is the *Coronation* altarpiece (fig. 9.10) that Bellini most probably produced between 1474 and 1476 for the church of San Francesco in Pesaro on the Adriatic coast (and near Urbino); it originally included not only the main panel, the predella, and smaller images of saints on the frame, but also a surmounting element known as a cimasa. The *pala* was relatively new in Venice, where Antonello counted among those pioneering the format around 1475, but in nearby Urbino we have seen that Joos van Ghent produced a large single-panel altarpiece in 1473–74 (*see* fig. 9.3), and Piero della Francesca had completed one for Federico da Montefeltro, possibly in the same year (*see* fig. 9.7).

Bellini probably never went to Pesaro (we do not know that he ever left Venice), and if he knew the Piero and the Joos paintings it was likely only by reputation. Intentionally or not, however, the work he produced would have astonished patrons who were hoping for something that would hold its own beside these artists. The command of perspective demonstrated in the marble pavement and the contemplative stillness of the group of standing saints are remarkably close to Piero in his Montefeltro altarpiece. The use of transparent layers of oil glazing achieves both a degree of coloristic intensity and a unifying golden luminosity that are unparalleled in other surviving paintings, whether Flemish or Italian, on this scale. Bellini betrays his ambitions with his self-conscious use of Alberti's "painting-as-window" theme: he refers to the rectangular frame of the altarpiece not only with the marble double throne, but also with the unusual opening in its back. The "window" in the throne frames the heads of Christ and the Virgin, and then it provides a view onto the hilly landscape beyond, bathed in sunshine. This setting departs from all of the earlier Coronations we have seen, in which painters tended to depict an otherworldly event accompanied by the hosts of Paradise. The radiant beauty of the earth here appeals to the experience of the beholder: the vista (which Bellini almost surely painted from imagination) becomes a metaphor for, rather than an image of, the heavenly. Like Antonello (*see* fig. 9.9), Bellini uses light to reinforce religious meaning: Christ receives the fullest illumination, which serves to associate him visually with the Holy

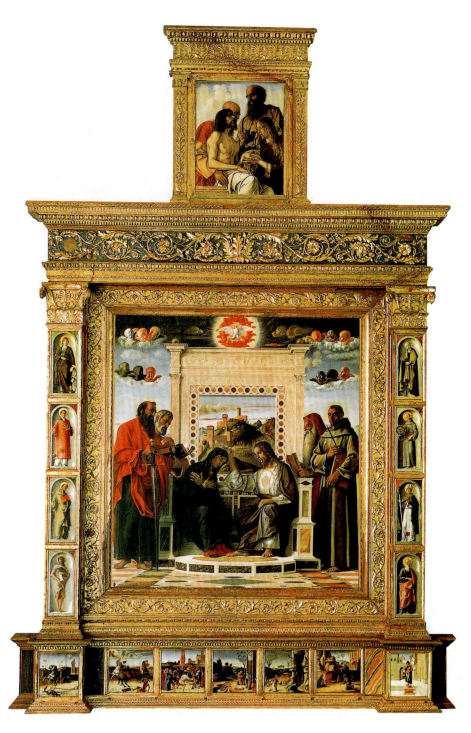

Spirit appearing over the throne. The light that plays on the Virgin's upper body reflects the gleaming white and gold of Christ's garments, underscoring his identity as all-powerful God and his transformation of the Virgin into the Queen of Heaven. The regal but tender Virgin, for her part, provides a poetic echo of the Magdalene's tragic *Anointing of Christ* in the cimasa; this adaptation of the *Pietà* theme indicates Bellini's close study of Antonello's *Dead Christ* paintings (*see* fig. 9.8).

Bellini's altarpiece for the church of San Giobbe was one of the first paintings in Venice to set a *sacra*

9.10

Giovanni Bellini, *Coronation of the Virgin* (Pesaro altarpiece), *c.* 1474–76. Oil on panel. Lower panels, Museo Civico, Pesaro. Cimasa, Pinacoteca Vatican. The photograph reunites the now separate pieces.

9.11
Giovanni Bellini, San
Giobbe altarpiece, *c.* 1478.
Oil on panel, 15'4" × 8'4"
(4.71 × 2.58 m). Galleria
dell'Accademia, Venice

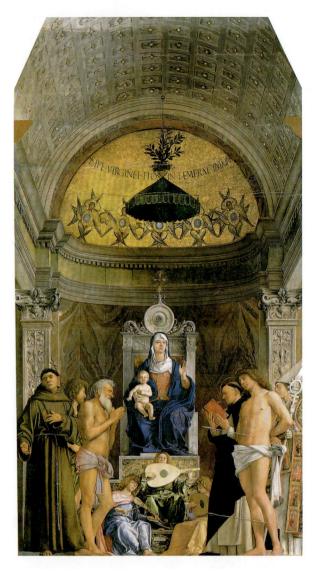

angel's drapery, and the weaving in St. Louis' cape. In all of this, Bellini, like Antonello, looks for ways to make light the real actor in the scene, whether in its reflections off the gold architectural decorations or in the modeling of the two nearly nude bodies.

The Bellini painting that may be most indebted to Antonello is the *St. Francis* (fig. 9.12) he painted for the government official Zuan Michiel, probably just before 1480. Unusually for a religious image, it treats its material as an opportunity for poetic invention, offering an entirely new subject, which in this case concerns sacred poetry. Contemporaries would have expected to see the moment when Francis, having withdrawn into the wilderness, is brought into ecstatic conformity with Christ, with a seraph in the sky shooting rays into the saint's hands, feet, and side as he himself assumed the pose of his crucified model (*see* figs. 6.12 and 6.51–6.52). Bellini's Francis, however, is more contemplative than this; having walked a few steps from a prayer book, he seems to be experiencing a more inward kind of ecstasy. The painter invites viewers to compare his scene to more conventional representations of the stigmatization, and he also merges this episode with another, familiar from Franciscan texts but never before pictured, when the saint composed a canticle in praise of the sun, the moon, and the earth and its plants and flowers, invoking the marvelous works of divine creation. Bellini gives most of his panel over to an extraordinary landscape, full of carefully individualized plants and animals. Each of these could have had an esoteric meaning to one versed in Franciscan theology, but they also simply demonstrate Francis's heightened awareness of the plenitude of the physical world. Most remarkable of all is the picture's light, originating from a break in the clouds at the upper left and brightening the laurel tree that bends toward it. As in Antonello's painting of the Annunciate Virgin (*see* fig. 9.9), the light here takes over the role traditionally given to the fiery angel, illuminating Francis rather than wounding him. Yet the substitution only underscores the possibility that the miracle here is the natural world, revealed as if by the sun itself in the painting's most impressive passages: the golden glow on Francis's sackcloth, for instance, or the bright faces of the strange rock formations. The natural luster of oil allows Bellini to suffuse the whole painting with a kind of glow, and the transparency of the medium lets him lay thin shadows over the parts he wishes to keep more veiled.

Life Study

Antonello's *Pietà* (*see* fig. 9.8) ostensibly shows Christ sitting on the edge of his tomb, yet this tomb is placed implausibly at the center of a landscape. Landscape was

conversazione in a church interior (his earlier altarpiece for SS. Giovanni de Paolo, or a now very damaged work by Antonello for San Cassiano, may have been the first), as if its characters have come to life in the familiar world of the fifteenth-century worshiper (fig. 9.11). The idea may have come from Flemish paintings like that of Joos van Ghent in Urbino (*see* fig. 9.3), though one thing that sets Bellini's picture apart from these is the low point of view: his Virgin and saints are personages that the churchgoer literally looks up to. Bellini's blurring of contours lends the painting an airy atmosphere uncommon in the more crystalline paintings of the north. Where he competes with the Flemish tradition, however, whether directly or through such mediators as Antonello, is in the way he uses oil to specify the materiality of the things he portrays: the inlaid tiles of gold and glass that constitute the mosaic, the watery patterns in the stone behind the Virgin's throne, the changing tones of the shot silk in the

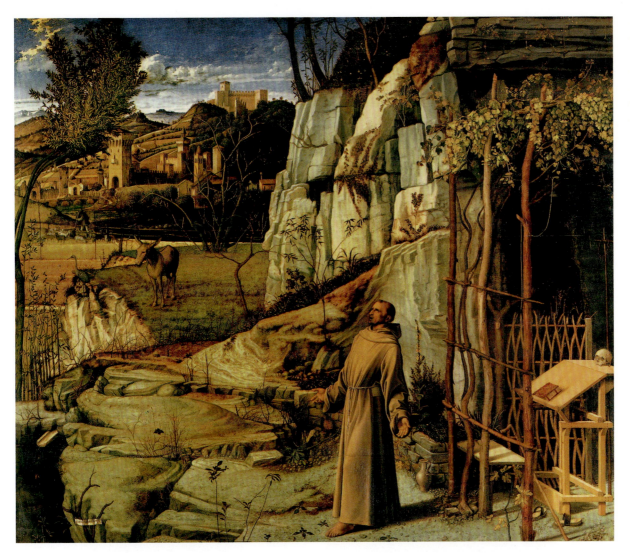

9.12

Giovanni Bellini,
St. Francis in Ecstasy,
c. 1480. Oil and tempera
on panel, 4'¾" × 4'8"
(1.2 × 1.37 m). Frick
Collection, New York

a primary interest of Bellini's as well, and this suggests that the new naturalism of painters was not merely a matter of the absorption of other regional styles or of an adjustment in the substances from which they made their works. It was also evidence of a new empiricism, a desire to capture likenesses of the things they saw around them.

The attraction to painters of life study was not new: the drawings of Pisanello and the birds and leaves in the reliefs with which Lorenzo Ghiberti surrounded his baptistery doors (*see* figs. 2.13–2.14 and 4.4) make this plain. In the early 1470s, though, it becomes apparent how life study had entered into workshop teaching. If, previously, apprentices had been made to copy exemplary compositions from the recent or distant past and ultimately to mold their own hand to that of their master, now youths were expected to render things placed newly before their eyes.

We find evidence of this in a group of drapery studies in ink and wash on linen that comes from the workshop of Andrea del Verrocchio (*c.* 1435–1488). Verrocchio was a true polymath: a goldsmith, painter, sculptor, bronze caster, and restorer of antiquities who was responsible for, among other works, lifesize wax effigies, wooden Crucifixes, and the ball that topped the lantern on Brunelleschi's dome for Florence Cathedral (*see* fig. 4.6). He was also a remarkably effective studio boss, controlling one of the two major artists' workshops in that city as well as a second shop in Venice. A number of the best artists of the following generation, including Pietro Perugino, Giovanni Francesco Rustici, and, as we shall see below, Leonardo da Vinci, owed their training to Verrocchio, and drawing draperies was probably the sort of exercise that all of these artists tried their hand at.

The aim of these studies was to reproduce the effects of light on cloth and the ways in which fabric reveals the form beneath it (fig. 9.13). The artists may have drawn from wet cloths that had been placed on clay models (Vasari claims that Piero della Francesca followed such a

procedure). To a certain extent, the creation of the sheets would have been an end in itself, though the survival of the studies inevitably shapes the way we see the works that come from Verrocchio's orbit.

Consider the *Christ and St. Thomas* (fig. 9.14), begun in 1467, completed in 1481. The pair was made for the niche on the exterior of Orsanmichele that had previously belonged to Donatello's *St. Louis of Toulouse* (**see** fig. 4.12). The Parte Guelfa, strapped for cash, had sold off the tabernacle to the Mercanzia, the body responsible for the city's commercial law courts, and had taken Donatello's statue to the church of Santa Croce. The decision to give the new commission to Verrocchio, known initially as a specialist in metalwork, may have reflected the patrons' decision to replace Donatello's figure with another work in bronze. The choice of St. Thomas as a subject would not have been a surprising one for the Mercanzia, for observers had often associated the theme of Thomas poking the wound of the risen Christ, to verify that he is who he seems, with the search for truth and thus with the work of the courts. What heightened the stakes, though, was that the subject of Thomas called for a two-figure composition – the only one of its kind at Orsanmichele. Convention required that Thomas be shown carrying out his famous probatory act, and thus

not alone but paired with the risen Christ. Thomas's hem offers the words he spoke on realizing that the body before him was real: "My Lord and my God, Savior of the people." On Christ's hem is his reply: "Because thou hast seen me, Thomas, thou hast believed: blessed are they that have not seen, and have believed" (John 20:29).

Nanni di Banco, confronting the problem of accommodating multiple figures within a single niche, changed the niche itself to give them more unity. Verrocchio, however, seems not to have wanted to damage the architecture Donatello had left. The problem was that if he made the figures roughly equal in height to others on the building and proportional to the niche itself, they would not both fit within it. In part for this reason, he opted to use not only the niche proper, but also the ledge before it.

One advantage of this was that Verrocchio could project the composition into the street, where it could be seen more readily by passersby walking between the cathedral and city hall. He could do so, moreover, and still align Christ himself on the axis of the niche, making him the viewer's focal point, no less than Thomas's. All of this meant, however, that Verrocchio had to make his figures even more shallow than his predecessors had. He must have studied Donatello's work with particu-

RIGHT

9.13

Andrea del Verrocchio, drapery study, 1470s. Brush and gray tempera on linen, 12½ × 6⅝" (31.5 × 16.8 cm). Musée du Louvre, Paris

FAR RIGHT

9.14

Andrea del Verrocchio, *Christ and St. Thomas,* **1465–83.** Bronze, height (Christ) 7'6½" (2.3 m), (Thomas) 6'6¾" (2 m). Orsanmichele, Florence

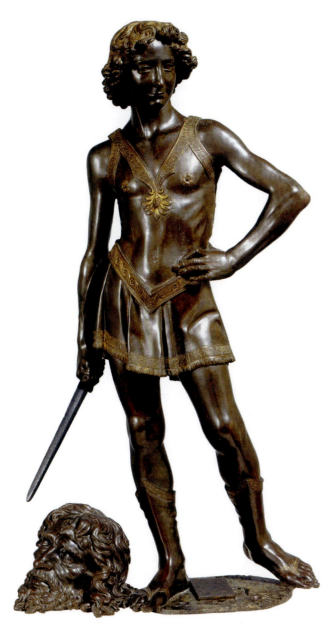

of little else. And while he gives us a few whole limbs – the raised right arm of Christ, the extended right leg of Thomas – Verrocchio also distracts us with masses of bunched folds, hanging in large swaths, which so impress us with their own richness and bulk that we forget to ask what is behind them.

That this approach was more a response to the circumstances of site than a hallmark of Verrocchio's style is suggested by the artist's roughly contemporary *David* (fig. 9.15), where the costume involves little that we could really call "drapery" at all. Just when Verrocchio started the statue remains uncertain, but it seems initially to have been in the hands of the Medici, for in 1476 the Signoria purchased it from the family. Perhaps it was Lorenzo the Magnificent who commissioned it, as a follow-up to the bronze statue on the same theme that Donatello had made for Lorenzo's grandfather. After the 1476 sale, in any event, a similar comparison would have been unavoidable, for the Signoria placed the bronze near Donatello's earlier marble in the Palazzo Vecchio. Seeing the two works together must at first have been disconcerting, for Verrocchio seems neither to follow the earlier artist's model nor to return, as Donatello himself had done, to ancient prototypes. Verrocchio's *David*, with his slim physique, his stylish contemporary haircut, and his swagger, looks more like a boy from the city than an evocation of an authoritative sculptural tradition. There is more attention to the rendering of anatomy than there is to capturing beautiful contours. And rather than showing the artist's mastery of movement, reproducing a classic shift of weight or swung hip, Verrocchio's boy gives the impression of a model striking a pose.

Leonardo da Vinci's Beginnings

It was in Verrocchio's workshop, with all of this happening, that Leonardo da Vinci (1452–1519) got his start. The painter was of illegitimate birth and his beginnings are obscure, but by the early 1470s he was working with Verrocchio – most modern scholars accept Vasari's assertion that Leonardo painted the angel on the left in Verrocchio's *Baptism, c.* 1476 (fig. 9.16), which again attests to the importance of drapery studies (fig. 9.17). Several of the surviving sheets, in fact, have shifted in attribution between Verrocchio and Leonardo, and the younger artist must have participated in whatever drawing exercises Verrocchio assigned to his students. Determining just what role Leonardo had in the workshop, however, is complicated by the fact that, by the time he worked with Verrocchio on the *Baptism*, he had already taken on independent commissions.

9.15

Andrea del Verrocchio, *David*, 1473–76. Bronze, height 49¼" (125 cm). Museo Nazionale del Bargello, Florence.

lar care: like the *St. Louis*, which Verrocchio could have seen from all sides during its removal, his figures are hollow behind: no expensive metal was wasted on parts that would not be visible. Like Donatello's *St. Mark* (*see* fig. 3.5), in fact, Verrocchio's Christ and St. Thomas are really nothing more than freestanding reliefs, designed to work only from the limited range of views that the wall of the **oratory** allowed. No less than Donatello before him, Verrocchio had to persuade viewers that they were looking at volumetric bodies and not just flat panels, and to do so with one figure that was projected into the street and available for inspection from different sides. It was onto the draperies that this burden fell: apart from the hands, feet, and heads, Verrocchio's sculptures consist

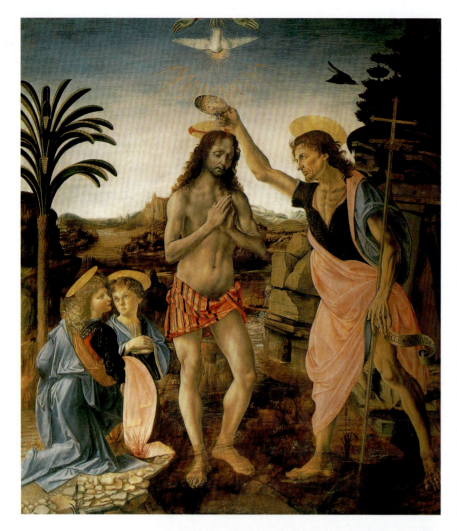

ABOVE

9.16

Andrea del Verrocchio
and Leonardo da Vinci,
Baptism of Christ, c. 1475.
Tempera and oil on panel,
5'10" × 4'¼" (1.8 × 1.52 m).
Uffizi Gallery, Florence

RIGHT

9.17

Leonardo da Vinci, drapery
study, 1470s. Brush and
gray tempera on linen,
7⅛" × 9¼" (18.1 ×
23.4 cm). Musée du
Louvre, Paris

ing after sculptures, while the interest in the landscape background and detailed depiction of different species of plants in the Virgin's garden betray the same kind of attention to nature that we see in Flemish paintings from the period. What really sets Leonardo apart from his predecessors in this early painting is the way he approached color.

Painters of the previous generation still depended largely on an "absolute color" system, one that had been in use with only modest changes since the Middle Ages. This system exploited the fact that the pigments painters used came from minerals, many of them valuable, and it put a premium on the richness of the resulting surface. Painters would arrange the hues on their palette in a series of gradations, starting with the most intense or saturated version of a pigment and proceeding through tones that had been made lighter by blending them with white. (Cennino Cennini describes one characteristic way of proceeding, according to which the painter would use three different tones of each hue, laying these in next to one another to model forms.) The painter would approach each object he wanted to represent with any given color more or less independently, modeling it with a pigment that had a greater or lesser proportion of white. A good example of the system is Filippo Lippi's *Adoration of the Magi* (fig. 9.19). Although there are some very dark passages – the vegetation, for example, or the black horses in the retinue of the Magi – the painter is reluctant to compromise the brightness of the costumes that any of the characters wear. The colors range from the deepest version of any particular hue to a nearly pure white highlight.

The absolute color system was particularly appealing for images where richness was itself a theme, but a painter who studied the real effects of light in nature was bound to be unhappy with it for a number of reasons. To begin, the relationship between light and color that it implied would be precisely the opposite of what one actually witnessed. Because in the absolute color system the darkest tones are typically the most saturated, truly intense colors correspond mostly to areas of shadow. But since the perception of color in nature depends on the reflection of light, it is in areas of illumination, not shadow, that they should appear. The system can also result in a kind of fragmentation of the picture, since the painting of any solid-colored object will be determined with a mind to the overall pattern of the surface but with minimal consideration of the tones used for any two neighboring objects. Coloristic effects, finally, could even contradict the apparent positioning of the object in the virtual space of the painting. Lighter colors seem to project forward and darker colors seem to recede. Because they were not planned in conjunction, the pink drapery

The most important of these was the *Annunciation* (fig. 9.18), now in the Uffizi, that Leonardo painted around 1473 for the convent of Monte Oliveto, outside Florence. The image of an angel communicating with a reclusive veiled Virgin who reads from a devotional text may have held special appeal for the nuns in the convent, though the painting's material derives from Leonardo's study of the world around him. The lectern before the Virgin may point to the experience of draw-

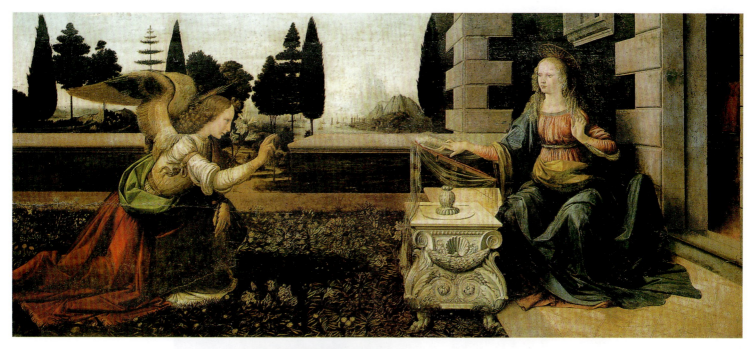

ABOVE

9.18

Leonardo da Vinci,

Annunciation, c. 1473.

Oil and tempera on panel,

38¾ × 85½" (98 × 217 cm).

Uffizi Gallery, Florence

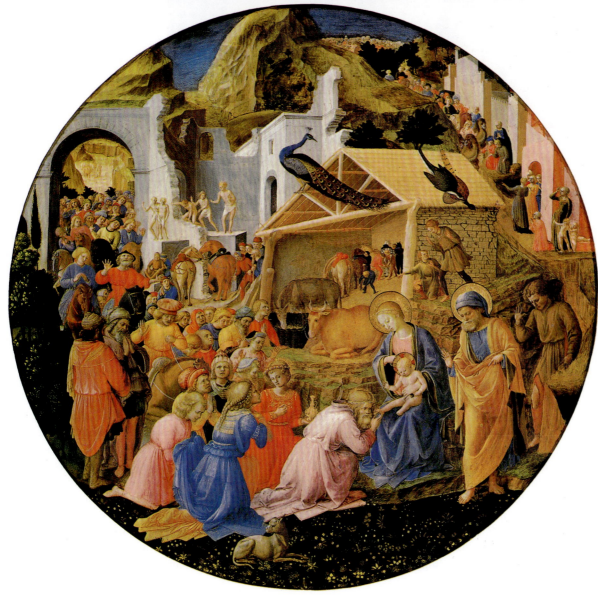

LEFT

9.19

Fra Angelico and

Fra Filippo Lippi,

The Adoration of the

Magi, c. 1445. Tempera

on panel, diameter 54"

(137.3 cm). Samuel

H. Kress Collection,

National Gallery of Art,

Washington, D.C.

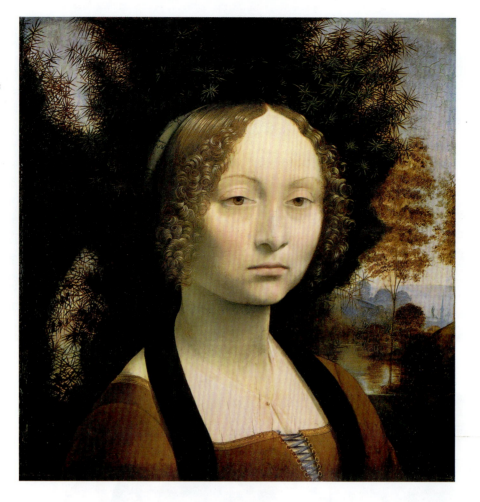

9.20

Leonardo da Vinci, *Ginevra de' Benci, c.* 1478–80.

Tempera and oil on panel, 15½ × 14½" (38.8 × 36.7 cm). National Gallery of Art, Washington, D.C.

worn by the attendant in the lower left of Lippi's painting appears to project forward more than the blue one beside it, even though the figure in blue is positioned closer to the picture plane.

It is for such reasons that Leonardo approached the problem of pictorial color differently. Rather than establishing the tonal range of a given hue by mixing in a greater or lesser proportion of white, he created for each color a scale that ran from white to black. This allowed him to show colors at lesser intensity where they were to be enshadowed, implying that the absence of color corresponded to the absence of light. In addition, he coordinated the tonal scale used for each hue with every other, so that the painting had a single overall light to dark range. Rather than accepting, for example, that yellow had to be higher in tone than blue, he created both whiter blues and blacker yellows. Neighboring objects, regardless of color, could thus be shown to react uniformly to the same conditions of illumination – a goal that the absolute color system, which encouraged painters to think of each color field apart from its neighbors, generally impeded. The results can be seen, to give just one instance, in the yellow sash that the Virgin in Leonardo's *Annunciation* (*see* fig. 9.18) wears around her waist, which reads convincingly as being further back in space than the blue cloth covering the tops of her legs,

despite the fact that blue in its most intense form is the darker of the two hues.

What Leonardo sacrificed with all of this was coloristic intensity. Modifying hues with respect to their neighbors required him to tone down the saturation of most of the pigments he used, and his pictures simply look less bright than those from earlier in the century. What Leonardo gained, on the other hand, was a cohesive effect of illumination. Just as the introduction of linear perspective resulted in a kind of pictorial unity, with all objects notionally occupying a single virtual space, so would those objects now be further unified through light. The effect is perhaps most apparent in his pictures' strong sense of modeling; from the beginning, Leonardo's paintings look almost sculptural relative to their predecessors, with an overall tonality that runs from true white to true black. Here it seems significant that Leonardo matured in a workshop that emphasized the study of light and dark on sculpted objects, including draped clay models.

In fact, the relationship between Leonardo's paintings and Verrocchio's sculptures is strikingly close, as can be seen from a comparison of Leonardo's first surviving portrait, the *Ginevra de' Benci* (fig. 9.20), with Verrocchio's *Woman with a Posy* (fig. 9.21). Leonardo hints at the identity of his sitter with the juniper (*ginepra*) that grows behind her, a pun on her first name. The painting

was originally longer, showing the sitter to her waist, but one of its owners at some point cut it down at the bottom. A surviving silverpoint drawing (fig. 9.22) may be a study for the part that is now lost, and the more defined of the two right hands on the sheet holds what appears to be a small bundle of flowers. The original gesture, then, may have been almost exactly what Verrocchio, too, shows – in both cases, the hand seems to hold the flowers against the woman's heart, to express affection – and the two women have similar features and nearly identical hair. It is possible that Verrocchio's sculpture even portrays the same woman, though other contemporary pictures reveal that hair in precisely this arrangement was much in fashion in the mid 1470s, and as we shall see at the end of this chapter, identifying the sitters in female portraits from the period is rarely a simple matter.

What is certain is that one artist had the other's work as a model. But which came first? In favor of Leonardo's priority is the fact that no earlier Renaissance portrait bust extends low enough to show a sitter's arms. The format, at least, of Verrocchio's marble was more radical. Then again, Verrocchio could have followed the example of earlier paintings just as easily as Leonardo did, and what distinguishes Leonardo's painting is its forceful plasticity. In part, Leonardo achieved this by shifting from a profile to a three-quarter view, as if it were a bust,

approached slightly from the side that he wanted to show. In part, he achieved the effect through his light–dark contrasts (the technical term is *chiaroscuro*), which generate the impression of relief. The juniper bush behind the sitter may be symbolic, but it also creates a nearly black background from which her face emerges. The greater the tonal range, the more three-dimensional the painter's illusion; by moving from the darkest zone of the picture to the lightest, Leonardo brings the sitter into our own space.

Here again, we see Leonardo unifying the picture through the action of light. And where he departs both from Verrocchio's own approach and from any kind of real sculptural interest, he develops still other techniques to contribute to that unity. Chief among these is his blurring of contours, especially those further back in space, to suggest the presence of an airy atmosphere, or *sfumatura*, that envelops the whole scene. From close up, we can see that Leonardo did not simply apply his paint evenly with the brush, but took full advantage of the new oil medium, smudging strokes he had made and occasionally even manipulating paint with his fingers to achieve a fine haze, dulling any sculptural edge. This helps explain his decision not to extend the dark ground he had established behind Ginevra's face across the whole surface of the picture, but rather to add at the right a view into a

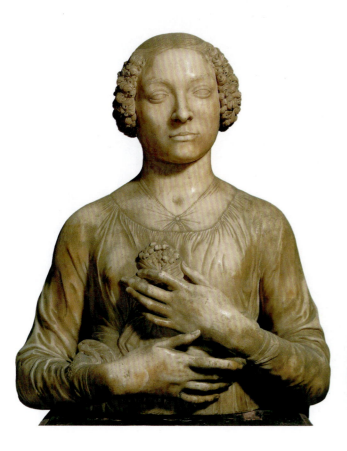

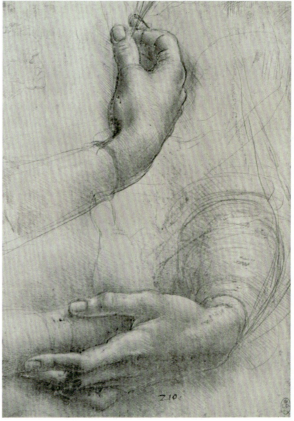

FAR LEFT

9.21

Andrea del Verrocchio, *Woman with a Posy,* c. 1475–80. Marble, height 24" (61 cm). Museo Nazionale del Bargello, Florence

LEFT

9.22

Leonardo da Vinci, studies of hands, 1478. Silverpoint on cream prepared paper, 8½ × 5⅞" (21.5 × 15 cm). Royal Library, Windsor

RIGHT

9.23

Andrea del Verrocchio, *Water Sprite, c.* 1470. Bronze, height 27¼" (69 cm). Sala del Cancelliere, Palazzo Vecchio, Florence

distant landscape. Here, more than anywhere, he would show the way that air shrouds faraway visions, diminishing what we can see. It also served as a reminder that although sculptors could frequently get away with rendering a single discrete object, painters had to portray entire worlds. The task of pictorial unification, for Leonardo a primary aspect of naturalism, could not depend on the artist's control of light and shade alone.

Nature and the Classical Past

To this point, we have been treating naturalism fundamentally as a problem of imitating the physical world: what sights the naturalistic painter might paint, and how he might approach the problem of painting them both technically and theoretically. A number of artists and patrons in the 1470s, however, preferred to see nature not as if in a mirror, but at one remove, with a symbolic visual language that only the most sophisticated of viewers would comprehend. An example is Verrocchio's *Water Sprite* of *c.* 1470 (fig. 9.23), made for the Medici Villa at

9.24

Sandro Botticelli, *Primavera*, mid 1470s. Tempera on panel, 6'8" × 10'4" (2.03 × 3.15 m). Uffizi Gallery, Florence

Careggi, near Florence. The motif of the winged infant (or putto) carrying a dolphin was an ancient one, though a sculptor in Verrocchio's time would have thought about the ancient prototype in conjunction with Donatello's *spiritelli* (*see* fig. 5.20). The animal this putto holds designates him as a water creature himself. Verrocchio's little statue originally topped a fountain, and his frolicking pose would have celebrated the curling streams of water that played down the basin's side, embodying both the "spirit" in all water and the particular pleasures that garden waters brought their visitors.

This is the kind of thinking that also guided another major Medici commission, Sandro Botticelli's (*c.* 1445–1510) *Primavera ("Spring")* (fig. 9.24), a painting that remains the subject of considerable scholarly controversy. Documents demonstrate that the work was, by the 1490s, in a house that had been occupied by Lorenzo di Pierfrancesco de' Medici, the ward of his older cousin Lorenzo the Magnificent until the younger Lorenzo's marriage, at the age of nineteen, in 1482. It may have been the younger Lorenzo, in fact, who commissioned the work, perhaps even on the occasion of his wedding: the flames that appear on the garment of Mercury, on the left, are the same used in another painting made for Lorenzo di Pierfrancesco in 1495. The more likely alternative, though, is that the picture passed to the younger Lorenzo from his guardian's collection, having been made for Lorenzo the Magnificent while Lorenzo di Pierfrancesco was just entering his teens.

The painting shows nine mythological characters arrayed in a garden setting. All were known primarily from ancient Latin texts, especially Ovid, Virgil, and Lucretius, who characterized one or other of these figures as rustic gods of nature and the earth or with the spring season, though there is no single story from classical antiquity that explains just this congregation. Reading from right to left, we see the nymph Chloris, who, raped by the wind god Zephyr, transforms into Flora, the goddess of flowers; it is as if the arrival of a warm west wind marking the end of winter and the beginning of the New Year were being re-enacted with human beings in nature's roles. In the center is Venus, attended by the Graces while her son Cupid floats overhead; she is here associated with April, in part on the basis of etymologies linked to her Greek name, Aphrodite. Mercury, on the left, represents May. He stirs clouds to bring a change in

9.25
Sandro Botticelli, *The Birth of Venus*, *c.* 1485. Tempera on canvas, 5'9" × 9'2" (1.75 × 2.8 m). Uffizi Gallery, Florence

the weather. Moving from the right to left, we essentially pass through the spring months, from the beginning to the end of the season.

The painting does not illustrate any particular scene or story from classical antiquity or any known text. The subject, in other words, is an invention, one in which the contemporary poet and philologist Angelo Poliziano probably played a significant role. Classical antiquity here provided motifs that an artist, in consultation with literati, could combine to convey an abstract idea. The means, in this case, are just as important as the ends, for to embody the arrival of spring in newly recovered ancient forms was to suggest that it was both a season and antiquity itself that were returning. Such was also the appeal to Lorenzo and his circle of a second mythology by Botticelli, *The Birth of Venus* (*see* fig. 9.25), *c.* 1485. On

9.26
Antonio del Pollaiuolo, *Portrait of a Young Woman*, 1467–70. Panel, 18⅛ × 13⅜" (46 × 34 cm). Museo Poldi Pezzoli, Milan

canvas rather than on panel and slightly smaller than the *Primavera*, the second painting may have been intended for an altogether different location, but the meaning is similar. The foam of the sea here brings Venus into being; wind divinities waft her to shore, where a nymph receives her. The Roman encyclopedist Pliny the Elder had recorded a celebrated work by the ancient Greek painter Apelles showing Venus arising from the sea; Botticelli thus had the opportunity to re-create a lost masterpiece. His approach, nevertheless, shows little attempt to emulate the art of antiquity: the fluttering hair and draperies recall relief images of dancing nymphs, but the figures' proportions are distinctly unclassical.

The myth concerns the birth of love itself, which results not only in the fertility of the earth and its creatures but also in the motivation for peace, civility, and the cultivation of the arts among human beings: this would have offered a mirror of the political myths that sustained the rule of Lorenzo. *The Birth of Venus*, like the *Primavera*, implied that their Medici sponsor was ushering a new Golden Age into Florence, one manifest not just in such images as these, but also in the pageants and other embellishments the Magnificent brought to the city. More broadly, the paintings offered an allegory of "the Renaissance" itself, for they showed the return of an old, lost knowledge as nothing other than a rebirth. That all of this happens in a garden hints that the "Renaissance" at issue depended on an experience of nature. By contrast to artists like Leonardo or Bellini, though, Botticelli suggests that such an experience could be captured only when painting behaved like poetry, with parts that fit together and had to be read, not merely seen.

Beauties beyond Nature

The *Primavera* and *The Birth of Venus* each tell a story, but Botticelli also composed both much in the manner of a triptych, centered on Venus. This makes clear that the paintings are not just about gardens, or the changing seasons, or the recovery of the past. They suggest a cult of love, and they raise the question as to just what kind of love was at issue. Perhaps the focus on Venus lends weight to the argument that one or both of the paintings were for a wedding. If Lorenzo the Magnificent was in fact the patron of the *Primavera*, though, the occasion of its commission would likely have been the joust that he and his brother Giuliano hosted in 1475, an event they dedicated not to their wives but to two other women, Lucrezia Donati and Simonetta Cattaneo. (Poliziano's poem in celebration of the joust contains a long description of a relief depicting *The Birth of Venus* that is close in many respects to Botticelli's painting.) Any case in favor

of this is complicated by the fact that no secure portraits of Lucrezia or Simonetta have ever been identified. Even if we did have portraits of the two, moreover, it is not clear what kind of evidence that would present.

We have been surveying ways of looking at the art of the 1470s that emphasize the truth of that art to the appearances it represents, in part to show that in using the term "naturalistic" (or "realistic") we must explain just what it is we are referring to. The general Renaissance interest in naturalism, however, often competed with other interests, especially where images of women were concerned. It would be difficult to imagine a more lovingly descriptive painting, for example, than Antonio del Pollaiuolo's (1431/32–1496) *Portrait of a Young Woman* (fig. 9.26), probably painted in the early 1470s. The hair running back from the woman's plucked forehead is mapped with special care, allowing the beholder to follow the bundled tresses, twisted into a bun then wrapped in a veil transparent enough to allow a clear view of the ear, or the few strands that escape this and curl to touch the string of pearls. The shoulder of her dress is distinguished both in color and texture, enough to allow a nearly exact impression of the brocade of which it was composed. Shown in profile, the woman does not return the gaze of whatever man commissioned or looked upon her, inviting him to linger on the rendering of the fine materials, the elongated neck, and the delicate contours of the face. The close cropping of the picture field only underscores the sense of nearness.

Particularly in a genre like the portrait, these features combine to give the sense of a present, living person, as if the portrait's object were just beyond the picture plane. And yet, nearly all of the details that seem most individualizing are also highly conventionalized. Facing to the left, the figure follows the format of nearly every other painted picture of a woman from the period. The sky and clouds behind her face are not markers of an actual place, but components of the standard blue background used in the Pollaiuolo workshop for such works, bringing out the lovely if suspiciously un-Mediterranean paleness of the woman's skin. Perhaps the sitter dyed her hair blonde, but even if she did not, the painter would likely have made her blonde for the permanent record, since this was an essential feature of the ideal that had been canonized in poetic descriptions of beautiful women. Even the profile itself has likely been adjusted to give the sitter the overbite that contemporaries found especially attractive. It is entirely possible that the jewels she wears resemble their model more than the face they ornament does, and it is symptomatic that the portrait, though made by a famous painter for a wealthy patron, remains anonymous.

The same fundamental issues, for example, bear on a series of marble female busts by Francesco Laurana

9.27
Francesco Laurana, *Isabella of Aragon* (?), *c.* 1490. Marble, height 17¼" (44 cm). Kunsthistorisches Museum, Vienna

(*c.* 1430–1502). Born in Vrana (a city in modern-day Croatia), Laurana worked in northern Italy and southern France before moving to Naples, where he was among the sculptors involved in the completion of Alfonso I's triumphal arch (*see* fig. 7.11). Documentary evidence shows him moving to Palermo in Sicily, then north through Naples to France, but this information does little to help with an object like the exquisite bust in Vienna (fig. 9.27). Laurana sculpted the portrait in marble; then, as though applying make-up, painted the lips, lashes, and eyebrows, adding further polychromy to the hair and dress. For other details, including the flowers in her wimple, Laurana fashioned pieces of wax and applied them to the finished sculpture. Here a poetic conceit of the lady having skin white as marble becomes literal.

Yet who is this? The bust usually goes under the name of Isabella of Aragon, on the assumption that Laurana made it in Naples, perhaps as late as 1490, but there is no real evidence for any of this. In fact, the entire chronology of Laurana's busts, which he began producing no later than the 1470s, remains a matter of speculation. Where women in portraits do not wear heraldic devices that associated them with their families and when the portraits themselves are not paired with portraits of their husbands, they verge on the generic. What naturalism there is here is an effect, one mitigated by the requirements that the portrait look like others of its kind, that it be a beautiful rendering of a beautiful subject.

1480–1490
Migration and Mobility

10

10

1480–1490
Migration and Mobility

Portable Art

Canvas and Bronze: Mantegna, Bertoldo, Pollaiuolo

When, in 1460, Andrea Mantegna painted the San Zeno altarpiece (*see* fig. 8.18), he had worked on panel, and indeed this was his preferred support for easel pictures through his early career. By 1480, however, he had shifted to working almost entirely on canvas. A large picture that Mantegna painted late in the decade for the Gonzaga in Mantua, showing the triumphal car of Julius Caesar in "Caesar in Triumph" (fig. 10.1), invites reflection on the change. The image drew on a group of ancient Greek and Latin authors who described the victory processions of Roman generals with their seemingly endless displays of captured arms, treasure, and prisoners. And, once Mantegna had completed the *Caesar*

canvas, he began expanding the theme into an ambitious project that would absorb him for twenty years. The nine paintings on canvas together depict the various stages of a Roman triumph, an inventive series with no precedent in panel painting. Preceding Caesar's car are images of standard-bearers, musicians, and prisoners of war, along with bearers of plundered works of art, military trophies, and gold coins (figs. 10.2–10.3). The whole formed a dazzling and colorful display, founded on Mantegna's deep antiquarian knowledge, but it placed a particular emphasis on the varieties of artifact then in circulation between dealers, artists, and collectors in different cities: weapons, armor, candelabra, paintings, vessels, jewelry, musical instruments. The array of products displayed in Mantegna's triumphal procession constitutes a kind of imaginary museum.

Ultimately, what Mantegna showed was a scene of transport, and this had a political dimension. Mantua was one of the Italian cities that had long claimed Caesar's modern counterpart, the Holy Roman Emperor, as its legal overlord. For decades, however, Emperor Frederick III had been culturally and geographically remote from his Italian territories, and held little real political influence there. The emperor, who had visited nearby Ferrara in 1468 and who had been portrayed by Mantegna in the Camera Picta (*see* figs. 8.19 and 8.21), was valued in Italy primarily for the noble titles he sold to replenish his diminishing financial resources. We have already seen (chapters 7–9) that rulers of Naples, Rimini, and other states had begun to fashion themselves according to the model of the ancient emperors, and the Gonzaga princes may themselves have been laying claim to the role of "new Caesar" with such commissions as the *Triumphs*. One striking feature of the work is that although the procession seems, in the first canvas, to begin in Rome, it soon appears to wander across open countryside. The implication is that it is moving toward Mantua, as if the imperial court were being translated to a new capital.

Though Mantegna was employed in Mantua primarily by a local patron, he would have recognized that the competition in court centers for work by the best artists in other cities, coupled with the increasing market throughout Italy for Netherlandish painting, had contributed to a need to make pictures more portable. For all of

10.1

Andrea Mantegna,
*The Triumphs of Caesar:
Caesar in Triumph, c.* 1488.
Distemper (?) on canvas,
8'9" × 9' (2.67 × 2.74 m).
Collection of Her Majesty
the Queen, Hampton
Court, Surrey

their beauty, panels were unwieldy, especially when they needed to be transported in ships or over unpaved roads. This is one reason why canvas gradually replaced wood as the favored support for paintings in Italy. We have already come across a few paintings on canvas: the triptych for the Scuola della Carità in Venice from 1446 (*see* fig. 6.37) is a very early example. Particularly in Venice, moreover, patrons sometimes asked for canvasses where their counterparts in other cities would have sought not panels but frescoes: canvasses had virtually no size limits, and they held up better than plaster in wet air. The major attraction of a painting on canvas, however, was that it was thin and lightweight; provided it was not primed too heavily, it could even be rolled or folded.

Painters were not the only artists experimenting with media that could be taken from place to place. Recognizing the monopoly that Verrocchio managed to maintain on monumental bronze projects in Florence (*see* figs. 9.14–9.15), his chief competitor, the goldsmith and painter Antonio del Pollaiuolo, began producing metalwork on a smaller scale. The statuette was still a relatively new kind of art object – the earliest datable examples are two equestrian bronzes that Filarete produced in Rome in 1456 and 1465 – and its appearance signals the emergence of a market of collectors who were interested in acquiring objects of artistic value, as opposed to images that served devotion and family commemoration. Filarete had written in his *Trattato* of how Piero de' Medici enjoyed "images in bronze, gold and silver." These gave pleasure not only because of the subjects represented but also on account of "the noble mastery of those ancient angelic spirits who with their sublime intellects made such ordinary things as bronze, marble and similar materials acquire great price." Some of Filarete's readers may have found it strange to see bronze described as an "ordinary thing," but his point was that the value of metals "become even greater through their mastery." And though he was writing primarily about ancient works, there was increasingly a sense that products by modern craftsmen could be appreciated in the same way.

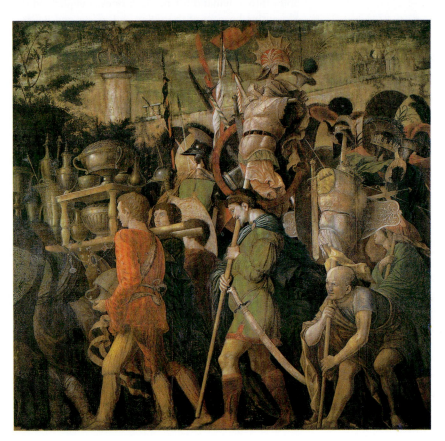

RIGHT ABOVE

10.2

Andrea Mantegna,
*The Triumphs of Caesar:
The Statue Bearers, c.* 1490.
Distemper (?) on canvas,
8'7" × 9' (2.62 × 2.74 m).
Collection of Her Majesty
the Queen, Hampton
Court, Surrey

RIGHT BELOW

10.3

Andrea Mantegna,
*The Triumphs of Caesar:
The Corselet Bearers,
c.* 1500. Distemper (?)
on canvas, 8'7" × 9' (2.62
× 2.74 m). Collection of
Her Majesty the Queen,
Hampton Court, Surrey

ABOVE LEFT

10.4

Bertoldo di Giovanni,
Pegasus and Bellerophon,
c. 1480. Bronze,
originally with gilding,
height 12⅞" (32.5 cm).
Kunsthistorisches
Museum, Vienna

ABOVE RIGHT

10.5

Antonio del Pollaiuolo,
Hercules and Antaeus,
before 1484. Bronze, height
18" (45.8 cm with base).
Museo Nazionale del
Bargello, Florence

This transformation of a taste for ancient collect-ables into a demand for modern ones is evident in the Florentine bronzes of the 1480s. A *Pegasus and Bellero-phon* (fig. 10.4) by Bertoldo di Giovanni (1420–1491), for example, derives largely from the marble fragments of the *Dioscuri*, or "horse tamers," on the Quirinal Hill in Rome, but it also fills in the then missing pieces and adds some new ones, turning the ancient horse tamers into an image of a Greek hero using a golden bridle to domesti-cate a winged mount. (The original work would probably have been gilded, making the hero's bridle all the more real and making bronze seem like an especially appro-priate material in which to re-create the subject.) The most technically accomplished example of the new form, though, was Pollaiuolo's *Hercules and Antaeus* (fig. 10.5), perhaps datable to the early 1480s, though there is no documentation regarding the work's original owner or location. What we can say with certainty is that Pollaiu-olo made the bronze for the private and domestic context described by Filarete in his *Trattato*: like Bertoldo's group, its subject matter embodies the principles of ancient heroic virtue that educated Italians sought in their read-ing of classical literature, and it would have responded to an owner's interest in the originality and ingenuity, or "virtue," of its maker.

The work epitomizes the incipient violence of many late fifteenth-century Florentine works centered on the human body, as if the artist's knowledge of human anat-omy and motion could be most fully revealed when a figure was subjected to extremes of emotional or physi-cal duress. Hercules' slaying of the earth-born Antaeus, who was immortal only as long as he maintained contact with the earth, provided the occasion for confronting a technical challenge. In crushing Antaeus, Hercules lifted him from the ground; Pollaiuolo needed to balance the bronze so that the asymmetric composition would not tip over. The interaction of two figures, one bracing itself to hoist and squeeze another who flails his limbs and arches his back in agony, affords possibilities for a rich variety of points of view. The triangular base – an idea derived, perhaps, from Donatello's *Judith and Holofernes* (**see** fig. 6.25) – invites the viewer to regard the statue from three principal sides, even to rotate it on a table. The head of the tormented Antaeus, at the apex of the group, is dominant in each of its aspects. His mouth is open as Hercules literally squeezes the life from him; a contempo-rary would have understood that Antaeus's "vital spirit" was issuing forth.

For all of their sophisticated use of materials, these bronzes by Bertoldo and Pollaiuolo were much simpler to produce than large statues, such as Verrocchio's *Christ and St. Thomas* (**see** fig. 9.14). The artist did not need to go to the trouble of creating a wax sheath around a clay core; he could cast the clay model directly by press-ing it into a mold, removing it, then filling the hollowed impression with molten metal. Still, Pollaiuolo appears

to have produced only a handful of statues, and *Hercules and Antaeus* is the only one with two figures. The output by other Florentine sculptors in the later fifteenth century remained similarly small, and it may be significant that Bertoldo's *Bellerophon* appears documented for the first time in Padua, the major early Italian center for the medium. The city where Donatello had made his great bronze *Gattamelata* (*see* fig. 7.24) had become known not only for collectable figures but also for bronze bells, lamps, candlesticks, inkwells, and other vessels, all adorned with mythological creatures and grotesque ornament. By the 1490s in Mantua the sculptor Antico (*c.* 1460–1528) began the more economical process of casting his figures in pieces with reusable molds.

Engravings and Drawings

Pollaiuolo also tried his hand at another new form of portable art: engraving. This, like the bronze statuette, required real skills in metalworking. The artist or an assistant would begin by hammering out a thin sheet of metal (usually copper), cut a design into it with a sharp instrument called a **burin**, then ink the grooves and print the image on paper. One attraction of the medium, made newly possible by the arrival of the printing press in Italy in the mid 1460s, was its capacity to generate inexpensive multiples, so that designs could be disseminated to a wider public. Engraving also allowed designers to think outside the range of subjects most commonly associated with commissioned paintings and sculptures. Pollaiuolo's own single engraving, the so-called *Battle of the Nudes* (fig. 10.6), has no discernible literary source or even clearly identifiable characters. The interest, rather, is in showing frenzied bodies in violent action from many different points of view. The dating of the work is disputed – specialists have placed it anywhere from the late 1460s to around 1490 – but it is not surprising that it comes from the hand of a sculptor. A few of the characters in the print, including the two central ones, seem to have been generated by rotating a three-dimensional model and drawing it from different angles.

10.6

Antonio del Pollaiuolo, *Battle of the Nudes*, before 1470. Engraving, 16¾ × 24" (42.4 × 60.9 cm). Cleveland Museum of Art, Cleveland

10.7
Andrea Mantegna,
Entombment of Christ,
c. 1475. Engraving and
drypoint, 11¾ × 17⅜" (29.9
× 44.2 cm). Washington
Patrons' Permanent Fund,
National Gallery of Art,
Washington, D.C.

10.8
Andrea Mantegna,
Battle of the Sea Gods,
c. 1475. Engraving and
drypoint, 11⅛ × 32⅝"
(28.3 × 82.6 cm).
Duke of Devonshire
Collection, Chatsworth

Pollaiuolo's approach to engraving differs in this respect from that of Mantegna, another artist who thought seriously about the new medium's possibilities. The engravings that go under Mantegna's name remain even more disputed than the one made by Pollaiuolo. Scholars have assigned them dates ranging from the 1460s to the 1490s; some have speculated that Mantegna, like Pollaiuolo, may have been responsible for the cutting of the plate as well as for the design, though a document of 1475 indicates that Mantegna provided a goldsmith named Gian Marco Cavalli with drawings to be engraved, which

casts doubt on this possibility. Unlike Pollaiuolo, Mantegna had no background in metalworking, so it seems more likely that he subcontracted another master to carry out all of the burin work and printing to his specifications. What is certain is that Mantegna produced many more designs for prints than Pollaiuolo, nearly half of them on pagan and other secular themes. One adapts an ancient relief showing the burial of the Greek hero Meleager into an *Entombment of Christ* (fig. 10.7). Another, a print known as *Battle of the Sea Gods* (fig. 10.8), involved a design so large that it stretched across two plates and

required two sheets to print. Its mythological subject matter, informed by several ancient sources but not corresponding to any single one, has no counterpart in Mantegna's paintings before the 1490s.

The rise of engraving as a medium reflects the widening availability of paper. It is thus not surprising that the most common form of portable art by 1490 was the drawing. When Pisanello, in the first half of the century, made drawings on location in the out-of-doors, he had little company. By the time of Mantegna and Pollaiuolo, however, many artists were making studies on paper, often in places they could not easily have taken the materials that their predecessors had used. Leonardo da Vinci may have filled a whole sketchbook just with drawings of horses (figs. 10.9–10.10). But architects, too, found such *taccuini* useful for making records of buildings or ruins they saw while visiting other cities, or for documenting their own projects (figs. 10.11–10.12).

10.9
Leonardo da Vinci, *A Rider on a Rearing Horse,* **not before 1481.** Metalpoint reinforced with pen and brown ink on a pinkish prepared surface, 5⅝ × 4¾" (14.1 × 11.9 cm). Fitzwilliam Museum, University of Cambridge

10.10
Leonardo da Vinci, *Two Horsemen,* **after 1481.** Metalpoint, reinforced with pen and brown ink, on a pinkish prepared surface, 5⅝ × 5" (14.3 × 12.8 cm). Fitzwilliam Museum, University of Cambridge

277

RIGHT

10.11

Francesco di Giorgio Martini, sketches of antique architectural and decorative parts of reliefs observed during a visit to Naples. 333Ar, Gabinetto Disegni e Stampe, Uffizi Gallery, Florence

FAR RIGHT

10.12

Giuliano da Sangallo, drawing of the Basilica Emilia, *c.* 1480. Pen and ink on parchment. Codex Barberiano, fol. 26r., 18 × 15⅜" (4.6 × 3.89 cm). Biblioteca Comunale, Siena

Artists on the Move

As art patrons, the merchant elite of Florence usually showed a preference for home-grown talent. Throughout the rest of Italy, those with money to spend on art saw it as a mark of prestige to attract distinguished artists from elsewhere. Sometimes this allowed potentates to use commissions to gain political and diplomatic advantage: Mantegna's Gonzaga employers in Mantua kept a check on who actually received his works, but they also arranged the artist's voyage to Rome in 1488 to decorate a chapel in the Vatican Palace for Pope Innocent VIII. The Sforza rulers of Milan, similarly, sent the locally born goldsmith and medallist Caradosso (*c.* 1452–1526) to work for the King of Hungary in 1489–90, even as they recruited Florentine architects and sculptors to their own court. Most cosmopolitan of all were the Aragonese rulers of Naples. They owned works by the best Netherlandish artists. In the mid 1480s, the future King Alfonso II persuaded Giuliano da Maiano (*c.* 1432–1490), then head of the Florence Cathedral works and one of the best architects in Italy, to move to his court. The king also showed appreciation of contemporary Sienese art, hiring the theorist, designer, and engineer Francesco di Giorgio Martini and, in 1488, ordering work from the painter Matteo di Giovanni (*c.* 1430–1495). A few years later, in 1492, Alfonso would commission a spectacular terracotta group from the Modenese sculptor Guido Mazzoni (1445–1518; fig. 10.13).

Venetian painters and sculptors commanded the widest reach in terms of the demand for their works. The workshops of the Vivarini family (*see* fig. 6.37) sent an altarpiece to Bologna in 1450 and another as far afield as Bari in southern Italy in 1465, while Giovanni Bellini, as we have seen, supplied the city of Pesaro with a great *Coronation* altarpiece around 1476 (*see* fig. 9.10). With its long tradition of marble carving in the brilliant local Istrian stone, Venice was also the setting for a rich artistic exchange between local sculptors, Florentine expatriates trained under Donatello, and a group of talented carvers from the Dalmatian coast, in what is now Croatia. Such artists as Niccolò di Giovanni Fiorentino, Giovanni Dalmata, Giorgio da Sebenico, and Francesco Laurana (*see* fig. 9.27) all produced their own inventive responses to the sculpture of Donatello and of antiquity, which they carried to such Italian centers as Urbino, Ancona, Rome, and Naples, as well as eastward to Ragusa (Dubrovnik), Zara (Zagreb), and Traù (Trogir).

The extent of these exchanges mirrored the expanse of the Venetian cultural sphere, which extended down the Istrian and Dalmatian coast as far as Crete and well into the Italian peninsula. The opportunities this could present are illustrated by the prolific Venetian painter Carlo Crivelli (*c.* 1435–*c.* 1495), who produced paintings for a clientele of merchants, feudal nobility, religious orders, and confraternities stretching from the Appenines to the Adriatic and the borders of the Kingdom of Naples. The

10.13

Guido Mazzoni,
Lamentation, 1492–94.
Terracotta. Santa Anna dei
Lombardi, Naples

10.14

Carlo Crivelli, *Coronation
of the Virgin*, *c.* 1490.
Tempera on panel, 8'4"
× 7'4½" (2.55 × 2.25 m).
Pinacoteca di Brera, Milan

artist had trained in Padua alongside Mantegna, but he later spent extended periods in cities of the Adriatic rim: Zara in Dalmatia; Fermo; and finally in Ascoli. Crivelli's motives for spending most of his career outside his native city may have to do with his being imprisoned for adultery there in 1457, but it is also the case that the busy trading centers across the region offered lucrative opportunities for fame and success. His output consisted almost exclusively of altarpieces (usually polyptychs), which dazzle the eye in their combination of splendid surfaces abounding in pattern and ornament, illusionistic tricks, and a strongly marked sense of three-dimensional space and volume. He sometimes worked up details of costume and the attributes of saints fully in three dimensions, using *pastiglia* to an extent that other artists would never have dared, and he re-created the texture of sumptuous fabrics with pointed tools and stamps.

Links with such Venetian contemporaries as the Bellini are not conspicuous – if anything, Crivelli offered an alternative to the dominant workshops of the Veneto, creating a regional art with a widespread appeal through sophisticated, modern adaptations of the gold-ground painting his public favored. He was aware of the ongoing prestige of the region's most famous painter, Gentile da Fabriano, and in 1490, he produced a *Coronation of the Virgin* (fig. 10.14) for the Franciscan church in Fabriano itself. Crivelli ignored Bellini's Pesaro *Coronation* (*see* fig. 9.10), which he could easily have seen. Instead,

10.15
Gentile Bellini, *The Sultan Mehmed II*, 1480. Oil on canvas, 27½ × 20½" (69.9 × 52.1 cm). National Gallery, London

he modeled his work on Gentile's own *Coronation* of 1414 for the nearby town of Valle Romita (*see* fig. 3.12), revising and updating the older painting. Crivelli's altarpiece, like Bellini's, is now a *pala* rather than a polyptych. It eliminates Gentile's gold ground but reminds viewers of that tradition by including a gold cloth, illusionistically gathered into folds behind the main characters. Equally magnificent luxury textiles enhance the figures' three-dimensional solidity. Whereas Gentile's Virgin and Christ hover in a flaming sunburst, Crivelli's solidly occupy an elaborately carved and gilded marble throne, adorned with two huge classical horns of plenty filled with apples, pears, and cherries. And whereas Gentile's God the Father sits magisterially behind the couple, presenting them to us, Crivelli's surges forward from what looks like a hole in the sky to place crowns on the heads of both the Virgin and Christ. Crivelli's Heaven is a place of material and sensual splendor. It no longer mirrors the private world of a prince (Pesaro's Chiavelli rulers had been exterminated following an uprising in 1435), though the artist's concept of dignity and honor remains inseparable from the idea of the court. His signature only enhances this dimension of the picture, referring to *Carolus Crivellus Venetus miles* ("Carlo Crivelli of Venice, Knight"). It is not known which ruler bestowed Crivelli's knighthood, but in the year he painted the *Coronation* he received the additional princely recognition of being appointed "familiar" to Prince Ferdinand of Capua.

Italy and the Ottomans

Gentile Bellini (*c.* 1429–1507) – himself named after the great painter of Fabriano, who had trained his father Jacopo – illustrates the international prestige of Venetian art in a particularly dramatic way. For sixteen years, the Republic had been fighting to save its overseas possessions in the eastern Mediterranean from the Ottoman Turks, but in 1479 the two empires concluded a peace treaty. The Ottoman Sultan in Constantinople, Mehmed II, asked the Venetian Senate to provide him with the services of a painter and sculptor; he would soon ask in addition for an architect and for a bronze caster. The painter that the Senate decided to send was Gentile, who was working at the time on a highly prestigious state commission, a series of history paintings for the Hall of the Great Council in the Doge's Palace. (Gentile da Fabriano and Pisanello had worked earlier on the same series, which was completely destroyed in 1577.)

A contemporary record noted that the Sultan wanted "a good painter who knew how to make portraits." Gentile produced at least one painted portrait of Mehmed, probably the small picture now in London (fig. 10.15),

and he supervised the making of a portrait medal. The London portrait, damaged and heavily restored, shows how Gentile responded to the demand to make a demonstration of Western painting "from life." He employed a device, sometimes featured in royal portraiture, of an illusionistic parapet and arch to enhance the sense of the panel as a window onto a virtual space, while placing the person of the ruler at a dignified remove. A jeweled cloth demonstrates the potential of oil to describe the physical world, and in this case to reproduce the splendor of crafts more costly than painting.

Other sources refer to Gentile portraying a wide range of subjects "from life" at Mehmed's request. An exquisite watercolor of a seated scribe may have been part of this series of works (fig. 10.16). Although its attribution to Gentile is sometimes doubted, an inscription added in Persian by a later collector refers to its author "son of mu'azzin" as "among the well-known masters of Europe." This suggests that it was regarded as an epitome of Western representational interests, even while the technique and a certain abstraction of the style show the artist responding to Ottoman and Persian art, especially book illumination: the near absence of shadow, the neutral background, and the gilt pattern on the blue robe give a linear and two-dimensional cast to a figure that otherwise reads as solidly three dimensional. A group of seven ink drawings of figures in local costume are

OPPOSITE
10.16
Gentile Bellini, *Seated Scribe*, 1480. Pen and brown ink with water colour and gold on paper, 7¼ × 5½" (18.2 × 14 cm). Isabella Stewart Gardner Museum, Boston

THE ILLUSTRATED BOOK IN THE AGE OF PRINTING

The manuscripts acquired by Duke Federico da Montefeltro (*see* fig. 9.6) and other elite collectors were usually supplied by dealers who employed teams of scribes, illuminators, and binders for work on particular projects. In the closing decades of the century, the producers of manuscripts were forced to take account of a revolutionary development in the manufacture of books, the recent German invention of printing with moveable type. In 1465, at Subiaco near Rome, the partnership of Conrad Sweynheym and Arnold Pannartz began to produce editions of Cicero's *De oratore*, the grammar of Donatus, Augustine's *City of God*, and other texts in high demand among students and clergy (fig. 10.17). The initial venture was not a commercial success, but the invention spread rapidly and took particular hold in Venice, where close to one hundred printing houses were active by 1500, many of them established by former dealers in manuscripts and by scribes. Though considerably less costly than the hand-copied texts that had served readers for centuries, printed books were still expensive and beyond the means of most students and clerics. Publishers sought to enhance the appeal to elite customers by employing traditional methods of decoration. They had scribes execute decorative initials, and, if the client required, they provided books with fully illuminated frontispieces that could contain all the components from the traditional manuscript: an author portrait in an initial, a decorative border, and often an elaborate "bas-de-page" (literally "bottom of page") painting where the client's coat of arms was presented by putti or by centaurs, frequently surrounded by cavorting animals or mythological creatures.

The type in these early books emulated the clear Roman characters employed by humanist scribes, and designers accordingly framed the blocks of printed text with elaborate classical structures that pursued startling illusionistic effects (for instance, the text might take the form of a frayed parchment sheet suspended in space with figures moving in front and behind).

10.17

Livy, *Roman History*, Third Decade. Printed in Rome, 1469, by Sweynheym and Pannartz. Illumination by the Master of the Putti, Venice, 1469. Graphische Sammlung Albertina, Vienna

10.18

Woodcut illustrations from Francesco Colonna, *Hypnerotomachia Poliphili*. Venice, Aldus Manntius, 1499

By around 1490, publishers began to respond to the appearance of cheaper illustrated books from Germany, with inserted woodcuts: the Venetian firm of Benalius and Capcasa printed an edition of Dante's *Divine Comedy* in 1490 with three full-page woodcuts – one for each part of the poem – which clearly imitated the form of hand-illuminated frontispieces. A range of different kinds of texts – lives of saints and of other famous men and women, medical handbooks, guidebooks for pilgrims, Bibles, Books of Hours – now began to feature woodcut illustrations. Authors, publishers, and artists, in turn, sought collaboratively to exploit the new possibilities for reproducing texts with images.

In 1499, the publishing house of Aldus Manutius in Venice produced one of the most extraordinary experiments in the history of the illustrated book: *Hypnerotomachia Poliphili* (*Polifilo's Dream of Amorous Turmoil*; fig. 10.18), a romance of amorous longing, erotic adventure, and antiquarian erudition loosely modeled on Dante's *Divine Comedy* and written in a challenging hybrid of Veneto dialect with Latin and Greek. The story concerns a lovesick young man called Polifilo who dreams of a journey through a strange land and describes – with a learned architectural vocabulary drawn from Vitruvius – a series of colossal ruins and marvelous statues. He also encounters nymphs, ancient divinities, triumphal processions, and exotic pagan rituals. Following the protagonist's adventures, the reader realizes that he or she is in a predicament similar to that of Polifilo, who struggles to make sense of strange spectacles and numerous cryptic inscriptions – most of them not merely described but actually presented to the reader in the woodcut illustrations – by drawing upon his classical learning (some of the original copies indicate that early readers annotated the text as they solved the various conundrums for themselves), and by vainly striving to prevent his prudent judgment being undermined by curiosity and erotic distraction. Although the work had a long afterlife and was translated into French and English (the illustrations carefully copied), it probably did not make a return on the publisher's investment, and the only subsequent illustrated books that come close in terms of the quantity and quality of illustrations are the architectural treatises of Sebastiano Serlio, Andrea Palladio, and their followers, who could count on a much wider appeal among professionals, gentlemen builders, and learned amateurs.

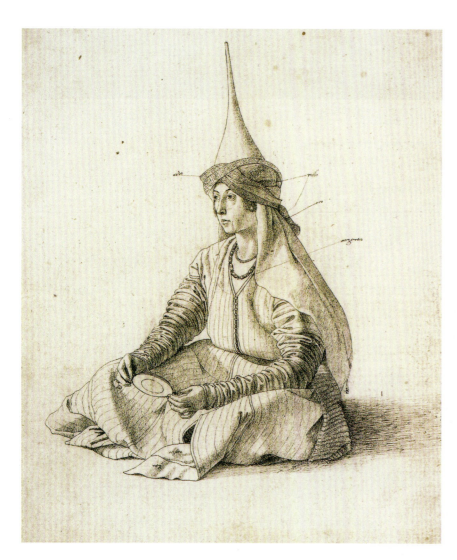

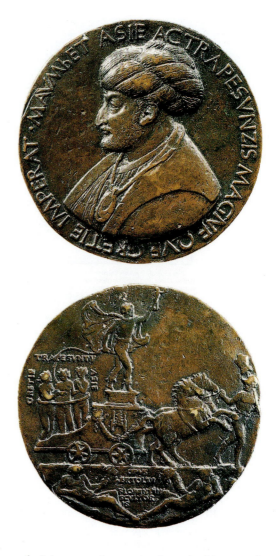

ABOVE

10.19

Gentile Bellini, *A Turkish Woman*, 1480. 8½ × 7" (21.4 × 17.6 cm). British Museum, London

ABOVE RIGHT

10.20 and 10.21

Bertoldo di Giovanni, medal of Mehmed II, obverse (top), and reverse (bottom), *c.* 1480. Diameter 3¾" (9.4 cm). National Gallery of Art, Washington, D.C.

among the most vividly descriptive life drawings produced in the fifteenth century (fig. 10.19), and among the earliest ethnographic studies produced by a European artist. Gentile seems to have prepared these as modelbook figures for paintings with an oriental setting, and within a few years they were known to other artists in Italy. He returned to Venice in 1481 with the titles of "knight" and "palace companion," along with a collar of gold.

Western-style portraiture would have been a novelty at the Ottoman court. Mehmed, who had conquered Constantinople in 1453, saw himself at the center of an expanding world empire encompassing Europe and Asia. His interest in Italian art, as well as sacred objects and relics, points to a desire to possess the distinctive achievements of the culture over which he aspired to rule. He had intervened to prevent the destruction of Byzantine mosaics when his forces took control of the city, and, in addition to paintings, he appears to have owned a collection of Florentine and Ferrarese prints,

several giving prominence to the naked human figure – a *St. Sebastian*, a group of dancing nudes, *Cupids with a Winepress*, a *Hercules and the Hydra* after Pollaiuolo. Mehmed's importation of art and artists from elsewhere, more-over, bears comparison to the practice of Italian rulers: it enhanced his own prestige, but it also had a diplomatic aspect, creating links with other powers. In 1480 he asked the Florentines to send him woodcarvers and sculptors. A medal that Bertoldo di Giovanni produced in Florence that same year (figs. 10.20–10.21) shows that Western artists were ready to reinforce the sultan's self-image as a universal conqueror. His portrait is inscribed "Mehmed, emperor of Asia and Trebizond and Greater Greece." The reverse shows an allegorical triumph in the classical style, with a nude male figure astride a chariot holding aloft a figure of Victory: three bound captives behind represent the three divisions of Mehmed's empire.

Florence and Venice were all too aware that Mehmed's inclination to conduct foreign relations

through the peaceful exchange of art and diplomatic honors could dissolve. King Ferrante of Naples had sent the sculptor Costanzo de Moysis (*c.* 1450–*c.* 1524) to Constantinople to make portrait medals in 1478, yet once Mehmed had secured peace with Venice the following year, he turned against his former ally. A Turkish fleet seized the southern town of Otranto on the heel of Italy in 1480, and although the Duke of Calabria finally expelled the invaders in a "crusade" the following year, the garrison of Otranto, having refused to embrace Islam, had by then been executed. Matteo di Giovanni's *Massacre of the Innocents* (fig. 10.22) attests to King Ferrante's fondness for Sienese art, but it may also have served as a memorial to the "martyrs of Otranto."

Florentine Bronze Sculptors in Venice and Rome

Verocchio, Leonardo, and the Equestrian Monument

Florence had long understood the diplomatic value of art, particularly the small bronzes and plaquettes regularly sent abroad as gifts. Its most prestigious artistic capital, however, was its sculptors, and foreign patrons sought out Florentines for two highly prestigious commissions – both of them bronze equestrian monuments – in Venice and Milan. In 1484 Ludovico Sforza consulted

10.22

Matteo di Giovanni, *Massacre of the Innocents, c.* 1480.

Oil on panel. Capodimonte Museum, Naples

with Lorenzo de' Medici on the availability of bronze technicians who could cast a colossal mounted statue of his father, the warlord Duke Francesco Sforza, in Milan. Meanwhile, Venice needed a sculptor for an equestrian monument, also in bronze, to the *condottiere* Bartolomeo Colleoni, a captain of the Venetian forces who had died in 1475 (*see* p. 134).

Colleoni had amassed substantial property, and his testament allowed this to go to the Venetian government on condition that a "metal horse" be erected in his memory in the Piazza San Marco; the Senate consented to the statue, but in a less prominent location outside the center, the piazza before the confraternity of San Marco. By 1483, Andrea del Verrocchio had won the commission, submitting a lifesize model of the horse in wax, and he moved to Venice in 1486 to begin work on the monument (fig. 10.23). The sculptor regarded the undertaking as a chance to compete with his predecessor Donatello's *Gattamelata* (*see* fig. 7.24) in nearby Padua. He was also mindful that his work would be compared with the famous bronze horses that adorned the facade of the basilica of San Marco (spoils of an inglorious attack on Constantinople in 1204), as well as with the definitive Marcus Aurelius statue in front of the Lateran Palace in Rome. Verrocchio signaled his own mastery of the medium by balancing the massive bulk of the horse and rider on three points – a challenge that the *Marcus Aurelius* had posed and that even Donatello's *Gattamelata* had been unable to match. One early drawing by Leonardo (fig. 10.24), a proposal for the equestrian monument that Ludovico Sforza desired, shows a rearing horse, ostensibly now on only two legs but in fact propped up by a fallen victim below. Imagining such a drawing carried out in three dimensions helps us to see how calculations of weight and equilibrium let artists in these years try to outdo one another as engineers and not just as designers of figures.

Still, it is in the expressive character of the group that Verrocchio's sculpture distinguishes itself from its predecessors. Many late fifteenth-century Florentine

ABOVE

10.23

Andrea del Verrocchio, equestrian monument of Bartolomeo Colleoni, *c.* **1481–95.** Bronze, height approx. 13' (4 m) without base. Campo Santi Giovanni e Paolo, Venice

LEFT

10.24

Leonardo da Vinci, design for the Sforza monument, *c.* **1488.** Metalpoint on blue prepared paper, 4⅝ × 4" (11.6 × 10.3 cm). Royal Library, Windsor

treatments of the male body focused on virile force and aggression, and these qualities must have seemed particularly appropriate for Colleoni, who sometimes spelled his named Coglioni ("testicles") and proudly made its meaning apparent in his coat of arms. Verrocchio called attention to the figure's character and expression, his bearing, gesture, and movement. Like other Florentine sculptors, the artist attempted to give his military subject a sense of liveliness, conceiving the body as a container for a violent and even disfiguring emotion that moved and distended the figure from within, as if seeking release. A furious energy has rendered the body of the mounted captain rigid; Colleoni pushes himself upright in his stirrups. The twist of the body on its axis creates tension in the neck, shoulders, and waist, while the elbow of the arm with the baton juts outward. The face has been pulled so taut that his eyes bulge forth in their sockets. To get this effect, Verrocchio worked up the relief of his bronze, deeply drilling the pupils so that they could be read easily from the piazza below; the figure borders on the horrifying, and was intended to. The final details of the work were the responsibility of a local casting master, Alessandro Leopardi, who oversaw the completion of the figures after Verrocchio died in 1488. Leopardi, a goldsmith by training, was proud enough of pulling it off that he had his own name inscribed on the belly of the horse – as if he alone had made it.

Pollaiuolo and the Papal Tomb

Leopardi's involvement in the Verrocchio project helps show the new opportunities that arose for goldsmiths in these years. Perhaps the greatest professional advantage that the format of the small bronze offered to an artist like Pollaiuolo was that it advertised his preparedness to produce much more ambitious works. In 1484, a year after Verrocchio secured the Colleoni commission, Pollaiuolo moved to Rome, where one of his former Florentine patrons had secured him a commission from Cardinal Giuliano della Rovere, the future Pope Julius II. One of the richest men in the city, Giuliano had resolved to honor his lately deceased uncle, Pope Sixtus IV, with a tomb in a suitably magnificent style (fig. 10.25): a massive work completely of bronze, it was equally without precedent in its format and its intellectual program. Most of Sixtus's predecessors had been interred in marble wall tombs, which normally included an effigy of the deceased lying in state surmounted by an apparition of God the Father or the Virgin Mary, sometimes with Saints Peter and Paul, who signified the heavenly reception of the Pope's soul. Sixtus's memorial, by contrast, is a floor tomb that originally occupied the center of the Chapel of the Canons in St. Peter's. Sixtus was a Franciscan, and the

10.25
Antonio del Pollaiuolo, tomb of Pope Sixtus IV, 1484–93. Bronze, length 14'7" (4.45 m). Museo Storico Artistico, St Peter's, Rome

10.26
Antonio del Pollaiuolo, tomb of Pope Sixtus IV, detail: effigy

decision to place the tomb on the floor was probably a gesture toward the humility that order espoused. This, at least, is the theme of the dedicatory inscription: "To Pope Sixtus IV of the Franciscan Order prince of all memory for his learning and greatness of spirit. He kept the Turks away from Italy, increased papal authority, endowed Rome with churches, a bridge, forum, streets, opened the Vatican Library to the public, celebrated the Jubilee and freed Liguria from servitude. Since he had given orders to be buried modestly and on level ground, Cardinal Giuliano erected [this] with more piety than expense."

Still, modesty hardly describes the impression made by the tomb, which rises above the floor in several tiers, with the Pope at its summit, effectively dominating the space around it. It seems to be borne upward by a kind of

vegetal growth, on swelling scrolls of acanthus leaves and monstrous lion paws. In the portrait of Sixtus IV, Pollaiuolo dwells unequivocally on the facts of death: the face is flaccid and sagging, the breath of life has clearly left this body (fig. 10.26). Yet the Pope is surrounded by signs of teeming life: in the *spiritelli* that bear his coats of arms, in the foliate ornament, and in the remarkable series of female personifications ranked in two tiers around the body. These allegorical figures supplement the highly individualized likeness of the Pope by presenting his moral and intellectual qualities, albeit in generic terms. The inner series shows the seven Virtues, while the sides present a series of larger figures in higher relief

designating Liberal Arts: to the canonical series of Grammar, Dialectic, Rhetoric, Arithmetic, Music, Philosophy, and Astrology are added Geometry, Theology, and, most remarkably, Perspective. The choice of "arts" to include would not have been Pollaiuolo's, but the fact that a technique the sculptor relied on in his reliefs had risen to the status of Philosophy or Dialectic indicated how the labors of a craftsman like Pollaiuolo could have won him particular distinction among the intellectuals of the papal court.

The Liberal Arts, unusual in a papal tomb, refer to Sixtus's earlier academic career as professor of theology and philosophy as well as to his promotion of learning through the reorganization of the Vatican Library. The papal tiara, too, reads as a celebration of Sixtus's accomplishments: the insignia one might expect if the reference were primarily to the papal office are completely absent, and there is indeed no overtly Christian imagery here at all. To be sure, Cardinal Giuliano made certain that the more traditional elements of papal commemoration were provided for at the site, and the chapel had an apse with frescoes by Pietro Perugino, portraying Sixtus in prayer before the Virgin. The dissociation of this imagery from the tomb itself, though, allowed Pollaiuolo's monument to be read in terms of the more secularizing ideals of fame. With its celebration of rhetoric on the side, it was all but a three-dimensional oration in praise of Sixtus, conventional in its ticking off of the standard spiritual and intellectual endowments of a good prince, but deeply original in its manner of

10.27
Antonio del Pollaiuolo, tomb of Pope Sixtus IV, detail: Dialectic

10.28
Antonio del Pollaiuolo, tomb of Pope Sixtus IV, detail: Theology

visualizing and embodying these generic aspects in the imagery of the human figure.

In the rendering of the Liberal Arts, Pollaiuolo showed his ability to give visible and even sensuous bodily form to abstract ideas. The figure of Dialectic (fig. 10.27), frowning in concentration, portrays in her very posture – the right leg placed over the left, the upper body turned toward the right – the principle of dialectic itself, which seeks to resolve contradiction by confronting opposed principles in argument. Pollaiuolo modified Dialectic's traditional attributes: normally the scorpion in her left hand would be balanced by a flowering branch (the poison of one is opposed to the honey yielded by the other): here the branch is the oak, emblem of the Della Rovere family. The panel showing Theology (fig. 10.28) is perhaps the most surprising of all. This is the only motif in the monument to display Christian symbolism: an angel carries a book with the opening of the Old and New Testaments, and the figure of Theology turns away from the book to look directly at its source, the three-personed God, who appears in a sunburst. Yet playing the role of the personification herself here is the pagan divinity Diana, the virgin huntress and goddess of the moon, who is represented as a nude. Her mythological character is crucial to the meaning of the work: we are shown how the science of Theology draws its light directly from God, just as the moon draws its light from the sun.

Florentine Painters in Rome: The Sistine Chapel Frescoes

While Florentine sculpture held a wide appeal for foreign patrons, the city's painters do not seem to have commanded the same interest in other parts of Italy as did the work of the Bellini siblings or their brother-in-law Mantegna. Around 1480 the profession was dominated in Florence by former students of Verrocchio – Sandro Botticelli, Domenico Ghirlandaio (1449–1494), and Pietro Perugino (1446–1524) – all of them in their mid thirties and without a significant reputation abroad. Through the diplomacy of Lorenzo de' Medici, however, Botticelli and Perugino, among others, commandeered the most prestigious pictorial commission of the later fifteenth century, the decoration of Sixtus IV's new chapel in the Vatican.

The Sistine Chapel was constructed rapidly in 1479–81, on a site between St. Peter's basilica and the Vatican Palace. It was meant to serve as a court chapel for the papal household and the College of Cardinals: one of its functions was to house the conclave that gathered to elect a new Pope. It was also a space for preaching, where sermons were increasingly being styled as classical Latin

10.29
Baccio Pontelli (?), Sistine Chapel, 1477–81. Exterior view. Vatican

orations that celebrated particular feast days and saints but also the Pope himself. The very structure and decoration of the chapel were rhetorical in conception: its aim was to promote the identity of Rome as a New Jerusalem, and to proclaim the descent of the papacy, through Christ and St. Peter, from Moses and Aaron, the priestly rulers of the ancient Israelites. The design for the structure (fig. 10.29), traditionally (but by no means securely) attributed to the military engineer Baccio Pontelli, provided for an exterior in the form of a plain, fortified box, one that nevertheless imitated Florence Cathedral and other Quattrocento holy spaces in reproducing the proportions of Solomon's Temple. The single element of classical architecture visible in the interior is a cornice that separates the windows from the murals below: the cornice also bears *tituli*, or captions for the frescoes in Roman epigraphic capitals. Between the windows, Botticelli and his workshop painted a series of portraits of sainted popes from St. Peter onward (fig. 10.30): the larger murals below confront scenes from the life of Christ with corresponding episodes in the life of Moses across the chapel.

289

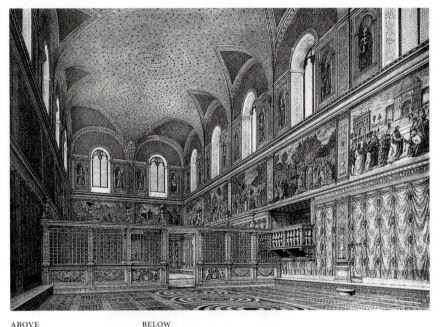

ABOVE

10.30

Gustavo Tognetti, imagined reconstruction from 1899 of the appearance of the Sistine Chapel *c.* 1483.

BELOW

10.31

Cosimo Rosselli, *The Adoration of the Golden Calf*, 1481–82. Fresco. Sistine Chapel, Vatican

Fifteenth-century Christians understood the histories of the Jews in the Old Testament in typological terms; they took every significant event in the Jewish Bible as a prophecy of an event in the life of Christ. This way of reading helped determine the arrangement of paintings with Old Testament narratives in the Early Christian churches of Rome. Following their model, the two narratives in the Sistine Chapel run in parallel on opposite walls; each incident from the life of Moses corresponds to a Gospel episode that simultaneously repeats and overturns it. A pair carried out by Cosimo Rosselli (1439–1506) offers one of the more straightforward examples of the way this worked. At the center top of his mural on the south wall, Rosselli shows Moses receiving the Ten Commandments from God on Mount Sinai (fig. 10.31); below, the divinely sanctioned legislator angrily breaks the tablets he has just received, having descended from the mountain and witnessed the Israelites dancing around a golden calf. Moses' people, shown here as contemporary Europeans, have violated one of God's first laws: "Thou shalt not have strange gods before me. Thou shalt not make to thyself a graven thing, nor the likeness of any thing that is in heaven above, or in the earth beneath, nor of those things that are in the waters under the earth." In the background right is the punishment that awaits

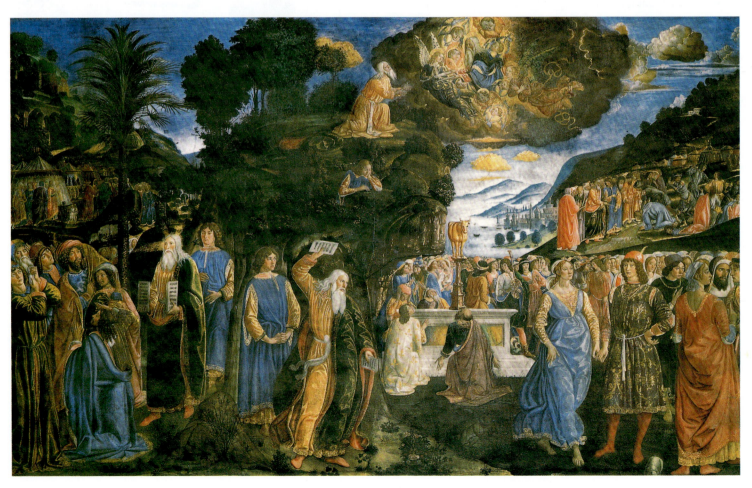

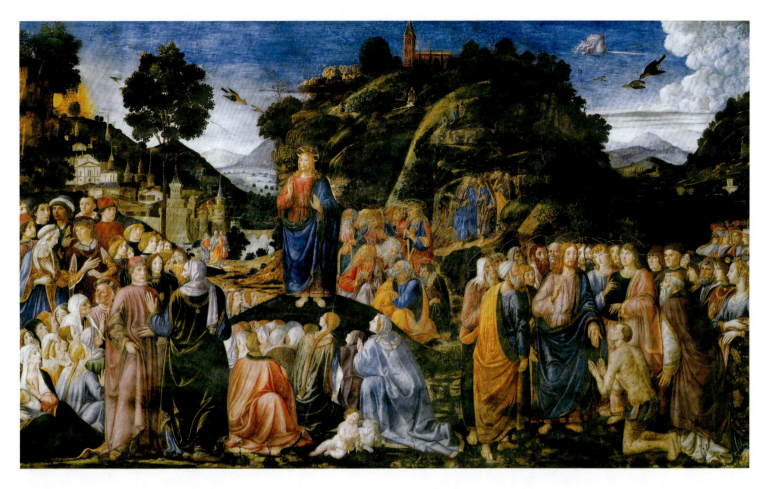

idolaters. The corresponding Gospel picture on the north wall is *Christ's Sermon on the Mount* (fig. 10.32), which began with the words "I am come not to destroy but to fulfill," and proceeded to a kind of critical commentary on the commandments that Moses had received. The similar landscape in the two pictures invites the viewer to compare them, and the listeners shown kneeling in attitudes of prayer suggest that Christ occupies the role given not only to Moses but also to the idol in the other wall.

Rosselli's paintings are of interest because they show that the themes of the Sistine Chapel bore on the topic of image-making per se. The form of his idol – a statue on a column – recalls the way that Donatello had installed his own Old Testament figures, such as Judith (*see* fig. 6.25) and David (*see* fig. 6.24). Its placement on what looks like a modern altar table, meanwhile, indicates that Christian images, particularly altarpieces, both borrowed from and corrected the functions of ancient art. The broadest theme the pair introduces is an antithesis between the "written law" Moses received from God and the "evangelical" law instituted by Christ; this opposition runs through the chapel as a whole, bearing equally on the frescoes executed by more talented painters.

Thus, an early episode from the Christ cycle shows the institution of Baptism at the historical moment when Christ encountered St. John (fig. 10.33). In a composition that he would repeat throughout his career, Perugino depicted the moment in which the divine nature of Christ was first revealed (he appears in an axial alignment with God the Father and the dove of the Holy Spirit). The scene possesses the formal order and balance of a religious ritual. Alongside the historical figures from the Gospel, a group of people in contemporary Italian dress, along with one whose costume designates him as a Byzantine Greek, appear to witness and discuss the new rite of purification and initiation. This emphasis on witnessing and discussing, apparent in Rosselli's *Sermon on the Mount* as well, shifts attention from the historical event to its trans-historical meaning: the inclusion of a Greek signifies the importance of consensus between members of different religious traditions.

The facing fresco (fig. 10.34), also painted by Perugino in 1481–82, depicts a prefigurative moment in the life of Moses (Exodus 4:24–26) that occurred during his return to Egypt with his wife Zipporah and family to deliver the Israelites from captivity. God had earlier instituted the covenant of circumcision, distinguishing the Israelites from other peoples, yet Moses had not performed this on his own son. Confronted by an angel with a sword, Moses is saved only by Zipporah's timely intervention: "And it came to pass by the way in the inn, that the Lord met him, and sought to kill him. Then Zipporah took a sharp stone, and cut off the foreskin of her son, and cast it at his feet, and said, Surely a bloody husband

10.32

Cosimo Rosselli, *Christ's Sermon on the Mount*, 1481–82. Fresco. Sistine Chapel, Vatican

291

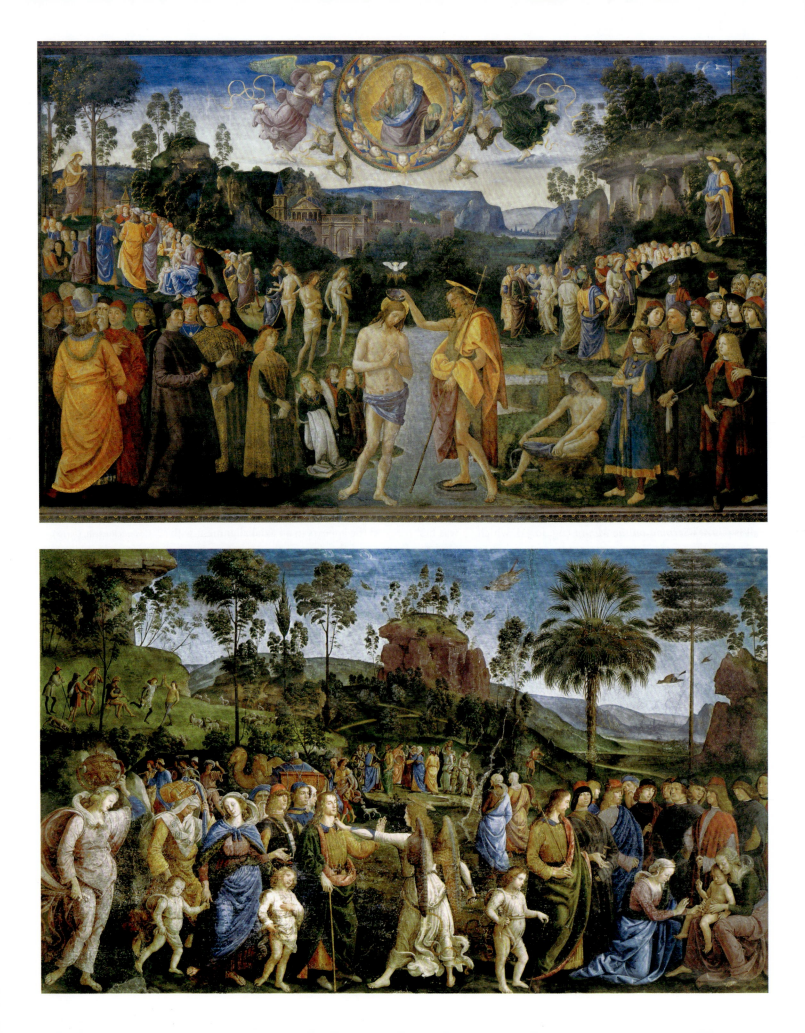

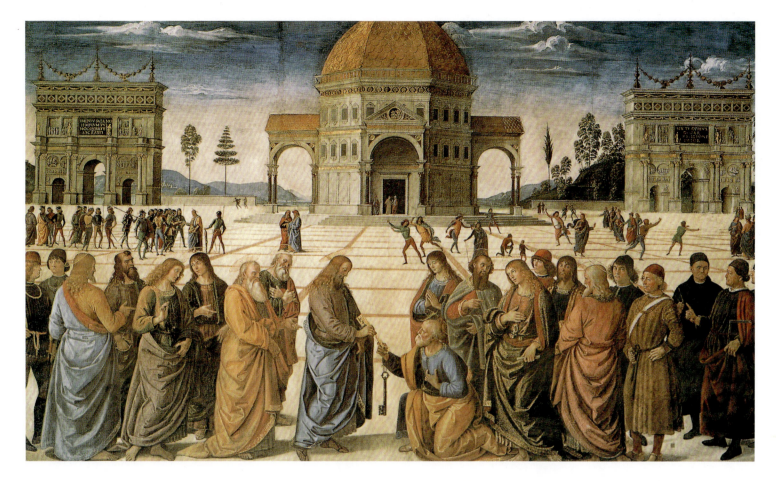

OPPOSITE, ABOVE

10.33

Pietro Perugino,

The Baptism of Christ,

1481–82. Fresco. Sistine

Chapel, Vatican

OPPOSITE, BELOW

10.34

Pietro Perugino,

The Circumcision of the Son

of Moses, 1481–82. Fresco.

Sistine Chapel, Vatican

10.35

Pietro Perugino,

The Charge to Peter,

1481–82. Fresco. Sistine

Chapel, Vatican

art thou to me. So he [God] let him go." Again, the event is witnessed by a circle of male figures distinguished by fifteenth-century costume and by their strongly particularized facial features. The Exodus episode, unusual in Christian art, foregrounds an element of violence and punitive justice that echoes the Rosselli scene and stands in marked contrast to the serenity of the Gospel scene. The frescoes show a newly militant papacy modeling its authority after the figure of Moses, lawgiver and leader of the Jews, yet also proclaiming its eclipse of that authority, even the redundancy of Judaism itself.

Perugino's *Charge to Peter* (fig. 10.35) from 1481–82, an icon of Renaissance utopian idealism in its sublime symmetry and monumental architecture, illustrates

Christ's words from Matthew: "You are Peter, the Rock, and on this rock I will build my church…. I will give you the keys to the kingdom of Heaven." The scene, traditionally used to justify the authority of the popes as the successors to Peter, is staged against a centrally planned, domed church that looked like no modern building in Italy, flanked by two triumphal arches. It is opposite Botticelli's *Punishment of Corah and the Sons of Aaron* (fig. 10.36), a rarely depicted story of religious transgression from the Book of Numbers. That painting, which, like the artist's earlier *Primavera* (*see* fig. 9.24), comprises three episodes and reads from right to left, begins with Corah inciting the Levites to rise up and challenge Moses and Aaron. Moses responds by proposing that he and Corah offer competing offerings to God, to see how the Lord responds. At the left, the earth opens and swallows the Levites, and Moses' gesture indicates that it was through him, with God's backing, that they were cast down. The whole drama takes place in front of a crumbling triumphal arch, a ruin that is itself a counter-image to Perugino's perfect city across the way. The inscription on it – "no one can assume the honor unless he is called by God, as Aaron was" – provides the explicit link to Perugino's scene of Peter's "calling," but also serves as a reminder that the whole cycle amounts to an

293

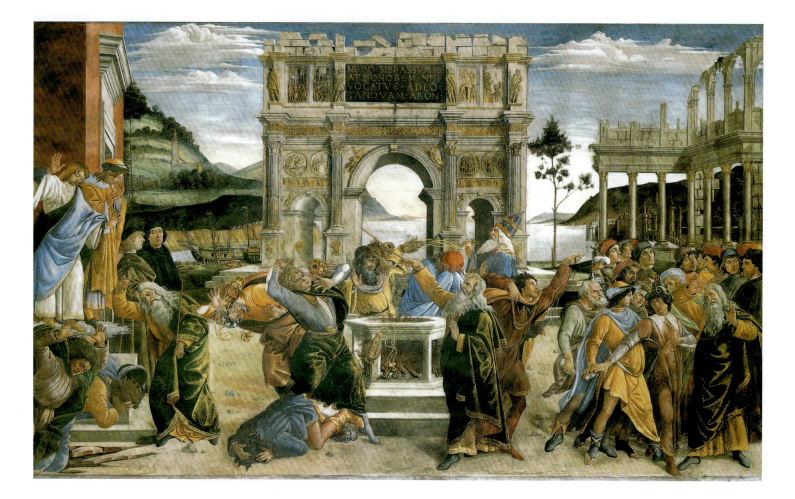

10.36
Sandro Botticelli, *The Punishment of Corah and the Sons of Aaron*, 1481–82. Fresco. Sistine Chapel, Vatican

argument, presenting the basis of papal authority. The cycle constructs Judaism not only as the precursor and origin of Christianity, but also as its other.

Leonardo Goes to Milan

One artist trained by Verrocchio is conspicuously absent from the team of painters who worked for Sixtus IV in 1481–82. Leonardo da Vinci had set up his own workshop in 1477. When, in 1478, Antonio Pollaiuolo turned down a commission from the government of Florence – a large altarpiece for the Chapel of St. Bernard in the Palazzo dei Priori – the job passed to Leonardo. His failure to complete a commission of such prestige and visibility may explain why the patrons passed him over for the Sistine Chapel undertaking. The next commission we hear Leonardo accepting could hardly have been more lacking in prestige: an altarpiece for a provincial Augustinian friary, provided for in the will of an obscure saddle-maker, depicting the Adoration of the Magi (fig. 10.37). What survives of this commission is a panel now in the Uffizi bearing underpainting that is not only incomplete but

also unresolved as a final design, which makes it difficult to imagine what the finished altarpiece would have looked like. It resembles no other known treatment of the *Adoration of the Magi, and i*t marks a complete departure from the conventions of the altarpiece.

Leonardo seems to have begun with a scheme where the event would be depicted in an architectural structure carefully worked out in perspective. This initial conception survives in a series of preparatory drawings and in the ruined vaulted structure in the background of the painting. At a certain point, though, he apparently became dissatisfied with the capacity of mathematical perspective to represent the nature of what the human eye registered. As he added figures to his composition, he constructed them as a single relief-like mass of light and shadow. In the throng of figures and horses around the Virgin and Child in the foreground, he does not precisely render the limits of individual bodies, and it is far from clear how this obscure twilight world relates to the broad daylight of the buildings and landscape beyond. Leonardo sought to pursue two possibilities at once: a traditional but precisely drafted Florentine perspective composition that recedes into the distance, and a project-

ing relief, built up using tonal contrasts. In attempting to render as many different kinds of visible phenomena as possible, he pushed two different modes of pictorial naturalism to the point that their incompatibility finally became clear. This experimentalism was certainly part of the culture of the Verrocchio workshop, with its commitment to technical problem-solving, but Leonardo alone in his generation seems to have pursued it at the level of painterly practice. It was certainly not an effective way of completing a commission in a timely manner.

The ultimate consequence of this experiment with pictorial effects was an utter transformation of the scene's emotional character. Earlier treatments of the subject (Gentile da Fabriano's version, for example; *see* fig. 4.3) had emphasized its pageantry and its ceremonial character. Leonardo gives an expressive urgency to the shadowy retinue surrounding the Virgin and Child, with their grasping hands and bearded, grimacing, skeletal faces. In addition to exploring conditions in which shadow-drenched figures become less immediately available to vision, Leonardo confronted the psychology of religious devotion itself. Pollaiuolo and Verrocchio had already treated emotion as an inner force that manifested itself in compulsive bodily actions, but no artist before Leonardo had applied this principle to the theme of Christ's incarnation. By comparison with the architectural utopias and pastoral landscapes of the Sistine Chapel, which characterize Christian civilization in terms of beauty, clarity, and order, Leonardo's conception of the coming of Christ is a traumatic and cataclysmic event, one that involves struggling figures and battling soldiers.

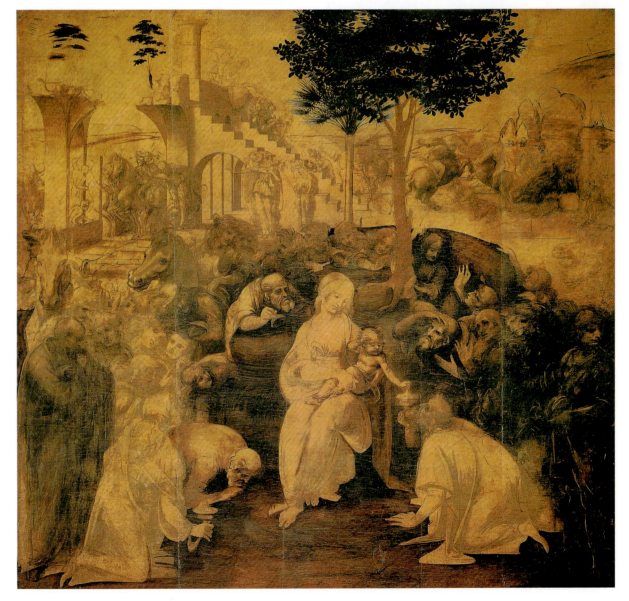

10.37
Leonardo da Vinci, *The Adoration of the Magi,* **1481–82.** Oil on panel, 8'1¼" × 8' (2.46 × 2.43 m). Uffizi Gallery, Florence

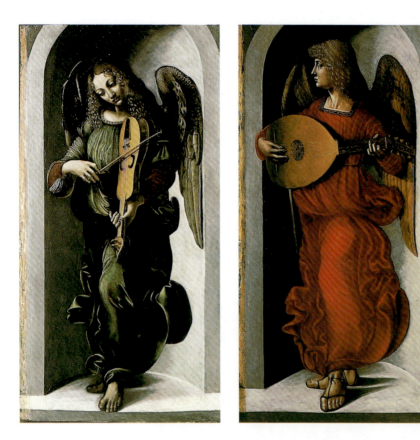

10.38
Ambrogio and Evangelista
Preda, angels from
the altarpiece of the
Immaculate Conception,
1483–90. Oil on panel.
National Gallery, London

Leonardo left Florence in 1482 and spent the next eighteen years in Milan. While he probably accompanied an official embassy on behalf of the Florentine government, he hoped for an appointment at the court of Ludovico Sforza, who co-ruled Milan with his young nephew, the hereditary duke. In a letter addressed to Ludovico, Leonardo described his expertise as an engineer and a designer of artillery and catapults; he listed painting and sculpture last among the many things he insisted he could offer, but it is likely that, even though he was apparently unproven as a sculptor in bronze, he had set his sights on the commission for the equestrian monument to Francesco Sforza: "I would undertake the work of the bronze horse, which shall endue with immortal glory and eternal honor the auspicious memory of the Prince your father and of the illustrious house of Sforza."

It was several years before Leonardo became a salaried member of the Sforza court. He was thus forced to fall back on the contract-based commissions that he had probably hoped to avoid after leaving Florence. In 1483 he formed a partnership with two brothers, Ambrogio and Evangelista da Preda, to collaborate on an altarpiece for the Confraternity of the Immaculate Conception at the Milanese church of San Francesco Grande. The contract prescribed an elaborate wooden polyptych comprising carved figures and ornaments as well as painted panels. In addition to decorating the wooden structure with colors, the painters were supposed to deliver an image of "Our Lady and Her Son," along with paintings of angels (fig. 10.38) and two prophets. Leonardo completed his *Virgin of the Rocks* (fig. 10.39) by 1490, but did not in the end hand it over to the Confraternity. The painting became the subject of a lengthy legal dispute following the artists' demand for a larger payment, and Leonardo ultimately helped produce an alternative version in 1508.

Leonardo's handling of light gives the painting an air of mystery. The Virgin, the Christ Child, a large angel, and the infant St. John all appear to emerge from deep shadows. Such effects enhance their three-dimensional presence, as Leonardo describes different intensities of light across the curved volumes of faces and bodies, but the shadowy countenances also reinforce the sense of contemplative absorption, of inner reserves of thought and feeling. Their lifelikeness, in other words, depends on a sense that each figure has a private or hidden dimension, which Leonardo calls upon the viewer to re-create or imagine. Yet "mystery" is also at the heart of the particular devotion that the image was designed to serve. Some of the painting's unusual features may make reference to the doctrine of the "Immaculate Conception" recently approved by Pope Sixtus IV. The controversial doctrine held that the Virgin's mother had conceived her without sin, and that this miraculous purification provided an absolute prerequisite for the salvation that Christians sought to obtain through the sacrament of Baptism (alluded to here through St. John) and through the Incarnation of Christ. The Office of the Immaculate Conception contains a text from the Biblical Book of Proverbs (8:22–25): "The Lord possessed me in the beginning of his way, before his works of old. I was set up from everlasting, from the beginning, or ever the earth was. When there were no depths, I was brought forth; when there were no fountains abounding with water. Before the mountains were settled, before the hills were brought forth." The scriptural text was taken by Franciscan theologians as a reference to the Virgin's primordial purity, pre-dating the earth with its "depths," hills, and rocks, and viewers disposed to look for similar metaphors in paintings could have found them here in the cavernous imagery of the landscape in the painting. It is also possible that a confraternity devoted to a newly approved cult simply welcomed Leonardo's initiative in making an image of the Virgin and Child with St. John that looked like no other. The painting could have proclaimed the newly legitimated cult of the Immaculate Conception; that is, simply by its striking differences from other altarpieces with the Virgin, yet without employing any hidden symbols particular to that cult.

10.39
Leonardo da Vinci, *Virgin of the Rocks* (altarpiece of the Immaculate Conception), 1483–90. Oil on panel, 6'6½" × 4' (1.99 × 1.22 m). Musée du Louvre, Paris. A second version of the painting, completed by Leonardo and the Milanese workshop many years later (1508), is now in the National Gallery, London.

1490–1500
The Allure of the Secular 11

11

1490–1500
The Allure of the Secular

From the Margins to the Center

Much of what looks truly new in late fifteenth-century art expands on what had previously been minor elements of artistic practice. Embellishments – added to familiar subjects, usually left to an artist's discretion, and regarded as demonstrations of skill – now become central, even become the basis of new pictorial genres. Artists had, for example, been including background landscapes and cityscapes in paintings for decades, but by the end of the century, the Florentine painter Baccio della Porta (1472–1517) – known as "Fra Bartolomeo" (Brother Bartholomew) after he joined the Dominican order – began to make independent drawings of outdoor vistas (fig. 11.2). These extend Leonardo's practice of studying the observable world (*see* fig. 10.39), but they also show that painters were beginning to regard such material as interesting in its own right. In the same years, the Venetians Gentile Bellini and Vittore Carpaccio would increasingly depict architectural and natural spaces that dwarf and envelop the sacred subject.

As we shall see, portraiture in these years underwent a comparable shift: although images of the patron

and elements of his or her world had frequently made appearances in religious painting, that world and its contemporary inhabitants now become the actual setting for the Biblical episode or saint's life being depicted. Similarly, themes from pagan mythology migrate from painted furniture and from the borders of manuscripts to become the subjects of panel paintings and sculptures. Andrea Mantegna and Antonio del Pollaiuolo had already treated similar secular and profane subjects in their engravings (*see* figs. 10.8 and 10.6), where the possibilities for experiment had a lot to do with the fact that printmaking was still a marginal rather than mainstream practice. Both artists, though, also began treating related material in other media, setting examples for their immediate followers. When in 1502 the humanist scholar Pomponius Gauricus complained in a Latin treatise on sculpture that the artists in his native Padua were wasting their time in the trivial production of "little satyrs, hydras, and monsters, the likes of which no one has ever seen," instead of devoting "mind and hand" to the representation of the human figure, he must have been thinking of the sort of object that the "collectable" bronzes of Pollaiuolo, and before him Filarete, had inspired: Bertoldo di Giovanni in Florence, Antico in Mantua, and

RIGHT
11.1
Andrea Riccio, *Satyr,*
c. **1500.** Bronze. Frick
Collection, New York

11.2
Fra Bartolomeo, *A Farm on*
the Slope of a Hill, c. 1500.
Pen and brown ink on
paper, 8¾ × 11⅝" (22.25
× 29.4 cm). Cleveland
Museum of Art, Cleveland

Andrea Briosco, known as "Riccio," in Padua, all served a rising market for intimately scaled and fanciful bronze statuettes with which wealthy Italians adorned their homes (fig. 11.1).

In these years, interest in "the antique" largely manifested itself in images of hybrid mythological creatures. Some of the patrons who displayed them must have been following trends in fashion and taste, though, at their most sophisticated, such creatures could also represent an endorsement of art based on poetic invention. Owners who used them to ornament domestic spaces demonstrated their cultivation and learning, though increasingly such images crept into more public and more sacred arenas as well. In the years between roughly 1489 and 1492, the Venetian sculptor Tullio Lombardo (1460–1532) and his workshop commenced work on a monumental tomb for Doge Andrea Vendramin (fig. 11.3). Although the design was modified when the tomb was moved to its present location in the nineteenth century, the overall conception followed standards by now long in place, with an effigy of the deceased lying on a bier, and Virtues below (*see* figs. 4.1–4.2 and 10.25). Tullio expanded this basic sculptural program with elements derived from a Roman triumphal arch, as well as with an *Annunciation* that frames a lunette showing St. Mark presenting Vendramin to the Virgin. What claims the most attention, however, is the startlingly prominent classical and mythological imagery. A younger and an older warrior stand guard, with expressions doleful and severe. *Tondi* showing passionate and violent pagan scenes (one of them apparently an abduction), reminiscent of those in Mantegna's San Zeno altarpiece (*see* fig. 8.18), appear over their heads; below, little cupid-like sprites cavort with a sea-horse and a sea-goat. A beautiful marble Adam (removed in the nineteenth century and now in New York) does not suggest the fallen sinner so much as a nude hero from the ancient past. Crowning the entire structure is a clypeus of the Christ Child, making a gesture of blessing, supported by two marine monsters in the form of voluptuous winged Sirens. Tullio's particularly "Venetian" version of classical antiquity gave mythical sea creatures an understandable but still surprising prominence.

The *Studiolo* of Isabella d'Este and Mythological Painting

Isabella d'Este, the wife of the lord of Mantua, created a celebrated suite of rooms to house her collection of antiquities and modern art and to serve as a *studiolo*: functionally a private space, but also a showpiece that proclaimed to members of the court and privileged visi-

tors the marchioness's literary interests and good taste. Like much of the art these rooms contained – which included several small bronzes by Antico – the *studiolo* was self-consciously marginal, detached from the serious business of ruling a state and the formality of life at court. Isabella and her contemporaries regarded it as a room for reading and meditation, necessary to heal the spirit from the cares and perturbations of everyday life; in many ways the *studiolo* represented a "profane" version of a private chapel or oratory.

The emergence of such spaces coincided with a parallel change in the workshops of artists, as painters and sculptors, too, began to organize their homes to include a dedicated area (sometimes a furnished room, sometimes

11.3
Tullio Lombardo, tomb of Doge Andrea Vendramin, *c.* 1490–1505. Santi Giovanni e Paolo (originally installed in Santa Maria della Vita), Venice

11.4

Andrea Mantegna, *Mars and Venus ("Parnassus")*, **1497.** Tempera on canvas, 5'3½ × 6'3⅝" (1.59 × 1.92 m). Musée du Louvre, Paris

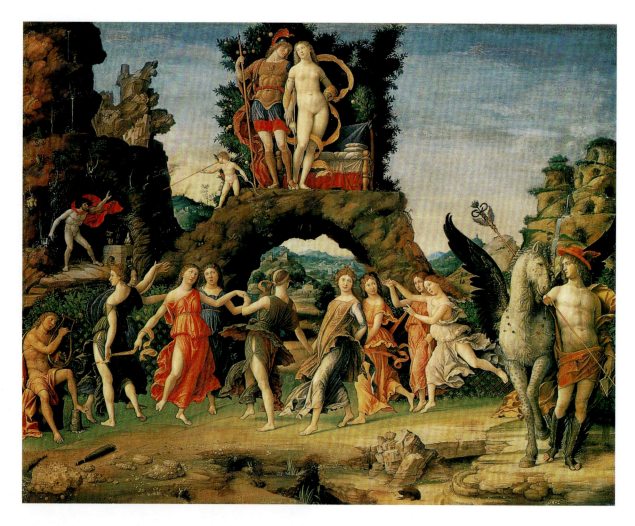

nothing more than a desk) where they could read, draw, and think through new inventions in solitude. When Isabella resolved in 1496 to decorate the walls of her *studiolo*, she turned to Mantegna, among others; he is documented to have had two *studioli* himself. Though artists outside of Mantua received detailed sets of instructions from the marchioness for the "fable" that she wanted to have painted, Mantegna – already known from his print designs as an inventor of mythological imagery – probably went to his books and devised his own subjects.

Viewers may have recognized the various protagonists of Mantegna's mythological paintings, but understanding the unfamiliar and often ambiguous compositions required an unusual level of engagement and reflection: the paintings demanded, in essence, to be read as poems. Thus, in the so-called *Parnassus* from 1497 (fig. 11.4), the viewer would have recognized Apollo and the nine Muses – the latter a common theme of *studiolo* painting. Yet unlike Cosmè Tura (*see* fig. 8.3), who rendered his Muses as enthroned goddesses, Mantegna turns his into dancers, in a form more reminiscent of the maenads or nymphs of classical relief and more compa-

rable to the figures in Sandro Botticelli's *Primavera* (*see* fig. 9.24). They represent one of the artist's most inventive essays in recapturing what he saw as the spirit of antique art: clearly, he was most impressed by that art's evocation of graceful and rhythmic motion. In the lower right of the painting, Mercury, the god of eloquence, stands with the winged horse Pegasus, who taps his hoof to make the inspiring waters of the Hippocrene flow. Decades earlier, Leon Battista Alberti in *On Painting* had encouraged artists to include in their *historie* a character that "admonishes and instructs us on what is happening": Mercury and Pegasus (i.e. eloquence and poetry) would have alerted the beholder that the painting is not only a new composition based on familiar poetic themes, but also a commentary on such compositions. This is not just a painted poem, but a painting about poetry.

At the top of the picture, the lovers Mars and Venus stand defiantly on top of a rocky "triumphal arch" while to their right Venus's cuckolded husband, the blacksmith god, Vulcan, rages (and prepares revenge) in his forge. What is this most profane of Homer's pagan tales doing at the center of such a self-reflective work? A number

of writers, both ancient and contemporary, had pointed to the trio as an example of gods behaving improperly and had used the example of their actions to discredit the art of poetry altogether. One Bolognese humanist, for example, tried first to find symbolic value in the union of Venus and Mars, only to reject the effort, concluding that Homer's purpose had been nothing more than an attempt at bawdy humor. Similarly, the fiery Dominican preacher Girolamo Savonarola (whose importance is addressed later in this chapter) complained that young girls in Florence knew more about the love of Mars and Venus than they did about scripture. Mantegna's inclusion of the three gods may make an ironic nod to such critics, though he, Isabella, and most other readers must have had a less conflicted attitude toward the subject. Mars and Venus crown Mantegna's Parnassus, because love and its complications were the main matter of art as well as of poetry, and the basis of their appeal.

Isabella undertook a series of negotiations with the leading artists of the time, including Giovanni Bellini, Leonardo da Vinci, Raphael, and Perugino, to produce additional paintings for the series. These were mainly unsuccessful, though Mantegna did make her a second picture as well (fig. 11.5). Here, another of the artist's kinetic *all'antica* heroines, the goddess Minerva (or Pallas), on a mission to rescue Wisdom (the mother of the Virtues) from a stone vault, scatters a swarm of mythological creatures and other monstrous beings labeled as Vices (a scroll with words acts as a "speech bubble" to indicate her cry for help). In visualizing the centaurs, male and female satyrs, and other creatures of ancient art, together with the maiden turned into a tree and the clouds assuming the form of human profiles, Mantegna displayed his inventive prowess to the full. The satyr mother with her children evoked the Roman Pliny the Elder's description of a celebrated lost work by the painter Zeuxis showing a centaur family, but Mantegna, professing his invention, paints satyrs instead. At the same time, the painting presents a warning about the dangers of artistic fantasy, suggesting that it may take one onto the path of unreason and delusion. It counsels prudence, personified by Pallas.

This kind of invention came easily to Mantegna, who may have designed his own subjects. Artists like

11.5
Andrea Mantegna, *Pallas Expelling the Vices from the Garden of Virtue*, **before 1503**. Tempera on canvas, 5'3¼" × 6'3⅞" (1.6 × 1.9 m). Musée du Louvre, Paris

Bellini and Perugino, on the other hand, appear to have required detailed instructions, which were duly prepared by a Mantuan court humanist. Bellini is supposed to have resented having his artistry thus constrained, although he was later quite content to paint a learned classical subject for the *camerino* of Isabella's brother, the Duke of Ferrara (*see* fig. 13.46). With Perugino, the problem seems to have been the unprecedented nature of the subject, the lack of an artistic model for him to imitate. When, in 1503, the artist still had not delivered despite repeated promises and procrastinations, Isabella wrote, "We want to have the picture from his hands because of the excellent painter that he is; but he also should want it to come into our hands, because we are thus honoring him." Unsurprisingly, she was disappointed with the final result: "If the work had been finished with more diligence – having to be placed beside the works of Mantegna, which are refined in the extreme – it would have brought more honor to you and more satisfaction to us. It is regrettable that you were dissuaded from using oil colors, even though that was what we wanted, knowing that oil painting is your particular expertise and is of greater loveliness." Isabella's vast correspondence preserves an unusually complete picture of the concerns of a Renaissance patron; although she was certainly not the only woman to commission pictures around 1500, she is one of the few to have left so rich a documentary record.

Corporate Devotion

Ghirlandaio's Tornabuoni Chapel

In religious works of the 1490s, elements from the contemporary world increasingly overwhelm the rest of the image. Emblematic is the chapel (fig. 11.6) that Domenico Ghirlandaio unveiled three days before Christmas in 1490 in the Florentine church of Santa Maria Novella. Covering every surface of wall and ceiling in the large choir zone, Ghirlandaio's team had spent five years making frescoes, an altarpiece, and even stained glass. The result can have left little doubt that Ghirlandaio fulfilled the requirements of his contract, which asked him to make "noble, worthy, exquisite" images.

The chapel's patron, Giovanni Tornabuoni, stated that he had commissioned the fresco cycle to show his piety and to enhance the church, one of the most prestigious in the city, as well as for "the exaltation of his house and family." Ghirlandaio's works give an indication of just what "house and family" might include. The chapel had two dedications, to the Virgin (the patron of the church) and John the Baptist (Giovanni's own name saint), but although John's prominence in the decorations and the space's function as Giovanni's burial site both singled out the patron's distinctive role in its origin, most of the decorations emphasize the collective over the individual. The *Birth of John the Baptist* (fig. 11.7) takes place in what

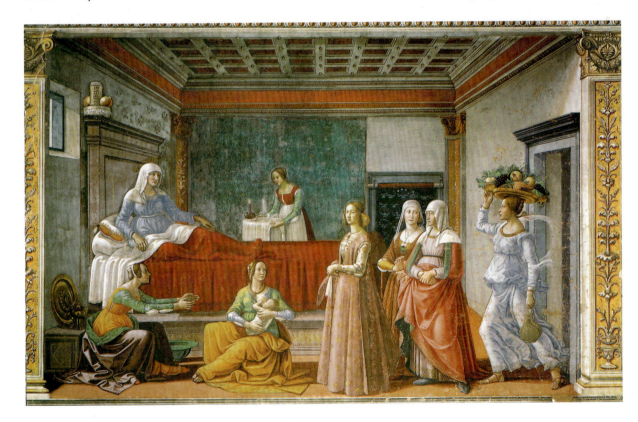

11.7
Domenico Ghirlandaio,
Birth of John the Baptist,
1489–90. Fresco.
Tornabuoni Chapel, Santa
Maria Novella, Florence

OPPOSITE
11.6
Domenico Ghirlandaio,
Tornabuoni Chapel,
1489–90. Santa Maria
Novella, Florence

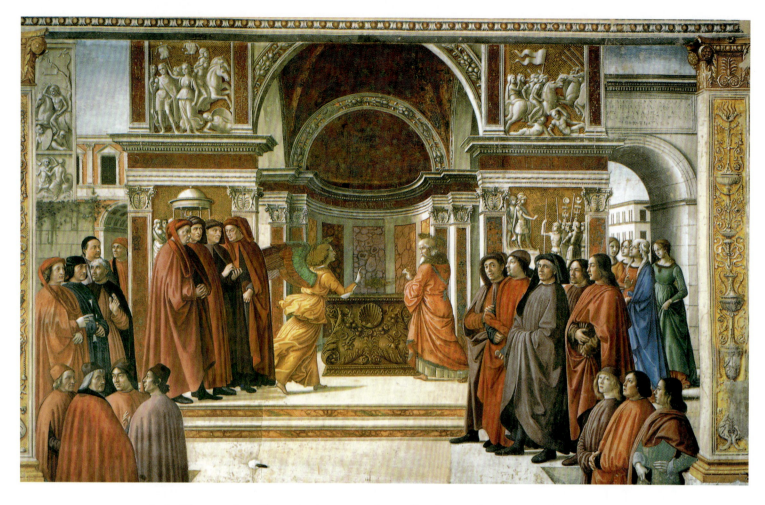

11.8

Domenico Ghirlandaio,
*Annunciation to
Zacchariah*, 1490. Fresco.
Tornabuoni Chapel, Santa
Maria Novella, Florence

looks like a modern Florentine interior, with a coffered ceiling and ornamented pilasters in the corners. The women attending St. John's mother, Elizabeth, include a nursemaid of the kind that Renaissance Italians entrusted with the care of their newborns. All the women wear contemporary fashions, and several appear to be portraits; one or more members of the Tornabuoni family may well figure in the painting.

Giovanni did not instruct Ghirlandaio to include these portraits merely out of affection. His late sister Lucrezia had been the wife of Piero de' Medici and the mother of Lorenzo the Magnificent, and she thus represented the most important Tornabuoni tie to the city's most powerful family. Giovanni himself worked as a manager in the Medici bank, and he could not have obtained the right to decorate such a prominent location without Medici support. (In fact, the Sassetti family, whose chapel Ghirlandaio had also recently decorated, had tried and failed to lay claim to this very chapel a few years earlier.) In other frescoes, Giovanni makes his membership of the Medici entourage unmistakable. At eye level on the right-hand wall of the chapel, an angel announces to Zacchariah (fig. 11.8), Elizabeth's husband, that his wife has miraculously become pregnant. The setting could be taken for an Italian church, were it not for the shell and garlands on the altar and the pagan reliefs

on the walls. Flanking the episode, if not exactly witnessing it, are several groups of Florentine men, including male Tornabuoni relatives on the right and several of the most prominent Medici literati – the philosopher Marsilio Ficino, the translator and commentator Cristoforo Landino, the poet and philologist Agnolo Poliziano – at the lower left. A surviving drawing by Ghirlandaio (fig. 11.9) labels a number of the figures in the scene, making it clear that these inclusions were not mere pictorial whimsies, and that the patron wished to approve the design in advance. Giovanni wanted his chapel to be the one in the most prestigious position, adjacent to the high altar of the church, but he had no desire to flaunt this honor on his own. His status in the city and even his career depended on family connections and the relationships they allowed, and he welcomed company in his space of prayer. Ghirlandaio's paintings are sacred images, but they are also political works, and the role they give to portraiture underscores the degree to which Florence was a culture of networks. Not everyone, as we shall see, found this harnessing of religious art to the ends of negotiating social status to be acceptable or legitimate.

11.9

Domenico Ghirlandaio, study for the *Annunciation to Zacchariah*, 1489–90. Pen and brown ink with wash over metalpoint, stylus, and black chalk on paper, 10⅛ × 14¾" (25.7 × 37.4 cm). Graphische Sammlung Albertina, Vienna

Bellini's Paintings for the Scuola di San Giovanni Evangelista

Structurally, Ghirlandaio's images eliminated the careful demarcation between the space that the kneeling donor had long occupied at the edge of the *sacra conversazione* and the center of the picture's action. It is instructive to compare the combinations of portraiture and history emerging in Venice around the same time. Gentile Bellini had returned from Constantinople in 1481, and he spent much of the next decade repainting the (subsequently destroyed) Great Council Hall pictures in the Ducal Palace. By the early 1490s, he was at work on a large cycle of decorations for another common space, the "Hall of the Cross" in the Scuola di San Giovanni Evangelista. The Venetian *scuole*, as we saw in chapter 6 (*see* p. 171), were the devotional confraternities to which most Venetian citizens belonged: the word *scuola* can refer both to the group and, as in this case, to the architectural space where that group conducted its activities. The confraternity dedicated to John the Evangelist counted among the largest and wealthiest in the city, and its members had the clout to convene the city's best painters, including not just Bellini but also his young protégé Vittore Carpaccio.

If Ghirlandaio's frescoes showed the bonds that extended from an individual patron, Bellini's canvasses

emerged as more direct expressions of collective interests. The painter did not merely insert contemporary faces into historical scenes as witnesses or participants, but began with group portraits, then activated these around narrative episodes, all of them having to do with the Scuola's prize relic. The Scuola owned what it took to be a piece of the "True Cross," the wood on which Christ had died; this was the only miracle-working relic owned by any of the large Venetian confraternities, and the picture cycle documented its powers. Bellini's *Procession with the Relic of the True Cross* (fig. 11.10) of 1496 shows a ritual performance that took place annually on the Feast Day of St. Mark, when citizens would gather to watch the men parade before the saint's eponymous basilica. Arrayed in the near foreground, in white robes with red crosses, are the members of the Scuola di San Giovanni. At the picture's center, nearly on axis with the main portal of the basilica, is the confraternity's reliquary, borne beneath a baldachin. There is a documentary quality to the scene, which includes little that residents could not witness personally in the piazza year after year on this day; it so emphasizes the typical, in fact, that the uninitiated viewer of the painting would miss the miraculous event at hand if it were not brought to his or her attention. A Brescian merchant named Jacopo de' Salis, who had learned the previous evening that a skull fracture had

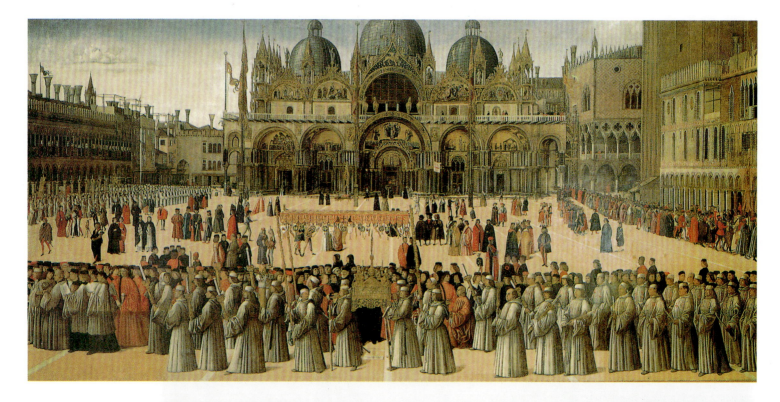

ABOVE
11.10
Gentile Bellini, *Procession with the Relic of the True Cross*, **1496.** Oil and tempera on canvas, 12' × 24'5" (3.67 × 7.45 m). Galleria dell'Accademia, Venice

RIGHT
11.11
Gentile Bellini, *The Miracle of the True Cross at the Ponte San Lorenzo*, **1500.** Oil on canvas, 10'7" × 14'1" (3.23 × 4.3 m). Galleria dell'Accademia, Venice

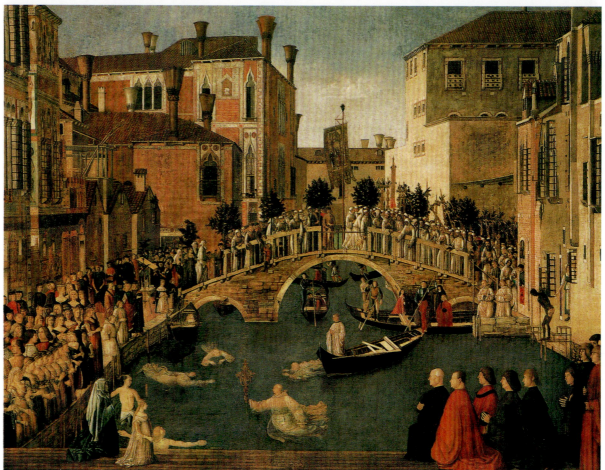

left his son in critical condition, kneels down just behind the confraternity members at center right, praying for his son's recovery. Immediately afterward, though "offstage," his son's injury will vanish. The canvas is enormous, twelve feet high and more than twenty-four feet wide. All viewers must have recognized that only an event of great civic import could justify a picture on this scale. For the members of the confraternity, however, seeing this in their headquarters, the picture would have contributed to a sense of group identity.

Bellini's second picture for the cycle, the *Miracle of the True Cross at the Ponte San Lorenzo* (fig. 11.11), takes a different approach. This time the artist moves the members of the Scuola to the background, positioning them as spectators. The arrangement allows the painter to depict his patrons frontally, and thus again to portray specific individuals; but it also puts the confraternity in the role of directing attention to the main event taking place in the water below. During another procession, the Scuola's reliquary fell into a canal. Onlookers dove into the water to try to save it, but whenever one approached, the Cross fled his grasp. Only when Andrea Vendramin, Grand Guardian of the Scuola (and ancestor of the recently deceased doge of the same name), threw himself into the canal did the holy object allow itself to be rescued.

Occupying the foreground this time is a strange, stage-like platform that bears no relationship to anything at the actual site and serves only to support the figures who kneel in profile at the sides. These, too, must be portraits, and though it is uncertain just whom they represent, they take over the parts typically played by the donors in devotional rather than narrative images (compare, for example, fig. 9.7). In giving less pictorial space to the confraternity and more to the kneeling citizens in their finery, the novel image of corporate devotion shifts back toward a more traditional assertion of family precedence. It is as though Bellini has used the miraculous event as a pretext for a scene that transcends history altogether, as though he has made a *sacra conversazione* but substituted the True Cross relic for the Madonna and Child. Or perhaps we should put things the other way around: Bellini has found an appropriate holy episode that could accommodate the members of the confraternity as spectators.

The World Ends

As earlier chapters of this book have shown, fifteenth-century images were nearly always conventional in subject, yet they were also often "customized" to acknowledge their patrons; painters had long added incident from the world around them to scenes that did not come from that world. With Bellini and Ghirlandaio, however, something different seems to be happening. Their pictures present themselves as "paintings of modern life," as though the lived world had elevated itself sufficiently to become a primary topic of monumental art. The paintings made visitors conscious not only of the eternal truths of sacred history, but also of the here and now. We might note that the most significant architectural change to the Piazza San Marco in the decade Bellini painted it was the addition of an enormous clock tower to the north-west side (fig. 11.12). Its face included not only the twenty-four hours, but also a rotating group of zodiacal signs and a disk indicating the phases of the planets; above, arabic numerals would change every five minutes. At the top of the tower, Cain and Abel struck a bell once every hour; twice yearly, Magi and an angel emerged to pay homage to the statue of the Madonna. The astronomical data the clock provided allowed consideration not only of the hour but also of the characteristics of any particular day. The skillful viewer would be able to "read" the stars as well as the time. The venerable basilica and the ritual activities that the piazza hosted lent the square a strong connection to the past, but this technological marvel –

11.12
Mauro Codussi, Torre dell'Orologio (clock tower), 1496–99. Piazza San Marco, Venice

11.13
Albrecht Dürer, "The
Whore of Babylon,"
1496–98. Woodcut from
The Apocalypse

back ride over the dead, the sun turns black, angels stop the wind from blowing, blaring trumpets cause hail and blood to fall from the sky. In the penultimate plate, "The Whore of Babylon" (fig. 11.13), a group dressed in contemporary German garb looks at a woman seated upon a seven-headed monster and holding up the cup that John describes as being "full of the abomination and filthiness of her fornication." The woman, too – John's "harlot who sitteth upon many waters" – wears a modern costume, though in her case that costume is Venetian.

The reliance on images rather than text to convey John's predictions ensured that even Italians into whose hands the book fell would have little trouble comprehending its topic. Many would have noticed not only Dürer's use of Italian fashion to embody the Whore of Babylon's vanities but also his dependence on Mantegna's mythological prints for his inventive approach. They would certainly have found the subject matter of the book topical, for in Italy, no less than in Germany, the approach of the year 1500 brought fears that Apocalypse might be just over the horizon, that the end of the century would also be the end of time.

Savonarolan Florence

In Tuscany, the charismatic Ferrarese preacher Girolamo Savonarola (1452–1498) had ascended through the ranks of the Observant Dominican Order. Made prior of Florence's convent of San Marco in 1491, he persuaded the Pope to allow him to reorganize the local system of religious houses according to a severe regimen that involved self-mortification and the renunciation of worldly goods. Savonarola's sermons, which frequently focused on the Apocalypse, drew ever-larger crowds; he attacked both the traditional clergy and the Medici, and his followers took him to be a prophet. When the French army defeated the Florentine forces in 1494, the city expelled the Medici and declared Christ to be "King" of a new theocratic government, with Savonarola transmitting Christ's will.

The political and religious transformation of the city under Savonarola's influence included "bonfires of the vanities" during the carnival season: in place of traditional annual amusements, citizens publicly burned their fancy clothes, secular books, musical instruments, and works of art. Savonarola also made artists a target in some of his sermons against luxury. In many ways, his denunciation sounds familiar, recalling the attack on curiosity and worldliness in the writings of an earlier prior of San Marco, Fra Antonino (*see* p. 144). Savonarola's oratorical skills added force to his charges, though, and he went further in his account of abuses: he deplored the fact that rich Florentines who would donate only the

occupied by the engineers charged to maintain it – made the space seem modern, a product of the present, as well.

Other contemporary productions probably had more of a far-reaching impact on the way both artists and patrons regarded the moment in which they were living. In 1498, the German painter and printmaker Albrecht Dürer (1471–1528), who had himself returned from Venice only a short time before, put out the first ever "artist's book": the earliest bound and printed volume conceived and executed by an artist rather than a publisher. It was issued in a Latin as well as in a German version, for Dürer sought an international audience. The book, comprising a series of fifteen woodcuts, brought to life the prophecies regarding the end of the world (or Apocalypse) that John the Evangelist had recorded in the Book of Revelation. Through the pictures, terrifying conquerors on horse-

smallest of sums for the relief of the poor would invest lavishly in chapels. "You would do it only in order to place your coat of arms there," he berated them, "and you would do it for your own honor, and not for the honor of God." He complained that painters would sometimes include portraits of contemporaries under the guise of saints in religious painting, and the young would go around saying to this girl and that, "She is the Magdalene, that other girl St. John." He disparaged the sensual and elegant depictions of the Virgin Mary that the Medici and other wealthy patrons had sought from such artists as Botticelli and Filippino Lippi: "Do you believe the Virgin Mary went dressed this way, as you paint her? I tell you she went dressed as a poor woman, simply, and so covered that her face could hardly be seen, and likewise St. Elizabeth. You would do well to obliterate these figures that are painted so unchastely, where you make the Virgin Mary seem dressed like a prostitute." In fact, Savonarola's denunciation of secularizing worldliness, vanity, and superfluity implicated many of the artistic developments presented in this chapter.

Some painters appear to have responded to Savonarola, and would work in a more sober style for patrons who were close to the friar. Such is the case with the son of the painter Fra Filippo Lippi, Filippino Lippi (1457–1504), who painted an altarpiece for Francesco Valori in 1498 (fig. 11.14) that adopted an archaic gold ground format and included the emaciated penitential figures of St. John and the Magdalene, which stand in marked contrast to the exquisitely refined figures in Botticelli's or even Ghirlandaio's work. Yet Savonarola's call for a new pious simplicity in religious images was also part of a wider tendency in the late 1400s. Perugino, for example, already worked in a "devout" style in which Savonarola would have found nothing to disapprove of. His serene and contemplative *Virgin with St. Sebastian and St. John* from the mid 1490s (fig. 11.15) was commissioned by Cornelia Salviati for San Domenico at Fiesole, an Observant Dominican foundation strongly linked to San Marco.

Savonarola's impact on the arts was immediately visible at the monumental heart of the city. Donatello's *Judith and Holofernes* (*see* fig. 6.25) took on new meaning when Florentines raided the palace where the Medici had formerly lived, removed the statue from its garden,

ABOVE

11.15

Pietro Perugino, *Virgin with St. Sebastian and St. John, c.* 1492. Oil on panel, 5'10" × 5'4⅝" (1.78 × 1.64 m). Uffizi Gallery, Florence

LEFT

11.14

Filippino Lippi, *St. John the Baptist and Mary Magdalene,* from the Valori altarpiece, 1498. Oil on panel, each 53½ × 22" (136 × 56 cm). Accademia, Florence. The panels originally framed a *Crucifixion,* now destroyed.

ABOVE

11.16

The Hall of the Great
Council, Palazzo dei Priori,
Florence. The present
appearance of the hall,
which was begun in 1494,
reflects its late sixteenth-
century restructuring and
redecoration.

RIGHT

11.17

Fra Bartolomeo, *Portrait of
Fra Girolamo Savonarola*,
1498. Oil on panel, 18 ×
12⅞" (45.5 × 32.5 cm).
Museo di San Marco,
Florence

and erected it in front of the old Palazzo dei Priori, where it became both an image of God's agent striking down the overindulgent and a physical trophy of victory over Medici tyranny. The building itself became a new focus of patronage, too, with the construction of a spacious room (fig. 11.16) to seat the large and now truly empowered "great council." The architects Antonio da Sangallo (*c.* 1453–1534) and Simone del Pollaiuolo (1457–1508, called "Il Cronaca") designed a chamber similar to the one on which Bellini had worked in Venice: anxious to extirpate every trace of Medici oligarchic rule, Savonarola had directed the Florentines to take the Venetian Republican government as their model. The woodcarver Baccio d'Agnolo (1462–1553) added balustrades, paneling, a frame for a large altarpiece commissioned from Filippino Lippi, and a loggia for the council's officers. Successive occupants continued to work on the room for decades afterward.

Ultimately, the great square overlooked by the Palazzo dei Priori proved to be the site of Savonarola's end. The preacher's close association with the Republican council and his open support of French military intervention aroused the ire of Pope Alexander VI, who

forbade him from preaching. The friar not only defied the order, but also attacked the Pope's luxurious lifestyle and abuse of his office. Alexander responded with excommunication, a sentence that Savonarola claimed to be fraudulent: he continued to distribute Communion. Meanwhile, the local tide turned against Savonarola as Florentines tired of the rigors of his moral crusade and grew skeptical of his mystical claims. Medici partisans were quick to capitalize on the discontent. Eventually, the Pope found enough support to have the Dominican friar arrested, tried, and hanged by the Florentines, who burned his body in the Piazza della Signoria, a few steps from Donatello's *Judith*.

None of these events dissuaded Savonarola's most ardent followers; in their eyes, on the contrary, it only made him a martyr. In fact, the impact that Savonarola had on Florentine visual culture may show itself most strongly in the paintings made just after his death. These include a haunting portrait (fig. 11.17) that Fra Bartolomeo painted after he joined the monastery where Savonarola had lived. The profile format lends the image an old-fashioned air, rejecting the plasticity and the effects of "presence" that Leonardo and other locals had pioneered more than two decades earlier (*see* fig. 9.20), as though these were frills inappropriate for an ascetic. With his wide-eyed stare, Savonarola appears almost to be in a trance. The inscription at the bottom of the picture, "Girolamo of Ferrara, the image of the prophet sent by God," affirms the visionary powers the preacher claimed.

Roughly contemporary with the portrait of Savonarola is a devotional painting by Botticelli that goes by the name of the *Mystic Nativity* (fig. 11.18). At its center is a motif comparable to the one Fra Filippo Lippi painted for the private palace chapel of the Medici (*see* fig. 8.30), with the Virgin looking down at the Child laid out on the ground. Little else in the picture, though, is expected. A strange architectural hybrid of primitive hut and natural cave provides cover to the Holy Family while also separating two groups who kneel at the sides in devotion. It is as though the artist has transformed the landscapes that had recently become settings for such scenes (*see* fig. 8.30) back into a kind of late medieval triptych. At the bottom of the picture, three pairs of angels embrace, and above, angels in a ring hold olive branches beneath a gaping golden sky. These figures relate to imagery propagated by Savonarola in his sermons – one sermon the friar delivered seven years earlier interpreted the advent of Christ as the birth of Truth into the world and imagined a nativity in which "Righteousness looked down from the sky" – though they follow the practice Botticelli had adopted in his earlier mythological paintings, of composing a new subject rather than illustrating a single text.

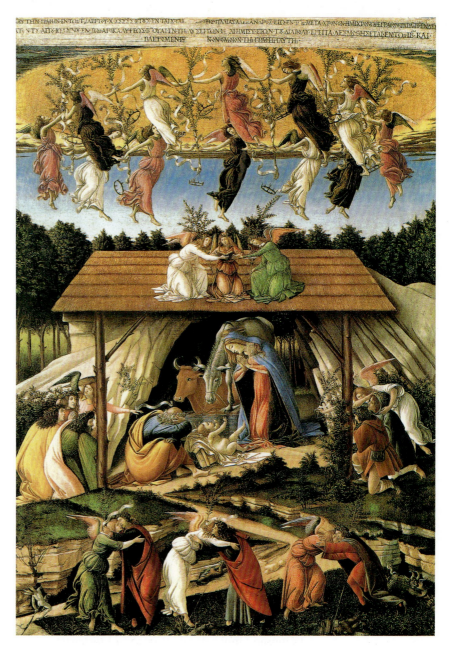

An inscription at the top of the painting that announces itself to be in Botticelli's own hand dates the image to 1500, "in the half time after the time according to the eleventh chapter of St. John in the second woe of the Apocalypse." This suggests that Botticelli was among those who believed that the turn of the century he was witnessing fulfilled one of the prophecies in Revelations. His choice to add this comment in Greek might remind us of the humanist circle around Lorenzo the Magnificent, of which Botticelli had been an important member. By the late 1490s, though, the painter seems to have embraced the message of the man who sought to destroy everything that Lorenzo represented.

11.18

Sandro Botticelli, *Mystic Nativity, c.* **1499.** Tempera on canvas, 42¼ × 29½" (108.6 × 74.9 cm). National Gallery, London

11.19

Carafa Chapel, Santa Maria sopra Minerva, Rome, with frescoes by Filippino Lippi dating from 1488–93.

OPPOSITE

11.20

Filippino Lippi, *St. Thomas before the Crucifix; St. Thomas in Triumph over the Heretics.* Fresco. Carafa Chapel, Santa Maria sopra Minerva, Rome

Filippino Lippi between Rome and Florence

Filippino Lippi, on the other hand, tended to adapt his style according to whether the patron employing him was a follower of Savonarola – as in the case of Francesco Valori – or of the old Medici oligarchy. The most powerful family in the precinct around Santa Maria Novella was the Strozzi, and in 1487 the banker Filippo Strozzi had commissioned Filippino to decorate in the church a chapel that could serve as his place of burial. The painter began work two years later, then broke off the project almost immediately to go to Rome, where he was sent by Lorenzo the Magnificent to work on a burial chapel (fig. 11.19) for Cardinal Oliviero Carafa. The Roman space, extravagant for a man of Carafa's rank, set

painted stages into an elaborate illusionistic framework, including a fictional marble arch on the rear wall. The image on the right side celebrates St. Thomas Aquinas's triumph over heresy (fig. 11.20). Carafa, a man of real learning with a taste for novelty, saw no inconsistency in celebrating the notion of religious orthodoxy while embracing the legacy of the pagan past. Surrounding the Aquinas scene are Christianized versions of the decorations recently discovered in the ancient palace, known as the "Golden House," of the Roman emperor Nero. That site's explorers at first thought that the "house," discovered underground, was a cave, or "grotto," and decorations of this sort – featuring animals, plants, humans, architecture, and hybrids of these – came to be called "grotesques." Their appeal would be enormous, and they would eventually stand as a byword for "invention," allowing artists to demonstrate both their power of imagination and their acquaintance with a genuine ancient art form.

Filippino finished the project and returned to Florence in 1493, where he discovered that things had changed. To begin with, Filippo Strozzi had died, leaving the painter to fulfill the commission under the supervision of the banker's heirs. With the expulsion of the Medici, moreover, Lippi found himself working on the city's most monumental Dominican commission at the height of Savonarola's sway. Presumably following the wishes of both the Strozzi and the friars, he dedicated the facing side walls of the chapel (fig. 11.21) to two saints: Philip, his patron's name saint as well as his own, and John, the author of Revelations. The main fresco on the south wall (fig. 11.22) shows John encountering a funeral procession for a woman of Ephesus named Drusiana on his return from the exile during which he wrote his Revelations. The deceased was a Christian, but Ephesus and its people are clearly identified as unconverted by the spectacular pagan buildings of the city and by the priest and priestess leading the procession. John raises Drusiana from the dead, implicitly promising a similar boon to those who show the right faith.

But there is a twist: the miracle occurs before a temple of the moon goddess Diana, which is adorned with a crescent. The crescent moon was the central feature of the Strozzi family coat of arms, which is itself displayed in the chapel with a prominence that would have outraged Savonarola. The fresco cycle starts with a story that confronts the true faith of the Christian missionary with the false belief of the pagan, but it also hints at the kind of knowledge, preserved in pagan imagery, that so fascinated Lorenzo the Magnificent and the humanist circle around him. Filippino presents Drusiana's people as doomed and fallen predecessors to Christianity, but it is that alien world that most allows the painter's

DECLARATIO SERMON
TVORVM ILLVMINAT

ET INTELLECTVM
DAT PARVVLIS

11.22

Filippino Lippi,
Raising of Drusiana,
1493–1502. Fresco.
Strozzi Chapel, Santa
Maria Novella, Florence

imagination to run free, to the point that we might ask whether the scene really rejects the pagan world at all.

Across from this scene Filippino depicted another confrontation between pagans and Christians (fig. 11.23). The Apostle Philip, captured by people who wished him to worship the demonically animated statue of Mars on their altar, instead causes the demon, in the form of a dragon, to break out of the base of the statue and slay the pagan priest's son. Philip has his back to us, just as a Catholic priest would at Mass in every church; the groups on either side lament the death of the boy or hold their noses at the dragon's sickening odor. The altar itself is

a fantastical assemblage, though it resembles no real ancient building so much as the altar zone of a Christian church, as though Filippino had taken a familiar architectural form and rendered it exotic and strange. Behind the statue, an accumulation of vases, weapons, banners, and other objects top the architrave and crowd the ledges behind the statue. The "bad" devotion imagined here involves the dedication of objects to the worshiped god, just as Catholics left **ex-votos** at their own altars. The statue, for its part, would have had its own strong local associations; not only did Florentines believe that their own baptistery had originated as a temple dedicated to

OPPOSITE

11.21

Strozzi Chapel, Santa
Maria Novella, Florence,
with frescoes by Filippino
Lippi dating from 1493–
1502. The crescent moon
at the top of the window
refers to the Strozzi
coat of arms.

Mars, but an inscription on the city's most central bridge, the Ponte Vecchio, also recorded a statue of Mars that had led the city into idolatry. Philip's expulsion of the dragon is thus also a kind of exorcism directed at Florence more widely. As a counterweight to the idol, Lippi added in the border of the fresco the "Veronica" – the true image of Christ produced miraculously when a woman of that name wiped his face during the Passion.

Before the expulsion of the Medici and the rise of Savonarola, it would have been hard to imagine any patron or painter associating the physical remains of antiquity, even ornament itself, so magnificently and menacingly with the demonic. And indeed, the chapel of the Strozzi – long-time Medici rivals, even if Filippo himself had built bridges with the family – represents a radical departure both from the neighboring Tornabuoni project of a few years before and from the chapel Filippino had recently painted in Rome. There are no portraits here, no assertions of mundane political ties, just the marvelous and slightly frightening works of God on earth, uneasily associated with the compelling splendors of a lost pagan antiquity. The preaching of Savonarola and his brethren only exacerbated the conflict felt by many Christians between the wisdom and beauty of the ancient world and the demands of orthodox belief and morality, and it is hard to know where in the end the painter himself stood. The pictures bring a completely unrestrained vision of pagan culture to the center of the stage, but to what end?

11.23
Filippino Lippi, *St. Philip and the Demon*, 1493.
Fresco. Strozzi Chapel, Santa Maria Novella, Florence

Judgment Day in Orvieto, "Last Things" in Bologna

Filippino Lippi's chapel in Santa Maria Novella is not explicitly apocalyptic. It imagines false religion and dwells on themes of death and resurrection, but it sets all of these in a distant past. More terrifying must have been a chapel that Filippino's near contemporary, Luca Signorelli (c. 1445–1523), painted to the south of Florence in the cathedral of Orvieto (fig. 11.24). Signorelli came from Cortona, a small town subject to Florentine dominion. In the 1480s he had painted alongside Botticelli and

Perugino in the Sistine Chapel in Rome, and around 1492 he had produced a monumental panel on a pagan theme, the *Court of Pan*, for Lorenzo the Magnificent: that extraordinary work (fig. 11.25), destroyed during the Second World War, showed the god Pan flanked by nude shepherds, nymphs, and rustic divinities in a manner that deliberately recalled the standard Christian theme of the Virgin surrounded by saints. Early in the decade, at least, Signorelli seems to have been able to suggest that Christianity and the ancient fables that preceded it both pointed to a common truth.

Signorelli had been outside of Florence during Savonarola's rise to power, and he may never have heard the

11.24

Cappella Nuova (San Brizio Chapel), Orvieto Cathedral. The frescoes in the altar end of the vault are by Fra Angelico; those on the walls by Luca Signorelli.

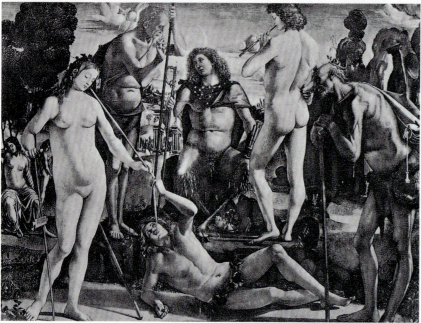

LEFT

11.25

Luca Signorelli, *Court of Pan, c.* 1492. Panel, 6'4½" × 8'5" (1.95 × 2.56 m). Formerly Berlin, destroyed 1945

ABOVE

11.26

Luca Signorelli, *Last Judgment*, 1499–1502. San Brizio Chapel, Orvieto Cathedral

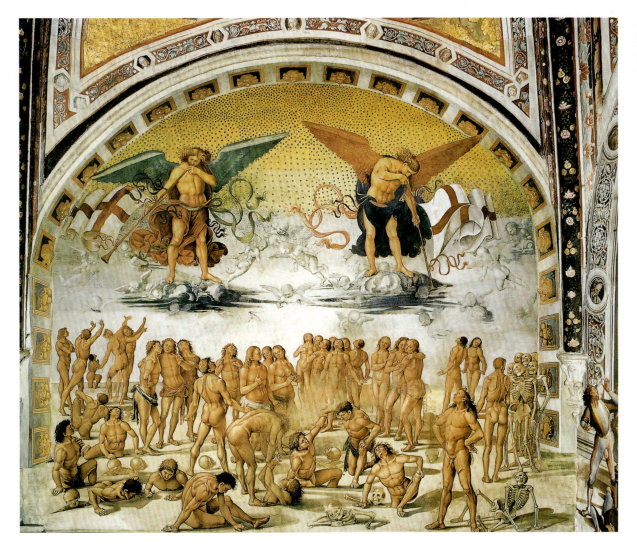

11.27
Luca Signorelli, *The "Plain of Dry Bones,"* 1499–1502. Fresco. San Brizio Chapel, Orvieto Cathedral

friar preach. Nevertheless, he showed himself even more capable than Botticelli of pivoting from the production of secular art for a humanist elite to visualizing how the world might end. Signorelli's point of departure in Orvieto was a group of figures that Fra Angelico and Benozzo Gozzoli had painted on the ceiling of the chapel in the 1440s, showing prophets and, in a mandorla over the south-east windows, a seated Christ, his right arm raised, his left hand on a globe. Signorelli used the figure of the Savior as the fulcrum for a *Last Judgment* (fig. 11.26), which he added to the wall below. On the left, angels play music and direct the elect upward to the heavenly realm they will join; in the foreground, before a fictive arch and seemingly in the space of the chapel itself, a man kneels in wonder and adoration. On the right, the naked damned flee and wail while a devil leads the way to a point of embarkation, where a demonic boatman will ferry them to the Underworld. Two archangels look down from above, ready with drawn swords to prevent anyone below from trying to pass upward.

This was already a fairly unusual subject for the altar wall of a chapel. More extraordinary still, though, are Signorelli's other murals. On the side walls of the first bay, he extended his depictions of the saved and damned. The elect now grow to a crowd of nudes striking graceful poses as they enjoy an angelic concert and the sight of Christ. The damned, opposite them, are a tumultuous pile, twisted into tortured poses by demons, whose weirdly colored bodies create a visual cacophony that represents the very opposite of the harmony across the way. Next to these scenes, on the larger walls that first confront the entering viewer, are two prophetic visions. That on the right (fig. 11.27) derives from the description in Ezekiel 37 of the "plain full of dry bones" that hear the word of God: "I will send spirit into you, and you shall live. And I will lay sinews upon you, and will cause flesh to grow over you, and will cover you with skin: and I will give you spirit and you shall live, and you shall know that I am the Lord." In Signorelli's version, a mix of skeletons and fully recomposed bodies

11.28

Luca Signorelli, *Deeds of
the Antichrist*, 1499–1502.
Fresco. San Brizio Chapel,
Orvieto Cathedral

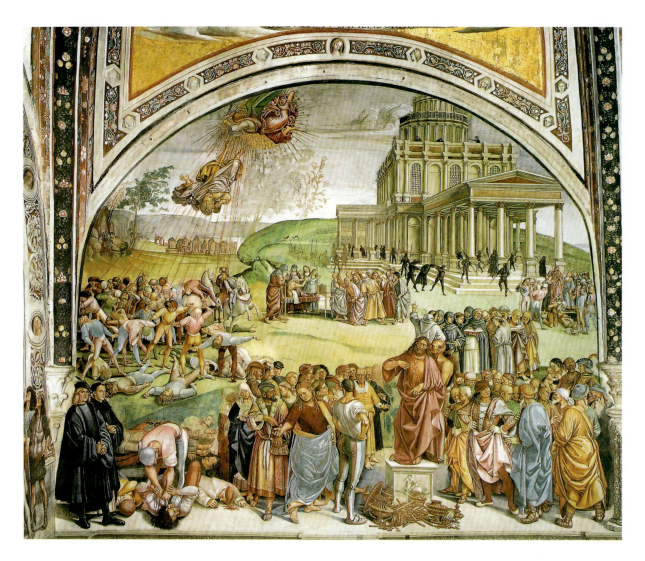

climb out of the ground; nude men and skeletons look
at one another, taking stock of their different conditions.
The image heralds the resurrection initiated by Christ on
the altar wall. At the same time, no subject could better
offer the opportunity to push one of Alberti's compo-
sitional principles to its logical extreme. In book 2 of
On Painting, Alberti recommended that painters "first
sketch the bones…then add the sinews and muscles,
and finally clothe the bones and muscles with flesh and
skin." He conceived this as a practical way of ensuring
anatomical accuracy when experimenting with the
body's various possible poses, but Signorelli aligned the
technique with the divine, as though to suggest that God
himself would create an Albertian picture at the end
of time.

Opposite the image of the "plain of dry bones" is the
densest painting in the chapel, *Deeds of the Antichrist*
(fig. 11.28). Its protagonist is a Christ-like figure who
stands on an ancient rostrum and speaks to an assem-
bled crowd. His words and even his body, though, do not
appear to be his own, and a devilish creature emerges
from his own form and speaks into his ear. This must
be the creature that Revelations describes as the "sec-
ond beast," who "had two horns, like a lamb" but who
"spoke as a dragon." The followers of this Antichrist have
heaped gifts at his feet, not unlike the pagan ex-votos in
Filippino Lippi's *St. Philip* (*see* fig. 11.23), and one promi-
nent listener appears to receive (or borrow) money from
a Jew (identifiable by his swarthy complexion and yellow
robe). In the background, a false saint appears to raise
the dead from a bier, suggesting that even such scenes as
Lippi's *Drusiana* (*see* fig. 11.22), encountered during the
Antichrist's reign, are not to be trusted. The left middle
ground promises the eventual casting down of the false
prophet and the killing of his followers. In the foreground
left, beside a scene of murder, walk two men in black.
They may be the "two witnesses" of whom John writes
in Revelations 11:3, though some have also taken them
for portraits of Signorelli himself and his dead artis-
tic predecessor Fra Angelico. Would Signorelli be in a

position to suggest that the whole event was something he himself had somehow "seen"?

Such a conceit could simply indicate that the episodes he shows unfold according to his own imagining, that he and Fra Angelico had witnessed what they painted in their own heads before rendering it on the wall. Signorelli, who may or may not have been following a brief approved by his patrons, here staged bold claims about the visionary power of poetry, and the identification of painters with visionary poets. In roundels in the lower zone of one wall, he showed the circumstances according to which the poet Dante claimed to have written the *Inferno* (fig. 11.29): the ancient Roman poet Virgil, Dante's key predecessor, guided the Italian through the Underworld, revealing to him the sights that the *Divine Comedy* would then describe. It is as if Signorelli now wished to present himself as a new Dante: just as Virgil led the poet through the *Inferno* he would describe in verse, so Fra Angelico accompanies Signorelli on a tour of the world he would paint. Another possibility is that Signorelli

11.29
Luca Signorelli, *Scenes from Dante's Inferno*, 1499–1502. San Brizio Chapel, Orvieto Cathedral

11.30
Luca Signorelli, *The Apocalypse*, 1499–1502. Orvieto Cathedral

11.31
Lorenzo Costa, *Triumph of Fame*, 1488–92. Fresco. Bentivoglio Chapel, San Giacomo Maggiore, Bologna

wished to connect the events of the Second Coming to *other* things he had personally observed. The friars that stand in the group behind the orator on the rostrum wear Dominican robes: they are members of Savonarola's Order. In the years after the preacher's death, his defenders and enemies debated whether he had been a true prophet, as he claimed, or a false one, like the Antichrist himself. Did Signorelli mean to suggest that recent his-

tory in Florence had fulfilled the Bible's own prophecies of how things would end?

Whatever the case, the image he gave to viewers leaving the chapel was the most ominous of all (fig. 11.30). To the right of the passage leading back into the cathedral proper, a prophet in a turban and a sibyl with a book foretell the destruction of the world, and what they describe unfolds behind them, as buildings crumble, the

11.32
Lorenzo Costa, *Triumph
of Death*, 1488–92.
Fresco. Bentivoglio
Chapel, San Giacomo
Maggiore, Bologna

sky darkens, and the moon and sun go into eclipse. To the left, demons breathe fiery rays onto a helpless crowd, which collapses toward the front of the picture plane. If Dürer and Savonarola brought the Apocalypse into the viewer's time, Signorelli brought it into their space.

In Bologna a decade earlier, between 1488 and 1491, the Ferrarese painter Lorenzo Costa (1460–1535) decorated a chapel for the leader of the city's dominant faction, which also gave visual form to "last things" (figs. 11.31–11.32). Costa, like Signorelli, drew on Italian poetry, but in this case the poetic material has assumed monumental form, and there is no trace of the terrifying imagery of the Book of Revelation. Costa's frescoes, like Lo Scheggia's childbirth tray from half a century earlier (*see* figs. 6.27–6.28), took as their starting point the *Triumphs of Petrarch*, a poem describing a dream vision

ABOVE

11.33

Lorenzo Costa the Elder,
*Virgin and Child with
Giovanni II Bentivoglio
and His Family*, 1488. Oil
on canvas. San Giacomo
Maggiore, Bologna

in which a series of allegories passes the poet in a spectacular procession. Its vivid images had been popular subjects for domestic decorations, but the appearance of the *Triumph of Fame* and *Triumph of Death* in a chapel is unprecedented. The two paintings are larger than the chapel's altarpiece, the *Virgin and Child with Saints* by the painter Francesco Francia (1450–1517), and correspond in scale to another, equally extraordinary image by Costa, the *Virgin and Child* (fig. 11.33), this time accompanied by portraits of Giovanni, his wife Ginevra Sforza, and their sons and daughters.

The innovative character of the Bentivoglio Chapel's decoration is indicative of the improvisatory character of Giovanni's regime. He was not the legitimate prince or lord of Bologna, but his patronage and ceremonial style imitated the rulers of Mantua, Ferrara, and Milan, with whom he cultivated ties of marriage and friendship, as he did with the Medici. Yet the support of such powers, and his very public attempts at emulating princely style, could not save the regime, which was swept away by the conquering Pope Julius II in 1506.

Leonardo in Sforza Milan

The enormous amount of wall space that Signorelli, Costa, and Lippi gave over to poetical fiction and antiquarian fantasy helps explain why Savonarola and others might have felt that sacred narrative was under threat. And as Leonardo's work from the 1490s shows, competition came not just from secular poetry but also from investigations into the natural world, as well as from the expectations of a courtly audience.

During Leonardo's first decade in Milan, where we left him at the end of the last chapter, his patron Ludovico Sforza employed him primarily in the production of entertainments. The painter staged plays, conceived ephemeral wedding decorations, and helped to organize tournaments. He invented emblems and heraldic devices. He wrote fables and satires. He composed witty reflections on the nobility of painting relative to other arts, such as sculpture, music, and poetry. Most of all, he drew. The description of Leonardo's volumes as "notebooks" and his famous backward writing can give the impression that these were private affairs, research that served no end but the advancement of his own knowledge. Still, just as many of the problems that occupied Leonardo had their roots in painting or engineering assignments, so must many of his drawings presume an audience, aiming at wonder and delight, or even at debate.

One interest that began in earnest at this time and continued throughout Leonardo's remaining life was the design of the human body. Working in the years just before the publication of the earliest illustrated anatomy books, he accompanied his pictures with carefully ruled blocks of text, suggesting that he may have had a similar project in mind. What differentiated his studies from those of other anatomists was his focus on dynamics: movement and force. Whereas contemporary illuminators and printmakers were apt to show the organs of the body, for example, no one else tried to picture what happened inside the human body during the act of sex (fig. 11.34). On the male side of Leonardo's fantastical diagram, tubes allow semen to travel to the penis not just from the testicles but also from the heart and brain; on the female side, another conduit leads from the uterus to the breast. Beyond the energetic positions adopted by the partners, the drawing implies a liquid changing form as it flows from one zone to the next.

In a roughly contemporary drawing (fig. 11.35), Leonardo sought to understand and to convey what happens beneath the surface of the human head. At left, he compares the layers of the scalp to those of an onion, characteristically attempting to make sense of something that is difficult to witness by presuming its likeness to a familiar sight. The larger drawing at the right shows the

11.34
Leonardo da Vinci, hemisection of a man and woman in the act of coition, *c.* 1492. Pen and ink. Royal Collection Trust, London

11.35
Leonardo da Vinci, the layers of the scalp compared to an onion and other studies, *c.* 1490–93. Pen and ink and chalk on paper. Royal Collection Trust, London

pathways from the eye to the brain, the different activities of which he associates with three small chambers: the first dedicated to the imagination, the second to judgment, the third to memory. The subject would have fascinated Leonardo not only as an anatomist but also as a painter, interested in how images entered the human mind and became the basis for pictorial inventions. Yet the drawing also exhibits an architectural sensibility that alerts us to the range and interconnectedness of Leonardo's interests. His approach to the head is to show it in section and, below, in plan: a combination that would become more typical for the rendering of buildings.

Leonardo himself proposed designs for domed churches, showing buildings – as he did bodies – in plan and in section, as well as in **axonometric** view (fig. 11.36). Elsewhere, architectural elements allowed him to explore other concerns. His design for the *Adoration of the Magi* (*see* fig. 10.37) had incorporated prominent staircases

with climbing figures, and another drawing (fig. 11.37) merges that motif with the kind of wheel Leonardo would have known from watermills, using the human body rather than a stream as a power source. The wheel, in turn, is used to load crossbows, turning the staircase into a war machine of the sort that Leonardo was paid to imagine for his employer Ludovico. Similar in spirit is the artist's description of a canon foundry (fig. 11.38). Working on the Sforza horse (*see* fig. 10.24), Leonardo would have been familiar with the wooden armatures necessary to move heavy pieces of equipment, and his military duties would furthermore have encouraged an interest in artillery. Here, though, the real subject is in the actions of the men who struggle with the weight of the giant bronze, the gestures that generate human force, and the levers that amplify it. These are the same movements that would be central to Leonardo's narrative paintings.

ABOVE

11.36

Leonardo da Vinci, plan, section, and axonometric design, from the Codex Ashburnham. Institut de France, Paris

RIGHT

11.37

Leonardo da Vinci, drawing of a war machine: a wheel driven by ten men, from the Codex Atlanticus. Biblioteca Ambrosiana, Milan

OPPOSITE

11.38

Leonardo da Vinci, a scene in an arsenal, *c.* 1485–90. Pen and ink over black chalk on paper. Royal Collection Trust, London

ABOVE

11.39

Leonardo da Vinci,
Two Allegories of Envy,
c. 1483–85. Pen and brown
ink, traces of red chalk,
8¼ × 11⅜" (21 × 28.9 cm).
Christ Church, Oxford

RIGHT

11.40

Leonardo da Vinci, *Group
of Five Grotesque Heads*,
c. 1494. Pen and brown ink,
10¼ × 8" (26 × 20.5 cm).
Royal Library, Windsor

OPPOSITE

11.41

Leonardo da Vinci, *Lady
with an Ermine (Cecilia
Gallerani)*, 1478–80. Oil
on panel, 21¼ × 15¾"
(54 × 40 cm). Czartoryski
Museum, Cracow

makes an obscene gesture toward God. On the right, a male figure of Virtue discovers Envy as a kind of conjoined twin, for "as soon as virtue is born, it gives birth to envy against itself" and because "one would sooner find a body without a shadow than virtue without envy." He pokes an olive branch into her eye, showing that the very sight of virtue hurts her. Explaining the meaning of such pictures would have functioned as a kind of courtly game, though the drawings also point in the direction of Leonardo's writings on art: "Painting is a poem that is seen and not heard, and poetry is a painting that is heard and not seen"; "If you call painting mechanical because at first it is manual, the hands figure what is found in the imagination, and you writers draw what you find in your minds manually with the pen."

A series of grotesque heads may reflect Leonardo's role as a purveyor of wonders for the Milanese courtly elite (fig. 11.40). Today it is tempting to dwell on the disturbing humor in the drawings, the curiosity about human deformity that they attest. Leonardo, however, probably had at least partly a more serious purpose. Some of the drawings appear to be caricatures of pompous courtiers, lascivious monks, delirious old people, and other types Leonardo would have seen around him in Milan; they also testify to his increasing interests in the relation between the mind (or soul) and the body. He observed on several occasions in his writings that the human soul, which established an individual's character and guided his movements, also left a permanent imprint on his physical form. The viewer supposedly knows what the people in such drawings are like simply from the way they look.

It is in the spirit of these interests – Leonardo's study of human nature and his courtly audience's fascination with the wonders of art – that we should approach Leonardo's portrait of Cecilia Gallerani (fig. 11.41), which probably dates from around 1490. The correlative to Leonardo's fascination with extreme human deformity was his ability to generate absolute and alluring beauty – a capacity that for Leonardo demonstrated the power of art itself. The sitter, a Milanese noblewoman, was also the favorite of Duke Ludovico. Like Ginevra de' Benci, whom Leonardo had painted in Florence around 1478–80 (*see* fig. 9.20), Cecilia was famous in her day as a poet, writing in both Italian and Latin. She had a dominant position in courtly life, especially before Ludovico's marriage to an Este princess and her own to another man in 1491. The ermine she holds alludes to the duke himself, as the animal had featured in one of Ludovico's *imprese*. It also flatters the sitter, however, for writers had long associated the white creature with purity and moderation. The portrait thus belongs in the emblematic tradition to which Leonardo had already contributed while living

Other drawings on poetic and allegorical themes aimed at delight no less than at science. A sheet now in Oxford, for example (fig. 11.39), shows the artist experimenting with ways to represent "Envy" in pictorial form. As the elaborate inscriptions explain, the female personification on the left rides a figure of Death to show that envy never dies. An arrow of laurel and myrtle, symbols of virtue, strikes her ear, indicating that the envious are offended by good deeds. With her left hand, Envy

RIGHT

11.42

Leonardo da Vinci, *Isabella d'Este*, 1500. Black, red, and white chalk, and yellow pastel (?) over leadpoint, on paper prepared with a bone-colour dry pigment, 24⅞ × 18⅛" (63 × 46 cm). Musée du Louvre, Paris

FAR RIGHT

11.43

Leonardo da Vinci, *Portrait of a Lady ("La Belle Ferronière")*, c. 1495–99. Oil on panel, 24¾ × 17¾" (63 × 45 cm). Musée du Louvre, Paris

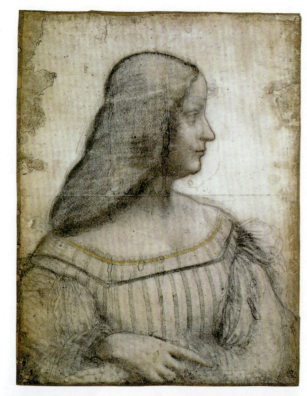

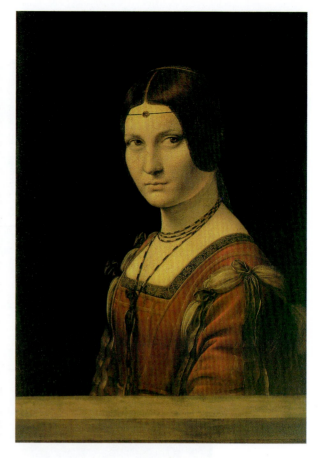

11.44

Giovanni Antonio Boltraffio, *Idealized Portrait of Girolamo Casio*, 1490s. Oil on panel, 16¾ × 11⅛" (42.5 × 28.3 cm). Duke of Devonshire Collection, Chatsworth

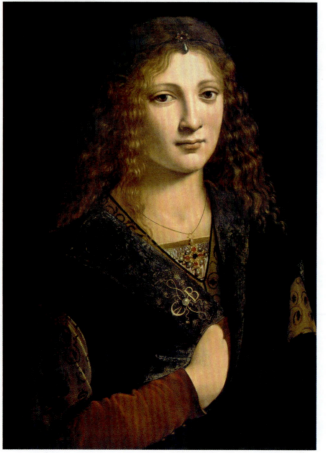

in Florence, in that it incorporates elements taken from nature that also symbolize the sitter. As earlier portraitists had done, the painter idealizes the sitter's features to such a degree that it may have been difficult to identify her. This, too, helps explain the inclusion of the animal, which puns on her name: *galee*, the Greek word for ermine, is nearly the root of "Gallerani." The joke is itself flattering, for only one of Cecilia's learning would have caught it.

Another of Ludovico's courtiers, the poet Bernardo Bellincioni, wrote a sonnet in praise of Leonardo's picture, rhapsodizing that the painter had made Gallerani's eyes so beautiful as to obscure the sun, that he had made it difficult to distinguish nature from art, that he made her "appear to listen." He cast the artist's achievement as one of attributing a psychology to his figure, suggesting that Cecilia seemed to look, to hear, not merely to be the subject of an adoring gaze. However conventional the verse may be, it draws attention to the difference between Leonardo's conception of the portrait and the almost subjectless profile views that had not yet gone out of vogue (compare, for example, fig. 9.26). The conceit also conforms with Leonardo's own research interests, including his attempt to find the location of the soul inside the body.

Leonardo's new mode of portraiture evidently appealed to Italy's courtly elites. Isabella d'Este, the Marchioness of Mantua, sought to borrow the Gallerani portrait in 1498; her attempts to have Leonardo paint her

own portrait after the fall of the Sforza a few years later came to naught, though he did produce a profile drawing (fig. 11.42) that seems to have less to do with Leonardo's portrait paintings than with the princely idiom of the portrait medal. No one has yet managed to identify the woman portrayed in the so-called "*Belle Ferronnière*" (fig. 11.43), but she was certainly a person of distinction. The turning of her body almost into profile, her sober expression, and the fictive balustrade separating her from the viewer all give the portrait a formality that distances it from the Gallerani picture. This may have seemed more appropriate for a married woman of high status, or it may simply indicate that Leonardo completed the painting in collaboration with a less gifted assistant. Both possibilities would suggest that Leonardo had become a commodity of limited availability for which prospective patrons would have to compete. This, as much as the inherent appeal of his manner, must account for the rise in these years of a circle of "Leonardesque" painters in Milan, including some, for example Giovanni Antonio Boltraffio (1446/47–1516), who specialized in portraits. In such paintings as the one now in Chatsworth (fig. 11.44), Boltraffio captures the hallmarks of Leonardo's Milanese style – black background, *sfumato* to soften the face, expressive gesture of the hand – but he dulls the expression and avoids the time-consuming and intellectually challenging task of unifying tones, favoring a more Flemish attention to surface and texture.

Leonardo and Sacred Painting

Leonardo's way of painting may not have seemed appropriate for all tasks. Ludovico Sforza is documented as having commissioned only one altarpiece, the *Pala Sforzesca* (fig. 11.45), made for the church of Sant'Ambrogio ad Nemus in Milan, and now in the Pinacoteca de Brera. Scholars have yet to provide a convincing attribution for the piece: it was certainly made by an artist familiar with Leonardo's painting, though what is striking is the degree to which it rejects that example. The squirming Christ Child suggests knowledge of Leonardo's experimentation with compositions that would link the infant to the Virgin in novel ways, but compared to the *Virgin of the Rocks* (*see* fig. 10.39), the picture is quite conservative in conception, placing all the characters in perfect symmetry. Though the gestures indicate that the saints in the back advocate for the donors in the front, every figure seems drawn into itself. Mary in particular sits in a kind of meditative trance: she interacts neither with her child nor with her worshipers nor with the beholder. The black background and the treatment of the Virgin's drapery – up-modeling the blue and down-modeling the red – pick up devices from Leonardo, but the

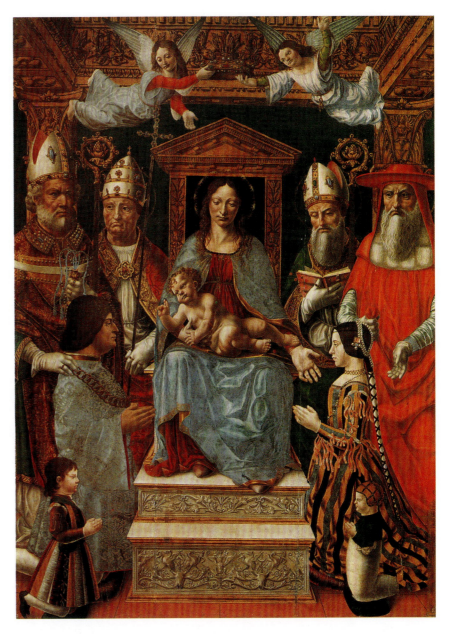

fierce expressions, the hardness of the forms, the fantastic classicizing furniture, and the profusion of ornament rather follow the manner of Andrea Mantegna. Did the duke favor a different pictorial mode for ritual settings?

Certainly Leonardo himself in these years also sought to take on larger projects connected to the Church. In 1490, he competed for (and lost) the commission to design the spire of Milan Cathedral; three years later he contributed decorations for the wedding of Ludovico's niece there. The artist's most important work in these years, however, turned out to be for the refectory, or dining hall, of the church of Santa Maria delle Grazie. Ludovico had chosen this church as his burial site and had consequently commissioned the painter-

ABOVE

11.45

Master of the Pala Sforzesca, *Pala Sforzesca*, **1490s.** Tempera on panel, 7'6⅞ × 5'5¼" (2.3 × 1.65 m). Pinacoteca di Brera, Milan

11.46
Crossing and choir by
Donato Bramante at Santa
Maria delle Grazie, Milan

BELOW
11.47
Leonardo da Vinci, *The
Last Supper*, 1494–98.
Mural. Refectory of Santa
Maria delle Grazie, Milan

architect Donato Bramante (1444–1514) to add a huge domed crossing and a choir extending behind the high altar (fig. 11.46). Bramante likely exchanged ideas with Leonardo, who had considered similar structures; Bramante's preoccupation with the theme would continue in Rome a decade later. The duke envisioned the new choir as a setting for his own tomb; the site is comparable in position to the tomb chapel that Ghirlandaio's patron Giovanni Tornabuoni had unveiled just a few years before (*see* fig. 11.6), though in scale the duke's vision more nearly rivaled Pope Nicholas V's unexecuted project for St. Peter's from nearly half a century earlier (*see* p. 193).

Leonardo, meanwhile, focused on the church's refectory. *The Last Supper* (fig. 11.47) belonged to a larger cycle of decorations, including a *Crucifixion* on the opposite wall with a portrait of Ludovico and his family. Above the scene with Christ and the Apostles, Leonardo painted monumental images of the Sforza family arms, giving its members a presence in that history, too, and a letter from Ludovico states that he additionally planned to have Leonardo paint a third wall of the room. *The Last Supper* was a

conventional subject for painted refectories, especially in Florence, where Leonardo trained. The duke chose a subject that corresponded to the function of the room, though he also wished to turn the space into something more personal than a monastic dining hall. The imaginary room in which the Apostles eat extends the upper level of the space into which the duke himself sometimes came for meals.

The Florentine convention, as we saw earlier with Andrea del Castagno (*see* fig. 6.16), was to place all the dining Apostles except the traitor Judas on the far side of a long table. Leonardo, too, adopted an arrangement that allowed all his characters to face the beholder; but here even Judas joins the rest of the company. This approach made it easier for the painter to use the assignment, the largest work he would ever complete, as an opportunity to translate experiments he had undertaken in other media. Leonardo treated each of the figures as an individual problem of human expression, a topic that had fascinated him at least from the beginning of the decade, as we saw with the grotesque heads (*see* fig. 11.40). One intense ink-and-metalpoint drawing on blue paper (fig. 11.49), for example, imagines St. Peter as a scowling character who turns and raises his arm as though in response to something taking place outside the picture field. Peter's physiognomy centers on a furrowed brow that in turn implies a mind in motion. In the mural itself (fig. 11.48), Peter directs the same brow and the same grotesque nose toward Christ, providing contrast both with Judas, who leans away from Christ, and with John, whose youthful sweetness (entirely conventional in *Last Supper* imagery) distinguishes his expression from Peter's anger.

Such confrontations reveal the artificial, staged quality of the composition. On the whole, though, Leonardo resisted supernatural effects. At the rear of the space are three windows looking out onto a landscape. The illumination these provide, and particularly the central one before which Christ sits, frames the heads of the holy personages in a way that suggests a radiating aura;

11.48
Leonardo da Vinci, *The Last Supper*, detail of central group. Mural. Refectory of Santa Maria delle Grazie, Milan

LEFT
11.49
Leonardo da Vinci, *Bearded Old Man in Half-Length, Three-Quarter View Facing to the Right (St. Peter).* Metalpoint, reworked with pen and brown ink, on blue prepared paper, 5¾ × 4½" (14.5 × 11.3 cm). Graphische Sammlung Albertina, Vienna

the windows in this way take over the traditional role of haloes. And in the hope of achieving the same kinds of atmospheric effects he had developed in his panel paintings, Leonardo worked not in true fresco, but in an experimental oil-based medium. Surely he knew the risks this involved, though he must also have been reluctant to work with the speed and regularity a more traditional approach would have required. A writer at the court, Matteo Bandello, reports that Leonardo:

> used to climb the scaffolding early in the morning… and from the rising of the sun until its setting, not once let the brush leave his hand, forgetting to eat and drink and painting continuously. Then there would be two, three, or four days when he would not set his hand to the picture, but would remain in front of it, and for one or two hours a day just contemplate, consider, and, examining them together, judge his figures….I have also seen him come directly to the church and, having ascended the scaffolding, take the brush, apply one or two strokes to a figure, then leave.

Ultimately, Leonardo's approach had disastrous effects, as the paint did not bind to the surface as true fresco would have; a writer in 1560 reports that the picture by that time was already in ruinous condition. The wrecked state of the wall invited subsequent users of the room to treat it badly. The monks cut a door into the mural in 1652, its eighteenth-century caretakers had the scene extensively repainted, and Napoleon's troops used the painting for target practice. Despite a careful recent restoration, the traces of Leonardo's own hand are no longer easily read.

In a sense, moreover, the work's illegibility is not merely a matter of its condition. The "response" of the sitter in the Cecilia Gallerani portrait (*see* fig. 11.41), along with Leonardo's physiognomic drawings and a number of his theoretical statements, encourage us to see the mural in terms of internally motivated actions and interactions, bodies whose gestures reveal a specific purpose. But just what is Christ, at the very center of the picture, doing? In John 13, Christ announces at the meal that one of his disciples will betray him; "the disciples therefore looked one upon another, doubting of whom he spoke." When asked, Christ replied only: "He it is to whom I shall reach bread dipped." Is Leonardo, then, showing the Apostles responding in confusion and dismay to Christ's words, as he gestures toward the bread and reaches for the wine in which he will dip it? Perhaps: but here, as throughout this book, it becomes clear that paintings do not simply illustrate texts. In Matthew 26, which tells a variation on the same story, the episode concludes with Christ taking

bread, blessing and breaking it, giving it to his disciples, and saying: "Take ye, and eat. This is my body." Catholics took this act to institute the ceremony of Communion. If the viewer understood Christ's hand to be indicating the bread he tells his troubled followers to eat, it would lend a ritual aspect to every meal that the monks in the refectory took before the painting. With the end of the century on the horizon and Ludovico's French enemies already threatening his territory, the image of Christ blessing the assembly may have appealed to him as well.

Michelangelo: Early Works in Marble

Florence

Some artists, as we have seen, were deeply taken by Savonarola's sermons in Florence. For others, however, it must have been the fall of the Medici as much as the rise of the Dominican that most affected them. Lorenzo the Magnificent had earlier invited the young Michelangelo Buonarroti (1475–1564), then a teenage apprentice to Ghirlandaio and perhaps an assistant on the Tornabuoni Chapel (*see* fig. 11.6), to join his household in Florence. It was probably Michelangelo's interest in ancient sculpture, more than his precocity with the brush, that attracted the patron's attention. Beginning in 1489, the fourteen-year-old had kept company with a group of young artists who worked and studied in the garden of a Medici property in the northern part of the city, little more than a block from where Savonarola would live and preach; indeed, one early biographer reports that Michelangelo taught himself

11.50
Michelangelo, *Battle of the Lapiths and Centaurs*, c. 1492. Marble, 33¼ × 35⅛" (84.5 × 89.2 cm). Casa Buonarroti, Florence

to sculpt after borrowing the tools of a mason working at the church of San Marco. The head of the garden clique was the aged Bertoldo di Giovanni, whose works included not only small statuettes, such as the *Pegasus* group (*see* fig. 10.4), but also at least one bronze relief on a classical theme. Among Michelangelo's earliest surviving works is a marble in a similar format (fig. 11.50), showing a mythical fight between a group of centaurs and the human tribe of Lapiths who had invited them to a wedding.

The episode, known from the Roman poet Ovid, was one the significance of which the humanist Poliziano is reported to have explained. Michelangelo's interest in the subject thus points to his connection with the philologists and other literary figures who surrounded Lorenzo the Magnificent; in this respect, it is as close conceptually to Botticelli's *Birth of Venus* (*see* fig. 9.25) as it is to anything from the 1490s. The actual story Michelangelo shows, nevertheless, is difficult to decipher. In contrast to Donatello, whose influential reliefs depended on the use of perspective to create illusionistic depth, Michelangelo simply filled up the available space with a tangle of bodies, covering the field from bottom to top in the manner of a Roman sarcophagus or a pulpit by Giovanni Pisano (*see* fig. 1.9). Nor are the identities of the characters Michelangelo depicts entirely clear. At the bottom of the scene, just left of center, is the haunch of a centaur, and elsewhere we get glimpses of a horse's leg or a tail; but it is not always easy to say which characters are centaurs and which are human. Other artists sometimes characterized the centaurs as enemies of civilization, giving their opponents modern weapons as the hybrid beasts fought with debris from the banquet. But the most prominent fighting instruments in Michelangelo's version are the large rocks wielded by the figures to the left, and these appear to be Lapiths.

Michelangelo may have modified the story to bring it closer to his own intellectual concerns. The choice to explore the expressive potential of the nude male body, even at the expense of legible narrative, dovetailed with Michelangelo's study of antiquities. What distinguished his work from the creations of other workshops of his day, however (even those with similar interests in the ancient past), was his devotion to a narrow range of media, the properties of which he made into objects of reflection in their own right. Across the top of the *Centaurs* relief is a wide band of partially worked marble, scored with a claw chisel, the tool that a marble sculptor would use to rough out compositions before proceeding to smaller chisels and files. The passage contrasts dramatically with the highly polished torsos of the central characters; the whole work draws attention to the process by which it was made, the degrees of finish a slab would pass through as the sculptor used finer and finer instruments. That large depicted stones should be put on

ABOVE LEFT AND RIGHT

11.51

Michelangelo, *Bacchus*, 1496–98. Marble, height 6′7½″ (2 m). Museo Nazionale del Bargello, Florence

such prominent display reminds the viewer that they are Michelangelo's own instruments no less than his characters' and suggest that he conceived his own art as a kind of battle. This is a conceit that would return in his *David* – another hero who uses a stone to fight – a decade later.

Lorenzo the Magnificent died in 1492, and the Medici household now headed by Lorenzo's son Piero seems not to have held the same appeal for the artist. In 1494, Michelangelo began traveling, first to Venice and then to Bologna, where he carved three small stone figures for a shrine. By the time he returned to Florence in 1495, the Medici had been expelled. The artist remained only briefly in the city, producing a marble *Cupid* so persuasively similar to an ancient work of art that an acquaintance allegedly managed to pass it off as an actual antiquity to Raffaele Riario, a cardinal living in Rome. Riario invited Michelangelo to the papal city, where he would complete his two most important early marbles.

Rome

The first, which Michelangelo started in 1496 and completed in 1498 while living with Riario, was a marble *Bacchus* (fig. 11.51). This lifesize mythological work seems to have been intended from the outset for display in a

sculpture garden, like the one owned by the Medici in Florence where the artist had begun his career: it is hard to imagine any other context that could accommodate such a blatantly pagan and sensual image. Riario himself had a sculpture garden, as did the banker Jacopo Galli, whom Giorgio Vasari names as the work's patron. Carved in the round, the statue invites the viewer to circle it: only from the side and the back do we get a proper view of the little satyr that accompanies the wine god. Marble sculptures of this size cannot stand on narrow stone supports with the diameter of human legs: Bacchus needs the second figure in order literally to stay on his feet. The question of whether he will stand or topple, on the other hand, is also central to the work's theme. From the time of Donatello, sculptors who conceived freestanding figures in imitation of the antique tended to show a shift of weight from one foot onto the other.

This seemed to be a principle to which the ancients had all adhered, and it gave the figure itself a graceful form. Michelangelo, however, pushes this to an absurd extreme, hinting that Bacchus leans back and to the side – onto the satyr – because he is staggering drunk. Whereas Leonardo explored the possibility of bringing depicted people to life by showing not just a surface appearance but some kind of interiority, Michelangelo carved a figure that seemed to be inhabited by spirits of a different kind. As the satyr chomps into a grape, Bacchus tries to steady his cup to prevent his drink from spilling.

The *Bacchus*, though displayed from the beginning in a private setting, must have attracted much attention in the city, for shortly thereafter the French Cardinal Jean Villiers de La Grolais asked Michelangelo to carve a *Pietà* (fig. 11.52) for a chapel dedicated to the Virgin on the side of St. Peter's. The space itself, circular in plan, was unusual, and its subsequent destruction makes it difficult to say with certainty just how the work was originally displayed. It may have functioned as an altarpiece, with the Virgin presenting Christ's flesh to the celebrant at the altar table, or it may have rested directly on the

BELOW LEFT

11.52

Michelangelo, *Pietà*, **1498–99.** Marble, height 5'8¼" (1.74 m). St. Peter's, Rome

BELOW RIGHT

11.53

Baccio da Montelupo, Crucifix, 1496. Polychrome wood, 5'6½" (1.7 m) (Christ); 11'6½" × 6'4" (3.5 × 1.95 m) (Cross). San Marco, Florence

ground as a tomb marker: Villiers, already in his late sixties, intended the chapel to serve as his place of burial, no doubt in emulation of the burial sites that counterparts, including Cardinal Carafa, were beginning to construct (*see* fig. 11.19).

Lifesize sculpted images of Christ were quite common in Michelangelo's day, though most were Crucifixions, done in wood: the workshop of Baccio da Montelupo (1469–*c.* 1523), a sculptor who had studied alongside Michelangelo in the Medici garden, turned out nearly two dozen of these. Baccio was a devout follower of Savonarola, who seems especially to have liked what the sculptor made: in 1496, the year Michelangelo began his *Bacchus*, the preacher had Baccio produce a lifesize Crucifix (fig. 11.53) for the church of San Marco in Florence. The sculptor employed a more vivid polychromy than Donatello and Brunelleschi had in their analogous works of the early fifteenth century: red blood pours from disturbingly real-looking nails and thorns across the flesh-colored body of Baccio's Christ. The sacral quality of the roughly hewn wooden cross may have seemed all the more insistent at a moment when sculptors were regularly responding to marbles of the pagan past. Against such a tradition, Michelangelo's *Pietà* group could not have looked more alien.

The white Carrara marble in which Michelangelo carved may have seemed especially suitable for the representation of deathly pallor; it also lent his figures an unreal beauty. The artist does not really treat them as living presences: like the increasingly well-known pagan statues of the ancients, the pair seems to belong to another time and place. Michelangelo opted for a version of the *Pietà* theme that centered not on Christ presented iconically by attendant angels (compare fig. 9.8), but rather on the Virgin's grief at her son's death. Her monumental drapery, itself a tour de force, adds mass and helps unify the horizontal male body with her own; this disguises the work's narrative disjunctiveness. Michelangelo gave Mary the face not of a woman who could be the mother of a thirty-three-year-old man, but of a teenage girl. He breaks with historical plausibility to elicit our sympathy, but also to show the Virgin in what contemporaries would have regarded as her most perfect state.

Ironically enough, Michelangelo's signature hinted at the work's *imperfection*. The inscription in the band that runs across the Virgin's chest (fig. 11.54) reads "Michelangelo Buonarroti of Florence was making this," using the Latin imperfect "faciebat" rather than the more common "fecit" ("he made this"), again to draw attention to the process and duration of the carving. Little of what is visible here, by comparison with his *Lapiths and Centaurs* (*see* fig. 11.50), could be said to be unfinished,

even if the pair sits on a distinctly rocky base; but the fact that Michelangelo wanted viewers in 1499 to think about his labors in connection with a devotional act suggests that he, too, may have had some trepidation about the century to come. Later in life, Michelangelo is said to have remarked that he could still hear the voice of Savonarola thundering in his head. With the exception of a historical bust and the sculptures that originated in other tomb projects, he would never again sculpt a work like the *Bacchus*, nor any other marble on an explicitly pagan theme.

11.54

Michelangelo, *Pietà*, detail.

St. Peter's, Rome

1500–1510
Human Nature

12

12

1500—1510
Human Nature

The Heroic Body and Its Alternatives

If art in the years leading up to 1500 returned repeatedly to images of catastrophe and the end of history, this corresponded with a lived experience of rupture with the past. In 1499, the French invaded the region for the second time in a decade, toppling Duke Ludovico Sforza in Milan. Naples, which had had four kings in six years, fell to France the following year. Venice, newly at war with the Ottoman empire, lost several major sea battles, the first in a series of military misfortunes that before the end of the decade would leave the city not only weakened on the water but also stripped of much of its huge territorial state in northern Italy. Florence, following the overthrow of the Medici and the revolt against Savonarola, entered the new century as a reborn republic, without the Medici pulling the strings. Pope Alexander VI was encouraging his son, the *condottiere* Cesare Borgia, to seize territory in central Italy, ousting the Malatesta in Rimini and the Montefeltro from Urbino, among others. Alexander himself would die after a violent illness in 1503, leaving his successor, Julius II, as the head of a militarized papal state, aimed at the domination of central Italy.

12.1

Piero di Cosimo, *Hunting Scene, c.* **1500.** Oil and tempera on panel, 27¾ × 66¾" (70.5 × 169.5 cm). Metropolitan Museum of Art, New York

Many Italians in these years, seeing all of this through the lens of the prophecies and astrological predictions that the half-millennium had inspired, feared that worse disasters were yet to come. Some, however, maintained a sense of possibility, even of optimism.

The Florentine civil servants Niccolò Machiavelli and Francesco Guicciardini, both of them political thinkers and historians, were among those who set aside the idea that history revealed the unfolding of a divine plan, with apocalypse or salvation as its climax; these men looked to history as a guide, wondering whether events that took place in the past provide reassurance of an orderly and positive outcome for the unsettled present. Did history teach us that outcomes could be shaped by the inspired actions of heroic human beings? Or, more pessimistically, did history reveal no more order than the random growth and decay visible in the natural world, in which human beings acted out of instincts hardly more rational or noble than those of other living creatures, and probably less so?

Michelangelo's *David* from 1504 (*see* fig. 12.3) seems to answer the first of these questions in the affirmative; while Piero di Cosimo's (*c.* 1462–1521) contemporaneous *Stories of Primitive Man* series corresponds to the latter

point of view. Piero's *Hunting Scene* (fig. 12.1) and *Return from the Hunt* (fig. 12.2) are believed to have been painted for the house of the wealthy anti-Medicean Francesco Pugliese. Like Botticelli's *Primavera* (*see* fig. 9.24), they were *spalliere*, and they drew their imagery from ancient poetry. The subject matter here, however, is not the idealized world of the ancient gods and heroes, the "Golden Age" described by the poet Ovid when the gods dwelt upon the earth. Piero's human figures, not to mention the half-human hybrids that appear in one of the panels, seem in addition worlds away from the delicate beings who populate the paintings of Andrea Mantegna and Filippino Lippi (*see* figs. 11.4–11.5 and 11.20–11.23), and the physical world they inhabit is distinctly harsher. Piero was a skilled landscape painter; he had been taught by Cosimo Rosselli, who was probably also the teacher of the pioneering draftsman Fra Bartolomeo (*see* fig. 11.2). Piero used landscape, however, to envision the most basic conditions of human life within the natural world. The series created an explicit alternative to the Golden Age mythologies of the Medici era, as if these were no more than lies that had sustained the rule of tyrants. Piero presents a far from idealizing view of the origins of man, reminding the viewer of the instinctual and violent creatures that the first human beings actually were. He drew freely upon the great philosophical poem *On the Nature of Things* by the first-century BCE Roman writer Lucretius. Lucretius was a "materialist," that is, he believed that there was no reality beyond the physical universe, which obeyed its own laws without divine intervention, and that human beings possessed no immortal souls. All natural phenomena, Lucretius maintained, could be explained through the movement of atoms. Gods did not intervene

in terrestrial affairs; what people called gods were mere metaphors for natural processes: Venus for sexual compulsion and the desire to reproduce, Mars for rage and aggression, and so on. History began with humanity's desperate struggle for survival in a world for which it was ill prepared, and to which it had to adapt by mastering tools and weapons and by harnessing the element of fire.

Italian humanists had rediscovered Lucretius's poem in 1415, but its shockingly un-Christian view of human nature prevented it from having much impact until its publication in Venice in 1495 and 1500, when it began to become the model for a new genre of scientific and didactic poetry. By that point, the Lucretian view of human nature corresponded with the "realist" historical and political analyses of Machiavelli, who as a youth had copied out Lucretius by hand.

Michelangelo's *David*

In this respect, both Lucretius and Machiavelli represented something completely at odds with the idealizing attitude behind Michelangelo's *David* (figs. 12.3 and 12.4). The very perfection of the hero's muscular body, his gigantic scale, and even the exaggerated proportions of his head and hands show that his actions manifest the will and power of God. The boy-warrior David had long been established as a symbol of the Florentine Republic, as we have seen in sculptures by Donatello and Verrocchio (*see* figs. 2.24 and 9.15). The revival of that symbol, in the commission given to Michelangelo (1475–1564), co-incided with the revival of a long-suspended project for Florence Cathedral: an assignment that Agostino di Duccio had begun and abandoned in the 1460s, to replace

12.2

Piero di Cosimo, *The Return from the Hunt*, *c.* 1500. Oil and tempera on panel, 27¾ × 66½" (70.5 × 168.9 cm). Metropolitan Museum of Art, New York

LEFT

12.3

Michelangelo, *David*,
1501–04. Marble, height
(incl. base) 13'5½" (4.1 m).
Accademia di Belle Arti,
Florence. The statue stood
for centuries to the left of the
main entrance to the Palazzo
dei Priori, where a copy can
be seen today.

ABOVE

12.4

Michelangelo, sheet with
verses and studies for
a *David*, 1501. Pen and
ink on paper, 10 × 7⅜"
(28 × 17.8 cm). Musée du
Louvre, Paris

Donatello's marble *David* of 1416, which had ended up
in the Palazzo dei Priori. Michelangelo received Agos-
tino's decades-old block with the elements of a figure,
including the pose and the proportions, already roughed
out, limiting the possibilities for dramatic revision; what
Michelangelo produced, in fact, is only really successful
from the front and from the right.

We know from a document that Michelangelo had
studied Donatello's bronze *David* (*see* fig. 6.23), and his
awareness of that figure is reflected in a surviving drawing
(*see* fig. 12.4). There is nothing retrospective or backward-
looking about the figure itself, however, except perhaps
in Michelangelo's self-conscious bid to outdo his Flor-
entine predecessors. Beyond the exponential increase in
scale, Michelangelo's *David* differs most strikingly from
the previous versions in the action it depicts. The sculp-
tor needed to include some element on the base to brace

the marble leg, and the obvious choice would have been the head of Goliath, a standard feature in such statues. Instead, Michelangelo included a cut-off tree, perhaps an allusion to fallen leaders and the prospect of renewal – and thus a symbol in the spirit of the "Golden Age" myths that Piero di Cosimo rejected. This David has no sword, nor even, more surprisingly, a rock. Staring into the distance, he is either preparing for his battle or, more likely, surveying what he has just accomplished. The conceit of the boy looking at what must, proportionally, be a truly towering Goliath on the horizon, seems to have carried particular symbolic weight for the artist. On the Louvre sheet, he wrote "David with his sling and I with my bow – Michelangelo" (*see* fig. 12.4). The "bow" to which the artist refers is probably the tool sculptors used to turn a drill when cutting marble, but the point is that Michelangelo saw his own task as one that bore direct comparison to his hero's.

The idea that David and Michelangelo alike were looking at giants is a reminder of the stunning size of the figure, and of the single block from which the sculptor carved it: nothing like this had ever been seen in Florence. Many would immediately have recognized that Michelangelo was vying with sculptors of antiquity. Rome, where he had been working in the years preceding 1501, preserved two famous examples of the colossal male nude in the *Horse Trainers* on the Quirinal Hill, and David's massive head and hands would have recalled the great fragments (also a head and hands) of the colossus of Constantine on the Capitol. Florentines were also aware that Leonardo da Vinci, who had returned to Florence in 1500, had tried and failed to complete a colossal bronze statue in Milan. Michelangelo's success may have marked the beginning of a public rivalry with Leonardo.

At the completion of Michelangelo's *David*, the Florentine government balked at the prospect of hoisting the colossal marble up onto the cathedral's exterior and consulted with artists and other experts (including Leonardo, Botticelli, Filippino Lippi, and Piero di Cosimo) on an alternative placement. Then, contrary to the advice of most of the artists, the Signoria had it erected outside the Town Hall. This was a highly charged location: everyone knew (and the recorded discussion indicates) that here it would replace Donatello's *Judith and Holofernes* (*see* fig. 6.25) and compensate for perceived inadequacies in Donatello's bronze *David*, then in the courtyard immediately behind. According to the Florentine official overseeing the meeting, it was "not considered proper that a woman should be shown cutting off the head of a man," and the statue had been "erected under an evil star" that had led to Florentine setbacks in the war against Pisa. Regarding the bronze *David*, the official is more

laconic – the criticism of it had something to do with the appearance, from behind, of one of the legs.

Michelangelo's *David* sent all the right messages: the figure was not only male, as opposed to the threateningly female *Judith*, but also swaggeringly masculine and physically powerful, unlike Donatello's androgynous and still childlike figure. The location to the side of the entrance to the seat of government had one further effect: it activated David's frowning gaze, which he turns on an enemy to the south, coming from the direction of Rome: that is where the exiled Medici had established themselves in readiness for their planned repossession of Florence.

Leonardo and Michelangelo in Florence

Depicting the Holy Family

Leonardo's work on his return to Florence in 1500 also responded to the appetite for the new and the

12.5

Leonardo da Vinci, *Virgin and Child with St. John and St. Anne*, 1507–08. Charcoal (and wash?) heightened with white chalk on paper, mounted on canvas, 4'8" × 3'5¼" (1.42 × 1.05 m). National Gallery, London

12.6
The Muse Terpsichore,
Roman, second century.
Marble, height 19¾"
(50 cm). Museo del
Prado, Madrid

a Medici adherent, did not mention was that Anne was an important patron saint of the Florentine Republic, one associated with the defeat of tyrants ever since the regime of the Duke of Athens collapsed on her feast day in 1348; Anne was also the subject of the altarpiece that the new republic had commissioned Filippino Lippi to make for its council hall in 1498. Leonardo's design, that is, was more than a generic, contemplative image of the Virgin and Child and the Holy Family, because it conveys a series of emotional states as ephemeral as the play of muted light and transparent shadow that reveals the powerful forms, or the fluid movement of the limbs of these intimately intertwined figures. Its historical theme, like that of Leonardo's *Adoration* twenty years before (*see* fig. 10.37), is the incarnation of God in human form as a momentous historical turning point. Anne's heavenward pointing gesture signals her understanding of the union of the human with the divine. The genealogy of Anne, Mary, and Christ – the ascent from human to divine – is figured in the curious fusion of the three bodies, the sense that together three separate individuals form a mysterious whole.

The effect is quite different from that produced through the use of voids and linking gazes in the grouping of figures in the *Virgin of the Rocks* (*see* fig. 10.39). There is more of a sense of a unified whole, one that reflects Leonardo's engagement with sculpture over the preceding

FAR RIGHT
12.7
Leonardo da Vinci,
Vitruvian Man, **1492.**
13½ × 9⅝" (34.3 ×
24.5 cm). Galleria
dell'Accademia, Venice

"marvelous." Receiving a commission for the high altarpiece of Santissima Annunziata in early 1501, Leonardo made a full-scale drawing for the painting, which characteristically he would never complete. The *Virgin and Child with St. John and St. Anne,* however, had an impact scarcely less dramatic than Michelangelo's *David* would three years later. The drawing was one of the first works of art we know of to be placed on public exhibition. For two days, according to Giorgio Vasari, everyone came to "gaze at the marvels of Leonardo, which caused all those people to be amazed." The cartoon now in London (fig. 12.5) is not the one displayed by Leonardo on that occasion, but it is a closely related version and conveys something of what must have impressed the Florentines.

Vasari singled out Leonardo's ability to represent inner character, such as the modesty of the Virgin, as well as fleeting effects of emotion: the Virgin's joy in seeing the beauty of her son, St. Anne's happiness in "beholding her earthly progeny becoming divine." What Vasari,

decade. Following the abortive equestrian statue project in Milan and the collapse of the Sforza, Leonardo had gone briefly to Rome. His notebooks record a visit to Rome and to the nearby hillside town of Tivoli in March 1501, where he would have seen the sculptures of Hadrian's Villa, among them a group of lifesized Muses, seated female figures with powerful bodies, their laps covered with richly carved cascades of drapery (fig. 12.6). As is the case with Michelangelo's *David*, ancient Roman sculpture is here a key element of the "modern" style being developed for Republican Florence.

Classical sculpture defines the body as a normative ideal, a fixed canon of proportions. But when a Renaissance artist depicted the body he also had to demonstrate an empirical knowledge grounded in life drawing and in dissection. Leonardo's earlier drawing of the "Vitruvian Man" (fig. 12.7) showed, for the younger artist, that the normative and the empirical approaches entailed no necessary contradiction. Just as all the forms of nature itself were variations on the fundamental geometric forms of the sphere, the cube, the pyramid, so – following the Roman writer and architect Vitruvius – the human body could express an ideal geometry, even though the individual bodies that an artist measured and dissected might fail to correspond to this. Yet Leonardo's anatomical studies in the 1500s (*see* fig. 11.34), which consumed his interest far more than painting did, would become more absorbed in the process of growth, ageing, and physical decay than in Vitruvian norms. For all of Leonardo's interest in classical sculpture, it is by no means apparent that the figures in the London cartoon (*see* fig. 12.5) would manifest ideal proportions if they were to stand on their feet. One consequence of the effect of unity achieved by Leonardo is that we do not notice right away that the Virgin is prodigiously tall, and that her head is small relative to her body. Just as the interlocking of figures suggests a composite single figure, so too each body seems hybrid in character, as if each limb had been designed individually before being merged with the larger whole.

Michelangelo, despite evoking an ancient colossus with his *David* (*see* fig. 12.3), also maintained a non-Vitruvian and subjective approach to human proportion: later in his career he would state that an artist needed no other compasses than his own eyes. As is the case with Leonardo, the bodies in Michelangelo's art, while reminiscent of antiquity and of drawing from the model, are something else again: they are imaginary constructions, more beautiful and powerful than bodies in everyday life. It is as if both artists studied the natural body in the form of human models and dissected cadavers in order to surpass nature. In a similar manner, Michelangelo's study of antique sculpture paradoxically distanced him from the ideal proportions of the ancients.

The *Virgin and Child* he carved between 1503 and 1506 (fig. 12.8) illustrates the extraordinary license he was willing to adopt. Though the Virgin is a variation on the figure of the Rome *Pietà* from the previous decade (*see* fig. 11.52), the child who seems to slip from her lap combines the proportions of a nursing infant (especially in the ratio of head to body) with the physical dimensions of an older child. Clearly, Michelangelo understands his figures to belong to a reality above ordinary experience.

12.8
Michelangelo, *Virgin and Child*, *c.* 1503–06. Marble, height (incl. base) 48" (1.2 m). Onze Lieve Vrouwekerk, Bruges

12.9
Michelangelo, *The Holy Family (Doni Tondo)*, c. 1506. Wood panel, diameter 47¼" (120 cm). Uffizi Gallery, Florence

The artist's allusion to his own *Pietà* seems deliberate: the gravity of the mother and child here, combined with the sense that Christ is stepping away from the Virgin, makes the pair into an intensely dramatic anticipation of his future death and of her sorrow. In its solemn character, the work contrasts markedly with the quiet rapture of Leonardo's *Virgin and Child with St. John and St. Anne* (*see* fig. 12.5). The marble may originally have been intended for the monumental tomb of Pope Pius III in Siena, but by 1503 a Flemish cloth merchant had taken over the commission; he transported it to Bruges, where it can still be seen in the church of Notre Dame.

Very different in character is the *tondo* made for the wool merchant Agnolo Doni around 1506, which shows Michelangelo adapting the heroic and powerful bodies that appeared in his sculptures to the world of private devotional painting (fig. 12.9). Even when the format was large (in this case just under four feet in diameter), images of the Holy Family for people's homes usually project quiet, unassertive intimacy. Far from being static and contemplative, however, Michelangelo's figures manifest dynamic energy to an almost athletic degree. The artist had closely studied Leonardo's project for the Annunziata altarpiece (a drawing marked "lenardo" survives in his hand), observing both the harmonious integration of monumental bodies and the psychological interaction of the figures. In his composition, however, Michelangelo has rethought the principles according to which the bodies are combined with each other, and produced a new way of dealing with the *tondo* format.

The powerful figure of Mary, seated upon the ground, turns her shoulders and waist as she receives the child from the lap of St. Joseph, whose imposing body seems to cradle hers. The rotation of her upper and lower limbs in contrary directions establishes a great circular arc and harmonizes with the round form of the painting.

Although the motion is complex, entailing a supreme artistic mastery of foreshortening, the effect is majestic and heroic. Using just the motions of the body, Michelangelo conveys how the Virgin invests her whole being in her historical role as bearer of the incarnate God. By placing her on the ground, Michelangelo recalls the traditional theme of the "Virgin of Humility," characterizing Mary as obedient to historical destiny. In his version, though, the Virgin is far from passive. The grouping of Mary, Joseph, and Christ, in other words, is traditional, but Michelangelo re-stages it as an action and an event, one invested with momentous importance.

What did Michelangelo intend with the array of naked young men who gather on the low ledge in the background, or the child Baptist who, turning his back on them, looks toward the Holy Family? Perhaps Michelangelo, whose art itself depends on the symbolic richness of the human body, wanted to allow for multiple associations, leaving it to the viewer to determine their meaning. The nudes could signify the world of pagan antiquity before the coming of Christ and of Christ's predecessor St. John the Baptist, or they could represent Christian initiates disrobed in order to receive the sacrament of baptism from the young saint. Whatever their iconographic role, they also function as a kind of artistic signature of Michelangelo, who was now celebrated for his mastery of the male nude. We have seen that images of the well-formed adolescent male body were in any case an established part of Florentine visual culture, a phenomenon that no one seems to have felt the need to justify: they could evoke the virtue and vigor of the Republic, or its fertility and prosperity, or the pride the city took in its actual handsome young citizens. So, too, the masculinity of the Virgin here (and of many of Michelangelo's female figures) reflects a common association between *virtue* and the virile body. Galen – the ancient medical writer whose books were central to the teaching of medicine – regarded the female body as an underdeveloped male, formed when an embryo lacked sufficient heat. The androgynous female in Michelangelo's art shows the artist seeking to restore to certain heroic women, like the Virgin, a measure of the perfection that they merited but physically lacked.

Leonardo vs. Michelangelo: Battle Paintings for the Great Council Hall

The idea of the vigorous male body as a symbol of the Republic operates in Michelangelo's next important project for the city of Florence as well, a fresco painting that placed him in open competition with Leonardo. By 1498 construction on the Great Council Hall in the Palazzo dei Priori had proceeded far enough that the sculptor Baccio d'Agnolo could begin working on a framework for the monumental altarpiece that was to go at one end of the room, as well as on a loggia (gallery), inlaid paneling, and balustrades. Filippino Lippi was to paint the altarpiece, and Andrea Sansovino was to make a sculpture of the Resurrected Christ to go opposite this. The walls of the room were to be adorned with battle scenes, again following the example of the council hall in the Doge's Palace in Venice. Among the paintings commissioned for the hall, only the altarpiece would be taken to an advanced stage of completion. After the death of Filippino in 1504 it was given to Fra Bartolomeo, but abandoned incomplete in 1512 (fig. 12.10). The friar had been to Venice, and, drawing from the example of Giovanni Bellini, he designed

12.10

Fra Bartolomeo, *Virgin and Child with St. Anne*, 1510–13. Oil on panel, 4'6½" × 3'5" (1.4 × 1.04 m). Museo di San Marco, Florence

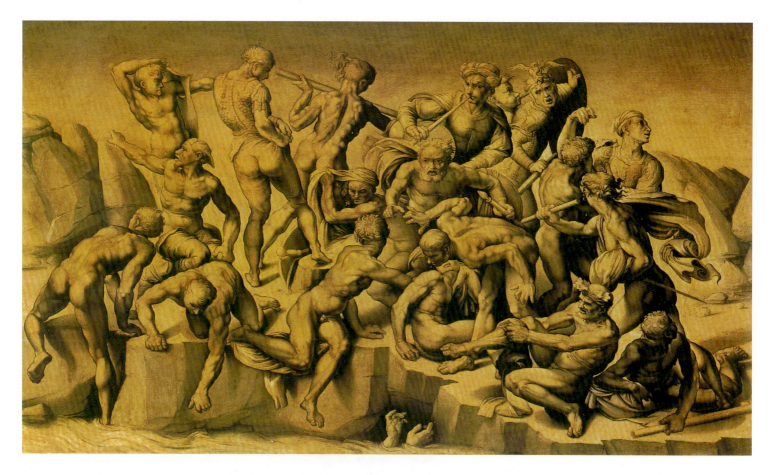

12.11

Aristotile da Sangallo, copy of Michelangelo's *Battle of Cascina*, *c.* 1542. Oil on panel, 30 × 52" (76 × 132 cm). Leicester Collection, Holkham Hall, Norfolk

a tall rectangular painting with a vertical composition of figures in a lofty architectural setting, which stands in marked contrast to Leonardo's cartoon (*see* fig. 12.5). St. Anne looks ecstatically toward the Trinity and the Scriptures emanating from heaven, while the infant St. John and other patron saints of the city and its government are arranged below.

In 1503, Leonardo received the commission to paint one of the murals, and by early 1504 the government had decided to have Michelangelo do another. The paintings, conceived on a colossal scale, were to depict two historical battles in which the Florentine Republic had been victorious against its enemies: Leonardo was assigned the *Battle of Anghiari*, in which Florentine forces had defeated Milan in 1440, and Michelangelo the *Battle of Cascina*, an episode from a war in 1364 against Pisa. The commission was a way for the Republic to create a patriotic yet also post-Medicean vision of its past, aligning itself with Republican imagery from other places. The particular episodes selected by the Florentines reflected a priority of the new Republic, representing the heroic achievement of Florentine citizens acting in a body against the enemies of the state. This was a principle advocated by the chancellor – at that time Machiavelli – who argued passionately that Florence's own citizens

should defend their city as soldiers, obviating the need for notoriously untrustworthy mercenary companies.

In the event, neither work got very far. Leonardo, perhaps as yet unaware of the quickly deteriorating condition of his recently completed *Last Supper* in Milan (*see* fig. 11.47), began to paint with a medium of linseed oil. Unable to get this to dry, he undertook extraordinary experiments, at one point going so far as to light a fire under what he had painted. After completing a small portion on the wall, he abandoned the project and returned to Milan. The mural he left was enclosed in a frame a few years later, and at mid century it still drew tourists, but Vasari then either destroyed or covered over whatever remained when he oversaw the redecorating of the room. Michelangelo's design, for its part, did not progress beyond the cartoon stage before he too left the city. Both projects are now known only from preparatory drawings that the artists made and from sixteenth-century copies after their designs, all of which record only portions of the overall compositions. The copies themselves, however, attest to the enormous influence that both works, though unfinished, ultimately had. The goldsmith Benvenuto Cellini (1500–1571) recalled half a century later that Michelangelo's cartoon had been "the school of the world," the memorization of which had become an

essential part of the education of younger Florentine artists. It appears, in fact, that the cartoon actually disintegrated from excessive handling. Some of the figures Leonardo invented for the wall, for their part, became illustrations in his posthumously assembled *Treatise on Painting*, one of the most widely studied theoretical writings on art of the later Renaissance.

The Florentine head of state who presided in the room had the title of *gonfaloniere* (standard-bearer), and the two battle scenes were related in theme: Leonardo's central event was a group of men on horses trying to retain or take possession of a standard; Michelangelo's seems to have included, in the back center, a man attempting to raise a flagpost. This implies that the two artists received at least some instruction as to what they were expected to feature. At the same time, the two frescoes had the character of competing manifestos, as if each artist had decided to emphasize the principles that most distinguished him from the other. Michelangelo designed a relief-like composition of muscular naked figures, which he spread across and above the surface rather than setting within pictorial depth. The crisp barren landscape provides nothing that would distract from the figures, each studied independently, and a body of drawings in a variety of graphic media provides a better indication than Aristotile da Sangallo's (1481–1551) painted copy of how the original cartoon might actually have looked (figs. 12.11–12.12). As false news of an impending attack interrupts their swimming, Michelangelo's soldiers rush to clothe and arm themselves – though the episode may well have appealed to the artist for just the opposite reason, the opportunity it presented to strip his figures down and show them as nudes and near nudes in a variety of poses. Throughout, he employed the most difficult foreshortenings, and figures thrust themselves into or out of the picture plane: notice the extreme torsion of the neck and waist of the seated figure at center, whose pose works formally to tie both halves of the composition together. It is difficult to imagine how any real person could have held these poses, and this may be part of the point: Michelangelo implies that he did not need live studio models. He worked on his cartoon in the Hospital of San Onofrio, where the prior provided him with cadavers for dissection. Figures like those in the *Battle of Cascina* draw attention to Michelangelo's power to move from a deep knowledge of human anatomy into a process of invention: as he fragments mortal and decaying bodies to understand their structure, he also constructs superior bodies in his imagination and in his art.

The various copies (for example fig. 12.13) give us only a partial impression of Leonardo's composition. Here, Florentine cavalry troops battle furiously to protect their flag from the Milanese forces led by the mercenary captain Niccolo Piccinino. The subject may have been assigned to Leonardo in part because of his undisputed expertise in the representation of horses, but the composition also shows his continuing interest in the rendering of extreme psychological states. His faces (fig. 12.14), largely unlike Michelangelo's, reveal inner character,

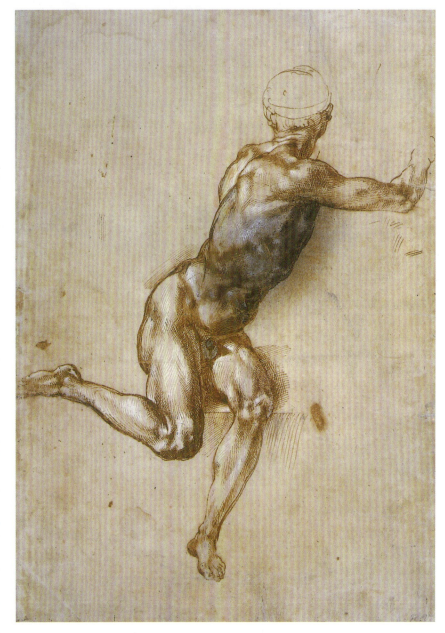

12.12
Michelangelo, study for the *Battle of Cascina*, 1504. 16⅝ × 11¼" (42.1 × 28.7 cm). British Museum, London

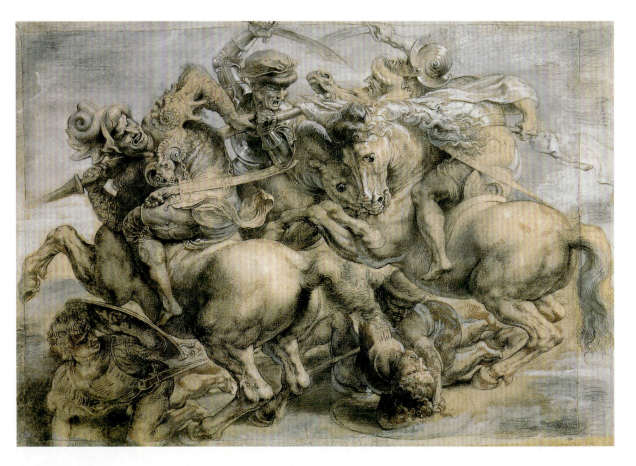

12.13
Peter Paul Rubens (?), early seventeenth-century copy after the central section of Leonardo da Vinci's *Battle of Anghiari*. Pen, ink, and chalk on paper, 17¾ × 25¼" (45 × 64 cm). Musée du Louvre, Paris. This drawing is often considered the best surviving record of Leonardo's original painting, although it must be a copy of a copy, since Leonardo's work was no longer viewable at the time Rubens arrived in Florence.

12.14
Leonardo da Vinci, study of a head for the *Battle of Anghiari*, 1503. Red chalk on paper, 9 × 7⅜" (22.6 × 18.6 cm). Szépművészeti Múzeum, Budapest

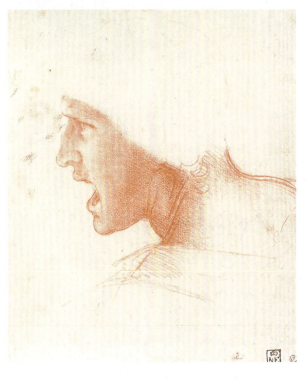

here bordering on outright savagery. The Florentine tradition of equestrian mercenary portraits – Hawkwood (*see* fig. 5.14), Gattamelata (*see* fig. 7.24), Colleoni (*see* fig. 10.23) – stands behind his characterization of the murderously violent horsemen. Drawings hint that

the setting for the picture would have included an elaborate river landscape: the most extraordinary aspect of the fresco might have been the range of coloristic and atmospheric effects that Leonardo planned. In his notebooks he wrote of a battlefield where the air was thick with smoke and dust, and where the predominant colors in the dusky light were the fiery red of the torches and of human blood pounded into mud. All of this would have been rendered through films of transparent paint that would have unified the figures and integrated them with their landscape. The effect of this emphasis on setting and atmosphere could not be more different from that planned by Michelangelo, whose sculptural figures were to be clearly visible, painted in the bright colors of true fresco.

Leonardo adorned both his Florentines and his mercenaries with fantastical armor that imitates the body parts of animals. The analogy between the human and animal condition appears to have particularly engaged him here, where horses fight vigorously alongside the warriors. In his notebooks, however, Leonardo expresses greater sympathy for the innocence of animals and disgust at human beings' barbarous appetite for destroying themselves and other living creatures. In his eyes, human beings were devourers of their fellow men:

[There is a] supreme form of wickedness that hardly exists among the animals, among whom are none

that devour their own species except for lack of reason (for there are insane among them as among human beings though not in such great numbers). Nor does this happen except among the voracious animals as in the lion species and among leopards, panthers, lynxes, cats and similar creatures, which sometimes eat their young. But not only do you eat your children, but you eat father, mother, brothers and friends; and this even not sufficing, you make raids on foreign lands and capture men of other races and then after mutilating them in a shameful manner you fatten them up and cram them down your gullet.

Leonardo's de-idealizing view of human nature corresponds with that of Machiavelli, who was managing Florentine diplomatic relations with Cesare Borgia in these years.

Motions of the Body and Motions of the Mind: *Leda* and *Mona Lisa*

Two other works made by Leonardo in this decade were destined for an extraordinary afterlife. One, *Leda and the Swan*, which was lost or destroyed after the artist's death, is known only through copies (fig. 12.15) and through preliminary drawings (fig. 12.16). The mythological tale of the god Jupiter taking on the form of a swan to seduce a mortal woman, and of the birth of their offspring (who included Helen of Troy and the twins Castor and Pollux) from eggs, probably appealed to Leonardo for its mingling of the animal, the human, and the divine. His image popularized a kind of extreme pose (one that Cosmè Tura had already used for the pagan gods in his *Annunciation* for Ferrara Cathedral; *see* fig. 8.7) that would come to be known as the *figura serpentinata*: this was because the upward-spiraling twist of the figure, who bends her hips while rotating her shoulder, resembles the fluid motion of a serpent. It was left to Michelangelo and Raphael to explore the full potential of such a figure – Michelangelo was already quoting the *Leda* in one of the nudes of the *Doni Tondo* (*see* fig. 12.9).

The other work is the portrait now generally known as *Mona Lisa* (fig. 12.17). The painting has become a byword for the romantic cult of enigma around the persona of Leonardo da Vinci, but the main historical problem with the work is less the figure's "mysterious smile" than her historical identity. The painting was first noted in France in 1517 as "a certain Florentine lady, made from nature at the instigation of the late magnificent Giuliano de' Medici." Vasari, who in 1550 discussed the portrait without ever having seen it, declared her to be the wife of Bartolomeo del Giocondo, a silk merchant involved not with the Medici but with the Republican

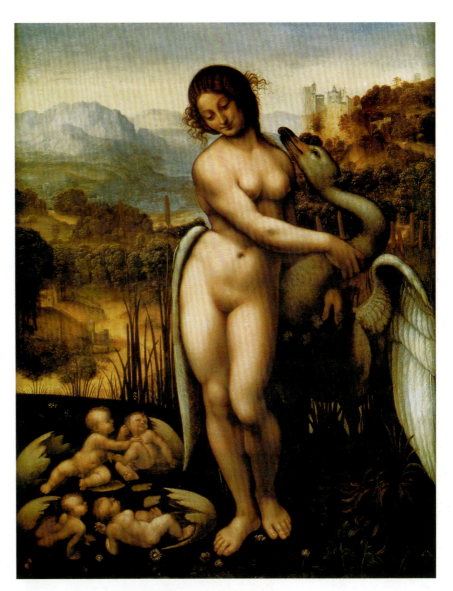

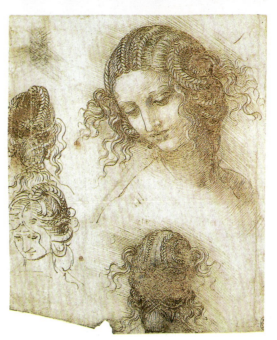

ABOVE

12.15

Cesare da Sesto after Leonardo da Vinci, *Leda,* **1504–09.** Oil on panel, 38 × 29" (96.4 × 73.6 cm). Pembroke Collection, Wilton House, Salisbury

LEFT

12.16

Leonardo da Vinci, study for the head of Leda, **1505–10.** 6⅜ × 5⅞" (17.7 × 14.7 cm). Royal Library, Windsor

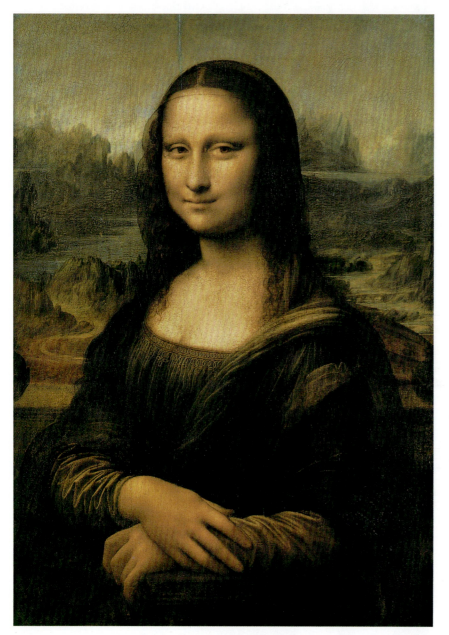

12.17
Leonardo da Vinci, *Mona Lisa,* **1503.** Oil on panel, 30⅜ × 20⅞" (77 × 53 cm). Musée du Louvre, Paris

The question of identity may finally be irrelevant, since instead of delivering the portrait to a client, Leonardo kept it in his possession, displaying it in his studio until the end of his life as a demonstration of his art. If earlier portraits had relied on emblematic imagery – a symbolic juniper bush, for example, or an ermine – to identify and characterize the sitter, here Leonardo added nothing more than a landscape, one that relates more to his notebooks and to the studies he made on his travels than to the historical Lisa Gherardini. The brownish tonality that suffuses the scene was probably not what Leonardo left: over the centuries the picture was re-varnished more than once, and the Louvre promises that it will never be "cleaned." Yet it is clear that Leonardo was aiming to shroud his figure with transparent layers in a way that he had never done in his previous portraits, as if the veil through which we see the top of her forehead and her hair were a double for the films of atmosphere through which we see the distant mountains, or the thin shadows that model her face. Leonardo seems even to extend the idea of semi-transparency to expression itself. If, when preparing his *Last Supper* (*see* fig. 11.47), he was writing of how the painter could reveal the "motions of the mind" through countenance and gesture, here he gives us an unprecedented sense of the interior person, even as it is hard to specify just what is happening in this woman's head. It is as though Leonardo wanted the central experience of seeing the picture to be that of knowing that one is being looked at by another thinking being. How far this is from the unresponsive, idealized profiles that had predominated in Florence just three decades earlier!

Raphael's Beginnings

In 1504, an enterprising young painter from Urbino arrived in Florence. Although only twenty-one years old, Raphael (Raffaello Sanzio; 1483–1520) was already well established as a maker of altarpieces and small devotional pictures. Trained initially by his father, a painter to the Urbino court who had died in 1494, Raphael formed an occasional association with Perugino, an artist much in demand not only in Florence but also in his native Perugia. The *Marriage of the Virgin* (fig. 12.18), which Raphael painted for the Albizzini family chapel in San Francesco in Città di Castello (a city near Urbino) in 1504, shows the apocryphal story according to which a group of suitors to the Virgin brought rods to the temple priest; Joseph's staff flowered, indicating his divine selection. The painting catered to a market that Perugino had established, and with it Raphael aimed to surpass the older painter in the very area in which he excelled. He not only draws

government that had kept them in exile. Vasari's identification is now generally accepted, and other sources reveal that Giocondo's wife "Monna Lisa" (i.e. Madonna, or Lady Lisa) was named Lisa Gherardini: she was still alive when Vasari wrote his account. In 1503, the year in which Giocondo and his family moved into a new house in Florence, the twenty-four-year-old Lisa gave birth to their fourth child, a boy: either of these circumstances could have led to the commissioning of a portrait, and by Giocondo himself rather than by Giuliano de' Medici. By mid century there were thus two traditions of identifying the sitter – one Medicean and one anti-Medicean – a division that points to the fundamental dilemma of Florentine identity in the 1500s.

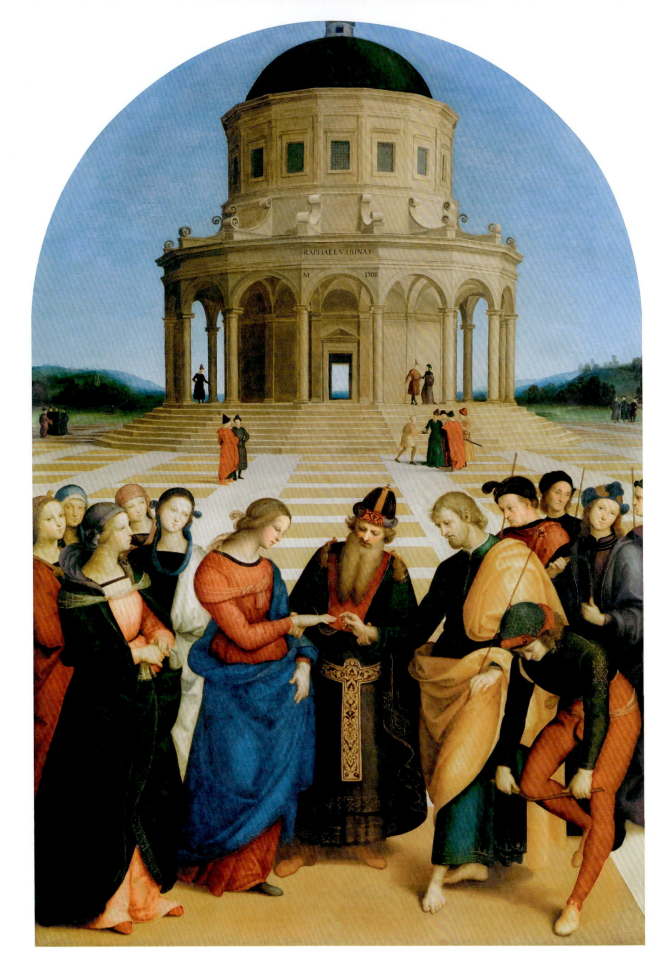

12.18
Raphael, *Marriage of the Virgin*, 1504. Oil on panel, 67 × 46½" (1.7 × 1.17 m). Pinoteca di Brera, Milan

355

RIGHT

12.19

Raphael, *Agnolo Doni,*
c. 1506. Oil on panel,
24½ × 17¼" (63 × 45 cm).
Galleria Palatina, Palazzo
Pitti, Florence

FAR RIGHT

12.20

Raphael, *Maddalena*
Strozzi Doni, c. 1506. Oil
on panel, 24½ × 17¼" (63
× 45 cm). Galleria Palatina,
Palazzo Pitti, Florence

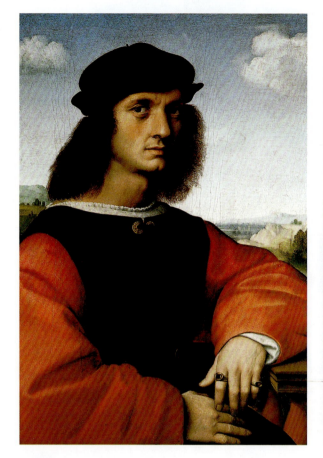

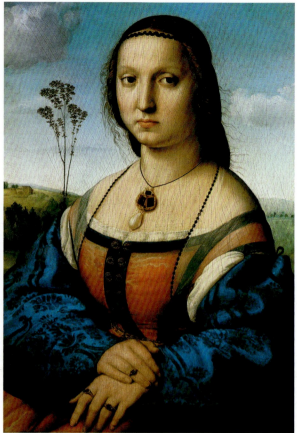

on Perugino's rich and glowing color, but also employs the compositional formula Perugino had first used in his Sistine Chapel *Charge to Peter* (*see* fig. 10.35), with its horizontal frieze of figures arranged in front of a vast paved piazza, in the midst of which rises a centralized temple with a dome. It would be easy to mistake some of Raphael's figures for Perugino's, and Raphael followed the older artist in his habit of repeating elements within a single picture: note the resemblance between the face and placid expression of the man in a black robe looking out at the viewer's right and that of the woman behind the Virgin to the left. But whereas in Perugino's group of figures there is little to disturb the sense of symmetry, Raphael has introduced an element of carefully planned disarray. Readers of Alberti's *On Painting*, who certainly included Raphael, would have recognized the young artist's concern with *varietà* (variety), which Alberti had considered essential to good painting. The priest's head is slightly off the central axis; one of the rejected male suitors to the right departs from the static assembly to balance on one leg and break a staff over his raised knee.

It was probably through Perugino that Raphael became acquainted with the leading artists of Florence, Leonardo among them, as well as with a group of wealthy clients that included Agnolo Doni, the same wool merchant who ordered the *tondo* from Michelangelo (*see* fig. 12.9). The marriage portraits that Raphael painted for Agnolo and his wife Maddalena around 1506 (figs. 12.19–

12.20) show the earliest impact of the *Mona Lisa* (*see* fig. 12.17) on traditional portraiture. Raphael paid particular attention to the role of the hands in Leonardo's painting, exploring the possibility of using hands not just to create formal variety but also to enrich the sense of interaction with the beholder. While Agnolo regards us calmly, his hands seem to fidget restlessly, imparting a slight sense of unease; this again invites speculation about the thoughts betrayed by the face, with its furrowed brow. Maddalena rests one hand on top of the other, self-consciously and even self-protectively. Where Raphael departed from Leonardo's example, perhaps at the patron's request, was in his simultaneous use of the hands to display the wealth and status of the family, in the form of their jeweled rings. The need to render precious objects like this, or like the enormous, eye-catching pearl that hangs around Maddalena's neck, is one reason why Raphael resisted Leonardo's *chiaroscuro* and his *sfumatura*, which would have excessively subdued the color needed to convey the preciousness of what Raphael was depicting. Far more than the *Mona Lisa*, the portrait of Maddalena conveys social meanings. This extended to the sitter's beauty, a valued attribute of young women of Maddalena's class. To make Maddalena appear more comely, Raphael relied on a process of abstraction: the contours of the shoulders and breast assume a highly artificial oval appearance, and so does the head onto which her large features are somewhat uncomfortably imposed.

Raphael quickly learned to absorb all that was new and most valued in recent Florentine art. His study of Leonardo is evident not just in the Maddalena Doni portrait, but also in a drawing he made after Leonardo's *Leda*. The paintings most characteristic of Raphael's Florentine years were a series of private devotional images of the *Virgin and Child*, several also including the infant St. John, in which he responded to Leonardo's *Virgin and Child with St. John and St. Anne* (*see* fig. 12.5). In 1505–06, Raphael painted the so-called *Madonna of the Meadow* (fig. 12.22) for Taddeo Taddei, a merchant of refined literary and artistic tastes with connections at the court of Urbino. Here Raphael modeled the Virgin on her counterpart in Leonardo's cartoon, adapting especially his treatment of the head and expression; although the downcast eyes of Raphael's figure establish a more wistful mood, as if she realized that Christ's gesture, grasping the prophet John's cruciform staff, hinted at her child's impending death. The three figures interlock to form a unity that could be circumscribed by a pyramid, in accordance with the two artists' common interest in uncovering the underlying geometric logic in nature. Raphael, though, has again taken this even further than Leonardo, abstracting the Virgin's shoulders and breasts into a spheroid form, and extending the figure's right leg across the front of her body. Anatomical distortion does not impair a sense of harmony, of things fitting together; nor do abstraction and idealization undermine the emotional tenor of the work, which, with its caressing hands

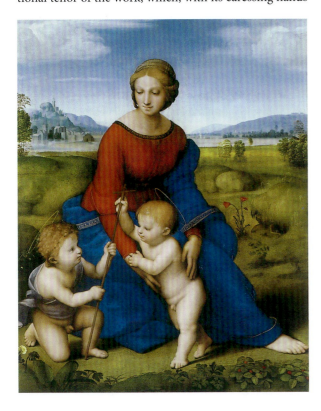

and soft infant flesh, solicits sentiments of tenderness from the beholder.

Activating the Altarpiece: The Perugia *Entombment of Christ*

While working in Florence, Raphael received only one altarpiece commission from a local client, and he never completed it. He did continue, nevertheless, to supply such works for other centers outside Florence, including Siena, Urbino, and Perugia, and it was for this last city in 1507 that he executed the first altarpiece to draw on the new art he was seeing, an *Entombment of Christ* (fig. 12.21) that he made for a chapel of the Baglioni family in the church of San Francesco al Prato in Perugia. The patron, Atalanta Baglioni, commissioned the painting in atonement for violent feuding among the male members of her family, mainly instigated by her own son, who had himself been killed after he had murdered various relatives. The patron's experience would have lent special meaning to the subject of the Virgin's farewell to the dead Christ. The commission elevated Atalanta's personal history, the events that shaped her identity, to a level of universal significance, articulating them through one of the great narratives of the Gospels. Recognizing this, Raphael made the unprecedented decision to treat the altarpiece as an *istoria*, a scene of figures performing an action, rather than as a static, iconic subject.

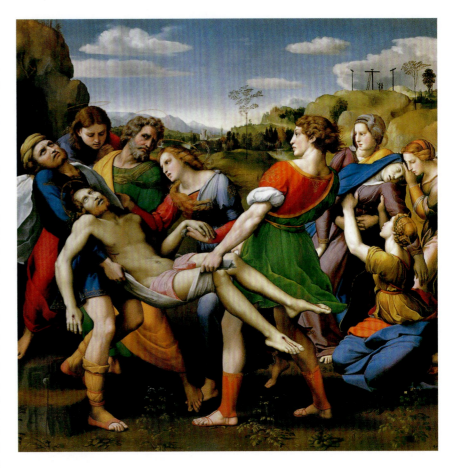

12.21

Raphael, *Entombment of Christ*, 1507. 6' × 5'9" (1.84 × 1.76 m). Pinacoteca, Vatican

LEFT

12.22

Raphael, *Madonna of the Meadow*, 1505–06. Oil on panel, 44½ × 34¼" (113 × 87 cm). Kunsthistorisches Museum, Vienna

Early designs for the altarpiece show a Lamentation group very close to treatments of the subject by Perugino, with the figure of the dead Christ laid out on the ground and surrounded by quietly sorrowing figures. The compositional idea changed, however, when Raphael began thinking more carefully about Mantegna's great engraving of the *Entombment* (*see* fig. 10.7). Raphael's father Giovanni Santi had been an admirer of Mantegna, and he would certainly have trained his son to study the Paduan artist's prints. The death of Mantegna the previous year, furthermore, may have led Raphael to conceive the work as something of a homage. The reference to the print is unmistakable: fellow artists and even non-artists would have spotted it. They would have noted in particular how Raphael transformed Mantegna's design, making it his own. Mantegna provided the idea of the composition in two episodes: the Virgin faints and her attendants support her; two bearers, accompanied by the sorrowing Magdalene, take the body of Christ to the sepulcher. Off in the left background, the cross from which the body came is visible on a hill. Raphael does not repeat a single figure from Mantegna; the closest is the man bearing Christ's upper body. Instead, he introduces a series of adaptations of figures from works by Michelangelo: the dead Christ is close to the Christ in the St. Peter's *Pietà* (*see* fig. 11.52), the woman who turns to support the Virgin is a variation on the turning Virgin in the *Doni Tondo* (*see* fig. 12.9), and the young man in profile recalls draw-

ings made by Raphael after Michelangelo's *David* (*see* fig. 12.3), where he modified the proportions of the head and the hands and altered the pose so as to give more flowing elegance to the line. The one thing that remains from Perugino's treatment is the color; just as Raphael had earlier avoided Leonardo's desaturated *chiaroscuro*, so here does he avoid the shrill, metallic hues of the *Doni Tondo*, with their white highlights and dark shadows.

That he took a narrative print as the basis for an altarpiece suggests Raphael had absorbed the compositional procedure that Alberti had laid out in *On Painting*. This text was not yet easily accessible to all, since it circulated in these years only in manuscript, but Raphael's practice leaves little doubt that he knew it well. Alberti had demanded that artists pay particular attention to the convincing representation of the dead, citing the very Meleager relief that Mantegna had probably used as a model for his own print. He had also written that the ideal number of figures in an *istoria* was ten, exactly the number Raphael includes. Finally, Alberti had advocated the method of composing bodies that we saw to be of particular interest to Luca Signorelli (*see* figs. 11.25–11.30), one that would have acquired a new resonance at a time when Leonardo and Michelangelo were known to practice human dissection, first sketching in the bones, then adding the sinews and muscles, flesh and skin. In conceiving the figure of the fainting Virgin, Raphael did precisely this, using a skeleton for his first studies (fig. 12.23).

Rome: A New Architectural Language

The temple in the background of Raphael's *Marriage of the Virgin* (*see* fig. 12.18) points to the artist's close connection with another expatriate (perhaps even a relative) from Urbino, the painter-architect Donato Bramante (1444–1514). Raphael may have known something of Bramante's dialogue with Leonardo at the court of Milan, but he would have been even more aware of the new architectural language Bramante developed after his move to Rome in 1499.

At first, Bramante supported himself there by working for Pope Alexander VI, though few of the things he produced in these years survive intact. In 1502, however, through agents of King Ferdinand and Queen Isabella of Spain, he gained an opportunity to translate his Milanese experiments with centralized architecture to a remarkable new purpose. His "Tempietto," or "Little Temple," is a miniature church, really a freestanding chapel, designed to mark the alleged site of St. Peter's crucifixion in the monastery complex of San Pietro in Montorio (fig. 12.24). The building combined the most basic geometric elements

12.23
Raphael, study for *The Entombment, c.* 1507. Ink on paper, 8¼ × 12⅜" (20.9 × 32 cm). British Museum, London

(two cylinders with a hemisphere) in the simplest proportions (the ratio of the cylinders is 1:2) to make a work that is monumentally self-sufficient despite its small scale. The Tempietto draws on ancient building types – there were several small Roman temples where a **peristyle** or ring of columns surrounded a cylindrical chamber – but the two-storey design is Bramante's invention and shows his modernity, his adaptation and translation of antiquity. The more pronounced verticality that results gives the building a heavenward orientation, providing a symbolic axis that links the site of the saint's death – the chapel preserved the hole in which Peter's cross was set – with the place of his immortal existence. As originally designed, the building was supposed to occupy the center of a round courtyard framed by another ring of columns: this indicates that Bramante, like Leonardo, had studied the remains of Hadrian's Villa at Tivoli near Rome, where the so-called Marine Theater also consists of a round structure encircled by an outer peristyle. Combined with the three shallow steps, Bramante's completed design would have conveyed the impression of a building extending its supremely refined form outward in space. Particularly influential was his exemplary use of one of the Roman orders: in this case, the Doric. Bramante was motivated by a concern to express the nature of the saint: writers on architecture regarded the Doric order as having masculine characteristics – robust proportions, relative plainness of ornament. Like Leonardo, Bramante would have held the conviction that the forms of ancient architecture in their geometric purity bore a fundamental relation to the perfectly proportioned human body.

The entablature, carefully scaled to the columns, signals once more the extent to which the Tempietto set out to be a model of Christianized antiquity: the **triglyphs** (the beveled, grooved sections of the frieze) align with the columns, as they should according to Vitruvian rules, but the **metopes** (the square panels between these) are adorned with images of liturgical objects.

The New St. Peter's

The Tempietto was scarcely begun in 1503, the year in which Cardinal Giuliano della Rovere, the nephew of Sixtus IV, became Pope, calling himself Julius II. The name, which everyone recognized as having more to do with Julius Caesar than with an early Pope named Julius, reveals political ambitions on an imperial scale. Giuliano's papal commissions recognized no difference between the public and private: ostentatious works dedicated to the glory of the papacy and the Church were also monuments of self-celebration, with no expense spared. Even large-scale, public projects for the city would bear his personal stamp: an example is the new street that was

laid out to link the Ponte Sisto with the Ponte Sant'Angelo, named the Via Giulia after the Pope himself.

The two most celebrated works of the pontificate of Julius II in many ways owe their existence to a third project that was never completed as he planned. Just as Julius, in the days when he was still a cardinal, had overseen the commissioning of Antonio del Pollaiuolo's bronze memorial for Sixtus IV (*see* fig. 10.25), so now in March 1505, scarcely two years after becoming Pope, he enlisted Michelangelo to design for him an even grander marble tomb.

According to Michelangelo's early biographers, the tomb was originally conceived as a gargantuan, multistorey, freestanding structure, with more than forty larger than lifesize marble statues. It was to be installed, like the tombs of Sixtus and most other popes, in St. Peter's basilica. But the scale of Michelangelo's plan soon led to doubts that the great basilica would be adequate to contain it while still allowing for its other ceremonial and religious functions. At first, Julius considered an extension of the building along the lines proposed the previous century by popes Nicholas V and Paul II, but by the summer of 1505 he had begun to contemplate a more drastic

12.24
Donato Bramante, "Tempietto," cloister of San Pietro in Montorio, Rome, begun 1502

ABOVE LEFT

12.25

Giuliano da Sangallo, proposed plan for New St. Peter's, 1505. Ink and wash on paper, 16⅛ × 15⅝" (41 × 39.7 cm). Gabinetto Disegni e Stampe, Uffizi Gallery, Florence

ABOVE RIGHT

12.26

Donato Bramante, project drawings for New St. Peter's, 1505. 16⅛ × 15⅝" (41 × 39.7 cm). Gabinetto Disegni e Stampe, Uffizi Gallery, Florence.

The drawing on the other side of the page (fig. 12.25) is visible through the paper, and Bramante seems to have used that as a starting point for the chalk sketches here.

BELOW LEFT

12.27

Donato Bramante, "graph-paper plan" for New St. Peter's, 1505. Ink on paper, 27 × 18½" (68.4 × 47 cm). Gabinetto Disegni e Stampe, Uffizi Gallery, Florence

BELOW RIGHT

12.28

Donato Bramante, "parchment plan," (Uffizi 1) for New St. Peter's, 1505. Gabinetto Disegni e Stampe, Uffizi Gallery, Florence

alternative: the complete demolition and rebuilding of the church. Old St. Peter's, which had been built in the fourth century over a venerated cemetery, was a focal point of European pilgrimage; most of the Christian world regarded its very fabric as sacred. Members of the Curia (papal court) were appalled at the Pope's idea, but Julius dismissed their protests with the insistence that the ancient building was in a serious state of disrepair. A line of defense taken up by the Pope's secretary, the humanist Sigismondo de' Conti, is particularly significant, and shows that the new sense of history entailed no uncritical reverence for the past. Conti argued that the old building, however grand and majestic, was aesthetically unworthy, having been built in an age that "had no idea of beauty and refinement in architecture." He regarded the present in which Julius and his court lived, in other words, as a time of renewal and of progress, a moment that reversed a long period of decline dating back to late antiquity. A few years later, a letter addressed to the Pope and bearing Raphael's name would make the same argument about art's decay in antiquity still more forcefully, and Vasari, around mid century, would give the idea of art's revival in modern times – a version of the myth of the "Renaissance" – its most influential form.

The most radical early suggestion for the new basilica seems to have come from Giuliano da Sangallo (*c.* 1443–1516), an architect who had been in Julius's service for more than a decade. (Sangallo, who had supervised the movement and installation of Michelangelo's *David*, came from a family of Florentine artists that would include his nephew, the painter Aristotile; *see* fig. 12.11). A drawing preserved in the Uffizi appears to show Sangallo reacting to the kinds of centrally planned designs that had appeared in Perugino's and Raphael's paintings and that Bramante, with his Tempietto, had been the first to realize in three dimensions (fig. 12.25). It proposes a perfectly square new church, conceived as a series of interlocking Greek crosses with towers in the four corners. The large piers indicate that the roof Sangallo envisioned would have been much heavier than the wooden trusses that the columns and walls in the original church supported – presumably a group of masonry domes, connected by barrel vaults. Most remarkable is that the north and south halves of the design are not only mirror images of one another, but also identical with the east and west halves: the drawing's multiple inscriptions add to the impression that it has no "correct" orientation.

Somehow the drawing fell into Bramante's hands, and his reaction to it was as surprising as it was forceful. Turning the sheet over, he traced Sangallo's proposal in a rough sketch. He then proceeded to transform the drawing in ways that provided both a critique and a new suggestion of his own (fig. 12.26). Where Sangallo had largely flat walls on all four exteriors, Bramante punched through these, creating what would have looked more like a traditional apse on the west end of the building and two siblings to this on the north and south sides. At the east end (the right side of the illustration), he rejected Sangallo's enclosure altogether, and extended three of his predecessor's Greek-cross forms to the edge of the sheet, essentially transforming them into a more traditional nave and side aisles. Remarkably, the architect whose name would in 1505 have been virtually synonymous with the centrally planned Christian building in Rome seems to have taken a stand against it when it came to St. Peter's.

Bramante pursued further experiments: in one of these, the so-called "graph-paper plan," he juxtaposed the plans of Old St. Peter's, the Nicholas V extension, and his own Sangallo adaptation, in an apparent attempt to reconcile features of the old basilica with the new design (fig. 12.27). Finally, in a drawing now known as Uffizi 1, he arrived at a simpler, more consolidated, and generally bolder idea (fig. 12.28); that he rendered this final idea with particular care on expensive parchment suggests that this was for presentation directly to the Pope. Flanking a great choir are two spaces in the form of Greek crosses – Bramante has now reconciled himself at least with these motifs, even if he minimized the masonry to provide for airier spaces. For one standing inside, the walls would barely have resembled walls at all, as they broke into a series of stepped indentations, recessed into niches, or opened into other areas. The massing indicates that they would have supported domes, much like those shown on Caradosso's foundation medal from the same year (fig. 12.29), and there is enough at the bottom of the drawing to hint that the central feature of the

12.29
Caradosso, portrait medal of Julius II: reverse, showing project for New St. Peter's, 1506. Diameter 2¼" (5.6 cm). Civiche Raccolte Archeologiche e Numismatiche, Milan

basilica would have been a much larger dome rising over the crossing. What Bramante does not tell us with this drawing – or rather, what he did not tell the Pope – was whether the building, when completed to the east, would be a mirror image of the portion represented in the plan, or whether the result would have a nave and look like a more traditional basilica. Perhaps he was hedging his bets here. Or perhaps he realized that this did not need to be decided in order for work to proceed. Demolition could start at the apse of Old St. Peter's, builders could begin construction on the choir, and Bramante could let his followers worry about what to do next.

Another reason why Bramante may have concentrated his proposal on the choir is because this is where Michelangelo's new tomb of Julius II was to go, on axis with the tomb of St. Peter himself to the east. Michelangelo, preparing for this project, spent much of 1505 in Carrara, supervising the quarrying of marble for the sepulcher. This was itself a hugely costly enterprise, since the marble had to be transported by river and by roads, some of which had to be newly built. One entire shipload of material was lost in the Tiber. Then, on returning to Rome in 1506, the sculptor learned that the tomb project had been cancelled. This probably resulted from the need to divert funds to Julius's wars, but Michelangelo, believing that Bramante had conspired against him, went back to Florence in disgust. Alarmed at the consequences of angering the Pope, the Florentine government sent him to plead for forgiveness at Bologna, which Julius II had conquered in 1506. The artist traveled north, was reconciled with the Pope, and then executed a colossal bronze portrait of Julius to commemorate his triumph over the subjected city – a work that the Bolognese would destroy when they regained their independence. Back in Rome in late 1508, Michelangelo found no revival of interest in the tomb he had started. Instead, the Pope had decided to encumber him with a project for which the artist professed no enthusiasm: the redecoration of the vault of the chapel built in the 1480s by Julius's uncle, Pope Sixtus IV.

The Sistine Ceiling

The Sistine Chapel, no less than St. Peter's, was an already completed work when Pope Julius II turned his attention to it (*see* figs. 10.30–10.36). In addition to the murals on the walls, it had been furnished with a vault decorated to signify the cosmos above, with gold stars on a blue ground. In 1504, a large crack had appeared in the vault, providing an occasion for repainting and – in the eyes of Julius – an opportunity for modernization. Julius at first wanted a scheme with twelve Apostles, and one of Michelangelo's first drawings for the project showed a

seated figure in a spandrel between two of the vaults, with smaller, geometrically regular fields above for less significant images. Early sources also indicate that the ceiling was to feature panels of grotesques, but Michelangelo, reconciling himself to several years of work on the fresco, persuaded the Pope to allow him to try something more ambitious. The result was the astonishing composition that Michelangelo finally completed in 1512. As Vasari later put it, the painter "used no rule of perspectives in foreshortening, nor is there any fixed point of view, but he accommodated the compartments to the figures rather than the figures to the compartments." In other words, Michelangelo abandoned the conception of the picture as something figures occupy, and instead made the figure the primary structural unit, such that the bodies in Michelangelo's ceiling seem at once to be in as well as on the partly fictive, partly real architecture. The frequent shifts in orientation, level of illusion, and scale – including, for example, nudes that appear at once to sit gravely on pedestals and to defy the gravity of the vault over our heads, and that hold medallions bigger than the fictive marble figures below them – are dizzying. To see everything that is happening, the viewer has to turn constantly, even as he proceeds down the nave.

In painting the ceiling, Michelangelo could not have seen anything like what the viewer sees looking up at it

RIGHT

12.30

Michelangelo, sonnet with caricature, 1509–10. 11⅛ × 7⅛" (28.3 × 20 cm). Biblioteca Medicea Laurenziana, San Lorenzo, Florence

OPPOSITE

12.31

Sistine Ceiling, general view with vault frescoes by Michelangelo, 1508–12. Vatican

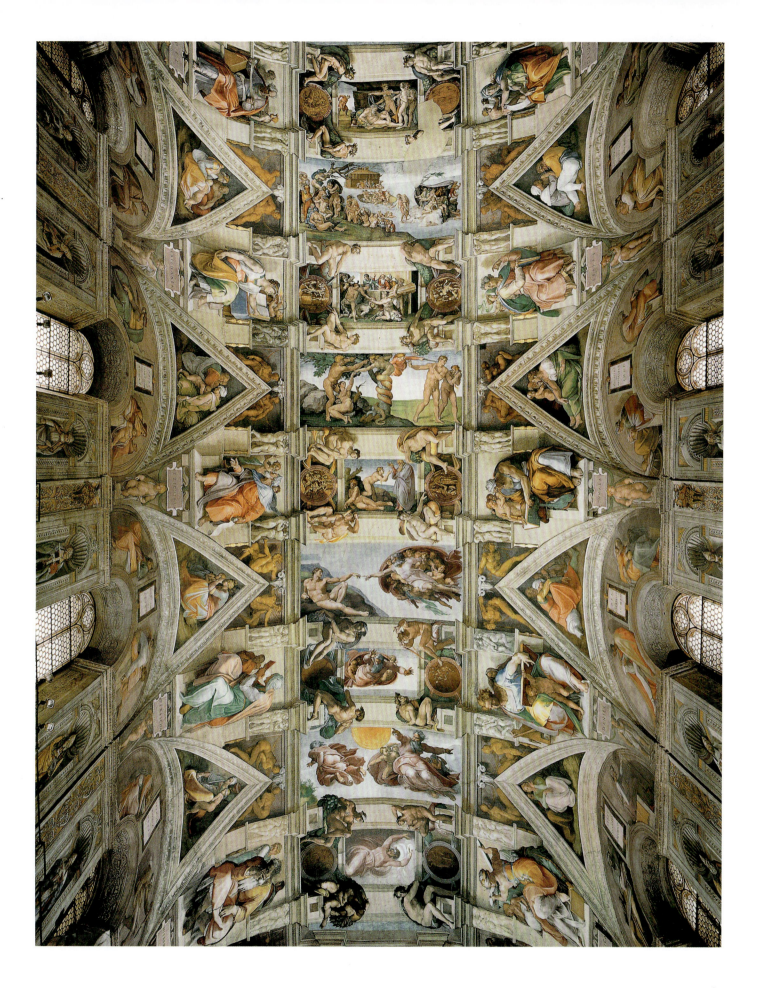

from the floor below: he had to remain elevated on an elaborately constructed scaffolding, bending over backward and painting figures that were often much, much larger than his own body, but which he could see only face-to-face. He wrote about the hardships in a poem, describing how, with his beard pointed up to heaven, his body became uncomfortably distorted and paint dripped down on his face. In this condition, he went on, he could not properly judge what he was doing: "the thoughts that arise in my mind are false and strange, for one shoots badly through a crooked barrel." Besides, he wrote, he was not even really a painter. In the margin of the poem, Michelangelo drew an image of himself in a tortured pose, slashing a monstrous creature onto the ceiling above him (fig. 12.30). The gesture the painter makes there evokes that of the God who creates the world in Michelangelo's Genesis scenes; what this twisted artist renders, however, bears little resemblance to the beauties Michelangelo in fact produced. This owes much to his extensive use of cartoons, full-scale drawings that let him work out each of his figures on paper, then trans-

fer them to the plaster surface. These show, among other things, that Michelangelo conceived even his draped figures initially as nudes, and that he studied male bodies to render female ones – two reasons why all of the bodies he included seem so powerful.

This is not to say that the paintings in the Pope's chapel were just about their painter. In the Sistine frescoes, Michelangelo aimed to demonstrate art's capacity to represent and even reveal Christian principles. This was possible because of a rare confluence of interests between the artistic and theological cultures of the papal court, especially concerning human nature and the human body. The preachers in the Sistine Chapel delivered sermons in elegant Latin modeled on the Roman orator Cicero, extolling the dignity of man as the image of God and the glorification of human flesh in Christ's incarnation. This was a significant departure from a long-established tradition, one that went back to the early Christian "Church Fathers," vilifying the body as a prison of the soul. St. Augustine (354–430 CE), in particular, had taught that the body, designed by God

12.32
Michelangelo, Sistine Ceiling, detail: *The Creation of Adam.* Fresco. Sistine Chapel, Vatican

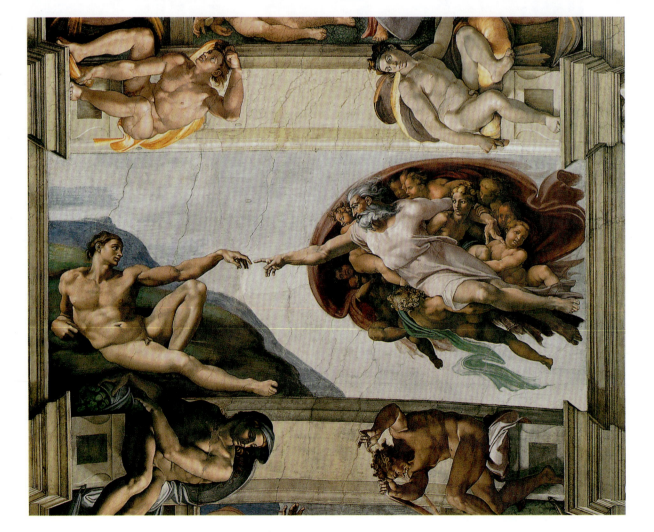

as the soul's instrument, became mortal, imperfect, and irrational through the sin of Adam and Eve, which led the soul to sin and damnation. Christian humanists around 1500, by contrast, began to see the body's beauty as a mirror to the soul's perfection. One or more of these learned men from the papal court would have advised Michelangelo on what scenes and figures to include, and how to interpret them, although the artist, a reader of Dante's poetry, probably had a good layman's grasp of scriptural interpretation.

Like the scenes from the 1480s on the walls below, Michelangelo's images all come from the Bible, but rather than simply illustrating episodes from Genesis, Kings, and Maccabees, the ceiling frescoes reconcile Jewish Scriptures with Christian teaching. On the ceiling's central axis, a series of nine narrative scenes shows events from the Book of Genesis (fig. 12.31). These begin over the altar with God separating light from darkness, crea-ting the sun and moon, and separating sea and sky. They continue with a triad of scenes treating the creation of Adam (fig. 12.32) and Eve, their temptation and disobedience, and their exile from Paradise, and conclude with three episodes representing the tragic and violent course of history after the Fall of Man. Though the Jews worship God with animal sacrifice, an angered Lord nonetheless sends the deluge that destroys all of humanity except the pious Noah and his family, who protect other living species in the ark. The final scene shows the Drunkenness of Noah, mocked by one of his sons, who will in turn be punished for his transgression (fig. 12.33). In the four corners of the ceiling, Michelangelo depicted

episodes from the history of the Jewish people, all of them dealing with themes of violence and retribution. In *The Brazen Serpent*, God punishes his people by sending a plague of serpents (fig. 12.34); they are healed only when Moses, commanded by God, raises a bronze effigy of a snake upon a staff. Two well-known Biblical heroes, David and Judith, appear here as instruments of justice over the enemies of the chosen people. Finally, Esther, the Jewish wife of King Xerxes of Persia, intervenes to secure the punishment by crucifixion of Haman, who conspired to have the Jews of Persia exterminated (fig. 12.35).

As with the earlier Moses and Christ cycles below, the coherence of which depend on the Christian reading of the Old Testament as a collection of "typological"

TOP
12.33
Michelangelo, Sistine Ceiling, detail: *The Drunkenness of Noah*

ABOVE
12.34
Michelangelo, Sistine Ceiling, detail: *The Brazen Serpent*

12.35
Michelangelo, Sistine
Ceiling, detail: *The
Crucifixion of Haman*

BELOW LEFT
12.36
Michelangelo, Sistine
Ceiling, detail:
*Ancestor Group (Ozias,
Ioatham, Achaz)*

BELOW RIGHT
12.37
Michelangelo, Sistine
Ceiling, detail: *Ancestor
Group (Roboam, Abias)*

predictions related to the coming of the Virgin, Christ, and the Church, so here do the frescoes refer forward in time: each is a type, at once the likeness and the antithesis of the "antitype" that would come after it. All four corner pendentives are antitypes of Christ and the Virgin: Haman, crucified for the good of the chosen people, is the precursor of Christ's Crucifixion, which offers redemption to everyone; so too is the brazen serpent. The same relationship explains the prominence of Michelangelo's Tree of Knowledge, the instrument of man's damnation; it, too, prefigures the Crucifixion, the instrument of his salvation. The newly created and sinless Adam (*see* fig. 12.32) is echoed in Noah, the figure of fallen mankind (*see* fig. 12.33). The fact that Noah's ark looks like a

modern building – indeed, like the Sistine Chapel itself – implies that the salvation Michelangelo represented was like that which the Christian would find when entering such a space.

The need to link the time of the Old Testament with the time of Christ (and after him, the popes) explains the eventual decision not to include Apostles in the spandrels and instead to show characters who would more clearly announce a great historical transition. In the lunettes above the windows, Michelangelo painted the passing generations before the coming of Christ; in the eight pendentives above the lunettes, the ancestors of Jesus Christ (fig. 12.36 and 12.37). Michelangelo's depictions of family groups here are a tour de force: it is as

though he has realized that Leonardo and Raphael had both regarded variations upon the Holy Family theme as a kind of test of their inventive powers, and showed that he could outdo them with a sequence that avoids any repetition. Still, when compared to the Holy Family group of Michelangelo's own *Doni Tondo* (*see* fig. 12.9), the pendentive figures have a brooding and melancholy character, devoid of the flow of energy that linked his Holy Family both emotionally and formally. The theme of listless waiting, of unconsciousness to historical destiny, of preoccupation in mundane tasks or in outright personal folly, is manifest even more in the family pairings of the lunettes, where couples are so absorbed in themselves that they seem oblivious to each other. Such, the ceiling implies, is the condition of the Jewish people as they wait for the Messiah.

In sharp contrast with the melancholy ancestors of Christ are the impressive enthroned men and women, who effectively dominate the entire design from illusionistic niches that seem to protrude into the space of the chapel. These are seven of the male Hebrew prophets, representing the books of the Bible that bore their names, and five of the female prophets, known as Sibyls, from the world of pagan antiquity. The prophecies of the sibyls, forged in late antiquity and passed down through early Christian writers, had provided the theological basis for Christian readings of the Old Testament as anticipations of events fulfilled in the Church's own time. Traditionally, Christian art showed the prophets and sibyls with scrolls bearing extracts from their writings. Michelangelo, remarkably, has almost entirely eliminated the written word from his portrayals, as if the poses and gestures of the figures were sufficiently eloquent to convey the import of their prophecies. These figures, much like the prophets that Nanni di Banco (*see* fig. 2.23) and Donatello had made for Florence Cathedral a century before, channel the word of God, which now manifests itself as an animating energy or spirit. While Zechariah, the furthest from the altar, merely mulls over his book, *spiritelli* rouse Joel and Isaiah, together with the Delphic and Erythraean sibyls, to a state of ecstatic inspiration. Spirits also take the form of breath – this is particularly evident in the figure of the Delphic sibyl (fig. 12.38), whose blond hair flutters in the air as she opens her mouth to speak. A passage in Joel's own prophecy seems to provide the foundational text for Michelangelo's interpretation of these figures (Joel 2:28–29): "And it shall come to pass after this, that I will pour out my spirit upon all flesh: and your sons and your daughters shall prophesy: your old men shall dream dreams, and your young men shall see visions. Moreover upon my servants and handmaids in those days I will pour forth my spirit."

12.38
Michelangelo, Sistine Ceiling, detail: *Delphic Sibyl*

OPPOSITE, TOP LEFT
12.40
Michelangelo, Sistine
Ceiling, detail: *Libyan Sibyl*

OPPOSITE, TOP RIGHT
12.41
Michelangelo, study for
Libyan Sibyl, c. 1511.
Red chalk on paper, 11⅜
× 8½" (28.9 × 21.4 cm).
Metropolitan Museum
of Art, New York

The poses of these visionary men and women become more elaborate as they get closer to the altar wall. The colors also become less natural, more brilliant, more self-consciously artificial and ornamental. Instead of modeling forms by changing the tone of a given hue, Michelangelo now produces a sense of light and shade by juxtaposing contrasting colors: a green turns red in the shadows, a red becomes orange in the highlights. The poses, too, suggest the transcendence of nature and the physical limitations of the wall surface: the body of Jonah (fig. 12.39), the most technically difficult of the figures, recedes in space as the vault curves outward. He himself looks up ecstatically at the image of God separating Light and Darkness on the vault above. The Libyan sibyl (figs. 12.40–12.42) is a variant of the *Doni* Madonna (*see* fig. 12.9): she exerts herself with her massive book, her body a counterpoint of turning shoulders, hips, and knees. The pose is quite impossible, but then this figure is more than human, and the energy that transfigures her came to be identified as a property of Michelangelo's own art. When Vasari wrote that these figures "appear truly divine to whoever studies their attitudes and expressions," he was referring to a quality of superhuman

inspiration available not only to the prophets but also to the painter himself. Within a few years after his completion of the ceiling, the artist would commonly be referred to as the "divine Michelangelo."

All the imagery in the ceiling is organized around the principles of divine energy or inspiration on one hand and inertia or unconsciousness on the other; Michelangelo generates meaning from different conditions of the heroic male body. The vigorous spiraling movement of God at one end of the series of narratives contrasts with the figure of Noah at the other, who has collapsed into a drunken slumber. In the almost central scene of the Creation of Adam (*see* fig. 12.32), the figure of the first man, "made in God's image," provides a more youthful variant of Noah: Michelangelo has given them similar poses and asks us to compare them. Instead of slipping, like Noah, toward sleep, Adam raises himself to consciousness, receiving an animating energy from God's right hand. (God's other hand caresses a child, the future Christ: theologians understood Adam to prefigure Christ and referred to Christ as the "New Adam," since his incarnation promised a redemption that would restore human beings to the perfect state that preceded the Fall.) The contrast between

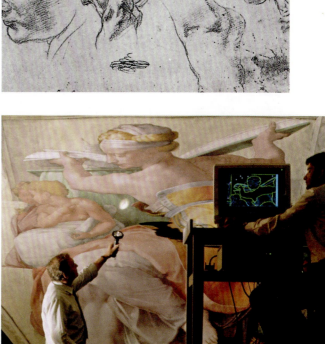

LEFT

12.43

Michelangelo, Sistine Ceiling, detail: Nude male figures above *Cumaean Sibyl*

ABOVE

12.42

Restorers at work on the *Libyan Sibyl*. The photo illustrates the scale and challenging angles at which Michelangelo worked.

12.44
Roman or Hellenistic,
Belvedere Torso,
mid first century BCE.
Parian marble, height
62⅝" (159 cm). Museo
Pio-Clementino, Sala delle
Muse, Vatican

12.45
Belvedere, Vatican, looking
south. The view planned by
Bramante was obstructed
by a wing of the Vatican
Library added in 1587–89;
this photograph shows an
additional transverse wing,
the Braccio Nuovo, added
in 1816–22.

Noah and Adam expresses that between human perfection before the Fall and moral corruption afterward.

Other episodes from the Jewish Bible appear in feigned bronze reliefs. Holding these in place is a series of figures who stand as among Michelangelo's most extraordinary and influential creations – all nude, all male, some quietly pondering, others once again in states of animation and elation that tend to gain in intensity toward the altar. Sometimes they enter into an almost athletic degree of hyperactivity. Like the nudes of the *Battle of Cascina* cartoon (*see* fig. 12.12), they assume poses that could not be sustained for more than a few moments, if at all, by any human being (fig. 12.43). The model here, in fact, was not a living being at all, but an actual piece of sculpture in the collection of Julius II – a colossal seated nude, bereft of arms, legs, and head, known as the "Belvedere Torso"(fig. 12.44). The twenty nude figures are a set of variations on this single ancient model. They are demonstrations of the artist's resourcefulness but also affirmations that the pagan image of the body could find a new place in modern Christian art, assertions of the beauty of man, made in God's image.

The Vatican Palace

While Michelangelo was painting the Sistine Ceiling, Bramante was giving the Vatican Palace a magnificent new form. On the hillside to the north of St. Peter's and the palace complex was a papal summer retreat known as the Villa Belvedere. Bramante conceived a scheme to join the villa to the main body of the residence with two great galleries, which would gradually diminish from three tiers to one as the ground rises (figs. 12.45–12.46). What Bramante aimed to do, in effect, was to subject an entire irregular landscape to the order and symmetry of architecture. Triple corridors were to enclose a series of terraces outfitted with gardens and a theater, as well as an arena for tournaments and equestrian events. At once showing his own study of ancient Roman remains and underscoring the dimension of spectacle, Bramante ornamented the facades of the raised corridors with repeating bays of arches and engaged columns or pilasters he based on the arcades at Rome's Colosseum.

The climax was to be a remodeled Villa Belvedere. Since the original villa angled away from the palace and the gigantic courtyard, Bramante designed for it a

RIGHT

12.46

Giovanni Antonio Dosio, the Vatican Belvedere courtyards under construction, looking north, *c.* 1558–61. Pen and brown ink with traces of chalk on paper, 8⅝ × 13" (21.9 × 33.2 cm). Biblioteca Vaticana, Rome

BELOW

12.47

Belvedere, Vatican: Bramante's spiral staircase

12.48

Roman or Hellenistic, *Laocoön.* Marble, height 8' (2.4 m). Vatican Museums, Rome.

The statue, discovered in 1506, may be an early first-century BCE marble by the Hellenistic sculptors Hagesandros, Athenodoros, and Ploydoros, or it may be a second-century CE Roman reconstruction.

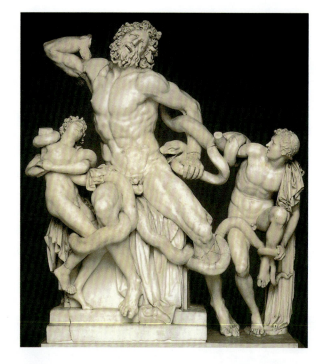

new facade at right angles to the corridors, incorporating a huge niche. (The facade was built only later in the century, by which time a new gallery housing the Vatican Library had partitioned the courtyard.) Within the Belvedere itself, moreover, he introduced a pair of spiral staircases (fig. 12.47) that, once again, ran through the succession of architectural orders: ascending the spiral stairs, Doric gives way to Ionic and then to Corinthian. The highlight of the building, however, was what it housed, the increasingly impressive papal collection of ancient sculptures. It was this site that gave its name to the famous torso that Michelangelo was studying (*see* fig. 12.44), as well as to the magnificent lifesize marble, discovered in the late fifteenth century, known henceforth as the "Apollo Belvedere." The work that had made news the year Bramante went to work on the building, however, the one that occasioned exchanges of letters and bursts of poetry, was the *Laocoön* (fig. 12.48).

In 1506, a Roman curious about a sealed-up chamber in his vineyard discovered the marble, which showed a Trojan priest and his two sons devoured by snakes in divine retribution for his having warned his countrymen about the treachery of the Greeks. The depicted episode would have been familiar to all readers of Virgil's *Aeneid*, beloved at the papal court for its account of the foundation of Rome. More significantly, however, Pliny the Elder had described what the discoverers took to be this very marble in his *Natural History* (*c.* 77–79 CE), in which he not only reported that the emperor Titus had kept the statue in his house but also attested that it was greater than all other ancient paintings or sculptures. Art-

ists wishing to measure themselves against the antique now had before them a nearly intact group of figures that ancient Rome's most distinguished historian of art himself assured them had no compare.

Eloquent Bodies: Raphael and the Stanza della Segnatura

Among the most enthusiastic young students of the *Laocoön* was Raphael, who, within a year of completing the Baglioni altarpiece (*see* fig. 12.21) had himself transferred to Rome; he would eventually respond to the ancient sculpture in drawings, prints, and paintings. Bramante seems to have been an advocate and something of a protector of his fellow artist from Urbino. Like Michelangelo, Raphael would avail himself of the Pope's incomparable resources to bring previously unthinkable projects into being: unlike Michelangelo, he managed to avoid the cross-purposes and clashes of ego that would lead to years of frustration for the older artist. Raphael stayed close to Bramante, who was forty years his senior and understood how to direct the Pope's often erratic impulses as a patron.

In 1508, the same year that Michelangelo started work on the Sistine Ceiling, Julius commissioned Raphael to decorate the rooms he intended to use as his official apartment. Overlooking Bramante's courtyard, in the structure known as the Borgia Tower (after the recent Pope, Rodrigo Borgia, or Alexander VI), these included the room that came to be called the Stanza della Segnatura – well after Raphael's time, the chamber housed the papal tribunal known as the "segnatura," the activity of which involved the signing of official documents. In Julius's own day, the space served as a papal library, with books arrayed on sloping shelves below large frescoes. (The shelves are now gone, and the frescoes in the lower zone of the room are later additions.) Raphael's paintings on each wall, along with the corresponding section of vault above (fig. 12.49), visualized the four major areas of learning represented: Theology, Philosophy, Poetry, and Law. Earlier libraries and studies had sometimes been decorated with figures of Muses or Allegories of the Liberal Arts, often including imaginary portraits of their most famous historical practitioners. What was most radical about Raphael's scheme was its separation of the allegorical figures from the portraits, so that the portraits now dominate the invention. It is as though the authors of the room's books have come to life on its walls.

In designing his ceiling, Raphael must have been aware of Michelangelo's early designs for the Sistine Ceiling, for although Raphael conceived his ceiling as a series of fictive mosaics, the arrangement of the compartments is close in conception to the scheme Michelangelo

OPPOSITE

12.49

Raphael, vault fresco with (counter-clockwise from bottom) allegories of *Poetry, Philosophy, Justice, Law*, 1508–10. Stanza della Segnatura, Vatican.

The octagon in the center is the work of Sodoma, who collaborated with Raphael on this part of the decoration.

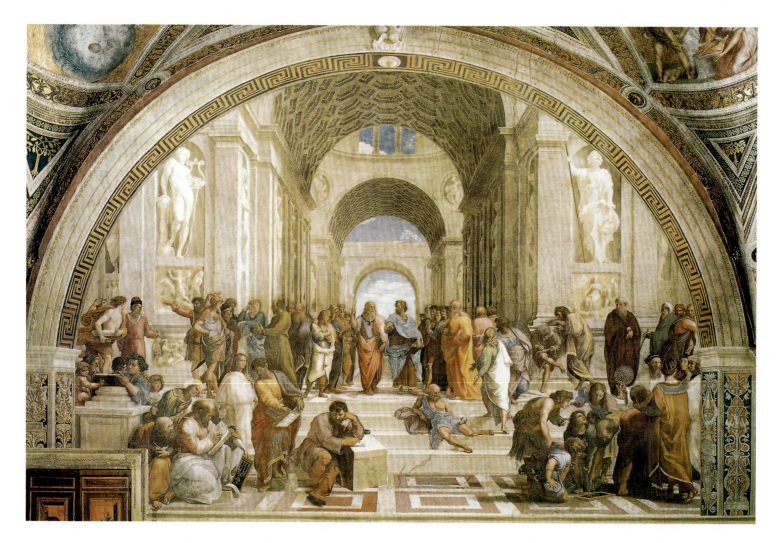

12.50

Raphael, *The School of Athens*, 1510–11. Fresco. Stanza della Segnatura, Vatican

considered and then abandoned. The powerful female figures that in Raphael personify the branches of knowledge follow Michelangelo's prophets and sibyls in their heroic proportions. Between the personifications is a series of symbolic stories and figures, each of which corresponds to the two flanking areas of knowledge: for instance, Urania, the Muse of Astronomy, relates to both Poetry and to Philosophy (which includes all of what are now called the sciences); Adam and Eve stand between Theology and Law, since the story of Adam and Eve concerns the operation of Divine Justice.

A caption (*titulus*) defines Philosophy as CAUSARUM COGNITIO ("the knowledge of causes"). In the great lunette below known as *The School of Athens* (fig. 12.50), all of the great philosophers of antiquity gather in a grand vaulted space that probably reflects current projects for St. Peter's. Raphael did more here than simply paint a group portrait of famous people from the past: the composition is a poetic invention that stays true to the principles laid down by Alberti, through which Raphael aimed at nothing less than the representation of Philosophy itself through depicted human action. The work asks beholders to "read" it, recognizing each figure not only from conventional attributes but also from

his character and his gestures. The only inscriptions are on the books held by the central figures, which serve to identify them as Plato (with his *Timaeus*) and Aristotle (with his *Ethics*). The pair are presented as the greatest of all philosophers, but also as the founders of two diverging philosophical traditions. Plato (429–347 BCE), who points to the sky, is the idealist, positing truth and reality not in the perishable material forms of nature but in the timeless, immaterial world of Ideas. His pupil Aristotle (384–322 BCE), who gestures toward the ground, inquires instead into the nature of physical reality and the world of human life and society. Aristotle had been the single most influential thinker in the universities of Europe since the 1200s, when his works were rediscovered in the West: his writings provided the fundamental texts on the study of the human mind and its capacity to know, on the natural world, and on politics and morality, as well as the basic methods of demonstrating and proving an argument. In the fifteenth century, the newly available texts and translations of Plato, edited by Greek and Italian scholars, led to disputes between self-appointed followers of the two philosophers. More recently, however, some humanist thinkers in circles close to the papal court had claimed that it was possible to reconcile the thought of Plato and

Aristotle despite their considerable differences in method and in the questions that engaged them. The principle of harmonizing differences is the generating conception of Raphael's fresco. The different schools of philosophy organized around Plato on one side and Aristotle on the other – schools that represent the widest variety of ancient cultures then known – manifest variety and difference on the individual level but together correspond to a great three-dimensional unity.

On Aristotle's side are the ancient practitioners of practical mathematics and astronomy: Ptolemy (foreground right) holds a terrestrial globe and wears a crown. (The ancient astronomer was often confused with an Egyptian king of the same name.) He is paired with the Persian prophet Zoroaster, who holds a celestial globe. Euclid appears here in the person of Bramante, who demonstrates with his compasses a theorem for a group of excited students. The young man in the black hat looking out of the fresco is Raphael himself, standing beside a figure identifiable as the Lombard artist Sodoma, who had also worked in the room: Raphael wants us to understand that painting, as a form of knowledge comprising the mathematics of perspective and the study of nature, can itself be classed as a form of philosophy. Among the philosophers on the opposite side is Pythagoras, who taught his students about the hidden mathematical ratios that organized both the motions of the planets and the notes of the musical scale. As Pythagoras writes in a large book,

the turbaned Arab philosopher and astronomer Averroes looks over his shoulder. Closer to the center of the picture is the brooding figure of Heraclitus, who held that the only reality in the universe is its process of constant change and transformation, and that all being is unstable and passes away. Raphael is generally believed to have represented Heraclitus in the person of Michelangelo, not just portraying his physical features but also imitating the style the older artist employed for the prophets and sibyls of the Sistine Ceiling. With characteristic wit, the figure's pose resembles that of the prophet Isaiah, but whereas Isaiah lifts his head from his hand with a flash of inspired energy, no such epiphany has come to the gloomy philosopher. He is also one of the few characters in the scene who interacts with no one: if Raphael, pairing himself with Sodoma, implied that his work was necessarily collaborative, he shows Michelangelo as an artist who thinks, and works, in near isolation. The portrait, seemingly painted after the rest of the fresco was complete, and certainly at a point when Raphael had finally had a chance to study what Michelangelo had been producing a few rooms away, created the indelible image of that artist as "il penseroso," the thinker. Standing to his right is Parmenides, the opponent of Heraclitus, who argued the case for stability and constancy of substance as opposed to endless transformation. Just as Raphael has portrayed Heraclitus using the style of Michelangelo, so now he models Parmenides on the figure of Leda

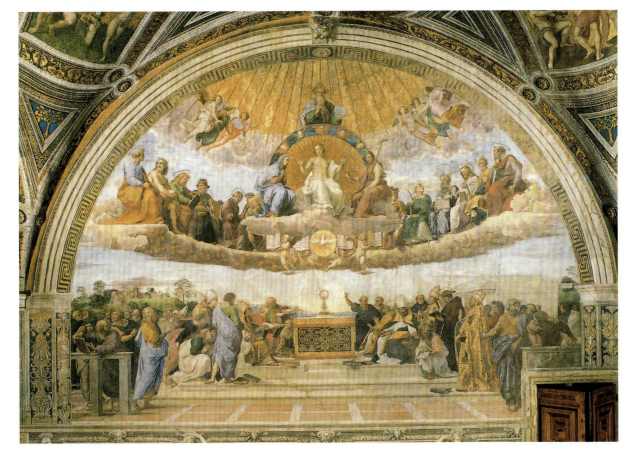

12.51
Raphael, *Disputà*, 1508–09.
Fresco. Stanza della
Segnatura, Vatican

(*see* figs. 12.15–12.16), recently invented by Michelangelo's celebrated rival Leonardo.

The slightly earlier fresco (1508 or 1509) of Theology on the opposite wall of the Stanza is sometimes called the *Disputà* (fig. 12.51), or "disputation," since some early writers believed that it depicted a debate about the nature of the Eucharist. Although there was certainly no lack of disputation about the Eucharist in the years when Raphael was painting, the postures suggesting lively intellectual exchange probably indicate Theology in general, conceived as a great collective seeking of knowledge under the guidance of the Holy Spirit, depicted above. Whereas the architecture of *The School of Athens* evoked the nave of a great basilica, the space here is more like a vast apse: though a hill in the distance suggests an outdoor setting, the pavement, steps, and altar below rather reconstitute the ceremonial focal point in every church, and the rows of clouds and the golden beams above curve to form a colossal semi-dome, as if the world were shaping itself to welcome God's presence. On axis with the Eucharist, God's miraculous manifestation on Earth, are the three persons of the Trinity. While Christ displays his wounds, the Holy Spirit once again functions as the principle of divine wisdom: accompanying the symbolic dove are the books of the four Gospels, directly inspired by God. To either side of Christ appear St. John the Baptist and the Virgin Mary, along with an entire semicircular tier of saints and prophets. Below, an energetic group of popes, cardinals, bishops, and members of various religious orders express the wonder that leads to contemplation and enlightenment. At the edges of the crowd,

heretics and dissenters turn away with their books, leaning into the space of the room itself, as a blond youth and a bearded patriarch gently direct them back toward the altar.

Having translated the abstractions of philosophy and theology into visible form in these two paintings, Raphael then tackled poetry. Here, he might have found himself on more familiar territory, since the Urbino court would have instilled in Raphael the humanist commonplace that there was a deep affinity between poetry and painting: both poets and artists communicate through images, whether descriptive or metaphoric. The wall this time presented more of a challenge, however, for Raphael had to paint around an existing window. In the *Parnassus* (fig. 12.52) he addressed the problem by using a hill as his setting, following the curve of the lunette and placing figures above and to the sides of the hole in the middle (which itself provided a view onto a real hill in the distance). Once again, Raphael composed with portraits, leaving it to the viewer to work out the principles of association linking them to each other and to a central guiding presence – in this case, the god Apollo, the patron not only of music and poetry but also of inspiration and prophecy. Apollo in turn looks up at the oculus in the ceiling above where Poetry appears as a winged divinity with the caption NUMINE AFFLATUR – "inspired [or 'inflated'] by the Divine." As Michelangelo had done with his sibyls, Raphael indicates the numen, or the presence of the divine, with an effect of breath or spirit, a movement of air that ruffles the drapery of the Muses around Apollo. On the hill toward the left and in blue toga-like drapery, close to the divine sources of poetic vision, is the Greek poet Homer, whose blind but ecstatic features are modeled on the *Laocoön* (*see* fig. 12.48). Behind him, in green, is Homer's most important imitator, the ancient Roman poet Virgil, who in turn looks back to Dante, in red, the "modern" poet who took Virgil as his guide. Further down the slopes on this side, in a pointedly less lofty position, are the poets of lyric and amorous verse: the ancient Roman poet Ovid, in a flame-colored toga; Daphnis, the mythical inventor of pastoral, who points to the laurel, symbol and reward of poetry in general (his own name means "laurel"); Petrarch, the great modern poet who celebrated the poet's laurels and his own love Laura, in three-quarter profile; the bearded Theocritus; and the female poet Sappho.

On the other side of the window is the aged figure of Hesiod, the Greek shepherd poet who wrote of the nature of the gods. Hesiod's gesture of pointing into the room would have had a particular significance to its original primary occupant, since a passage in this poet's *Theogony* (II:29–35) appeared to prophesy the future greatness of Julius II: "so spoke great Zeus's ready-speaking

12.52
Raphael, *Parnassus*,
1510–11. Fresco. Stanza
della Segnatura, Vatican

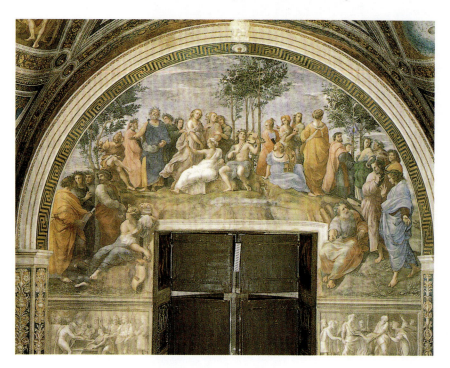

daughters, and they plucked a staff, a branch of luxuriant laurel, a marvel, and gave it to me; and they breathed a divine voice into me, so that I might glorify what will be and what was before, and they commanded me to sing of the race of the blessed ones who always are, but always to sing of themselves first and last. But what is this to me, about an oak and a rock?" The stone is a familiar sign for Peter, the first Pope, whose name meant "rock"; the oak (*rovere* in Italian) is the emblem of the family (Della Rovere) of Julius II.

Venice

Pope Julius II cultivated diplomatic ties with the great powers across the Alps, in part because his nearer neighbors were more worrisome. In 1508, he entered into an alliance with the Holy Roman Empire, France, and other powers, known as the League of Cambrai, which through open warfare would succeed in curtailing Venetian influence in the peninsula. Venice's own ambitions very much correspond with the portrayal of the city by Jacopo Barbari (*c.* 1440–before 1516; fig. 12.53). This colossal woodcut celebrates the city's status as the center of an empire founded on trade and the domination of the sea. The sea god Neptune assures that nature itself protects the destiny of Venice – he bears an inscription declaring "I Neptune reside here, smoothing the waters at this port," to which Mercury answers, "I Mercury shine

favorably on this above all other trading centers," thus dignifying the sources of Venice's power. In its quality and scale – it was produced from six blocks on six sheets of paper and measures four by nine feet – it constitutes a Venetian equivalent to the other monumental projects of the decade in Rome or Florence. The *View of Venice* also marks the beginning of a gradual shift in the mechanism of print production. Whereas some earlier printmakers, including Mantegna and Pollaiuolo, had initiated their own projects, Barbari's woodcut originated as a private commercial venture by the printer-publisher Anton Kolb. Kolb justified his request for a government "privilege" (an early form of copyright) by maintaining that the print served "principally for the glory of this illustrious city of Venice."

What is most remarkable about the image is that it is a bird's-eye view, showing the city as it might look from an imaginary point in the sky. The exchange of looks between the gods Mercury above and Neptune below enhances the viewer's sense of being physically located above the city, even of an ability to move through space as he scans the winding streets, canals, gardens, and squares. The minute precision in the rendering of buildings, public spaces, trees, and ships gives the impression of a completely faithful portrait, promising that the prints could serve as a map. In fact, the *View of Venice* combines the mathematical techniques of mapmaking, still in its infancy in these years, with those of painting in perspective. Barbari used the measurements provided by

12.53

Jacopo Barbari, *View of Venice*, 1500. Woodcut, 4'4¾" × 9'2½" (1.34 × 2.81 m). Museo Correr, Venice

a team of surveyors, while also making drawings from a number of elevated positions in the city, notably the campanile of San Marco. The overall coherence, however, is a synthesis of Barbari's, produced by intuitive as much as by empirical means: he exaggerated the scale of certain elements, such as the two central islands, and diminished others, to demonstrate their relative importance. Because the image was composed from multiple views, the angle of vision sometimes shifts – compare the receding perspective of the Piazza San Marco with the almost overhead view of the area below the Rialto Bridge on the sheet above.

In the years Barbari was producing his woodcuts, Giovanni Bellini continued to dominate the painting profession in Venice. He held a prestigious state appointment as painter of the Hall of the Grand Council, and he ran the large workshop in which the major figures of a new generation would be trained: Giorgione, Sebastiano del Piombo, and Titian. The San Zaccaria altarpiece of 1505 (fig. 12.54), a work Bellini painted in his mid seventies, shows the culmination of a lifetime's investigation into the properties of light and its effects on colored surfaces. The spatial illusion and psychological impact of the world represented here make it seem continuous with our own: the architecture that houses the Virgin and saints appears to extend the architecture of the frame; the saturated red of St. Jerome's robe indicates a light falling with full intensity, whereas St. Peter's yellow mantle is revealed through illumination reflected from other surfaces. Bellini works with naturalistic effects not for their own sake but to evoke the sacred as a mood or an atmosphere that extends itself to the world beyond the painting through the sensory and emotional engagement of the beholder. This is a mirage-like place of mystical stasis and near silence: the figures seem absorbed in meditation to the degree that all motion has been suspended, and the delicacy with which the angel plays its *lira da braccio* beckons the viewer, as if, in approaching, he might actually be able to hear the music.

Foreigners in the City

Some of the younger artists who trained under Bellini were just beginning to set up independent workshops in the 1500s, years when Venice was an international crossroads for different traditions of painting and printmaking. These younger painters would have been aware that, in addition to Bellini, two of the world's most famous artists were briefly present in their city during the 1500s: Leonardo passed through in 1500 as a consultant to the government on military matters, while Albrecht Dürer spent 1505 and 1506 there as an agent for a German trading company. Nothing from

Leonardo's hand can be securely associated with his Venetian sojourn, but Dürer, in the course of his stay, produced a major altarpiece.

Even before coming south, Dürer was already an artist of considerable reputation in Italy, where his engravings and woodcuts (including the *Apocalypse* series; *see* fig. 11.13) were known to artists and collectors. Vasari reports that one of the reasons that Dürer came to Venice was to seek redress against the printmaker Marcantonio Raimondi, who had been making pirated copies of his engravings. The episode is a major event in the history of "intellectual property." At the time Dürer traveled south, it had never occurred to legal authorities that an artist's work might in some way belong to him. Copyright law did not then exist; publishers of books and prints, such as Anton Kolb, were the only ones who could obtain a "privilege," or sole right of production, for

OPPOSITE

12.54

Giovanni Bellini, *Virgin and Child with Saints Peter, Catherine, Lucy and Jerome,* **1505.** Oil on canvas, transferred from panel, 16'5⅛" × 7'9" (5 × 2.4 m). San Zaccaria, Venice

12.55

Albrecht Dürer, *Adam and Eve,* **1504.** Engraving, 10 × 7⅝" (25.2 × 19.4 cm). British Museum, London

12.56
Albrecht Dürer, *Feast of the Rose Garlands*, 1506. Oil on panel, 5'3¼" × 6'4¾" (1.62 × 1.95 m). Národní Galerie, Prague

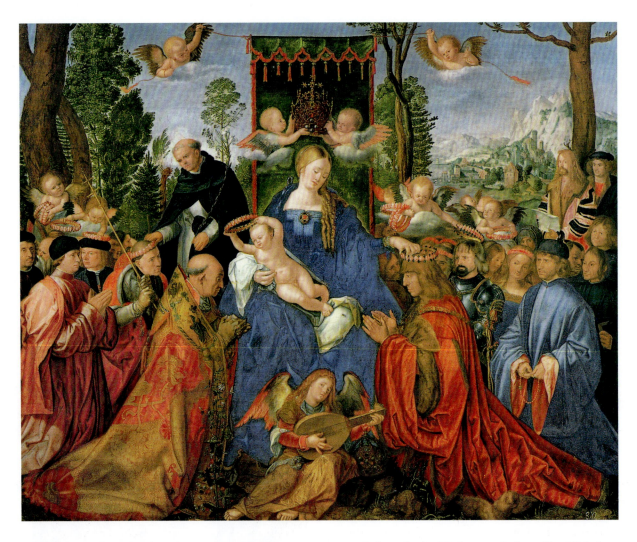

a limited period. Dürer, though, won his case, obtaining a ruling whereby his own prints would be distinguishable from those of his copyists: Marcantonio was permitted to make his own versions, but not to reproduce Dürer's distinctive monogram, which now had the status of a trademark. At least in theory, customers would now be certain they were acquiring an authentic print from the hand of Dürer.

Dürer's 1505 visit to Venice was by no means his first exposure to Italian art. He may have made an earlier trip south. He was familiar, even in Germany, with the engravings of Mantegna, and in 1500 he had made the acquaintance of de' Barbari, then working in Nuremberg. According to Dürer's own account, Jacopo had shown him how to use Vitruvian proportions to draw human figures: the engraved *Adam and Eve* of 1504 (*see* fig. 12.55) was Dürer's attempt to render the human body according to this idealized system of measurement, with the implication that only before the Fall, in bodies God himself had made, would such perfect proportions have been found in man and woman. In Germany, the print would

certainly have looked Italianate; Italians like Michelangelo, on the other hand, found it labored. After arriving in Venice, Dürer changed his mind about what could be learned from Italy, and wrote to a friend at home that he now realized there were better painters than Jacopo de' Barbari. In particular, he was impressed by Giovanni Bellini, whom he befriended. Dürer's letters also suggest that he had begun to worry that his insufficient knowledge of antiquity would limit the international appeal of his works, though this did not prevent him from issuing a painted challenge to the other artists in the city.

This was the *Feast of the Rose Garlands* of 1506 (fig. 12.56), which Dürer produced for a highly visible location in San Bartolomeo al Rialto, a church that served the local German community. The altarpiece demonstrated the principles of painting that pertained north of the Alps, while also showing that Dürer could outdo the Venetians in all the artistic qualities at which they excelled: the handling of color and light, the rendering of landscape. As Dürer himself wrote in 1506: "My picture… is well painted and beautifully colored.… I have stopped

the mouths of all the painters who used to say that I was good at engraving, but as to painting I did not know how to handle my colors. Now everyone says that better coloring they have never seen." Other evidence indicates that Dürer did not lack for resistance in the artistic community: the city fined him in 1506 for practicing painting without a license from the local guild.

By presenting the Virgin and Child enthroned in outdoor light, Dürer was seeking comparison with Bellini's San Zaccaria altarpiece (*see* fig. 12.54), which he had studied closely. The arrangement of colors across the surface, the figure of the musician angel, even the two flanking trees all correspond to elements in Bellini's painting. Yet Dürer does not pursue Bellini's spatial effects, the sense of figures detached from each other in a continuous volume of light and air. The picture is packed; bustling interaction replaces the static detachment of Bellini's composition. Dürer re-imagines the traditional formula of enthroned Madonna with votive portraits as an action or performance. While two cherubim crown the Virgin as Queen of Heaven, she and the Christ Child, along with angels and St. Dominic, distribute rose garlands to the kneeling figures around the throne: these appear to be portraits, perhaps of confraternity members, but only two are clearly identifiable. In the place of honor to the Virgin's right, Pope Julius II receives a rose crown from Christ, while the Virgin wreathes the splendidly attired Holy Roman Emperor, Maximilian. Contemporary relations between the empire and the papacy stand behind this unusual imagery. The emperor's political successes had led to considerable speculation that he would soon descend on Rome to receive the imperial crown from Julius II; Dürer hoped to join the emperor's party from Venice. In the event, this never occurred, but Dürer's altarpiece offered an optimistic vision of a unified Christendom, one that the League of Cambrai would soon shatter. Dürer himself appears in the picture as a witness to the history he was making sacred: he stands to the far right, before an Alpine landscape, holding a scroll bearing his name and the implausible assertion that he had completed the altarpiece in five months. This invited viewers to marvel all the more at the quality of labor-intensive detail, the meticulously described fabrics, furs, jewels, and flowers.

Giorgione and the Young Titian

It is by no means clear that Leonardo had allowed Venetian artists to see any of his works during his brief visit to the city. Nevertheless, one of the younger artists from the Bellini studio was working by the middle of the decade in a radical new style that later sixteenth-century viewers, such as Vasari, saw as a response to his influ-

ence. Giorgione (*c.* 1477/8–1510) eschewed Leonardo's habit of making serial preliminary studies, then building up paintings over strong underdrawing, preferring instead to compose with pure tone directly on the surface of the painting. Still, such works as his *Boy with an Arrow* (fig. 12.57) from around 1506 recall Leonardo's practice of immersing human figures in transparent shadow from which their features seem gradually to emerge into the light. Just as the *Mona Lisa* (*see* fig. 12.17) is no conventional portrait, so Giorgione's image seems unlikely to depict an actual person, though it follows the conventions of portraiture. The work could best be described as a poetic idea, but one with a rich and alluring ambiguity that challenges the spectator to participate in making meaning more than any written poem of the period could. Who is this boy? Does the arrow signal that he is the pagan god Cupid, or does it mean that he is merely *like* Cupid, a non-divine being who also gives rise to the emotions of love?

The Venetian poet and scholar Pietro Bembo (1470–1547) in just these years reported that Giovanni Bellini, Giorgione's probable teacher, had come to insist that pictorial inventions could not simply be dictated by patrons, but had to be "suited to the painter's own imagination." Bellini, Bembo wrote, expected "always to wander as he pleased in his paintings." No disciple internalized this idea of painting more than Giorgione, who in the few years before his premature death produced a series of pictures not dedicated to prayer, commemoration, or propaganda, but simply intended for acquisition and display in Venetian private homes, where they could be exhibited alongside ancient bronzes or marble sculptures and admired as examples of the virtuosity of a great painter. Such works as *Boy with a Flute* and the so-called *Tempest* did more than simply define the category "modern art." In the lush landscape of *The Tempest* (fig. 12.58), where lightning, rolling clouds, and the density of the atmosphere signal the onset of a storm, a male wanderer comes upon a semi-nude woman who nurses a child by a spring. What we are given resembles the beginning of a story, and we are invited to complete it. But what narrative or body of ideas could lead to this strange association of elements?

For some viewers, the work needed to be no more than a landscape – or, as one early witness called it, a "little landscape on canvas with a storm, with the gypsy and the soldier." As the depiction of a meteorological event, unprecedented in its rendering of rolling clouds, fitful sunlight, and even the particular visibility of air thick with moisture, it is understandable why the storm might have been singled out as a principal point of interest. But the original owner of the painting, Gabriele Vendramin (1484–1552), a man of learning from a noble family, was

12.57
Giorgione, *Boy with an Arrow, c.* 1506. Oil on panel, 18⅞ × 16⅝" (48 × 42 cm). Kunsthistorisches Museum, Vienna

OPPOSITE
12.58
Giorgione, *The Tempest, c.* 1509. Oil on canvas, 31¼ × 28¾" (79.5 × 73 cm). Galleria dell'Accademia, Venice

interested in paintings with philosophical subject matter that he could keep by him in his *studiolo* and throughout his house. Vendramin might have ascribed philosophical significance to the suggestive juxtaposition of vulnerable and exposed human beings and the unleashing of nature's fury – this was a major theme of the epic philosophical poem *On the Nature of Things* by Lucretius. In describing a natural world without divine agency, Lucretius had sought to explain the causes behind a range of physical phenomena, from weather and climate to human sensory perception. Superstitious human beings might regard such natural occurrences as thunder and lightning as actions of angry gods, he wrote, but the true philosopher understood these as the movement of atomic particles, and therefore as nothing to be feared. Lucretius celebrated the ancient Greek philosopher Epicurus

(341–270 BCE), who was the first to "wander" in search of the true causes of things, and to liberate mankind from superstitious fears of the gods. If Vendramin found that the painting alluded to Lucretius, he would have understood that it was more than an illustration: Giorgione has taken pains to locate his scene in the contemporary world, dressing his male figure in the particolored hose of a contemporary Venetian libertine, and adding the coat of arms of a city in the Venetian territory over the city gate. The subject of the painting thus becomes the modern philosopher's contemplation of nature and the natural condition of man, undeterred by the storm and the gathering darkness: these in themselves may have recalled the troubles of Venice plunged into a war with the major powers of Europe, and the necessary philosophical outlook needed to confront them.

Giorgione's *Sleeping Venus* (fig. 12.59), made for the Venetian official Girolamo Marcello, is a kind of picture that we have seen before (*see* figs. 9.25 and 11.4): a mythology with the ancient goddess of love and fertility as its protagonist. Her identity would initially have been clearer, since her son Cupid originally appeared in her company (that area of the canvas, heavily damaged, was painted over in 1837). What is more unusual, however, is the emphasis on a single nude figure, who dominates the painting, and the prominence of the landscape setting. As with *The Tempest*, Giorgione wants the viewer to reflect on the relation between the body (in this case, the body of a figure who stands for human sexuality itself) and the natural world: the curves of the figure's limbs, torso, and breasts echo the gentle rolling hills of the landscape. Even a viewer who was not learned in philosophy might be moved to reflect on the nature of human beings as part of a wider continuum of physical life in the natural world. Through the senses, one comes not only to know the world but also to feel oneself as part of the world. Readers of Lucretius, Virgil, or the fourteenth-century Italian poet Giovanni Boccaccio would remember that these poets had invoked Venus to refer to the power of visual attraction and compulsion that led living things

to reproduce. Just as Giovanni Bellini used landscape and atmosphere to draw his viewers toward a state of imaginary participation in the contemplative world of his saints and Madonnas, so Giorgione now offers a parallel experience, one pursued by secular philosophers and poets, and no less dignified.

Little is known about Giorgione himself, beyond the fact that he received a commission to fresco the facade of the warehouse-office complex of the German community in Venice in 1506, and that he had died by 1510. Around that time, another artist produced a work that seems to be an attempt to continue Giorgione's specialization in sensuous and ambiguously evocative secular subjects. The so-called *Pastoral Concert* (fig. 12.60) has often been attributed to Giorgione, but most art historians now regard it as an early work by Titian (1488/90–1576), the painter who would dominate the profession in Venice for the next sixty years. It was Titian, in fact, who had probably completed the *Sleeping Venus*, and the *Concert* shows us that Titian now saw himself as both the heir and interpreter of Giorgione's pictorial experiments. Like *The Tempest*, the *Concert* responds to the recent vogue for landscapes with figures – both paintings juxtapose naked females with clothed males, and the seated female is a

12.59
Giorgione and Titian?, *Sleeping Venus, c.* 1510. Oil on canvas, 42¾ × 69" (1.1 × 1.75 m). Gemäldegalerie Alte Meister, Dresden

12.60

Titian, *Pastoral Concert*,
c. 1510. Oil on canvas,
approx. 3'7" × 4'6"
(1.09 × 1.37 m). Musée du
Louvre, Paris

variation on the woman in *The Tempest*, in a similar pose but viewed from a different point of view. The technique of rendering the softness of flesh by constructing figures in light and dark tones directly on the canvas itself is also similar to the method Giorgione used. By comparison with Leonardo or Dürer, whose *Leda* (*see* figs. 12.15–12.16) and *Adam and Eve* (*see* fig. 12.55) demonstrate the study of anatomy or ideal proportion, Titian merely suggests the structure of the body. Arranged in the foreground plane like Giorgione's Venus, the two nudes appeal to the sense of touch as well as sight. The landscape, with its grassy slopes and patches of alluring shade, has a density and sense of substance that is reinforced by the thickness of the paint, the visibility of brushstrokes, and of the canvas support.

Who are these figures? What is their relation to the men, who do not seem to register their existence? Titian assigned the men themselves social identities: the lute player is an affluent city dweller, whereas his singing companion wears the coarser clothing and unkempt hairstyle of a farmer or a shepherd. (A shepherd appears with his flock on the same diagonal recession into the pictorial space.) This suggests that the painting should be understood in a literary context: the presence of shepherd musicians immediately evokes the classical and modern tradition of the "pastoral," a genre of poetry that celebrated the escapist or therapeutic pleasures of the countryside. It is a predominantly male world, where women are generally evoked as absent love interests, as Muses or as nymphs – natural spirits of the trees or the fountains. Titian here is composing a pastoral in paint, rather than illustrating a particular text, and already in his lifetime, contemporaries referred to such works as *poesie*, "pieces of poetry."

We have already seen these mythological symbols of poetry (the Muses, the fountain), which appeared in Raphael's contemporary painting of *Parnassus* (*see* fig. 12.52), but the tone of Titian's work is very different: it is more intimate and even more modern. It seems more concerned to produce an alternative to the classical tradition than to proclaim continuity with it, which is the point of Raphael's gathering of ancient and modern poets, all garlanded with laurel. Titian here is working out the principles of Venetian painting as it would come to be understood later in the century – as a rival tradition to that of Florence and Rome, characterized by a greater immediacy of appeal to the senses, as well as a certain elusiveness that demanded the active imaginative involvement of the spectator.

Italian Renaissance Materials and Techniques

Renaissance artists learned as youths to work materials in the ways their masters had, and they in turn passed down their own knowledge to subsequent generations. Even as they expected apprentices to spend years refining their handling of tools and materials, however, craftsmen were remarkably experimental, such that the history of Renaissance art can to a certain extent be told as a history of techniques.

For all of its continuities, the period also saw that introduction of new methods and the disappearance of older ones. This appendix aims to provide a basic introduction to the most common practices artists followed. Readers of our chapters will see, however, that not all methods were possible at all times, and that the most interesting artists frequently made choices to approach things differently from their contemporaries, to do things that looked conspicuously old-fashioned or unexpectedly unconventional.

Drawing

Throughout the early Renaissance, artists used drawings to develop ideas, to convey proposals to clients, and to create a store of figures and motifs that could be re-used in future works. Drawing also served as a means by which artists sought to understand the work of their predecessors and to study the world around them.

In the 1300s, apprentices practiced drawing on re-usable wooden panels coated with wax. Most workshops kept a stock of model drawings – templates for figures, faces, animals (*see* above right), draperies, and other commonly required motifs – on more permanent supports. Until the mid-1400s, the most common of these supports was parchment, a durable but expensive material made from sheep- or goat-skins that were otherwise used for important documents and for books.

Metalpoint

Artists using this technique would coat a page with bone dust suspended in oil, sketch over this in charcoal, then draw a more final version of the design with a sharpened metal stylus, sometimes of lead but usually of silver, which left a fine trace of black silver oxide when dragged over the prepared surface. Silverpoint (*see* right) demanded precision and deliberation. The medium did not lend itself to broken lines, nor to very deep tones; when an artist needed to create areas of shading, he had to resort to **hatching** (short, close, parallel strokes) or to the addition of watercolor washes. Preparing a surface to accept silverpoint was itself time-consuming, and the raw materials were costly; once drawn on such a surface, moreover, silverpoint lines could not be erased.

ABOVE RIGHT

Giovannino de'Grassi, animal studies from his drawing book (*Taccuino*), late fourteenth century. Ink and watercolor on parchment, 10¼ × 7" (26 × 18 cm). Biblioteca Civica, Bergamo

RIGHT

Raphael, *Heads of the Virgin and Child* (detail), *c.* 1509–11. Silverpoint on pink prepared paper, 5½ × 4⅝" (14.3 × 11.1 cm). British Museum, London

Pen and ink

The increasing availability of paper, produced by pouring boiled linen over a metal screen, eventually led to a more exploratory approach to drawing, since the material was cheaper than parchment or wooden supports. Pisanello was among the earliest documented users of quill-pen and ink on paper, which allowed artists to employ a looser or sketchier manner as they considered different possibilities or responded to moving figures or animals. Sometimes they augmented these linear forms by adding water-based colored washes or an opaque suspension of white lead called heightening. Sandro Botticelli's *Abundance* (*see* right) offers a particularly refined example of pen and ink wash in combination with chalk and white heightening.

Chalk

In the later fifteenth century, black chalk became more common as artists drew from the model or worked out approaches to more important or difficult elements of a composition, such as hands or faces. Leonardo da Vinci and his followers popularized red chalk as well, and by the 1570s Federico Barocci had pioneered the use of colored chalks, similar to modern pastels. Chalk could be sharpened or blunted and also rubbed, permitting an easy transition from fine line to blended contours and shadows of varying intensity (*see* below).

ABOVE
Sandro Botticelli, *Abundance* (detail), *c.* 1480–85. Pen and brown ink with brown wash, heightened with white, over black and red chalk, on paper, $10^{1}/_{2} \times 6^{3}/_{4}$" (26.6 × 17.1 cm). Musée du Louvre, Paris

LEFT
Leonardo da Vinci, *Isabella d'Este,* 1500. Black, red, and white chalk, and yellow pastel (?) over leadpoint, on paper prepared with a bone-color dry pigment, $27^{7}/_{8} \times 18^{1}/_{8}$" (63 × 46 cm). Musée du Louvre, Paris

Painting

Panel Painting

The making of a panel painting (*see* above right) was an intensively collaborative process. Its wooden support required many hours of labor, even before the painter could lay his hand to the work. Designed to last, the panel had to undergo a series of procedures to make it stable and durable. Wood, unless it is properly treated, tends to crack or to split as it becomes drier over time: it can also warp, causing the painted surface to flake and detach. Larger panels, composed of several vertical planks of poplar or another wood glued together, usually required additional bracing in the form of horizontal strips fixed to the reverse.

The first task faced by workshop assistants when the panel arrived from the woodworker was to apply a smooth ground in several layers. The goal was to provide a durable, regular surface on which the artist could begin applying his design. The process of preparing the panel involved the following steps:

1) The painters' assistants would first seal the panels with animal glue, adding strips of linen to mask the joins in the wood;

2) The team would then apply layers of liquid ground on top of this, in the form of a white powder known as *gesso* (sometimes called "gypsum" in English) combined with animal glue. Each coating required several days to dry.

3) The painter's assistants would work the final layer with pumice to render it as smooth as possible.

4) At this point, the head of the workshop would draw the image to be painted on the *gesso* surface. Doing so in charcoal had the advantage of allowing the artist to change his mind or brush away mistakes, but braver artists sometimes worked with pen and ink. Artists also engraved lines into the surface with a needle, either to establish a basic perspectival scheme or to clarify boundaries for planes of color and gold.

5) Before beginning to paint, members of the workshop would add gold backgrounds. The most common and durable technique involved a red adhesive called bole. To this, the artist could attach fine sheets of gold foil (*see* below right).

Well into the fifteenth century, it was customary to ornament haloes and other gilded details using metal punches. Only after this work was complete would the artist begin adding pigment to the surface.

ABOVE RIGHT

Leonardo da Vinci, *The Adoration of the Magi*, 1481–82. Oil on panel, 8'1¼"× 8' (2.46 × 2.43 m). Uffizi Gallery, Florence. In this photo, taken while the painting was in restoration, the joins between the wood panels are visible to the naked eye. The panel's unfinished condition also allows an unusual view of the artist's extensive underdrawing.

RIGHT

Detail showing gold leaf: Gentile da Fabriano, *The Adoration of the Magi* (Strozzi altarpiece), 1423. Tempera on panel, 9'10½" × 9'3½" (3 × 2.8 m). Uffizi Gallery, Florence

Canvas

Fifteenth-century artists sometimes used canvas supports for portable objects, such as processional banners. With these, they typically painted quickly and thinly in a glue-based medium called size. Toward the end of the century, artists began preparing canvases in the manner of panels, with layers of *gesso*. This had the advantage of allowing artists to work with larger surfaces. Andrea Mantegna (*see* right) preferred to work on unprimed canvas or linen, using a glue-based medium called distemper, the texture of the support remaining visible. By the 1500s most artists in Venice were painting with oils on minimally prepared canvases, often exploiting the grain of the canvas for textural effect.

Tempera Paint

The paint medium was **tempera**: mineral or organic pigments, ground by assistants to a fine powder, mixed with egg yolk. The painter would lay in colors with small, precise strokes, proceeding slowly across the surface. Within a dimly lit church interior the intense tones of the tempera (*see* below) would have glowed like jewels.

LEFT
Fra Angelico, *Deposition from the Cross* (detail), 1432–34. Tempera on panel, 5'9¼" × 6'¾" (1.76 × 1.85 m). Museum of San Marco, Florence

ABOVE
Andrea Mantegna, *Dead Christ,* *c.* 1480. Tempera on canvas, 26¾ × 31⅞" (68 × 81 cm). Pinoteca di Brera, Milan

BELOW
Antonello da Messina, *Annunciate Virgin* (detail), *c.* 1476. Oil on panel, 17¾ × 13⅝" (45 × 34.5 cm). Galleria Nazionale della Sicilia, Palermo

Oil Paint

From the early 1400s artists sometimes used oil-based varnishes to enhance the brilliance of their paintings. By the 1440s, following the practice of such Netherlandish painters as Jan Van Eyck, Italians began to experiment with linseed oil as a binding medium. Oil-based paint dried slowly, allowing painters to modify and develop ideas as they worked. It could be applied in transparent layers, allowing for greater tonal range and for more variety in the rendering of shadows. The technique was particularly effective in the differentiation of surfaces and materials and in the rendering of lustrous objects, for example polished metals. Oil allowed the Sicilian Antonello da Messina (*see* right) and the Bellini family of Venice to achieve heightened effects of figural presence.

Mural Painting

The term "mural" (from the Latin *murus*, "wall") refers to paintings done on walls, regardless of medium. Most surviving Italian Renaissance murals, however, use the technique of fresco (from the Italian for "fresh" or "wet"). To make a fresco:

1) The artist's assistants would coat the entire area to be painted with a layer of rough plaster, called an *arriccio*.

2) Onto this layer the artist would draw his design. He might sketch with charcoal or incise lines into the plaster. Often, artists would employ **cartoons**, or one-to-one scale drawings of the painting to be executed. Painters employed various means of transferring the cartoon drawing to the wall. One was to prick the lines and then tap charcoal dust or pounce along these perforations, leaving a trace of the design in the form of small dots or *spolveri* on the wall. A rare surviving cartoon by Raphael for *The School of Athens* has been squared for transfer (*see* below).

BELOW

Raphael, cartoon for *The School of Athens*, c. 1509. Charcoal and chalk, 9'4¼" × 26'4⅝" (2.85 × 8.03 m). Biblioteca Ambrosiana, Milan

BOTTOM

Lorenzo da Viterbo, *The Marriage of the Virgin*, 1469. Detail of the frescoes in the Mazzatosta Chapel, Santa Maria della Verita, Viterbo

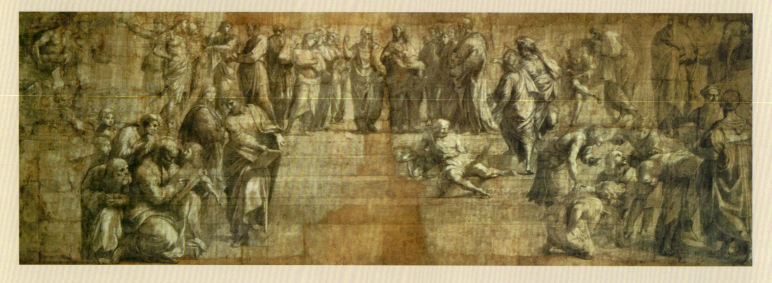

3) To finalize the design, the artist often painted in *sinopia*. The word originally denoted a dark red earth commonly used for underdrawings, but could also be used to refer to fresco underdrawings in general. (*Sinopie* become visible when the *intonaco* is removed: *see* right, and step 4.)

4) With the drawing in place, the painting team would add another layer of finer plaster over the *arriccio*. This layer, called the **intonaco**, provided a smooth surface on which to paint. While the *intonaco* dried, the artists worked with water-based pigments that fused with the wet surface. When the fresco dried, the paint was physically part of the wall. So long as the environment was generally dry, such paintings could last for centuries. Typically, artists painted frescoes only in the summer months, working from morning to evening on a single section, called a **giornata** (the Italian word for the passing of a day.) When the team reached the end of the *intonaco*, it had to stop. If the artists had applied more plaster than they painted, the colorless edges of the surface would have to be chipped away the next morning, before work could continue. Often, the lines between two *giornate* are visible even to the naked eye.

5) Occasionally, artists would paint on top of the dried (*secco*) mural. They might do this to add details to a costume, or they might add whole figures, as Raphael did with his Heraclitus in *The School of Athens*. Painters might also work *a secco* in order to employ pigments suspended in binders other than water. This is what Leonardo did, for example, when painting his *Last Supper* in Milan.

Sculpture

Carving in stone

Italy has a tradition of stone sculpture extending back into pre-Roman times, as well as abundant sources of marble with locally distinctive qualities. To produce a work in marble, the sculptor had first to concern himself with the material he would be using. Sometimes, artists sent instructions to the quarry laborers, in the form of drawings (*see* right). Other times, they supervised the excavation of blocks themselves. Once the stone was in the workshop:

1) The sculptor would often begin by drawing or painting an outline on one side of a rectangular block. Assistants would then use axes to cut away the surplus stone. The basic form of the figure was established in rough using punches struck with mallets.

2) The form would be gradually defined using claw chisels and drills.

3) Fine details and smooth surfaces would then be achieved with flat chisels.

4) The slow process of smoothing and polishing continued as the workshop team used metal rasps, emery (crushed stone), and pumice.

Carrara marble, from quarries in Northern Tuscany, was often favored for its greyish-white color and its luminous crystalline content. Donatello, however, sometimes used a cheaper, non-lustrous grey limestone known as *pietra serena*, more commonly used in architectural moldings. Until about 1500, sculptors typically enhanced stone carvings by gilding or coloring the eyes, hair, and other details.

ABOVE

Michelangelo, drawing of marble blocks required for sculpture on the facade of San Lorenzo. Casa Buonarroti, Florence

LEFT

Michelangelo, *Madonna* (Pitti Tondo), *c.* 1504. Marble, 33½ × 32¼" (85 × 82 cm). Museo Nazionale del Bargello, Florence, Italy. In this relief, the sculptor intentionally left traces of the various chisels he had used to carve it.

Carving in wood

Wood sculpture, with pine or poplar the preferred material, was cheaper but less durable than stone, since it was prone to cracking in dry conditions, warping through damp, and damage from woodworm. The procedures for carving it were similar to those used for stone sculpture, beginning with a design on a split tree-trunk. Carving figures in wood often involved the piecing in of additional sections (the arms of the figure, in the work at right), which was more difficult in stone and even frowned upon in later periods, when such carvers as Michelangelo prized the integrity of the block. Italian wood sculptures were usually painted in bright colors, and frequently incorporated other materials: glass, stone, and cloth stiffened with *gesso*.

Modeling

Wood and stone sculpture, along with ivory and gem carving, involved the removal of durable and resistant material: in this respect, the practice used to produce them typically stood in contrast with modeling, a process in which the artist normally built up figures in pliable, soft materials, such as wax and clay. These relatively cheap and plentiful media lent themselves to all manner of uses: sculptors could make exploratory sketches at different scales and models to show to clients. Sculpture in colored wax was also common in Renaissance Italy, especially for votive portraits in churches, but no examples of this popular technique from the period have survived.

Clay is a more durable medium, especially when it is fired at high temperature, which transforms it into terracotta ("cooked earth"): the process had long been used for making pottery. It was by experimenting with potters' techniques that Luca della Robbia, around 1440, discovered a means of making tin-glazed terracotta sculptures that could withstand outdoor use. Tin oxide applied to terracotta and heated to a high temperature resulted in a white, opaque, impermeable surface; colored pigments could be mixed with the glaze before firing. For more than a century, the workshop established by Luca produced and exported large quantities of brightly colored Madonna-and-Child reliefs, altarpieces, coats-of-arms, and architectural decorations, the latter mostly well-preserved to the present day.

A tin-glazed terracotta frieze still decorates the facade of Pistoia's Ospedale del Ceppo. It was completed by Santi Buglioni in 1515–25, and the roundels beneath it were made in the same medium by Giovanni della Robbia, the great-nephew of Luca della Robbia.

TOP
Filippo Brunelleschi, *Crucifix* (detail), *c.* 1410–15. Polychromed wood, 5'7" × 5'7" (1.7 × 1.7 m). Santa Maria Novella, Florence

ABOVE AND BELOW
Santi Buglioni and Giovanni della Robbia, facade of the Ospedale del Ceppo, Pistoia, 1515–25. Tin-glazed terracotta.

Lost-Wax Casting

Clay modeling served as the basis of sculpture cast in bronze, gold, or silver. The procedure was difficult and dangerous, and the materials were expensive. Figures were cast from earthen molds, which had previously been fired at high temperature to withstand the molten metal. Throughout the Renaissance, such sculpture was generally produced using the "lost wax" method. The simpler version of the lost-wax process was direct casting:

1) The sculptor would first produce a full-scale figure with a wax surface. For a small, solid-cast figure, he might simply make the whole figure in wax; larger figures, sculptural groups, and multi-figure reliefs were usually cast in several pieces. When the sculptor wished the finished metal figure to have a hollow core, he would make a full-scale figure in a material such as clay, then add a thin coat of wax, reworking details to provide additional definition.

2) To the wax surface he would then attach a series of wax rods, or "sprues."

3) Next he would enclose the whole structure in a mold, usually of clay. If the sculptor was making a hollow bronze, he would add metal pins at various points from the mold to the clay form inside.

4) Submitting this to heat would at once fire the mold and cause the wax to run out. If the sculptor was preparing a solid cast work, the remaining void would be the negative form of the original wax model. If the sculptor was preparing a hollow cast, the heated and drained mold would have a thin empty space between the core and its external "negative," as well as empty channels where the sprues had been.

5) Finally, the casting team would run molten bronze into the mold, either through the channels left by the sprues or through a larger opening at the top. Other channels allowed air to escape.

6) When the metal cooled, the team would first chip away the clay mold and then cut off those sprues that had not been incorporated into the design and refine the surface of the work, filing, polishing, and gilding. This final stage of work could last for months.

LEFT

Lorenzo Ghilberti, *St. John the Baptist, c.* 1410. Bronze, height 8'4" (2.55 m). Orsanmichele, Florence

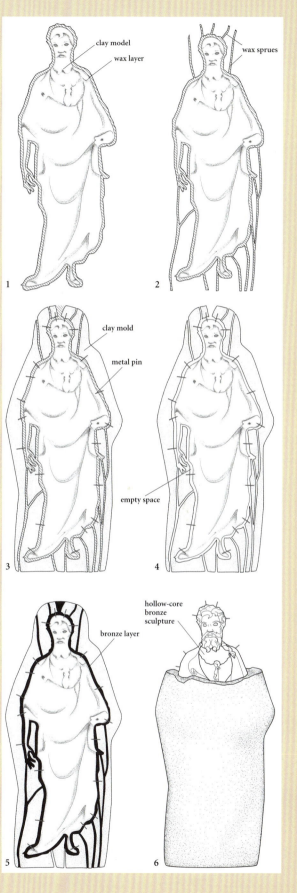

Printmaking

Woodcut

The earliest technology available in Europe for the reproduction of two-dimensional images was the woodcut. Although used in Japan several centuries earlier, the technique seems to have been developed independently by skilled wood-carvers in Central Europe in the early fifteenth century.

By the later fifteenth century, craftsmen were capable of cutting more complicated designs, including the delicate parallel lines (hatching) draftsmen used to create shading. The German artist Albrecht Dürer's virtuosic woodcuts were well known in Italy. In Italy, as north of the Alps, woodcuts were combined with movable type to create illustrated books.

To make a woodcut:

1) An artist would draw with pen or brush on a wooden plank (a "woodblock").

2) A carver – sometimes the draftsman but increasingly a different specialist – would then use a gouge to cut away wood from the blank areas of the design, leaving a fine ridge corresponding to the draftsman's line.

3) The printer would then apply ink to the raised image.

4) Finally the printer would place dampened paper on top; he would apply pressure to the paper, sometimes by rubbing a smooth pebble where the paper made contact with the ridges.

After the print dried, it was sometimes hand-colored, often by yet another person.

LEFT

Giovanni Britto after Titian,
Emperor Charles V, c. 1535–40.
Woodcut, 19½ × 13"
(49.5 × 35.2 cm). Davison Art
Center, Wesleyan University,
Middletown, Connecticut

Engraving

Intaglio printmaking depended on the incision of a design into a plate – by 1500, usually copper – rather than the creation of a relief. The most basic form of intaglio was engraving. To make an engraving:

1) A specialist, usually a trained metalsmith, would cut directly into the plate with a variety of chisel known as a burin.

2) The plate would be covered with ink.

3) The inked plate would then be wiped so that the ink remained only in the incised grooves.

4) The image could be transferred to paper.

Engravings could be augmented with other, related techniques, including drypoint, in which the craftsman used a sharp, stylus-like instrument rather than a burin. The regularity and malleability of copper allowed greater precision and finer detail than woodcut. The technique seems to have originated among goldsmiths north and south of the Alps, but the earliest masters were the Germans Martin Schongauer and Albrecht Dürer. Early Italian pioneers were the Florentine Baccio Baldini and Antonio Pollaiuolo; the engravings associated with Andrea Mantegna are the most refined and technically ambitious to come out of early Renaissance Italy, but it is now thought that the painter engaged the services of a goldsmith to engrave his designs, which were much copied by other printmakers.

BELOW LEFT
The engraving published by Philips Galle after the artist Stradano shows, right to left, the cutting of a plate, the inking of the plate, the printing press, and prints hung on the wall to dry.

Etching

Beginning shortly after 1500, a number of artists began to experiment with the technique of etching (*see* right). An experienced printmaker would apply a layer of acid-resistant varnish or wax, called a "ground," to a metal plate. Using a needle, an artist would scratch a design into the ground to expose the metal underneath. The team would then bathe the plate in acid, which would eat away the exposed metal but not the portions still protected by the ground, leaving an intaglio design. Once the ground was removed, the plate could be printed like an engraving. Etching may have been developed by armorers seeking ways to produce images on hard steel, but because the design process required nothing more than the ability to draw with a needle, any artist with a practiced collaborator could try his hand at the technique. The plates (or "matrices") used for intaglio printing were sometimes reworked after their initial printing. Prints showing modified images are referred to as "states."

ABOVE
Parmigianino, *The Resurrection* (detail), *c.* 1527–30. Etching and drypoint, 8³⁄₈ × 5³⁄₈" (21.1 × 13.6 cm). British Museum, London

Chronology of Rule 1400–1450 Key Centers

Rulers and Forms of Government	1400	1405	1410	1415	1420	1425	1430	1435	1440	1445

Ferrara
D'Este; Marquesses until 1471, then Dukes
- Niccolo III d'Este 1393–1441
- Leonello d'Este 1441–50

Florence
Republic, dominated from 1434 by Medici; Dukes 1532–69, then Grand Dukes
- Elected Republic, headed by a council called the "Signoria," with new elections every two months
- Cosimo de' Medici, though holding no official title, controls the government 1434–64

Mantua
Gonzaga; Marquesses until 1530, then Dukes
- Gianfrancesco Gonzaga 1407–44

Milan
Visconti Dukes until 1447; Sforza Dukes until 1524
- Giovanni Maria Visconti 1402–12
- Filippo Maria Visconti 1412–47
- Ambrosian Republic 1447–50

Naples
Angevin Kings until 1442; then Aragonese Kings
- Ladislas of Durazzo 1400–14
- Giovanna II 1414–35
- René of Anjou 1435–42
- Alfonso I of Aragon 1442–58

Rome
Popes
- John XXIII 1410–15 and two other claimants
- Martin V 1417–31
- Eugenius IV 1431–47
- Nicholas V 1447–55

Urbino
Montefeltro; Counts until 1474, then Dukes
- Guido Antonio di Montefeltro 1404–43
- Oddantonio di Montefeltro 1443–44
- Federico II di Montefeltro 1444–82

Venice
Doges
- Michele Steno 1400–13
- Tommaso Mocenigo 1414–23
- Francesco Foscari 1423–57

Holy Roman Emperors
- Rupert III 1400–10
- Sigismund 1410–1437
- Albert II 1438–39
- Frederick III 1440–93

Key Events
- 1406: Venice annexes Padua
- 1409: King Ladislas of Naples takes Rome and Papal States
- 1417: Council of Constance elects Martin V
- 1433: Cosimo de' Medici banished from Florence
- 1435: Alberti writes *On Painting*
- 1438–39: Council of Ferrara-Florence
- 1440: Forgery of *Donation of Constantine* exposed
- 1443: Alfonso of Aragon takes Naples

1450	1455	1460	1465	1470	1475	1480	1485	1490	1495	Rulers and Forms of Government

Ferrara
D'Este; Marquesses until 1471, then Dukes

Borso d'Este 1450–71
Ercole I d'Este 1471–1505

Florence
Republic, dominated from 1434 by Medici; Dukes 1532–69, then Grand Dukes

Lorenzo "the Magnificent" 1469–92
Piero de' Medici 1464–69
Piero the Younger 1492–94
Florentine Republic 1494–1512
Followers of Savonarola 1494–98

Mantua
Gonzaga; Marquesses until 1530, then Dukes

Federico I Gonzaga 1478–84
Ludovico Gonzaga 1444–78
Francesco Gonzaga 1484–1519

Milan
Visconti Dukes until 1447; Sforza Dukes until 1524

Francesco Sforza 1450–66
Giangaleazzo Sforza 1476–94
Galeazzo Maria Sforza 1466–76
Ludovico "il Moro" 1494–1500
King Louis XII of France 1499–1512

Naples
Angevin Kings until 1442; then Aragonese Kings

Ferrante I 1458–94
Alfonso II 1494–95
Ferrante II/ Charles VIII of France 1495
Ferrante II 1495–96
Federico 1496–1501

Rome
Popes

Calixtus III 1455–58
Paul II 1464–71
Innocent VIII 1484–92
Pius II 1458–64
Sixtus IV 1471–84
Alexander VI 1492–1503

Urbino
Montefeltro; Counts until 1474, then Dukes

Guidobaldo I di Montefeltro 1482–1508
(interrupted by Cesare Borgia 1502–03)

Venice
Doges

Niccolo Tron 1471–73
Marco Barbarigo 1485–86
Pasquale Malipiero 1457–62
Niccolo Marcello 1473–74
Agostino Barbarigo 1486–1501
Cristoforo Moro 1462–71
Pietro Mocenigo 1474–76
Andrea Vendramin 1476–78
Giovanni Mocenigo 1478–85

Holy Roman Emperors

Maximilian I 1493–1519

Key Events

1453: Ottomans take Constantinople
1475: Vatican Library established by Sixtus IV
1454: Peace of Lodi
1465: First printing press in Italy
1491: Girolamo Savonarola becomes Prior at San Marco in Florence
1478: Pazzi conspiracy against the Medici
1494: Charles VIII invades Italy

Chronology of Rule 1500–1550 Key Centers

Rulers and Forms of Government	1500	1505	1510	1515	1520	1525	1530	1535	1540	1545

Ferrara
D'Este; Marquesses until 1471, then Dukes

Alfonso I 1505–34
Ercole II 1534–59

Florence
Republic, dominated from 1434 by Medici; Dukes 1532–69, then Grand Dukes

Piero Soderini, elected "Gonfaloniere" for life 1502
Ippolito and Alessandro 1523–27
Medici-controlled government under Giovanni de' Medici 1512–13
"Last Republic" 1527–30
Alessandro, first Duke of Florence 1530–37
Giuliano de' Medici 1513
Cosimo I 1537–74 (Duke until 1569, Grand Duke thereafter)
Lorenzo, Duke of Urbino 1513–19
Cardinal Giulio 1519–23

Mantua
Gonzaga; Marquesses until 1530, then Dukes

Federico II 1519–40
Francesco III 1530–50

Milan
Visconti Dukes until 1447; Sforza Dukes until 1524

Ludovico "il Moro" 1500
Massimiliano Sforza 1512–15
Imperial Viceroys after 1525, including Ferrante Gonzaga 1546–55
King Louis XII 1500–12
King Francis I of France 1515–21
Francesco II Sforza 1521–24
King Francis I 1525

Naples
Angevin Kings until 1442; then Aragonese Kings

Spanish Rule Louis I 1501–03
Imperial Viceroys after 1503, including Pedro Álvarez de Toledo 1532–53

Rome
Popes

Leo X 1513–21
Paul III 1534–49
Pius III 1503
Adrian VI 1522–23
Julius II 1503–13
Clement VII 1523–34

Urbino
Montefeltro; Counts until 1474, then Dukes

Cesare Borgia 1502–03
Lorenzo de' Medici 1516–19
Guidobaldo II della Rovere 1538–74
Papal Rule 1519–20
Francesco Maria della Rovere 1508–16
Francesco Maria I della Rovere 1521–38

Venice
Doges

Antonio Grimani 1521–23
Pietro Lando 1539–45
Leonardo Loredan 1501–21
Andrea Gritti 1523–38
Francesco Donato 1545–53

Holy Roman Emperors

Charles V 1519–58

Key Events

1509: League of Cambrai formed
1530: Charles V crowned in Bologna
1517: Martin Luther posts his 95 theses
1540: Foundation of the Jesuits (Society of Jesus)
1520: Papal condemnation of Luther
1524: French defeat at Battle of Pavia
1545: First Session of the Council of Trent
1527: Sack of Rome by imperial forces
1528: Andrea Doria effective leader of Genoa
1529: Siege of Florence

1550	1555	1560	1565	1570	1575	1580	1585	1590	1595	**Rulers and Forms of Government**

Ferrara
D'Este; Marquesses until 1471, then Dukes

Alfonso II 1559–97
Papal Rule 1597–

Florence
Republic, dominated from 1434 by Medici; Dukes 1532–69, then Grand Dukes

Francesco de' Medici 1564–87 (regent 1564–74)
Ferdinando I 1587–1609

Mantua
Gonzaga; Marquesses until 1530, then Dukes

Guglielmo 1550–87
Vincenzo I 1587–1612

Milan
Visconti Dukes until 1447; Sforza Dukes until 1524

Imperial Viceroys after 1555

Naples
Angevin Kings until 1442; then Aragonese Kings

Imperial Viceroys after 1553

Rome
Popes

Julius III 1550–55
Marcellus II 1555
Paul IV 1555–59
Pius IV 1559–65
Pius V 1566–72
Gregory XIII 1572–85
Sixtus V 1585–90
Urban VII 1590
Gregory XIV 1590–91
Innocent IX 1591
Clement VIII 1592–1605

Urbino
Montefeltro; Counts until 1474, then Dukes

Francesco Maria II della Rovere 1574–1621

Venice
Doges

Antonio Trevisan 1553–54
Francesco Venier 1554–56
Lorenzo Priuli 1556–59
Girolamo Priuli 1559–67
Pietro Loredano 1567–70
Alvise Mocenigo 1570–77
Sebastiano Venier 1577–78
Niccolo da Ponte 1578–85
Pasquale Cicogna 1585–95
Marin Grimani 1595–1605

Holy Roman Emperors

Ferdinand I 1558–64
Maximilian II 1564–76
Rudolf II 1576–1612

Key Events

1550: Vasari publishes first edition of *Lives of the Artists*
1556: Philip II succeeds Charles I (Emperor Charles V) as King of Spain (rules until 1598)
1562: Foundation of the Accademia del Disegno in Florence
1563: Final decrees of the Council of Trent
1565: Carlo Borromeo moves to Milan
1571: Battle of Lepanto
1577: Founding of the Accademia di San Luca in Rome

Glossary

acanthus classical architectural ornament in the form of stylized spiny foliage, used in friezes and Corinthian capitals.

aedicule from the Latin *aedicula* meaning "little temple" or shrine; a classicizing framing device consisting of paired columns or pilasters supporting a pediment.

all'antica Italian; "in the ancient manner."

apse in church architecture, the semidomed recess opening behind the high altar, or sometimes housing the high altar, usually at the east end of the structure.

architrave see **entablature**.

arriccio Italian; coarse layer of plaster, the first to be applied to the wall in the fresco painting process.

avant-garde "frontline" or "vanguard"; term normally used with reference to Modern Art to designate groundbreaking or pioneering achievement.

axonometric a form of three-dimensional projection newly used for drawings of buildings after about 1500.

baldachin a canopy carried in processions or placed over the altar to honor the thing or person beneath; also, a permanent architectural structure made in the form of such a canopy.

baptistery a chapel or free-standing structure – often vaulted and centralized – in which the ritual of baptism is celebrated.

barrel vault an arched masonry ceiling.

basilica the most characteristic form of church design in the Middle Ages, adapted from the large Roman public building type of the same name used to house civic and legal business. A basilica is normally rectangular in plan, with a central nave divided by rows of columns or arches from paired side aisles, a second nave-like space running perpendicular to this and known as a transept, and an apse to designate the sacred precinct of the altar.

Benedictine Order the first of all monastic orders, founded in adherence to the rules of prayer and discipline composed by St. Benedict for the community he established at Monte Cassino south of Rome in 529 CE. During the Middle Ages and Renaissance, a number of other Orders followed versions of the Benedictine Order: Camaldolese, Cassinese, Cistercians, Foglianti, Olivetans, and Sylvestrines.

Black Death the pandemic that devastated the populations of Europe and Asia in the 1340s, apparently borne from the Crimea to Genoa and other Italian port cities in merchant ships. The horrifying symptoms have been associated since the nineteenth century with the disease known as "bubonic plague," but some scholars consider the evidence for identifying this with the 1340s and later outbreaks to be inconclusive. (Modern bubonic plague kills animals as well as humans, and no fourteenth-century source records animal deaths.) Recurrences of "plague" are thought to have reduced the population of Europe by as much as two-thirds by 1420.

bole red clay substance applied to a panel painting as an adhesive for gold leaf.

burin in printmaking, the metal tool used to engrave a design into a metal plate.

buttress in architecture, a segment of arch or a heavy pier erected, usually on the exterior of the building, to counter the lateral thrust of a tall vault or dome.

Byzantine pertaining to the sphere of cultural influence of the Byzantine empire, centered in Byzantium (the ancient city of Constantinople, modern Istanbul) until the Ottoman conquest of 1453.

campanile (pl. *campanili*) Italian; the bell tower of a church. From *campanile* comes the term *campanilismo*, competitive pride in one's own city.

campo the Italian word for "field," used in some cities (notably Venice) to designate a public square.

cardo The principal north–south road in an ancient Roman city.

Carmine the Carmelite friary in an Italian city. *Carmine* is the Italian for Mt. Carmel, the site in Sinai that the Carmelite Order claimed as its ancient place of origin.

cartoon from the Italian *cartone*, meaning "large sheet of paper." A full-scale drawing for a painting or tapestry, either for details (heads, hands) or for the entire composition. Cartoons for paintings allowed the transfer of the design from paper to picture surface by the process of **pouncing**.

cassone (pl. *cassoni*) Italian; a large wooden chest used as household furnishing, often richly ornamented with painted or carved decoration. Families would present well-to-do brides with *cassoni*, which would contain textiles and other luxury items identified as the bride's personal property.

cella Latin; the main enclosed space of an ancient Roman temple.

cenotaph a memorial to the dead, often in the form of a tomb, though not at an actual site of burial.

chasing the process of finishing a cast metal artifact using small chisels.

chiaroscuro Italian term meaning "bright-dark," referring to the handling of light and shadow contrasts in painting to achieve modeling or atmosphere.

choir the sacred precinct of a church, often separated by steps, a rail, or screen from the main public congregation space and containing the principal altar. In the churches attached to houses of religious orders, the clergy normally assembled for Mass and other offices in this area. These offices were generally sung, hence the modern sense of the word "choir."

Cinquecento Italian; the 1500s.

classical pertaining to ancient Greek and Roman culture.

clerestory in church architecture, a zone with windows in the upper part of a wall.

clypeus Latin; in Roman monumental and funerary sculpture, a round, shield-like frame usually carried by a pair of spirits or angels and enclosing a portrait or half-length likeness.

coffer in architecture, a module in a wooden ceiling or concrete vault defined by a recessed square panel. Originally in ancient Roman architecture coffering served to lighten the weight of the vault; Renaissance coffering was often primarily decorative.

colonnette slender column employed especially in Gothic architecture.

comune (pl. *comuni*) Italian term usually translated as "commonwealth," referring to a city as a governmental or administrative entity.

commensuration "measuring together"; the principle of carrying consistent proportions through a large architectural design or across a representation in perspective.

Composite order see **orders, classical**.

condottiere (pl. *condottieri*) Italian; the leader of a mercenary company.

confraternity a religious organization for lay people, usually devoted to a saint, to the Virgin, or to the Eucharist, which assembled for prayer and for the organization of charitable works at a designated altar in a church or in its own headquarters. The charitable works might be on behalf of the confraternity's own members or the local poor; some confraternities escorted the Eucharist to the bedside of persons nearing death; others prepared condemned criminals for execution. Some (*disciplinati*) devoted themselves to such penitential exercises as self-flagellation. Most Italian Christian men in this period were members of at least one confraternity; membership of some confraternities (such as the larger Venetian *scuole*) carried social distinction and influence.

contrapposto Italian term referring to the principle of antithesis, or the juxtaposition of opposites. In Renaissance art, forms of contrapposto (placing near next to far, large next to small, light next to dark, etc.) constituted a basic compositional technique. Modern writers on classical statuary have also used the term to designate weight shift in a figure, where the body resting on one leg produces an asymmetrical arrangement in the other parts.

Conventual see **Mendicant Orders**.

Corinthian see **orders, classical**.

cornice see **entablature**.

crenellation a low wall on the top of a defensive structure, comprising alternating screens to provide cover for bowmen and artillery and open spaces (crenels) through which they could shoot.

cruciform in the form of a cross; often used with reference to the ground plan of a church.

cupola a dome.

decumanus The principal east–west road in an ancient Roman city.

dome a convex ceiling, usually covered by a concave roof. Domes may rest on a cylindrical or polygonal structure known as a drum, as in the case of Florence Cathedral. More commonly, as in the case of Brunelleschi's Old Sacristy, the dome rests on four curved triangular vaults known as **pendentives**, which serve as transitions to the planar surface of the supporting walls below.

Dominican see **Mendicant Orders**.

Doric see **orders, classical**.

drum see **dome**.

duomo from the Latin *domus*, "house," the term used in many Italian cities for the cathedral.

embossed adorned with a raised abstract pattern.

entablature in classical architecture, the sequence of horizontal elements supported by the columns. Each order has a characteristic set of entablature forms: the most basic, that of the Doric, comprises the **architrave**, a simple lintel or beam that sits directly on the columns; the frieze, a band decorated with square panels of ornament (the fluted **triglyph** alternating with the plain **metope**); and above this, the pronounced molding known as the **cornice**.

Etruscan pertaining to the ancient civilization that dominated large parts of Italy, notably Tuscany, before the rise of Rome.

Eucharist in the Mass, the real presence of the body of Christ manifest in the forms of consecrated bread and wine.

ex-voto an offering made in fulfillment of a vow.

fluting decorative vertical grooves incised in a column or pilaster.

foreshortening abbreviating the lines or forms that represent such an element as a body or limb to create the illusion that it projects outward toward the viewer; considered one of the chief "difficulties" of painting.

Franciscan see **Mendicant Orders**.

fresco Italian; technique of mural painting where paint is applied to wet or "fresh" plaster,

as distinct from painting onto plaster that is dry (*secco*). See the fuller description in chapter 5.

gesso a coating of plaster and animal glue forming a smooth white surface for painting.

giornata (pl. *giornate*) Italian; a day's work on a fresco painting. See the fuller description in chapter 5.

Gothic term applied beginning in the eighteenth century to a style principally of architecture that arose in the area of Paris in the mid 1100s, characterized by pointed arches, rib vaults, and flying buttresses, as well as a repertoire of foliate ornament manifest above all in tracery patterns. The term is also applied to painting, sculpture, and decorative arts from the thirteenth to the sixteenth centuries that show comparable qualities of linear enrichment, fine detail, and elongated proportions.

grisaille a painting in monochrome.

groin vault the intersection of two perpendicular barrel-vaults.

guild an organization representing and regulating a particular trade or profession. A guild licensed the training and certification of professionals, determined who had the right to practice in its area or jurisdiction, and supervised the conduct of its members.

hatching in drawing and painting, the technique of providing shading through minute parallel strokes of the pen or brush.

herm in classical and classicizing architecture, a figure that becomes a pillar from the waist down.

Holy Roman Empire a federation initially of Germanic peoples that separated from the Carolingian Empire (the lands conquered by Charlemagne, 742–814, and his descendants) in the early tenth century and elected a common ruler. By the reign of Emperor Charles V (1519–1558), it comprised not only these territories but also Spain, Burgundy (the modern Netherlands and Belgium as well as eastern France), and Bohemia (the modern Czech Republic).

humanist a scholar of classical languages and culture; by the late fifteenth century, humanism designated the study of the *studia humanitatis* ("humane studies") comprising poetry, rhetoric, history, philosophy, and all fields covered by classical authorities.

icon an image of a saint, the Virgin, or Christ, sometimes believed to be of miraculous origin, venerated through prayer and meditation.

iconoclast a defacer of images.

iconography the art-historical practice of identifying the "subject matter" of a work; also, the collection of familiar characteristics through which a particular subject can be identified.

impresa A figure or image, combined with a motto, adopted by an individual as a heraldic device.

indigo purple dye extracted from a shellfish known as *murex*.

indulgences reductions in the time the dead must spend suffering in Purgatory before ascending to Paradise. In the Middle Ages and the Renaissance, Christians could acquire indulgences by undertaking prescribed pious actions, such as making a pilgrimage to particular holy sites, by venerating specific relics or images, by reciting certain prayers, or by donating money and property to the Church.

intarsia Italian; decorative wood inlay; marquetry.

intonaco see **fresco**.

Ionic see **orders, classical**.

Istrian stone white marble from the region of Istria near Trieste in the eastern Veneto.

jamb the lateral, vertical part of a doorway.

keystone the central wedge-shaped stone in an arch; the keystone acts as a lock holding the other stones of the arch together.

lantern architectural element surmounting a dome; the weight of the lantern allowed it to serve the structural function of a **keystone**, though the word refers to the fact that it was through the lantern that light entered the building interior below.

lapis lazuli blue semi-precious stone mined in Afghanistan, used in inlay work and in finely ground form as the basis for the pigment ultramarine.

leadpoint see metalpoint.

linear perspective see **perspective**.

loculus (pl. *loculi*) Latin; "little place." In the Roman catacombs, a horizontal recess, excavated from the wall of a passageway, into which the dead body was placed.

loggia An open arcade, usually in the lower storey of a building but sometimes in the *piano nobile*.

mandorla Italian; "almond." In painting, an almond-shaped aura designating the divine or other-worldly status of the person it encloses; in architecture, an almond-shaped frame that evokes such an aura.

maniera Italian; "manner" or "style," as in an artist's style or a period style; the word can also mean "stylishness."

Mendicant Orders priestly orders mainly founded in the thirteenth century, committed to communal living in an urban setting and an active ministry of preaching. The word "mendicant" literally means "beggar," and initially these orders were defined by a prohibition on the ownership of property – their means of living, their housing, and their churches were all donations from the laity. By the late fifteenth century, such Mendicants as the Franciscans and Dominicans had split internally: Observants pursued a more austere "observance" of the rules governing poverty, while Conventuals followed a more moderate practice, especially with regard to vows of poverty.

metalpoint a pointed stick of silver or lead used in drawing on vellum or paper. Silverpoint, which produces a dark oxide mark, was preferred for its finer line.

metope see **entablature**.

Middle Ages the "medieval" period, or *media tempestas*, a description in circulation in the fifteenth century (and still current) to define the centuries between the fall of the Roman Empire in 476 CE and the era of *renovatio* or "Renaissance."

narthex in some medieval churches, a space between the main entrance and the nave, serving as a vestibule.

nave the main space of a church, on axis with the high altar.

Observant see **Mendicant Orders**.

oculus (pl. oculi) Latin; "eye"; a round window.

Olivetans monastic order founded in 1313 near Siena, adopting the Benedictine Rule in 1344.

oratory a small room for private prayer; in some cities, a place where confraternities held meetings or engaged in communal prayer.

orders, classical a system of architectural forms consisting of a vertical element (column) and a horizontal element (entablature), each with distinctive, conventionalized proportions and sets of parts. The three basic orders, known from buildings like the Colosseum in Rome and from the writing of Vitruvius, were most easily recognizable from the form of their capitals: the Doric capital has plain moldings; Ionic has scroll forms; Corinthian has stylized acanthus foliage. Later Renaissance architects and theorists sometimes introduced a fourth order, the Composite, which combined scrolls with acanthus, and a fifth, the Tuscan (or Etruscan), a simpler, stouter form of the Doric.

orthogonal in perspective, a line notionally perpendicular to the picture plane. Orthogonals appear to converge on a common vanishing point.

pala Italian; an altarpiece consisting of one major panel, usually square in form; after about 1440, the alternative to the **polyptych**, which consisted of multiple panels.

Papal States the central Italian territories directly subject to the Pope, although often ruled in practice by so-called papal vicars who founded dynasties of their own.

paragone (pl. *paragoni*) Italian; "comparison." A term applied beginning in the nineteenth century to a literary set-piece that evaluated the relative merits and limitations of competing art forms – poetry vs. painting, painting vs. sculpture, painting vs. music, etc.

pastiglia Italian; raised relief ornament constructed in **gesso** on the surface of a panel painting, often gilded to suggest goldsmith's work in metal.

paten liturgical instrument used during Mass to hold the **Eucharistic** wafer.

pediment in architecture, a triangular element placed over windows, doors, or the main facade of a temple or church. A segmental pediment replaces the two sloping sides of the triangle with an arc.

pendentive see **dome**.

peristyle a colonnade that surrounds the *cella* of a temple or an open courtyard or square; the term can also be used to refer to the space so surrounded.

perspective from the Latin *perspicere*, "to look through"; the term now normally refers to the techniques for creating illusionistic space using geometric devices (linear perspective) or coloristic ones (atmospheric perspective).

philology the study of language and literature, especially applied to the humanistic study of ancient Latin, Greek, and Hebrew texts.

piano nobile Italian; "noble floor"; the second storey of an Italian palazzo, often given a special architectural distinction as the level frequented by the palace's principal inhabitant and used to receive important guests.

piazza Italian; the word used in most Italian cities to denote a large urban public space, typically adjacent to a church, an important civic building, or the residence of a powerful family.

pier a non-columnar vertical support. The term can refer to a pillar that is square rather than round, to an irregularly shaped concrete or masonry structure that supports a **dome** or other heavy load, or even to a section of bearing wall.

pietra serena Italian; "serene stone"; gray limestone mined near Florence, used for architectural ornament and occasionally for sculpture.

pigment colored animal, botanical, or mineral substance combined with a medium (egg yolk, lime water, or oil), to make paint.

pilaster a "flattened" column applied as relief to a wall.

polychromy in sculpture, applied color.

polyphony form of musical composition arising in the later 1200s in which different instruments and/or voices perform different lines of music simultaneously, the whole governed by mathematical principles of harmony and rhythm.

polyptych a painting, usually an altarpiece, consisting of multiple panels or sections. A diptych is a polyptych with two panels, a triptych with three.

porphyry a stone, red, purplish-red, or black in color and famed for its hardness, mined in antiquity and used for columns, stone inlay, and, more rarely, sarcophagi. Only in the late sixteenth century did sculptors rediscover the means to carve figures in porphyry, using new varieties of tempered steel.

portico a columned porch.

pouncing the technique of transferring a design from a cartoon to a surface to be painted by pricking holes along the lines of a cartoon, then rubbing or tapping charcoal dust through them. See also *spolvero*.

predella a row of painted or carved scenes on which the main panel or panels of an altarpiece rest.

pronaos in an ancient Greek or Roman temple, the vestibule-like space that precedes the *cella*.

pumice abrasive volcanic stone used in polishing marble.

Purgatory In Christian belief, a place of temporary punishment in the afterlife. Living Christians could reduce their prospective sentences by obtaining **indulgences**; souls already in Purgatory could be delivered through the prayers of the living on their behalf. The Renaissance conception of Purgatory was largely shaped by Dante's description in the second part of his epic poem *The Divine Comedy*.

putto (pl. *putti*) Italian; "little boy." Term used to describe child angels, cupids, or *spiritelli* ("little spirits") in art.

quatrefoil French; "four leaf": In Gothic art, a decorative form – often used to frame an image – in which four rounded lobes alternate with four points.

Quattrocento Italian; the 1400s.

quoin stone blocks forming the corner of a building.

revetment in Roman and in Italian Renaissance architecture, fine stone that covers a wall constructed of brick or other material.

rib a raised molding defining and dividing the segments of a vault or dome.

rustication in architecture, a textural effect produced when the faces of stone blocks are left unfinished, or where the joins between the blocks are emphasized to stress their distinctness and their massiveness.

sacristy a room in a church used for the storing of vestments and liturgical objects, and where the robing of a priest takes place.

scriptorium a room in a convent or monastery devoted to writing and to the preparation of manuscripts.

scuola (pl. *scuole*) Italian; see **confraternity**.

secco see **fresco**.

serliana in architecture, a tripartite window or door consisting of an arched central opening flanked by vertical rectangular openings. Though ancient in origin, the form is named after the architect Sebastiano Serlio, whose illustrated *Books of Architecture* (1537–47) popularized the motif. Also referred to as a "Palladian motif."

serpentine a lustrous colored stone (gray, green, yellow, or brown) characterized by veins and blotches.

Servite a **Mendicant Order** founded outside Florence in the thirteenth century.

sfumato, *sfumatura* from the Italian *fumo*, "smoke": the blurring of edges or borders in a painting to create the effect of atmosphere or of transparent, "smoky" shadows, and to merge figures with their surroundings.

Sibyl one of the pagan prophetesses or female oracles of the ancient world.

signoria (pl. *signorie*) Italian; "lordship," referring either to a state governed by a single, unelected lord or to the elected body of lords in a republic.

silverpoint see metalpoint.

sinopia reddish brown pigment used to make the underdrawing for a fresco.

spalliera (pl. *spalliere*) from the Italian *spalla*, "shoulder." A painted or marquetry (wood-inlaid) panel or series of panels set into a wooden wainscotting at shoulder height.

spandrel see **dome**.

spoglia (pl. *spoglie*) from the Italian *spogliare*, "to strip." An architectural element, epigraphic inscription, or sculpture removed from its original context and re-embedded in a new architectural setting, typically the exterior wall of a palace or church. The transposition sometimes signifies the triumph of Christianity over paganism, or the territorial domination of one city or state by another.

spolvero (pl. *spolveri*) Italian; charcoal dust applied to the perforations in a **cartoon** in order to transfer the outline to a wall or panel.

string course in architecture, a narrow, continuous horizontal molding running the length of a facade or entablature.

stucco (pl. stucchi) Italian; plaster made from lime, sand, and water, used to fashion sculptural elements for architectural decoration.

tabernacle a window treatment taking the form of a miniature building; in churches, also a container in the form of a miniature building, usually placed on an altar, designed to hold the **Eucharist**.

taccuino (pl. *taccuini*) Italian; "sketchbook."

tempera paint that uses watser and egg yolk (rather than oil) as a binder.

terra verde Italian; "green earth"; greenish pigment used for the underpainting of flesh in panel painting and for **grisaille** painting on walls.

tessera (pl. tesserae) cube of colored stone or glass used to make mosaics.

timpanum (pl. *timpana*) arch-shaped space over a door; the surface inside a pediment.

tondo (pl. *tondi*) Italian; "round." A circular painting or relief.

tracery decorative interlaced stone moldings or framing elements for stained glass, characteristic of Gothic architecture.

transept see **basilica**

Trecento Italian; the 1300s.

triglyph see **entablature**.

trilobe ornamental motif consisting of three linked round forms.

triptych see **polyptych**.

ultramarine see **lapis lazuli**.

vault a curved ceiling.

Bibliographical Notes and Suggestions for Further Reading

The following notes identify sources on which we drew for particular discussions and give recommendations for further reading in English.

Introduction

The most recent edition of the *Commentarii* is the one edited by Lorenzo Bartoli (Florence: Giunti, 1998); this has not completely supplanted Julius von Schlosser's 1912 German edition. There is no complete English translation of the text.

Chapter 1: 1300s

Three good introductions to fourteenth-century painting are Diana Norman, et al., *Siena, Florence and Padua: Art, Society and Religion 1280–1400*, 2 vols. (New Haven, CT, and London: Yale University Press, 1995); Hayden B. J. Maginnis, *Painting in the Age of Giotto: A Historical Reevaluation* (University Park, PA: Penn State University Press, 1997); and Christine Sciacca, ed., *Florence at the Dawn of the Renaissance: Painting and Illumination 1300–1350* (Los Angeles, CA: The Getty Museum, 2012).

Nicolai Rubinstein's excellent *The Palazzo Vecchio 1298–1532: Government, Architecture, and Imagery in the Civic Palace of the Florentine Republic* (Oxford: Clarendon Press, 1995) surveys the building's decorations up to the establishment of the Medici Duchy. This should be read in conjunction with Marvin Trachtenberg, *Dominion of the Eye: Urbanism, Art, and Power in Early Modern Florence* (Cambridge: Cambridge University Press, 1997).

John Pope-Hennessy, *Italian Gothic Sculpture* (Oxford: Phaidon Press, 1985) provides a general overview of fourteenth-century sculpture. We also drew on Joachim Poeshke, *Die*

Skulptur des Mittelalters in Italien (Munich: Hirmer, 2000); Max Seidel, *Nicola and Giovanni Pisano* (Munich: Hirmer, 2012); and Seidel, "The Pulpit as a Stage: The Function of the Pulpits of Nicola and Giovanni Pisano," in Seidel, ed., *Italian Art of the Middle Ages and the Renaissance* (Munich: Deutscher Kunstverlag, 2005), II, 127–132. For Tino da Camaino, see especially Tanja Michalsky, "Mater Serenissimi Principis: The tomb of Mary of Hungary" in Janis Elliott and Cordelia Warr, eds., *The Church of Santa Maria Donna Regina: Art, Iconography and Patronage in Fourteenth-Century Naples* (Aldershot: Ashgate, 2004), 61–77.

The standard study on the artist and writer Ghiberti is Richard Krautheimer and T. Krautheimer-Hess, *Lorenzo Ghiberti* (Princeton, NJ: Princeton University Press, 1956).

Two essential recent studies of the new Mendicant Orders and the arts are Donal Cooper and Janet Robson, *The Making of Assisi: The Pope, the Franciscans, and the Painting of the Basilica* (New Haven, CT, and London: Yale University Press, 2013) and Joanna Cannon, *Religious Poverty, Visual Riches: Art in the Dominican Churches of Central Italy in the Thirteenth and Fourteenth Centuries* (New Haven, CT, and London: Yale University Press, 2014).

Our chronology of Giotto's travels reflects the findings in Cooper and Robson. Andrew Ladis's *Giotto and the World of Early Italian Art: An Anthology of Literature* (New York, NY: Garland, 1998) provides a useful point of entry into the older literature on that artist and on some of his followers. On the Arena Chapel, recent bibliography in English includes Anne Derbes and Mark Sandona, *The Usurer's Heart: Giotto, Enrico Scrovegni, and the Arena Chapel in Padua* (University Park, PA: Penn State University Press, 2008); Laura Jacobus, *Giotto and the Arena Chapel: Art, Architecture and Experience* (London: Harvey Miller, 2008), and Andrew

Ladis, *Giotto's O: Narrative, Figuration, and Pictorial Ingenuity in the Arena Chapel* (University Park, PA: Penn State University Press, 2008).

There is far less good English-language literature on Duccio, but see Keith Christiansen's *Duccio and the Origins of Western Painting* (New Haven, CT: Yale University Press, 2008). For Trecento Siena more broadly, a good place to start is Diana Norman, *Siena and the Virgin: Art and Politics in a Late Medieval City State* (New Haven, CT, and London: Yale University Press, 2000). The far richer literature on Simone Martini includes Andrew Martindale, *Simone Martini* (Oxford: Phaidon, 1988), C. Jean Campbell, *The Commonwealth of Nature: Art and Poetic Community in the Age of Dante* (University Park, PA: Penn State University Press, 2008); Pierluigi Leone de Castris, *Simone Martini* (Milan: Federico Motta, 2003), and Charles Dempsey, *The Early Renaissance and Vernacular Culture* (Cambridge, MA: Harvard University Press, 2012). Campbell also discusses the murals in the Palazzo Pubblico, which are the subject of an important chapter in Randolph Starn and Loren Partridge, *Arts of Power: Three Halls of State in Italy, 1300–1600* (Berkeley, CA: University of California Press, 1992) and of two iconographic studies by the intellectual historian Quentin Skinner: "Ambrogio Lorenzetti: The Artist as Political Philosopher," *Proceedings of the British Academy* 98 (1991), 1–56, and "Ambrogio Lorenzetti's Buon governo Frescoes: Two Old Questions, Two New Answers," *JWCI* 72 (1999), 1–28.

The best general study on the civic and religious role of the image in the preceding centuries and through the 1500s remains Hans Belting, *Likeness and Presence: A History of the Image in the Era before Art* (Chicago, IL: Chicago University Press, 1994). Other important books on related topics include David

Freedberg, *The Power of Images: Studies in the History and Theory of Response* (Chicago, IL: University of Chicago Press, 1989); Erik Thunø and Gerhard Wolf, *The Miraculous Image in the Late Middle Ages and the Renaissance* (Rome: L'Erma di Bretschneider, 2004); and Alexander Nagel and Christopher Wood, *Anachronic Renaissance* (New York: Zone Books, 2010). For the specific case of Florence, see Richard C. Trexler, "Florentine Religious Experience: The Sacred Image," *Studies in the Renaissance* 19 (1972), 7–41, and the impressive recent study by Megan Holmes, *The Miraculous Image in Renaissance Florence* (New Haven, CT, and London: Yale University Press, 2013). On Orsanmichele specifically, see Diane Finiello Zervas's bilingual *Orsanmichele a Firenze* (Modena: F. C. Panini, 1996) and Carl Brandon Strehlke, ed., *Orsanmichele and the History and Preservation of the Civic Monument: Studies in the History of Art*, vol. 76 (Washington, D.C.: Center for Advanced Study in the Visual Arts, 2012).

Millard Meiss's classic *Painting in Florence and Siena after the Black Death* (Princeton, NJ: Princeton University Press, 1951) launched a controversy that continues today. Key responses to Meiss's thesis include Ernst H. Gombrich's review of the book in *The Journal of Aesthetics and Art Criticism* 11 (1953), 414–16; Henk van Os's "The Black Death and Sienese Painting: A Problem of Interpretation," *Art History* 4 (1981), 237–49; Diana Norman's "Change and Continuity: Art and Religion after the Black Death," in Norman, ed., *Siena, Florence and Padua: Interpretative Essays* (New Haven, CT: Yale University Press, 1995), 177–95, and Maginnis, *Painting in the Age of Giotto*, cited above. On Altichiero, see John Richards, *Altichiero: An Artist and His Patrons in the Italian Trecento* (Cambridge and New York: Cambridge University Press, 1999).

Chapter 2: 1400–1410

There is no good history in English of the building of Milan Cathedral. Our discussion relied heavily on Carlo Ferrari da Passano, *Il duomo di Milano: Storia della veneranda fabbrica* (Milan: NED, 1998), and Giulia Benati and Anna Maria Roda, eds., *Il duomo di Milano: dizionario storico artistico e religioso* (Milan: NED, 2001). The literature on Florence Cathedral is substantial, but a volume occasioned by the 1997 centenary gives a sense of the state of the field and includes many further references: Margaret Haines, ed., *Santa Maria del Fiore: The Cathedral and Its Sculpture* (Fiesole: Edizioni Cadmo, 2001). Charles Seymour's *Michelangelo's David: A Search for Identity* (Pittsburgh, PA: Pittsburgh University Press, 1967) informed our reading of the prophet cycle.

For the first Florence baptistery doors, see Anne Fiderer Moskowitz, *The Sculpture of Andrea and Nino Pisano* (Cambridge and New York: Cambridge University Press, 1986); on Ghiberti, Brunelleschi, and the baptistery doors competition, see Krautheimer, *Lorenzo Ghiberti* (as in chapter 1 above), and Antonio Paolucci, *The Origins of Renaissance Art: The Baptistery Doors, Florence*, trans. by Françoise Pouncey Chiarini (New York: George Braziller, 1996). For a recent survey of early Renaissance sculpture in Florence, see the catalog *The Springtime of the Renaissance: Sculpture and the Arts in Florence 1400–60*, ed. Beatrice Paolozzi Strozzi and Marc Bormand (Florence: Mandragora, 2013). On the Fonte Gaia, see Anne Coffin Hansen, *Jacopo della Quercia's Fonte Gaia* (Oxford: Clarendon Press, 1965). The two English-language monographs also discuss the fountain: Charles Seymour, Jr., *Jacopo della Quercia, Sculptor* (New Haven, CT: Yale University Press, 1973) and James Beck, *Jacopo della Quercia* (New York: Columbia University Press, 1991). A more recent resource in Italian is the well-illustrated exhibition catalogue *Da Jacopo della Quercia a Donatello: Le Arti a Siena nel primo Rinascimento*, ed. Max Seidel (Milan: Motta, 2010).

Chapter 3: 1410–1420

On contractual procedures and on the language used to describe works of art in the 1400s, see Michael Baxandall, *Painting and Experience in Fifteenth-Century Italy* (Oxford and New York: Oxford University Press, 1988). We also drew on Ulrich Pfisterer, "Civic Promoters of Celestial Protectors: The Arca di San Donato at Arezzo and the Crisis of the Saint's Tomb around 1400," in *Decorations for the Holy Dead: Visual Embellishments on Tombs and Shrines of Saints*, ed. Stephen Lamia and Elizabeth Valdez del Alamo (Turnhout: Brepols, 2002), 219–32. Christa Gardner von Teuffel notes that a "persistent convention in altarpiece commissions, and particularly those of elaborate polyptychs, was that they should 'copy' an older prototype"; see *From Duccio's Maestà to Raphael's Transfiguration: Italian Altarpieces and their Settings* (London: Pindar Press, 2005), 11.

Diane Finiello Zervas, *Orsanmichele a Firenze* (see chapter 1 above), collects the crucial documentation related to the building and ornamentation of Orsanmichele and gives a balanced and cautious chronology of the tabernacles and sculptures. Our discussions of Nanni di Banco and Lorenzo Ghiberti were informed by the study day hosted by the National Gallery in Washington during the 2005 exhibition, "Monumental Sculpture from Renaissance Florence: Ghiberti, Nanni di Banco and Verrocchio at Orsanmichele."

For the circumstances surrounding the two Lorenzo Monaco *Coronation* altarpieces, see especially Dillian Gordon and Anabel Thomas, "A New Document for the High Altar-Piece for S. Benedetto fuori della Porta Pinti, Florence," *Burlington Magazine* 137 (1995), 720–22, and Dillian Gordon, "The Altar-Piece by Lorenzo Monaco in the National Gallery, London," *Burlington Magazine* (1995), 723–27. The standard monograph on Gentile da Fabriano remains that of Keith Christiansen, *Gentile da Fabriano* (Ithaca, NY: Cornell University Press, 1982), though see also the catalogue from the major 2006 exhibition *Gentile da Fabriano and the Other Renaissance*, ed. Laura Laureti et al. (Milan: Electa, 2006).

On Renaissance hospitals, see John Henderson, *The Renaissance Hospital: Healing the Body and Healing the Soul* (New Haven, CT, and London: Yale University Press, 2006), which discusses Brunelleschi's Ospedale degli Innocenti as well as San Matteo. For more on Brunelleschi as an architect, see Eugenio Battisti, *Filippo Brunelleschi: The Complete Work*, trans. Erich Wolf (New York: Rizzoli, 1981); Christine Smith, *Architecture in the Culture of Early Humanism: Ethics, Aesthetics, and Eloquence, 1400–1470* (New York and Oxford: Oxford University Press, 1992); and Howard Saalman, *Filippo*

Brunelleschi: The Buildings (University Park, PA: Penn State University Press, 1993).

Chapter 4: 1420–1430

There is little substantial literature in any language on Andrea da Firenze or the funerary monument to King Ladislao, but see the brief description in George L. Hersey, *The Aragonese Arch at Naples* (New Haven, CT, and London: Yale University Press, 1973). On foreign sculptors in Naples in the early Renaissance see also Nicholas Bock, "Center or Periphery? Artistic Migration, Models, Taste and Standards," in *"Napoli è tutto il mondo": Neapolitan Art and Culture from Humanism to the Enlightenment*, ed. Livio Pestilli, Ingrid D. Rowland, and Sebastian Schütze (Pisa and Rome: Serra, 2008), 11–36.

The original Italian for the Ghiberti passage we quote can be found in the Bartoli edition, p. 95. Ours slightly modifies the translation in Elizabeth Holt, *Literary Sources of Art History: An Anthology of Texts from Theophilus to Goethe* (Princeton, NJ: Princeton University Press, 1947), 90. Amy Bloch, *Lorenzo Ghiberti's Gates of Paradise: Humanism, History, and Artistic Philosophy in the Italian Renaissance* (New York: Cambridge University Press, 2016), offers an extended recent discussion of the second Baptistery doors.

On Brunelleschi and Renaissance perspective, see Samuel Y. Edgerton Jr., *The Renaissance Rediscovery of Linear Perspective* (New York: Basic Books, 1975); for a contrasting view, Martin Kemp, *The Science of Art: Optical Themes in Western Art from Brunelleschi to Seurat* (New Haven, CT, and London: Yale University Press, 1990). See also James Elkins, *The Poetics of Perspective* (Ithaca, NY: Cornell University Press, 1994). Our emphasis on commensuration and the incommensurate owes a particular debt to Daniel Arasse, *L'annonciation italienne: Une histoire de perspective* (Paris: Hazan, 1999).

The best general monograph in English on Donatello is still H. W. Janson, *The Sculpture of Donatello* (Princeton, NJ: Princeton University Press, 1957). Nicholas Eckstein's good anthology, *The Brancacci Chapel: Form, Function, and Setting: Acts of an International Conference* (Florence: Olschki, 2007), looks at the chapel from many points of view. On both the chapel and the *Trinity*, see also Paul Joannides, *Masaccio and Masolino: A Complete Catalogue* (New York: Phaidon Press, 1993), and Janet V. Field, "Masaccio and Perspective in Italy in the Early Fifteenth Century," in *The Cambridge Companion to Masaccio*, ed. Diane Cole Ahl (Cambridge and New York: Cambridge University Press, 2002). Our account also drew on Carl Strehlke, *Italian Paintings, 1250–1450, in the John G. Johnson Collection and the Philadelphia Museum of Art* (University Park, PA: Penn State University Press, 2000).

Chapter 5: 1430–1440

For Fra Angelico's Linaiuoli tabernacle, see Diane Cole Ahl, *Fra Angelico* (London and New York: Phaidon Press, 2008). Eve Boorsook offers a clear description of fresco technique in *The Mural Painters of Tuscany: From Cimabue to Andrea del Sarto* (Oxford: Oxford University Press, 1980).

On Cennino Cennini, see Cennini, *The Craftsman's Handbook (Il Libro dell'arte)*, trans. D. Thompson Jr. (New Haven, CT, and London: Yale University Press, 1933). On Cennini's relation to contemporary intellectual life, see Andrea Bolland, "Art and Humanism in Early Renaissance Padua: Cennini, Vergerio, and Petrarch on Imitation," *Renaissance Quarterly* 49 (1996), 469–88.

A valuable introduction to Pisanello that draws on a large corpus of research on the artist since the 1990s is Luke Syson and Dillian Gordon, *Pisanello: Painter to the Renaissance Court*, exh. cat. (London: National Gallery, 2001); see also Joanna Woods-Marsden, "French Chivalric Myth and Mantuan Political Reality in the Sala del Pisanello," *Art History* 8 (December 1985), 397–412.

On Alberti and his treatise, see Leon Battista Alberti, *On Painting and On Sculpture: The Latin Texts of "De Pictura" and "De Statua,"* trans. C. Grayson (London: Phaidon Press, 1972); see also the re-issue of the Grayson translation of *De Pictura* with an introduction by Martin Kemp (New York: Penguin Books, 1992). On Alberti and the culture of humanism, see Michael Baxandall, *Giotto and the Orators: Humanist Observers of Painting in Italy and the Discovery of Pictorial Composition 1350–1650* (Oxford: Oxford University Press, 1970, 1988). On Sassetta and Giovanni di Paolo, see the exhibition catalogue by Keith Christiansen, Carl Brandon Strehlke, and Laurence B. Kanter, *Painting in Renaissance Siena, 1420–1500* (New York: Abrams, 1988).

On Uccello, see Paolo and Stefano Borsi, *Paolo Uccello* (London: Thames & Hudson, 1994). For Uccello's drawings, and for a comprehensive account of Renaissance drawing media and techniques, see Carmen Bambach, *Drawing and Painting in the Italian Renaissance Workshop: Theory and Practice 1300–1600* (Cambridge and New York: Cambridge University Press, 1999). James Watrous, *The Craft of Old-Master Drawings* (Madison, WI: University of Wisconsin Press, 1957), remains useful as well.

On the *cantorie*, see John Pope-Hennessy, *Donatello, Sculptor* (New York: Abbeville Press, 1993); and *idem, Luca della Robbia* (Oxford: Oxford University Press, 1980); for an interesting contextual study of Luca's work, see Robert L. Mode, "Adolescent Confratelli and the Cantoria of Luca della Robbia," *Art Bulletin* 68 (1986), 67–71. Our understanding of Donatello's frolicking children as *spiritelli* depends on Charles Dempsey, *Inventing the Renaissance Putto* (Chapel Hill, NC: University of North Carolina Press, 2001), and on Ulrich Pfisterer, *Donatello und die Entdeckung der Stile: 1430–1445* (Munich: Hirmer, 2002).

On Jacopo Bellini as a draftsman, see Bernhard Degenhart and Annegrit Schmitt, *The Louvre Album of Drawings* (New York: George Braziller, 1984). There is also useful discussion in Patricia Fortini Brown, *Venice and Antiquity: The Venetian Sense of the Past* (New Haven, CT, and London: Yale University Press, 1996). On the Doge's Palace, see Edoardo Arslan, *Gothic Architecture in Venice* (London: Phaidon Press, 1972), and Deborah Howard, *Venice and the East: The Impact of the Islamic World on Venetian Architecture 1100–1500* (New Haven, CT, and London: Yale University Press, 2000).

Chapter 6: 1440–1450

The illustration on p. 145 uses as its basis Francesco Magnelli and Cosimo Zocchi's map of Florence from 1783, which shows the city before the dramatic nineteenth- and twentieth-century transformations of the urban grid.

Dale Kent's *Cosimo de' Medici and the Florentine Renaissance: The Patron's Oeuvre* (New Haven, CT, and London: Yale University Press, 2000) is a comprehensive account of the major Medici commissions before 1460. On Florentine families and corporations, see also Patricia L. Rubin, *Images and Identity in Fifteenth-Century Florence* (New Haven, CT, and London: Yale University Press, 2007). On Antonino, Fra Angelico, and the Dominicans, see William Hood, *Fra Angelico at San Marco* (New Haven, CT, and London: Yale University Press, 1993); on Fra Angelico and the invention of the *pala*, see Carl Strehlke, *Angelico* (Milan: Jaca Book, 1998).

Our treatment of Fra Filippo Lippi draws on Megan Holmes, *Fra Filippo Lippi: The Carmelite Painter* (New Haven, CT, and London: Yale University Press, 1999). On the St. Lucy altarpiece, see Helmut Wohl, *The Paintings of Domenico Veneziano* (New York: New York University Press, 1980), and Keith Christiansen's catalogue entry in *From Filippo Lippi to Piero della Francesca: Fra Carnevale and the Making of a Renaissance Master*, exh. cat. (New York: Metropolitan Museum of Art, 2005), 190–91. For Castagno, see Anne Dunlop, *Andrea del Castagno and the Limits of Painting* (Turnhout: Harvey Miller, 2015), and on the *Last Supper* in particular, Andree Hayum, "A Renaissance Audience Considered: The Nuns at S. Apollonia and Castagno's Last Supper," *Art Bulletin* 88 (2006), 243–66. Our attention to the marbles follows Georges Didi-Huberman's brilliant *Fra Angelico: Dissemblance and Figuration*, trans. Jane Marie Todd (Chicago, IL: University of Chicago Press, 1995).

Two good surveys of Quattrocento sculpture, both of which discuss Bernardo Rossellino and Desiderio da Settignano's Santa Croce tombs, are John Pope-Hennessy, *Italian Renaissance Sculpture* (New York: Phaidon, 1985), and Joachim Poeschke, *Donatello and his World: Sculpture of the Italian Renaissance* (New York:

Abrams, 1993). A useful collection of essays is Sarah Blake McHam, *Looking at Italian Renaissance Sculpture* (Cambridge: Cambridge University Press, 1998).

The literature on Donatello's bronzes *David and Judith* is vast: we relied especially on Pfisterer, *Donatello* (see chapter 5 above) and on Francesco Caglioti's monumental *Donatello e i Medici: storia del David e della Giuditta* (Florence: Olschki, 2000). In English, see the Pope-Hennessy and Poeschke surveys, as well as Janson, *Donatello* (as in chapter 4 above), and the stimulating discussion in Joost Keizer's, "History, Origins, Recovery: Michelangelo and the Politics of Art" (unpublished dissertation, University of Leiden, 2008), 43–55.

On Lo Scheggia and domestic arts, see the exhibition catalogue *Art and Love in Renaissance Italy* (New York: Metropolitan Museum of Art, 2008); Luke Syson and Dora Thornton, *Objects of Virtue: Art in Renaissance Italy* (Los Angeles, CA: Getty Museum, 2001); Roberta J. M. Olson, *The Florentine Tondo* (Oxford and New York: Oxford University Press, 2000); and Cristelle Baskins, *Cassone Painting, Humanism, and Gender in Early Modern Italy* (Cambridge and New York: Cambridge University Press, 1998).

On the Pazzi Chapel, see the monographs on Brunelleschi by Battisti, *Filippo Brunelleschi*, and by Saalman, *Filippo Brunelleschi* (as in chapter 3 above); Brunelleschi's authorship is challenged by Marvin Trachtenberg, "Why the Pazzi Chapel is not by Brunelleschi," *Casabella* (June 1996), 58–77, and "Why the Pazzi Chapel is by Michelozzo," *Casabella* (February 1997), 56–75.

On Donatello's Padua altar, see Geraldine Johnson, "Approaching the Altar: Donatello's Sculpture in the Santo," *Renaissance Quarterly*, 52 (1999), 627–66. The Mascoli Chapel mosaics are examined by Patricia Fortini Brown, *Venice and Antiquity* (see chapter 5 above).

For Sassetta and Domenico di Bartolo, see the exhibition catalogue *Painting in Renaissance Siena* (New York: Metropolitan Museum of Art, 1988), and Timothy Hyman, *Sienese Painting: The Art of a City-Republic (1278–1477)* (London: Thames & Hudson, 2003). On the

Palermo *Triumph of Death*, there is little to read in English, but see Jane Bridgeman, "The Palermo Triumph of Death," *The Burlington Magazine* 117 (July, 1975), 478–84. We also drew on Umberto Santino, *Un cavallo e la fontana: dipingendo il Triomfo della morte* (Palermo: Grifo, 2002).

On Filarete and the doors of St. Peter's, we have profited especially from John Onians, "Alberti and 'PHILARETE': A Study in their Sources," in Onians, ed., *Art, Culture, and Nature: From Art History to World Art Studies* (London: Pindar Press, 2006), 141–66; and from Ulrich Pfisterer, "Filaretes historia und commentarius: über die Anfänge humanistischer Geschichtstheorie im Bild," in Valeska von Rosen and Klaus Krüger, eds., *Der stumme Diskurs der Bilder: Reflexionsformen des Ästhetischen in der Kunst der Frühen Neuzeit* (Munich: Deutscher Kunstverlag, 2003), 139–76; and Helen Roeder, "The Borders of Filarete's Bronze Doors to St. Peter's," *Journal of the Warburg and Courtauld Institutes* 10 (1947), 150–53.

Chapter 7: 1450–1460

For an account of the early Renaissance papacy and its problems, see Charles Stinger, *The Renaissance in Rome* (Bloomington, IN: Indiana University Press, 1985); Charles Burroughs deals with questions of urbanism and design in *From Signs to Design: Environmental Process and Reform in Early Renaissance Rome* (Cambridge, MA: MIT Press, 1990); Carroll William Westfall's older *In This Most Perfect Paradise: Alberti, Nicholas V, and the Invention of Conscious Urban Planning in Rome* (University Park, PA: Penn State University Press, 1974) remains useful as well. The richest recent resource on the topic, however, is in Italian: Stefano Borsi, *Nicolo V e Roma: Alberti, Angelico, Manetti e un grande piano urbano* (Florence: Polistampa, 2009).

Burroughs also discusses Fra Angelico's Vatican frescoes, as does Cole Ahl, *Fra Angelico* (see chapter 5 above); in addition, see Carl B. Strehlke, "Fra Angelico: A Florentine Painter in 'Roma Felix,'" in Laurence Kanter and Pia Palladino, *Fra Angelico* (New York: Metropolitan Museum of Art; and New Haven, CT, and London: Yale University Press, 2005), 203–14.

Syson and Gordon, *Pisanello* (see chapter 5 above), provide an accessible account of Alfonso's court at Naples with a focus on Pisanello; Hersey, *The Aragonese Arch* (see chapter 4 above), is the standard reference on that monument.

Our discussion of Rimini was informed by the recent catalogue *Il potere, le arti, la Guerra. lo splendore dei Malatesta* (Milan: Electa, 2001). For the architecture, see Charles Hope, "The Early History of the Tempio Malatestiano," in the *Journal of the Warburg and Courtauld Institutes* 55 (1992), 51–154; despite Hope's critique of the attribution, we continue to recognize Alberti as the architect of the building. On the humanist programs of the San Francesco chapels, see Stanko Kokole, "Cognitio formarum and Agostino di Duccio's Reliefs for the Chapel of the Planets in the Tempio Malatestiano," in *Quattrocento Adriatico: Fifteenth-Century Art of the Adriatic Rim* (Bologna: Nuova Alfa, 1996), 177–207.

The most useful discussions of Mantegna's Padua frescoes remain Ronald Lightbown, *Mantegna: With a Complete Catalogue of the Paintings, Drawings and Prints* (Oxford: Phaidon Press, 1986), and Keith Christiansen, *Andrea Mantegna: Padua and Mantua* (New York: George Braziller, 1994). On Donatello's *Gattamelata*, see the monographs by Pope-Hennessy and Janson, as well as the more general survey by Poeschke (as in chapter 6 above).

Readers can find Pius II's own account of Pienza in his *Commentaries*, ed. and trans. Margaret Meserve and Marcello Simonetta (Cambridge, MA: Harvard University Press, forthcoming), vol. 2. Charles Mack, *Pienza: The Creation of a Renaissance City* (Ithaca, NY: Cornell University Press, 1987), includes an appendix of texts in translation as well. See also Nicholas Adams, "The Construction of Pienza (1459–1464) and the Consequences of Renovatio," in *Urban Life in the Renaissance*, eds. Susan Zimmerman and Ronald F. E. Weissman (Newark, NJ: University of Delaware Press, 1989), 50–80. The standard English edition of Alberti's treatise on architecture is *On the Art of Building in Ten Books*, trans. Joseph Rykwert, Neil Leach, and Robert Tavernor (Cambridge, MA: MIT Press, 1988).

For an account of Alberti's career and a guide to the vast body of scholarship, see Anthony Grafton, *Leon Battista Alberti: Master Builder of the Italian Renaissance* (New York: Hill & Wang, 2000).

Chapter 8: 1460–1470

On court art, see Martin Warnke, *The Court Artist: On the Ancestry of the Modern Artist*, trans. David McLintock (Cambridge: Cambridge University Press, 1993), and – in response to Warnke – the collection *Artists at Court: Image Making and Identity*, ed. Stephen J. Campbell (Chicago, IL: University of Chicago Press, 2004).

On the impact of Alberti's *De Pictura* in Ferrara, see Michael Baxandall, "A Dialogue on Art from the Court of Leonello D'Este," *Journal of the Warburg and Courtauld Institutes* 26 (1963), 304–26. For Guarino, the Belfiore *studiolo*, and Cosmè Tura, see Stephen J. Campbell, *Cosmè Tura of Ferrara: Style, Politics, and the Renaissance City, 1450–1495* (London and New Haven, CT: Yale University Press, 1997). There is little good material in English on Palazzo Schifanoia, but see Aby Warburg's pioneering essay, "Italian Art and International Astrology in the Palazzo Schifanoia in Ferrara," in *German Essays on Art History*, ed. Gert Schiff (New York: Continuum, 1988), 252–53, as well as Kristen Lippincott, "The Iconography of the Salone dei Mesi and the Study of Latin Grammar in Renaissance Ferrara," in *La corte di Ferrara e il suo mecenatismo 1441–1598: The Court of Ferrara and its Patronage*, ed. Kari Lawe and Marianne Pade (Modena: Panini, 1990).

The standard reference on art and astrology in the Renaissance, unfortunately, remains untranslated: Dieter Blume, *Regenten des Himmels: astrologische Bilder in Mittelalter und Renaissance* (Berlin: Akademie Verlag, 2000).

The literature on Filarete in Milan is large, but see Evelyn Welch, *Art and Authority in Renaissance Milan* (London and New Haven, CT: Yale University Press, 1995). On Mantegna, see Ronald Lightbown, *Mantegna* (Berkeley, CA: University of California Press, 1986); also Jane Martineau, Suzanne Boorsch et al., eds., *Andrea Mantegna*, exh. cat. (Milan: Electa,

1992); and for a review of more recent scholarship Luke Syson, "Thoughts on the Mantegna Exhibition in Paris," *Burlington Magazine* 151 (August 2009), 526–36. For the Camera Picta, see several of the essays in *Mantegna: Making Art (History)*, ed. Stephen J. Campbell and Jérémie Koering (London: Wiley-Blackwell, 2016).

For Alberti and the Gonzaga, see Eugene Johnson, *S. Andrea in Mantua: The Building History* (University Park, PA: Penn State University Press, 1975), and Robert Tavernor, *On Alberti and the Art of Building* (New Haven, CT, and London: Yale University Press, 1998). For the palace of Urbino, Pasquale Rotondi, *The Ducal Palace of Urbino: Its Architecture and Decoration* (New York: Transatlantic, 1969), and on the library see the catalogue, *Federico da Montefeltro and his Library*, ed. Marcello Simonetta (New York: Pierpont Morgan Library, 2007).

For the Medici Palace chapel, see Dale Kent, *Cosimo de' Medici* (as in chapter 6 above), and Diane Cole Ahl, *Benozzo Gozzoli* (New Haven, CT, and London: Yale University Press, 1996). Two recommended English-language monographs on Piero are Marilyn Aronberg Lavin, *Piero della Francesca* (London: Phaidon Press, 2002), and Ronald Lightbown, *Piero della Francesca* (New York: Abbeville, 1992). Carlo Ginzburg, *The Enigma of Piero*, 2nd edn. (London: Verso, 2000), deals with the contemporary context of the fall of Byzantium and the mooted crusade, although we would question the author's framing of Piero's art as an "enigma."

Chapter 9: 1470–1480

On Flemish painting in Italy, see Bert W. Meijer, "Piero and the North," in *Piero della Francesca and his Legacy*, ed. Marilyn Lavin (Washington, D.C.: National Gallery of Art, 1995), 143–60. We drew as well on the essays and entries in two good catalogues: *Dipinti fiamminghi in Italia 1420–1570*, ed. Licia Collobi Ragghianti (Bologna: Calderini, 1990), and *Fiamminghi a Roma: 1508–1608; artistes des Pays-Bas et de la principauté de Liège à Rome à la Renaissance*, ed. Anne-Claire de Liedekerke (Milan: Skira, 1995). Essential on the Corpus Domini altarpiece is still Marilyn Aronberg Lavin, "The Altar of

Corpus Domini in Urbino: Paolo Uccello, Joos van Ghent, Piero della Francesca," *Art Bulletin* 49 (1967), 1–24. See also Dana E. Katz, "The Contours of Tolerance: Jews and the Corpus Domini Altarpiece in Urbino," *Art Bulletin* 85 (2003), 646–61.

On the introduction of oil (and for painting techniques in general), see the excellent, accessible *Giotto to Dürer: Early Renaissance Painting in the National Gallery*, ed. Jill Dunkerton (London and New Haven, CT: Yale University Press, 1991). Our understanding of Antonello da Messina benefitted from Mary Pardo, "The Subject of Savoldo's Magdalene," *Art Bulletin* 71 (1989), 67–91.

Two good but very different overviews of Bellini's painting are Anchise Tempestini, *Giovanni Bellini*, trans. Alexandra Bonfante-Warren and Jay Hyams (New York: Abbeville, 1999), and Oskar Bätschmann, *Giovanni Bellini* (London: Reaktion, 2008). See also Rona Goffen, *Giovanni Bellini* (New Haven, CT, and London: Yale University Press, 1989), and the exhibition catalogue *Giovanni Bellini*, ed. Mauro Lucco and Giovanni Carlo Federico Villa (Milan: Silvana, 2008). Within the much larger literature on the Frick panel, three stand-out studies are Millard Meiss, *Giovanni Bellini's "St. Francis" in the Frick Collection* (Princeton, NJ: Princeton University Press, 1964); John Fleming, *From Bellini to Bonaventure: An Essay in Franciscan Exegesis* (Princeton, NJ: Princeton University Press, 1982); and Emanuele Lugli, "Between Form and Representation: The Frick St. Francis," *Art History* 32 (2009), 21–51.

For the Verrocchio workshop, see Patricia Rubin and Alison Wright, *Renaissance Florence: The Art of the 1470s* (London: Yale University Press, 1999), as well as Andrew Butterfield, *The Sculptures of Andrea del Verrocchio* (New Haven, CT, and London: Yale University Press, 1997). On the drapery studies, see the essays and entries in *Leonardo da Vinci, Master Draftsman*, exh. cat., ed. Carmen Bambach (New York: Metropolitan Museum of Art; and New Haven, CT, and London: Yale University Press, 2003).

Three useful broader overviews of Leonardo da Vinci are Martin Kemp, *Leonardo da Vinci: The Marvellous Works of Nature and Man* (London:

J. M. Dent, 1981); Pietro C. Marani, *Leonardo: The Complete Paintings* (New York: Abrams, 2000); and Frank Zollner and Johannes Nathan, *Leonardo da Vinci, 1452–1519: The Complete Paintings and Drawings* (Cologne: Taschen, 2003). On Leonardo's Ginevra de' Benci portrait, see *Virtue and Beauty: Leonardo's Ginevra de' Benci and Renaissance Portraits of Women*, exh. cat., ed. David Alan Brown (Washington, D.C.: National Gallery of Art, 2001). On Leonardo's rejection of the absolute color system, see John Shearman, "Leonardo's Colour and Chiaroscuro," *Zeitschrift für Kunstgeschichte* 25 (1962), 13–47, and James S. Ackerman, "On Early Renaissance Color Theory and Practice," in *Studies in Italian Art and Architecture: 15th through 18th Centuries*, ed. Henry A. Millon (Rome: Edizioni dell' Elefante, 1980), 11–44.

Our discussion of Pollaiuolo's portraits is indebted to Alison Wright, *The Pollaiuolo Brothers: The Arts of Florence and Rome* (New Haven, CT, and London: Yale University Press, 2005). On Florence under Lorenzo, see F. W. Kent, *Lorenzo de' Medici and the Art of Magnificence* (Baltimore, MD: Johns Hopkins University Press, 2004), and Rubin and Wright, *Renaissance Florence* (as under Verrocchio above). For Botticelli's mythologies, see Charles Dempsey, *The Portrayal of Love: Botticelli's "Primavera" and Humanist Culture at the Time of Lorenzo the Magnificent* (Princeton, NJ: Princeton University Press, 1992).

Chapter 10: 1480–1490

On Mantegna's *Triumphs of Caesar*, see Stephen J. Campbell, "Mantegna's *Triumphs*: The Cultural Politics of Imitation 'all'antica' at the Court of Mantua, 1490–1530," in Stephen Campbell, ed., *Artists at Court* (as in chapter 8 above), 91–105. The standard account remains Andrew Martindale, *The Triumphs of Caesar by Andrea Mantegna: In the Collection of Her Majesty the Queen at Hampton Court* (London: Harvey Miller, 1979). On the introduction of canvas, Dunkerton, *Giotto to Dürer* (see chapter 9 above).

On the small bronze as a format, nothing in English can yet replace Hans Weihrauch, *Europäische Bronzestatuetten: 15.–18. Jahrhun-*

dert (Braunschweig: Klinkhardt & Biermann, 1967). For Pollaiuolo's *Hercules*, see Alison Wright, *The Pollaiuolo Brothers* (as in chapter 9 above.) Our discussion of Bertoldo drew on Ulrich Pfisterer, "Künstlerische potestas audendi und licentia im Quattrocento: Benozzo Gozzoli, Andrea Mantegna, Bertoldo di Giovanni," *Römisches Jahrbuch der Bibliotheca Hertziana* 31 (1996), 107–48; on James Draper, *Bertoldo di Giovanni, Sculptor of the Medici Household* (Columbia, MO: University of Missouri Press, 1992); and on Luke Syson, "Bertoldo di Giovanni, Republican Court Artist," in *Artistic Exchange and Cultural Translation in the Italian Renaissance City* (Cambridge and London: Cambridge University Press, 2004).

On the origins of Italian printmaking, see David Landau and Peter Parshall, *The Renaissance Print: 1470–1550* (New Haven, CT, and London: Yale University Press, 1994). Landau and Suzanne Boorsch give competing accounts of Mantegna's engagement with engraving in *Andrea Mantegna*, exh. cat., ed. Jane Martineau (Milan: Electa, 1992); on Mantegna and the goldsmith Cavalli, see Andrea Canova, "Gian Marco Cavalli incisore per Andrea Mantegna e altre notizie sull'oreficiaria e la tipografia a Mantova nel XV secolo," in *Italia medioevale e umanistica* 42 (2001), 149–79.

On Crivelli, see *Ornament and Illusion: Carlo Crivelli of Venice*, ed. Stephen J. Campbell (Boston, MA: Isabella Stewart Gardner Museum, 2015) and Ronald Lightbown, *Carlo Crivelli* (London and New Haven, CT: Yale University Press, 2004), which also gives a detailed account of the culture of the Marches in the fifteenth century. For Gentile Bellini's work in Constantinople, *Bellini and the East*, ed. Alan Chong and Caroline Campbell (Boston, MA: Isabella Stewart Gardner Museum, 2005); also Lisa Jardine and Jerry Brotton, *Global Interests: Renaissance Art between East and West* (London: Reaktion Books, 2000).

On the Colleoni monument, see Butterfield, *The Sculptures of Andrea del Verrocchio* (as in chapter 9 above), as well as Diane Cole Ahl, ed., *Leonardo da Vinci's Sforza Monument Horse: The Art and the Engineering* (Bethlehem, PA: Lehigh University Press, 1995). Pollaiuolo's *Sixtus IV Monument* is treated in detail by Alison

Wright, *The Pollaiuolo Brothers* (see chapter 9 above).

For the architecture of the Sistine Chapel, see Roberto Salvini, "The Sistine Chapel: Ideology and Architecture," *Art History*, 3 (1980), 144–57. On the frescoes, see Leopold D. Ettlinger, *The Sistine Chapel before Michelangelo: Religious Imagery and Papal Primacy* (Oxford: Oxford University Press, 1965); for an interpretation governed by Sixtus's formation as a Franciscan and theologian, see Rona Goffen, "Friar Sixtus IV and the Sistine Chapel," *Renaissance Quarterly* 39 (1986), 218–62; for a political interpretation, Andrew C. Blume, "The Sistine Chapel, Dynastic Ambition, and the Cultural Patronage of Sixtus IV," in *Patronage and Dynasty: the Rise of the della Rovere in Renaissance Italy*, ed. Ian F. Verstegen (Kirksville, MO: Truman State University Press, 2007), 3–19.

On Leonardo's *Adoration of the Magi* and *Virgin of the Rocks*, see (in addition to the monographs by Kemp and Marani cited under chapter 9 above) the comprehensive accounts in Zöllner and Nathan, *Leonardo da Vinci* (as in chapter 9 above).

Chapter 11: 1490–1500

For the landscape drawings of Fra Bartolomeo, see Chris Fischer, *Fra Bartolomeo: Master Draughtsman of the High Renaissance* (Rotterdam: Museum Boymans-van Beuningen 1990); for Riccio, Denise Allen, ed., *Andrea Riccio: Renaissance Master of Bronze*, exh. cat. (London: Wilson, 2008). Alison Luchs's exhibition catalogue *Tullio Lombardo and Venetian High Renaissance Sculpture* (New Haven: Yale University Press, 2009) includes extensive bibliography on Venetian sculpture; on the Vendramin tomb in particular, see Wendy Stedman Sheard, "Tullio Lombardo in Rome? The Arch of Constantine, the Vendramin Tomb, and the Reinvention of Monumental Classicizing Relief," *Artibus et Historiae* 18 (1997), 161–79, and Sheard, "'Asa Adorna': The Prehistory of the Vendramin Tomb," *Jahrbuch der Berliner Museen* 20 (1978), 117–56, also with further references.

On the mythological paintings for Isabella's *studiolo*, see Stephen J. Campbell, *The Cabinet of Eros: Renaissance Mythological Painting and the Studiolo of Isabella d'Este* (New Haven, CT, and London: Yale University Press, 2006). For Ghirlandaio, see Jean K. Cadogan, *Domenico Ghirlandaio: Artist and Artisan* (New Haven, CT, and London: Yale University Press, 2000), and the conference volume *Domenico Ghirlandaio: 1449–1494*, ed. Wolfram Prinz and Max Seidel (Florence: Centro Di, 1996). On the Scuola di San Giovanni Evangelista canvasses, see Patricia Fortini Brown, *Venetian Narrative Painting in the Age of Carpaccio* (New Haven, CT, and London: Yale University Press, 1988). For the Bentivoglio Chapel, see Clifford M. Brown, "The Church of Santa Cecilia and the Bentivoglio Chapel in San Giacomo Maggiore in Bologna. With an Appendix Containing a Catalogue of Isabella d'Este's Correspondence Concerning Lorenzo Costa and Francesco Francia," *Mitteilungen des Kunsthistorischen Institutes in Florenz* 10 (1967–68), 301–24.

On the problem of Savonarola's influence on artists, see the different approaches by Marcia Hall, "Savonarola's Preaching and the Patronage of Art," in T. Verdon and J. Henderson, eds., *Christianity and the Renaissance: Image and Religious Imagination in the Quattrocento* (Syracuse, NY: Syracuse University Press, 1990), 493–522, and Jill Burke, *Changing Patrons: Social Identity and the Visual Arts in Renaissance Florence* (University Park, PA: Penn State Press, 2004). On the new council hall, the best introductory overview remains Johannes Wilde, "The Hall of the Great Council of Florence," *Journal of the Warburg and Courtauld Institutes* 7 (1944), 65–81.

The standard reference on Filippino Lippi, though co-authored by an American, is unavailable in English: Jonathan Katz Nelson and Patrizia Zambrano, *Filippino Lippi* (Milan: Electa, 2004). The San Brizio Chapel has provoked competing readings: ours draws on Jonathan B. Reiss, *The Renaissance Antichrist: Luca Signorelli's Orvieto Frescoes* (Princeton, NJ: Princeton University Press, 1995); Creighton Gilbert, *How Fra Angelico and Signorelli Saw the End of the World* (University Park, PA: Penn State University Press, 2003); and Sara Nair James, *Signorelli and Fra Angelico at Orvieto: Liturgy, Poetry, and a Vision of the End of Time* (Aldershot, UK: Ashgate, 2003).

On the Pala Sforzesca and the problem of defining a "painting by Leonardo," see Luke Syson, "Leonardo and Leonardism in Sforza Milan," in *Artists at Court* (as in chapter 8 above), 106–23. Our reading of Leonardo's drawings of machines reflects the account in Michael Cole, *Leonardo, Michelangelo, and the Art of the Figure* (New Haven, CT, and London: Yale University Press, 2014). Our discussion of the artist's allegories depends on Bambach, ed., *Leonardo da Vinci, Master Draftsman* (see chapter 9 above). For Leonardo's Milanese portraits, see the discussions in the monographs by Kemp, Marani, and Zollner, as well as Brown's *Virtue and Beauty* catalogue. On the *Last Supper*, see *Leonardo: The Last Supper*, with essays by Pinin Brambilla Barcilon and Pietro C. Marani, trans. Harlow Tighe (Chicago, IL: University of Chicago Press, 2001). For a controversial but stimulating account of the same work, see Leo Steinberg, *Leonardo's Incessant Last Supper* (New York: Zone Books, 2001).

For Michelangelo's early sculptures, see the essays in the first volume of William Wallace's useful collection, *Michelangelo: Selected Scholarship in English* (New York: Garland, 1995). We drew especially on Wallace's own "How Did Michelangelo Become a Sculptor?" in *The Genius of the Sculptor in Michelangelo's Work*, exh. cat. (Montreal, 1992), 151–69; and "Michelangelo's Rome Pietà: Altarpiece or Grave Memorial?" in *Verrocchio and Late Quattrocento Italian Sculpture*, ed. Steven Bule and Alan Phipps Darr (Florence: Casa Editrice le Lettere, 1992), 243–55. On Baccio da Montelupo, the only substantial study in English is John Douglas Turner's unpublished doctoral dissertation, "The Sculpture of Baccio da Montelupo," Brown University, 1997. We drew as well on the catalogue *L'officina della maniera: varietà e fierezza nell'arte fiorentina del Cinquecento fra le due repubbliche 1494–1530*, ed. Alessandro Cecchi et al. (Venice: Marsilio, 1996).

Chapter 12: 1500–1510

Our reading of Piero di Cosimo is indebted to Alison Brown, "Lucretius and the Epicureans in the Social and Political Context of Renaissance Florence," *I Tatti Studies: Essays in the Renaissance* 9 (2001), 11–62; see also Dennis

Geronimus, *Piero di Cosimo: Visions Beautiful and Strange* (New Haven, CT, and London: Yale University Press, 2006); on Michelangelo's *David*, see Charles Seymour, *Michelangelo's David* (as in chapter 2 above), and Saul Lewine, "The Location of Michelangelo's *David*: The Meeting of January 25th, 1504," *Art Bulletin* 56 (1974), 31–49. The relation between the *Virgin and Child with St. John and St. Anne* and the *Muses of Tivoli* is proposed by Marani, *Leonardo da Vinci* (see chapter 9 above). The best recent study of the *Doni Tondo* is Chiara Franceschini, "The Nudes in Limbo: Michelangelo's 'Doni Tondo' Reconsidered," *JWCI* 73 (2010), 137–80. For a reading of the *Doni Tondo* that emphasizes the role of the Baptist, see Andree Hayum, "Michelangelo's *Doni Tondo*: Holy Family and Family Myth," *Studies in Iconography* 7–8 (1981–82), 209–51. Our understanding of Michelangelo's Bruges *Madonna* was shaped by Leo Steinberg, "The Metaphors of Love and Birth in Michelangelo's Pietàs," in *Studies in Erotic Art*, ed. Theodore Bowie and Cornelia V. Christenson (New York: Basic Books, 1970), 231–85.

Wilde's classic article on the murals in Palazzo dei Priori, "The Hall of the Great Council in Florence" (see note to chapter 11 above), remains standard reading. The most recent discussion, with further bibliography, is Cole, *Leonardo, Michelangelo and the Art of the Figure*, cited above. On the Leda as a "figura serpentinata," see David Summers, "Maniera and Movement: The Figura Serpentinata," *Art Quarterly* 35 (1972), 265–301.

The best general book on Raphael is Roger Jones and Nicholas Penny, *Raphael* (New Haven, CT, and London: Yale University Press, 1983). For Raphael's early career, see the exhibition catalogue *Raphael before Rome* (London: National Gallery, 2004); also Jürg Meyer zur Capellen, *Raphael in Florence*, trans. Stefan B. Polteron (London: Azimuth Editions, 1996). On the Baglione *Deposition* we have drawn on Alexander Nagel in *Michelangelo and the Reform of Art* (Cambridge and New York: Cambridge University Press, 2000), which revives the interpretation of Jakob Burckhardt, *The Civilization of the Renaissance in Italy*, trans. S. G. C. Middlemore (New York and London: Penguin Books, 1990), 35–38.

On the origins of the Julius tomb, see the essays in Wallace, *Michelangelo: Selected Scholarship*, vol. 4 (as in chapter 11 above). Our survey of the early designs for St. Peter's follows the revisionist history in Horst Bredekamp, *Sankt Peter in Rom und das Prinzip der produktiven Zerstörung: Die Baugeschichte von Bramante bis Bernini* (Berlin: Klaus Wagenbach, 2000), with extensive further bibliography. The approach to the Sistine Ceiling presented here is indebted especially to Edgar Wind, "Michelangelo's Prophets and Sibyls," *Proceedings of the British Academy* 51 (1960), 47–84, and John O'Malley, "The Theology behind Michelangelo's Sistine Ceiling," in C. Pietrangeli, ed., *The Sistine Chapel: The Art, The History, and the Restoration* (New York: Harmony Books, 1986), 92–148. On anti-Judaism and the Sistine, see Barbara Wisch, "Vested Interest: Redressing Jews on Michelangelo's Sistine Ceiling," *Artibus et historiae* 48 (2003), 143–72.

On the Belvedere, see James S. Ackerman, "The Belvedere as a Classical Villa," *Journal of the Warburg and Courtauld Institutes* 14 (1951), 70–91; on its collection of sculptures, Hans Brummer, *The Statue Court of the Vatican Belvedere* (Stockholm: Almqvist & Wiksell, 1970). For Raphael in the papal apartments, Matthias Winner, "Projects and Execution in the Stanza della Segnatura," in *Raphael in the Apartments of Julius II and Leo X* (Milan: Electa, 1993) and the same author's "Lorbeerbäume auf Raffaels Parnaß," in *L'Europa e l'arte italiana*, ed. Max Seidel (Venice: Marsilio, 2000), 197–209; David Rosand, "Raphael's School of Athens and the Artist of the Modern Manner," in *The World of Savonarola: Italian Elites and Perceptions of Crisis*, ed. Stella Fletcher and Christine Shaw (Burlington, VT: Ashgate, 2000), 212–32; and Ingrid Rowland, "The Intellectual Background of the School of Athens: Tracking Divine Wisdom in the Rome of Julius II," in *Raphael's "School of Athens,"* ed. Marcia Hall (Cambridge and New York: Cambridge University Press, 1997), 131–70. An older but still good reference is John Shearman, "*The Vatican Stanze: Functions and Decoration*," *Proceedings of the British Academy* 57 (1971), 3–58.

On Venetian painting circa 1500, see David Alan Brown and Sylvia Ferino Pagden, eds., *Bellini, Giorgione, Titian, and the Renaissance of Venetian Painting* (Washington, D.C.: National Gallery of Art, 2006). On Jacopo de' Barbari, see Simone Ferrari, *Jacopo de' Barbari: Un protagonista del Rinascimento tra Venezia e Dürer* (Milan: Mondadori, 2006); on his view of Venice, Juergen Schultz, "Jacopo de' Barbari's View of Venice: Map Making, City Views, and Moralized Geography before the Year 1500," *Art Bulletin* 60 (1978), 425–78, and Bronwen Wilson, *The World in Venice: Print, the City, and Early Modern Identity* (Toronto: University of Toronto Press, 2005). The San Giobbe altarpiece is discussed in Bätschmann, *Giovanni Bellini* (see chapter 9 above). For Dürer's Venetian sojourn, Katherine C. Luber, *Albrecht Dürer and the Venetian Renaissance* (Cambridge and New York: Cambridge University Press, 2005), and *Renaissance Venice and the North: Crosscurrents in the Time of Bellini, Dürer*, ed. Beverly Brown and Bernard Aikema (New York: Rizzoli, 2000). On Giorgione, see Jaynie Anderson, *Giorgione: The Painter of "Poetic Brevity"* (New York and Paris: Flammarion, 1997). For a critical account of readings of the *Tempesta*, see Stephen J. Campbell, "Giorgione's *Tempest, Studiolo* Culture, and the Renaissance Lucretius," *Renaissance Quarterly* 56 (2003), 299–333; Salvatore Settis reviews the literature through 1990 in *Giorgione's Tempest: Interpreting the Hidden Subject*, trans. Ellen Bianchini (Chicago, IL: University of Chicago Press, 1990).

There are surprisingly few good general introductions to Titian; a recent one is Peter Humfrey, *Titian: The Complete Paintings* (New York: Abrams, 2007). For an account of his early career, with much debated attributions, Paul Joannides, *Titian to 1518: The Assumption of Genius* (New Haven, CT, and London: Yale University Press, 2001). On the Titian *Concert*, Patricia Egan, "Poesia and the Concert champêtre," *Art Bulletin* 41 (1959), 29–38.

Chapter 13: 1510–1520

For an overview of Raphael and his workshop in Rome, see the catalog *Late Raphael*, ed. Tom Henry and Paul Joannides (London: Thames & Hudson, 2013). Michael Rohlmann provides well-illustrated and comprehensive accounts of Raphael's *Farnesina* and later Vatican frescoes in Julian Kliemann and Michael Rohlmann, *Italian Frescoes: High Renaissance*

and Mannerism, 1510–1600 (New York: Abbeville, 2004). On Raphael's experiments in the rendering of light and shadow in particular, see Janis Bell, "Re-Visioning Raphael as a 'Scientific Painter,'" in *Reframing the Renaissance Visual Culture in Europe and Latin America, 1450–1650*, ed. Claire Farago (New Haven, CT, and London, 1995), 91–111.

The most substantial overview of Marcantonio as a printmaker is the catalogue to the exhibition curated by Innis H. Shoemaker, *The Engravings of Marcantonio Raimondi* (Lawrence, KS: Spencer Museum of Art, University of Kansas, 1981); on issues of collaboration and authorship, see especially Lisa Pon, *Raphael, Dürer, and Marcantonio Raimondi: Copying and the Italian Renaissance Print* (New Haven, CT: Yale University Press, 2004).

For the Sistine tapestries, see Sharon Fermor, *The Raphael Tapestry Cartoons: Narrative, Decoration, Design* (London: Victoria & Albert Museum, 1996), and John Shearman, *Raphael's Cartoons in the Collection of Her Majesty the Queen, and the Tapestries for the Sistine Chapel* (London: Phaidon Press, 1972). The best introduction to Raphael as an architect is the catalog to the exhibition curated by Christoph Luitpold Frommel, Stefano Ray, and Manfredo Tafuri, *Raffaello architetto* (Milan: Electa, 1984). In English, see Ingrid D. Rowland, "Raphael, Angelo Colocci, and the Genesis of the Architectural Orders," *Art Bulletin* 76 (1994), 81–104, as well as the discussion in Jones and Penny, *Raphael* (as in chapter 12 above).

Our discussion of Sebastiano drew on the catalogue *Sebastiano del Piombo 1485–1547* (Milan: Motta, 2008). The major monograph in English is Michael Hirst, *Sebastiano del Piombo* (Oxford: Clarendon Press, 1981). For the *Fornarina*, see Jennifer Craven, "Ut pictura poesis: A New Reading of Raphael's Portrait of La Fornarina as a Petrarchan Allegory of Painting, Fame, and Desire," *Word and Image* 10 (1994), 371–94, though we doubt Raphael's authorship of the painting.

Major English-language scholarship on the Julius tomb includes Charles de Tolnay, *The Tomb of Julius II* (Princeton, NJ: Princeton University Press, 1954), and volume 4 of Wallace, *Michelangelo* (see chapter 11 above). On the

theme of the "arts bereft," see Erwin Panofsky, *Tomb Sculpture: Its Changing Aspects from Ancient Egypt to Bernini* (London: Thames & Hudson, 1964); on Michelangelo and the *non-finito*, Juergen Schulz, "Michelangelo's Unfinished Works," *Art Bulletin* 57 (1975), 366–73.

An exhibition at the Uffizi in 1996 revisited the idea of the "schools" of San Marco and the Annunziata: see the catalogue *L'officina della maniera* (as in chapter 11 above). There is no modern monograph in any language on Fra Bartolomeo, though two starting points for future work will be the catalogue to the exhibition *L'età di Savonarola. Fra Bartolomeo e la scuola di San Marco* (Venice: Marsiglio, 1996) and the catalogue of the drawings by Fischer, *Fra Bartolomeo* (see chapter 11 above). On Andrea del Sarto, see John Shearman, *Andrea del Sarto*, 2 vols. (Oxford: Clarendon Press 1965); on early Rosso, David Franklin's sometimes polemical *Rosso in Italy: The Italian Career of Rosso Fiorentino* (New Haven, CT, and London: Yale University Press, 1994); for the *Madonna of the Harpies*, John Shearman, *Only Connect: Art and the Spectator in the Italian Renaissance* (Princeton, NJ: Princeton University Press, 1992). Shearman also includes a useful section on the Camerino of Alfonso d'Este. Beyond this, see Anthony Colantuono, "*Dies Alcyoniae*: The Invention of Bellini's *Feast of the Gods*," *Art Bulletin* 73 (1991), 237–56; idem, "Tears of Amber: Titian's Andrians, the River Po and the Iconology of Difference," in *Phaethon's Children: The Este Court and Its Culture in Early Modern Ferrara*, ed. Dennis Looney and Deanna Shemek (Tempe, AZ: Arizona Center for Medieval and Renaissance Studies, 2005), and Campbell, *The Cabinet of Eros* (see chapter 11 above). A still essential discussion of Titian's *Assumption of the Virgin* is Rona Goffen, *Piety and Patronage in Renaissance Venice: Bellini, Titian, and the Franciscans* (New Haven, CT, and London: Yale University Press, 1986).

Chapter 14: 1520–1530

On Rome in the 1520s, see the essays in *The Pontificate of Clement VII: History, Politics, Culture*, eds. Sheryl Reiss and Kenneth Gouwens (Burlington, VT: Ashgate, 2005). A good over-

view is also provided by André Chastel, *The Sack of Rome, 1527*, trans. Beth Archer (Princeton, NJ: Princeton University Press, 1983). On mannerism, the starting point for all recent discussions is John Shearman, *Mannerism* (Harmondsworth: Penguin, 1967).

On Giulio Romano and the Hall of Constantine, see the relevant pages in Chastel, *The Sack of Rome*, and in Kliemann and Rohlmann, *Italian Frescoes* (see chapter 13 above), as well as Philipp Fehl, "Raphael as Historian: Poetry and Historical Accuracy in the *Sala del Costantino*," *Artibus et Historiae* 14 (1993), 9–76; also Jan L. de Jong, "Universals and Particulars: History Painting in the 'Sala di Costantino' in the Vatican Palace," in *Recreating Ancient History: Episodes from the Greek and Roman Past in the Arts and Literature of the Early Modern Period*, ed. Karl A. E. Enenkel, Jan L. de Jong, and Jeanine De Landtsheer (Boston, MA, and Leiden: Brill, 2001).

On Parmigianino, two essential recent works are Mary Vaccaro, *Parmigianino: The Paintings* (Turin: Allemandi, 2002), and the exhibition catalogue by David Franklin, *The Art of Parmigianino* (New Haven, CT, and London: Yale University Press, 2003).

A useful account of Rosso and Pontormo in the 1520s is *Pontormo and Rosso Fiorentino: Diverging Paths of Mannerism*, ed. Carlo Falciani and Antonio Natali (Florence: Mandragora, 2014). For Rosso as a printmaker, beginning with the Roman period, the basic reference is Eugene A. Carroll, ed., *Rosso Fiorentino: Drawings, Prints, and Decorative Arts* (Washington, D.C.: National Gallery of Art, 1987). Our account of Rosso's response to Michelangelo in these years summarizes the fuller discussion in Stephen Campbell, "'Fare una cosa morta parer viva': Michelangelo, Rosso, and the (Un)divinity of Art," *Art Bulletin* 84 (2002), 596–620. On print culture and erotic imagery, see Bette Talvacchia, *Taking Positions: On the Erotic in Renaissance Culture* (Princeton, NJ: Princeton University Press, 1999).

For Michelangelo's *Risen Christ* we have drawn on Irene Baldriga, "The First Version of Michelangelo's Risen Christ," *Burlington Magazine* 142 (2000), 740–45, and William Wallace, "Michelangelo's Risen Christ," *Sixteenth-Century*

Journal 28 (1997), 1,251–80. Our brief comment here on Michelangelo's *Victory* and *Slaves* as figures of mastery alludes to Michael Cole, "The *Figura Sforzata*: Modeling, Power, and the Mannerist Body," *Art History* 24 (2001), 520–51. A useful reference on Michelangelo's sculpture and that of his followers is Joachim Poeschke, *Michelangelo and his World: Sculpture of the Italian Renaissance* (New York: Abrams, 1996).

Pontormo's *Poggio a Caiano* lunette is treated by Janet Cox-Rearick, *Dynasty and Destiny in Medici Art* (Princeton, NJ: Princeton University Press, 1984), as well as by Kliemann and Rohlmann, *Italian Frescoes* (see chapter 13 above); for his other works and for Florentine art in the 1520s, see David Franklin, *Painting in Renaissance Florence 1500–1550* (New Haven, CT, and London: Yale University Press, 2001), and the exhibition catalog *L'officina della maniera* (as in chapter 13 above). Leo Steinberg provides a persuasive description of the Capponi Chapel frescoes as responses to Michelangelo's *Pietà* in "Pontormo's Capponi Chapel," *Art Bulletin* 56 (1974), 385–99.

Our approach to Correggio is strongly indebted to Carolyn Smith, *Correggio's Frescoes in Parma Cathedral* (Princeton, NJ: Princeton University Press, 1997), and to Giancarla Periti, "Nota sulla 'maniera moderna' di Correggio a Parma," in *Parmigianino e il manierismo europeo*, ed. Lucia Fornari Schianchi (Milan: Silvana, 2002), 298–304. For an introduction to the artist, see David Ekserdjian, *Correggio* (New Haven, CT, and London: Yale University Press, 1997).

The best guide to the scholarship on Lotto is Peter Humfrey, *Lorenzo Lotto* (New Haven, CT, and London: Yale University Press, 1997). For Andrea Odoni and collecting practices in sixteenth-century Venice, see Monika Schmitter, "'Virtuous Riches': The Bricolage of *Cittadini* Identities in Early Sixteenth-Century Venice," *Renaissance Quarterly* 57 (2004), 908–69.

On Titian's Pesaro altarpiece, see Rona Goffen, *Piety and Patronage in Renaissance Venice* (as in chapter 13 above), and for the Averoldi see the same author's *Renaissance Rivals: Michelangelo, Leonardo, Raphael, Titian* (New Haven, CT, and London: Yale University Press, 2002).

For contrasting views of Pordenone's Cremona frescoes, see Carolyn Smith, "Pordenone's 'Passion' Frescoes in Cremona Cathedral: An Incitement to Piety," in *Drawing Relationships in Northern Renaissance Art: Patronage and Theories of Invention*, ed. Giancarla Periti (Burlington, VT: Ashgate, 2004), 101–29, and Charles Cohen, *The Art of Giovanni Antonio da Pordenone: Between Dialect and Language* (Cambridge and London: Cambridge University Press, 1996). There are good illustrations in Kliemann and Rohlmann, *Italian Frescoes* (see chapter 13 above).

On the Siege of Florence and Pontormo's Guardi portrait, see Elizabeth Cropper, *Pontormo: Portrait of a Halbardier* (Los Angeles, CA: Getty Museum, 1997). For Parmigianino's importance within the history of etching, see Michael Cole, ed., *The Early Modern Painter Etcher* (University Park, PA: Penn State University Press, 2006).

Chapter 15: 1530–1540

Our discussion of Titian's work for Francesco della Rovere and Eleanora Gonzaga drew especially on Diane H. Bodart's essential *Tiziano e Federico II Gonzaga: storia di un rapporto di committenza* (Rome: Bulzoni, 1998).

For the *Venus of Urbino*, see the essays in Rona Goffen, ed., *Titian's Venus of Urbino* (Cambridge: Cambridge University Press, 1997). On Titian's nudes more generally, see Mary Pardo, "Artifice as Seduction in Titian," in *Sexuality & Gender in Early Modern Europe: Institutions, Texts, Images*, ed. James Grantham Turner (Cambridge and New York: Cambridge University Press, 1993), 55–89, and Maria H. Loh, *Titian Remade: Repetition and the Transformation of Early Modern Italian Art* (Los Angeles, CA: Getty Research Institute, 2007).

On Giulio at the Palazzo del Tè, see the chapter in Kliemann and Rohlmann, *Italian Frescoes* (as in chapter 13 above). Our reading of the Medici Chapel draws on Charles Dempsey, "Lorenzo's Ombra," in G. C. Garfagnini, *Lorenzo il Magnifico e il suo Mondo* (Florence: Olschki, 1994), 341–55, and Creighton Gilbert, "Texts and Contexts of the Medici Chapel," *Art Quarterly* 34 (1971), 391–409. An intrigu-

ing but to us ultimately unpersuasive attempt to challenge the standard identification of the two *capitani* is Richard C. Trexler and Mary E. Lewis, "Two Captains and Three Kings: New Light on the Medici Chapel," *Studies in Medieval and Renaissance History* 4 (1981), 91–177. On the importance of drawing for the artist's transition from sculpture to architecture, see Cammy Brothers, *Michelangelo, Drawing and the Invention of Architecture* (New Haven, CT, and London: Yale University Press, 2008). Poeschke, *Michelangelo and his World* (see chapter 14 above) discusses Bandinelli among other mid sixteenth-century sculptors. For Pontormo's and Bronzino's portraits, see especially the essays by Carl Strehlke and Elizabeth Cropper in *Pontormo, Bronzino, and the Medici: The Transformation of the Renaissance Portrait in Florence*, exh. cat. (Philadelphia, PA: Philadelphia Museum of Art, 2004). For the Pontormo portrait of Alessandro de' Medici in particular, see also Leo Steinberg, "Pontormo's Alessandro de' Medici, or, I Only Have Eyes for You," *Art in America* 63 (1975), 62–65. For Bronzino's *Cosimo as Orpheus*, see the account with bibliography by Janet Cox-Rearick in *The Medici, Michelangelo, and the Art of Late Renaissance Florence*, exh. cat. (New Haven, CT, and London: Yale University Press, 2002), 153–54. The best general monograph in English is Maurice Brock, *Bronzino* (Paris: Flammarion, 2002).

On the patronage of Paul III, see Guido Rebecchini, "After the Medici: The New Rome of Paul III Farnese," *I Tatti Studies* 11 (2007), 147–200. For Heemskerck in Rome, see Christof Thoenes, "St. Peter als Ruine: zu einigen Veduten Heemskercks," in *Opus incertum: italienische Studien aus drei Jahrzehnten* (Munich: Deutscher Kunstverlag, 2002), 245–75; English translation (with fewer illustrations) in *Sixteenth-century Italian Art*, ed. Michael Cole (Oxford: Blackwell, 2006), 25–39. On the compositional origins of Michelangelo's *Last Judgment*, see Bernardine Barnes, "The Invention of Michelangelo's 'Last Judgment,'" (unpublished doctoral dissertation, University of Virginia, 1986). The most balanced account of the fresco may still be Charles de Tolnay, *Michelangelo: The Final Period* (Princeton, NJ: Princeton University Press, 1960), though provocative readings of particular passages include Leo Steinberg, "Michelangelo's 'Last Judgment' as Merciful Heresy," *Art in America*

63 (1975), 49–63; Marcia B. Hall, "Michelangelo's Last Judgment: Resurrection of the Body and Predestination," in *Art Bulletin* 58 (1976), 85–92; and Bernardine Barnes, "Metaphorical Painting: Michelangelo, Dante, and the 'Last Judgment,'" *Art Bulletin* 77 (1995), 65–81.

Chapter 16: 1540–1550

There is no good study in English of Pontormo's lost San Lorenzo frescoes; the starting point for any future research is the Italian historian Massimo Firpo's *Gli affreschi di Pontormo a San Lorenzo: eresia, politica e cultura nella Firenze di Cosimo I* (Turin: Einaudi, 1997).

For a range of essays on Medici court culture, see *Vasari's Florence: Artists and Literati at the Medicean Court*, ed. Philip Jacks (Cambridge and London: Cambridge University Press, 1998).

On Salviati and the *Furius Camillus* cycle, see Melinda Schlitt, "The Rhetoric of Exemplarity in 16th-Century Painting: Reading 'Outside' the Imagery," in *Perspectives on Early Modern and Modern Intellectual History (Essays in Honor of Nancy S. Struever)*, ed. Melinda Schlitt and Joseph Marino (Rochester, NY: University of Rochester Press, 2001), 259–82, as well as the chapter on Salviati in David Franklin, *Painting in Renaissance Florence, 1500–1550* (as in chapter 14 above).

On Bronzino and literary culture, see Deborah Parker, *Bronzino: Renaissance Painter as Poet* (Cambridge: Cambridge University Press, 2000); for the chapel in the Palazzo Vecchio, see Janet Cox-Rearick, *Bronzino's Chapel of Eleonora in the Palazzo Vecchio* (Berkeley and Los Angeles, CA: University of California Press, 1993).

For the Sala Paolina, see the chapter in Kliemann and Rohlmann, *Italian Frescoes* (as in chapter 13 above). Our preferred English translation of Michelangelo's poetry is that of Christopher Ryan (London: Dent, 1996). Our discussion of Michelangelo's gift drawings benefitted from Alexander Nagel's important "Gifts for Michelangelo and Vittoria Colonna," *Art Bulletin* 79 (1997), 647–68. Leonard Barkan, *Transuming Passion: Ganymede and the Erotics of Humanism* (Stanford, CA: Stanford University Press, 1991), includes a suggestive discussion of the drawings for Tommaso Cavalieri. Our emphasis on the ambiguity of Michelangelo's subject matter follows Wolfgang Stechow's still-important "Joseph of Arimathea or Nicodemus?" in Wolfgang Lotz and Lisa Lotte Möller, eds., *Studien zur toskanischen Kunst: Festschrift für Ludwig Heinrich Heydenreich zum 23. März 1963* (Munich: Prestel, 1964), 289–302. Two classic essays on the Florence *Pietà* are Leo Steinberg, "Michelangelo's Florentine 'Pietà': The Missing Leg," *Art Bulletin* 50 (1968), 343–53, and Irving Lavin, "The Sculptor's 'Last Will and Testament,'" *Bulletin of Allen Memorial Art Museum* 35 (1978), 4–39. Steinberg responded to critics of his interpretation in "Michelangelo's Florentine Pietà: The Missing Leg Twenty Years After; Animadversions," *Art Bulletin* 71 (1989), 480–505.

Our sense of the politics in the Varchi circle owes much to Michel Plaisance's classic study, "Culture et politique à Florence de 1542 à 1551: Lasca et les Humidieux prises avec l'Académie Florentine," in André Rochon, ed., *Les écrivains et le pouvoir en Italie à l'époque de la Renaissance* (Paris: CIRRI, 1974), 149–242. Our presentation of Bronzino's London *Allegory* offers a slight variation on Robert W. Gaston, "Love's Sweet Poison: A New Reading of Bronzino's London *Allegory*," *I Tatti Studies* 4 (1991), 247–88.

Two good and recent though very different introductions to Fontainebleau are Henri Zerner, *Renaissance in France: The Invention of Classicism* (Paris: Flammarion, 2003), and Rebecca Zorach, *Blood, Milk, Ink, Gold: Abundance and Excess in the French Renaissance* (Chicago, IL: University of Chicago Press, 2005). For Cellini, see Michael Cole, *Cellini and the Principles of Sculpture* (Cambridge and New York: Cambridge University Press, 2002).

Bruce Boucher's monograph on *The Sculpture of Jacopo Sansovino* (New Haven, CT, and London: Yale University Press, 1991) complements Deborah Howard's book on the buildings, *Jacopo Sansovino: Architecture and Patronage in Renaissance Venice* (New Haven, CT, and London: Yale University Press, 1987). On urbanism in Genoa, see George L. Gorse, "A Classical Stage for the Old Nobility: The Strada Nuova and Sixteenth-century Genoa," *Art Bulletin* 79 (1997), 301–27, with good further bibliography. Our discussion draws on the fundamental study by Ennio Poleggi, *Strada nuova: una lottizzazione del Cinquecento a Genova* (Genoa: Sagep Ed., 1972). Our comments on the poetics of Michelangelo's architecture follow Charles Burroughs, "Michelangelo at the Campidoglio: Artistic Identity, Patronage and Manufacture," *Artibus et Historiae* 28 (1993), 85–111. The only available English-language study of Montorsoli is Sheila Ffolliott, *Civic Sculpture in the Renaissance: Montorsoli's Fountains at Messina* (Ann Arbor, MI: UMI Research Press, 1984). We also drew on Birgit Laschke, *Fra Giovan Angelo da Montorsoli: Ein Florentiner Bildhauer des 16 Jahrhunderts* (Berlin: Gebr. Mann, 1993).

Harold E. Wethey's standard reference work, *The Paintings of Titian* (London: Phaidon Press, 1975), treats the paintings from the 1540s; see also, more recently, Filippo Pedrocco, *Titian*, trans. Corrado Federici (New York: Rizzoli, 2001).

Two good starting points for the Pauline Chapel are William E. Wallace, "Narrative and Religious Expression in Michelangelo's Pauline Chapel," *Artibus et Historiae* 10 (1989), 107–21, and Leo Steinberg, *Michelangelo's Last Paintings: The Conversion of St. Paul and the Crucifixion of St. Peter in the Cappella Paolina, Vatican Palace* (London: Phaidon Press, 1975).

Chapter 17: 1550–1560

A useful survey of the concept of *disegno* can be found in Catherine E. King's chapter "Disegno/Design," in *Representing Renaissance Art c. 1500–c. 1600* (Manchester: Manchester University Press, 2007). Also good is Robert Williams, *Art, Theory, and Culture in Sixteenth-century Italy: From* Techne *to* Metatechne (Cambridge: Cambridge University Press, 1997).

On the concept of *colore* and *colorito* in Venetian art, see the opening chapter of David Rosand, *Painting in Sixteenth-Century Venice: Titian, Tintoretto, Veronese* (New Haven, CT, and London: Yale University Press, 1983 and 1997), and Daniela Bohde, "Corporeality and Materiality: Light, Colour, and the Body

in Titian's San Salvador Annunciation and Naples Danae," in *Titian: Materiality, Likeness, Istoria*, ed. by Joanna Woods-Marsden (Turnhout: Brepols, 2007), 19–29. See also Sydney J. Freedberg, "*Disegno* versus *colore* in Florentine and Venetian Painting of the Cinquecento," in S. Bertelli, C. H. Smyth, N. Rubinstein, eds., *Florence and Venice: Comparisons and Relations* (Florence: Olschki, 1977).

For Dolce and his dialogue, see Dolce's *"Aretino" and Venetian Art Theory of the Cinquecento*, ed. and trans. Mark W. Roskill (New York: New York University Press, 1968). On the relationship between artistic and literary polemics, see Fredrika H. Jacobs, "Aretino and Michelangelo, Dolce and Titian: Femmina, Masculo, Grazia," *Art Bulletin* 82 (2000), 51–67, and Una Roman d'Elia, *The Poetics of Titian's Religious Paintings* (Cambridge and New York: Cambridge University Press, 2005).

On the *poesie* for Philip II, the most even-handed account is Thomas Puttfarken, *Titian and Tragic Painting* (New Haven, CT, and London: Yale University Press, 2005). On the question of gender and movement in Titian's *Venus and Adonis*, Sharon Fermor, "Poetry in Motion: Beauty in Movement and the Renaissance Concept of *leggiadrìa*," in *Concepts of Beauty in Renaissance Art*, ed. F. Ames Lewis and M. Rogers (Aldershot, UK: Ashgate, 1998), 124–34.

On Tintoretto, see Rosand, *Painting in Sixteenth-Century Venice (see above)*, as well as Tom Nichols, *Tintoretto: Tradition and Identity* (London: Reaktion, 1999), and the catalog *Tintoretto*, ed. Miguel Falomir (Madrid: Prado, 2007); for the competition between Titian and Tintoretto, see Frederick Ilchman, *Titian, Tintoretto, Veronese: Rivals in Renaissance Venice* (Boston, MA: Museum of Fine Arts, 2009).

On the manufacture of tapestries in Florence, see Graham Smith, "Cosimo I and the Joseph Tapestries for Palazzo Vecchio," *Renaissance and Reformation* 6 (1982), 183–96, and the relevant entries in the catalogue by Thomas P. Campbell, *Tapestry in the Renaissance: Art and Magnificence* (New York: Metropolitan Museum of Art; New Haven, CT, and London: Yale University Press, 2002). For an account with good photographs of the Farnese casket,

see Christina Riebesell, "La cassetta Farnese," in *I Farnese. Arte e collezionismo. Studi*, ed. Lucia Fornari Schianchi (Milan: Electa, 1995), 58–69.

On the Villa Giulia and Casino of Pius IV, see David Coffin, *The Villa in the Life of Renaissance Rome* (Princeton, NJ: Princeton University Press, 1979), and Graham Smith, *The Casino of Pius IV* (Princeton, NJ: Princeton University Press, 1977).

For the Uffizi and other large-scale projects undertaken for Cosimo de' Medici, see H. T. Van Veen, *Cosimo de' Medici and His Self-Representation in Florentine Art and Culture* (Cambridge: Cambridge University Press, 2006). Leon Satkowski, *Giorgio Vasari: Architect and Courtier* (Princeton, NJ: Princeton University Press, 1994), includes a good introduction in English to the architecture of the Uffizi. On the Laurentian Library, see the discussion in James S. Ackerman, *The Architecture of Michelangelo* (Chicago, IL: University of Chicago Press, 1986). Ammanati's role in completing the vestibule is sometimes overlooked, though not by William Wallace, *Michelangelo at San Lorenzo: The Artist as Entrepreneur* (Cambridge and New York: Cambridge University Press, 1994).

Morten Steen Hansen's impressive *In Michelangelo's Mirror: Perino del Vaga, Daniele da Volterra, Pellegrino Tibaldi* (University Park, PA: Penn State University Press, 2013) informed our discussion of those artists' projects in the 1550s. On Daniele da Volterra, see also Paul Barolsky, *Daniele da Volterra: A Catalogue Raisonné* (New York: Garland, 1979), and the catalog of the exhibition *Daniele da Volterra amico di Michelangelo*, ed. Vittoria Romani (Florence: Mandragora, 2003); for his work at Santissima Trinità dei Monti, see Carolyn Valone, "Elena Orsini, Daniele da Volterra, and the Orsini Chapel," *Artibus et Historiae* 11 (1990), 79–87, and *idem*, "The Art of Hearing: Sermons and Images in the Chapel of Lucrezia della Rovere," *Sixteenth-century Journal* 31 (2000), 753–777; for the destroyed stuccoes, see David Jaffé, "Daniele da Volterra's Satirical Defense of his Art," *Journal of the Warburg and Courtauld Institutes* 54 (1991), 247–252. The most comprehensive account in English of Pellegrino Tibaldi's frescoes in Palazzo Poggi is in

Kliemann and Rohlmann, *Italian Frescoes* (see chapter 13 above).

On Italian artists active in Central Europe, see Thomas DaCosta Kaufmann, *Court, Cloister, and City: The Art and Culture of Central Europe, 1450–1800* (London: Weidenfeld & Nicolson, 1995). On Sofonisba Anguissola, the essential literature now is in Italian and German, but see Mary D. Garrard, "Here's Looking at Me: Sofonisba Anguissola and the Problem of the Woman Artist," *Renaissance Quarterly* 47 (1994), 556–622; Fredrika Jacobs, *Defining the Renaissance virtuosa: Women Artists and the Language of Art History and Criticism* (Cambridge and New York: Cambridge University Press, 1997); and Joanna Woods Marsden, *Renaissance Self-Portraiture: The Visual Construction of Identity and the Social Status of the Artist* (New Haven, CT, and London: Yale University Press, 1998). For the Leoni, we relied especially on the catalog to the exhibition *Los Leoni (1509–1608): escultores del Renacimiento italiano al servicio de la corte de España*, ed. Jesús Urrea (Madrid: El Museo, 1994), and Eugène Plon's still indispensable *Leone Leoni, sculpteur de Charles-Quint, et Pompeo Leoni, sculpteur de Philippe II* (Paris: Plon, Nourrit & Cie, 1887).

An excellent and comprehensive survey of printmaking in late Renaissance Italy is provided by Michael Bury, *The Print in Italy 1550–1620* (London: British Museum Press, 2001). On the adaptation of Raphael and other artists by printmakers, see Jeremy Wood, "Cannibalized Prints and Early Art History: Vasari, Bellori and Fréart de Chambray on Raphael," *Journal of the Warburg and Courtauld Institutes* 51 (1988), 210–20. For Ghisi, see Bury's "On Some Engravings by Giorgio Ghisi Commonly Called 'Reproductive,'" *Print Quarterly* 10 (1993), 4–19, as well as Suzanne Boorsch et al, *The Engravings of Giorgio Ghisi* (New York: Metropolitan Museum of Art, 1985). On the means printmakers developed for translating color into line, see especially Walter S. Melion, "*Vivae Dixisses Virginis Ora*: The Discourse of Color in Hendrick Goltzius's *Pygmalion and the Ivory Statue*," *Word & Image* 17 (2001), 153–76 and the same author's "Hendrick Goltzius's Project of Reproductive Engraving," *Art History* 13 (1990), 458–87.

Chapter 18: 1560–1570

For a summary of sixteenth-century disputes concerning sacred art, see Giuseppe Scavizzi, *The Controversy on Images from Calvin to Baronius* (New York: Peter Lang, 1992). On Moroni, see the catalog *Giovanni Battista Moroni: Renaissance Portraitist* (Fort Worth, TX: Kimball Museum, 2001). On Moroni, Moretto, and other Lombard painters, the best source in English is Nicholas Penny, *National Gallery Catalogues: The Sixteenth-century Italian Paintings Vol. 1: Paintings from Bergamo, Brescia, and Cremona* (London: National Gallery, 2004). On Rota and reformist responses to the *Last Judgment*, Bernardine Barnes, *Michelangelo's Last Judgment: The Renaissance Response* (Berkeley, CA: University of California Press, 1998); Barnes, "Aretino, the Public, and the Censorship of Michelangelo's *Last Judgment*," in *Suspended License: Censorship and the Visual Arts*, ed. Elizabeth C. Childs (Seattle, WA: University of Washington Press, 1997); and, specifically on prints, Barnes, *Michelangelo in Print: Reproductions as Response in the Sixteenth Century* (Farnham: Ashgate, 2010).

Our dating of Vittoria's projects follows that of Lorenzo Finocchi Ghersi, *Alessandro Vittoria: Architettura, scultura e decorazione* (Udine: Forum, 1998). Vittoria's words about the *Sebastian/Marsyas* are cited in Manfred Leithe-Jasper's very useful entry on the bronze in *La bellissima maniera: Alessandro Vittoria e la scultura veneta del Cinquecento*, ed. Andrea Bacchi, Lia Camerlengo, and Manfred Leithe-Jasper (Trent: Servizio beni culturali, 1999), 342–45.

For the Jesuits and the production of art, see Gauvin A. Bailey, *Between Renaissance and Baroque: Jesuit Art in Rome, 1565–1610* (Toronto: University of Toronto Press, 2003). On the Farnese and the building of the Gesù, Clare Robertson, *Il gran cardinale: Alessandro Farnese, Patron of the Arts* (New Haven, CT, and London: Yale University Press, 1992), and the review by Walter Melion in *Art Bulletin* 77 (1995), 324–27; James Ackerman, "The Gesù in the Light of Contemporary Church Design," in Rudolf Wittkower and Irma B. Jaffe, eds., *Baroque Art: The Jesuit Contribution* (New York: Fordham University Press, 1972), 15–28, remains important as well.

Robertson also deals with Caprarola, as does Coffin, *The Villa in the Life of Renaissance Rome* (see chapter 17 above); Loren Partridge provides a detailed account of the Zuccari's historical frescoes in "Divinity and Dynasty at Caprarola: Perfect History in the Room of the Farnese Deeds," *Art Bulletin* 60 (1978), 494–530.

The standard English-language introduction to the Italian Renaissance garden is Claudia Lazzaro, *The Italian Renaissance Garden* (New Haven, CT, and London: Yale University Press, 1990), which has a chapter on Bagnaia and also discusses a number of the other gardens and garden sculptures mentioned in this book.

On Palladio, the best places to start are the short survey by James S. Ackerman, *Palladio* (London: Penguin, 1967), the catalogue *Palladio*, ed. Guido Beltramini and Howard Burns (New York: Abrams, 2008), and Bruce Boucher, *Andrea Palladio: The Architect in His Time* (New York: Abbeville, 1998). On Veronese at Villa Barbaro, see Richard Cocke, "Veronese and Daniele Barbaro: The Decoration of Villa Maser," *Journal of the Warburg and Courtauld Institutes* 35 (1972), 226–46, and Kliemann and Rohlmann, *Italian Frescoes* (as in chapter 13 above).

There is no substantial study in English of Bomarzo and its patron. We drew especially on Horst Bredekamp, *Vicino Orsini und der heilige Wald von Bomarzo: Ein Fürst als Künstler und Anarchist* (Worms: Werner, 1985).

The late Richard J. Tuttle was the authority on Giambologna's Neptune Fountain; his posthumous monograph is *The Neptune Fountain in Bologna: Bronze, Marble, and Water in the Making of a Papal City* (London: Harvey Miller, 2015).

Vasari's revisions between the 1550 and 1568 *Lives* are treated by Patricia Rubin, *Giorgio Vasari: Art and History* (New Haven, CT, and London: Yale University Press, 1994). The best general account in English of the early history of the Accademia del Disegno is Karin-edis Barzman, "The Università, Compagnia ed Accademia del Disegno," (PhD dissertation, Johns Hopkins University, 1986); Barzman later published a quite different book under the title *The Florentine Academy and the Early Modern State* (Cambridge and New York: Cambridge University Press, 2001). The standard reference for readers of Italian is Zygmunt Waźbiński, *L'Accademia Medicea del Disegno a Firenze nel Cinquecento: idea e istituzione* (Florence: Olschki, 1987). For Cellini's *Crucifix*, see Cole, *Cellini and the Principles of Sculpture*, and Lavin, "The Sculptor's 'Last Will and Testament,'" (as in chapter 16 above); our lines here on the poetry around it condense the argument in Cole, "Cellinis Grabmal – Poetik und Publikum," in Joachim Poeschke et al., ed., *Praemium virtutis: Grabmonumente und Begräbniszeremoniell im Zeichen des Humanismus* (Münster: Rhema, 2002), 175–89. On the other sculptures discussed in this and the following chapters, see Michael Cole, *Ambitious Form: Giambologna, Ammanati, and Danti in Florence* (Princeton: Princeton University Press, 2011), with further references. Michael Cole and Diletta Gambernini, "Vincenzo Danti's Deceits," *Renaissance Quarterly* 26 (2016), 1296–1342, reidentify the subject matter of the Bargello allegory. For Vasari's renovations of the Mendicant churches, see Marcia Hall, *Renovation and Counter-Reformation: Vasari and Duke Cosimo in Sta Maria Novella and Sta Croce, 1565–1577* (Oxford and New York: Oxford University Press 1979). For a more extended treatment of the argument about Bronzino's last fresco as a riposte to Michelangelo's critics, see Stephen J. Campbell, "Bronzino's *Martyrdom of St. Lawrence* in San Lorenzo," *RES* 46 (2004): *Polemical Objects*, 96–119.

Chapter 19: 1570–1580

On Bishop Gabriele Paleotti and his treatise, see Pamela A. Jones, "Art Theory as Ideology: Gabriele Paleotti's Hierarchical Notion of Painting's Universality and Reception," *Reframing the Renaissance: Visual Culture in Europe and Latin America, 1450-1650*, ed. Claire Farago (New Haven, CT, and London: Yale University Press, 1995), 127–323. Luise Leinweber's *Bologna nach dem Tridentinum: private Stiftungen und Kunstaufträge im Kontext der katholischen Konfessionalisierung* (Hilderheim: Olms, 2000) informed our reading of Fontana's *St. Alexius Distributing Alms*. Evelyn Carole Volker's doctoral dissertation (New York: Garland, 1977) provides a translation and commentary

on Carlo Borromeo's *Instructiones fabricae et supellectilis ecclesiasticae.*

A standard reference on the Veronese trial is Philipp Fehl, "Veronese and the Inquisition: A Study of the Subject Matter of the So-Called 'Feast in the House of Levi,'" *Gazette des beaux-arts* 103 (1961), 325–54.

For the Counter-Reformation and art in Venice more broadly, see Peter Humfrey, "Altarpieces and Altar Dedications in Counter Reformation Venice and the Veneto," *Renaissance Studies* 10 (1996), 371–87. On the church of the Redentore, see Tracey Cooper, *Palladio's Venice: Architecture and Society in a Renaissance Republic* (New Haven, CT, and London: Yale University Press, 2007).

On Federico Barocci, see Stuart Lingo, *Federico Barocci: Allure and Devotion in Late Renaissance Painting* (New Haven, CT, and London: Yale University Press, 2008). On the Campi, Bram de Klerck, *The Brothers Campi: Images and Devotion: Religious Painting in Sixteenth-century Lombardy* (Amsterdam: University of Amsterdam Press, 1999). For San Rocco, see Nichols, *Tintoretto: Tradition and Identity* (as in chapter 17 above). The best access to the literature on the Oratory of the Gonfalone is Nerida Newbigin, "Decorum of the Passion: The Plays of the Confraternity of the Gonfalone in the Roman Colosseum, 1490–1539," *Confraternities and the Visual Arts in Renaissance Italy: Ritual, Spectacle, Image*, ed. Barbara Wisch and Diane Cole Ahl (Cambridge and New York: Cambridge University Press, 2000).

On the dome of St. Peter's, see *The Renaissance from Brunelleschi to Michelangelo: The Representation of Architecture*, ed. Henry A. Millon and Vittorio Magnago Lampugnani (Milan: Bompiani, 1994). No publication within the now-large literature on Rome's fountains and waterworks can yet replace Cesare D'Onofrio, *Le fontane di Roma* (Rome: Staderini, 1962); the most recent book in English is Katherine Wentworth Rinne, *The Waters of Rome: Aqueducts, Fountains, and the Birth of the Baroque City* (New Haven, CT: Yale University Press, 2011).

For Bassano, *Jacopo Bassano c. 1510–1592*, ed. Beverly Louise Brown and Paola Marini (Fort Worth, TX: Kimbell Art Museum, 1993). On

the rise of genre painting in Italy, see especially Tom Nichols, *The Art of Poverty: Irony and Ideal in Sixteenth-century Beggar Imagery* (Manchester: Manchester University Press, 2007); also Sheila McTighe, "Foods and the Body in Italian Genre Paintings, about 1580: Campi, Passarotti, Carracci," *Art Bulletin* 86 (2004), 301–23.

The key documents relating to the *Studiolo* of Francesco I are collected in Ettore Allegri and Alessandro Cecchi, *Palazzo Vecchio e i Medici* (Florence: SPES, 1980). The best discussion in English is Scott J. Schaefer's unpublished doctoral dissertation, "The Studiolo of Francesco I de' Medici in the Palazzo Vecchio in Florence," Bryn Mawr College, 1976. Larry Feinberg provides a shorter and more accessible overview in "The Studiolo of Francesco I Reconsidered," in *The Medici, Michelangelo, and the Art of Late Renaissance Florence* (New Haven, CT, and London: Yale University Press, in association with the Detroit Institute of Arts, 2002), 47–65.

Chapter 20: 1580–1590

The essential study of the Renaissance grotto is Philippe Morel, *Les grottes maniéristes en Italie au XVIème siècle: théâtre et alchimie de la nature* (Paris: Macula, 1998), partially translated in Cole, *Sixteenth-century Italian Art* (see chapter 15 above).

On the Carracci, see Charles Dempsey, *Annibale Carracci and the Beginnings of Baroque Style*, 2nd edn. (Florence: Cadmo, 2000); Anton W. Boschloo, *Annibale Carracci in Bologna: Visible Reality in Art after the Council of Trent* (New York: Schram, 1974); and Clare Robertson, *The Invention of Annibale Carracci* (Milan: Electa, 2008). For Ludovico Carracci, see the catalog by Gail Feigenbaum, *Ludovico Carracci, 1555–1619* (Fort Worth, TX: Kimball Art Museum, 1993). Essential also for Bolognese art in this period is *The Age of Correggio and the Carracci: Emilian Painting in the Sixteenth and Seventeenth Centuries* (Washington, D.C.: National Gallery of Art, 1986). Our reading of the Lavinia Fontana portrait develops that in the introductory chapter of Michael Cole and Mary Pardo, eds., *Inventions of the Studio, Renaissance to Romanticism* (Chapel Hill, NC: University of North Carolina Press, 2004).

On Varallo, see Alessandro Nova, "Popular Art in Renaissance Italy: Early Response to the Holy Mountain at Varallo," in *Reframing the Renaissance*, ed. Farago (as in chapter 19 above). All studies of the early maps of Rome rely on Amato Pietro Frutaz, *Le piante di Roma* (Rome: Istituto di studi romani, 1962), the beautiful plates of which can be enjoyed even by those who do not read Italian. Francesca Fiorani's excellent *The Marvel of Maps: Art, Cartography, and Politics in Renaissance Italy* (New Haven, CT, and London: Yale University Press, 2005) discusses the Vatican Hall of Maps at length. On urbanism in late sixteenth-century Rome, see Sigfried Giedion's great *Space, Time, and Architecture: The Growth of a New Tradition* (Cambridge, MA: Harvard University Press, 1941).

The best general English-language discussion of Sixtus's use of obelisks is Erik Iversen, *Obelisks in Exile* (Copenhagen: Gad, 1968). The reading presented here rehearses Michael Cole, "Perpetual Exorcism in Sistine Rome," in Michael Cole and Rebecca Zorach, eds., *The Idol in the Age of Art: Objects, Devotions, and the Early Modern World* (Aldershot, UK: Ashgate, 2009), 57–76. The quotes relating to Giambologna's *Sabine* come from Elisabeth Dhanens, *Jean Boulogne / Giovanni Bologna Fiammingo* (Brussels: Paleis der Académiën, 1956), and Raffaello Borghini, *Il Riposo* (Hildesheim: G. Olms, 1969); Lloyd H. Ellis Jr. has published a partial English translation of Borghini under the title *Borghini's Riposo* (Toronto: University of Toronto Press, 2007). On the subject(lessness) of the statue, see Michael Cole, "Giambologna and the Sculpture with No Name," *Oxford Art Journal* 32 (2009), 337–60.

Chapter 21: 1590–1600

For accounts of additional projects of Early Christian archeology and renovation, see Alexandra Herz, "Cardinal Cesare Baronio's Restoration of SS. Nereo ed Achilleo and S. Cesareo de'Appia," *Art Bulletin* 70 (1988), 590–620, and *idem*, "Imitators of Christ: The Martyr Cycles of Late Sixteenth-century Rome Seen in Context," *Storia dell'arte* 62 (1988), 53–70; and Irina Oryshkevich's magisterial but unpublished dissertation, "The History of the

Roman Catacombs from the Age of Constantine to the Renaissance," (Columbia University, 2003).

Little of the fundamental literature on Stefano Maderno is in English, but see Tobias Kämpf, "Framing Cecilia's Sacred Body: Cardinal Camillo Sfondrati and the Language of Revelation," *Sculpture Journal* 6 (2001), 10–20. On Catarina Sforza, Carolyn Valone, "Women on the Quirinal Hill: Patronage in Rome, 1560–1640," *Art Bulletin* 76 (1994), 129–46, with further references.

On Procaccini as an etcher, see the important catalog edited by Sue Welsh Reed and Richard Wallace, *Italian Etchers of the Renaissance and Baroque* (Boston, MA: Northeastern University Press, 1989). Among the few helpful published studies in English of Florentine painting at the end of the sixteenth century is is Jack Spalding, "Santi di Tito and the Reform of Florence

Mannerism," *Storia dell'arte* 47 (1983), 41–52. On the Roman patronage system, see Francis Haskell, *Patrons and Painters: A Study in the Relations between Italian Art and Society in the Age of the Baroque* (London: Chatto & Windus, 1963). On sculpture and urbanism in Tuscany, see Michael Cole, *Ambitious Form* (cited above). On the Medici collecting of New World objects, see Lia Markey, *Imagining the Americas in Medici Florence* (University Park, PA: Penn State University Press, 2016).

Michael Fried discusses the new pre-eminence of the gallery picture in *The Moment of Caravaggio* (Princeton, NJ: Princeton University Press, 2010). On the Farnese Gallery, see Charles Dempsey, *Annibale Carracci, the Farnese Gallery, Rome* (New York: George Braziller, 1995).

On Zuccaro as art theorist, see Robert Williams, *Art, Theory, and Culture in Sixteenth-*

century Italy (as in chapter 17 above). Our attention to the Chapel of the Angels follows Kristina Herrmann-Fiore, "Gli angeli, nella teoria e nella pittura di Federico Zuccari," in Bonita Cleri, ed., *Federico Zuccari: le idée, gli scritti* (Milan: Electa, 1997), 89–110. For Federico Borromeo, see Pamela Jones, "Federico Borromeo as a Patron of Landscapes and Still Lifes: Christian Optimism in Italy ca. 1600," *Art Bulletin* 70 (1988), 261–72. Within the vast literature on Caravaggio, we would single out the monograph of Howard Hibbard (London: Thames & Hudson, 1983); the biography by Helen Langdon (London: Chatto & Windus, 1998); and Fried, *The Moment of Caravaggio* (see under the pre-eminence of the gallery picture, above). Steven Ostrow and Conrad Rudolph make a case against the conventional identification of the subject of Caravaggio's *St. John the Baptist* in "Isaac Laughing: Caravaggio, Non-traditional Imagery, and Traditional Identification," *Art History* 24 (2001) 646–81.

Sources of Quotations

Introduction

p. 12: Ghiberti from complete translation of Ghiberti's second *Commentary*, in *Italian Art 1400–1500: Sources and Documents*, ed. Creighton Gilbert (Englewood Cliffs, NJ: Prentice Hall, 1980), 75–88.

Chapter 1

p. 25: Giovanni Pisano inscription from Joachim Poeschke, *Die Skulptur des Mittelalters in Italien* (Munich: Hirmer, 1998), vol. 2, 118.

pp. 26, 27, 38, 53: Ghiberti from Creighton Gilbert, cit. 75–88.

pp. 34–36: On Duccio's *Maestà*, from ibid., 55.

p. 39: Most of the Italian and Latin Simone Martini inscriptions are clearly documented in Andrew Martindale, *Simone Martini: Complete Edition* (New York: New York University Press, 1988), catalog no. 35, 204–09. Our English translations follow C. Jean Campbell, *The Commonwealth of Nature* (University Park, PA: Pennsylvania State University Press, 2008), 67–71.

p. 48: Lorenzetti inscription from *Siena, Florence and Padua. Art, Society and Religion 1280–1400*, 2 vols., ed. Diana Norman (New Haven, CT, and London: Yale University Press, 1995), II, 167.

p. 56: Giovanni Villani from Richard C. Trexler, *Public Life in Renaissance Florence* (Ithaca, NY, and London: Cornell University Press, 1980), 217.

p. 56: Benvenuto da Imola from Millard Meiss, *Painting in Florence and Siena after the Black Death: The Arts, Religion and Society in the Mid-Fourteenth Century* (New York, Evanston, and London: Harper Torchbooks, 1951), 5.

Chapter 2

p. 68: On the duomo 1296 from Margaret Oliphant, *Makers of Florence: Dante, Giotto, Savonarola and their City* (London: Macmillan, 1897), p. 103; translation modified, based on the Italian citation in Emanuele Repetti, *Notizie e guida di Firenze e d' suoi contorni* (Florence: Guglielmo Piatti, 1841), 330.

Chapter 3

p. 94: On Lorenzo Monaco's *Coronation* from George R. Bent, "A Patron for Lorenzo Monaco's Uffizi Coronation of the Virgin," *Art Bulletin* 82 (2000), 348–54, quoted passage on 348.

Chapter 4

p. 105: Ghiberti from *A Documentary History of Art Vol. 1: The Middle Ages and the Renaissance*, ed. Elizabeth Gilmore Holt (Princeton, NJ: Princeton University Press, 1981), 161.

p. 114: Vasari on Masaccio from Vasari, *Lives of the Painters, Sculptors and Architects*, trans. Gaston de Vere, 2 vols. (London: Everyman's Library, 1996 [originally 1916]), I, 317.

Chapter 5

p. 125: Cennino from *The Craftsman's Handbook. "Il Libro dell'Arte." Cennino d'Andrea Cennini*, trans. Daniel Thompson, Jr. (New York: Dover, 1960), 8 and 3.

p. 130: Alberti from Leon Battista Alberti, *On Painting and on Sculpture. The Latin Texts of De Pictura and De Statua*, ed. and trans. Cecil Grayson (London: Phaidon, 1972), 79 and 97.

Chapter 6

p. 144: Antonino from Creighton Gilbert, "The Archbishop on the Painters of Florence, 1450," *Art Bulletin*, 41 (1959), 75–85.

p. 159: Bruni epitaph from John Pope-Hennessy, *Italian Renaissance Sculpture* (New York: Vintage, 1985), 278.

p. 163: Epigram from Christine Sperling, "Donatello's Bronze *David* and the Demands of Medici Politics," *Burlington Magazine* 134 (1992), 218.

p. 164: Inscription from Pope-Hennessy, cit. 265.

p. 187: Filarete from *Filarete's Treatise on Architecture: Being the Treatise by Antonio di Piero Averlino, Known as Filarete*, 2 vols., ed. and trans. John R. Spencer (New Haven, CT: Yale University Press, 1965), I fol. 179r.

Chapter 7

p. 190: Manuel Chrysorolas from Christine Smith, *Architecture in the Culture of Early Humanism: Ethics, Aesthetics, and Eloquence, 1400–1470* (New York: Oxford University Press, 1992), 199–215.

pp. 193–94: Manetti from Ludwig Von Pastor, *The History of the Popes from the Close of the Middle Ages* (London: Kegan Paul, Trench, Trübner, and Co., 1901), II, 166.

p. 201: Pius II from *Memoirs of a Renaissance Pope: The Commentaries of Pius II*, trans. Florence A. Gragg (New York: Putnam, 1959), Book II, 110; and from Pope Pius II, *Commentaries*, 2 vols., ed. and trans. Margaret Meserve and Marcello Simonetta (Cambridge, MA: Harvard University Press, 2003), I, 329.

p. 205: Virgil from *Aeneid* IV, 238–59, in *Virgil*, 2 vols., trans. H. Rushton Fairclough (London: Heinemann, 1916), I, 413.

p. 213: Pius II from Gragg, cit. Book IX, 287.

p. 215: Alberti from Leon Battista Alberti, *On the Art of Building in Ten Books*, trans. Joseph Rykwert with Neil Leach and Robert Tavernor (Cambridge, MA: MIT Press, 1991), 5, 120, 155, 195, 242.

Chapter 8

p. 225: Picatrix from authors' translation of *Picatrix* II xi, 75–76. *In Picatrix: the Latin version of the Ghāyat al-ḥakīm*, ed. David Pingree (London: Warburg Institute, 1986).

p. 228: Filarete from Spencer, cit. I, 176.

p. 233: Florentine ambassador from Evelyn Welch, "Galeazzo Maria Sforza and the Castello di Pavia, 1469," *Art Bulletin* 71 (1989), 352–75, at 362.

Chapter 9

p. 248: de Holanda from Francisco de Holanda, *Four Dialogues on Painting*, trans. Aubrey F. G. Bell (Westport, MA: Hyperion Press: 1928), 15–16.

p. 252: Facio from Michael Baxandall, "Bartholomaeus Facius on Painting," *Journal of the Warburg and Courtauld Institutes* 27, 102.

Chapter 10

p. 273: Filarete from Spencer, cit. I, 320.

p. 287: Dedicatory inscription from Alison Wright, *The Pollaiuolo Brothers: The Arts of Florence and Rome* (New Haven, CT, and London: Yale University Press, 2005), 360.

p. 296: Leonardo from Edward McCurdy, *The Notebooks of Leonardo da Vinci* (London: Duckworth, 1906), 1152.

Chapter 11

p. 305: Isabella d'Este from Stephen J. Campbell, *The Cabinet of Eros: Renaissance Mythological Painting and the Studiolo of Isabella d'Este* (New Haven, CT, and London: Yale University Press, 2006) 174–75.

p. 311: Savonarola from *Creighton Gilbert*, cit. 157; slightly modified with reference to the original text.

p. 322: Alberti from Grayson, cit. 75.

p. 330: Leonardo from original text in Carmen Bambach, *Leonardo da Vinci, Master Draftsman* (New York: Metropolitan Museum of Art, 2003), 401–03.

p. 330: Leonardo from Claire Farago, *Leonardo da Vinci's Paragone* (Leiden: Brill, 1991), 215, 213.

p. 336: Bandello from authors' translation from the dedication to novella 58 in Matteo Bandello's *Le Novelle*, cited in Martin Kemp, *Leonardo da Vinci: The Marvelous Works of Nature and Man* (Cambridge, MA: Harvard University Press, 1981), 80.

Chapter 12

pp. 352–53: Leonardo from McCurdy, cit. 84.

p. 353: On a Florentine lady from Antonio de'Beatis, quoted in Martin Kemp, *Leonardo da Vinci: The Marvelous Works of Nature and Man* (London: J. M. Dent, 1981), 268.

p. 361: On de'Conti from Pastor, cit. VI, 479.

p. 364: Michelangelo from Michelangelo Buonarroti, *The Poems*, trans. Christopher Ryan (London: J. M. Dent, 1996), 201.

p. 377: Hesiod, *Theogony* (II: 29–35) from *Hesiod: Theogony, Works and Days, Testimonia*, ed. and trans. Glenn Most (Cambridge, MA: Harvard University Press, 2006), 5.

pp. 380–81: Dürer from *The Literary Remains of Albrecht Dürer*, ed. and trans. William Martin Conway (Cambridge: Cambridge University Press, 1889), 55.

Chapter 13

p. 415: Vasari on Rosso from de Vere, cit. I, 899.

Chapter 14

p. 435: Sebastiano del Piombo quotation from authors' translation from *Il Carteggio di Michelangelo*, 5 vols., ed. Giovanni Poggi with Paola Barocchi and Renzo Ristori (Florence: Sansoni, 1965–83), II, 314.

p. 450: On the Sack of Rome from André Chastel, *The Sack of Rome, 1527* (Princeton: Princeton University Press, 1983), 91.

Chapter 15

pp. 465–66: Michelangelo from Ryan, cit. 201.

p. 466: Michelangelo from ibid.

p. 479: Cellini's dream from *The Life of Benvenuto Cellini*, trans. Robert Henry Hobart Cust (London: Bell, 1910), I, 318–19.

Chapter 16

p. 482: Vasari from de Vere, cit. I, 621.

p. 489: Michelangelo from Ryan, cit. 201.

p. 491: Michelangelo from ibid.

Chapter 17

p. 514: Doni from Catherine E. King, *Representing Renaissance Art c. 1500–c. 1600* (Manchester: Manchester University Press, 2007), 71.

p. 514: Vasari from de Vere, cit. II, 791.

p. 515: Dolce on Michelangelo from *Dolce's "Aretino" and Venetian Art Theory of the Cinquecento*, ed. and trans. Mark W. Roskill (New York: New York University Press, 1968, rep. University of Toronto Press, 2000), 171, 173.

p. 517: Titian from Charles Hope, *Titian* (New York: Harper and Row, 1980), 125.

p. 540: Ghisi's *The School of Athens* from Jeremy Wood, "Cannibalized Prints and Early Art History: Vasari, Bellori and Fréart de Chambray on Raphael," *Journal of the Warburg and Courtauld Institutes* 51 (1988), 210–20, at 213.

Chapter 18

pp. 544–45: On the character of images in churches from Anthony Blunt, *Artistic Theory in Italy 1450–1660* (Oxford: Oxford University Press, 1940), 110.

p. 548: Gilio in the authors' translation from Giovanni Andrea Gilio da Fabriano, *Due dialogi* (Rome: SPES, 1986 [facsimile of 1564 edition]), 70v.

p. 561: Palladio from James Ackerman, *Palladio* (Harmondsworth: Penguin, 1966), 70.

pp. 564–65: Cesi from Richard Tuttle, *Piazza Maggiore: studi su Bologna nel Cinquecento* (Venice: Marsilio, 2001), 183.

p. 566: Vasari from de Vere, cit. II, 695.

Chapter 19

p. 576: Paleotti from authors' translation from *Scritti d'Arte del Cinquecento*, 3 vols., ed. P. Barocchi (Milano/Napoli: Ricciardi Editore, 1971–77), I, 334.

p. 581: On Veronese and the Inquisition, translation modified from Elizabeth Gilmore Holt, *Literary Sources of Art History* (Princeton, NJ: Princeton University Press, 1947), pp. 245–48. Original Latin and Italian text in Philipp Fehl, "Veronese and the Inquisition: A Study of the Subject Matter of the So-called *Feast in the House of Levi*," *Gazette des Beaux-Arts* 58 (1961), 349–51.

p. 583: Friar quoted from Tracey Cooper, *Palladio's Venice* (New Haven, CT, and London: Yale University Press, 2005), 240.

Chapter 20

p. 606: Virgil's Atlas from Rushton Fairclough, cit. I, 413, cited in Claudia Lazzaro, *The Italian Renaissance Garden* (New Haven, CT, and London: Yale University Press, 1990).

p. 615: Carlo Cesare Malvasia on Ludovico Carracci from *Malvasia's Life of the Carracci*, trans. Anne Summerscale (University Park, PA: Penn State Press, 2000), 127.

Chapter 21

pp. 651 and 651–52: Bellori on Caravaggio from Giovan Pietro Bellori, *The Lives of the Modern Painters, Sculptors and Architects. A New Translation and Critical Edition*, ed. and trans. Alice Sedgwick Wohl, Hellmut Wohl, and Tomaso Montinari (Cambridge: Cambridge University Press, 2005), 180.

Picture Credits

Collections are given in the captions alongside the illustrations.
Key: t=top; b=bottom; r=right; l=left

akg-images 36, 119, 131, 135l, 496r; akg-images/ Maurice Babey 483t; akg-images/Orsi Battaglini 149, 634; akg-images/Cameraphoto 173b; akg-images/De Agostini Picture Library 107t, 537t; akg-images/Electa 236t, 500; akg-images/ Andrea Jemolo 552b; akg-images/Erich Lessing 274l, 532r; akg-images/James Morris 594; akg-images/Rabatti-Domingie 115, 150, 450, 472; Alinari/Bridgeman Art Library 181, 285, 548; Alinari/TopFoto 25tl, 660b; Stefano Amantini/© Atlantide Phototravel/Corbis 21t; Art Archive/Gianni Dagli Orti 579; Photo Art Media/Heritage Images/Scala, Florence 277t; Azoor Photo/Alamy Stock Photo 355; Barber Institute of Fine Arts, University of Birmingham/Bridgeman Art Library 419t; Bridgeman Art Library 69, 173t, 211, 228, 338r, 400b, 473, 477, 573t, 573bl, 573br, 603r, 627, 641t; The Trustees of the British Museum 128t, 656b, 657t; Cameraphoto Arte Venezia/Bridgeman Art Library 444; reproduced by permission of Chatsworth Settlement Trustees/Bridgeman Images 332bl; Michael Cole 76, 562t, 562b, 563t, 563b, 564; A. Dagli Orti/Scala, Florence 503; De Agostini Picture Library/V. Pirozzi 430; De Agostini Picture Library/Scala, Florence 203b, 238t, 552t, 638; Reinhard Dirscherl/Alamy Stock Photo 370b; © John Ferro Sims/Alamy 557br, 558t; Fine Art Images/HIP/TopFoto 55; Fitzwilliam Museum, University of Cambridge, UK/ Bridgeman Images 538, 539; Photo Gabinetto fotografico, Soprintendenza alle gallerie, Florence 110; Giraudon/Bridgeman Art Library 270, 292b, 344r; © David Keith Jones/Alamy 60, 66b; © Maurice Joseph/Alamy 636t; Norma Joseph/Alamy 71b; Ralph Larmann 107bl; Created by Martin Lubikowski 63, 68, 145, 191, 454, 476, 607, 619; Magritte © ADAGP, Paris and DACS, London 2011 14br; Courtesy Father Jacob Maurer 597t; Mondadori Electa/Bridgeman Art Library 446; Museo Civico Medievale, Bologna 43; © Elliot Nichol/Alamy 67l; Photo Opera Metropolitana Siena/Scala, Florence 178l, 178r; Photo Paolo Manusrd 633tr; Reproduced by permission of Penguin Books Ltd (3 diagrams from On Painting by Leon Battista Alberti translated by Cecil Grayson (Penguin Books, 1991) Introduction copyright © Martin Kemp, 1991) 108; Photographic Department, Museo Galileo, Florence 99; © Succession Picasso/DACS, London 2011 15; Private Collection/Bridgeman Art Library 618; Photo Will Pryce from World Architecture: The Masterworks, Thames & Hudson Ltd., London 23; Photo The Print Collector/Heritage-Images/ Scala, Florence 286b; © Sarah Quill/Alamy 497; © Sarah Quill/Bridgeman Art Library 141t, 309, 498; Courtesy Mauro Ranzani/Castello Sforzesco 229b; © Vittoriano Rastelli/Corbis 369br; Photo RMN-Grand Palais (musée du Louvre)/Michèle Bellot 128b; Photo RMN-Grand Palais (Institut de France)/René-Gabriel Ojéda 328t; Royal Collection Trust, Her Majesty Queen Elizabeth II, 2016/Bridgeman Images 327l, 327r, 329; Photo Scala, Florence 9, 20, 45tr, 45b, 49, 24tr, 38, 39, 50, 51, 54, 57, 62, 64, 74, 75tl, 75b, 77, 78tl, 102, 134, 161l, 162, 164tr, 175, 186, 196, 200t, 201, 204, 212, 214, 246, 268, 291, 292t, 312t, 331, 347, 366t, 399, 406t, 406b, 427, 447, 458t, 458b, 483b, 499, 501t, 522b, 523t, 533, 565, 583t, 583b, 599t, 603tl, 604, 614b, 620t, 637, 643, 646, 661t; Photo Scala, Florence s2017 527; Photo Scala, Florence – courtesy the Ministero Beni e Att. Culturali 40, 44, 93, 97, 100, 129, 142, 147, 161r, 163b, 170b, 184, 192, 193, 208b, 261, 300tr, 312b, 346b, 360tl, 360tr, 360bl, 419b, 496l, 526b, 556, 568, 584l, 584r, 609, 615, 659tl; Photo Scala, Florence/BPK, Bildagentur für Kunst, Kultur und Geschichte, Berlin 219, 410t; Photo Scala, Florence/Fondo Edifici di Culto – Min. dell'Interno 25b, 53, 317, 318, 324, 325, 389b, 570l, 577; Photo Scala, Florence/ Mauro Ranzani 67r, 231; Photo Scala, Florence/ Luciano Romano 103, 529; © Gordon Sinclair/ Alamy 631t; Photo Spectrum/Heritage Images/ Scala, Florence 22t; Andreas Solaro/Getty Images 658t; Merilyn Thorold/Bridgeman Art Library 557bl; Drazen Tomic 663r, 664r; Courtesy Mark Tucker, Aronson Senior Conservator of Paintings, Philadelphia Museum of Art 468r; © Robert van der Hilst/Corbis 371b; Eric Vandeville/akg-images 617; © Sandro Vannini/Corbis 144, 323b; Veneranda Biblioteca Ambrosiana/DeAgostini Picture Library/Scala, Florence 328b; Walters Art Museum, Baltimore, USA/Bridgeman Art Library 119t; Ken Welsh/ Bridgeman Art Library 624tl; White Images/ Scala, Florence 25tr, 179b; Yale University Art Gallery/Art Resource, NY/Scala, Florence 574, 590r.

Index

694

D

M

N

W

Z